VERVE

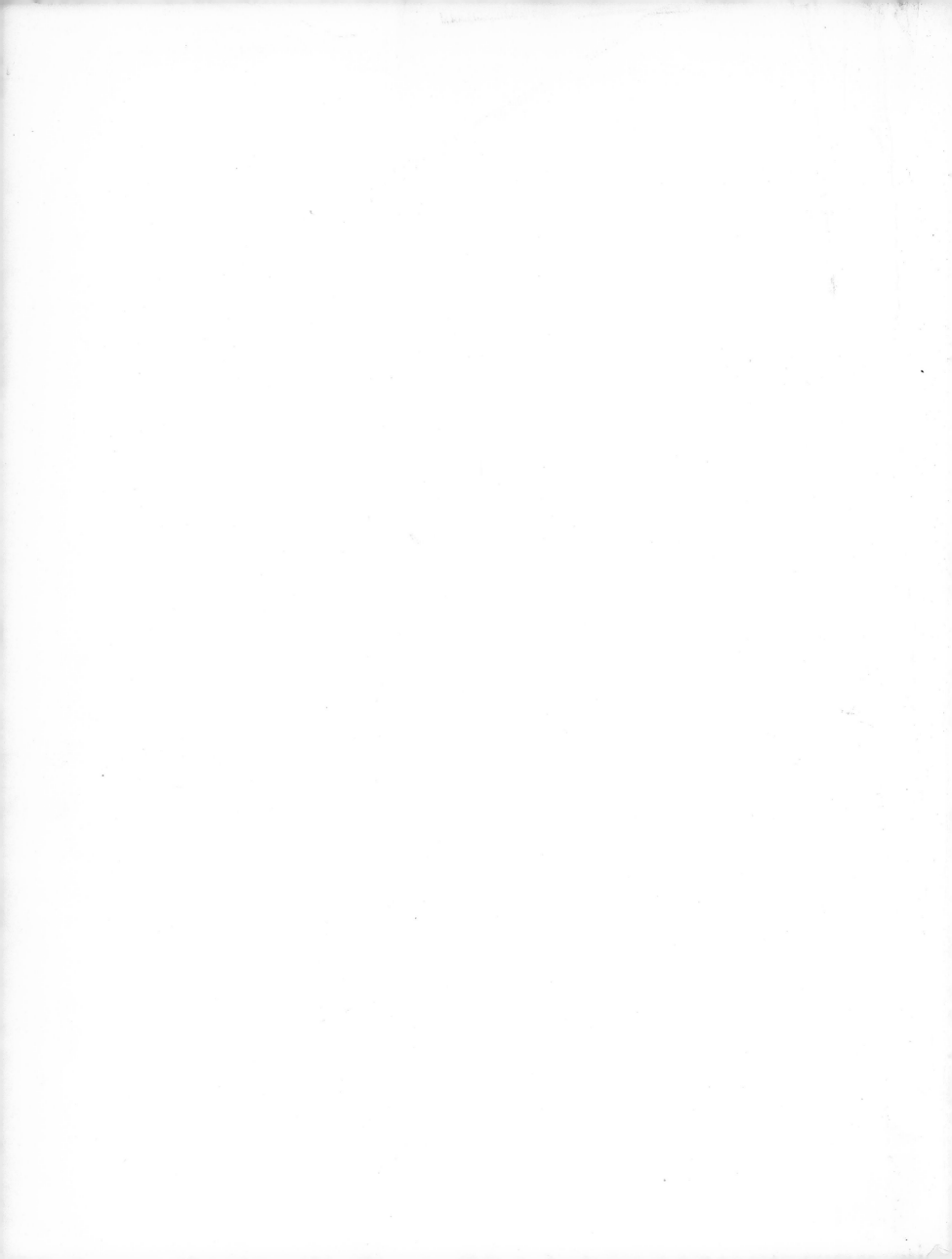

VERVE

Michel
Anthonioz

The Ultimate Review
of Art and Literature (1937–1960)

Harry N. Abrams, Inc., Publishers, New York

Senior Editor: Adele Westbrook
Associate Editor: Carey Lovelace
Layout: Martine Mène
Typography: Maria Miller

Translation Note: The text in this book has been translated from the French by I. Mark Paris
(with the exceptions noted below). For all editions of *Verve* that appeared simultaneously in English, and from
which English-language excerpts have been drawn, the translators are noted as follows: *Verve* No. 1,
Verve No. 2, *Verve* No. 3, *Verve* No. 4, Robert Sage and Stuart Gilbert; *Verve* Nos. 5/6,
Robert Sage and Stuart Gilbert (except Alfred Jarry by I. Mark Paris, since the text in the English-language
edition appeared only in French); *Verve* No. 7, Robert Sage; *Verve* No. 8, Robert Sage and
Stuart Gilbert (except Georges Rouault by I. Mark Paris, since the text in the English-language
edition appeared only in French); *Verve* Nos. 29/30, Robert Sage and Stuart Gilbert

This work represents a study of the history and development of *Verve*,
and a review of its contents. It would obviously be impossible to reproduce in a single volume all of
the material contained in the thirty-eight issues of this magazine. Thus the reader
will find selections taken from the various texts and illustrations that appeared in *Verve* from its first issue in the
Winter of 1937 until its final appearance in the Summer of 1960.

The index, prepared in collaboration with Béatrice Tardif, contains a complete list
of the texts and illustrations published in the various editions of the magazine, listed under the names of
the authors and the artists.

The publishers wish to thank Ruth Nathan, whose idea it was to devote a book to *Verve*.

Library of Congress Cataloging-in-Publication Data

Album Verve. English.
Verve: the ultimate review of art and literature (1937–1960)
Translation of: L'Album Verve.
Bibliography: p. Includes index.
1. Arts. 2. Tériade, E.—Criticism and interpretation. 3. Verve (Paris, France)
I. Anthonioz, Michel, 1947–. II. Verve (Paris, France) III. Title.
NX60.A38 1988 700 88–6385
ISBN 0–8109–1743–2

To Madame Alice Tériade

Contents

TÉRIADE'S OEUVRE

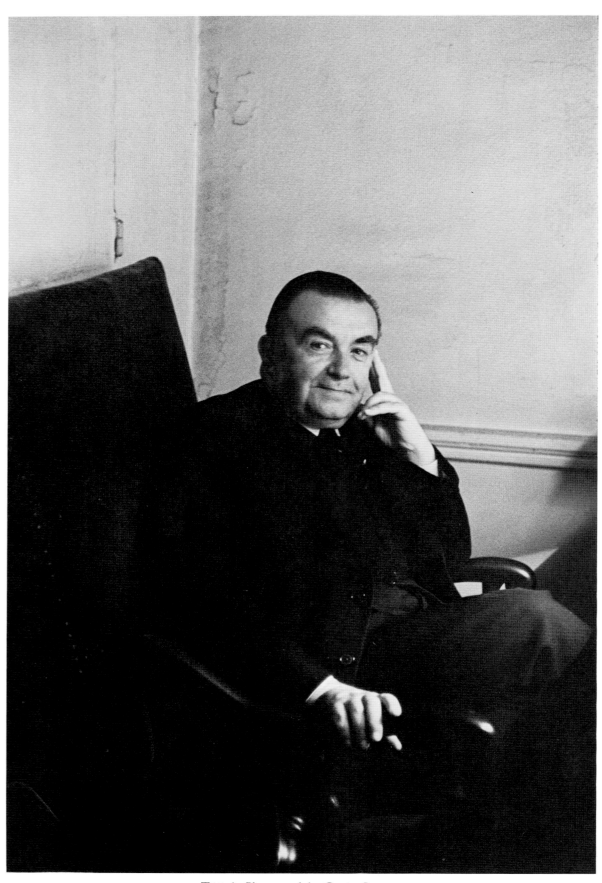

Tériade. Photograph by Cartier-Bresson

Lesbos (1897–1915)

Efstratios Eleftheriades was born May 2, 1897, in Varia, a small village on the outskirts of Mytilene, "capital" of Lesbos. A Greek island legendary for its women, poets, and captivating scenery, Lesbos is the setting for *Daphnis and Chloe*. This was the first of many signs of what lay in store for him: Longus's pastoral romance, whose illustration Tériade would later entrust to Marc Chagall, was to be one of two high points in his publishing career—the other was Matisse's famous *Jazz*.

Tériade (the name he adopted once he had settled permanently in France) was the only son of one of Mytilene's leading citizens. His father owned a small factory that made soap from olive oil, the island's chief natural resource. None of Tériade's relatives or forebears was known as an artist, nor could the influence of any friend or family member be called decisive in planting the seeds of his fascination with painting, or in setting him on the path that would lead to art criticism and publishing.

Young Efstratios was brought up in a cosmopolitan milieu that looked to France as its sole cultural polestar, and followed that country's artistic and intellectual lead. The upper classes of Mytilene, a sprawling trading post centered around a harbor, traveled widely and were more interested in the latest news from Paris than in anything from Athens. They entertained and spoke in French, as a kind of elitist game, and subscribed to *L'Illustration, L'Echo des Modes,* and *La Revue des Deux Mondes.* The fine houses in the fashionable quarter bore a resemblance to those in Neuilly. Chekhov would not have felt at all out of place in this atmosphere.

Mytilene opens onto the Gulf of Izmir; on a clear day you can see the shores of Turkey, Greece's age-old enemy. Time and again, the history of Mytilene has been punctuated by periods of invasion and occupation. However, even if Lesbos may be closer to Istanbul than to Athens as the crow flies, in terms of language, ethnic makeup, religion, culture, and geography, the island lies wholly within the orbit of Greece. In this respect, Mytilene is not unlike those Alsatian villages that cling all the more tenaciously to France the closer they lie to the German border.

However, to gain a true sense of Tériade's childhood and its influence upon him, we must look beyond Mytilene's cosmopolitanism and the island's geographic vulnerability. He must also have been imbued with memories of Lesbos's rusticity: its irrigated gardens, the beauty of its rich, green earth and deep blue skies, its vistas so expansive that one can easily forget it is surrounded by water. Tériade spent his early boyhood in the country, in a square house at the edge of a wonderful olive grove, a patrician, two-story house. On the ground floor, a sitting room faced east; all around the room were long, low benches ready to receive chance visitors who might stop in for some conversation over the traditional sweet and glass of water. In front of the house, and shaded by a trellised vine, the terrace was a natural extension of the sitting room. At dusk the family would gather to dine there, lingering outdoors for hours on end. It was surely no coincidence that the house Tériade would choose years later, in Saint-Jean-Cap-Ferrat (the Villa Natacha), resembled his house in Mytilene. There, on the French Riviera, Tériade and his wife Alice would continue Mytilene's tradition of unstinting hospitality. Except that the guests at the Villa Natacha were the leading artists and writers of their day!

Today, several buildings stand in the middle and at the edge of that olive grove: the Tériade Museum, a vast white structure he and his wife donated to Greece so that his lifework as a publisher might be gathered together and exhibited in one place; the Theophilos Museum, dedicated to that

inspired peasant-painter (another gift from Tériade to his homeland); and a small chapel with a crystal-clear spring.

Beyond the olive trees, terraces of lush orchards and gardens give forth their bounty of fruits and vegetables. Lesbos is not like those rocky, sun-bleached islands tourists flock to the Cyclades to admire. It is a true "region," in the fullest sense of the word, like Perche or Provence—a region famous for the unsurpassed quality of its light. Nowhere is the intense, unfiltered light of the Mediterranean more diaphanous than in Greece. It was this light that shaped the way Tériade looked at things. In 1935, at the request of a friend who arranged "cultural" cruises through the Greek Islands, Tériade published three short pieces in a little magazine (*Voyage en Grèce*) that characterize his view of that land:

"Suddenly, the landscape of Greece began to stir. The ground heaved as mountains broke through the surface everywhere. Forests were born amid the disordered slopes. Rocks as shapely and sleek as statues rose above the chaotic plains, as in mythological times. In the hollow of curving bays, roofs slowly turned white in the light of morning. A Greece bucolic, sylvan, and crepuscular, filled with ancient ruins, golden beaches, and gleaming towns, appeared all at once before the eyes of the traveler. The idealized land, the make-believe Greece of schoolroom imaginings, faded into memory. A Greece of the here and now, palpable and—whether one believes it or not—a Greece always physically the same, revealed itself in all its moving reality, no longer an abstract construction, made of illustrious names and papier-mâché."[1]

In another text, Tériade stressed the importance of light. "Summer light ravages mainland Greece, blots out the islands, obliterates the sea, distorts the sky. No more mountains, no more trees, no more towns, no more water, no more land. Man is enveloped in light, inundated by it, eroded, until there is nothing left but his shadow. But his shadow grows immensely, protected by his sacrifice.

"Resistance to light—therein lies the meaning of Greek architecture. The Parthenon, white on white, clarity on clarity, transparency on transparency, evinces its enigmatic inevitability under an Attic midday sun at its most intense, when only blurred Nereids traverse the bedazzled air.

"At noon, in summer, Greece ceases to exist. It is wiped off all the maps. But in this serene death the world finds a devoutly-desired consummation. This passionate, furious, motionless light makes Greece disappear during the limpid hours of beautiful summer days. But it is restored faithfully every evening, under the artful half-light of dusk and the delicate presence of the moon.

"At night, Greece is itself once more. It reappears on maps—a place of dreams."

These passages on the subject of light (reminiscent of his friend Pierre Reverdy) bear comparison with those Tériade wrote about trees—in particular, about the cultivated varieties. Lesbos is a paradisiacal orchard. Despite the heat, water flows everywhere. (In antiquity, health-conscious Greeks "took the waters" at a spot near Varia where a warm, bubbling spring seethes up from the ground.) Tériade liked to compare his books to gardens—Matisse, Giacometti, and Chagall all drew pictures of the cultivated "jungle" at the Villa Natacha. The tree is the perfect metaphor for artistic creation. With its head in the light and its roots in the water, a tree is a symbolic link between man and nature.

It was in this extensive olive grove and in the orchards surrounding his family home that Tériade experienced his first childhood sensations. In a remarkable text (one which Francis Ponge could have written) entitled simply, "Note on Trees,"[2] we find an echo of those earliest impressions, known to loom so large in the formation of a personality:

"The earth of Greece teems not only with asphodel and flame-like spikes of acanthus. Its shores are covered with tender pine forests and fleshy vines. Its springs bring forth herculean plane trees, like monuments. Its secluded plains shelter orange trees. Its mountains are enveloped in aromatic herbs.

Greece proffers the paradisiacal and familial orchards of its great islands—Corfu, Lesbos, and Crete—as well as those of Thessaly and the Peloponnesus.

"Nowhere does the humanity of fruit trees shine forth as in Greece. Those delicate, retiring formations of dainty boughs, trunks that seem spent from gestation, sparse foliage—the peach tree's curly feathers, the apricot's folded hearts, the fig's hand-like clusters—those trees whose fruit falls with a faint sound at the culmination of a silent blossoming.

"Then there is the olive tree: the tree without a shadow, perfectly adapted to the heat, perfect to the point of indifference; unveiling its smoky whorls beneath the threatening summer skies.

"Greece's venerable black-olive tree looks like a roll of thick cardboard half undone, riddled with holes, bloated, grotesque, covered with cuts and bruises, souvenirs of its confrontations with the wind. It is an old, gentle creature with slender little branches of new life sprouting from its squat head. It is the tree of endurance. Several olive trees together, even thousands of them, lined up across flatlands, scaling cliffs, or crowning mountains, never form a forest. There are no olive tree forests, just as there are no shadows cast by olive trees—or any such thing as a shadowless forest.

"There are, however, fields of olive trees, just as there are wheat fields. And, traversed by light, these groves take on the deep, turbid, silky color of olive oil, the same way wheat fields betoken the color of bread."

As Tériade was developing his keen observations of nature, he was also discovering—in the Parisian fashion magazines to which his parents subscribed—the creations of a world which seemed to him to follow in the footsteps of classical Greece. Fashion attracted him. (Thirty years later, thanks to Pierre Reverdy, he would become friendly with Christian Dior and Coco Chanel; in turn, they would introduce him to David Smart, head of the company that published *Esquire* . . . and future initial backer of *Verve*.) The imaginative designs of the great couturiers, then freeing themselves from the legacy of constraint inherited from the nineteenth century, offered him a glimpse of the kind of creativity he unconsciously longed for. He began to form an idealized image of France.

Tériade read the great classical texts he found in his father's library—Homer, Aesop, Theocritus—and popular French writers, such as Anatole France and Victor Hugo. He thought of Paris as a new Athens, a City of Light that illuminated the world.

In Mytilene, it was customary for a man to ride on a donkey, while women followed behind on foot. That was how young Efstratios returned to Varia each evening, perched on a burro, with a female servant trotting along behind. "I grew up like a Russian prince," he would later observe, with a burst of laughter.

He began painting in secret. Surviving from this period are two little paintings that hung on the wall of the master bedroom of the house at Varia throughout Tériade's life. In the one he valued most, a *Still Life with Pomegranates* (painted when he was fifteen years old), we get an inkling of the Tériade who wrote "Note on Trees." Classical in its composition and treatment, it brings to mind the concise style of the Illuminated Manuscripts he loved so much.

In his mind's eye, Tériade envisioned a group of preeminent artists whose respect for the work of art would bind them into an ideal community. Yet, little space was devoted to painting in *L'Echo des Modes* and *L'Illustration*! His first meaningful contact with painting came through the work of Theophilos, to whom he would later dedicate a museum. This great artist, after having worked as a postman, depended at that time on the charity of prominent families who welcomed him under their roofs and gave him food and shelter. In exchange, he would paint murals on bare plaster or pictures on flimsy, makeshift supports. In those days, such itinerant painters were not uncommon in Greece. Theophilos,

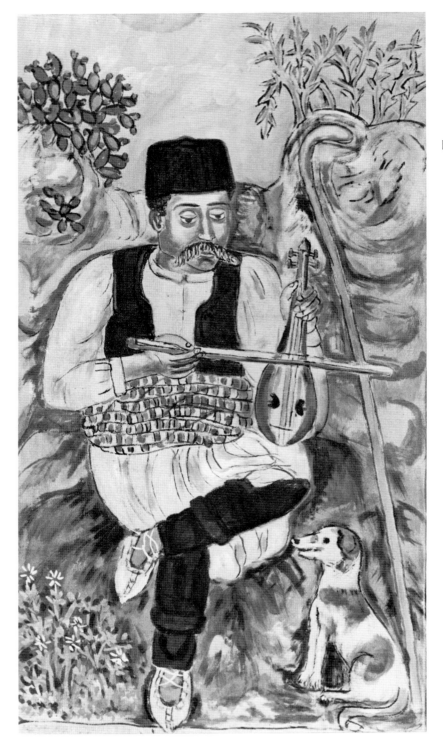

Painting by Theophilos

however, turned out to be one of the most important Greek artists of the first half of the twentieth century.

In time, Tériade would have the good fortune to take Theophilos under his wing and thus acquire much of this artist's later work—all of which Tériade would eventually donate to Greece. It is this important collection that now stands in the olive grove in Varia, alongside the national museum whose white walls come alive with the multicolor pages of Tériade's splendid publications.

Such is the character sketch we have of Tériade as he was about to leave Mytilene for France.

The Years of Apprenticeship:
Cahiers d'Art (1926–1931) and *L'Intransigeant* (1928–1933)

In the spring of 1915, having finished secondary school in Mytilene, Tériade obtained permission from his father to travel to Paris to study law. His father gave the boy his blessing, along with enough money for the eighteen-year-old to live on—modestly, to be sure, but at least he would never have to work just to put bread on the table.

He landed in Marseilles, dressed in the stiff collar and tailored coat typical of a young man from a respectable family. All his life he would maintain an elegant appearance.

A photograph from that era shows him with a fancy handkerchief and slicked-back hair. His face is round, somewhat fleshy, his hazel eyes slightly bemused, his lower lip full. We see little, chubby hands, clumsy as a child's, contrasting with an extremely alert expression and eyes that are sparkling and gentle; a balanced combination of kindness and resolve, idealism and resourcefulness, caution and conviction.

Tériade's first contact with France was a disaster. The country was at war, and the thing uppermost in people's minds was survival. The filth and confusion of Marseilles left him dumbstruck; more than sixty years later he still remembered that first encounter with sadness. Was that all there was to France, his ideal fiancée, the dream he had cherished all those years? Quickly, he caught a train to Paris and found a hotel near the Panthéon, where the Law School was also located. He enrolled there but did not bother to show up for classes. He went back to Mytilene for the summer, returning to Paris in September—this time to stay.

Tériade studied law, as he had promised his father, but it bored him to tears. Like Ambroise Vollard—whose work was to be, in a way, carried on by Tériade—he used his studies as a pretext, a way to reassure his family. He was forever dragging things out, ostensibly to take additional examinations. His father waited for him to come back home and take over the family business, but he waited in vain, for Paris had become Tériade's new home. He paid regular visits to the Louvre, the few galleries that existed at the time, movie houses, bookstores, and cafés popular among the literati. Le Dôme, La Coupole, La Rotonde in Montparnasse, as well as the Brasserie Lipp, Les Deux Magots, and the Café de Flore on the Boulevard Saint-Germain—they became his sitting rooms, offices, and verandas. In time, he met everyone. The Paris of that period bears little resemblance to the Paris of today. Visits to cafés played a vital role in everyday life then. People would go there to warm themselves, body and soul. In those days, it was not unusual to spend three or four hours over a beverage, talking, talking, talking all the while. "That's how I developed the habit of drinking nothing but cold coffee," Tériade would say. "Hot coffee scalds my mouth!" In a café, one could sit and read a newspaper at length, write letters on stationery furnished by the house, and—most of all—vanquish loneliness just by being near dreams of glory, and involved in daily contact with the give-and-take of ideas and ideals.

For Tériade, who was not yet aware that he wanted to be a publisher, café life played a crucial role in his personal development, and it was in those surroundings that he encountered the writers and artists who would become his friends.

From 1915 to 1925, that was how he lived. To quote Jean Leymarie, he had found "the artistic home of his dreams, the glory of a latter-day Athens."[3] It was during those years that he acquired the aura of introspection that struck everyone who came in contact with him. Seldom in motion, he was never at rest. Like a mystic who never tires of perusing psalms to the glory of God, Tériade perused

painting. It obsessed him, possessed him. He had no illusions about the artworks he had produced back in Varia. He had never been cut out to be a painter. And yet, nothing interested him more. Before long, artists of every kind began to treat him as an equal, and being in their company was his chief delight. Up to the last months of his life, he would reminisce about his conversations with Matisse, Laurens, Giacometti, Picasso, Braque, Chagall, Léger, and Miró. With all his being he shared their enthusiasms—as well as their doubts—and became deeply involved in the great adventure of modern art.

It was in 1926 that his first real venture into the Parisian art scene took place—albeit in a marginal fashion. Christian Zervos, an older fellow-Greek, had just begun publishing *Cahiers d'Art*, a magazine that "aspired to bring out the universality of the plastic arts by subjecting to the same uncompromising scrutiny not only the most recent of modern trends, but also those from the past that inevitably resurface in a modern context."[4] Tériade was put in charge of the "modern section." This collaboration, which would last five years, began in the first issue (1926) with Tériade's piece on Vlaminck—its opening sentence is emblematic: "The path stretches out and broadens before us, at the urging of our desire."

We do not have the space here to analyze all of Tériade's forty-two contributions to *Cahiers d'Art*. But we will look at a few "highlights" that seem to illuminate the path that would lead, ten years later, to the birth of *Verve*.

In addition to routine reviews of art exhibitions, Tériade published four articles of considerable depth and significance. The first was entitled "Reflections on the Tuileries Show" (*Cahiers d'Art*, No. 5, 1926): "This is indeed the golden age of painting. No use fighting it—we are under the spell of its irreducible laws, its captivating verve, the healthy creativity of its revels. . . .

"Today, Paris, fortunate capital of the arts, welcomes to its salutary working atmosphere all those wanting to be in step with their times, dreading wearisome seclusion and unproductive withdrawal into themselves, who come here to sense the perpetual excitement, to respond to the ceaseless anxiety, to gauge themselves against others, and to absorb that profoundly human quality without which no work of art can long endure: moderation." In that one sentence, Tériade paints a self-portrait and "signs" it by saving the key word for last. As far as he was concerned, moderation, restraint, a sense of proportion—call it what you will—was the hallmark of excellence in the plastic arts.

In the article on "Marc Chagall" (*Cahiers d'Art*, No. 6, 1926), Tériade wrote: "Chagall is a born Romantic . . .

"To see the world through bouquets of flowers! Full, enormous bouquets, in all their resonant profusion, in all their haunting radiance! To see only through the lush bounty plucked at random from gardens, no one knows how and with what natural equilibrium—what more priceless joy could we have wished for?"

Gradually, Tériade developed a personal aesthetic. He eschewed criticism and commentary. He "talked painting" as only painters do: "Does one paint light? Does one paint God?

"No. Like a wise man who knows how to make use of what he has, [Friesz] tries to create his own light himself.

"With what he has. Colors, his longings for form, his cravings for balance, and then, a love for spacious houses, intensely green vegetation, fruit and women with firm flesh. He realized that for man—and, consequently, for painting—there can be only one kind of light, the kind that comes *from* things. . . . Because one can never shed light on things, but one can bring out the light that is within them." ("Recent Work by Friesz" in *Cahiers d'Art*, No. 9, 1926).

Finally, writing about Pascin (*Cahiers d'Art*, No. 10, 1926): "He loves life, women, the wine of

Tériade in the 1930s

night. Everything lavishes the same love on him in return. He is filled to overflowing, he is rich. He doesn't fight it. He welcomes it. He notes his pleasure in order to re-experience it. He recollects a heap of essential things and copies them in the hope of rediscovering their hidden destiny. He works."

The following year, Tériade wrote an absorbing introduction to an interview with the art dealer Kahnweiler that appeared as part of a supplement entitled "Loose Leafs" (*Cahiers d'Art*, No. 2, 1927). "The Galerie Simon stands in a nondescript courtyard off the Rue d'Astorg. From the outside, it resembles the offices of a tax collector or perhaps an insurance company. Art is kept under lock and key here, its resonance is under wraps. The inhabitants of the building go about their business calmly; neither the dreams of Masson nor the stark truths of Vlaminck disturb the rhythm of their daily lives. We are at Mr. Kahnweiler's establishment. He takes pride in having been the first to defend the revolutionary Cubist movement during its early days.

"He championed it commercially. Champion is an agreeable word for those who have dedicated and sometimes risked their fortunes in the picture business (the most intelligent of all businesses).

"There is something profoundly maternal about it. It means taking a painter in the first, vulnerable flush of youth, when he is exposed to all the elements, making sure his life is free from cares (at least of the more pressing variety), goading and guiding his passions, and finally showing him the way—like a good family administrator—to success, to triumph, to glory.

"Kahnweiler was a champion of the cause from the very start. He bought paintings that had no value so that they would become valuable. That was his way of serving as a champion."

In addition to writing articles on the current art scene, Tériade spoke up for young artists in whom he believed. Thus, in *Cahiers d'Art* No. 3 of 1928, he published a major article on Francisco Borès, an artist to whom he later devoted a monograph, and whom he would support all during his lifetime.

Once again, we approach the essence of Tériade's philosophy: "I mentioned that Borès's work is intriguing. Generally speaking, it involves the very plasticity of painting.

"The *plastic idea* is his starting point and guiding concept. He develops it through simple pictorial elements, with an unmediated, virtually tactile result in mind: purity of sensation obtained without the artifice of narration."

Another one of Tériade's passions—a painter to whom he would remain forever dedicated—was André Beaudin. As early as 1928, in a lengthy article on Beaudin's work (*Cahiers d'Art*, No. 8), Tériade seemed to anticipate what was to come between Beaudin and recognition: the Cubist legacy.

"Beaudin's painting embodies a rediscovered mellowness. Its severity and self-restraint typify Cubism as an age of consummate order.

"Just as the Impressionists trace their roots to Manet, or to Delacroix, the Fauves to the Impressionists, and the Cubists to Cézanne and Seurat, Beaudin is a natural outgrowth of Cubism. Early on, he grasped the spiritual and plastic truths of the movement, and internalized them completely.

"Beaudin's work is the kind that shapes, that anticipates the yearnings and aspirations of an entire generation, and that affirms a new spirit in painting."

Tériade also wrote articles on Braque. ("There is nothing to compare with the sheer joy of writing about Georges Braque—as pleasurable and satisfying as writing on beautiful, satiny paper.") There were also pieces on Masson, Dufy, Matisse, and Lipchitz.

In 1929 (*Cahiers d'Art*, No. 9), the first in an important series entitled "New Painting: A Documentary" appeared, in which Tériade expanded at great length upon the history of contemporary painting and the obstacles it would have to overcome during the years ahead.

Tériade's association with *Cahiers d'Art* ended in 1931 with a major article entitled symbolically, "*Jeunesse*" (Youth), in which he recapitulates all the factors that led him to profess his faith in a segment of the younger generation of painters: Masson, Borès, Beaudin, but also Vines, Cossio, Menkès, Ghika, and Ismaël de la Serna—artists he continued to support long after the chapter in his life dedicated to *Cahiers d'Art* had come to a close.

In all honesty, it must be noted that the collaboration between Tériade and Zervos at *Cahiers d'Art* was a difficult one. Both men cast equally long shadows, as publishers and as personalities. Tériade never liked to discuss this period of his life, and we shall respect his reticence in this regard.

In 1928, while still writing for *Cahiers d'Art*, Tériade was hired as a regular contributor at *L'Intransigeant*, a national daily newspaper with a "chic" Parisian feel to it. Together with his friend, Maurice Raynal, he wrote for the "Arts" column; the two of them used a pen name, "*Les Deux Aveugles*" ("The Two Blind Men"), whenever they did not wish to be credited personally with an article. Jean Leymarie knew both of them quite well. "From the very start, Raynal had been one of the most dependable eyewitnesses to the heroic adventure of Cubism, and now, in his critical reviews, he displayed a zest and sense of humor worthy of his friend Apollinaire. The human qualities in the best artists would strike him first, and he had a knack for spotting excellence—often before anyone else did. Tériade, who was younger, had hit it off with him early on. They had temperaments that complemented one another, and their viewpoints meshed seamlessly."[5]

Tériade looked upon his contributions to *L'Intransigeant* as "indiscretions of youth." Even though not all of the artists he wrote about were destined to become famous, his column is nonetheless of interest for a number of reasons. Perhaps even more than in *Cahiers d'Art*, it was here that Tériade threw down the gauntlet in defense of modern art. The enemy? Establishment art, to be sure, but also the influence of literature, and the inviolate concept of the "Beautiful."

Forgoing personal commentary as much as possible, Tériade preferred to let artists speak for themselves. Every interview provided an opportunity for a concise "psychological portrait." Here is how Tériade prefaced an interview with Matisse: "A window overlooking the Mediterranean has just been flung open. The morning light of Nice, a fresh radiance that has not yet had time to grow weary, spreads throughout the blissful room. It drenches everything. Nothing stands in its way, no opposition, no contrast—as will soon again be the case in the late afternoon. Everything dissolves in the light. That is how bright, fresh, and spontaneous it is.

"The odalisque is already there, slouched in her armchair. Her bare, youthful bosom is visible in the crystal-clear light. Loose-fitting trousers are draped about her hips...

"Well, not quite. I wish it had been that way! Instead, I'm in a dreary room in a deluxe hotel on the Left Bank that looks out onto a hushed inner courtyard, at nine in the morning. Matisse was passing through Paris, so that's where I found him, in his pajamas. He had just awakened—I may have been the one who awakened him.

" 'I got to bed a little late last night,' he tells me. 'Let's make it short, we have only about an hour.' "

Tériade's interview with Georges Braque (April 3, 1928) echoes the tone of the artist's *Carnets*. "Some painters have used theories as a starting point for their work. The qualities of a work of art are often those that lie in the work itself, not those a painter thinks he's put there."

Another of Tériade's innovations was the "Traveling Artists" series (*Voyages d'artistes*). Fernand Léger's impressions of Berlin were published in the April 16, 1928 issue of *L'Intransigeant*: "A German begins with a cigar. Light is what makes Berlin modern. Eight days in Berlin; never saw night. Light at six o'clock, at midnight, at four o'clock. Light all the time. Paris is a drab city with intermittent gleams. Berlin is a glowing block." One can understand and appreciate Léger's fascination with modernity and artificial light. His political optimism, however, was less well-founded: "A few cigar stores, filled with wonderful cigars, arranged in companies, battle groups; army corps of cigars, as if on parade—clearly, that's all that's left of the imperialism of our neighbors!"

These articles in *L'Intransigeant* render a portrait of Tériade that is lifelike and unerring. They also show his predilection for rapid-fire, devastating quips. On June 4, 1928, he interviewed Georges Rouault.

"Have you given any thought to what you're going to ask me?"

"No."

"On that, we left for dinner."

In a more serious vein, Tériade's article on Corot (June 11, 1928) is a probing consideration of the *esprit français* to which he was so attached: "Corot is the culmination of French painting. In the primitive masters, a peculiarly French quality first surfaced. Then Poussin managed to find it again within the grandeur of the Renaissance. But Corot liberated this quality and expressed it in all its limpid purity—this uniquely human combination of grace, discrimination, and restraint."

There were times when his tone could become more vehement, as it did in an article entitled "Artistic Hygiene: End of a Season or End of an Era" (early summer, 1928). "The tumultuous season of liquidations is upon us. Our era seems determined to take stock of itself. Profits and losses. Our age must clean house if it is to retain its exceptional standing and continue to unload the unnecessary burden of useless values.... We lack the robust, wholesome, passionate younger artists who will pose anew the essential problems of painting.

"Because nothing else matters."

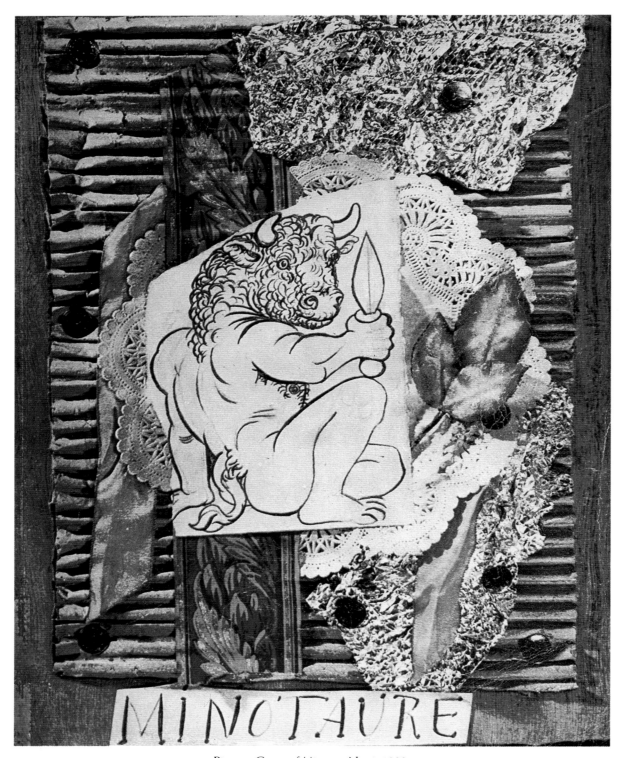

Picasso. Cover of *Minotaure* No. 1. 1933

The Lure of Surrealism:
Minotaure (1933–1936) and *La Bête Noire* (1935–1936)

Tériade and Christian Zervos went their separate ways in 1931, but by then Tériade had met Albert Skira, a dealer in deluxe editions who eventually became one of the most celebrated publishers of art books in this century. Tériade and Skira would join forces to produce editions of Ovid's *Metamorphoses* (illustrated by Picasso) and Mallarmé's *Poems* (illustrated by Matisse), both of them watersheds in the history of art publishing. Bibliophiles will find only Skira's colophon in these books, but it should be noted that Tériade was the driving force behind Skira's extraordinary illustrated edition of Mallarmé's *Poems*.

In 1933 they formed a corporation, officially known as "Albert Skira, Inc., Publishers." (Tériade would continue to work with Skira until July 1937, that is, until he started up his own publishing company, the "Société des Editions de la Revue *Verve*," or "*Verve* Magazine Publishing Company.")

An agreement had been reached on December 1, 1932, whereby Tériade would serve as artistic director, and Skira as managing director, of a prospective venture to be known as *Minotaure*.

This publication was of no small importance in the evolution of the Surrealist movement. For one thing, it was the first regularly published periodical that André Breton and his colleagues agreed to write for. But it was with his good friend, Georges Bataille, that Tériade laid the groundwork for *Minotaure*, and came up with the title. He wished to reconcile the Surrealists with Bataille, "that mystic." (Breton, who had already excluded Sadoul, Leiris, Aragon, Gilbert-Lecomte, Vailland, Daumal, and other "dissidents" from his coterie, had saved his harshest invective for Bataille.) Since Breton saw *Minotaure* as a chance to fulfill a number of cherished objectives—high-quality reproductions, typography, paper, etc.—he resigned himself to sharing space with non-Surrealist painters (Picasso, Braque, Derain, Beaudin, Borès, Balthus, Matisse), as well as with writers who did not share his preoccupations (Saint-Exupéry, Vollard, Elie Faure, Mallarmé, Venturi), or whom he was willing to tolerate despite their dissent (Leiris). But to Breton, Bataille was "dangerous"and he repeatedly stated his position in no uncertain terms. Although Tériade had no choice at the time but to give in, Breton's displays of intolerance did not sit well with him. Later on, Bataille would write for *Verve* on a regular basis.

Although *Minotaure* devoted the lion's share of space and attention to Surrealism and its adherents, Breton had the good sense not to try to take it over completely. He was in danger of becoming a prisoner in a ghetto of his own making, and his overriding concern at that point was to find some way out.

Tériade, for his part, did not become too deeply involved in the venture. As he noted in 1972: "I created *Minotaure* partly as a response to purist strains in Cubism, but also because the prospect of mixing all sorts of ideas together appealed to me. A certain amount of feverish excitement seemed very healthy and fruitful at the time." Surrealism piqued Tériade's curiosity and elicited a degree of sympathy from him, but he was never a dyed-in-the-wool Surrealist.

Since a reprint[6] of *Minotaure* is now available, we shall limit our discussion of the first nine issues Tériade supervised to those articles he wrote that shed light on his personal development.

The seventh issue of *Minotaure* features what Tériade considered—as do we—his most probing text. In it he articulated his concept of painting and the adventure of modern art with unprecedented

clarity and intensity. It is worth noting that it was here, in one of Surrealism's holy places, that he proclaimed the primacy of painting's tangible qualities over those of the imagination: "Painting has only its skin, not one that covers it (as it would have us believe), but one from which it is *entirely constituted*.... To provide us with an infinite variety of illusions over the centuries, painting has managed to do wonderful things with its skin. First stretched stiff and taut like a wire, it then blossomed, clothing itself in the exuberant forms of the Renaissance. Later, it became crumpled with the agitation of the Baroque, then powdered with the genteel gracefulness of the Rococo, only to rise up for the flights, or false starts, of Romanticism. One fine day, it tore. And it was modern painting that accomplished this delicate and audacious operation.

"Modern painting splits open that skin. It shows the thin skeleton, its construction made up of waves through which light makes its mysterious presence known. It lays bare its intimate color, the taut places where this color works its real magic. These lacerations do not alter in the slightest the serene evenness of this vibrant skin. On the contrary, they take on the importance, the moral value, of definitive interventions."

Eventually, this concept of painting led Tériade to distance himself from Surrealism. But when it came time to make his position known, he did so with characteristic diplomacy and finesse. In a lead-in to an illustrated survey of art in *Minotaure* No. 8 (June 1936), he praised Surrealist painting the better to induce it to serve the needs of the moment! "The frenzy of artistic activity and deluge of painting that marked the early postwar years urgently demanded a healthy response to the conventional, cut-and-dried, contemptible materialism in which—thanks to insipid copycats—Cézanne's apples, Picasso's guitars, and Matisse's interiors were foundering.

"Surrealism provided that response. Painters, fleeing the sad and sterile popularization that seemed to be negating an entire system of beautiful painterly truths (already drained by the demands suddenly placed upon them), turned to poetry for guidance. Perhaps they could borrow from poetry that which pictorial means could no longer provide. At a certain juncture, painting despaired of rediscovering within itself a fresh sense of creative power, and so put itself resolutely in the service of poetry."

Tériade's association with *Minotaure* ended with the next issue (October 15, 1936). The following year, he would divest himself of his interest in "Albert Skira, Inc., Publishers" and—his own master at last—launch the magazine and publishing house that came to be known as *Verve*.

Meanwhile, no longer contributing to *L'Intransigeant*, our *"deux aveugles"* had been on the lookout for a way to express their views with no strings attached. What better way to be truly free than not to have to answer to anyone? Thus, in 1935, Tériade and Raynal had pooled their savings with those of a few friends and started up a newspaper of their own—it was closer to a "rag" than a national paper. Michel Leiris came up with a title, and André Beaudin designed it: *La Bête Noire* was unleashed!

They made their position clear in the opening statement: *"La Bête Noire* is a newspaper, nothing more, nothing less. An activist newspaper of art and literature. *La Bête Noire* is directed against those who have deserted the modern spirit—as well as those who cash in on it. Its sole objective is to authenticate and highlight the original elements of that spirit. *La Bête Noire* is into everything. It puts the powers that be in their place. *La Bête Noire* is as young as Diderot, and as old as Alfred Jarry. It will suprise no one, but it will stun everybody. In other words, this poor beast has its work cut out for it."

This little monthly, peddled by the people who wrote it, could always be counted on for a zest and brand of sarcastic humor very much in the style of Surrealism. From first issue to last, however (there were only eight issues over an eleven-month period), it never came under the influence of the Breton group, and happily welcomed "dissidents" into the fold.

The editorial in the first issue (entitled *"Paris s'em..."*) set the tone: "Heroic Marshal Pétain won another war the memorable day of his visit to the Musée de Grenoble, when he soundly thrashed the 'horrors' of modern art and that deuce of a 'defeatist curator' who had collected this garbage—those Matisses, Picassos, Derains, Légers, Rouaults, along with others such as Zurbarans and Philippe de Champaignes!

"'Uh-oh!' exclaimed the great soldier in language worthy of an Academician. 'Why, it's stuff like this that rots the younger generation. Clear away this unspeakable filth, lock it up, don't let me see it again.' Little did the Marshal know that what he said would come to pass. He was obeyed on the spot, and that is why the paintings from the Musée de Grenoble were whisked off to Paris and placed—as everyone knows—in the Petit-Palais where, no doubt, the Marshal has never ventured."

The front page of the second issue is a masterstroke of design: a Balthus portrait of the dramatist Antonin Artaud, surrounded by Artaud's article on *The Cenci*. This text gives us an idea of how Artaud's concept of the play differed from the way it is often performed today. For him, in performance, Shelley's freely-adapted text was of lesser consequence. "Action and movement carry as much weight as the words," he wrote. "The text was put there to give everything else something to react to."

With the third issue of *La Bête Noire*, which came out on June 1, 1935, the format was enlarged. There were illustrations by Borès and Beaudin; Fernand Léger issued a warning against the "polychrome invasion." And Antonin Artaud responded to the detractors of *The Cenci*. "Now this slobbering old gutter whore who turned out snippets of verse before the war—I refer to Mr. François Porché—feels compelled to vent his ire about a production which, thank God, bears no resemblance to anything he has done. The fact remains, however, that *The Cenci* has created more of a stir than have his plays, which—numerous though they may be—have seldom been given the chance to flaunt their mediocrity. This literary erotomaniac can go off to a day nursery and daub pictures of the Czar Lenin, for all I care, but I certainly won't take the trouble to comment on his abortive work."

Virtually all of the fourth issue is given over to a report on the *Congrès des Ecrivains pour la Défense de la Culture et l'Espoir en l'Homme* (Writers' Convention for the Defense of Culture and Hope in Man). Tériade published Breton's speech in which he masterfully backed away from Communism once and for all. There were also articles by Le Corbusier, René Daumal, Jacques Baron, and Roger Vitrac.

The fifth issue is organized around two lengthy articles—one by Reverdy (illustrated by Braque), the other by Artaud—but there are also a number of short, highly eclectic pieces, including "What's on Painters' Minds: Marc Chagall and Borès."

The table of contents of the sixth issue attests to the same eclecticism: Vitrac, Raynal, Le Corbusier, as well as an article in which an enthusiastic Artaud hails the pro-Indian cultural policies being implemented by Mexican authorities at the time.

In the seventh issue, Dr. Allendy touches on a pressing subject: "Fascism and Homosexuality." "Many servicemen and clergymen fall into this category. Unconscious homosexuality is the most dangerous kind, socially speaking. Since it cannot be consummated in overt acts, it replaces them with a mystique of adulation for a manly ideal of strength and power. This type of homosexual cultivates manliness all right, but the way women do, that is, outside of themselves, in other men. When their leader stands before them, they react to him the way extremely womanly females instinctively react to a male lover. They do more than just acquiesce to servitude; they actually solicit it."

This issue also features three articles on "Precursors of the Cinema," and a text by Maurice Raynal on André Beaudin.

The eighth, and last, issue of *La Bête Noire*, published in February 1936, features a premonitory headline on its front page: *Disparition* (Disappearance). This was actually an allusion to the disappearance of horse-drawn delivery wagons from the Bazar de l'Hôtel-de-Ville, a department store in Paris.

After a two-page spread—featuring poetry by Michaux, Supervielle, Bacon, Audiberti, and Follain—there is a lengthy article by Le Corbusier entitled "I Am an American," wherein the foremost French architect of the day states his admiration for the architecture of New York. Also included in this final issue are contributions by Audiberti and André de Richaud.

Quite a few of the artists, writers, and critics who supported and contributed to *La Bête Noire* were to do the same for *Verve*.

Verve, The Review of Art and Literature
(1937–1960)

The first issue of *Verve* appeared in December 1937. Tériade was to channel most of his energy into *Verve*, which was first a magazine and later a publishing house. He had left *Minotaure* the year before, and now—after a brief excursion to his native Greece—he started alone down a road on which many before and after him have come to grief: the foundation of a major, ambitious, and free-spirited publication focusing on art and literature.

Tériade had the good fortune to secure significant financial backing from the very start. Coco Chanel had facilitated this by putting him in touch with David Smart, then head of the company that published *Coronet* and *Esquire* in the United States. Smart wanted nothing less than to create "the most beautiful magazine on earth." A publishing firm was set up, and Tériade was named managing director. He had "carte blanche." The Americans would provide the capital, the Frenchman, his connections and know-how. The first five issues of *Verve* (which originally was to be called *Pan*) appeared in both French and English, the joint venture of a powerful American press conglomerate and a "man of letters," as he was described in contracts and other official documents.

But had it not been for Angèle Lamotte and, later, her sister Marguerite Lang, *Verve* might never have gotten off the ground.

Angèle Lamotte had met Adrienne Monnier in her bookstore on Rue de l'Odéon. Tériade was friendly with painters; Angèle and Adrienne brought him contributions by writers. When Angèle Lamotte passed away, Monnier wrote an article[7] (illustrated by two Matisse drawings) in memory of her friend, in which she tells the story of how *Verve* came into being. "In the spring of 1937, having asked to see me to talk over some serious matters, she came up, sat down near me, and let me in on her secret: the imminent birth of *Verve*. I didn't yet know Tériade. I had to meet him, that much was certain, but he was very much a loner, as contemplative as an Oriental sage, forever fearful of disturbing or being disturbed. Angèle seemed to feel the timing of our meeting would be of the utmost importance; an auspicious beginning, she believed, would guarantee a fruitful association. In the meantime, she handled secretarial matters for the magazine, so she asked my advice about the authors Tériade and she wanted to solicit for material. First and foremost, the three giants: Claudel, Valéry, and Gide, whose work she personally enjoyed with a passion. How should she approach them? Surely they would be even more unapproachable than Tériade! She wondered if I might be willing to act as a go-between. The way she sat there, anticipating the difficulties that lay before her, made me laugh! That was when I first realized how astonishingly unassuming she was. After questioning her about the resources *Verve* would have at its disposal, I suggested that it would be best for her to write to the authors herself, on the magazine's letterhead, being very specific about the terms of publication. Since Tériade was on friendly terms with all the leading painters, and had already had dealings with the literary avant-garde during his *Minotaure* days, it should be smooth sailing ahead. And, for *Verve*, smooth—no, splendid—sailing it was."

Monnier's optimism proved well-founded as far as *Verve*'s beginnings were concerned, but after that Tériade and Angèle Lamotte had to contend with an increasing number of obstacles. First of all, their American partners backed out, because the magazine did not generate the kind of sales they had hoped for, at least in the United States. Yet the figures submitted to Angèle Lamotte during an emissary

mission to Chicago seemed phenomenal by French standards: 15,000 copies of the first issue sold. In 1937, that was quite a respectable showing for a review of art and literature! Actually, there had been a misunderstanding about the kind of publication *Verve* was supposed to be. No doubt, the American side had something more eye-catching in mind, something reflecting a "Parisian atmosphere," more attuned to fashion and the glamorous side of arts and letters. In any case, this misunderstanding made possible the birth of a magazine whose importance was to surpass—by far—the anticipated "product."

Secondly, history itself dealt Tériade and Lamotte an unfavorable hand. The German occupation, the resulting censorship, and other war-related hardships jeopardized the very existence of a venture that had been three long, taxing years in the making. Despite the difficulties in getting from one place to another, the rationing of paper, and other handicaps, six issues of *Verve* managed to emerge between 1940 and 1945. *Verve* No. 8, with its black cover and tribute to "The Nature of France," testified to where Tériade and Angèle Lamotte stood with respect to the Nazis and their stooges.

What made *Verve* such a momentous phenomenon was that it brought together traditionally segregated fields of artistic and literary endeavor at a special moment in history. The Surrealist movement was on the wane; the great classical authors were at their zenith; a new crop of "revolutionary" writers (Bataille, Sartre, Michaux) was coming into its own; while other figures, such as Malraux, were entering a new phase. All of this coincided with an unusually rich period of artistic creativity (Matisse, Picasso, Braque, Chagall). The place of conjunction was *Verve*, the *idée fixe* of a man obsessed by all creativity, regardless of type or medium. One must keep in mind that this "ideal meeting-place"—this "temple," this garden—existed solely on paper. Its contents would not have "connected" if Tériade had not visualized the connections in his mind's eye. These links were anything but chronological. The interweaving of texts, illuminated manuscripts, photographs, and paintings was not arranged according to any analytical or pseudo-objective grouping. Documents and artworks speak for themselves, creating an individual rhythm, so that each issue is a fresh composite of connections and interruptions. However, these interactions would not have succeeded in their fullest sense had Tériade not insisted on reproductions of the highest quality, done with the utmost care. As the following statement from the opening page of the English-language edition of *Verve* No. 1 indicates, this was always a priority.

VERVE proposes to present art as intimately mingled with the life of each period and to furnish testimony of the participation by artists in the essential events of their time.

It is devoted to artistic creation in all fields and in all forms.

VERVE has adopted a traditional form.

It will present documents as they are, without any arrangement which might detract from their naturalness. The value of its elements will depend on their character, the selection of them that has been made and the significance they assume through their disposition in the magazine.

That the illustrations may retain the import of the originals, *VERVE* will utilize the technical methods best suited to each reproduction. It will call on the best specialists of heliogravure in colors and in black and white, as well as of typography, and will not disdain to employ the forgotten process of lithography.

The luxuriousness of *VERVE* will consist in the publication of documents as fully and as perfectly as possible.

In any reproduction, a work of art cannot avoid losing some of its physical presence. In both his magazine and his art books, Tériade went to extraordinary lengths to respect the artist's wishes in order to recapture as much of that original presence as possible. While he lacked technical training, properly speaking, he strove to recreate true chromatic relationships and the exactitude of colors. The wide range of expensive processes that went into each and every issue of *Verve* was an unheard-of extravagance at the time and demonstrated his demand for fidelity. Artists appreciated this unflagging vigilance and came to expect it—especially Matisse, who regularly insisted on technical *tours de force*, regardless of cost.

The printing processes Tériade used (color photogravure, black-and-white photogravure—two of the techniques in which the French printer, Draeger Frères, excelled) give the pages of *Verve* the velvety softness and sharp definition usually reserved for deluxe art books; nonetheless, Tériade used them to illustrate his magazine. The results were spectacular, and give these visual documents an inestimable quality that modern printing techniques, unfortunately, do not even approach.

Even more startling was Tériade's use of lithography. To be sure, the process had long been applied to book covers, posters, and original prints. But Tériade commissioned one lithograph after another, all from the greatest artists of the day. With the help of gifted craftsmen—Fernand Mourlot and his associates—artists were given the chance to work directly with colors just as they would appear when printed. Thus were produced many important, high-quality lithographs that most of *Verve*'s readers might otherwise not have had an opportunity to see.

After the war, there were fewer "general" issues and more special issues devoted to the work of an individual artist. Time and again, three geniuses—Matisse, Chagall, and Picasso—treated the readers of *Verve* to dazzling displays of "creation-in-progress." At one time or another, each was commissioned to do the magazine's cover, frontispiece, and title page in so-called *numéros spéciaux* that focused on a single phase (for example, *Picasso at Vallauris*), a single facet (such as Matisse's paper cut-outs), or a single subject (Chagall's illustrations for the Bible).

This approach, together with the lavish printing techniques employed, make it easy to forget that *Verve* was a magazine; yet it was not an art book in the traditional sense.

The last issue of *Verve*, entirely devoted to Chagall (his *Dessins pour la Bible*) came out in 1960. After that, Tériade could still be found every day in his office on the Rue Férou. But from then on he divided his time between enjoying life with his wife Alice, and working with Miró and a few others on the books that were to bring his career as a publisher to a close.

In 1973, at the prompting of Bernard Anthonioz, the National Center for Contemporary Art (CNAC) organized an exhibition entitled *Hommage à Tériade*. The significance of this richly deserved tribute was not lost on Tériade. There, on the walls of the Grand Palais, near the gardens of the most beautiful avenue on earth, the pages that had been created by this wizard were displayed for all to see—a dazzling spectacle.

For a Greek, enthralled by beauty, who had arrived in Paris sixty years earlier without credentials or connections, France's tribute meant more to him than any words could say. Paris—the City of Light that owes so much of its brilliance to artists—had acclaimed Tériade, the publisher of what had, indeed, turned out to be "the most beautiful magazine on earth."

In this book we are presenting each issue of *Verve* in chronological order, to give a sense of its historical development. However, Tériade had the habit of grouping them in three "families": "general" (*les numéros variés*), those "devoted to illuminated manuscripts" (*les numéros consacrés aux enluminures*), and those "devoted to an individual artist" (*les numéros entièrement consacrés à un artiste*). Since these terms appear throughout our text, we have listed them below.

General Issues:
No. 1 (Winter 1937). Cover by Henri Matisse.
No. 2 (Spring 1938). Cover by Georges Braque.
No. 3 (Summer 1938). Cover by Pierre Bonnard.
No. 4 (Fall 1938). Cover by Georges Rouault.
No. 5/6 (Spring 1939). Cover by Aristide Maillol.
No. 8 (Summer 1940). Cover by Henri Matisse.
No. 27/28 (December 1952). Cover by Georges Braque.

Issues Devoted to Illuminated Manuscripts:
No. 7 (Spring 1940). *Les Très Riches Heures du Duc de Berry: Le Calendrier.*
No. 9 (October 1943). *Les Fouquet de la Bibliothèque Nationale.*
No. 10 (October 1943). *Les Très Riches Heures du Duc de Berry: Images de la Vie de Jésus.*
No. 11 (March 1945). *Les Fouquet de Chantilly: Les Heures d'Etienne Chevalier: La Vie de Jésus.*
No. 12 (March 1945). *Les Fouquet de Chantilly: Les Heures d'Etienne Chevalier: La Vierge et les Saints.*
 La Vie de Jésus.
No. 14/15 (March 1946). *Les Heures d'Anne de Bretagne.*
No. 16 (November 1946). *Traité de la Forme et Devis d'un Tournoi.*
No. 23 (April 1949). *Le Livre du Coeur D'Amour Epris.* Cover by Henri Matisse.

Issues Devoted to Individual Artists:
No. 13 (November 1945). *De la Couleur*, Henri Matisse. Cover and frontispiece by the artist.
No. 17/18 (Fall 1947). *Couleur de Bonnard.* Cover and frontispiece by the artist.
No. 19/20 (April 1948). *Couleur de Picasso.* Cover by the artist.
No. 21/22 (Fall 1948). *Vence, 1944–1948*, Henri Matisse. Cover and frontispiece by the artist.
No. 24 (Summer 1950). *Contes de Boccace.* Washes by Marc Chagall and paintings from the Illuminat-
 ed Manuscripts of the Dukes of Burgundy (Bibliothèque de l'Arsenal). Cover by Chagall.
No. 25/26 (October 1951) *Picasso à Vallauris*, 1949–1951. Cover and frontispiece by the artist.
No. 29/30 (Fall 1954) *Suite de Cent Quatre-Vingts Dessins de Picasso.* Cover by the artist.
No. 31/32 (Fall 1955). *Carnets Intimes de Braque.* Cover by the artist.
No. 33/34 (September 1956). *Bible*, Marc Chagall. Cover by the artist.
No. 35/36 (Summer 1958). *Dernières Oeuvres de Matisse*, 1950–1954. Cover by the artist.
No. 37/38 (Summer 1960). *Dessins pour la Bible*, Marc Chagall. Cover by the artist.

The Art Books (1943–1974)

In the course of his association with Albert Skira during the 1930s—the period that had witnessed the publication of the "Matisse Mallarmé"—Tériade had had a unique opportunity to learn firsthand what publishing art books was all about. What Tériade produced, however, both then and later, were more than just *livres d'art*; they were *livres de peintres*, meaning books wholly designed by one artist. In this respect, he took up where the great Ambroise Vollard had left off. Publishers of deluxe editions tended to be a cautious and conservative breed. As a rule, they would commission conventional painters to turn out a set of pictures that engravers could transform into illustrations. The publisher then took care of the rest.

Tériade, like Vollard, reversed the process. Now the artist was directly involved in selecting the text (possibly his own, as was the case with Matisse, Miró, Léger, and Giacometti), and in deciding upon the calligraphy or typography, any embellishments (the endpapers, decorative initials, etc.), and—of course—the illustrations. In short, the artist supervised every facet of production. In this sense, the word "illustration" is misleading. One of the most striking examples is Matisse's writing in a splendid hand that the lines he is drawing were "grisaille" meant simply to give the plates some "breathing room." In Tériade's *livres de peintres*, text took a back seat to painting.

There were times when a text was important in its own right, as with Pierre Reverdy's *Le Chant des Morts* (illustrated by Picasso) and his *Au Soleil du Plafond* (illustrated by Gris). However, among the twenty-six *livres de peintres* Tériade published, such examples are rare.

Picasso and Reverdy. *Le Chant des Morts*

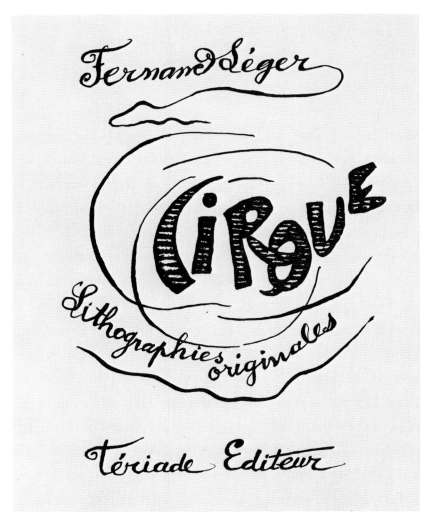

Fernand Léger.
Cover of *Cirque*

By giving the painter a say in the choice of text, how big the page should be, even what cuts to make, Tériade revived the tradition of the medieval illuminated manuscript. For all their monumentality, and despite the painstaking care taken with the typography (often entrusted to the Imprimerie Nationale), these books are, more than anything else, sets of original prints.

Since our book is devoted primarily to the magazine *Verve*, we shall not discuss these masterpieces of the bookmaker's art in detail, but refer the reader to the catalogue which the National Center for Contemporary Art (CNAC) published in conjunction with its tribute to Tériade in 1973 (*Hommage à Tériade*, Grand Palais, Paris).[8] A concise list of these books also appears in the Bibliography.

As François Chapon pointed out,[9] and rightly so, Tériade "dealt with temperaments as dissimilar as Laurens and Chagall, Matisse and Léger, Giacometti and Miró. As *magister operis*, he recommended texts, subjects, and processes that gave each and every one of them a chance to blossom."

According to Reverdy, "He was not partial to any particular process. Wood, copper, stone, depending on how well the support, and the way it is worked, would suit the person who 'continues to think with his hands.' It wasn't virtuosity that managed to match every concept flawlessly to the material that gives it substance. No. Every fiber, every grain naturally deferred to the concept as it took shape, happy to do its bidding. So much the worse for routine craftsmanship, for safe, tried-and-true procedures."

ALFRED JARRY

UBU ROI

LITHOGRAPHIES ORIGINALES DE
JOAN MIRÓ

PARIS
TÉRIADE ÉDITEUR – 1966

Tériade ventured off the beaten path of conventional art book publishing and into uncharted territory. Many bibliophiles did not follow his lead right away. To quote Jean Leymarie: "The art books Tériade published are in a class by themselves. Many look like modern illuminated manuscripts, where the painter is the calligrapher of his own text and is given a free hand to orchestrate writing, drawings, and painting into an organic whole."[10]

1. "Solitude de la Grèce," *Voyage en Grèce*, 2, 1935.

2. *Voyage en Grèce*, 4, 1936.

3. Jean Leymarie, "Le Jardin sur la Mer," in *Hommage à Tériade*, Editions du CNAC, Paris, 1973.

4. *Ibid.*

5. *Ibid.*

6. *Minotaure*, Éditions Skira (2 vols.)

7. *Verve* No. 13, November 1945.

8. *Hommage à Tériade*, CNAC, Ministère des Affaires Culturelles, Paris, 1973. Prefaces by Jean Leymarie and B. Anthonioz. Text by Michel Anthonioz.

9. *Bulletin du Bibliophile*, 1973–II, Paris.

10. *Hommage à Tériade, op. cit.*

VERVE

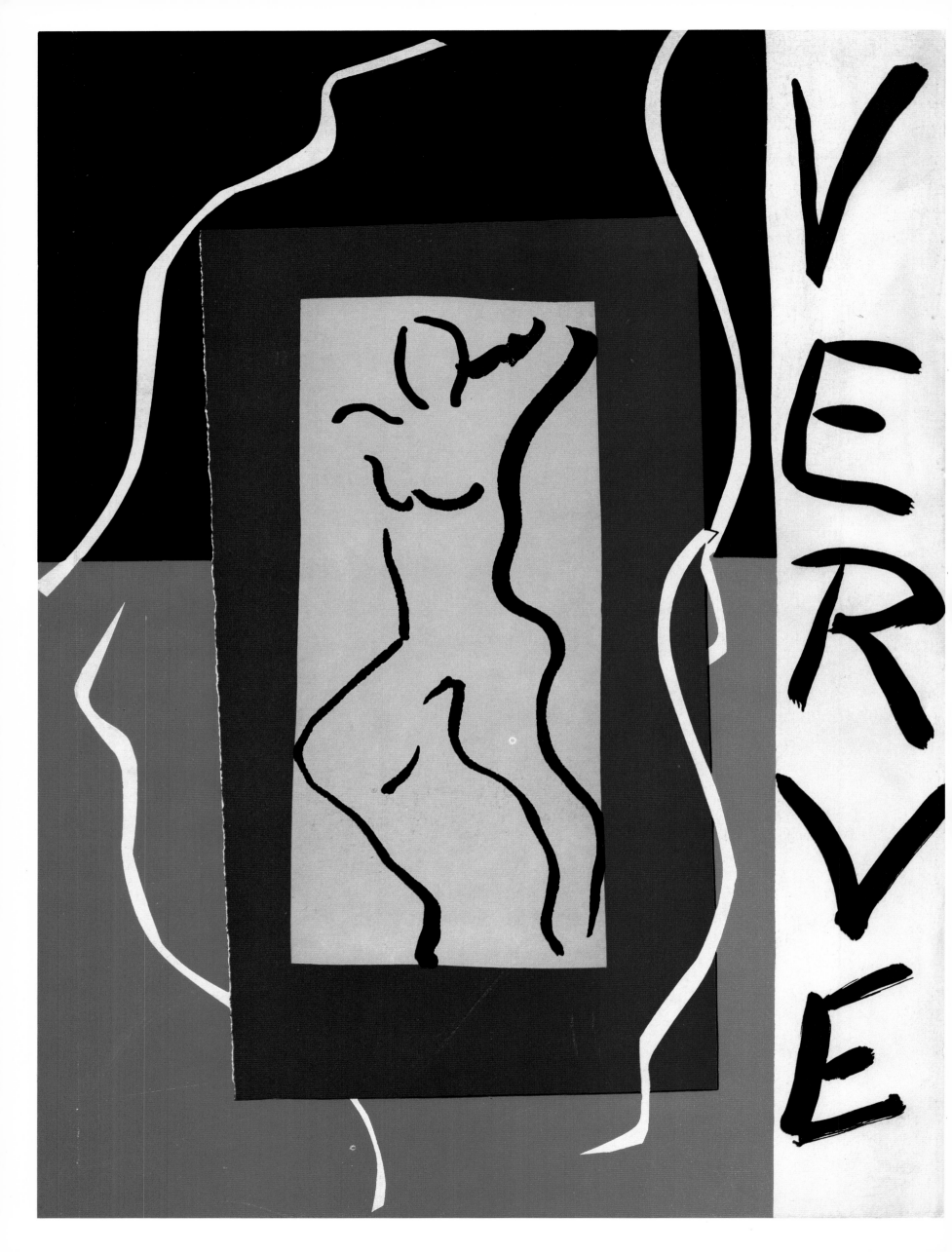

VERVE
Number 1 Winter 1937

The inaugural issue of *Verve!*

The first issue of a periodical, like a politician's first hundred days in office, is usually a reliable barometer of developments to come. *Verve* was no exception to the rule. Everything was there from the very start: Tériade was alone at the helm, no longer constrained by the Surrealist slant of *Minotaure*. Now he was free to choose his own material and to orchestrate it as he saw fit—painting, sculpture, literature, photography, art history, illuminated manuscripts, and items I shall refer to as "curios."

The cover of *Verve* No. 1 is by Henri Matisse; it consists of three unmodulated colors—red, blue, and black—that the master cut directly from printers'-ink specimen books. In the center of this lively composition we see a drawing of a standing nude figure whose curves seem to echo the contours of the "cut-out" colors, as well as those of the sinuous letters VERVE running down the right edge of the cover. Matisse himself drew the title with brush and India ink. And there is a story behind the choice of that title. At the outset, the magazine was to have been called *Pan*. During initial conversations with David Smart (president of Esquire-Coronet, Inc., and backer of Tériade's ambitious scheme), two titles, *Pan* and *Creation*, had been considered not only appropriate but workable in both French and English. (That is why *Pan* appears in Matisse's first version of the cover.) But Tériade soon hit upon a more inspired and scintillating name for his magazine and publishing company: *VERVE*.

Matisse's cover for the first issue, lithographed by Fernand Mourlot Printers, was an original work of art created expressly for the magazine—as would be practically all of *Verve*'s covers, with the exception of some issues that appeared during the war. As the following letter from Matisse (December 1, 1937) attests, the painter took great pains to make sure that the cover would turn out exactly as he wished.

"I am sending you two frames so that the two maquettes of the cover—*which I value a great deal*—may be placed under glass before being photographed for reproduction. That way, the pasted cutouts stand a good chance of being protected. Should any of them fall off, I implore you to let me know so that I may put them back myself—make that clear to the printer—because it is a trifle that could jeopardize my work.

Sincerely,
Henri Matisse

If the maquettes are at the printer's, the bearer of this letter may leave the frames there."

Nowhere else in Matisse's letters to Tériade do we find the phrase "I implore you." That conveys some idea of how much this cover meant to Matisse and how much store he set by his own standards, so exacting that he felt they might be compromised by a "trifle." His approach was the same for every cover he subsequently did for Tériade; often he would settle for nothing less than technical *tours de force*. The care Matisse lavished on what others might consider a minor undertaking was one of the hallmarks of Tériade's publications. How did he induce the greatest artists of this century to give the very best of

themselves? Through friendship? No doubt. But there had to be more to it than that. The lure of fame? Matisse was already famous, and Tériade was a young publisher just starting out on a perilous adventure. Money, finally, seems not to have been a consideration—at least at the time. With all due respect to skeptics and cynics, the answer must lie elsewhere: Matisse and Tériade shared a common ideal. For both of them, painting was life itself. Their correspondence, and the frequency of their collaboration, bears that out. (Although Matisse mentions "two maquettes" in his letter of December 1, 1937, to our knowledge there was only one. The "second" may have been the back cover which, when combined with the "first" or front, formed a single unit.)

In this first issue, the statement of *Verve's* goals and "battle plan" appears immediately after the Table of Contents.[1] In a significant gesture, Tériade gave the production technicians a place of honor by listing them directly beneath this opening statement. "Typography and Process Color Work: Imprimerie des Beaux-Arts. Heliogravure in Colors: Draeger Frères. Heliogravure in Black and White: Néogravure. Lithography: Mourlot Frères." By and large, Tériade relied on the same craftsmen and printing processes to the very end. He never "talked technique," but he always attached tremendous importance to the quality of reproduction and printing. Nothing was too beautiful for *Verve*. Each particular art form was matched to the printing process best suited to it. I know of no other magazine that has made such regular use of lithography and photogravure. This insistence on quality did not stem from any commercial considerations; its sole purpose was to gratify the publisher, the artists, the technicians, and the readers. These extremely high standards must have been one of the incentives that induced prominent artists to become involved with *Verve*—what other magazine could offer such luxury?

Tériade and Angèle Lamotte[2]—who, through Adrienne Monnier, had solicited texts from Valéry, Claudel, and other famous writers—assembled an outstanding constellation of contributors. The first issue opens with a text by André Gide, "A Few Reflections on the Disappearance of the Subject in Sculpture and Painting," in which the author attempts to show that in painting, as in music, representation is an illusion largely irrelevant to the nature of art. Facing this article is a superb lithograph by Fernand Léger, followed by an equally fine lithograph by Joan Miró. On the heels of this comes a dazzling display of Brassaï's photographs of Matisse with his birds in his Parisian studio. Gide, Léger, Miró, Matisse, Brassaï, then—all of a sudden—Georges Bataille! (In 1973, Tériade told me that when he co-founded *Minotaure* with Albert Skira, one of his hopes had been to contravene Breton's ban on this Dionysian writer, and force the Surrealists—the reigning group at the time—to acquiesce to Bataille's presence among them; but Tériade had not reckoned with Breton's unyielding intolerance.)

After the Bataille piece on "Van Gogh as Prometheus," there are articles by René Huyghe, Roger Caillois, and José Bergamin. Bergamin's text, entitled "The Museum of Marvels," is illustrated with a photograph of the main gallery of the Prado cluttered with sandbags, and is faced by a splendid Borès lithograph with a black background. Then, John Dos Passos's piece on "Fire" is followed by Dora Maar's extraordinary photograph of *Guernica* (portraying the conflict taking place at that time in Spain), showing this work as it hung in Picasso's studio on the Rue des Grands-Augustins. *Verve* No. 1 also featured "some fragments" of André Malraux's work on "The Psychology of Art," and there is a remarkable sequence of photographs by Man Ray, Cartier-Bresson, Brassaï, and Blumenfeld, after which comes the "Chinese Portrait" by Henri Michaux (Bataille and Michaux reunited in the same publication!). And, as we previously mentioned, *Verve* was also a showcase for "curios." A case in point is an astonishing series of sepia reproductions of photographs taken in 1850 by a pharmacist named

Guichard. Aside from their historical interest, these scenes of middle-class life also demonstrate that "in his modest way [Guichard] worked the way artists do, out of enthusiasm and for his own pleasure."

There is also a tribute to Tériade's precursor, Ambroise Vollard. To whom else could Tériade be compared, if not to this eminent publisher who discovered Cézanne and Picasso, pioneered the concept of the *livre de peintre*, produced Degas's first bronzes, and guided Chagall, Rouault, and so many others toward engraving and lithography? Tériade had sent Vollard a questionnaire, and he used the answers as the basis for an article which, interestingly enough, serves as a pendant to Gide's piece. Using the work of several artists as examples, Vollard argues that in painting the subject is of little consequence. Packed with anecdotes and written in a style resembling brilliant café conversation, it reveals a fascinating connection between Vollard—who died two years later—and Tériade, who would go on to publish some of the older man's unfinished projects (Gogol's *Dead Souls*, La Fontaine's *Fables*, and the Bible, all illustrated by Marc Chagall). One day, the full story of this amazing man—born on the island of La Réunion, destined for a career as a notary—who became one of the most perceptive figures in the history of modern art, should be told.

"The influence of painting on the mind is so real that a painting can even have a therapeutic effect," Vollard writes. This was a natural lead-in to Matisse, who displays his incomparable drawing prowess with a series of line drawings from 1935. Accompanying these pen-and-inks, we find a text ("Divagations") and a painting. After full-color works by Derain, Bonnard, and Maillol comes an entire section devoted to Maillol: wonderful photographs by Blumenfeld and Brassaï of the sculptor's studio at Marly-le-Roi. Collectively, they form a kind of reportage—archives of Maillol's "work-in-progress" that shatter stereotypes and convey the humble mystery of creation that once filled a shed in that little garden in the Ile-de-France.

Tériade asked Fernand Léger to sketch his impressions of the Exposition Universelle of 1937— thus taking up once again the concept of the "artist as reporter" that the "two blind men"[3] had pioneered in *L'Intransigeant*.

The first issue of *Verve* concludes with a piece by Tériade's lifelong friend, Maurice Raynal; then letters from Cézanne as a youth to Emile Zola (passed on to Tériade by John Rewald); an autobiographical article by Elie Faure; and a selection of pages from illuminated manuscripts which had been shown at "the Exhibition of the Most Beautiful French Manuscripts from the Eighth to the Sixteenth Centuries at the Bibliothèque Nationale, Paris, 1937" (including one entitled *Love's Game of Chess*, which had been "executed for the instruction of the future King Francis I").

1. Cf. Introduction, "*Verve.*"
2. Adrienne Monnier, in *Verve* No. 13, November 1945.
3. Cf. Introduction, "Years of Apprenticeship."

A FEW REFLECTIONS
ON
THE DISAPPEARANCE OF THE SUBJECT
IN SCULPTURE AND PAINTING

By ANDRÉ GIDE

Rodin's studio in the last days of his life was invaded by men of letters. A statuette which happened to be there represented a nude young woman with her hands and knees on the ground, on all fours, like an animal.

"What are you going to call that?" asked one of the men of letters.

"I don't give a damn," Rodin was, I hope, on the point of answering, but another man of letters intervened.

"In your place," he said earnestly, "I should call it *Psyche*."

And the statue was then and there seen to stand for an entire profession of faith—subversive, and even perhaps blasphemous, charged, at any rate, with a signification which Rodin had certainly not originally thought of, and which wouldn't have prevented the work from being frightful, if it hadn't been admirable, and which didn't make it more admirable than it had been in the first place without any ulterior intention.

Intention has never made the value of a work of art, and it is no business of the painter or the sculptor to inform his canvas or marble with significations. I consider any confusion, any trespassing of one art on the domain of another as disastrous, and I protest equally against "ut pictura poesis" as against "ut poesis pictura." Each of the arts has at its disposal its proper means of expression, its special eloquence, its own particular processes. I push this need for differentiation so far (but this is merely the expression of an artistic faith which is entirely personal to myself) that I have banished from my novels and tales—though not of deliberate purpose and rather from a kind of instinct—almost all descriptions of scenery and people, which seemed to me to belong more properly to painting. How greatly I suffered in the days of my youth from the admiration of certain writers for Wagner! In most cases, knowing nothing about music, it was really literature they admired in the *Niebelungen* or *Tristan*. I remember the ecstasies of Pierre Louÿs: "And you know what Kundry answers? She answers *nothing*. She utters a single cry. Don't you think that that's sublime?"

As a consequence of this, I took refuge in an unbounded admiration for chamber music—music that has no signification, or at any rate does not pretend to express anything that is not purely musical, and only by its own peculiar means

Matisse never seems to me greater or better than when he abandons himself unreflectingly to his gifts, without allowing his intelligence or his theories to intervene overmuch. In other words, the most pertinent and surest of his qualities is, in my opinion, his instinct.

Courbet, Manet, Degas and Renoir gave a powerful impulse to the movement that hurried painting along the road to total emancipation; and my admiration for the accomplishment of their work is too lively for me to feel any regrets. I simply wish to remark that from a certain date, which it would not be very difficult to define, the painter, in reaction against anecdotic, or historical, or moralizing, or didactic art, began to paint for himself and a few initiates, and so to lose contact with the people, who, on the contrary, are first and foremost interested in the subject. . . .

How many contradictions and uncertainties there are in everything I have just said! The fact is it is useless to speak of art without taking into account the artists themselves, each of whom works according to his own temperament and according to a more or less definite aesthetic, inspired, I hope, rather by his instinct than by his intelligence, and special to himself alone. But each of them belongs, in spite of what he may think, to his own period, and obeys, often without being aware of it, the demands—if not the orders—of the public. And I think it not uninteresting to remark that, in an age which is so full of solicitude for the people, their needs and claims and culture, painting satisfies only a very small number of privileged persons, and that every attempt to *vulgarize* art has so far met only with disastrous results.

(Excerpts)

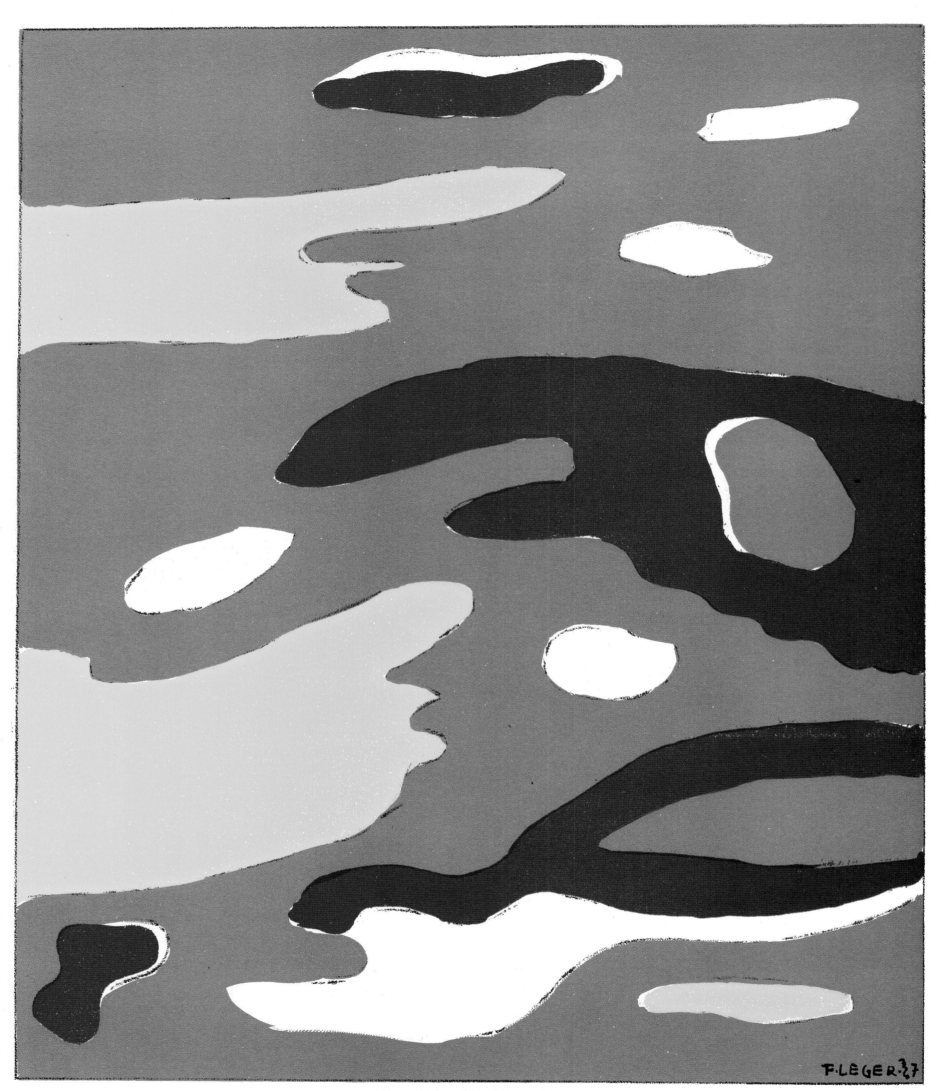

Fernand Léger. *Water*. Lithograph

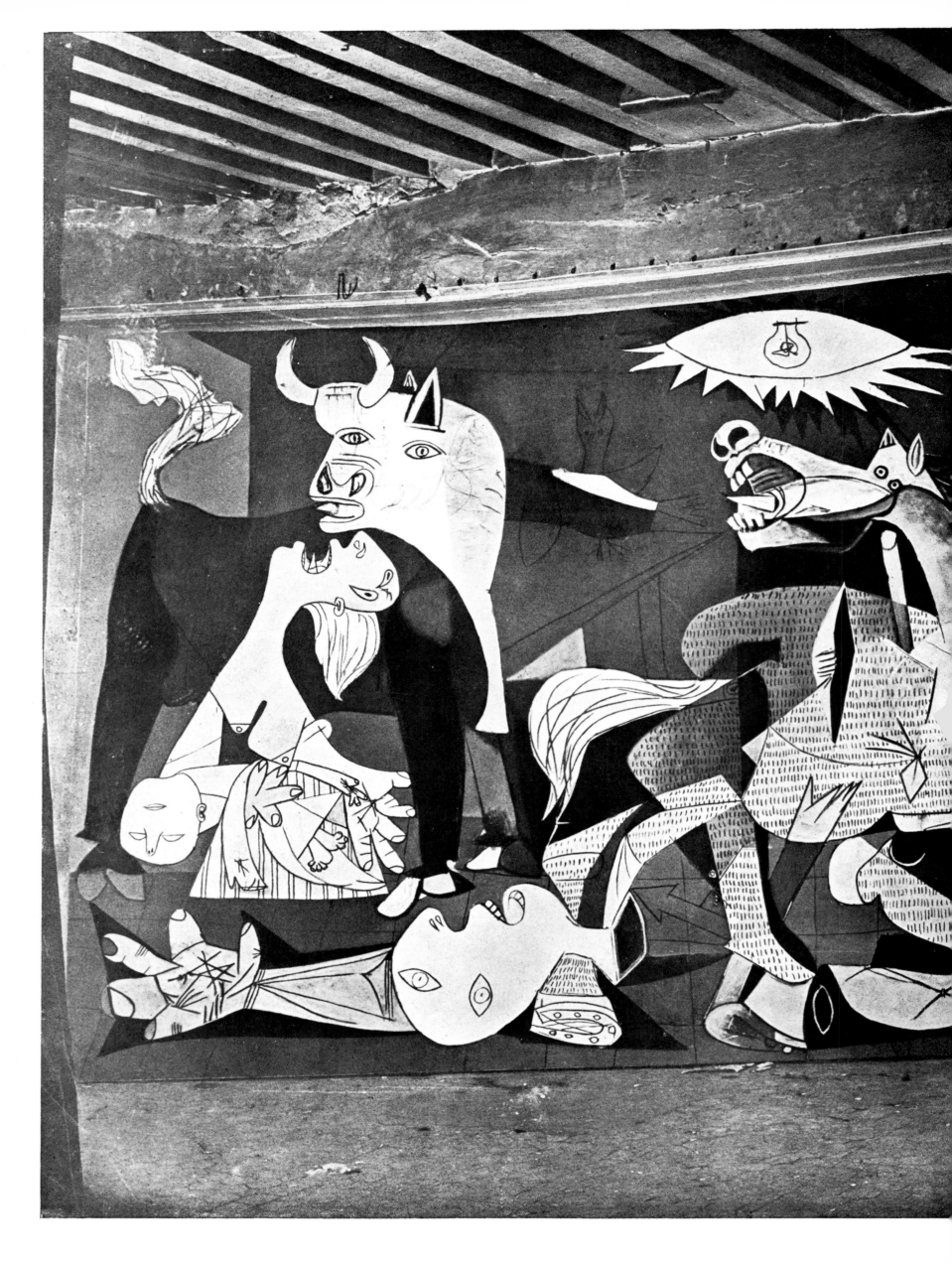

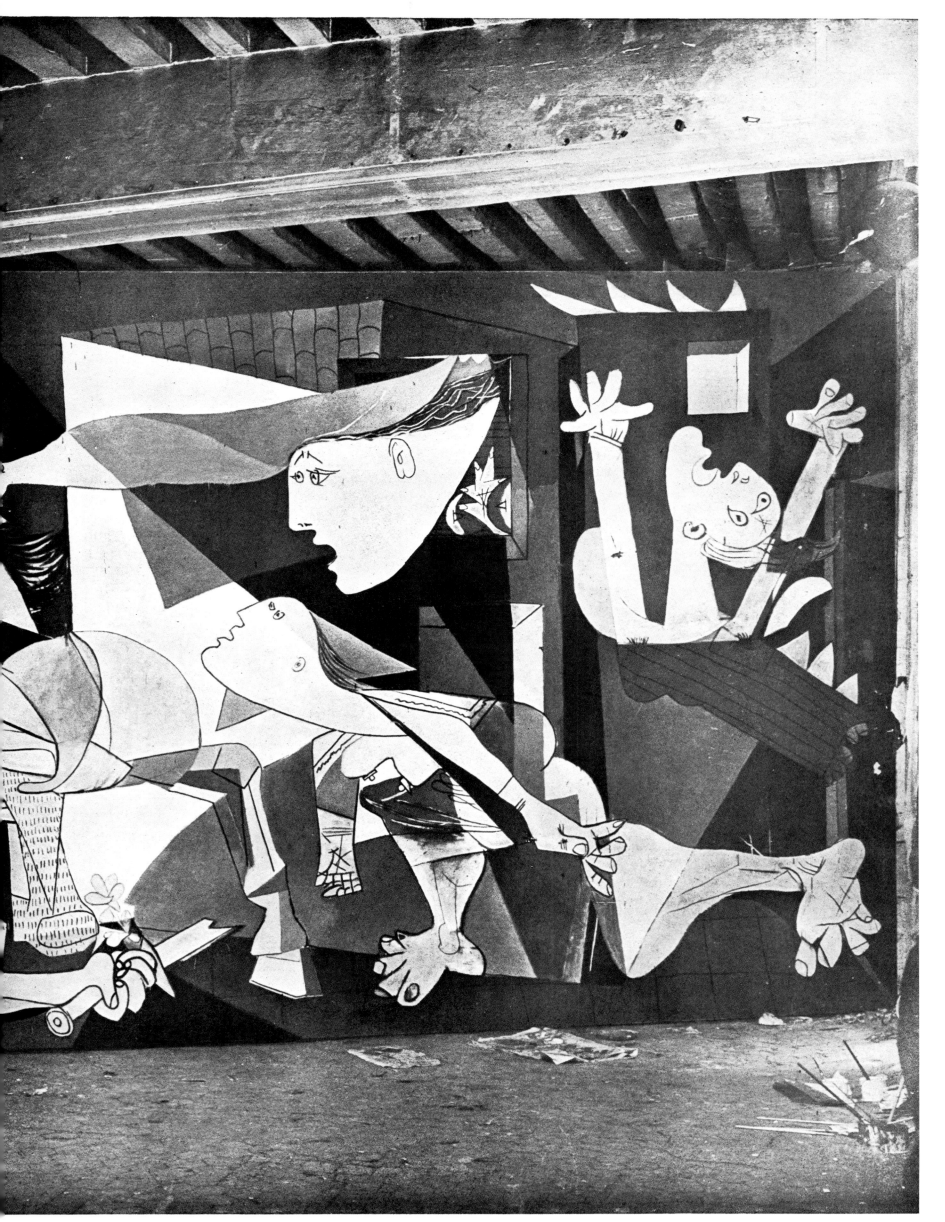

Picasso. *Guernica*. Photographed in the studio by Dora Maar

THE
PSYCHOLOGY
OF ART

By ANDRÉ MALRAUX

Whether an artist begins to write, paint or compose early or late in life, and however intense the vitality of his earliest works, behind them always looms the museum, the cathedral or the library. Behind every form, at its inception, lies another form—and, at the starting-point of all, the sign. Drawing did not begin with the sketching of a figure, but with the hieroglyph; indeed it seems that the destiny of the fine arts was uniquely this: to load the sign with as much of the human element as it could bear.

Obviously the only portion of any art that can be taught is its element of craftsmanship—in other words, the ways and means an artist has for laying hold on life, by utilizing the methods employed by previous artists for a like end. Yet that most elementary form of knowledge, the knowledge of proportions—what use is it to an Expressionist? Gothic pupils learned the rudiments of a Gothic representation of the world, just as the students of the Baroque epoch learned the rudiments of a Baroque portrayal of it. A master often fancies he is teaching the elements of a rendering of the world, when, in actual fact, he is imparting the idiosyncrasies of a style.

Some years ago I often used to examine old art-school drawings from the nude in the picture-dealers' shops on the Left Bank of the Seine. Whether a *sanguine* study of the Florentine school fails or succeeds in giving a good likeness of the model, it always points to the teacher of the pupil who made it, more even than to the sometimes bungling efforts of the pupil; so much so that we can guess its date before we know its author. What the draughtsman had in mind was not the model (for to "hit off" the model does not imply art but technical competence); what he aimed at was a work of art. Indeed, in his eyes, the drawing was justified less by its likeness than by a special kind of likeness, by a *style*. I had seen Japanese art students at Kyoto instinctively copying their model in the Japanese style, and at Paris in an occidental idiom; and, once they had achieved emancipation, I saw them blossoming as artists on the lines of one or other of these styles, in terms of it. . . .

Whether or not he has recourse to a living model, whether as a novelist he uses the words with which his language has equipped him, or, as a painter, the forms presented by the pageant of life—the artist is akin to the composer and the architect, creators who can express themselves without being limited to the representation of a living form. The first steps he takes are invariable; painter, novelist and poet set out from art, the novel and poetry, as the composer starts out from the art of music. The gamut of actions, words and forms is used in the same way as that of sounds. To begin with, an artist is no more impressionable than any other man; to be romantically inclined does not make a man a novelist, pensiveness does not make the poet. A painter is not, at the outset, a man in love with scenery; he is primarily a man in love with pictures. Nor is a poet a man in love with sunsets, he is a man who loves poetry. The prime mover of the artist is never life, but always another work of art.

(Excerpts)

Joan Miró. *Air.* Lithograph

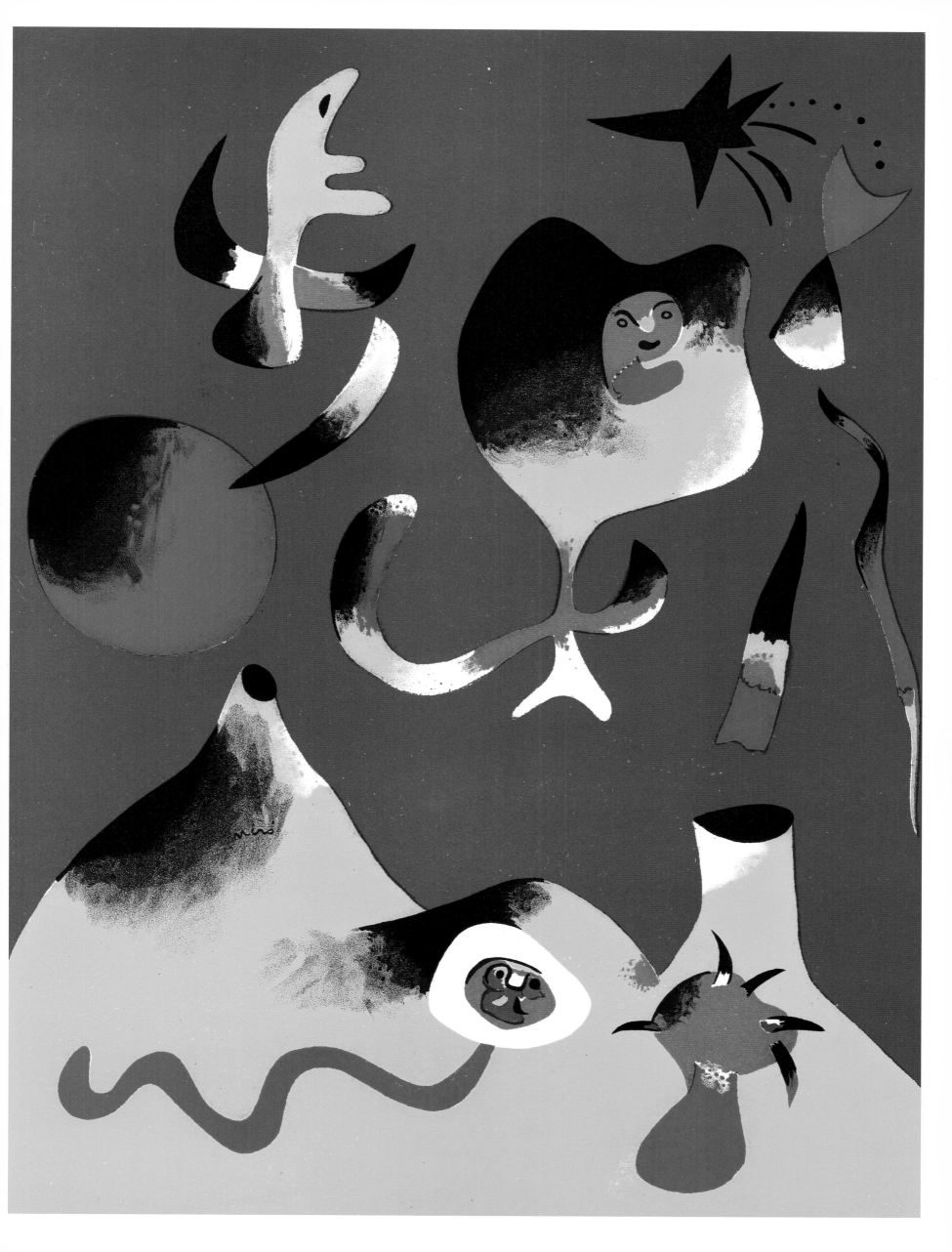

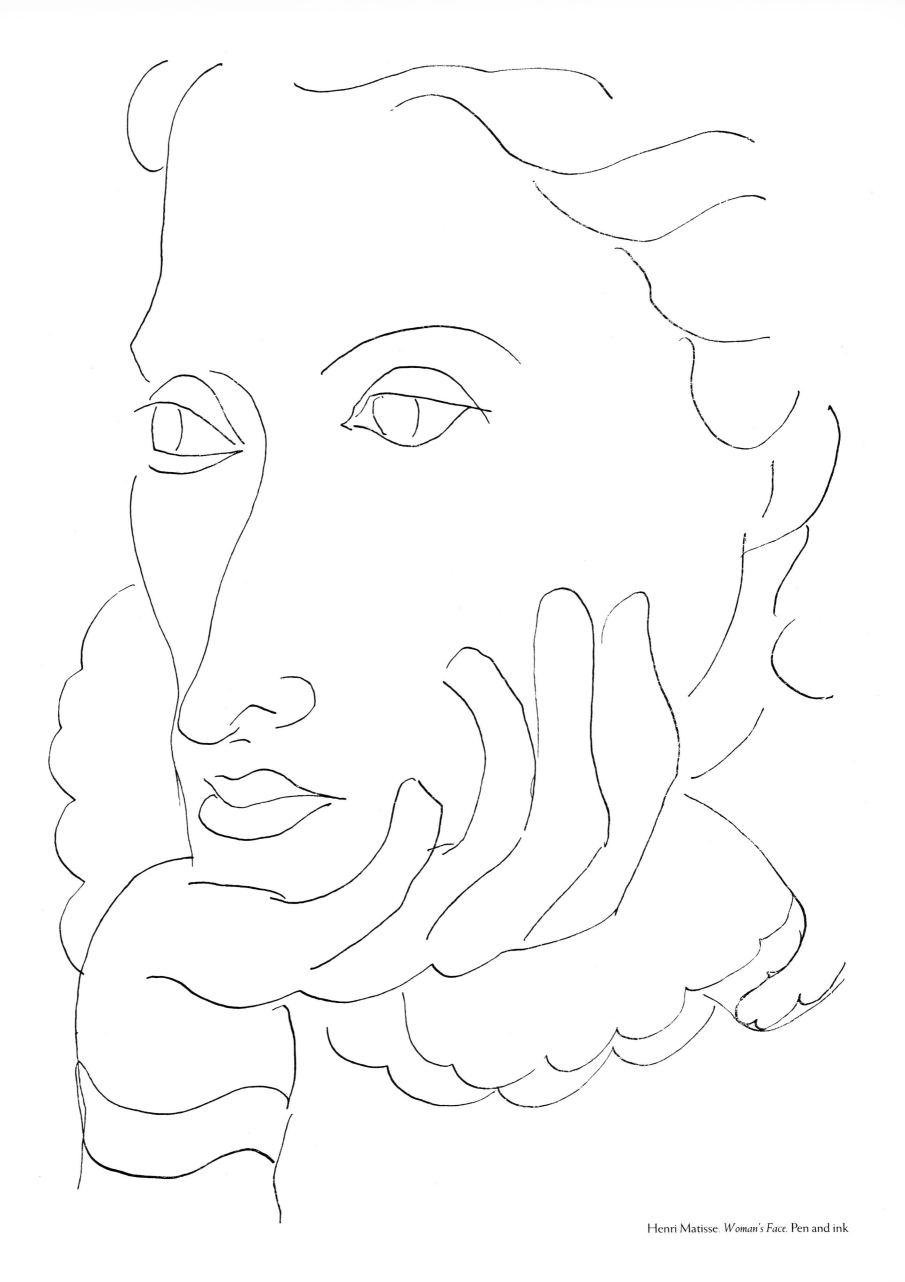

Henri Matisse. *Woman's Face*. Pen and ink

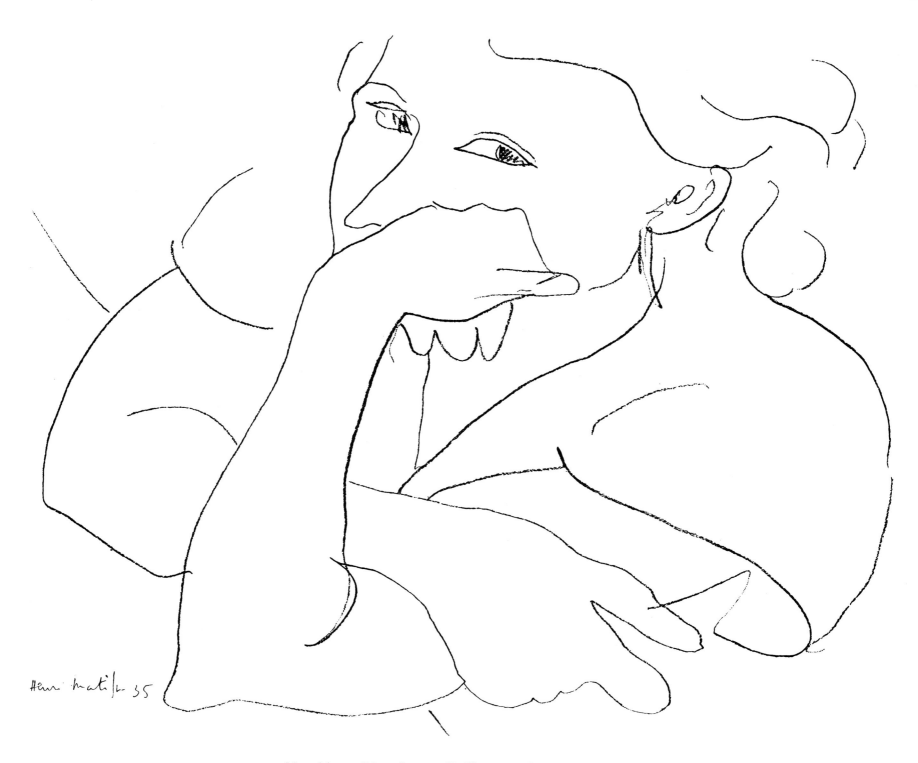

Henri Matisse. *Woman Leaning on Her Elbow*. 1935. Pen and ink

DIVAGATIONS

By HENRI MATISSE

"*D*rawing is the probity of art." Many years ago I used to find myself frequently standing perplexed before this affirmation graven above the signature of Ingres on the marble of the little monument which is dedicated to him in the vestibule of the drawing class called "Cours Yvon" at the Ecole Nationale des Beaux-Arts.

What exactly does this inscription mean? I readily agree that it is necessary first of all to draw, but what I do not understand is the word "probity." Do you hear words of this sort spoken by Corot, Delacroix, Van Gogh, Renoir, Cézanne? And yet I am not annoyed when Hokusai is called "the old man crazy about drawing."

REFLECTIONS ON THE SUBJECT OF PAINTING

By AMBROISE VOLLARD

What should be the relation of the art dealer to the art-lover? In my opinion, he should never undertake to guide the latter, and above all should abstain from explaining the subject matter, from pointing out the proper way to look at a picture, etc.... In this connection, I recall the collector who sent me a photograph of a painting he had taken out on approval. "I should like," he said, "to find a companion piece to this canvas, in which I recognize a familiar Castilian landscape. I have never seen the atmosphere of this region so well rendered." In my reply to his letter I explained that the canvas represented not a landscape but a man playing a guitar.

I expected he would thank me, but he sent back the picture instead.

Another influence the title of a picture may exert: I was preparing a Cézanne exhibition which included an open-air picture representing some nude women with a person who, from his costume, might be taken for a herdsman. The picture had been put in a frame from which I had forgotten to remove the inscription, *Diana and Actaeon*. In the press criticisms the painting was described as though the subject were really the bath of Diana. One critic even extolled the nobleness of the goddess' attitude and the chaste appearance of the virgins who were standing about her. He especially admired the attendant, who, at the entrance to the glade, was extending her arm as though to say, "Go away!"

This picture greatly pleased one of my customers.

"If I didn't already have a large *Diana in the Bath* by Tassaert," he said, "that canvas would go straight to my apartment."

Some time later I was asked for a *Temptation of St. Anthony* by Cézanne to hang in an exhibition. I promised it but was unable to send this particular canvas, as it had been sold in the meantime. In its place I sent the so-called *Diana and Actaeon*, on the frame of which there was no title this time. As a *Temptation of St. Anthony* was expected, however, it was under this title that the picture promised by me had been entered in the catalogue. The result was that a magazine described the work as though it really were a *Temptation of St. Anthony*. Where Diana's noble attitude had previously been praised, the present critic found the bewitching as well as perfidious smile of a daughter of Satan. The attendant's gesture of indignation was transformed into a seductive invitation. The pseudo-Actaeon had become the pathetic figure of St. Anthony.

On the last day of the exhibition I noticed the arrival of the collector who had turned down the picture when it was baptized *Diana and Actaeon*. He was carrying the magazine of which I have just spoken, and he triumphantly announced:

"I have just purchased that *Temptation*. Its realism is amazing!"

The next time I saw Cézanne I asked him what the subject of his picture was.

"Why, there isn't any subject," he said. "I was simply trying to render certain movements...." *(Excerpt)*

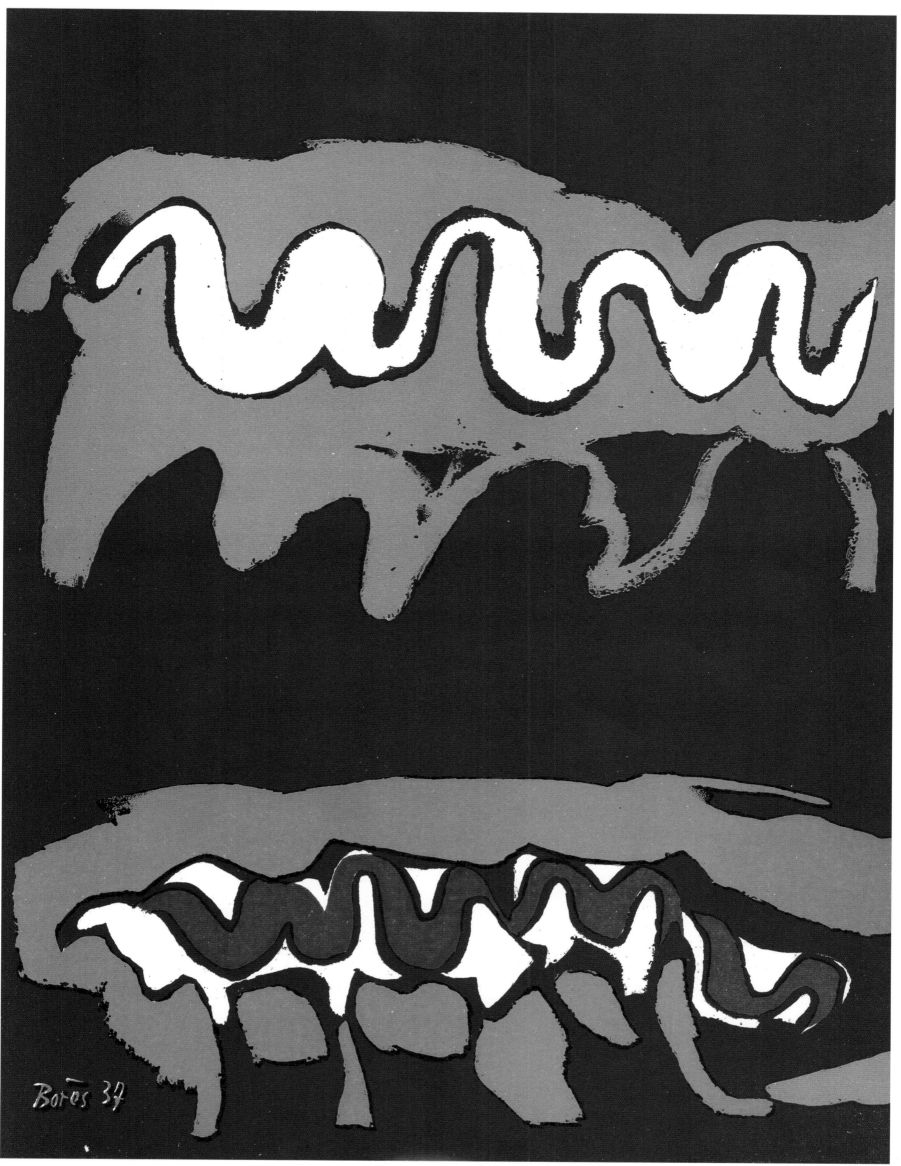

Borès. *Earth*. Lithograph

Opposite: *Nude*
Right: *Hong Kong*
Photographs by Zucca

THE IMPULSE OF PERSONALITY

By E. MINKOWSKI

n the drab background of daily life rises the creative act. It expresses itself through personal works. Refractory to all sociological, psychological, or biological considerations, jealous of its independence and its spontaneous gushing of becoming-surges, it stands before us in all its power and irreducible originality. Our mind marvels at it. But our thought, too servilely attached to the principles of scientific explanations, will speak rather of blindness, or, recognizing its impotence, will say with bitterness and resignation, "I don't understand." Or else it will grow obstinate and wear itself out with considerations which are called scientific but which are incapable of arriving at the essence of the phenomenon studied. Yet the creative impulse remains the "purest" and most precious thing in life. It is what gives a direction to this life, and, by its very irreducibility, determines its underlying structure. Rare in daily life, in accordance with its nature, it nevertheless serves, by the very fact of its possibility and its potential presence every moment, as a support of human existence. Thus we are faced with the question of knowing whether, instead of yielding to the exigencies of scientific processes, we should not make of the creative impulse itself the starting point of our researches in order to restore it to the place where it belongs among all the vital phenomena, and whether we should not also endeavor to throw some light on the essential notions of which it admits.

If, taking the thought of Bergson as a guide, we consider the problem of time, we soon perceive that time, far from being an empty form capable of being filled—as space makes it, for objects, events,

facts, and movements—represents, on the contrary, a fundamental, if not the most fundamental, phenomenon of life—full, in its primitive dynamism, of mysterious and inexhaustible riches and forces, destined through eternal renewal to give birth to everything life permits, everything that assumes substance and form in it. *Biological time* thus extends far beyond what takes place and is inscribed isolatedly in *time*. Inaccessible to discursive thought, which isolates and juxtaposes, it offers itself in its true nature and in the intimate and mobile penetration which emanates from it, to the intuition—which is itself penetrated with it and finds in it its foremost destination without being able, or rather without even experiencing the need, to translate into words what is thus revealed to it.

Irrational in its essence, experienced time is also irrational in that it does not in the least lend itself to a radical opposition between itself and the empty time—compared with space—of thought, as it does not lend itself to the opposition of thought and intuition. Considered as an end or point of departure of the researches to be undertaken on its nature, or considered as an expression of the intense life which palpitates in it, this opposition remains foreign to it. And, as a matter of fact, we see it impregnated in its fashion with certain rational attributes; we see it blossom forth in a formative movement, continually renewed before our eyes, in the form of a diversity of phenomena of a temporal nature, as succession and continuity, as the now and the experienced present, as memory and forgetfulness, as regret and hope, as remorse and aspiration, as human life itself.... *(Excerpt)*

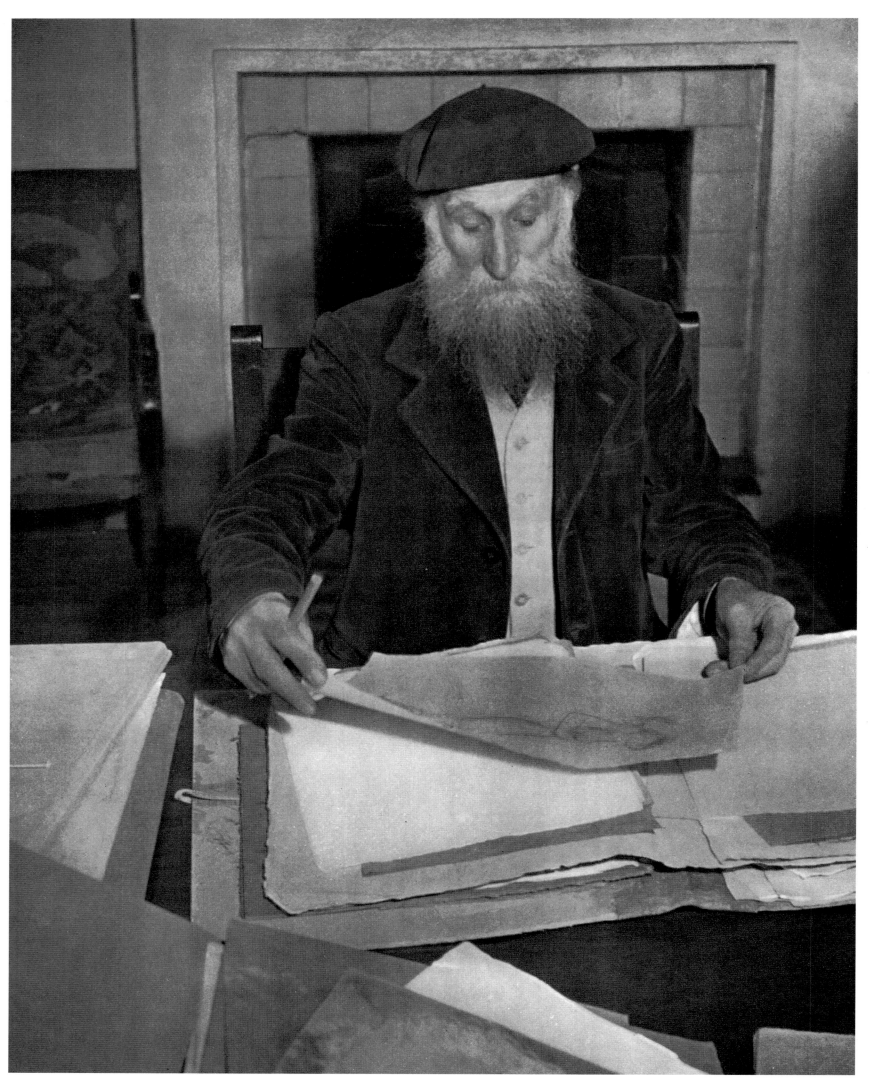

Aristide Maillol at the age of seventy-five. Photograph by Brassaï. © Mme. Brassaï

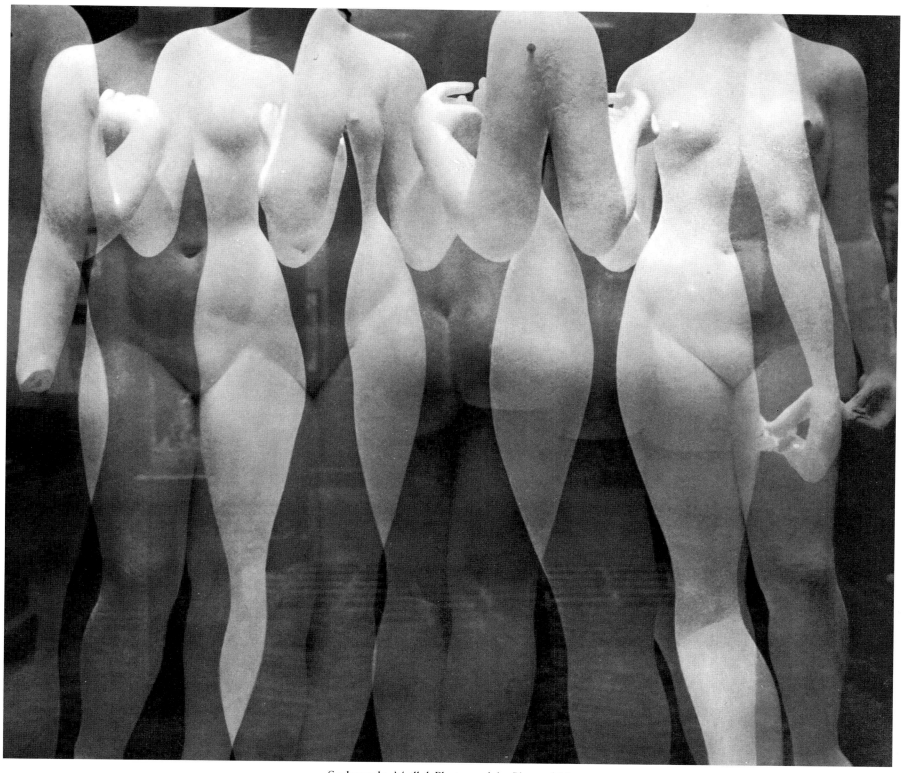

Sculpture by Maillol. Photograph by Blumenfeld

Sculpture by Maillol. Photograph by Blumenfeld

For these cosmopolitan crowds the gods graciously consented to step down from their pedestals.

They will have seen everything, heard everything, understood everything. All is plain, it lies within easy reach of the hand, the eye, the finger.

A blinding light fell over their deep silence. The Religion of the Arts and Sciences, until then poured out to the initiated, was unveiled.

EXPOSITION 1937

By FERNAND LÉGER

They came out of the Exhibition Temple, heads held high, stiff-legged, hats like this, walking like that, insolence in their eyes.

One would like to conceive of another show of this kind, but in the other direction. The film would be run through backward. The sanctuaries close up, the lights go out, the hierarchies and mysteries go back to their places.
Why not?

What we would like is . . . an exhibition recalling respect for the great natural forces. An oak which can be destroyed in twenty seconds requires several centuries to grow again. Birds are always remarkably clever. Progress is a meaningless word, and the cow which provides the world with nourishment will always jog along at three kilometers an hour.

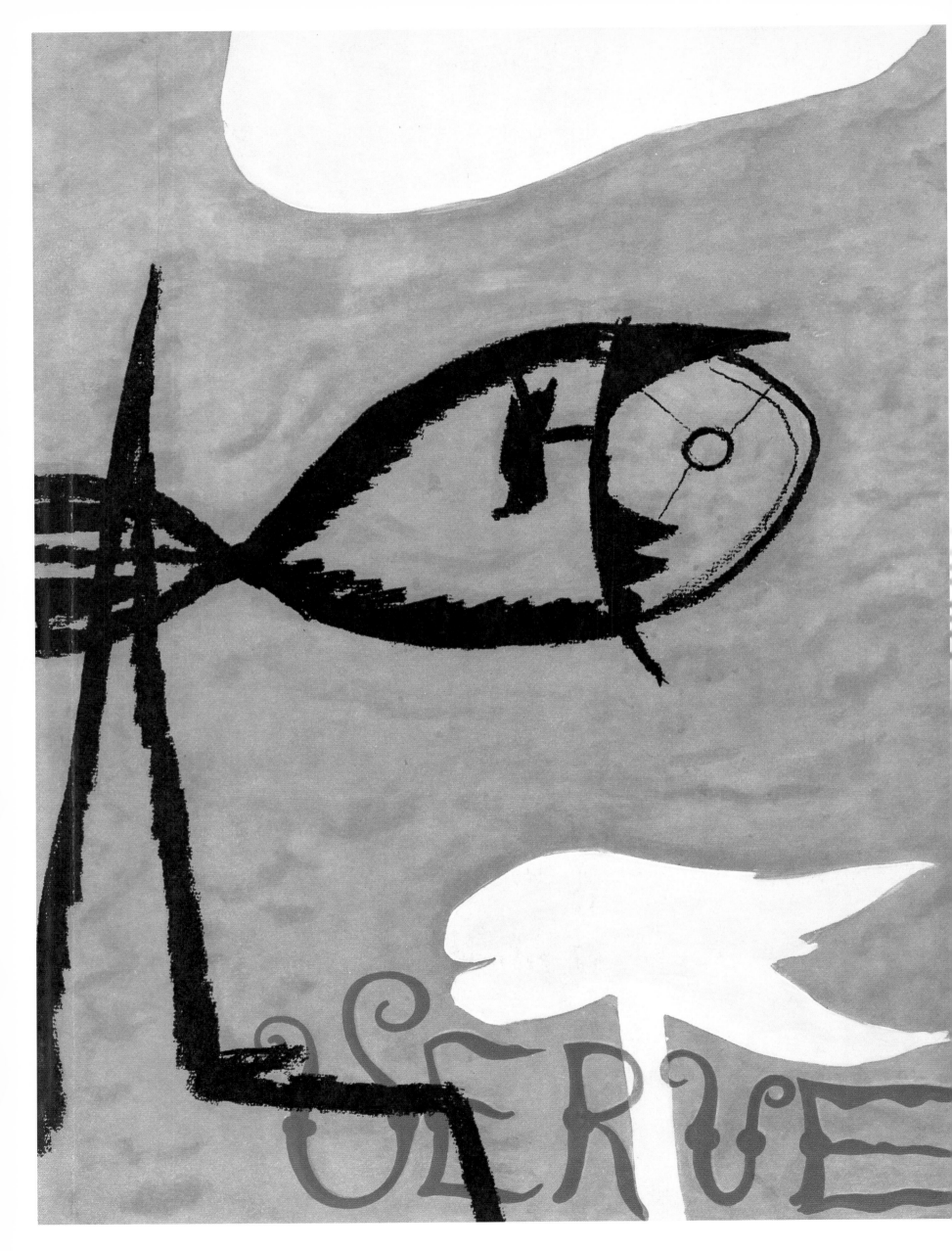

VERVE
Number 2 Spring 1938

"An Artistic and Literary Quarterly Appearing in December, March, June and October," reads the description on the title page of the first issue of *Verve*. Tériade's contracts with David Smart, as well as the very nature of a periodical, forced him to publish at regular intervals. Maintaining this pace was far from easy, however, considering that the magazine had a two-member "staff" who had to do justice to a wealth of high-quality material, while contending with various technical limitations.

Nevertheless, *Verve* No. 2, as stipulated, came out in the Spring of 1938. Although the mention "Sole American Representatives: Esquire-Coronet, Inc." appears on the title page of the French edition (a near-duplicate of its English-language counterpart), Tériade was, and always would be, the one really in charge of the enterprise. Esquire-Coronet acted primarily as the magazine's distributor in the United States.

Pursuant to the terms of the agreement with his American "associate," Tériade had secured the reproduction rights to a relatively large number of texts, photographs, and other material. Since they covered the whole of Europe and America, these rights (acquired with *Verve*'s own funds) were tantamount to world rights.

In December 1937—between the publication of *Verve* No. 1 and *Verve* No. 2—Tériade flew to Chicago to sign a second agreement that would fill in any gaps left by the first. Specifically, it assigned distribution rights in the United States, which were to remain with Esquire-Coronet until the fourth issue.

It was Tériade's only trip to the United States, and he remembered it vividly. The minutes of the meeting held in Esquire-Coronet's Chicago offices indicate that the Americans went to extraordinary lengths to avoid direct legal involvement. A firm christened "Editions de la Magazin Verve" (sic), operating in the United States as a legal American entity, was authorized to enter into a contractual relationship with Esquire-Coronet. *Verve* was allowed to distribute on the Continent and in Great Britain, while Esquire-Coronet was given distribution rights for "the rest of the world."

Under the terms of their agreement, the company's "manager" was empowered to "enter into any negotiations, sign all documents, and do whatever is reasonably necessary or appropriate to implement the terms of this contract and to ensure the anticipated gain." Tériade's American partners may have been sole backers of the venture—they even supplied him with a financial officer to file quarterly reports—but Tériade was the one they put at the helm.

The cover of the second issue of *Verve* features a startlingly modern cropped composition by Georges Braque that is a flawless reproduction of the artist's original lithograph. Opposite the opening "Reflections" excerpted from Braque's notebooks, Tériade placed Giotto's *St. Francis Preaching to the Birds*, thus creating a subtle interaction of themes and artistic visions. This is followed by "The Nude," an article in which Paul Valéry examines the transition of the concept of the nude from an object of shame to that of an unabashed representation of the human body. Although Valéry wrote this piece expressly for *Verve*, one looks in vain for any reference to the contemporary art of his day.

Pierre Reverdy was one of Tériade's closest friends, and his first article for *Verve* appeared in this issue; it would be followed by many others. In a seminal piece of writing entitled "Posterity and the

Poet's Present," Reverdy attempts to delineate his concept of poetry almost as if he were talking—and thinking—aloud: "Poetry, as a literary classification, has always profoundly bored me. Under certain conditions, providing it be examined a bit, I have even found it moderately nauseating." Then comes a wonderful text by Gide on "Travels in English Literature" and, a little farther along, James Joyce's "A Phoenix Park Nocturne" (published in English in the French edition because it was deemed "untranslatable").

Tériade followed the "preview" of Malraux's "The Psychology of Art" that had begun in *Verve* No. 1 with another installment that includes the now-famous page illustrated with Giotto's *Lazarus Rising from the Dead* reproduced upside down. "Often," Malraux writes, "one may regard a Giotto fresco as a bas-relief in which only the faces and the position of the hands have undergone a change. We need only examine a reproduction of it upside down (this does not alter volumes in any way, though it eliminates expression on the faces) to find we are looking at a bas-relief." Elsewhere, Malraux notes that "when Giotto produces an effect seemingly of depth, it is not conveyed by means of values or perspective; it is of a quite different order. Roman and Northern artists suggest depth by hollowing out the painted surface, Giotto by embossing it. In fact what he gives us is relief rather than depth."

This issue also contains some photographs by Maywald that convey the mystery of Van Gogh's and Renoir's last homes. The contrast between the Dutchman's modest second-story hotel room in Arles and Renoir's magnificent residence and studio at Cagnes-sur-Mer, in the south of France, is startling. Then comes a "portfolio" of strange illustrations: "The Twelve Mansions of Heaven" from a *Livre d'Astronomie* that had belonged to the Duc de Berry. Next, Ernest Hemingway, in an article entitled "The Heat and the Cold," shares his memories of the Spanish Civil War. Once again, Braque becomes a thematic thread running through this issue: photographer Bill Brandt portrays him, along with some work in progress, at his house and studio at Varengeville.

The next section is a mixed bag: Greece, as seen through Herbert List's hieratic photographs; a portfolio on the theme of the Apocalypse, introduced by André Suarès—lithographic reproductions of plates from various manuscripts, including a copy of the Commentary of Béatus produced in the eleventh century at the Abbey of Saint-Sever in the Landes (southwest France), as well as pages from the *Apocalypse of Arroyo* (Spain, thirteenth century), and from a fifteenth-century *Apocalypse* of the Netherlands. These reproductions—like most of the pages from illuminated manuscripts that appeared in *Verve*—would not have been possible without the cooperation of Emile A. Van Moé. Today, we take such reproductions for granted, but at the time it was a momentous event. Many of these manuscripts from the collection of the Bibliothèque Nationale had never been photographed before. Moreover, the public seldom had a chance to see the manuscripts themselves, and even when there were reproductions, they appeared only in specialized publications. The tie-ins between the artistic expressions in these manuscripts and the work of Matisse and Braque were novel. Although others may have had the same idea, it was Tériade who presented it in an entirely different way.

This issue had opened with a text by Valéry on the Nude; now, a remarkable series of photographs by Blumenfeld and others brings this subject full circle. The miscellany that follows seems to echo "The Twelve Mansions of Heaven," as if to repeat the opening measures of this symphony of painting and sculpture: "Stars" and "Comets," two lithographs by Kandinsky, a text by Georges Bataille entitled "Heavenly Bodies," followed by two André Masson lithographs, "The Sun" and "The Moon." There are superb photographs by Brassaï; a text by Henri Michaux ("Children") with photographs by Henri Cartier-Bresson, Herbert List, and Bill Brandt; and finally, a reproduction of Hieronymus Bosch's *The Conjuror*, with a commentary by Roger Caillois.

Georges Braque.
Io. Bas-relief

REFLECTIONS

By GEORGES BRAQUE

To paint is not to depict. To write is not to describe. To define a thing is to substitute the definition for the thing. Sensation is revelation.

What resembles the truth is but a deception. Let us avoid deception. What is common is true. What is similar is false. Trouillebert resembles Corot, but the two have nothing in common.

In two things which are regarded as similar, there is always one which is the counterpart of the other. (When, as a result of the resemblance, we take one thing for the other we say we made a mistake.)

It is only in opposites that the common is to be discovered.

There are two manners of developing ideas: I. By seeking what is favorable to them—which permits an ideal development. 2. By seeking what is adverse to them—which prevents all development, but tests their resistance.

One cannot create through a comparison. One ends in a metaphor.

The survival of a thing does not efface remembrance.

Repose will never be ours; the present is everlasting.

Will is but a reflection of constancy.

It is a mistake to draw a line around the unconscious and to situate it within the borders of reason.

Reason is reasonable.

Action is a series of despairing acts—which permits us to keep on having hope.

The future is only the projection of remembrance, conditioned by the present.

Progress is only the illusion given by a displacement of values.

A period is determined by the limitation of its aspirations: this cre-

ates a spiritual complicity, whence the illusion of progress.

A myth whose consequences may be foreseen is called a Utopia.

There is an art of the people and an art for the people, the latter invented by the intellectuals. I do not believe that Beethoven or Bach, taking their inspiration from popular airs, had any thought of establishing a hierarchy.

The art for the people is the chromo. The art for the bourgeois is the drawing on the mantelpiece. There exists authentic art, from which everything springs.

Ideas are destined to be deformed as they are used. To recognize this fact is a proof of disinterestedness.

It isn't that the artist is unappreciated but that he is ignored.

The artist is not responsible for the consequences of his art.

Build opposed to construct.

Progress opposed to evolution.

The everlasting opposed to the eternal.

Hope opposed to the ideal.

Constancy opposed to habit.

The common opposed to the similar.

To construct is to assemble homogeneous elements. To build is to put together heterogeneous elements. Cézanne built.

Liberty is to be taken but not given.

I do not protect my ideas; I prefer to leave them out in the open.

It is the precariousness of his production which places the artist in a heroic posture.

Man walks straight ahead the same as water flows.

These thoughts were selected from the artist's numerous notebooks.

THE NUDE
A FANCIFUL DISCURSION ON THE HUMAN BODY
By PAUL VALÉRY
de l'Académie Française

Prodigiously transformed by a sudden access of intelligence, that odious Look which quickened the first inklings of shame in Eve and in unhappy Adam, marked a turning-point in world history. Once they had disobeyed, once they had tasted that potent fruit of the Forbidden Tree, quite suddenly it happened; for the first time they saw each other, for the first time took stock of their resemblances and differences. Though how they had contrived so far to know each other in such sweet simplicity is hard to tell.

So now, stricken by enlightenment, under the full light of day—they alone enfleshed amongst so many creatures fully clad in fur or scales or feathers—those two gazed at each other and, gazing, realized the utter helplessness of their estate.

And as the Man's gaze settled to a stare and hers grew misted, and a blush mantled all her body, gone was Nature's innocence; mystery and deceit began to mar the outward aspects of desire.

Adam pale and distraught; Eve rosy-red; the careless raptures of their love-play suddenly incongruous with the sunlight, and under the leaves a sinuous watcher hissing, taunting them—how charged that moment with intense significance, and what a wealth of sinister beauty was in that marvelous composition of a splendid setting with extraordinary emotions! One of the greatest poets of our race has visioned and resumed it to perfection in two lines.

Tum patuisse gemunt oculos, nam culpa rebellis
Fulsit, et obscoenos senserunt corpora motus.

We will not deal with the metaphysical consequences of that fateful event; they are sufficiently well-known and we have no occasion to enlarge on them. But from that happening what a variety of consequences has ensued! Nothing, indeed, is more remarkable, worthier of our meditation, than the strange fecundity of that one impulsive gesture.

All our laws, our manners, morals and our Arts derive from the Fall. For, with it, man acquired a new sense implementing those by which he realized an Outside World, and this new sense brought home to him the presence of a constantly besetting peril, imminent with the imminence of his own body.

Further, the reprobation of our most instinctive, and therefore purest, forms of expression, and also of our most natural acts, has split up each of us into two personalities; one of which—the personality we show the world—is forbidden to reveal anything which might "give away" the feelings of the other, the hidden personality; while the latter betrays only what it thinks fit to divulge.

Thus it is that, ever since the day when Eden saw that concept of the Nude come into being, every human community has consisted of almost completely covered bodies, which convey by word or gesture as little as may be of their most intense emotions. We cannot even conceive of a well-ordered society, seemly institutions, a priesthood, a civil or military establishment, an educational system, a medical or legal profession, as existing without this concealment of the flesh; and its observance is proportionately stricter as a race is further on in culture, or, anyhow, more anxious to keep up appearances. The mere removal of clothing would, in many circumstances, spell disaster, and suffice to render many words impossible to speak or to hear.

Once "decency" was mooted, the moral—we might almost say "political"—considerations, which prescribed the wearing of clothes, were reinforced by the severity of climates, the jealousy of married people, and the self-interest of all who made, or trafficked in, attire.

The prestige of the Nude was a natural by-product of that glamour of secrecy and instant danger with which, in its dual role of an illicit revelation and a pernicious lure, it was invested. Man is equally apt to cover up what he feels to be his weakest point and what he holds most dear; and often, naturally enough, he tends to confuse these two things which, though so different, are concealed in exactly the same way. Each of us hides his most cherished possession and his sores from the public eye; and what has been hidden out of bashfulness grows powerful behind the veil.

(Excerpt)

Ingres. *The Turkish Bath*. Musée du Louvre, Paris

A PHOENIX PARK NOCTURNE

By JAMES JOYCE

t darkles (tinct, tint) all this our funnaminal world. Yon marshpond is visited by the tide. Alvemmarea! We are circumveiloped by obscuritads. Man and belves frieren. There is a wish on them to be not doing or anything. Or just for rugs. Zoo koud. Drr, dess, coal lay on and, pzz, call us pyrress! Where is our highly honourworthy salutable spouse-founderess? The foolish one of the family is within. Haha. Huzoor, where's he? At house, to's pitty. With Nancy Hands. Tsheetshee. Hound through the maize has fled. What hou! Isegrim under lolling ears. Far wol! And wheaten bells bide breathless. All. The trail of Gill not yet is to be seen, rocksdrops, up benn, down dell, a craggy road for rambling. Nor yet through starland that silver sash. What era's o'ering? Lang gong late. Say long, scielo! Sillume, see lo! Selene, sail O! Amune! Ark!? Noh?! Nought stirs in spinney. The swayful pathways of the dragonfly spider stay still in reedery. Quiet takes back her folded fields. Tranquille thanks. Adew. In deerhaven, imbraced, alleged, injoynted and unlatched, the birds, tommelise too, quail silens. ii. Was avond ere a while. Now conticinium. As Lord the Laohun is sheutseuyes. The time of lying together will come and the wildering of the nicht till cockeedoodle aubens Aurore. Panther monster. Send leabarrow loads amorrow. While loevdom shleeps. Elenfant has siang his triump, *Great is Eliphas Magistrodontos* and after kneeprayer pious for behemuth and mahamoth will rest him from tusker toils. Salamsalaim. Rhinohorn isnoutso pigfellow but him ist gonz wurst. Kikikuki. Hopopodorme. Sobeast! No chare of beagles, frantling of peacocks, no muzzing of the camel, smuttering of apes. Lights, pageboy, lights! Brights we'll be brights. With help of Hanoukan's lamp. When otter leaps in outer parts then Yul remembers Mei. Her hung maid mohns are bluming, look, to greet those loes on coast of amethyst; arcglow's seafire siemens lure and wextward warnerforth's hookercrookers. And now with robby brerfox's fishy fable lissaned out, the threads simwhat toran and knots in its antargumends, the pesciolines in Liffeyetta's bowl have stopped squiggling about Junoh and the whalk and feriaquintaism and pebble infinibility and the poissission of the hoghly course. And if Lubbernabohore laid his horker to the ribber, save the giregargoh and dabardin going on in his mount of knowledge (munt), he would not hear a flip flap in all Finnyland. Witchman, watch of your night? Es voes, ez noes, nott voes, ges, noun. Darkpark's acoo with sucking loves. Rosimund's by her wishing well. Soon tempt-in-twos will stroll at venture and hunt-by-threes strut musketeering. Brace of girdles, brasse of beauys. With the width of the way for jogjoy. Hulker's cieclest elbownunsense. Hold hard! And his dithering dathering waltzers of. Stright! But meetings mate not as forsehn. Hesperons! And if you wand to Livmouth, wenderer, while Jempson's weed decks Jacqueson's Island, here lurks bar hellpellhull-pullthebell none iron welcome. Bing. Bong Bangbong. Thunderation! You took with the mulligrubs and we lack mulsum? No sirrebob! Great goodness, no! Were you Marely quean of Scuts or but Chrestien the Last, (our duty to you, chris! royalty, squat!) how matt your mark, though luked your johl, here's dapplebellied mugs and trouble-bedded rooms and sawdust strown in expectoration and for ratification of your information, Mr. Knight, tuntapster, buttles; his alefru's up to his hip. And Watsy Lyke sees after all rinsings and don't omiss Kate homeswab homely, put in with the bricks. A's the sign and one's the number. Where Chavvyout Chacer calls the cup and Pouropourim stands astirrup. De oud huis bij de kerkegaard. So who over comes ever for Whoopee Weeks must put up with the Jug and Chambers.

This is the final and entirely rewritten version of a *detail* of a fragment from *Work in Progress* which appeared originally in *Transition* No. 22, (1933) and later in a *de luxe* edition at the Servire Press, The Hague, under the title *The Mime of Mick, Nick and the Maggies*. The entire work under its yet undivulged title is expected to be published in England and the United States of America on the fourth of July next by Messrs. Faber and Faber and The Viking Press respectively.
(*Note to the original text.*)

Renoir, *The Promenade*

etoiles

Kandinsky. *Stars*. Lithographs

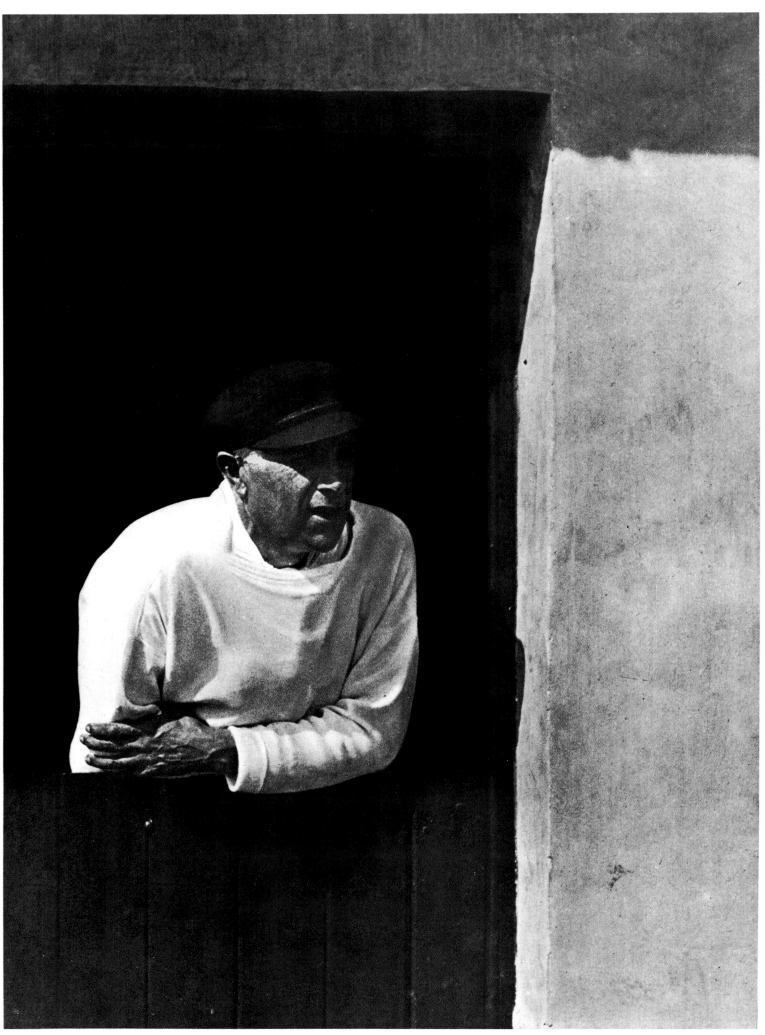

Georges Braque. Photograph by Bill Brandt

Braque's reading stand. Photograph by Bill Brandt

HEAVENLY BODIES

By GEORGES BATAILLE

Of whatever nature they may be, the heavenly bodies are composed of atoms; but, at least in the case of the stars whose temperature is the highest, the atoms of radiating heavenly bodies are unable to be a part of another particular composition on the interior of the body itself: they are *in the power* of the stellar mass and its central movement. Conversely, the atoms of the terrestrial periphery—of the atmosphere's surface—are free from this power: they may enter into composition in the bodies whose independence is well developed in relation to the power of the mass. The whole surface of the planet is formed not only of molecules, each united in a small number of atoms, but also of much more complex compositions, some crystalline and others colloidal—the latter terminating in the autonomous bodies of life—plants, animals, mankind, human society. The stars of a relatively low temperature, among which the sun should be included, tolerate when necessary the fragile autonomy of the molecules, but the intensity of radiation retains practically the entire mass in the atomized state. The cold earth is not able to hold the atoms of its surface in the power of a radiation which is almost nil, and the "movement of the whole" which is composed about the earth takes place in a different way from that of a movement which is arranged on the interior of a heavenly body of high temperature. A sun wastes its force in space, while the particles which at the earth's periphery succeed in escaping the power of the central nucleus, and agglomerate to form bodies that become more and more elevated, are no longer dispensers of force but, on the contrary, consumers of it. All that is condensed and animated on the earth which bears us is thus smitten with avidity. And not only is each composite particle avid of the solar energy that is freely available on all sides or the terrestrial energy which is likewise free, but it is avid of all the energy accumulated in other particles. Thus the absence of radiation, the cold, leaves the earth's surface to a "movement of the whole" which appears like a movement of general *devourment* of which the extreme form is life.

Anthropocentrism is situated at the peak of an achievement of this kind. The weakening of the terrestrial globe's material energy has made possible the constitution of autonomous human existences, which are really just so many denials of the movement of the universe. These existences are comparable to that of the feudal lord, who became independent as the central power ceased to act energetically. But mankind's avidity is far greater than that of a local sovereign. The latter is satisfied if he prevents the king's agents from meddling in his affairs, while the human being is unconscious of the reality of the world which bears him, the same as the parasite is unheedful of the states of sorrow or joy of the person from whom it draws its sustenance. Moreover, seeking, that he may better shut off the world lying about him, to conceive of an all-embracing principle, he has a tendency to substitute for the palpable lavishness of the heavens their constituent avidity: in this way he gradually effaces the image of a celestial reality shorn of significance and pretension, and replaces it with the personification (of an anthropomorphic nature) of the *immutable* idea of Good. *(Excerpt)*

André Masson. *The Moon.*
Lithograph

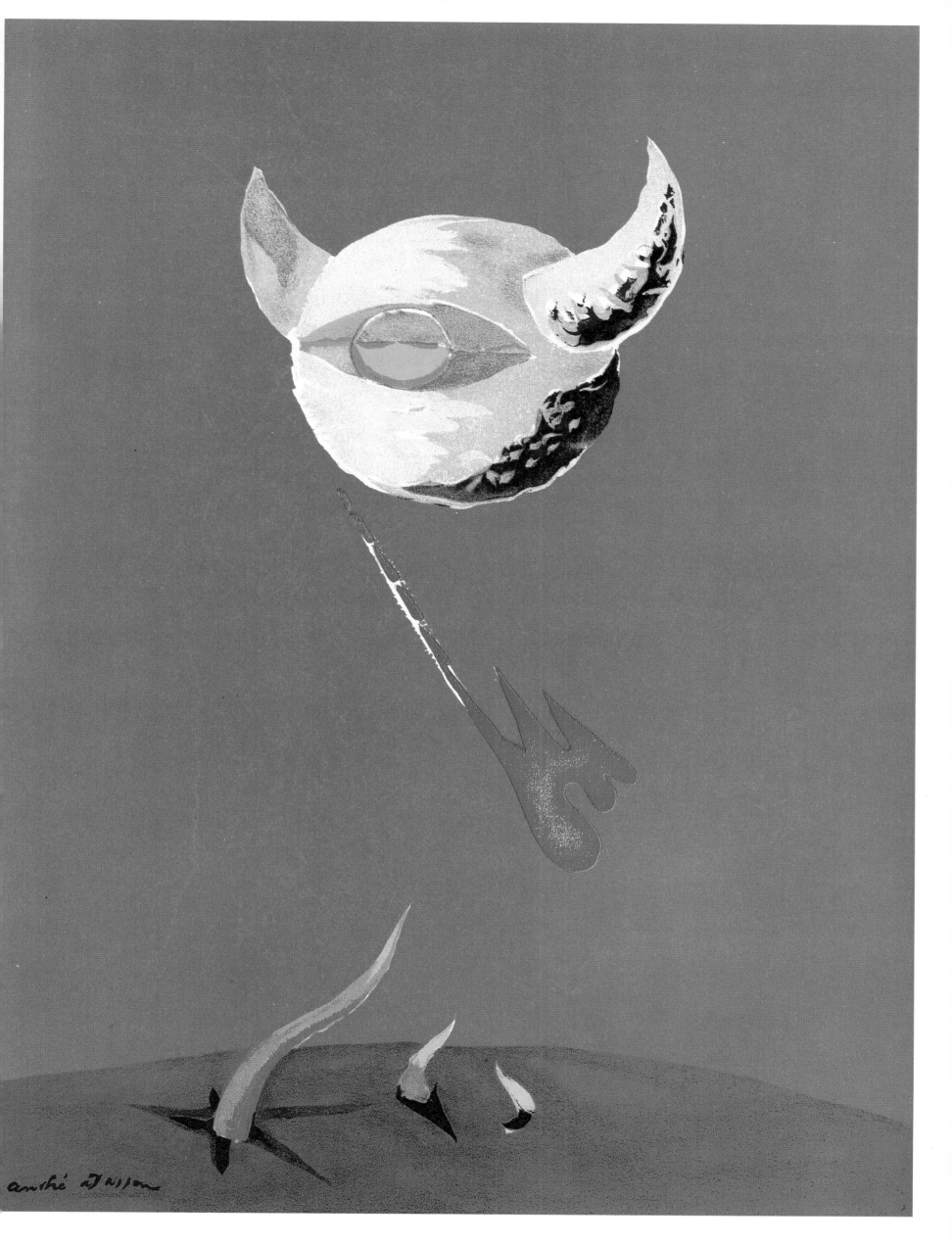

Budapest. Photograph by Jenö Denkstein

Hieronymus Bosch. *The Conjuror*. Musée Municipal de Saint-Germain-en-Laye

BOSCH'S "THE CONJUROR"

By ROGER CAILLOIS

One of the few times that Hieronymus Bosch left his imaginary worlds to become briefly a painter of reality it was to represent a prestidigitation scene, as though he wished to cast doubts on what is real and indicate that he only admitted with reservations that life was a serious matter. If this should be regarded as a coincidence, the occurrence is in any case full of significance. The paintings of this picture-maker have been called paintings with a thesis, rebuses in the grand manner which must be deciphered figure by figure, rebuses which make claims to debate, demonstrate or teach a lesson. This one, the authenticity of which has sometimes been contested, likewise has a motive: its simplicity is apt to prove disconcerting beside the multitudes of living beings and objects in the swarming "deviltries" which testify that Bosch was possibly the most inventive mind that ever lived as far as this particular field is concerned. The group in "The Conjuror," however, is no less complete than the grotesque rogues' galleries of the other pictures; and in the imperturbable charlatan's little audience may be seen the various ages of man and classes of society, which in nowise prevents the figures from being individualized by their own particular characteristics. Their attention is held by an impassible and silent master-trickster, who, tight-lipped and looking steadily before him, is performing before a wall with portable equipment as others would with an arquebus in a corner of a wood. His paraphernalia is of the simplest—a hoop, some goblets, some small balls, a little dog which is rather alarming-looking in its pointed hat; hanging from his belt in a reed basket is the sinister osprey, the bird of night, recognizable by the large circles of light down that surround its round eyes.

As has been already remarked by L. Maeterlinck, genuine conjury is performed right in public—and the spectator who is the most taken in (the man with spectacles), is likewise the most practical. A political allusion, it is ordinarily affirmed. And yet, compared with the *Nef des Fous*, the picture also appears to be an illustration of the pessimistic philosophy of the painter. The mutual linking together of the characters is worthy of notice—the child with the rattle watching the woman who is happily ignorant of the fact that she is being robbed, the lover pointing out the thief to his sweetheart. In this way, the spectators are linked together, none is really isolated and each in turn becomes the center of attention. From innocent conjury to actual theft, between the onlookers and the charlatan, there is thus established a kind of dialectics of reality and appearance, of the manifest and the dissimulated, of imbecility and ruse, a reversal of situations where each person to some degree takes his place and plays his role. *(Excerpt)*

VERVE
Number 3 Summer 1938

The third issue of *Verve* marks the debut of the "thematic issue," a concept that would dominate the rest of the magazine's run. Here, the theme is the Orient, taken in its broadest sense. Tériade asked Bonnard to do the cover, and the artist obliged with a design that showed a festive red tablecloth spread across a vertically aligned table. Seldom have the meanings of "cover" been so appropriate: a feast for the eyes awaits readers about to open this issue of *Verve*. Reminiscent of a woven design, the title appears both across the table and at the top of the page. As usual, the cover is an original lithograph, printed by Fernand Mourlot's studio.

As a diminutive echo of the Oriental-looking Bonnard on the cover, a line drawing of elephants appears as a vignette in the lead text. Tériade had opened the first issue with a Gide article: "A Few Reflections on the Disappearance of the Subject in Sculpture and Painting," and the second with excerpts from the notebooks of Georges Braque. Tériade was Greek, but a Greek from Lesbos. Asia Minor is a stone's throw from his native island; from Mytilene one can see the coast of Turkey. Yet, Tériade decided to broach the complicated subject of the Orient, not by way of Asia, but through the writings of the Indian philosopher Rabindranath Tagore—whose "Reflections on Art" might have been written by Tériade himself! "Art is a solitary pedestrian who walks alone among the multitude, continually assimilating various experiences, unclassifiable and uncatalogued.... Its vision is new though its view may be old.... Because it is not disturbed by a mind which ever seeks the unattained, and because it is held firm by a habit which piously discourages allurements of all adventures, it is neither helped by the growing life of the people nor does it help to enrich that life."

There is no mistaking Tériade's objective: this will not be a banal travelogue. In a lush piece of writing entitled "Orientem Versus," Paul Valéry further indicates the direction this issue will take: "*Orient* is the word of words, my predilection For this word to produce its full effect, it is essential that the hearer should never have set foot in the imprecise region it denotes. He should know of it by pictures, books, and hearsay, and by a few curios—but only in the least scientific, most inaccurate, indeed the vaguest way. For that is the best way to amass the stuff of dreams. What is wanted is a hotchpotch of space and time, of the seeming-true and obviously false, microscopic details and over-size immensities. That is the 'Orient' of the mind."

What do Valéry and Reverdy have in common? Nothing, except perhaps a distrust of literature and literati, of pseudo-creativity, of counterfeit poetry. In his elegy to the arabesque, Valéry notes that "it bans from art idolatry and hocus-pocus, rules out the picture with a 'story,' excludes credulity and travesties of nature and of life—everything, in short, that is not *pure*." He concludes: "Our artist is its one and only begetter. He cannot count on any picture pre-existing in the mind of others and he dare not think of 'recalling' or *e*voking anything at all; rather, indeed, it is his task to 'call up' something, to *in*voke." For Reverdy, however, the matter at hand is "to finish with poetry." "Poetry," he writes, "is an excessive love of life. The need of expressing this love, the feeling of being incapable of expressing it, the transformation of this love, of this need of expressing it, of this feeling of impotence—all this is quite

Indian Girl Holding a Flower. Seventeenth century. Bibliothèque Nationale, Paris

another thing which is called a poem, the miracle, far from reality. I wish to affirm that life is everything, first, last, and always."

Tériade often told me that he made Reverdy's profession of faith his own. He never stopped musing on art; he continually "manducated" it the way mystics manducate the word of God. However, he never forgot that art had no meaning except "in life." Academicism, theories, and "glosses" were his avowed enemies. As I heard him say, "Critics and art historians have no reason to exist unless their writings serve as a form of 'grisaille' that sets off the plates."

Some of Tériade's close friends called him "Hariri," and the nickname may have been inspired by a remarkable set of miniatures that Emile A. Van Moé presents in this issue. (Van Moé made many invaluable contributions to *Verve* in the field of illuminated manuscripts.) "The illustrious Abu Mo-

hammed al Kasim ibn Ali al Hariri was a pellucid mind, brilliantly elucidating the last years of the Abbāsid dynasty (twelfth century)." It is impossible to summarize his work. Visually, it is given the generic title of "assemblies": a dual character, Al-Harith/Abu Zayd, son of Hammam, relates fifty episodes from his life of adventure. These adventures were drawn and illuminated in 1237 by Yahya Al-Wasithi. Also included in this Middle Eastern "portfolio" are illustrations of fables attributed to a Brahman named Bidpai, translated into Arabic in the eighth century and illustrated in Syria about 1220. Lastly, from a third manuscript recopied and illuminated in Istanbul in 1582, *The Rising of the Stars of Felicity, and the Sources of Sovereignty*, Tériade selects a few of the "Wonders of Creation" that had been added at the end of this book for the edification and pleasure of Sultana Fatima, daughter of the Padishah of Istanbul, "Shadow of Allah on the World."

To show us how these "shadows of Allah" really lived, Tériade includes sepia reproductions of some superb nineteenth-century photographs of the Shah of Persia, his chamberlains, and the pitched tents of his encampment. Then, another mingling of photography and painting: Henri Rousseau's *The Snake Charmer* serves as a lead-in to a series of photographs of India. And more "curios"—this time, an illustrated album of "Chevalier Gentil's Souvenirs of India." (Gentil lived in India in the eighteenth century and, as a notation puts it, "strove to maintain French influence there." He commissioned Indian artists to make these drawings, which he brought back with him to France shortly before he died.) Then, curios of a more literary nature: René Daumal presents masks from a "school of dramatic arts" in southern India that "attempts to keep [these arts] alive and to reconstruct the original theatre-temple."

A "Hindu Portfolio" by photographer Gaetan Fouquet is a prelude to "Idolatry," an important text by Henri Michaux: "Prayer is organic. Religion is a function. Worship is a hunger—and it is not to be satisfied by a few social exaltation-cigarettes. Woe to the epochs abundant in sunspots, unless they possess an adequate religion. Man has an amazing desire to go beyond himself. He is an animal that makes everything sacred." As proof of that capacity to "make everything sacred," *Verve* presents us with dazzling colored lithographs of "The Indian Pantheon."

Then we return to Bonnard. After several reproductions of his work there is an unsigned text by Tériade: "Savor! Bonnard is in the habit of saying that, first and foremost, he seeks to paint the savor of things. This modest ambition has made a great painter of Pierre Bonnard." This tribute includes photographs of Bonnard at Deauville, "as intimate testimony of the solitary and simple life of the artist."

For the third consecutive issue, there are excerpts from Malraux's forthcoming work *The Psychology of Art* (also called *Metamorphosis of the Gods*). The text here is entitled "Portrayal in the West and Far East."

Another tribute, this time to Matisse and his "works in progress": oils and charcoal sketches fresh from the studio. This was part of the miracle of *Verve*: its contemporaneity with the most productive periods of some of the greatest artists of the day. Thus it was able to present the public with art-in-the-making, and to do so, as Tériade put it, "point blank."

In a scholarly, yet stimulating, comparative study of Chinese characters and Western writing, Paul Claudel attempts to demonstrate that both are equally rich in ideographs. Claudel drew the illustrations himself.

Also featured prominently in *Verve* No. 3 were an extraordinary set of photos of China, as well as original lithographs by Miró, Chagall, and Klee.

IDOLATRY

By HENRI MICHAUX

Not with impunity has man worshiped for thousands of years.

Once the stomach has been formed, it is too late to say that bread serves no useful purpose.

Prayer is organic. Religion is a function. Worship is a hunger—and it is not to be satisfied by a few social exaltation-cigarettes.

Woe to the epochs abundant in sunspots, unless they possess an adequate religion.

Man has an amazing desire to go beyond himself. He is an animal that makes everything sacred.

In the lack of a greater subject, he must needs, if he be of some base tribe, make that base tribe sacred.

Little matter the subject as long as he is able to disregard the determinism that restrains him, the part of his physiological existence which is vegetative, mean and "scullery," and those restraints and ideas originating in it. He has need of washing away the workaday, the multiple, the intolerable bonds, all the shabby details. He must lift anchor, whip up his nervous currents and depart without baggage, upward like an arrow.

God has always been the type problem, inevitably encountered; the non-existent object, thinkable only, making all else absurd, including even him who does the thinking; the only thing really existing, the most arid of all subjects, the excellent, he who gives nothing, to whom all must be given but to whom nothing can be given without being at once taken away—the ideal pole toward which one wonders why all souls do not levitate.

Several centuries of monotheism, and then of skepticism and atheism, and then of the mania for measuring and weighing things, people and phenomena, have desecrated the world (what was sacred having withdrawn from all places where man had succeeded in establishing it) and have chilled it through a gradual and imperceptible glaciation which is appalling, were we yet capable of realizing it.

To understand it, you have to go to India. An inconceivable delirium will there be found. You feel yourself being covered on the inside, as the other fellow said. India is the sole country whose obsessions, transformed into stone and scattered about everywhere, make you understand immediately that its population is composed of men.

Gods and literature of desire! A veritable physics of language and exaltation.

They are to be found everywhere, outdoors through the countryside, within the myriad temples, behind all the altars—and there is one in every home—countless and monstrous (monstrous and deliberately so, as monstrous as thought, as all image associations, as all phrases, as all ideograms, essentially composite and monstrous).

One of them sits astride a bear, another a rat; Kama, the Hindu cupid, rides a parrot; Ganescha carries a trumpet; still another has a monkey's face, and is followed by yet another carrying in its four pairs of arms wheels, torches, a lasso, an impaled man, a drum. Another is having intercourse with a hoopoe.

"It is marvelous," says the *Mahabharata* itself, "to see these groups of owl-faced creatures ... similar to vultures, jackals, curlews, Ranku antelopes ... their bodies like that of the svavidh, the salyaka (a kind of porcupine), the Godha lizard; creatures with the face of a tiger, an ichneumon babhruka and sea monsters ... the annihilator, the water-spouter, the one with the cry of a wolf, the swastika, the one born of a Fleming, the one with the face of a vegetable, the one with the sugar cane face ..." and, inexhaustibly, like a flowing river, the procession of gods and demigods goes on and on.

Not created to be idealized, far from being saintly or noble (combative moreover—another pleasure, to fight the gods—and frequently vanquished by ascetics and devout Brahmans), allied to savagery, violence, vengeance, sadism, cupidity and disorder, they are first and foremost the exalted-exalting image of all that is *motor* in the Cosmos...

(*Excerpt*)

Death of Bali. Eighteenth century. Bibliothèque Nationale, Paris

The Bath. Seventeenth century. Bibliothèque Nationale, Paris

TO FINISH WITH POETRY

By PIERRE REVERDY

lmost as dexterous as he is debilitated, the poet has spun his spider's web over the horizon's boundless space—and yet he is not the spider but the fly.

Poetry which is too pleasing to the ear never gets as far as the mind, and poetry which grows heavy on the mind does so because it has lost the feathers from its wings. The ear is the keyhole of the door opening on the heart.

There are very few genuine human gestures that count and many false ones that do not count. Genuine poetry is a gesture that counts, false poetry a gesture that does not count.

Just as there is black coal and white coal, there is white poetry and black poetry, the one being an accumulation and the other a concentration of matter, and both of them being productive of power and energy. The remainder, which is poured out drop by drop or is spread over a surface minute by minute, does not count.

A powerful poetic expression is sometimes the unforeseen and violent out-pouring of a sensation recorded years before.

Poetry is an excessive love of life. The need of expressing this love, the feeling of being incapable of expressing it, the transformation of this love, of this need of expressing it, of this feeling of impotence—all this is quite another thing which is called a poem, the miracle, far from reality.

I wish to affirm that life is everything, first, last and always; that art is but a fascinating reflection of it, an illusion; that art can never be more than a dupery; that at best it is an ornament of life—and I will not admit the aesthetic notion that the true poet is he who is primarily stirred by the love of verse, unless an extraor-dinary sensibility has prematurely charged him with the obscure and fatal need of breaking through to the very sources of life by the most unsuitable and desperate means.

It is nevertheless true that the nascent poet first turns to the work of art—and he is right. There he will find emotion expressed—transformed but ex-pressed—and, when he has seen that before being expressed all emotion must be transformed, he will understand the craft. But it is also true, and perhaps it will bear repeating, that, unless he has the stuff in him, or at least unless he can remain in close contact with life; unless he communes with it, sorrowfully perhaps but with profound intimacy; unless he is a crucible in which all life's sensations are blended, he will stumble at the threshold of expression and his pen will never trace anything but lines of ashes on a sheet of paper.

Little accumulators or big ones, what counts is the charge and discharge.

Poetry which is only the love of poetry is but veneer. . . . (Excerpt)

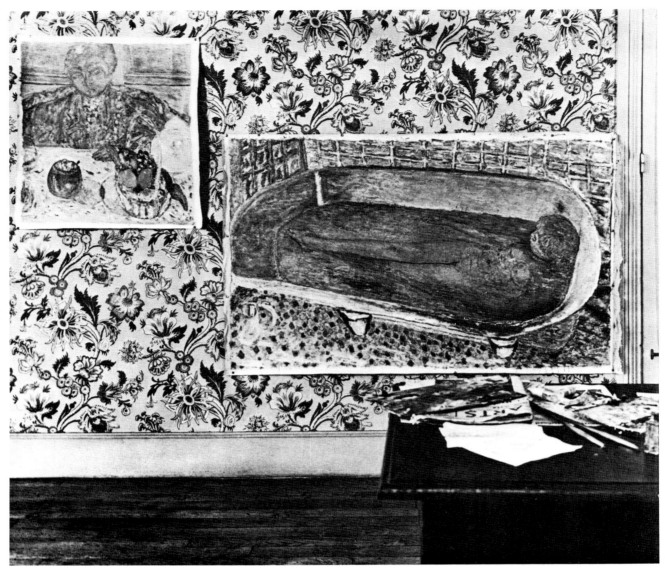

Bonnard's studio. Photograph by Rogi-André

The intimate and natural evolution of Pierre Bonnard's work blossoms forth today with the liberty and boldness of Cézanne, Renoir, and Van Gogh. The work of Bonnard, conveniently situated amidst a vague Post-Impressionism, today assumes a particular significance. Far from being a prolongation of Impressionism, it represents an ardent effort to solve, on a strictly pictorial plane, the problem of vision and its plastic expression. From the very beginning, this has been the capital problem of painting.

With Bonnard, the painter is once more introduced into his painting. No longer does he record his impressions. He himself is present in the plastic action of the image. Objects, space, light—all these bear witness to his presence. Thus it is that light takes on a new value, space reconquers its mysterious reality, and objects recover their "savor."

Savor! Bonnard is in the habit of saying that, first and foremost, he seeks to paint the savor of things.

This modest ambition has made a great painter of Pierre Bonnard.

TÉRIADE

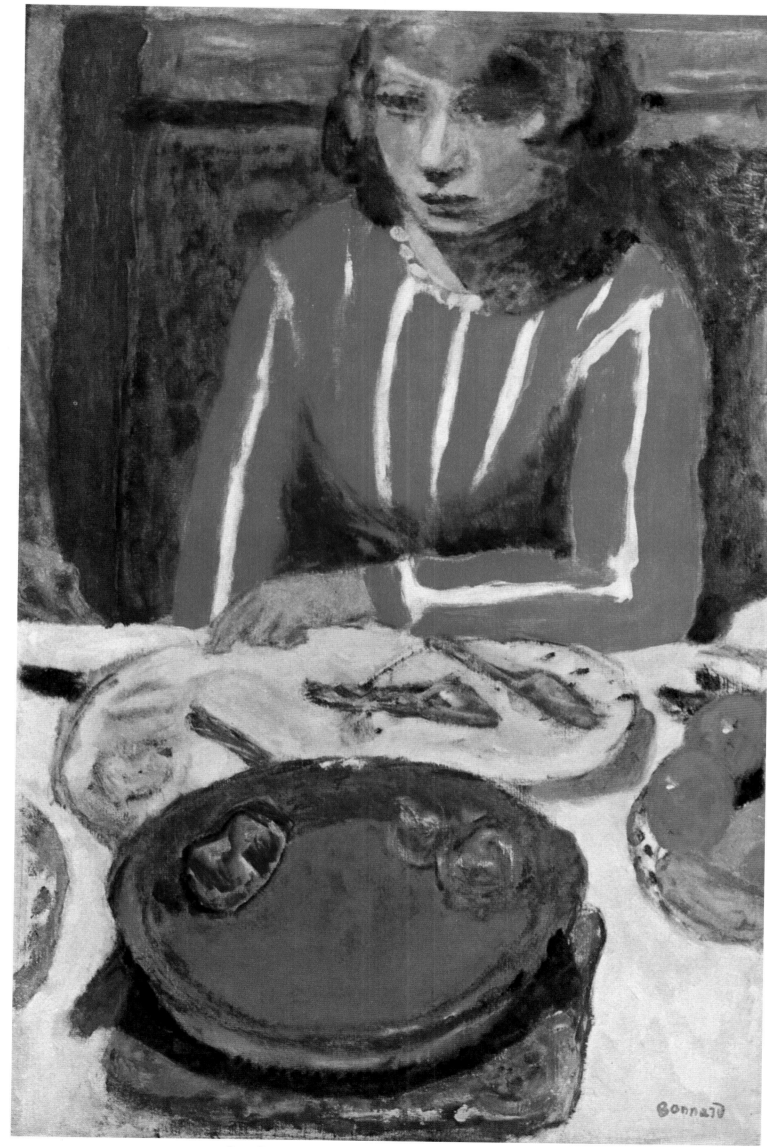

Pierre Bonnard. *Le Déjeuner*. 1922. Oil on canvas. 67.5 x 37.5 cm.

Old Japanese photograph

Écritures

L'écriture Chinoise, bien qu'un défaut d'études ne m'ait jamais permis de l'interpréter couramment, a toujours exercé sur moi une espèce de fascination, que j'attribue à son immobilité intrinsèque, et, si je puis dire, _intemporelle_, toute différente de ce sillage persistant que cette pointe métallique entre nos doigts de notre personalité en voie d'explicitation laisse derrière elle. Quand, écrivant : _Il est trois heures_, ma plume arrive à la fin de la phrase, il n'est déjà plus trois heures. Mais les trois traits du pinceau Chinois suffisent à inscrire ce court moment sur la substance de l'éternité. Non seulement il est trois heures, mais chaque fois qu'un œil humain se fixera sur ce lacs intellectuel, il ne cessera jamais d'être trois heures. Entre tous les caractères qui forment la page, de papier, de bronze ou de granit, proposé à mon attention, il n'y a plus succession, il y a simultanéité. Il n'y a plus son, il y a idée. Il n'y a plus courant, liaison ininterrompue du discours moyennant toutes les articulations et inflexions de la sonorité et de la syntaxe, il y a une série de notions isolées entre lesquelles on laisse à notre œil et à notre intelligence le soin d'établir des rapports. Quand j'écris : _Je vais à la maison_, me servant de ma plume à la manière de mes jambes, je répète en court l'acte qui m'y a amené et qui continue à entrainer le lecteur. Mais le Chinois, d'un poil délicat et noir, se borne à élever à la dignité de figures trois concepts en quelque sorte impersonnels : _Moi — aller — maison_. C'est au lecteur après l'écrivain à transformer en mouvement ce qui n'était que juxtaposition. Il y a évocation d'un fait, il n'y a plus communion avec un acte.

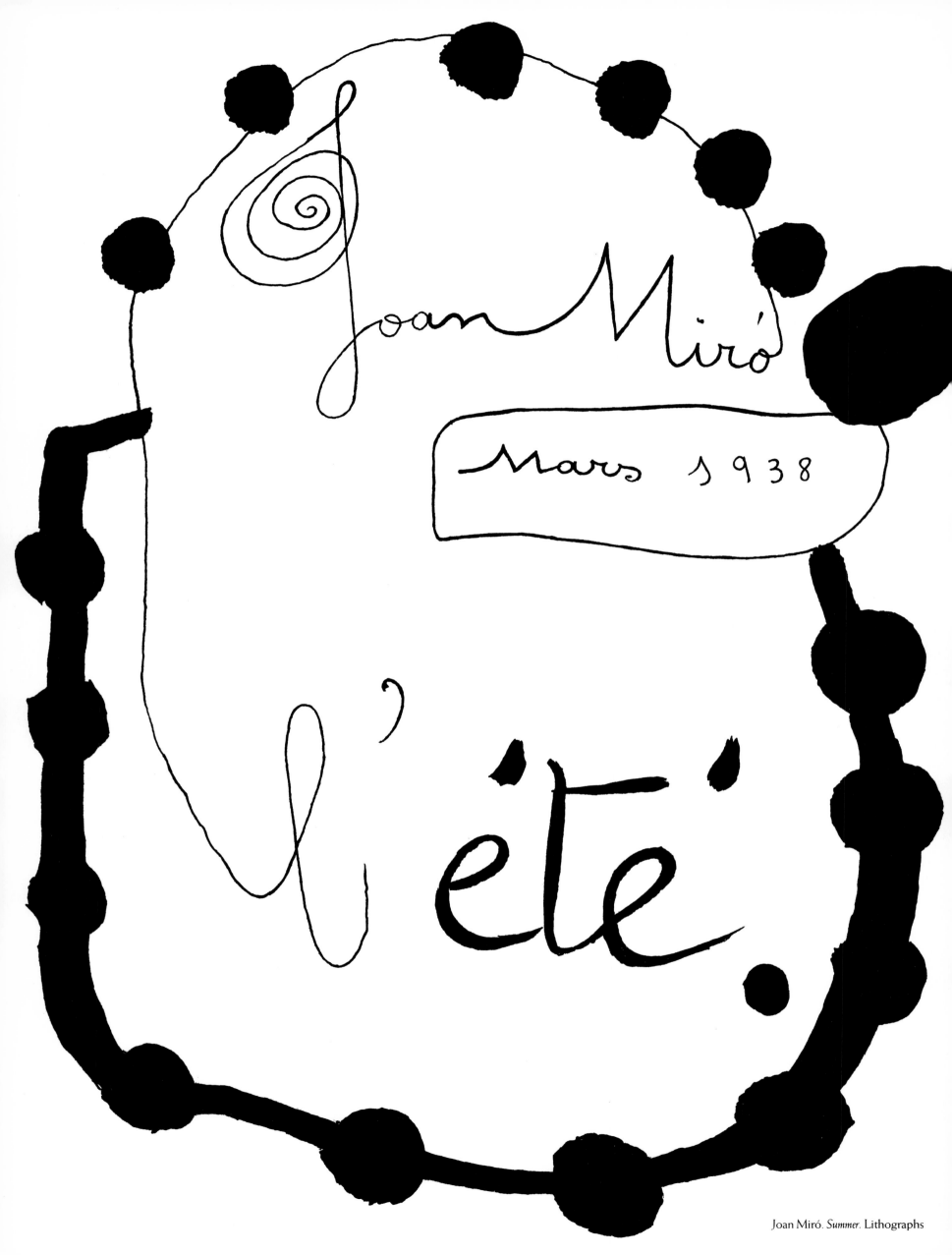

Joan Miró. *Summer.* Lithographs

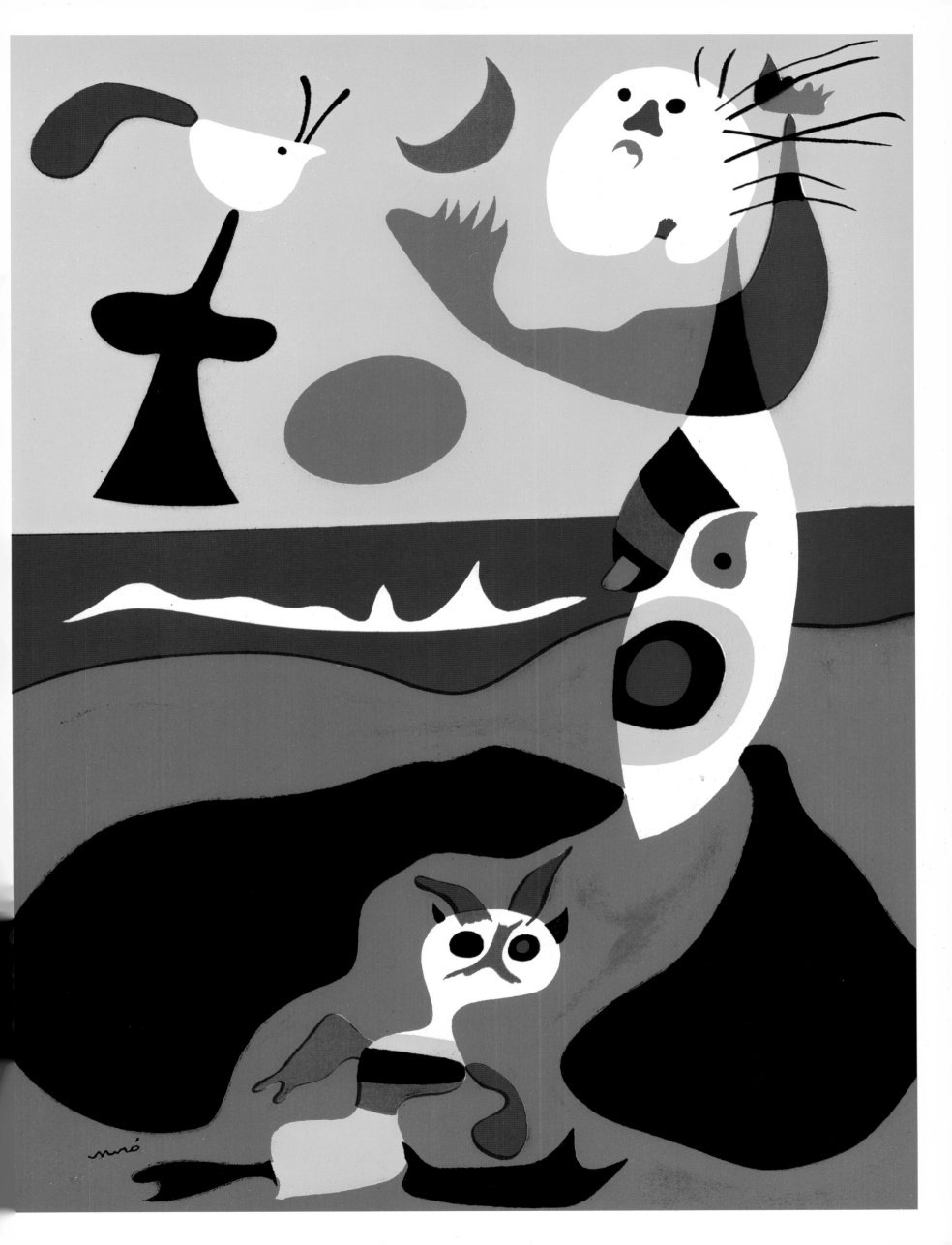

Top: *Chinese Countryside.*
Bottom: *The Great Wall of China.*
Right: *Chinese Boy with Tulip.* Photographs by Thérèse Le Prat

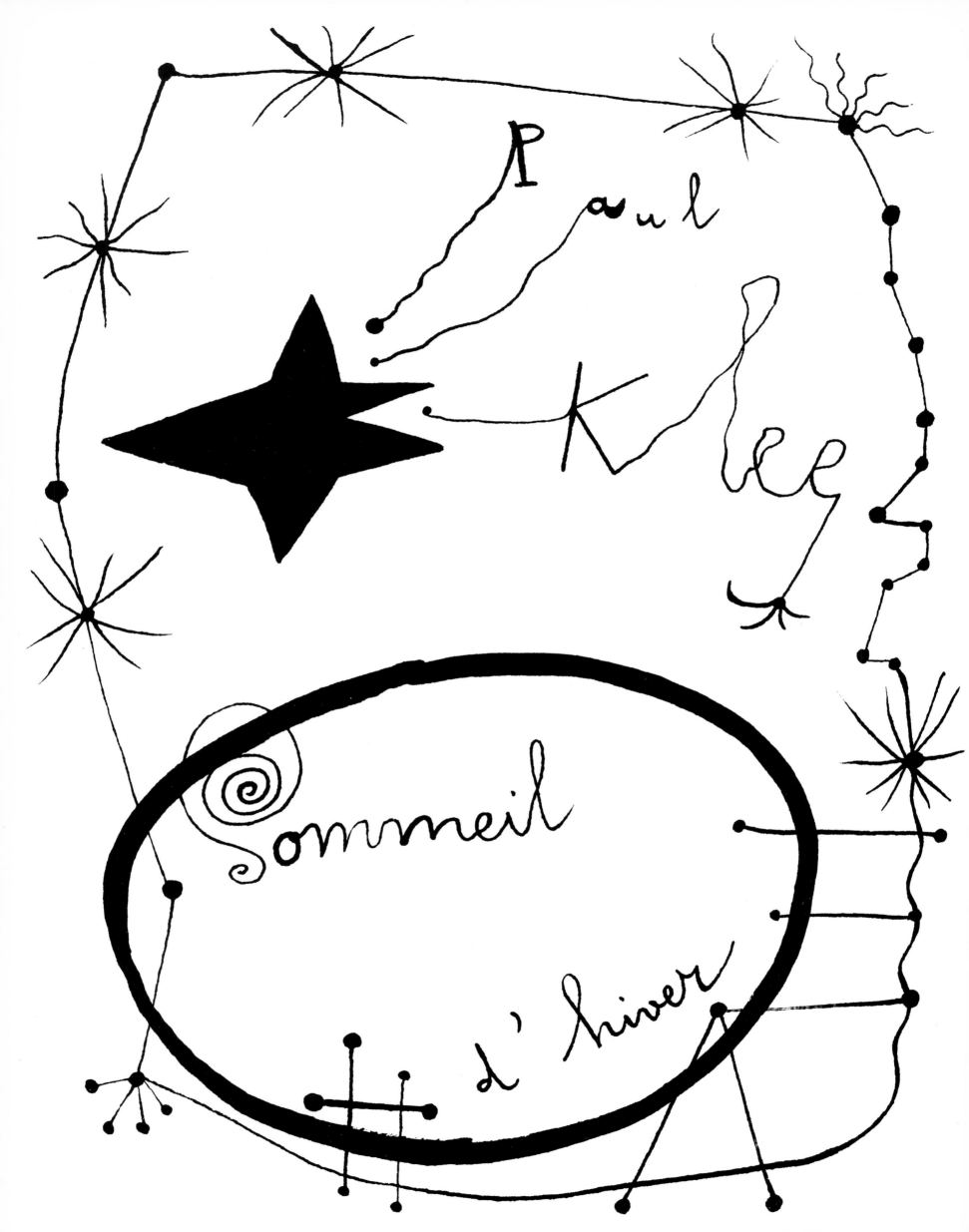

Paul Klee. *Winter*. Lithographs

VERVE
Number 4 Fall 1938

The fourth issue of *Verve* is a veritable cornucopia of art, filled to overflowing. Did Tériade have any premonition of the problems he was to experience with his American partners? Was he afraid that his magazine might suffer an early demise, as had so many before it? Perhaps he simply did not want to keep his readers waiting for the bounty he had reaped. In any event, the opulence of *Verve* No. 4 is nothing short of mind-boggling. The printing date was November 15, 1938. Tériade had kept his end of the bargain: four issues of *Verve* had come out within a single year.

The cover by Georges Rouault is an original lithograph, as were the covers of the three previous issues. The magazine opens with Paul Valéry's "Colloquy Within a Mind," whose premise harks back to the author's *Monsieur Teste*: a dialogue between *A* and *B*—two aspects of the same self—*A* drawing *B* out and upward, *B* forcing *A* back and inward, toward withdrawal and death. After this text, by way of an introduction to a fifteenth-century calendar (from *Les Heures de Rohan*), there is a series of pen-and-ink drawings done expressly for *Verve* by Henri Matisse. They, too, form a calendar of sorts. In "Remember," a symbolic allusion to winter, the painter represents his own hands writing this word, one that might also (a coincidence?) be an extension of Valéry's thoughts, and simultaneously a prelude to the upcoming evocation of time and the seasons. Matisse joins spring and summer together: the south of France was now his home, and he shows the seasons of flowers as a profusion of blossoms strewn across two facing pages. Fall, finally, is the season of fruit and the harvest. The Matisse drawings and the illuminated manuscripts lead us from Valéry to Reverdy.

By means of successive overlappings, pairings, and contrasts that force modernity and classical equilibrium to meet head on, Tériade created a quasi-cinematographic sequence. The conceptual linkage characteristic of his thought processes and perception of art here might be broken down as follows: Petrarch's *Triumphs* ("The Defeat of Time")/Valéry/Matisse ("Remember")/Calendar (*Rohan*) /Matisse (flowers)/Calendar (*Rohan*)/Matisse (fruit)/Reverdy. These connections attempt to demonstrate one of Tériade's fundamental concepts: the continuity of painting.

With a touch of humor, he discreetly slips in another clue to the meaning of this sequence: "An illumination from Louis XII's copy of Petrarch showing the triumph of *Love* over mankind was reproduced in the first number of *Verve*. But *Love* is conquered by *Chastity*, and the latter by *Death*. In turn, *Death* is defeated by *Fame*, and *Fame* by *Time*. All that remains is *Eternity*."

"Were certain illuminations to be enlarged, it would be found that they possessed the plastic value and pictorial qualities of frescoes." This statement seems plausible, especially since lithographic reproduction, one of Tériade's favorite techniques, might be compared with the preparation of a mural surface for painting: a film of color is spread across the wall. Furthermore, the reproductions of miniatures from a fourteenth-century *Tacuinum Sanitatis*, or "Book of Health," prove that even diminutive plates can convey a monumental quality without sacrificing their inherent characteristics.

Tériade believed that French painting is an intrinsically small-scale art form. He cites Fouquet and juxtaposes a page from *The Book of Hours of Anne of Brittany* by Jean Bourdichon and Courbet's *The Woodsman*, reproduced in the same size to obscure the difference in actual scale. The illuminated

manuscripts in the Musée Condé at Chantilly and in the Bibliothèque Nationale had left an indelible mark on Tériade at an early age. In all likelihood, his zealous commitment to art books produced entirely by artists can be traced to this "discovery." How happy he must have been when Picasso (of course!) turned Reverdy's *Le Chant des Morts* into a latter-day antiphonary by filling the margins of Tériade's edition with large, abstract decorations inspired by medieval illumination. As Tériade said time and again: "Painting's got to be presented point blank." The effect, whether the reader opened a fifteenth-century illuminated manuscript or Matisse's *Jazz*, was the same: color in all its purity, leaping out at you from the page.

Then, another variation on the theme of time: an article by José Bergamin on "The Processional Meaning of Spring," accompanied by photographs taken from a document by Barna on "Rilke in Paris," that correspond to the poet's impressions of the French capital, a city that seemed not to have changed at all.

This was *Verve*'s first fall issue and, in November, the activity of the season is the hunt. In a fourteenth-century manuscript that is as beautiful as it is historically important, we see Count Phébus, who lived at the time of Charles V, indulging his taste for that sport. Opposite these plates from *Count Phébus at the Hunt*, Tériade placed three large Brassaï photographs of nature scenes. With this, the section on the seasons comes to an end.

Then, across two vibrant facing pages (and framed on preceding and succeeding pages by linoleum cuts of skaters in motion against a brick-red background) is Matisse's *La Danse*. This was not merely a photograph of the fresco he had done for Albert Barnes, or of the work now in the Musée d'Art Moderne de la Ville de Paris, but an original lithograph in colors bursting with freshness and intensity. In a letter to Tériade dated September 12, 1938, Matisse commented at length on this remarkable ensemble.

"Dear Monsieur Tériade, my friend,

"Here are the sundry things you've been expecting for your issue of *Verve*.

"1) 2 linos for the back of the reproduction of *La Danse*—their title is *Skaters* (conjures up movement). I indicated which way the images go by signing my initials.

"They are to be printed in a fairly bright blood red—not too earthy. I think the colorist will understand. Would you send me your proofs in these shades? Also, the ones for *La Danse*, which, of course, you promised me.*

"Their layout is shown on a sheet of manila paper which I am sending along with them.

"Movement released

 1st verso

"Movement restrained is for the end

 last verso

"2) 3 drawings for the seasons

 A. Winter, REMEMBER

 B. Two-page spread of flowers for spring-summer

 C. Fruit, autumn.

"These were done on paper that matches the dimensions of the magazine. All you have to do is make plates the same size.

"It is absolutely essential to photograph the 4 dots at the corners of the drawings to ensure proper alignment. Alignment is just as crucial as the lines themselves. It has taken me YEARS of work to assimilate this. Not to respect it would be doing me a tremendous injustice. I know there's no need to

write this to an experienced man such as yourself—forgive me for doing so—I can't help it. These drawings—I went to considerable trouble to position them just the right way—should be looked upon as the watermark of the paper on which the main things (*La Danse*, the *Seasons*) are printed, but one of the very highest quality. I did them out of deference to those works. For all of these reasons, kindly see to it that your people follow all my instructions, and that they act as responsibly as I by sending me the proofs as soon as possible. . . . Please take note: a roulette may not be used to tone down the line plates; it makes ghastly little holes in the surface."

*"I'm not sure whether black wouldn't be better for the *Skaters,* but I think it would look too severe. Pull a proof and see."

Continuing in the sprit of *La Danse*, Tériade offers variations on the "eternal feminine": some Amazons (text by Jules Supervielle and a reproduction of a Vittore Carpaccio painting), followed by *Legendary Women in Love*, a late fifteenth-century manuscript. Further along, Tériade dazzles us with a "concertante" passage devoted to the female body: page after page of women by Lucas van Leyden, Tintoretto, Bellini, Altdorfer, Rembrandt, Mantegna, Degas, Toulouse-Lautrec, and Rubens; and a correlative text by Roger Caillois on "Festivals, or The Virtue of License."

Tériade's favorite approach was to cluster illustrations from a stylistic or thematic point of view, sweeping aside all historical considerations. In a letter to Draeger (the printer), he once explained that under no circumstances were the color plates for his publication on *Versailles* to be scattered throughout the book, that clustering them would create a feeling of lavishness.

This issue of *Verve* also featured a consideration of "Chance" by Georges Bataille, and "American Memories" by Ambroise Vollard. After an entertaining piece by Marie Renard, entitled "In the Day of the 'Poseuse,' " Maywald takes us on a photographic stroll through artists' haunts: along the banks of the Seine and on the island of La Grande Jatte (Seurat), into a greenhouse (for a parody of academic painting), and toward the water lilies at Giverny (Monet).

Gradually, in fragments, Tériade reveals a corner of his universe: "Granada," with text and drawings by Federico García Lorca; a sample of "automatic writing" by Miró; *The Savor of Fruit* by Borès; a statue by Laurens; and a curious photograph by Devaux-Breitenbach of "the scent given off by a rose petal."

Then a shift in tempo and framework, starting with a tale "in the Oriental tradition" by Dr. J.-C. Mardrus, entitled "In the Garden of Allah," illustrated with lithographs by André Derain; and André Suarès's "Yorick: Essay on the Clown," illustrated with a Georges Rouault painting. Tériade—who would publish Rouault's *Divertissement* a few years later—includes here a photograph of that artist, a text by him ("Pictorial Conceits"), and an engraving from his art book *Le Cirque de L'Etoile Filante* (published by Vollard). Again, Tériade indulges his taste for unexpected associations by juxtaposing this engraving against photos by Bill Brandt and engravings by Gustave Doré.

The fourth issue of *Verve* also includes an excursion into the world of food, illustrated by Brandt, Matisse, Vuillard, Magnasco, and Pascin—with some musings by Jean-Paul Sartre, who claimed to have learned: "the *truth* about food" in Naples.

91

JULIUS

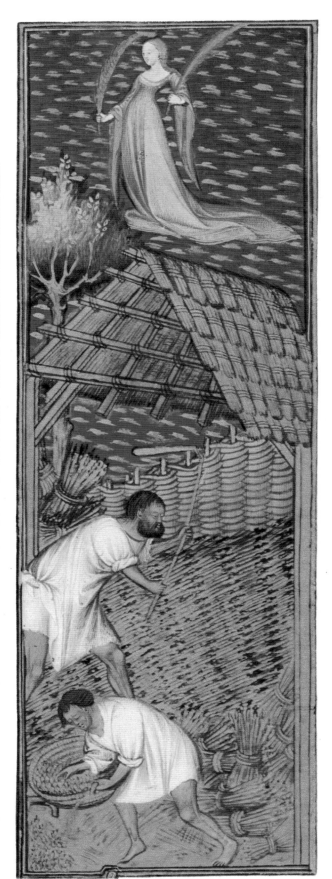

AUGUSTUS

SEPTEMBER

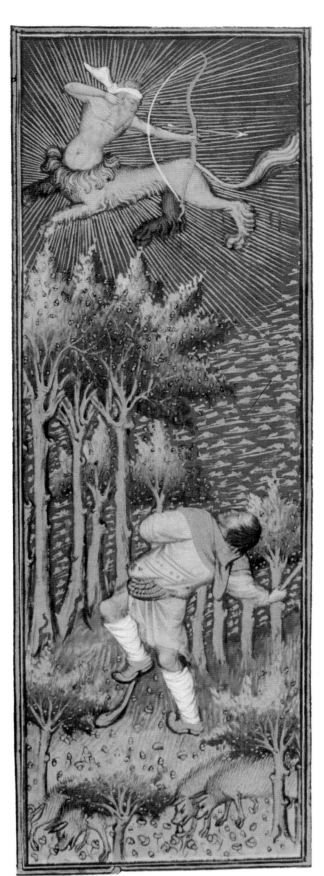

NOVEMBER

OCTOBER

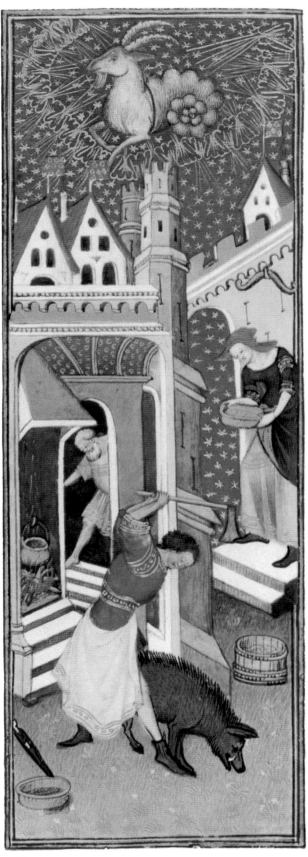

DECEMBER

Les Heures de Rohan.
Selections from the Calendar: "Labors of the Months."
Fifteenth century. Bibliothèque Nationale, Paris

THE DANCE

By HENRI MICHAUX

There was a time when for me the dance was the same thing as petrifaction. Each time I saw people indulging in it I was transformed into stone. Not only did I not respond; I was like a person listening to the radio against his will—he constructs a sort of chest of silence within himself, a counter-noise, a tremendous barrier of muteness.

I lost this feeling in the Orient. It was a queer impression. The corset slipped off. Not that I began dancing, but I discovered the dance, whereas before I had known only agitation.

I saw strange ideas spreading over the bodies before me. I saw bodies tenanted like heads, and that curious inner assemblage and circulation, together with that complete and perceptible repose sometimes to be found in our part of the world in girls sewing by lamplight, stitching away, unaware of being observed, occupied elsewhere, within themselves, as when they are asleep.

I saw the entire world flowing through these bodies, and in them the unexpressed appeared as forcibly as the expressed due to great submissiveness and extraordinary mental concentration.

Movements, so slight that they were imperceptible and unanalyzable, registered life's breadth, they registered meditation, myths, the world, the reasons for existing, and I was at last fostered by a thing that had always been at my side, but I, like so many persons, had never really suspected the fact.

To be seen in it was not life's joy but its light, not misfortune but infinity, not strife but the eternal.

There were secrets full of movement, which although clear-cut and well ordered, were reduced as nature is in the evening when the hum of the insects ceases and one "hears" a great silence, growing greater and greater.

It was a sort of paradise lost of movement, of cosmic appendage, of a time when we had not become poor devils going in for physical culture.

But a large part of the dancer's regret is not to be a fish, or a bird, or a tiger, or a gazelle—not because of their temper, their strength, their environment or their exploits, but because of their movement. Through movement it is that man seeks to be a part of life.

In all countries man is to be seen periodically returning to his body as to a neglected poor relation. He returns. He leans over it. Why has it too not risen? He attempts to put it back in the rank and at the level of the progressive portion of us. But he does not succeed in recapturing it; he makes it go in for gymnastics, but that only takes it farther away. A great hiatus always remains, and the body which appeared so accessible and easy to handle becomes unwieldy and remote once he seeks to make it speak. Of all symbols and pictographic material, the human body is the most cumbersome, the most unwieldy, the one most destined to exert an influence, to trespass, to falsify, the one which makes you say more than you wished and less when more was needed. This is so to such an extent that man practically makes use of his body no longer, except in one of its outlying districts named *figure*, which draws all to self—an embarrassing dualism!

(Excerpt)

Henri Matisse. *The Skaters*. Linoleum cuts

Henri Matisse has painted for *VERVE* a replica of his large painting,
La Danse, now in the Moscow Museum.
This is reproduced lithographically on the following pages.

Two figures of skaters in motion have been composed on linoleum
by Matisse to precede and follow *La Danse*.

Henri Matisse.
La Danse. Lithograph

Joan Miró. *Harlequin's Carnival*. Oil on canvas

The ball of yarn unraveled by the cats dressed up as Harlequins of smoke twisting about my entrails and stabbing them during the period of famine which gave birth to the hallucinations enregistered in this picture beautiful flowering of fish in a poppy field noted on the snow of a paper throbbing like the throat of a bird at the contact of a woman's sex in the form of a spider with aluminum legs returning in the evening to my home at 45 Rue Blomet a figure which as far as I know has nothing to do with the figure 13 which has always exerted an enormous influence on my life by the light of an oil lamp fine haunches of a woman between the tuft of the guts and the stem with a flame which throws new images on the whitewashed wall at this period I plucked a knob from a safety passage which I put in my eye like a monocle gentleman whose starving ears are fascinated by the flutter of butterflies musical rainbow eyes falling like a rain of lyres ladder to escape the disgust of life ball thumping against a board loathsome drama of reality guitar music falling stars crossing the blue space to pin themselves on the body of my mist which dives into the phosphorescent Ocean after describing a luminous circle.

JOAN MIRÓ

Henri Laurens. *Amphion or the Musician*. Sculpture

YORICK
ESSAY ON THE CLOWN
By ANDRÉ SUARÈS

The art of the clown goes far deeper than is generally supposed. It is neither tragic nor comic. It is the comic mirror of tragedy and the tragic mirror of comedy. The broad farce of Molière is comedy's surplus. Only occasionally does parody prevail in it. This farce is the prose of the species, while the clown in Shakespeare is its poetry. Just as the whole Greek theatre springs from Homer, so is Shakespeare's fool the god and the father of all clowns....

II

It is not usually realized that the clown is sentimental. Sentiment is his genius. Like those who are the most poetic, he is acquainted with ideas only in the state of sentiment. With this he combines the excessive in gesture: he carries it to extreme parody: he has the courage to make the gesture which is not only the opposite of the one expected, but the opposite of the one expressing the emotion he feels. This is the principle of his reserve; it is his impassive force. The farce is of the South, and the clown is of the North. Silence is his loudest cry. Astonishment is his eloquence. Consequently, he is familiar with the sublime virtue of silence. And yet his emotion speaks for him, doing so through the whole carriage of his body. For this reason it is that Shakespeare's clown sings—and song is the voice of emotion. A blackbird in a cage, a bird of parody, Shakespeare's clown is replete with songs of every sort.

III

The expressive instant which separates laughter from weeping is the distinguishing mark of the clown's style. It is an essential moment, during which revery and action merge. The face needed for this is not that of a child, nor yet that of a death's head, but one which has something of both. The clown is the death's head of a child in a doll's dress. We are conscious that beneath it lies a skeleton. The skeleton possesses and plays with all our passions. In one and the same individual are to be found the pensive termination and the beginning's keen petulance and elasticity: what an epitome of mankind, what a requisition of all that exists!

Between laughter and weeping, in the contraction of antagonistic muscles, the eyes grow small, become tiny dots like the eyes of a hen. The distortion of the lips leaves the cheek furrow wavering between a smile and a sob. This is why the cheek, with its color and form, plays such an important part in the clown's art: it is but the continuation of the mouth. One looks at the mouth or the cheek of the clown as one looks at the brow of another man. Frequently, the mouth is the brow of a farce.

The cheek draws on the lips and modulates the grimace. What is

Georges Rouault. *Clowns.* Oil on canvas

going to tumble out of the money-box? Its wide slit is full of surprises.

Many children have the same expression: they laugh while crying, and cry while laughing. But the will has nothing to do with this. The mind is absent. In the clown, the play follows the intent, and what is seen is composed of all that is not seen. The grimace's hesitancy between laughter and weeping is the principle of an aesthetic theory. Such a thing, of course, would never occur to a dolt of a metaphysician, Hegel least of all. He is surrounded on every side by the clown.

Hegel is incapable of either laughing or weeping. And Yorick cannot look at Hegel without weeping and laughing. *(Excerpt)*

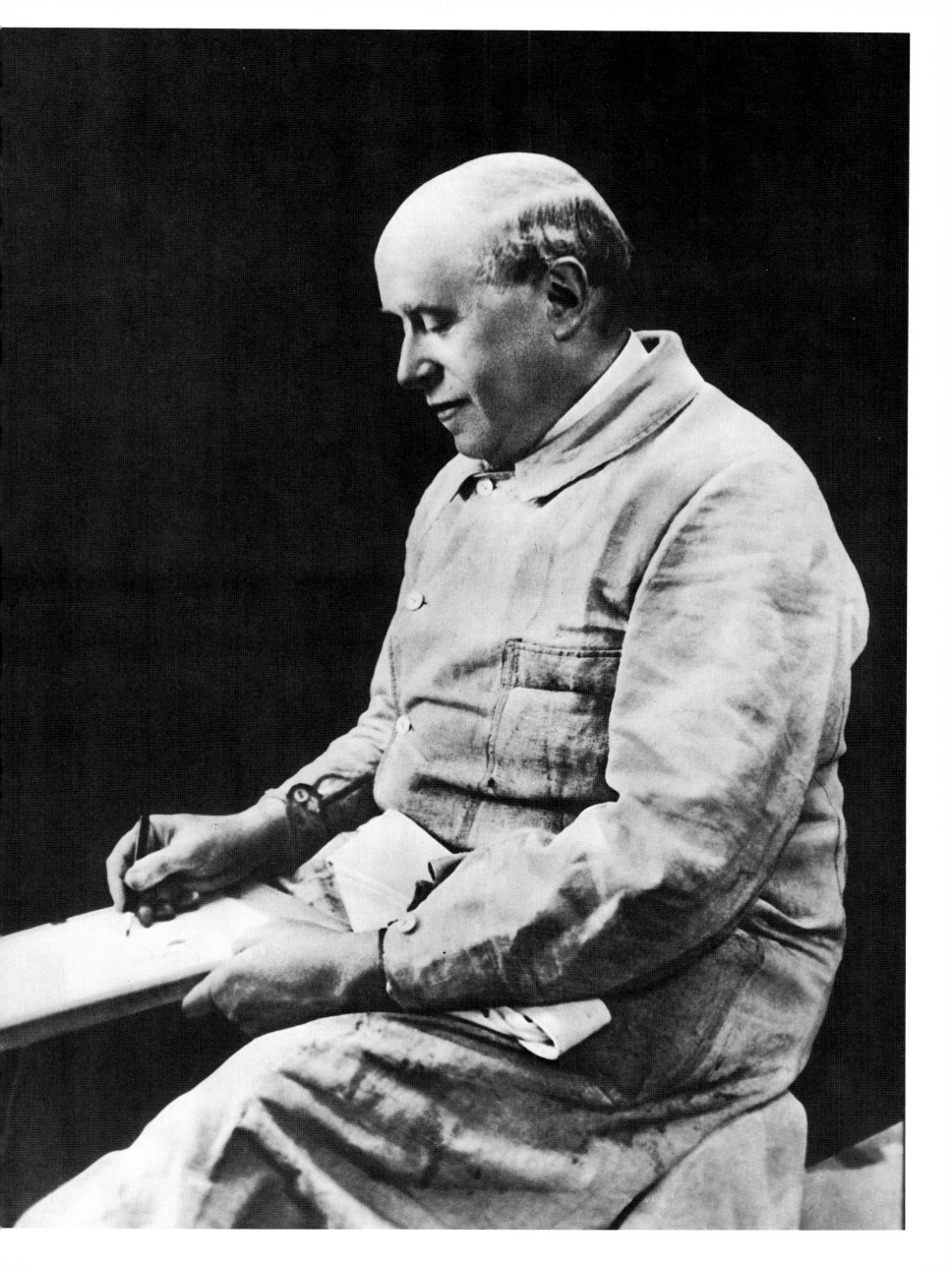

Mantegna. *Bacchus.* Engraving. Bibliothèque Nationale, Paris. Photograph by Chaumien

VERVE
Numbers 5/6 Spring 1939

Although *Verve* had gotten off to a brilliant start, it had to weather its first crisis before publication of issue Nos. 5/6 in the spring of 1939. David Smart, the "silent partner" who had backed the magazine from its inception and distributed it in the United States, suddenly decided to bring everything to a halt. For one thing, he was disappointed with sales of the first few issues, although they had been quite respectable by European standards. More importantly, however, the magazine had not turned out to be what he had expected. He made a bid to break his contract with Tériade unilaterally. After a period of temporizing, Tériade dispatched Angèle Lamotte to negotiate compensation for Smart's about-face. The magazine survived, but from now on it would have to rely solely on its own resources.

These difficulties delayed publication of the issue slated to come out in the winter of 1938. In order not to lose the various material advantages associated with a periodical, No. 5 and No. 6 were combined into a single volume of exceptional richness. It was devoted to the human figure—becoming the second "thematic issue." (*Verve* No. 3 had been dedicated to the Orient.)

The lithographs for both the front and back covers were created by Maillol; he also drew the title in gold-colored letters. Two nude, blonde girls appear to be dancing, embracing, or sparring. Their youthful bodies, throbbing with freshness and vitality, are a departure from the solidly-built female figures usually (even if mistakenly) associated with Maillol. The eroticism they exude brings to mind certain works by Cranach, especially the figures on the back cover, who join hands together above their heads. Both enigmatic couples, at once classical and Dionysian, emerge from whitish grass as thick and pearly as sea foam. In 1939, this sensuous, provocative cover raised many an eyebrow. These young women with firm breasts, powerful thighs, and rippling bellies bore little resemblance to caryatids. A concept had been shattered: Bataille was not far off.

This unconventional approach is obvious again in the subject that opens the magazine: "Official Portraits," illustrated by full-length renderings of Charles the Bald, Francis I, Louis XIV, and Napoleon Bonaparte. The text is unsigned, but it was probably by Tériade. Although he had established a rule not to sign articles in "his" magazine, its conclusion sounds so much like him that it is probably safe to assume he wrote it.

"It has been realized that the official portrait, which protects man from himself, is a religious object. The tyrant who had his likeness suspended from a pole on the city square and ordered the people to bow before it was quite right, for the place of ceremonial pictures is atop a pole, like a totem. It is well that they be there and that people bow before them. In this way, perhaps, it is hardly necessary that they be regarded at all."

After this comes an innocuous piece by Paul Valéry, "The Visage," and a breezy evocation of spring by Gide: "Then a tremor will suddenly thrill [the youth] as he listens at dawn to the blackbird's song; . . . then he recovers his assurance—the whole city is still asleep; he is alone to hear; it is a matter between the blackbird and himself; and when it is the turn of men to waken, the bird is silent."

But it is Jean Paulhan who introduces the reader to the very heart of this issue's theme with his "Portrait of Montaigne": "One would be more inclined to take him for Gilles de Retz or Sade. What

strikes one about the face is its cruelty, combined with a vague suggestion of treachery and cowardice. Also a washed-out, owlish air. No more than that." Paulhan reverses the normal procedure—he does not judge Montaigne by his portrait, but the portrait by the man. With a nonchalance worthy of Boileau, he examines the features and the "Language of the Face," to arrive at the conclusion that Montaigne should be commended "for having banished cowardice, sloth, and cruelty to the exterior, flaunting them alongside the red robe and the shells, an outer husk, dead skin already ripe for sloughing."

This brings us to the *Mythological Figures* from a fifteenth-century manuscript, *Love's Game of Chess*. These nine peerless reproductions, pasted by hand on thick, high-quality paper, are as lustrous today as they were a half-century ago, almost as though they had just left the artist's studio. They are accompanied by a text supplied by Supervielle, who, in his "blank-verse" style, creates a disconcerting story from the narrative threads of these playlets—a fairy tale for grown-ups.

And the portraits that had been promised? Here they are at last, "clustered," the way Tériade liked them, by theme. In succession: *Two Bankers or Usurers* counting gold (by Marinus); Rubens's *Portrait of Suzanne Fourment*; two Rembrandts (in bistre photogravure); a painting ascribed to Corneille de Lyon; the famous painting of Gabrielle d'Estrées affably pinching the nipple of the Duchess of Villars; and other portraits of female subjects, including a sumptuous Reynolds work, also in photogravure.

Tériade enlisted Jean Grenier to provide the commentary for this "museum without walls." "These triumphs in what is human have something akin to the winter's cold, the wind, the sea, or silence; they are *elemental*." But one of the highlights of *Verve* Nos. 5/6 is Jean-Paul Sartre's article on "Faces," which begins: "In a society composed of statues, life would be a deadly bore, but it would be lived according to the dictates of justice and reason. Statues are bodies without faces; blind and deaf bodies, without fear or anger, and uniquely concerned with obeying the laws of rightness, that is, of poise and movement."

These remarks evince a philosopher who offers a strange appraisal of human passions. Alberto Giacometti, for his part, seems bent on undermining Sartre's comments, by juxtaposing against his article a photograph of Pigalle's huge, full-length statue of Voltaire. (He was responsible for this sequence, although not explicitly credited with it.) Small wonder that the statue caused a scandal in its day: the inordinately large, veiny neck, the drooping shoulders, sunken chest, creased belly, and long, spindly legs convey the decrepitude of old age. But the contrast between Voltaire's withered body and his glowing, almost mocking expression creates a psychological portrait whose sensitivity and profound humanity challenge Sartre's clinical description of the human body. The two pages of portrait busts that follow were also Giacometti's idea. The first ("masculine") page, is a riot of noses, haughty expressions, gesturing chins, and offended foreheads. Most of these are busts by Antoine Coysevox, who framed the violent, asymmetrical faces in wigs with large, loose curls cascading down both sides of the neck to reestablish a feeling of equilibrium and composure. These dukes, regents, and kings are accustomed to giving orders, and it shows. The other page (the "feminine" one) is more varied. These women, children (and men as well), mainly in sculptures by Houdon, are high-ranking, too; but they have been relieved of ponderous wigs. Their hair—or lack of it—is plain to see. Their faces, as stripped-down as any by Giacometti himself, have a certain gentleness about them. An excerpt from Pierre Reverdy's *Journal*, which follows these two pages, neatly sums up the contrast between these two sets of pictures: "I wonder if a face is lovelier as a deceptive mask or as a window wide open on life. Whether the thrill of deceit is more beautiful than that of love."

Pierre Bonnard. *Le Petit Déjeuner* (detail). Lithograph

The theme of the human figure inspired Alfred Jarry to ponder the question of imitation in art, that audiences "insist on a certifiable similarity to what is familiar and recognizable. Fortunately or not, there appear from time to time three or four actors who see this dependence as a stepping-stone and whose footing is secure enough to come up with something new and different each and every time. The kinder critics say that they are 'trying to find their way.'"

After Jarry's text, a break in the flow: lithographs by Constantin Guys serve as a lead-in to a section on women. "The Man of humanism disintegrated into individuals, and Woman became the concrete myth and the general figure of the new Human Comedy. And all women were called upon to play the role of Woman. Whether in poems, paintings, or even photographs, women were to be seen striving to fill this role." A series of illustrations follows to back up Tériade's (unsigned) observations: Corot, Prud'hon, a two-page spread showing *la bonne société* in the Parc de Neuilly (in a photograph from 1860), Renoir, another Corot, a photograph by Nadar, and lithographs by Braque, Rouault, Derain, Léger, Bonnard, Matisse, and Klee. Reproductions of works by François Clouet, Cranach, Dürer, Renoir; the *Portrait of the Brontë Sisters* by Patrick Branwell Brontë (who "eliminated" himself from the picture before committing suicide); a composite of Balzac's heroines, another of George Sand's, and miniatures from an illuminated manuscript presenting "Boccaccio's Fair and Renowned Ladies."

Interspersed among this dazzling series of images are texts by Marcel Jouhandeau, Jean Giraudoux, and Henri Michaux.

The next grouping takes the reader back in time and into the third dimension. Statues of Jeanne de Laval and Egyptian, Byzantine, Greek, and Etruscan portrait statues are a prelude to an unexpected pairing of Alain and René Daumal. The moralist Alain examines "The Human Countenance" and analyzes it rationally: "Hegel furnishes us with the method for conducting this analysis. The nose is one of the most important facial traits. Now, the nose has two functions—to perceive and to smell. The first is human; the second, animal. The human countenance consequently indicates a relationship between the nose and the brow." Daumal, however, turns the question around and bids us enter the head itself: "The head and the face, described from within.—From the inside of the head, where I have just entered, I shall try to describe for you what I perceive. There is one part, mostly soft, pierced with openings, through which I can see, listen, smell, taste, swallow, and which I call the face or the front; and one part, mostly hard, without openings, which neither sees, hears, smells, nor tastes, and which I call the skull or the back. . . . The whole machinery in the middle of the head is for thinking. Think, it can. But think of what? That does not depend on its decision. Who then decides? I? Who am I?"

Next, Herbert List captures the timelessness of Greece in photographs of priests and shepherds; then, Adrienne Monnier shares some thoughts on the work of photographer Gisèle Freund in "The Land of Faces." (Thirty-five years later, this title was to become the name of a film by Frédéric Rossif and, in 1985, of a book by Gisèle Freund. Freund, like Angèle Lamotte, was to remain loyal to the memory of Adrienne Monnier.) Concerning the anguished expressions worn by Claudel, Gide, Valéry, Romains, Fargue, and Supervielle, Monnier notes: "The writers, the poets, the wielders of words—they are the most tortured scenes in the land of faces, the strangest, the least beautiful by the canons of contemporary beauty—beauty doesn't worry, at least it shouldn't let on if it does—but they can't do otherwise. For them are the eddies, the erosions, the storm-bitten summits, the rivers of fire, all the disturbances, great and small. How is a form to remain quietly within them, whose task it is to express the revolutions of forms? . . . Gisèle Freund has a feeling for humanity which makes her akin to Nadar, whom she has taken for her master."

Georges Rouault. *Pierrot.* Lithograph

Finally, *Verve* Nos. 5/6 offers texts by Rouault, Suarès, and Vollard. In an article entitled "My Portraits," the dealer and publisher recalls, "I had already posed for [Renoir] when he executed the portrait of Bernstein (1910), that canvas in which there is such an extraordinary symphony of blue. After seeing it, I had but a single idea—to have a portrait of myself done in a similar symphony of blue."

This double issue would be remembered as one of the most sumptuous magazines ever published. The dazzling section of a seemingly endless series of illustrations, speaks for itself: Maillol's studio (photographed by Brassaï), David, Bonnard, Goya, Frans Hals, Miró, Giacometti, Borès, Derain. Then, studio photos of Edward VII as the Prince of Wales (Mathew Brady), General Ricketts (Brady), Emile Zola, Whistler, Rodin, Wagner (by Hanfstaengl), Corot, Poe (Brady), Baudelaire (Carjat), Walt Whitman (Brady), Maillol (Breitenbach), Liszt (Hanfstaengl), and Hans Christian Andersen (Hanfstaengl), as well as portraits by D.O. Hill (this last, with an appreciation by Gisèle Freund). Then, the now-famous shot of a man fervently kissing the hand of Cardinal Pacelli (the future Pius XII), by Cartier-Bresson.

Still more discoveries await the reader: twenty-four ivory-colored pages of lustrous art paper that feature, for the first time anywhere, the Musée Condé's treasure trove of miniatures by Jean Fouquet. This was part of the miracle of *Verve:* every art form was matched to a suitable printing process and paper that would show it to its best advantage, regardless of cost or technical difficulties. The ensemble of Fouquets is introduced by Henri Malo, then curator of the Musée Condé, who comments on each miniature in a style that is lively and informative. This, too, was a departure from traditional art history.

Printed by Draeger Frères, these color-and-gold photogravure reproductions of miniatures from *The Book of Hours of Etienne Chevalier* fairly leap out at the reader from the sturdy pages upon which they were hand-pasted. Fifty years later, the blues, golds, reds, and greens have lost none of their original luster. The final miniature in this issue devoted to the human figure shows the saints and the heavenly hosts gathered around "The Trinity in Its Glory."

It is difficult to believe that this issue of *Verve* came out in 1939, at about the same time as the *Exposition Internationale du Surréalisme* in the Galerie des Beaux-Arts, and that Tériade had once been the artistic director of *Minotaure!*

Alberto Giacometti. Above: *Bust on a Plinth*. Below: *The Mother of the Artist*. 1937.

Marie Laurencin.
Young Woman. Drawing

MAKING RAIDS ON FACES

By MARCEL JOUHANDEAU

The remembrance of a recent and vague lust, foreign though it may be to certain mouths, hovers about them so insistently that the purest face, without one being able to say why, occasionally resembles an indecency, takes on the outline of an obscenity.

A person is haunted by an image; and you are neither aware or unaware of the image; yet what a mystery is this visible reflection of the imagination on the face, this presence of the subject of thought in the look or expression of the physiognomy, which surrenders it to the first stranger who comes along; and, in turn, you yourself are possessed, utterly overwhelmed, your nerves atingle, until you have succeeded in seeing and touching the base or lofty thing the other person was imagining.

It is permissible to know the heights and depths in which another person moves, and the degree of hardship or ease in which he is accustomed to live; and it is permissible to know this through observing his manner of expression, whether he looks at you directly or indirectly as he approaches you, at what level of your personality he finally adopts a basis of candor with you, to what precise spot he is driven mechanically, whether he attempts artfully to conceal his game or whether the machinery is set in motion automatically, without his volition.

I am aware that many persons are interested only in the things they refrain from staring at for fear of betraying themselves, but there is nothing as confidential as reticence of this sort; such elaborate precautions produced by an obsession border on a kind of confession—better yet, on evidence.

It is precisely because Peter sees but one thing that he never looks at it, but that his glance and the chosen subject are brought together! Such a serious disturbance is produced that his agitation escapes no one—the flushed brow, the starting sweat, the stammer, the panic-stricken eyes turning in all directions like a dazzled and terrified bird seeking shelter.

Every face bids me to conceive a soul, every soul a world. At the passage of two persons walking together or a lone man going his way with his idea, all the affinities of the eyes and mouth are perceptible to me. I breathe in the drama, I hear the symphony. The couple or the monk go their way and I go mine. The memory of them stays with me for a long time, like a vague strain of music, then it escapes me, it is gone before I have been able to determine a nuance here, a line there, just as I was about to catch a glimpse of a world I shall never enter but which, as I passed near it, I suspected to be so wondrous that I am left with the melancholy of regret.

(Excerpt)

Georges Braque. *Figure.* Lithograph

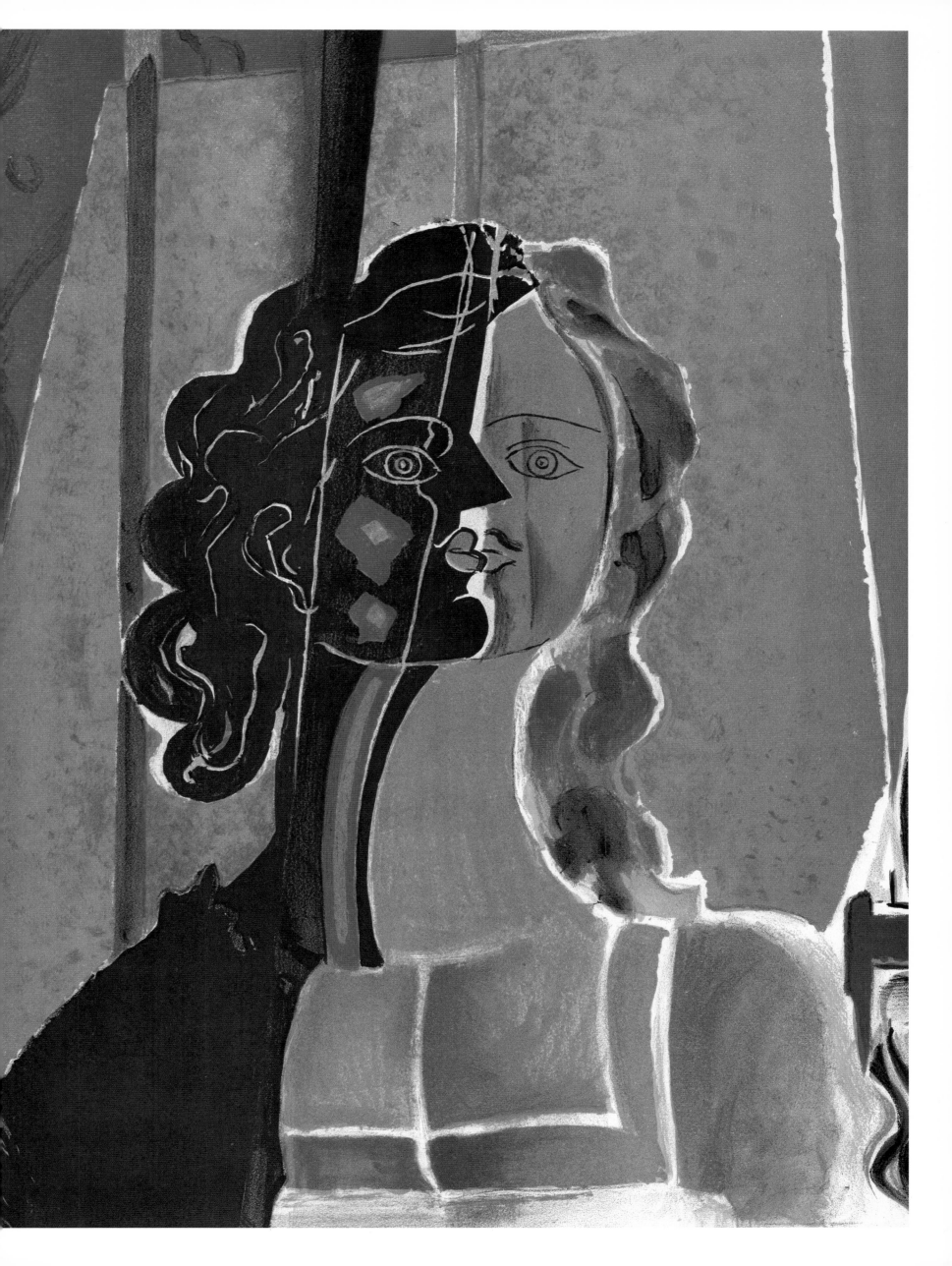

THE TIARA OF WORDS

By ALFRED JARRY

Imitation, deemed reprehensible when it comes to tiaras, paintings, statues, and other tangibles, was for many centuries (and for many still is) the criterion of good literature. One of those centuries was called a golden age because it lived by the dictum "Copy classical antiquity." True, you don't often hear the expression *beau comme l'antique* anymore; yet people are quite willing to say, "I can't make head or tail of it," which comes down to the same thing.

When an artist is still a novice and has not yet learned to be himself, before he copies nature directly (another form of imitation), he is curious about how others went about copying things. This is not hard to understand. If a person takes the same tool as his neighbor, it stands to reason that he'll borrow the way he uses it, too. He becomes an extension of the tool. But there is another factor that people rarely take into consideration: the strength to handle the tool. Some people are sufficiently sure-footed not to need that crutch we call a lever. Archimedes showed how weak he was when, to illustrate the principle of the lever, he said, "Give me a place to stand and I will move the world." At some point he would have needed a fulcrum, and there is no end to this kind of borrowing.

A writer copies for another, quite human reason: he has to answer to a buyer. You see, a person about to purchase a book wants to know what category of book it is before he parts with his money. We are using the word "category" on purpose, because categories exist to this day. They still print "A Novel by . . ." or "Poems by . . ." on the cover, or you can look inside and tell by the typography or layout what kind of book it is.

These categories are themselves subdivided into other categories which, if not spelled out in black and white, are made known verbally. People will ask, "Does this read like So-and-So?" (Here, the appropriate name for the subcategory would be "style.")

It's a perfectly reasonable question. A prospective buyer of a book would like to see what's inside, something which reading the book would tell him. But if he read ahead, what would there be left to read? He makes do by getting a general idea, courtesy of the bookseller. This idea, which is based on pre-existing ideas, sums up the book for him. The author's name, if known, sums up that summing-up. In every reader's head there are five or six names floating about that he associates with a greater or bigger name—in any event, a name that was there first.

There is undoubtedly a phase during adolescence when a person evaluates books in terms of Robinson Crusoe or Mme. de Ségur.

There is undoubtedly a phase—though it can last a lifetime—during which some people evaluate a book in terms of Xavier de Montepin, or more recent authors whom we esteem even less.

Imitation is modeled on reproduction. However, since works of literature are illegitimate children, they cannot benefit from the *Is pater est.* The public insists upon a birth certificate we call "likeness" or "similarity."

(Excerpt)

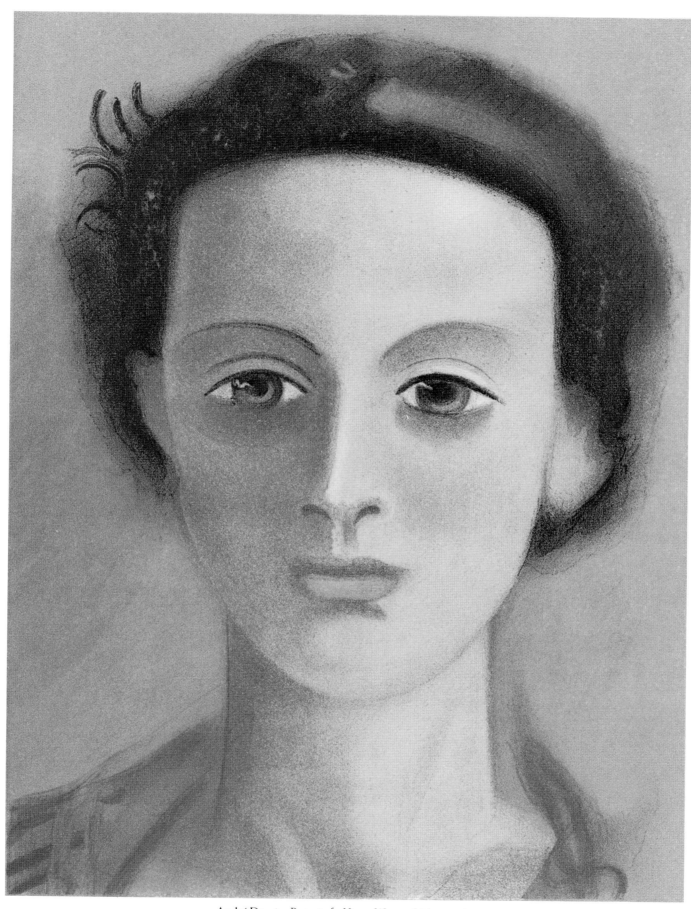

André Derain. *Portrait of a Young Woman*. Lithograph

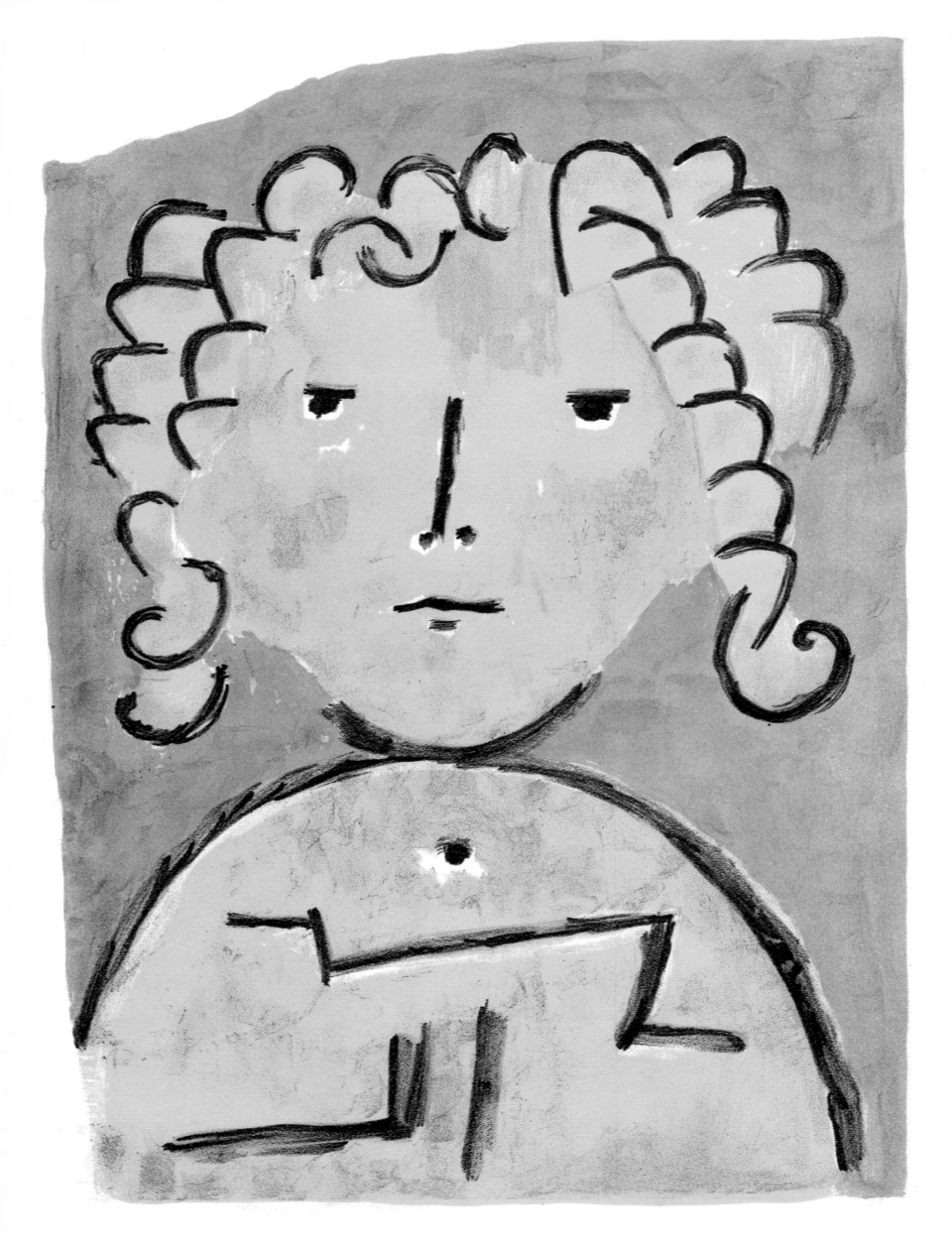

MAIDENS' FACES

By HENRI MICHAUX

A land of beautiful girls is a good land, a land where the people know how to live. Mankind has been a success there, and that's saying not a little.

In the face of a girl is inscribed the civilization in which she was born. It is judged therein, satisfactory or not, with its own characteristics.

The land is therein judged to an even greater extent, likewise whether the water is healthy, limpid, properly mineralized, what the light is worth, the food, the mode of life, the social system.

A civilization which cannot form beautiful maidens is not a civilization, or else, by way of excuse, it has come from the exterior, it is unsuitable, badly adapted, badly imposed, ailing, better rejected.

Poverty alone cannot have mastery over beauty. Epidemics, maladies, are more successful in that.

It isn't that I don't personally prefer the civilizations which produce hearty old people: those are the most intelligent. India manages to realize both. There the adult man alone fails to come off. He lacks something of the fighter's nobility, a look of aggressiveness, of adventure, the total absence of which is always displeasing in a man.

The faces of the girls is the very stuff the race is made of, more so than the faces of the boys (the boys, because of their precocious activity and determination, seem rather to be designs for a future race), more than those of children (the child is not yet oriented toward the man), more than those of the old man (his bones distend and split his face, his skin rumples it and his flaccid muscles dislocate and warp it).

The girl's face, being the most impersonal, is the genuine mirror of the species. All this should not be an illusion resulting from beauty. As for girls, I used to be more against them than for them. How annoying they can be, those young ladies! That aggregate of submission, of conformity and of "yes, yes, yes," which is so visibly and everlastingly to be found in them, that too facile and unmerited charm, and especially that insensitive-sensibility. An orchid enraptures them, while ten dying persons leave them cold.

But we won't quarrel over that. You mustn't ask too much of them. Their face is their work of art, their unconscious and consequently faithful translation of a world.

Traveling in foreign countries where you do not know the girls so well, where you stroll among their faces rather than their persons, you become fairer to them.

Faces of Chinese girls, when I saw you for the first time in Hong Kong and Canton, miraculous faces in which China remains forever at the age of fifteen, in which it awakens to life as in its first dream; so fresh after so many centuries, with its unparalleled delicacy, its soul of flowers and fish, albeit firmly established and with the elephant's confidence, and very young in spite of its reserve, how you struck me with wonder! Girlhood, China, beauty, culture—all. It seemed that, through them, all was revealed to me. All and myself.

Since then I have looked on life with a different eye.

Girlish faces, since then you have appeared different to me; full, full, however empty may be the words of the person who wears them. Even the girlish faces of hateful lands, disagreeable faces, lovely a few months at most, on which the nose of an alcoholic and gluttonous ancestor soon begins to swell, soon, too soon, to swell insidiously, lovely and moving faces which irresistibly turn into ugliness, defeat, animality, dullness, but which remain for a short time vibrant and luminous, how extraordinary you are!

(Excerpt)

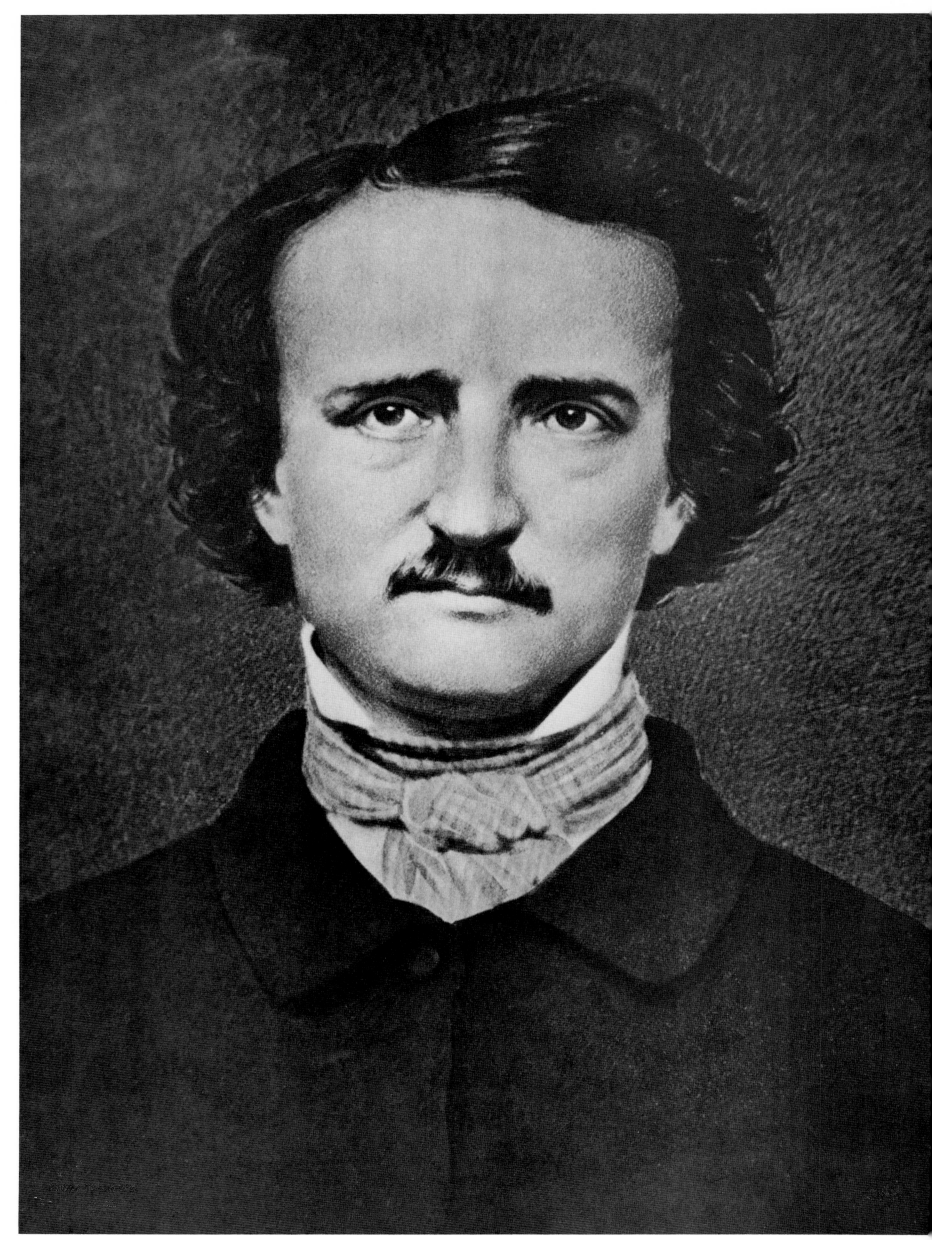

Edgar Allan Poe. Photograph by Mathew Brady

Baudelaire. Photograph by Carjat

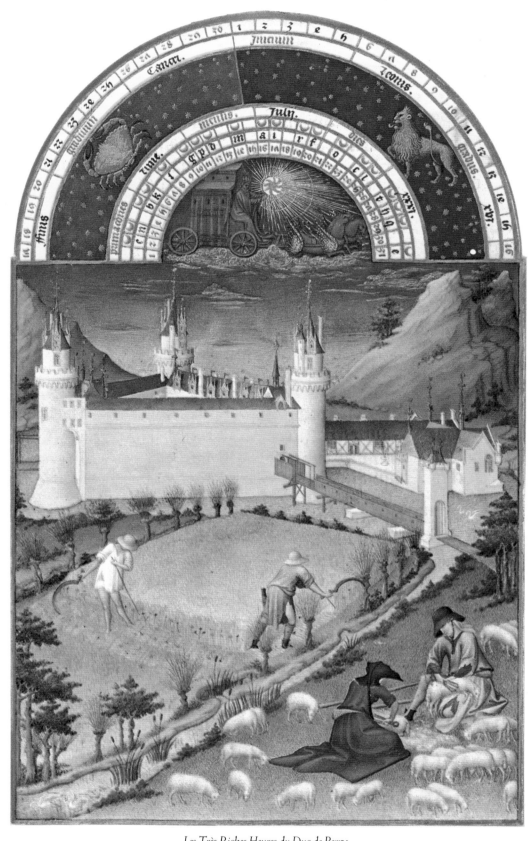

Les Très Riches Heures du Duc de Berry.
Calendar miniature for the Month of July: "The Chateau at Poitiers." Musée Condé, Chantilly

VERVE
Number 7 March 1940

Les Très Riches Heures du Duc de Berry: The Calendar
by Pol de Limbourg and Jean Colombe

Tériade had always found room for selections from French illuminated manuscripts in *Verve's* early "miscellaneous or general issues." With *Verve* No. 7, this predilection was in full flood. The Calendar from *Les Très Riches Heures du Duc de Berry* inaugurated a series devoted exclusively to illuminated texts from the thirteenth, fourteenth, and fifteenth centuries. *Verve* Nos. 7, 9, 10, 11, 12, 14/15, 16, and 23—which spanned a nine-year period—attest to the importance Tériade attached to this art form. In one of the most revealing texts he ever wrote ("*La Peau de la Peinture*"[1]), he had noted that in the Middle Ages painting's skin was "stiff and taut like a wire"—an apt description of the concise and concentrated style typifying the work of Pucelle, the Limbourg Brothers, Fouquet, and others.

Just as the very first issue of *Verve* had opened with a "profession of faith," so does the seventh. In a statement placed opposite the title page, Tériade explains how and why these great paintings were being made available to the public.

"By way of introduction, we should like to say a word about the difficulties which had to be surmounted in order to present in facsimile the Calendar from *Les Très Riches Heures du Duc de Berry*.

"Begun in July, 1939, it was largely due to the courtesy of M. Henri Malo, curator of the Condé Museum at Chantilly, that the slow work of reproduction was able to be continued during the first months of the war.

"There are no more exquisite paintings in the world than those contained in this manuscript, and their colors are so delicate that faithful reproduction seemed impossible by means of mechanical processes using chemical tones to replace the lapis lazuli, purple, and vert de fer employed by the artists of the fifteenth century. The purity of the manuscript's colors, as Robert Draeger discovered, defied the sensitive emulsions of photographic plates. Only after patient effort could the minute drawing and transparent colors be reconstituted.

"The result achieved demanded extraordinary craftsmanship, and may well mark a date in the history of colored reproduction.

"For the first time, the Calendar of *Les Très Riches Heures du Duc de Berry* now belongs to the public in its integrality and in the exact dimensions of its original paintings.

"No document exists which shows more fully and accurately the life of Medieval France: in it are expressed the elegance, the refinement and the vigor of the France of the past.

"All who appreciate the graphic arts will readily recognize the qualities of these paintings, which are not mere illustrations but actual *pictures*, small in size but great in genius. The marvelous organization of the highly reduced painted surface permits the precise and tangible evocation of majesty. Between the variations of heaven and the smallest details of terrestrial life, the balance remains perfect. The spirit of space is the very essence of painting."

The Duc d'Aumale had given this priceless manuscript to the Institut de France. When *Verve* No. 7 came out, Henri Malo, then curator of the Musée Condé in Chantilly where the manuscript was

121

housed, related the story behind *Les Très Riches Heures du Duc de Berry*.

"Jean de France, Duc de Berry, brother of King Charles VI, was the monarch of manuscripts and the prince of bibliophilism. . . . The magnificence of his own library is attested by the volumes which have come down to us. He had his own calligraphers and his own illuminators. He treated them as equals, for he was fond of the company of artists and paid them royally for their works.

"At the age of seventy, he crowned his career as a bibliophile by ordering a prayer book that he wished to be the last word in perfection. He spared nothing to achieve his end. He wanted the calligrapher to be the most talented obtainable, the leaves of vellum to be the whitest and smoothest, the gold to be the purest, the lapis lazuli to be the most concentrated, the most transparent, and the richest, for this was the costliest of all materials.

"The Duke secured the services of an illuminator of genius, Pol Malouel, called Pol de Limbourg after the name of his birthplace. He was the nephew of Jean Malouel, who had come from Gelderland to work as the painter of the Duc de Bourgogne. The real master of the work was Pol, and, with his brothers Hennequin and Hermant, under his orders, he started on his task about the year 1409.

"When the Duc de Berry died June 15, 1416, the illumination of the manuscript was still in an unfinished state. As the spendthrift art lover who had ordered it left numerous debts and the Limbourg Brothers were an expensive luxury, the heirs cut off the funds and the vellum folios were laid away in a casket, where they remained untouched for sixty-nine years.

"They were in the possession of the Duc de Savoie, Charles I, in 1485 when he married Blanche de Montferrat, and the couple decided to order the completion of the glorious manuscript. The Duke had employed, for the past three years, an illuminator of repute who had been recommended to him by his aunt, Charlotte de Savoie, the second wife of King Louis XI. Given the commission, this man, Jean Colombe of Bourges, brother of the famous sculptor, Michel Colombe, took two years to complete the decoration of the book which so fully deserves as title *Les Très Riches Heures*.

"In the foreground of each [Calendar] miniature is depicted a farm scene—snow-clad fields, workers tilling the soil, sowing, haying, reaping wheat, shearing sheep, gathering grapes—or a scene from life at court—the gathering of spring flowers, lovers plighting their troth, merrymaking, hawking, the killing of the boar. The contrast between these two worlds (which meet, but do not overlap) is striking; yet, they coexist in sweet harmony. The wealth of realistic detail (such as the exposed member of the servant who lifts his tunic by the fire) is surprising for a prayer book.

"In the backgrounds, the châteaux and towns possessed by the Duc de Berry are represented in the most minute detail. To these are added the old Louvre, and the Sainte-Chapelle, which were to be seen from his Hôtel de Nesle; and Vincennes—where he was born."

1. *Minotaure* No. 7, June 1935.

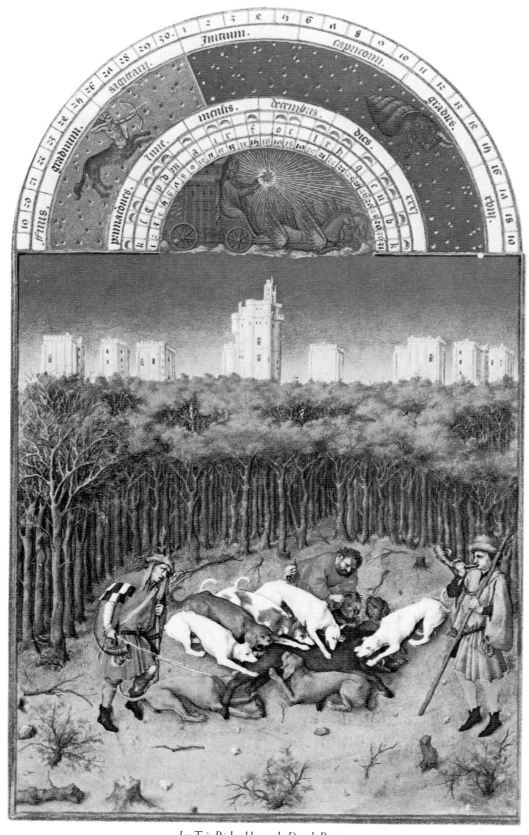

Les Très Riches Heures du Duc de Berry.
Calendar miniature for the Month of December: "The Chateau at Vincennes." Musée Condé, Chantilly

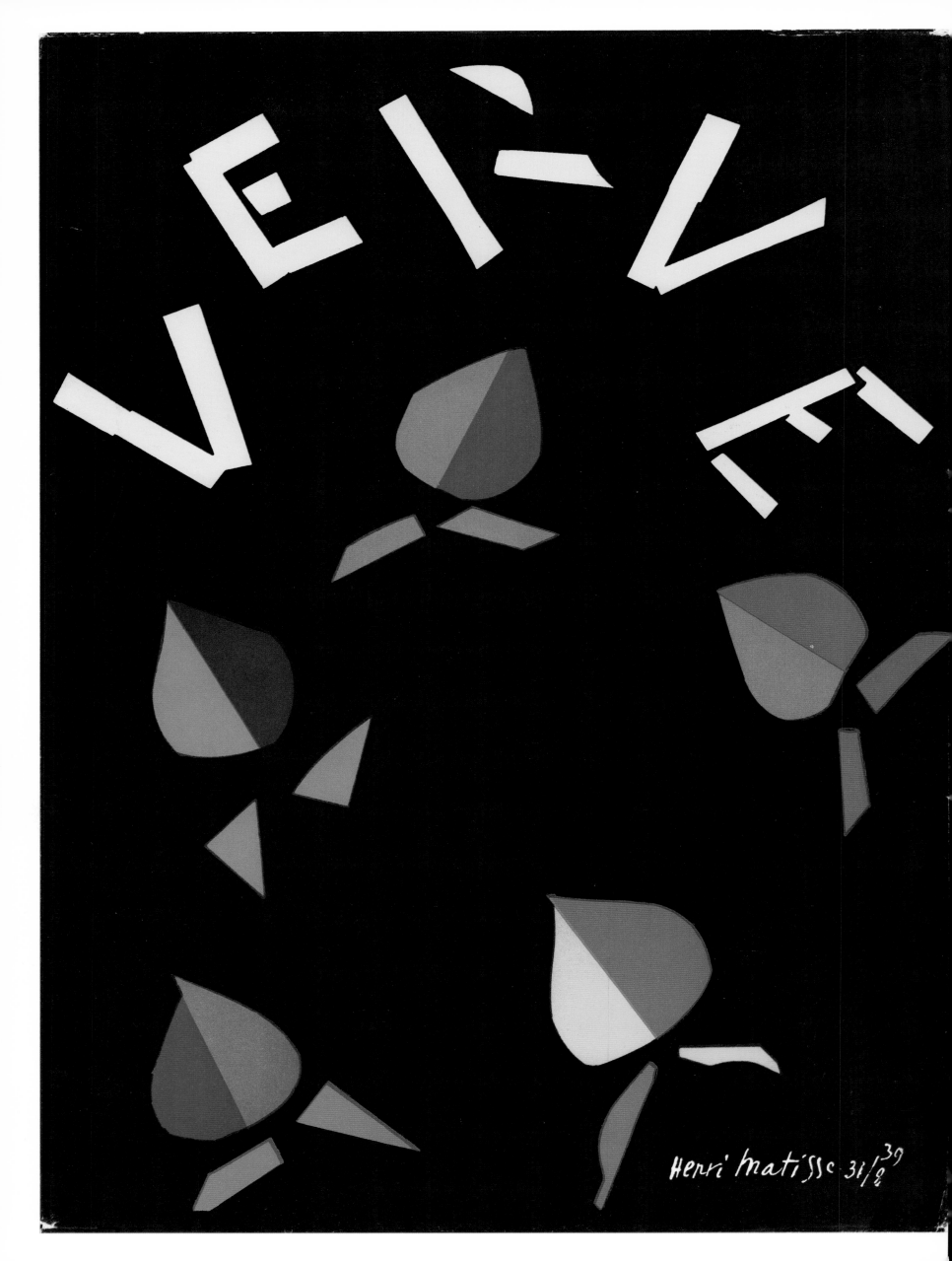

Henri Matisse 31/8 39

VERVE

Number 8 Summer 1940

This issue of *Verve* appeared during one of the darkest moments in the history of the twentieth century. Europe was engulfed in war, and by 1940 the conflict had spilled over onto French territory. Tériade used to refer to *Verve* No. 8 as the "wartime issue" or by a title ("*La Nature de la France*") that appears on its very last pages. In a way, this was a manifesto: Tériade, a Greek, was taking his own stand against the barbarism of the Nazis. It was clear which side he was on.

The extraordinary original cover Henri Matisse produced for this issue of *Verve* is at once realistic and symbolic; it conveys the impression of multicolored precious stones strewn across a black cloth. It evokes the blackouts imposed by air-raid alerts:[1] windows of buildings blacked out to stifle any rays of light that might pierce the night. But life continued, searing the dark shroud that the Occupation had laid over Paris. That sparkling light, as brilliant as Rimbaldian fires, continued to shine brightly despite everything—this was Matisse's message.

Much has been said about the way Matisse—unlike Picasso, for example—distanced himself from politics. Pierre Schneider has examined this aspect of the artist's life so thoroughly that there is no need to discuss it at length here.[2] For Matisse, this exceptional work, created for the cover of the leading art magazine of the day, a cover meant to be seen and circulated widely, was an act of faith, and, in effect, an act of courage. Using the weapons at his disposal, the tools of his craft, he proclaimed for all to see that there was still hope, that "France has lost a battle, but she has not lost the war."

In a brief, unsigned opening statement, Tériade writes: "Henri Matisse [finished] the covers for this number the day before the war broke out. The successive printings necessary to reproduce the twenty-six different colors of the leaves constituted a difficult task, and considerable time was required under wartime conditions to print the *Chromatic Symphony*, as it is called by Matisse. He wrote us in the month of February. 'I am very glad to see that your perseverance has been rewarded by a war number that seemed almost too much to hope for when last I went to the Rue Férou to see you. It's true that it was there and then that I composed the covers—I, too, have my nerve.'"

This work by Matisse is important in many respects. It was one of the very first of his *papiers découpés* (paper cut-outs). It is true that he had already experimented with "color cut out alive" when he did *The Dance* (commissioned by Barnes) a few years earlier; at that time, however, he worked with paper he colored with gouache and then pasted on to a support. Now, he cut right into pages from printer's-ink specimen albums, the color charts that lay strewn around Tériade's Rue Férou offices. Matisse's scissors bit and danced in pure colors that would subsequently be used by the printer himself. The artist would insist that these raw hues be reproduced with absolute fidelity; hence, the twenty-six runs Tériade mentions in his foreword, an astronomical figure compared with the usual four (occasionally six) runs through the printing press. It was a costly procedure, almost inconceivable today even for lithographic reproduction, but it ensured spectacular results for this, as well as all other original *Verve* covers.

Prodded by Matisse's exacting standards, Tériade turned graphic reproduction itself into an art form. (Witness the stencil printing process he would later use for *Jazz*.) In this respect, Matisse's cover

Cover by Henri Matisse

for *Verve* No. 8 is also an example of Tériade's own work: the publisher had transformed a magazine cover into a historic and significant work of art, a masterpiece that ranks among Matisse's finest works on paper.

After a table of contents stunningly illustrated with four "instruments of war" drawn from an illuminated manuscript, *Verve* No. 8 opens with a frontispiece (a Matisse painting) and a drawing (again by Matisse). In two revealing letters, both dated February 1940, the artist writes about these reproductions, as well as the subject of reproduction in general.

"Nice, February 1940

"My dear Monsieur Tériade,

"You must have my little painting by now. Do you think it will do as a frontispiece? If so, I have a few things to say about it. How do you intend to reproduce it? Not as a lithograph, I assume. In any event, please see to it that no liberties are taken with it. May I bring a few points to your attention? In some areas the canvas is bare—any color adjacent to them must not overlap—and you must duplicate this canvas color, which is in harmony with the other colors, and the corresponding shade in the reproduction must come out as a bona fide color, not as a smudge. The hands are the color of the canvas; the features are often in various colors, and they'll have to be reproduced just as they are.

"I cannot give you any drawings of leaves—they are of no interest to anyone but me. They do not have leave to appear on your cover, for the time being. So much for them."

Fortunately, Tériade managed to persuade Matisse that his drawings of leaves were of interest to others besides himself—and they were published!

In another letter (apparently a follow-up to Tériade's reply to the first), Matisse returns to questions of reproduction. "I requested two pages for two line drawings. One is of a head, the result of a series of preliminary drawings and which has a vigorous, glorious side I find captivating. The other is a page from an album of drawings of hands. I think it will do nicely, as there is something eloquent about it. I did these drawings with a graphite pencil, but to tell the truth, [if you stand] a meter away, you'd think the head was done in ink; that's how bold and decisive the linework is. With a decent plate you should be able to do something nice with it.

"The shades [printers use] for reproducing pencil are usually washed out, so it would be better to print with a subdued black. If the hands are scaled down to fit the page, they shouldn't become too overbearing. But further reduction would result in confusion. For that one you'll have to make a good plate that does not deprive it of feeling. This drawing of hands is one of a series. It's the one I selected as the best of the lot. I attach importance to these hands because, for me, they represent increased interest in my work. Hands, like the leaves on trees, have assumed a reality which they didn't have up to now. I used to devote myself entirely to the representation of my human figures by the head, the body, and the arms and legs, as in the case of trees I did by the trunk and branches. As for the hands and leaves, I considered them merely as terminations which did not appear to me necessary, and hence were boring. I now begin painting a person by the hands.

"Anyway, if you don't have a good enough plate for the hands, don't use them."

After this introductory section on Matisse comes "A Corner of France," a previously unpublished text by Paul Claudel, with illustrations from *La Gaule*, a fifteenth-century illuminated manuscript. This "corner" is Brangues, where Claudel spent the last years of his life. "Then, greeting, evening star!

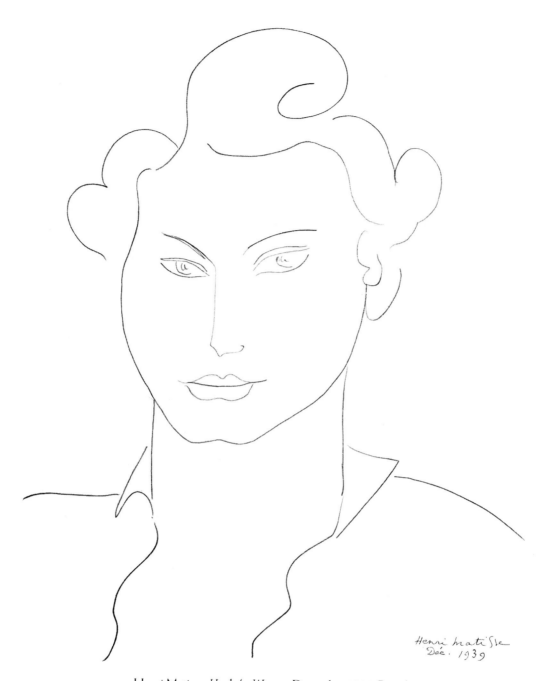

Henri Matisse. *Head of a Woman.* December 1939. Pencil

Gently to guide my eyes to your high home above the distant trees there stands in a far corner of my garden a tall poplar, slim as a taper—like an act of faith, or love. There, beside an ancient wall buried in moss and ferns, I have chosen my abiding place."

This issue of *Verve* brings together Claudel, author of *Partage de Midi*, and painter Georges Rouault, his contemporary. Yet the two paintings that Claudel selected to appear at the end of the issue are dramatic proof of his baffling ignorance of contemporary painting. He writes: "One, the reproduction of a picture by Elysée Bourde, evokes with no small liveliness and gusto a parish council meeting at the little village of Saint-Benoît in the Ain Department. The other, from Moreau-Nélaton's brush, depicts the St. George's Day fête at Villeneuve-sur-Fère, my birthplace. I used to know all these characters, so vividly lifelike here...." There can be no underestimating the salutary role that *Verve* played as a "bridge between the arts and literature."

For his part, Rouault contributed a poem in free verse entitled "Countenance of France." "And this Countenance, I also find it, oh Péguy, in the air you breathe as you arrive in Chartres, 'neath gray skies that would have pleased Corot." This poem was illustrated with four-color reproductions of the artist's paintings from 1940; the title and a correction, in brush and ink, were done by Rouault himself.

"Seafruit" is a ruminatory piece by Paul Valéry that appeared in this issue through the efforts of Adrienne Monnier. The opening lines set the mood: " 'This room,' the Man-with-the-Key told me, 'has a sea view.' He lied. It was not the sea. It was the lake of everlasting fire the room looked out on. From a vast reflection—they call it a bay—all the sunlight of the sky was hurled back into the room; it clashed on mirrors, flared up anew on every glass or metal ridge, making one yearn for darkness." An etching and a line drawing, both by Valéry, illustrate the text.

This issue also contained André Derain's "Calendar"; on the page opposite each of his eleven big drawings done in orange lines is a reproduction of a miniature from the *Calendar of Charles d'Angoulême* (fifteenth century). All of Derain's pictures sound a pastoral theme: *The Repast, The Forest, The Boats, The Road, Four Bathing Scenes, The Banquet, Two Hunting Scenes*. The names of the months and the signs of the zodiac were also drawn by Derain.

Then, some vivid thoughts on still-life painting by Pierre Reverdy. "History is canned horror and canned heroism, ready to eat when times are good. Art is the unceasing effort to preserve the savor of life as time goes by."

As an echo to Reverdy's text, but one in the same "key," Tériade inserted some thoughts of Georges Braque, illustrated with vignettes from two of his paintings. "Art is meant to disconcert; science, to reassure." "I am not a revolutionary painter. I do not seek rapture; I am satisfied with fervor." "You don't invent truth, you approximate it."

A more directly sobering reminder of France's tragic plight at the time is embodied in an anguished text by Jean Giraudoux, illustrated by two wonderful drawings. "Once upon a time, it was possible to think of French landscapes as pictures that never changed or deteriorated. . . . Today this Poussin and this Bonnard look out at me like portraits from a family album, faces of the dead or dying."

After a landscape by Derain, an eloquent tribute to France by Adrienne Monnier, "*La Nature de la France*." Inserted within it is a two-page spread of an original color lithograph by Pierre Bonnard, *Sunset Over the Mediterranean*. Bonnard was in Le Cannet at the time; twice a week Tériade would receive heart-wrenching letters from him.[3] But loneliness and privation could not dim the Mediterranean light that Bonnard found so dazzling. In this work, the sea and the sky are an equally pure, almost stupefying yellow. Along with the book *Correspondances* and the "*Couleur de Bonnard*" issue of *Verve* (Nos. 17/18), this work was one of the most important ever published through the association of Tériade and Bonnard.

Monnier probed the essence of French art and sensibility. Fundamentally, her thoughts were very close to Tériade's own on this subject. "Discretion, on which taste and moderation undoubtedly depend. French taste, French moderation. . . ."

For Tériade, discretion and moderation—so alien to his fellow-Greeks—were cardinal virtues, rules to live by. They influenced everything he did—the way he behaved, the way he dressed and talked. Tériade became more French than many Frenchmen. "The men in our land," notes Monnier, "willingly remain silent when they draw near the centers of life; they do not want it to be talked about. Rather do they laugh." That description would have fit Tériade to a tee.

Monnier also reminisces about her close friend, Angèle Lamotte, who did so much for *Verve*, especially during the wartime years. One can picture the two of them discovering the miniatures that were later to grace the pages of the magazine. "The first time I saw the miniatures of Fouquet and the Limbourg Brothers at Chantilly, I was so carried away that my eyes filled with tears.... Before *Les Très Riches Heures du Duc de Berry*, I seemed to see, as in a magic emerald, the very nature of France: our soil and its people garbed in bold colors...movements of work as pure as rituals...ladies in flower-dresses...fanfares of leisure...babbling water and spreading branches...desires and loves...magnificent châteaux in the distance...a reassuring sky...our farm animals beside us...days tinted with hope and delicately spun...."

A last text in Tériade's "wartime issue": André Malraux's seminal "Outlines of a Psychology of the Cinema," published there for the first time. (The previous year, Malraux had finished *Sierra de Teruel*, a feature film based on his novel *L'Espoir*.)[4]

Verve No. 8 concludes with a Surrealist juxtaposition reminiscent of Lautréamont's phrase, the "chance meeting on a dissecting table of a sewing machine and an umbrella." On the left, two academic paintings by Elysée Bourde and Moreau-Nélaton, with a commentary by Paul Claudel (see above); on the right, *Le Coq*, by Joan Miró (1940).

1. Henri Matisse to André Rouveyre (June 3, 1947): "I stayed behind in Paris, as I was getting ready for my trip.... When the air-raid sirens forced me into the cold, dank shelters, I couldn't stand the monotony and the thought of leaving the city crossed my mind."
2. Pierre Schneider, *Matisse*, trans. M. Taylor and B.S. Romer, Rizzoli, New York, 1984.
3. Unpublished correspondence.
4. Adaptation: Max Aub. Editing: Boris Pekine. Cameraman: Louis Page. Producers: Edouard Corniglion-Molinier and Roland Tual.

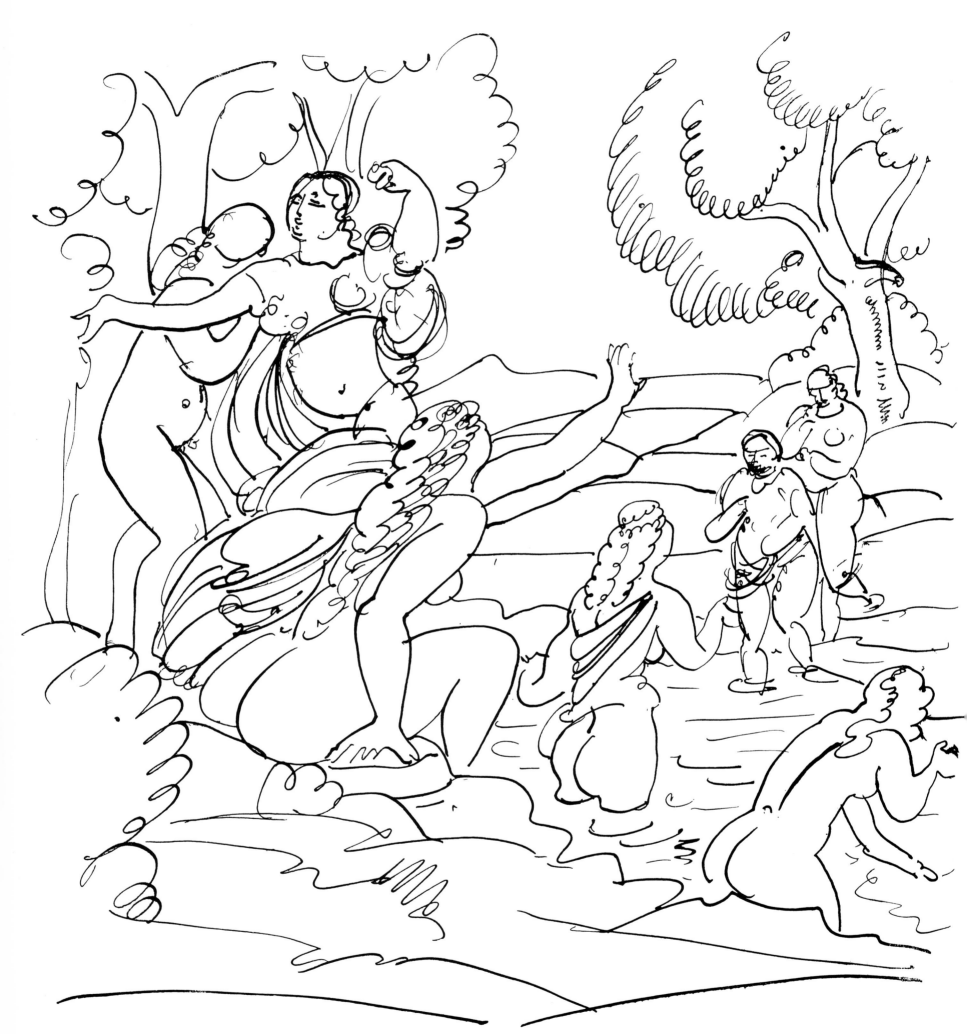

André Derain. *June*. Drawing in colored crayon done expressly for this issue

Calendar of Charles d'Angoulême.
Miniature for the Month of June:
"Labors of the Months." Fifteenth century.
Bibliothèque Nationale, Paris

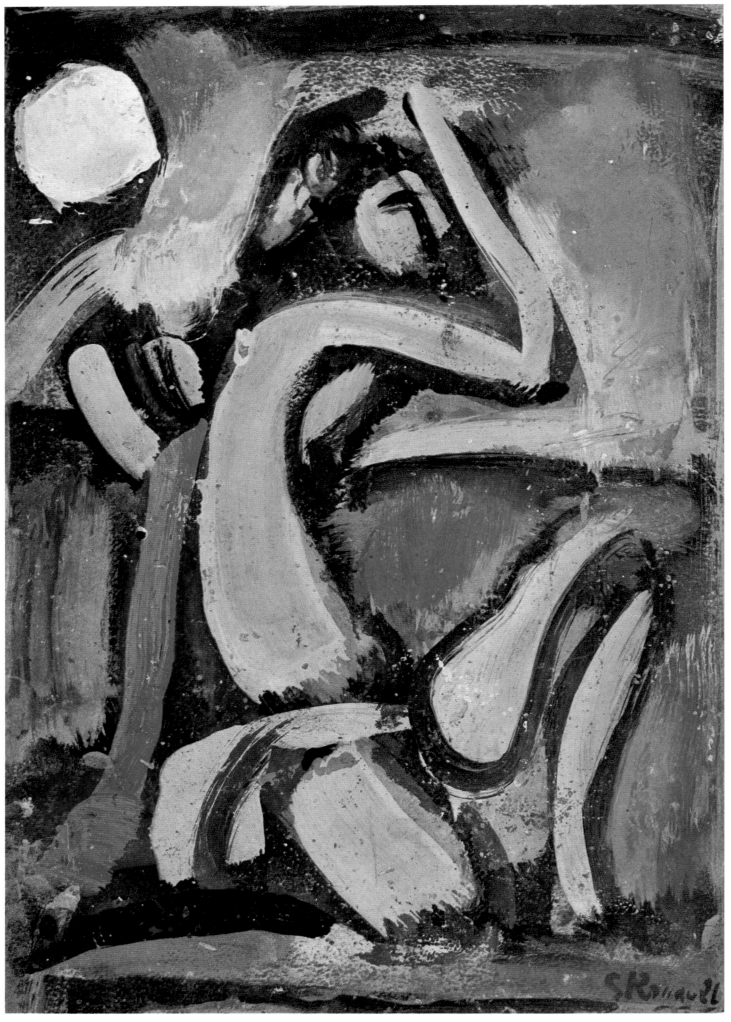

Georges Rouault. *Legendary Figure.* 1940. Oil on canvas

COUNTENANCE OF FRANCE

By GEORGES ROUAULT

*T*his Countenance is not in the Panthéon—amid the hodgepodge of paintings hung on its walls about 1880—or in official art exhibitions on Varnishing-Day at the Salon.

It is multifaceted and shall thus remain until the end of time.

When [I am] on the Place du Vieux-Marché in Rouen, I think about the Trial of Joan of Arc, about those answers next to which so much famous literature pales by comparison.

I think about the houses of worship built with patience and love by journeymen whose names no one remembers any more.

And I see that Countenance again, oh Péguy, in the air you breathe as you arrive in Chartres, beneath gray skies that would have pleased Corot.

Fine, stark stone: hallmark of modest, nameless workers.

Since, like so many others, I was born poor, and since I have no problem admitting it nor so much pride as to brag about it, I have done little traveling.

Poor devil that I am, I do not for a moment claim to be a European, much less a citizen of the Universe.

> When you were just an apprentice
> you used to cut your fingers
> on that stained glass, so fine and pure.
> Your frail, reverent hands worked with
> reds muted and flaming, golden yellows,
> ancient ultramarines deep as the
> waters of the Pacific.
> Our elders were so well-versed in
> their craft, but not as erudite
> as we think, Lord!
> Theirs was hereditary experience
> of eyes and hands,
> handed down from father to son,
> from masters to journeymen.
> Péguy, son of Chartres, I am following
> you and hear you loud and clear.

If I may, I shall muse upon, not earthly conquests, but *The Descent from the Cross* in Avignon (not to slight El Greco, Rembrandt, or Grünewald); the smiling angel of Rheims Cathedral, which even damaged I cannot help preferring to the Mona Lisa; Chardin's little *Benediction*; *The Embarkation for Cythera* by Watteau; old Corot's *Old Bridge* along the light ocher road; the vistas afforded by Le Nôtre's gardens at Versailles; the French School and its many different kinds of artwork— and let's not overlook Cézanne.

Forgive me for going on this way about my paltry self when so much misfortune weighs upon the world. I may be talking about myself, but it is you, brother-in-woe, I am thinking about. Perhaps more so, upon my word, than could be expressed by eloquent speeches in the Forum.

Retiring, modest, silent, industrious France, it lies with us, your spiritual sons, to see to it that you do not appear under an assumed identity in far-off lands.

I have lived through three wars during my nearly seventy-year sojourn in this latter-day Byzantium; and yet, oh sweet France, I still feel for you the total abandon of the Prodigal Son in the arms of his elderly father.

Georges Braque. *Still Life*. Oil on canvas

Art is meant to disconcert; science, to reassure.

You must always have at least two ideas, one to destroy the other.

Art does not lie in the realization of an idea.

When we say a person is imagining things, that means he's withdrawing from reality; if he imagines just one, we say he's obsessed, and put him away.

Everyone gets ideas. Intelligent people make them credible. That's all.

To defend an idea is to adopt an attitude.

Inevitability is stripped of ideas.

Georges Braque. *Still Life.* 1939. Oil on canvas

Changing his mind does him no good; he is like me: his nose is still in the middle of his face.

I am not a revolutionary painter. I do not seek rapture; I am satisfied with fervor.

Error is not the opposite of truth.

You don't invent truth; you approximate it.

Painters know things by sight, writers by name. The latter have the benefit of prejudice in their favor. That is why criticism is easy.

You must not ask artists for more than they can give, or critics for more than they can see.

GEORGES BRAQUE

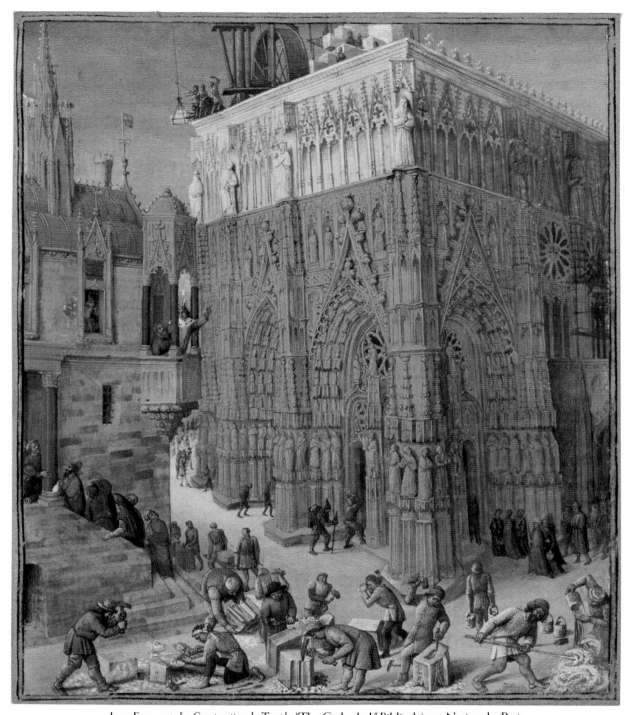

Jean Fouquet. *La Construction du Temple.* "The Cathedral." Bibliothèque Nationale, Paris

VERVE
Number 9 October 1943

The Fouquets in the Bibliothèque Nationale, Paris

Although many medieval manuscripts could be held easily in one's hand, there were others so monumental that they had to be maneuvered onto a lectern in order to be viewed. But it was worth the trouble, for these tomes often contained "illuminations" or "pocket paintings" that could be contemplated lovingly in the privacy of one's study. These miniatures could be thought of as cloistered pictures, sometimes seen by no one except the painter and the nobleman who had commissioned them.

The Fouquet illuminations featured in this issue of *Verve*, reproduced in their original size, are authentic paintings in every sense of the word. In terms of composition, subject, number of figures, action, complexity of planar relationships, and subtle interplay of light and of colors, they produce the same effect as their larger counterparts.

"*Verve* has set a wonderful and unprecedented example," writes Paul Valéry, who authored the preface for this selection, and whose admiration for these miniature masterpieces is tangible.

The year was 1943. France was still occupied by the Nazis. The publication of these masterworks represented a true miracle: difficulties in acquiring supplies of paper and printer's ink, problems with the ever-watchful eyes of the censors, and with transportation, all required efforts of heroic proportions in order to present the readers of *Verve* with their first glimpse of virtually unknown illuminated manuscripts.

The conflict had scattered writers and artists, making it virtually impossible to put together any "general issues." Therefore, most of *Verve*'s "wartime issues" were devoted to medieval miniatures. But Tériade had featured illuminated manuscripts in his magazine from the very start. For him, these precursors to easel painting had always been one of the finest chapters in the history of French art. Now they took on added meaning. A preface by Paul Valéry provided an extra measure of protection against the shafts of Vichy's mediocrity.

We have already seen that, when it came to painting and sculpture, the author of *Le Cimetière Marin* was a dyed-in-the-wool academic. He launched his analysis through a discussion of craft. "In a way, these pages have a mission," he writes. "Thanks to these wonderfully faithful reproductions, everyone now has a chance to see masterpieces of French art that otherwise would be all but inaccessible to them. Artists may study them at leisure. I'd like them to linger over them a good long time. Why?

"The modern age has diluted and even belittled the virtue of patience. We have witnessed the disappearance of the infinite care that used to be lavished on a work of art, which created between it and the artist an intimacy akin to love."

These observations lay the foundation for a general critique of modern art. It warrants a closer look.

"These days we turn out hardly anything but rough drafts. Where are the painters who won't put brush to canvas until they've done countless studies and preliminary drawings, until they've spent long hours with a piece of charcoal or black chalk, trying to perfect the modeling of the body, or the way a piece of drapery hangs? Where are the painters who ponder a little before they paint? Where are the painters who wouldn't dare lift a brush until they've spent ten years learning the finer points of their

trade? All you see nowadays are virtuosos who waste day after day trying to rid their hands and voices of all constraints, trying to become what they wish to be. What's more, the fact that even the most summary sketches are finding their way into museums—not to mention the prices they fetch—fosters this lax attitude. Why should an artist deny himself what the world seems so willing to bestow upon him? He settles for opinions that he knows full well come from people whose sole qualification for judging painting is that they say he has talent. The idols of genius, novelty, intuition, and original feeling are nothing but seductive masks. They are just an easy way out."

To think that Valéry, whose article was leveled at Picasso, among other artists, and in fact at all those seeking emancipation from academic art, submitted these comments for publication in *Verve*, a champion of modern art! Did he hope to convert the infidels?

In any case, his remarks about the art of illumination have stood the test of time, and the poet sheds considerable light on this art form.

"Illumination started off as a simple embellishment of letters that, little by little, took over the page and invaded the volume; pure ornament, extending downward from the majuscule through the margins, elaborated itself into emblems, symbols, leafage, spirals, crosiers, then incarnated itself into vegetation, animal-shapes, finally into human forms, as if by natural evolution, albeit an incomplete one, as the beings it presented were still too pliable in the artist's hand and so emerged as fantastic monsters that were not particularly lifelike. In time, however, illuminators arrived at an increasingly accurate representation of aspects of the tangible world.

"For the illuminator, the main thing was that the substances he applied to the vellum should withstand the passage of time. They had to *endure*.

"The illuminator himself prepared all the materials he would need for his work. First, the support: delicate sheets of vellum, smoothed if necessary with a wolf's tooth, then carefully sized. He compounded his own pigments. There were eight natural colors: black, red, yellow, blue, violet, pink, green, and white. The others were artificial, that is, they called for special, often very complicated, recipes. But time meant nothing. Next, the picture would be outlined; then, the contours having been decided upon, work would proceed layer by layer. A light color would be applied as a ground over the area to be painted, often as a single tone, like the background for a cameo. The artist would come back to this later, finishing by painting in the shadows. The laying down of gold was the final touch in this slow, meticulous operation."

Needless to say, Valéry's observations apply to illuminated manuscripts in general, not just to those featured in this edition of *Verve*.

There is also an informative introduction (indispensable to a full understanding of these illuminations) by Emile A. Van Moé; together with Henri Malo, he was largely responsible for *Verve*'s publication of medieval miniatures. "We should mention the subject of the manuscript. It includes two works by the historian Flavius Josephus, combined in a single volume and rendered into French by an anonymous translator. The *Antiquitates Judaicae* traces the history of the Jews from the Creation to the year A.D. 66, just before the outbreak of hostilities with Rome. The *Bellum Judaicum* takes up the story from the time of Antiochus Epiphanes (175 B.C.) to the fall of Jerusalem under Titus."

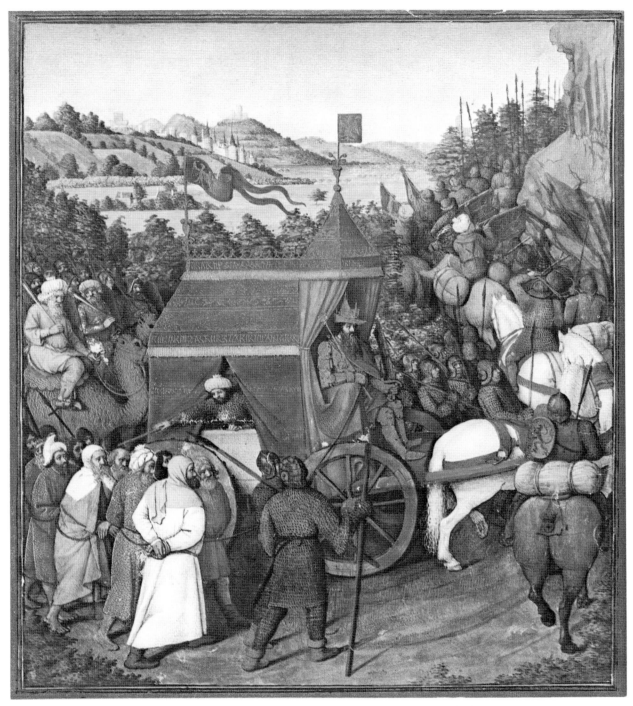

Jean Fouquet. *Triomphe de Josaphat.* "Landscape." Bibliothèque Nationale, Paris

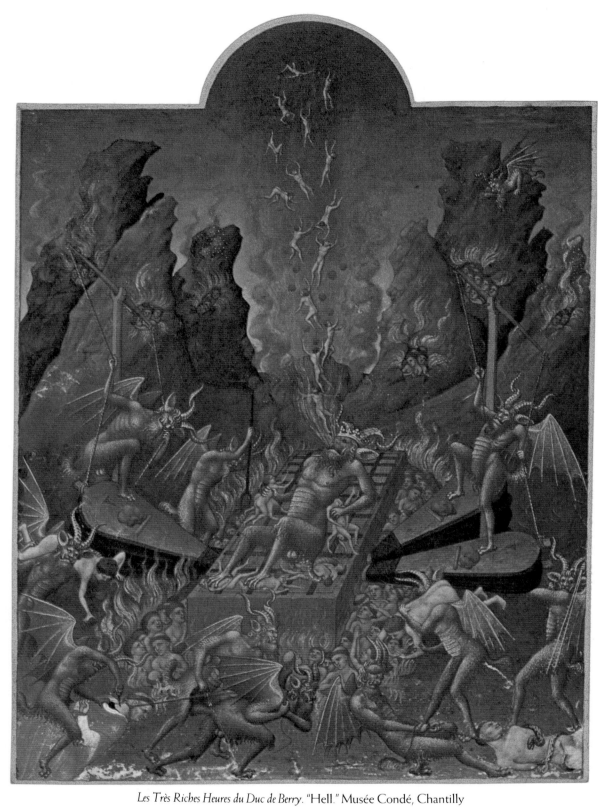

Les Très Riches Heures du Duc de Berry. "Hell." Musée Condé, Chantilly

VERVE
Number 10 October 1943

Les Très Riches Heures du Duc de Berry: Images de la Vie de Jésus,
by Pol de Limbourg (and his brothers) and Jean Colombe.
Musée Condé, Chantilly

The tenth issue of *Verve* marks the continuation of reproductions drawn from the sumptuous *Très Riches Heures* commissioned by Jean, Duc de Berry, brother of King Charles V, and a noted bibliophile. The Calendar had already been reproduced in *Verve* No. 7 (Spring 1940). This time, the sequence of miniatures is devoted to the life of Jesus Christ. They are presented "in the logical order in which events took place in time," as Henri Malo notes in his introduction. "We go back to the very origins of this great drama, to the 'Fall of the Rebel Angels,' the 'Fall of Man,' 'Hell,' and 'Purgatory,' which are represented by four of the most flawless miniatures this splendid ensemble has to offer."

These four illuminations are offered as a preface to the pictorial sequence on the Life of Christ. The paintings, isolated here from the text within which they appear, were executed in part by the Limbourg Brothers, who worked for the Duc de Berry from 1409 until his death in 1416; they were completed by Jean Colombe in 1485 for Charles I, Duc de Savoie.

The style of the Limbourg Brothers can be easily distinguished from that of Colombe. In terms of elegance of composition, clarity of design, boldness of color, skillful handling of modeled surfaces, and of receding space to create the illusion of depth, as well as their success in capturing outward expression and conveying inner feeling, the Limbourgs carried on the tradition of illumination known at the French court during the fourteenth century, and as exemplified by Jean Pucelle.[1]

In his introduction, Henri Malo describes the techniques followed by the various individuals who had a hand in the making of the manuscript. "What course did the making of this manuscript follow? As was the custom, a calligrapher wrote the text, leaving blank certain areas and indicating to the illuminators which subjects they were to paint there. In this case, the calligrapher was Yvonnet Leduc, court scribe to the Duc de Berry. From his hands the vellum leaves passed to those of the illuminators.

"How did the illuminators go about their work? We can trace the various steps involved because the death of the Duc de Berry brought the project to a sudden halt and the paintings in progress were left in their different stages of completion. First, the artists drew an ink sketch, spread a flat color over it, filled in the details, painted light and shadow to highlight surfaces, and added touches of gold to enhance the overall effect. For human figures, they would paint the clothing before the heads. They finished backgrounds and buildings before they did the foregrounds. This encouraged division of labor and opened up opportunities for collaboration. Yet the guidance of a master—in this case, Pol de Limbourg—gave the work overall consistency. 'Pol and his brothers,' are listed in account books of the time, but only he is mentioned by name."

"The Limbourg Brothers, Rhenish by birth, began to work at an early age for Jean de Berry, after having served at the court of the Duc de Bourgogne. As was true of most artists of their time, they were influenced by Italian art. Goods and commodities circulated throughout medieval Europe; so did paint-

ings, tapestries, and precious metalwork. The Limbourgs almost certainly drew part of their inspiration from the innovations and styles of their counterparts to the south."

However, as Tériade used to point out, the most striking thing about these plates is their uniquely "French" sense of balance and restraint, combined with uncompromising realism. Incredibly detailed clothing and architecture bear witness to the Limbourgs' keen powers of observation. Yet, judging by their more whimsical scenes, they could also give free rein to their imagination, while never straying from the prescribed subject.

To quote Henri Malo: "They had readily before their eyes the scenery, monuments, and people of France—the framework of their daily life. Committed to steering French art back to nature and the existence of the individual, they copied that setting with meticulous realism and close attention to local color and picturesque detail. They depicted exactly what they saw: buildings, countryside, costumes. They replaced the conventional backdrops fashionable among their predecessors with actual landscapes."

1. Cf. François Avril, *L'Enluminure à la Cour de France au XIV^e Siècle,* Éditions du Chêne, Paris, 1978.

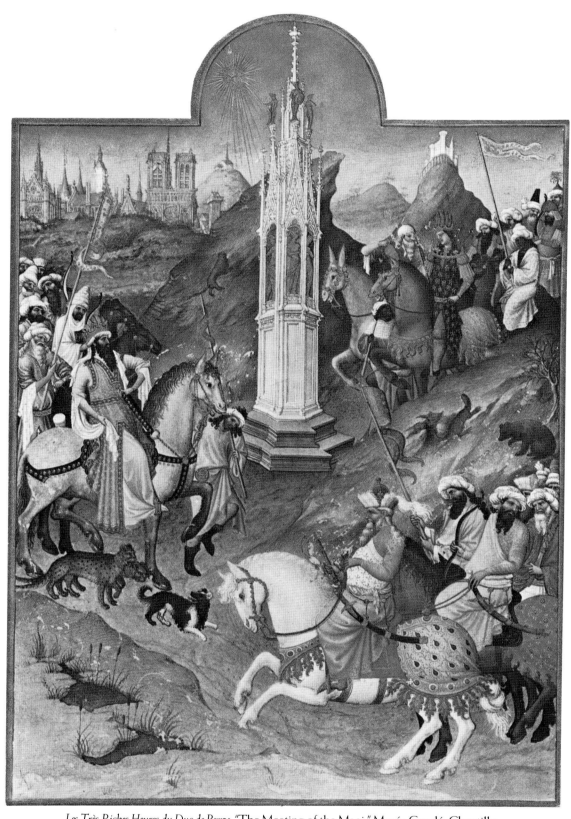

Les Très Riches Heures du Duc de Berry. "The Meeting of the Magi." Musée Condé, Chantilly

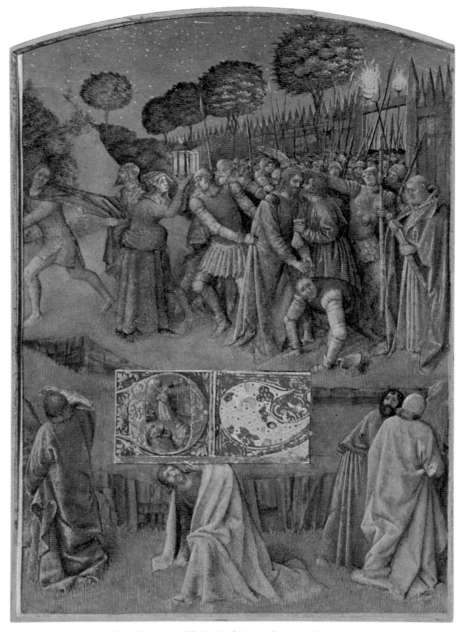

Jean Fouquet. *The Book of Hours of Etienne Chevalier.*
"The Arrest of Jesus." Musée Condé, Chantilly

VERVE
Number 11 and Number 12 March 1945

The Fouquets of Chantilly: *The Book of Hours of Etienne Chevalier—* "The Life of Jesus." "The Virgin and the Saints." Musée Condé, Chantilly

Today it is difficult to fully appreciate the surprise and wonderment of the reader who opened the editions of *Verve* devoted to illuminated manuscripts. We are constantly bombarded with images, and technological progress in the field of reproductions has conditioned us to expect extraordinary forms of expression; thus, even the greatest innovations tend to seem ordinary.

In 1945, to reproduce the paintings of Jean Fouquet so jealously guarded in the Musée Condé was a tremendous novelty. The selection in *Verve* No. 11 was a continuation of *Verve* No. 9, which had been devoted to the twelve Fouquet miniatures illustrating the Flavius Josephus in the Paris Bibliothèque Nationale; and it was a prelude to *Verve* No. 12, also devoted to the *Book of Hours of Etienne Chevalier.* It was a revelation to artists, as it was to numerous art lovers who had never before had access to these fragile and precious masterpieces.

A Book of Hours was a personal prayer book with devotions arranged according to the date and the time of day. In the Middle Ages, these manuscripts were often lavishly illustrated. The work reproduced here belonged to Etienne Chevalier, treasurer of France, counselor to King Charles VII (to whom he introduced the King's future mistress, Agnès Sorel, in 1444). He was Louis XI's ambassador to Pope Paul II, and patron to Jean Fouquet, whom he commissioned to paint the Melun Altarpiece and his now-famous Book of Hours. Sometimes history immortalizes the powerful through those who served them.

The paintings reproduced in *Verve* No. 11 illustrate the Life of Christ, but the backgrounds are actual sites in Touraine and the Ile-de-France. Fouquet depicted monuments and landmarks that were familiar to him: the Cathedral of Notre-Dame, Sainte-Chapelle, the Palace, the Temple tower, the gallows of Montfaucon, the keep at Vincennes, and the Porte Saint-Antoine.

From a formal point of view, one of the hallmarks of Fouquet's miniatures is their incomparable feeling for space. It is almost impossible to believe that these paintings are reproduced in their actual size. The confidence of the drawing and the solidity of the forms, linked with an extraordinary command of perspective, succeed in conveying the impression of a three-dimensional relief.

Fouquet was partial to a restrained, mellow palette of mauves, pinks, violets, and greens. But contrasts between the blues and golds abound, too.

Steeped in Christian sentiment, Fouquet painted the Life of Jesus with extreme care, remaining scrupulously faithful to the biblical account.

The four miniatures in *Verve* No. 12 are devoted to the Virgin and the Saints. Together with those already published in the ninth and eleventh issues of *Verve*, they complete the magazine's publication of the forty Fouquet miniatures in the Musée Condé.

Medieval miniatures were meant to illustrate a specific text. In the case of a Book of Hours, liturgical dictates took precedence over chronological sequence. "First, a calendar with each month's

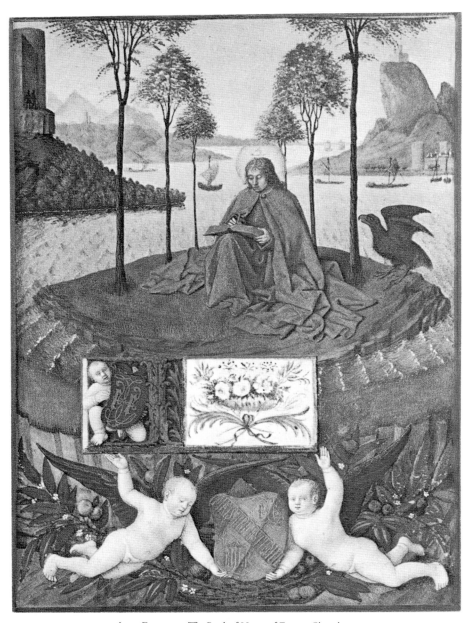

Jean Fouquet. *The Book of Hours of Etienne Chevalier.*
"St. John on the Island of Patmos." Musée Condé, Chantilly

sign of the zodiac and principal occupation, which the artist was free to interpret as he wished. Then, passages from the four Evangelists, two prayers to the Virgin Mary, and lastly, the Hours." (Malo)

The first three paintings are devoted to the Virgin. Curiously, Fouquet depicted her death, funeral, and assumption first. The artist has given her a face that is still youthful. Surrounded by a garland of angels, Christ welcomes into Heaven his mother's soul (represented as a child, which was traditional in the Middle Ages). In terms of composition and symbolism, this trio of illustrations depicting the death and resurrection of Mary resemble icons; their idiomatic character is striking. Yet, they do not lack freedom or inventiveness. Without straying from the prescribed theme, Fouquet endeavored to give his subjects a freshness through direct observation of reality, rendered exactly as he saw it, without embellishment. A case in point: "The Martyrdom of James the Greater," which depicts not one, but two decapitations.

The abundance of gold gives these paintings a strongly graphic character, imparting an almost abstract quality to some of the figures. Thus did the lives of the saints and martyrs of the Church become a part of world mythology.

VERVE
Number 13 November 1945

De la Couleur, Henri Matisse

"A person cannot live in a household that's overly neat or fussy. So he heads for the back of the beyond, to come up with simpler ways that do not stifle his mind." That is what Henri Matisse had to say in 1929[1] about the "tyranny of Divisionism," which the Fauvist painters had repudiated. "At that time, there was also the influence of Gauguin and Van Gogh," Matisse continues. "Here's what was in the air back then: structuring with colored surfaces. A search for intensity through color, the subject being immaterial. Reaction against the diffusion of local color in light. Light was not done away with; rather it was expressed through the relationship of intensely colored surfaces. My painting *La Musique* was done with a lovely blue for the sky, the loveliest blue imaginable. [The surface was colored to its saturation point, that is, to the point where the color blue, the idea of absolute blue, came through completely.] Green for the trees, a vibrant vermilion for the bodies. With these three colors I achieved my harmony of light, as well as purity of color. In particular, color was proportional to form. Forms changed according to their reactions to neighboring colors. The source of expression comes from the colored surface which the viewer grasps in its entirety."

These remarks appear at the end of *Verve* No. 13—on all counts a remarkable publication—and they are the key to this issue. Despite its appearance of serenity and bliss, "*De la Couleur*, Henri Matisse" came out at a particularly distressing time for both Tériade and Matisse. Angèle Lamotte, who had worked side by side with Tériade at the Rue Férou offices of *Verve* from its inception, had fallen ill and died prematurely, early in 1945. In a splendid article illustrated by two Matisse line drawings, Adrienne Monnier reminisces about this remarkable individual who had devoted all of her strength, talent, and faith to the magazine.

Recalling Lamotte's last days, Monnier writes: "She always had a pencil and sheets of paper within reach. When the pain eased she would work on *Verve*, writing down everything she felt was important, and advising her sister,[2] who was to continue her task. . . . *Verve* . . . the very word lit up her face on the eve of her death as she still struggled to focus on ideas and projects."

For Matisse, too, these were trying times. Early in 1941 he had undergone a serious operation in Lyons and had been confined to the hospital for several months.[3] Returning to Nice, he stayed first at the Hotel Regina, then, fleeing the German bombings, he moved to Vence in 1943. There, he rented a villa ("Le Rêve") that his friend André Rouveyre, then living in the pension "La Joie de Vivre," had brought to his attention. "His operation had left him with a prolapsed stomach," notes Pierre Schneider, "that meant he had to wear an iron belt, making it very painful for him to remain standing for more than an hour at a time. He had to put up with gallstones that would trigger jaundice from time to time and force him to keep to his bed." Matisse was drained mentally and emotionally, too. He knew that his wife, his daughter Marguerite, and his son Jean were active in the French Resistance. They were later arrested, and Marguerite was tortured. "His determination to devote himself to the creation of joy was not an active 'commitment,' but neither should it be seen as a soft option."[4]

His only consolation was that friends lived nearby—friends whom the war had also driven south,

to the Côte d'Azur: André Rouveyre, Bonnard, Camoin, Manguin, Marquet, Rouault. And Tériade, too, who had moved into the Villa Natacha in Saint-Jean-Cap-Ferrat by Easter of 1943, coming from Souillac in Lot. During that period, from both Souillac and Saint-Jean, Tériade corresponded regularly with Angèle Lamotte, who had remained in Paris, and with Matisse. The "Matisse issue" of *Verve* was already taking shape during the first part of 1943.

Matisse did the cover, as well as the title page for *The Fall of Icarus* (which reappeared in *Jazz*)—both original lithographs—as well as an original text. *Verve* No. 13 was more than two years in the making—during this period Matisse also started work on *Letters of a Portuguese Nun*, *Jazz*, and *Poèmes de Charles d'Orléans*.

As we have already noted, Matisse had unshakable views about reproduction and was demanding to a fault. In a long letter, typewritten and corrected in his own hand, Matisse brought up this point in the context of the upcoming *"De la Couleur"* issue.

"I have just received from [Éditions du] Chêne the portfolio of sixteen reproductions of my paintings. It hasn't changed my mind about reproduction technique. You know all too well how I feel about this. I reiterate: the four-color or three-color process can only convey the relationships between things, the way a photograph does, in its way. Often, the colors lack intensity. Some do not come across as vividly as they do in the original. Since these things are intended for public consumption—and the public has shallow views about artists, especially when it comes to new creations, which they admire largely out of a slavish kind of snobbery, thus out of incomprehension—printers deem it necessary to 'enhance' colors. And still they don't come out as bright as in the original. The painting is thus thrown completely off balance. The artist who created it sees his work ruined and gives up hope that he will ever be understood through this inexact reproduction.

"Someone said to me, 'Obviously that's not quite it. But it makes something else.' What 'something'? Another combination of colors? No. It's absolutely nothing. The colors come together the way they do when you shake a kaleidescope for a few minutes: a purely random combination, surprising for just a few seconds, but gone as soon as the retina is saturated. The mind registers nothing whatever. Thus, you end up with something completely alien to the painting that was supposed to have been reproduced."[5]

Despite his misgivings, Matisse sent Tériade (who had not yet left Paris at that point) eight paintings to use as reference for "retouching the color proofs," and a few days later asked him if he was "satisfied with the paintings that finally have made their way to you and your printers." Not until *Verve* No. 13 was finally published to critical acclaim were the artist's lingering doubts finally dispelled.

In his prefatory text, Matisse tells how he began to make innovative use of color. However, as he himself admitted, he was "not a writer," so *Verve* came up with a far more original and dramatic way of presenting his thoughts on the subject of color. Tériade hit upon the idea of placing opposite sixteen paintings (reproduced through the four-color process), Matisse's preliminary drawings indicating exactly how the artist wanted the colors to be printed. In these intriguing sketches—we know of no others like them—Matisse gives a completely personal interpretation to the integration of word and image. This eternal preoccupation had been revived by the Cubists, then by the Surrealists. In one case, words were integrated as formal elements, and in the other, they played a narrative, even a poetic, role. Under the guise of providing purely technical instructions, Matisse creates a veritable *manifesto of color, in black and white*. Once again we see the care the artist lavished on reproduction: the complexity and range of colors he indicates, each hue with its own name, creates a spectrum whose range is as varied as colors in a box of pastels.

Henri Matisse. *The Fall of Icarus.*
Lithograph

Consider the sketch for the first painting, *Young Woman by a Window, White Dress and Black Belt* (1942): "Cobalt violet; pure blue; Lefranc light ultramarine; the balcony grillwork, blue like the sky; speckled emerald green + raw sienna; lemon yellow; scarlet lake, Lefranc cobalt violet; yellow ocher scumble; dress, white scumble tinged with light ultramarine, belt outlined in half-tone black and filled in with burnt sienna; Lefranc scarlet lake; light cadmium red and white; yellow ocher, blue scumble."

For the reproduction of *Tabac Royal* (1943), numbers and corresponding colors are listed under the sketch. There are no fewer than fourteen. In the sketch opposite *The Yellow Dress and the Scottish Dress*, Matisse not only indicated the general color scheme but also the shades of which the plaid is composed.

The interaction between reproduction and captioned drawing was so persuasive that one can understand why *Verve* No. 13 was so well received, even in New York.

Line drawings and comments by the artist are interspersed among the succession of interiors featuring young women at a window, beside a table, or posing in an armchair—as well as occasional still lifes. A remark by Matisse sheds some light on this "feminine" ensemble: "Everything an artist sees and unthinkingly puts into his pictures is part of his unconscious enrichment. An acacia on the Vésubie, its movement, its svelte grace, may have led me to conceive the body of a dancing woman."

André Rouveyre, Matisse's confidant, wrote an article on his then neighbor, who was so keen on having it appear in *Verve* that he himself worked out the terms of its publication with Tériade. In this article, Rouveyre expounds on several of the paintings in the "Matisse issue," and his thoughts are of even greater interest because we know that they reflect conversations he had with the artist. Here is what he has to say about paintings such as *The Purple Dress; Young Woman in a Pink Dress, Open Window and Closed Shutters; The Black Door; Dancer at Rest, Pink and Blue Tiles; Dancer, Black Background, The Rococo Armchair;* and *The Idol*—all of which date from late 1942 and early 1943 and are reproduced in *Verve* No. 13: ". . . . The same woman, a world away in thought but very much a part of the here and now, is depicted nude in a living, breathing atmosphere the painter sees with his eyes and in his mind's eye, an atmosphere trembling with contrasts of light and shadow that recall both the scorching desert and gentle, starry nights. The room, with its closed or half-opened shutters, holds her captive to this glowing palpitation, to the serene, profound vitality all around her. She is utterly passive and untouchable, reduced or exalted (as you wish) to the status of some exceedingly rare and valuable hothouse plant. The rhythmic throbbing of the creative spirit is around her and within her; it suffuses everything in the spacious room with an intimate, phosphorescent light."

1. Henri Matisse to Tériade (*L'Intransigeant*, January 14, 1929, and *Verve* No. 13).
2. Mrs. Marguerite Lang.
3. "It was in fact something of a miracle that he should have come through an operation for duodenal cancer and the two pulmonary embolisms that ensued. 'I found out a few days ago that the nuns in the clinic referred to me as *Le Ressuscité* (the Risen one).'" (Schneider, *Matisse, op. cit.*).
4. *Op. cit.*
5. Unpublished correspondence.

Henri Matisse. *Young Woman in a Pink Dress, Open Window and Closed Shutters.* 1942. Oil on canvas

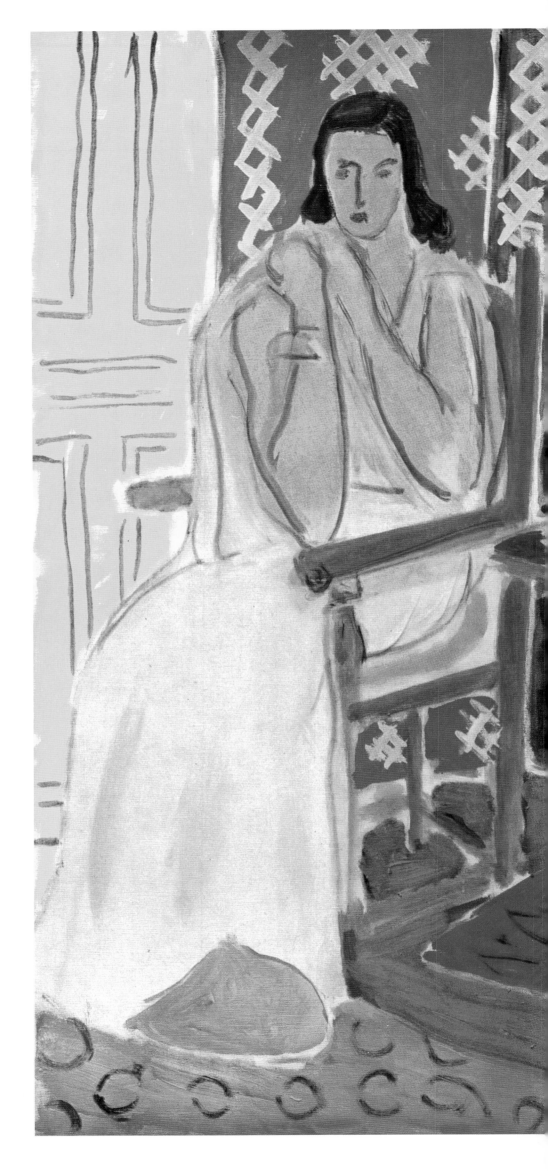

Henri Matisse.
Tabac Royal. 1943.
Oil on canvas, 62 x 80 cm.

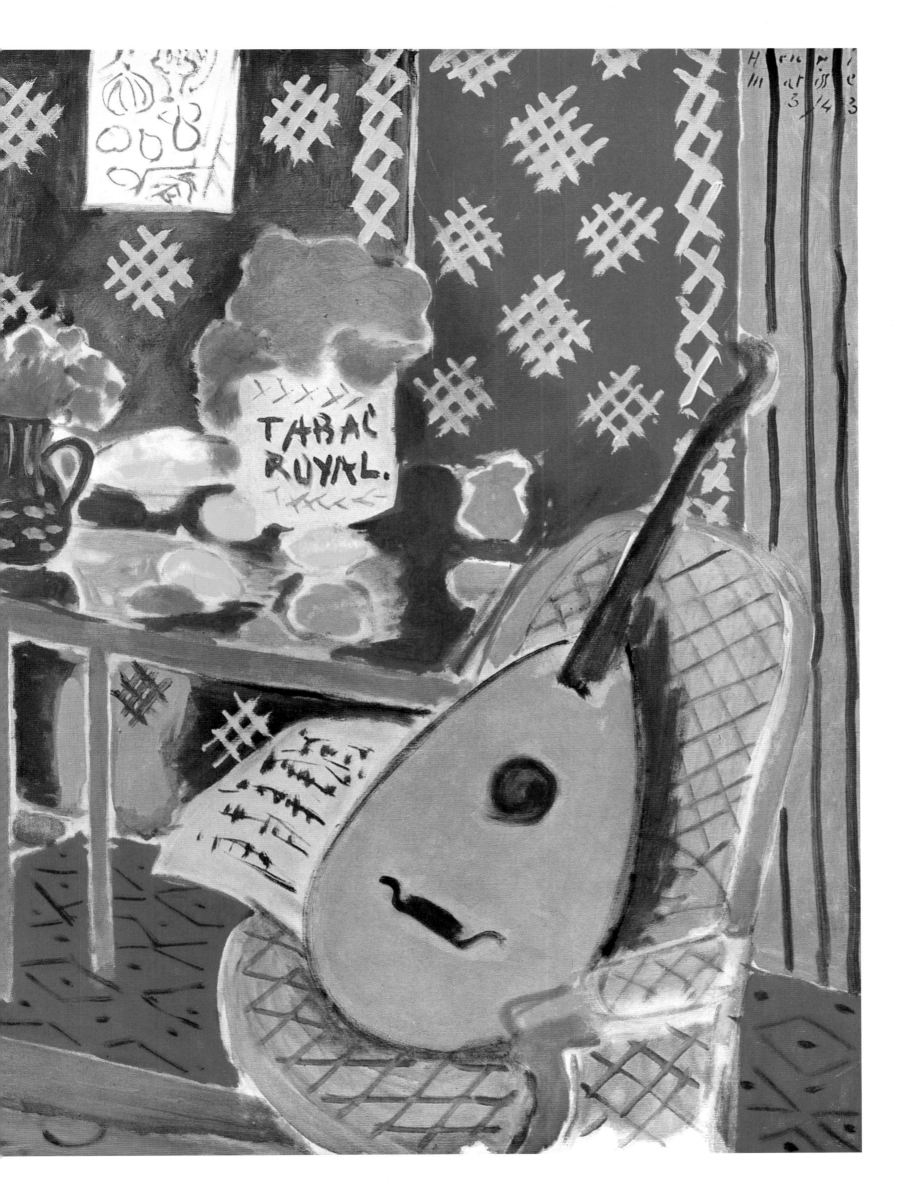

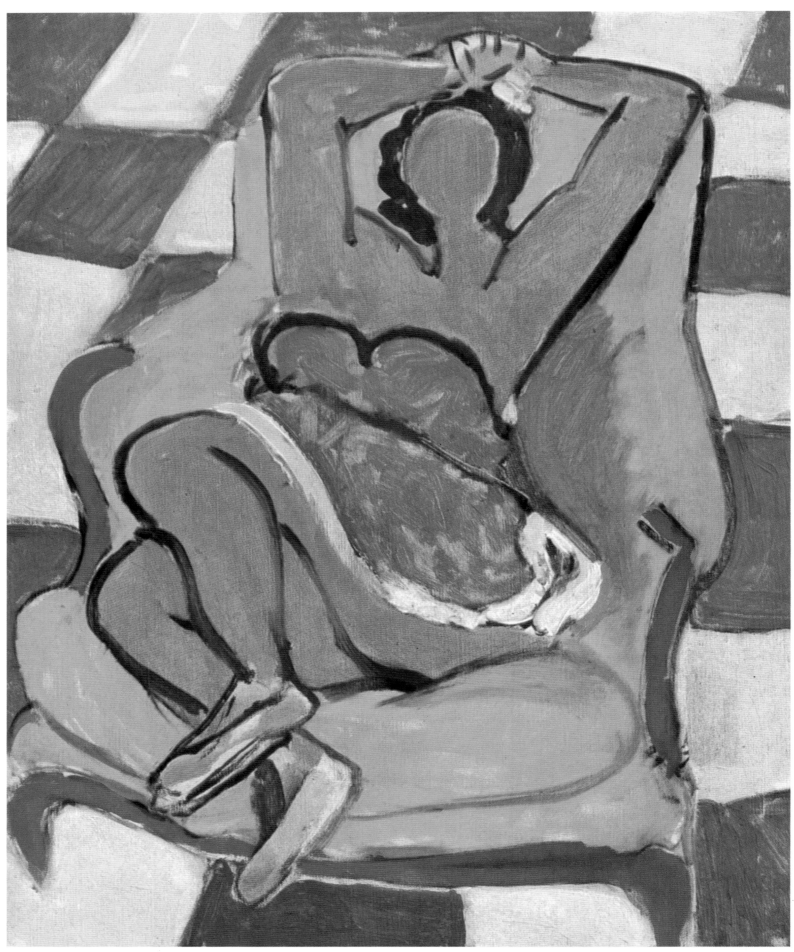

Henri Matisse. *Dancer at Rest, Pink and Blue Tiles.* Oil on canvas

157

MATISSE:
CONVERSATION WITH
TÉRIADE

(first published in *Minotaure*, 1936)

When [a painter's] means have become so spare, so economical that they dilute their expressive impact, he has to go all the way back to the fundamentals that shaped human language. These are the principles that "revive," that seize life afresh, that give us life. Paintings characterized by overrefinement, subtle gradations of color, and listless dissolves call for beautiful blues, beautiful reds, and beautiful yellows—substances that have a profound effect on the senses. That was Fauvism's starting point: courage to rediscover purity of means.

Our senses go through a period of development that depends, not on our immediate environment, but on cultural context. We are born with the sensitivities of a particular civilization. And that counts far more than everything we might learn about an era. So it is with the arts, which evolve not just from individuals, but from all the momentum that civilization has gathered before our era. A person does not do anything he likes. A gifted artist cannot create anything he likes. If he relied solely on his own resources, he would not exist [as an artist]. We are not the masters of what we turn out. It is thrust upon us.

In my most recent paintings I have made the achievements of the past twenty years a part of my very fiber, of my essence.

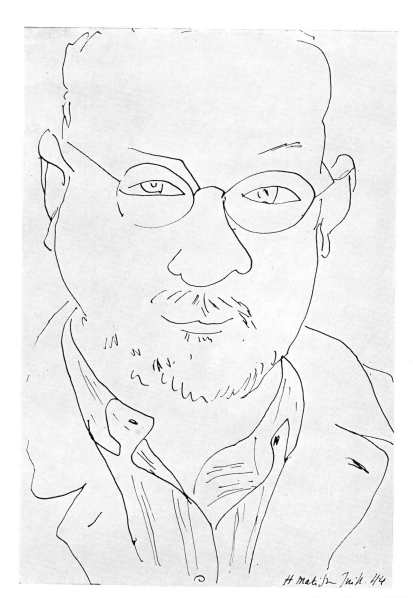

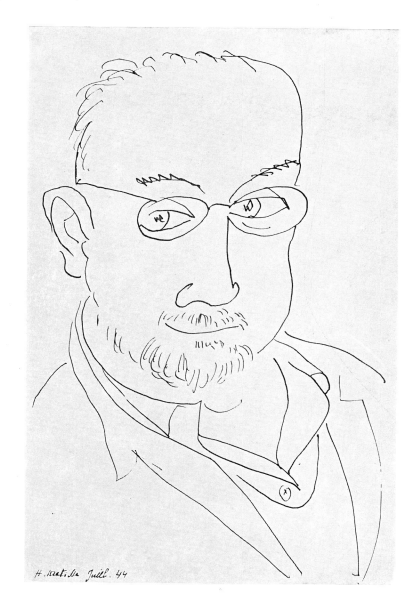

Henri Matisse. *Self-Portraits.* 1944. Pen and ink

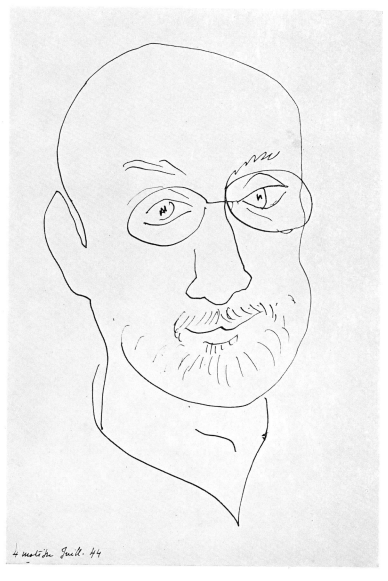

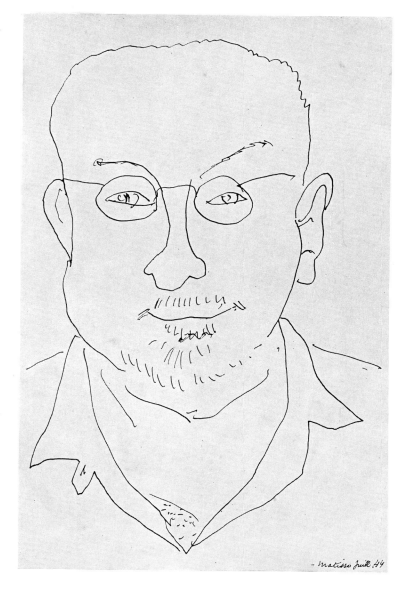

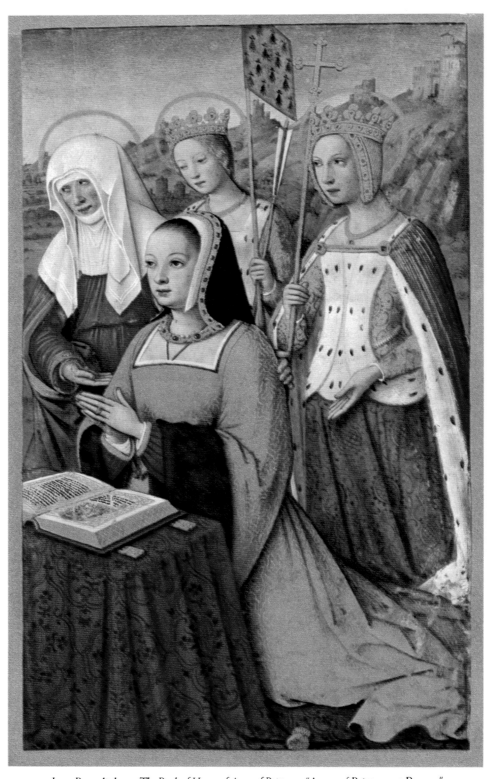

Jean Bourdichon. *The Book of Hours of Anne of Brittany.* "Anne of Brittany at Prayer."
Bibliothèque Nationale, Paris

VERVE
Numbers 14/15 March 1946

The Book of Hours of Anne of Brittany, by Jean Bourdichon

Of all the issues of *Verve* devoted to illuminated manuscripts, this is one of the most important, and it certainly ranks among the most beautiful publications on the subject in recent history. The preparation and production of *Verve* Nos. 14/15 extended from early 1943 until February 28, 1948. It took five years to achieve the high caliber of color photogravure reproduction befitting these breathtaking miniatures, armorial bearings, and decorative fruit and flowers.

The painter, Jean Bourdichon, served no fewer than four Kings of France: Louix XI, Charles VIII, Louis XII, and Francis I. "Charles VIII," writes Emile Mâle, "took the young man into his service and was so pleased with him that he appointed him King's Painter with the coveted title of *valet de chambre*. Probably it was Anne of Brittany [the widow of Charles VIII] who introduced him to Louis XII, her new husband. The King took him on and he retained his titles. About 1500, Anne of Brittany, who was quite taken with Bourdichon's work, commissioned him to paint her wonderful Book of Hours."

Judging by a disbursement order signed by the Queen, he must have worked on it for quite some time. "To our beloved Jehan Bourdichon, painter and *valet de chambre* to Monseigneur [the King], the sum of 1500 *livres tournois* to be paid in 600 gold crowns...as compensation for lavishly and richly illustrating and illuminating a Book of Hours for our use, upon which he spent considerable time, as well as for other services rendered...."

(When Louis XII died, Bourdichon became painter to Francis I, and in 1520 was commissioned to decorate *The Camp of the Cloth of Gold*. He died the following year.)

The book opens with a portrait of Anne of Brittany in a loose-fitting golden tunic, kneeling in prayer. Before her we see a table covered with a sumptuous brocade; upon it lies an illuminated manuscript, which might possibly be *The Book of Hours of Anne of Brittany*. In the background, the Queen's three patron saints (St. Anne, St. Ursula, and St. Helen) look on.

Every Book of Hours included a Calendar, usually illustrated with depictions of the occupations and pursuits of the months, and this one was no exception. The text is surrounded by ornamental borders of flowers and fruit. The rest of the manuscript consists of thirty miniatures divided into four sections:

—The Archangels: Michael, Raphael, Gabriel;

—The Evangelists; Matthew, Mark, Luke and John;

—The Virgin Mary and Christ: The Annunciation, the Visitation, the Nativity, the Annunciation to the Shepherds, the Adoration of the Magi, the Flight into Egypt, the Holy Family, the Rearing of Jesus, the Kiss of Judas, the Crucifixion, and the Pietà;

—Lives of the Saints: SS. Cosmas and Damian, St. Peter of Verona, St. Nicholas, St. Martin, St. Hubert, St. Ursula, St. Mary Magdalene, St. Margaret, St. Sebastian, St. Maurice and the Martyrs of Agaunum, and the Virgins.

As Emile Mâle notes, "*The Book of Hours of Anne of Brittany* marks the end of miniature painting, which originated in Alexandria and remained a great and vital art form for nearly fifteen centuries. The appearance of the Gutenberg press marked the end of the Middle Ages."

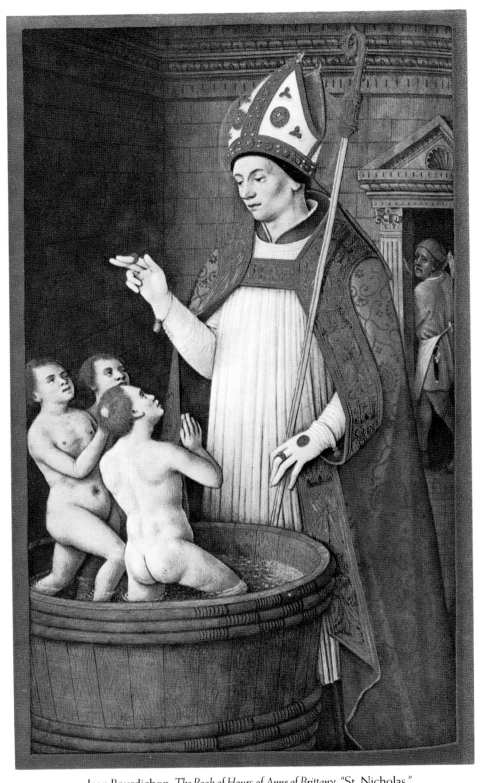

Jean Bourdichon. *The Book of Hours of Anne of Brittany.* "St. Nicholas."
Bibliothèque Nationale, Paris

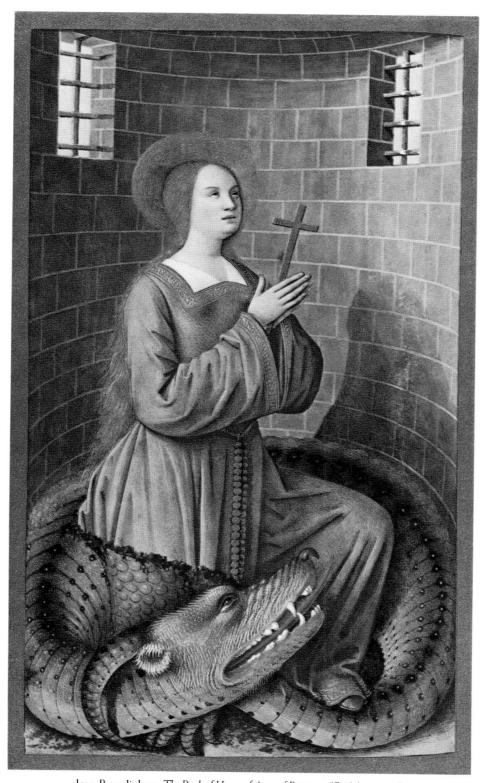

Jean Bourdichon. *The Book of Hours of Anne of Brittany.* "St. Margaret."
Bibliothèque Nationale, Paris

Le Livre des Tournois of René d'Anjou: *Traité de la Forme et Devis d'un Tournoi*

Tériade used to say that the renaissance of the *livre de peintre* marked a return to the tradition of illuminated manuscripts. For him, these restrained, inventive, and graceful miniatures on paper were the quintessence of French painting.

Furthermore, this was an art form that required the cooperation of a scribe and a painter, although sometimes a single artist was responsible for both the calligraphy and the painting.

No discussion of *Le Livre des Tournois (The Book of Tourneys)* would be complete without mentioning the man said to be its author, the remarkable René d'Anjou, "born in the castle of Angers on January 16, 1409, the great-grandson of Jean le Bon, then King of France, and younger son of Louis II, Duke of Anjou." So writes Edmond Pognon, then Curator of the Bibliothèque Nationale, who monitored the production of this issue of *Verve* from its inception, transcribed René d'Anjou's text into modern French, and wrote a postscript. As Pognon notes: "This youngest member of the family inherited one illustrious title after another (some more unforeseen than others): Count of Provence, Duke of Bar, Lorraine, and Anjou, King of Naples (or, as it was called then, 'Sicily'). War and politics cost him nearly all of them. When he died in 1480, his only title was Count of Provence."

King René's fate as an author was just as unenviable. Until the late nineteenth century, numerous works in prose and poetry, as well as many paintings were attributed to him. By 1946, his credits had been reduced to some occasional verse to Charles d'Orléans, two allegorical poems (*Le Mortifiement de Vaine Plaisance* and *Le Livre du Coeur d'Amour Epris*), and *Le Livre des Tournois*.

On the other hand, we know for certain that René d'Anjou was a distinguished patron of the arts. "Architects, sculptors, and goldsmiths, some of them very talented, gave him the best years of their careers: Jeannot le Flamand, Geffelin d'Angers, Coppin Delf, Pierre Garnier (called Préfichaut), Victor Hailler, Georges Truber—to name just the painters and manuscript illuminators who were among his favorites. Nicolas Froment, a latecomer to King René's court, painted the renowned *Burning Bush* triptych now in the Cathedral of Aix-en-Provence. However, it seems that René was partial to a painter indiscriminately referred to in account books as Barthélemy de Clerc, or de Eilz, or de Cilz, or de Ecle, or d'Eick. This confusing diversity of names has fueled a great deal of speculation, such as the hypothesis that he was a member of the Van Eyck family. Barthélemy's name appears in the records from 1440 to 1476, with the title of *valet de chambre* to the King of Sicily."[1]

Imprecision in the spelling of names is only one reason why critics attribute these paintings and drawings at their peril; another is that information added subsequently to the manuscripts can be misleading. Pognon proceeds with extreme caution: "The manuscript does not give the slightest clue as to its origin. An inscription on the endpaper—'This manuscript was commissioned by King René of Sicily and painted in his own hand'—dates from the late sixteenth century, by which time the legend of René the Painter had already spread far and wide. Consequently, it is of no value whatever. Whoever did the drawings, albeit certainly not René, must have been one of René's painters, for the same style

reappears in the exquisite miniatures that grace a copy of *Le Livre du Coeur d'Amour Epris*, executed for King René and now in the Nationalbibliothek, in Vienna. The two manuscripts must have been done about the same time, judging by the similarity of costumes and headdresses: the broad-shouldered doublets, high boots, whimsical hats, and medium-length hair suggest the years 1460–1465."[2]

The author spells out the purpose of *Le Traité de la Forme et Devis d'un Tournoi* in an opening dedication to Charles d'Anjou: "To His Royal Highness, my beloved and only brother, Charles of Anjou, Count of Maine, Mortain, and Guise. Mindful of the pleasure you take in seeing new pictures and new writings, I, your brother, René of Anjou, decided to write an exhaustive treatise on the rules and regulations governing tourneys, should any noblemen hold one at Court or elsewhere in France. These rules I modeled as closely as possible after those of tourneys in German and Rhenish lands, as well as in Flanders and Brabant, and I even consulted old documents to see how they used to be done in France. From these three sets of rules I took what seemed fit and proper and compiled a fourth, as you shall see."

The book opens with a frontispiece showing the principal herald or "king of arms" holding the banners of the knights. The code of tournaments is then presented in minute detail, and by way of illustration the author pits the Duke of Brittany against the Duke of Bourbon in a fictitious contest. Combatants had to be "if not a prince, then at least a high-ranking baron or knight" and delivered a prescribed speech: "King of Arms, take this sword and go to my cousin the Duke of Bourbon. Tell him on my behalf that, in view of his bravery, probity, and chivalry, I send him this sword as a token of my wish to engage in combat with him in the lists, in the presence of ladies and damsels and all other spectators, on the appointed day and at a place that shall be deemed fit and proper."

Then follows a vivid portrayal of the pageantry of velvet and satin, ladies fair, heralds, and retainers. The festivities commence when "the herald with the loudest voice takes three deep breaths and shouts, 'Now hear this! Now hear this! Now hear this!' with long pauses in between." Noblemen from all around were invited to attend. There are detailed pictures of the lists and of houses gaily decked out for the tournament. Clearly, *Le Livre des Tournois* served a twofold purpose: as a practical guide to tournaments, and as literature promoting tourneys. Attractive vignettes of the panoply of these contests— crested helmets, cuirasses, streamers, gauntlets, swords, maces, the covered viewing stands—grace the text from start to finish.

This issue of *Verve* also features rarely seen preliminary drawings for some of the paintings.

1. Edmond Pognon, postscript, *Verve* No. 16.
2. *Ibid.*

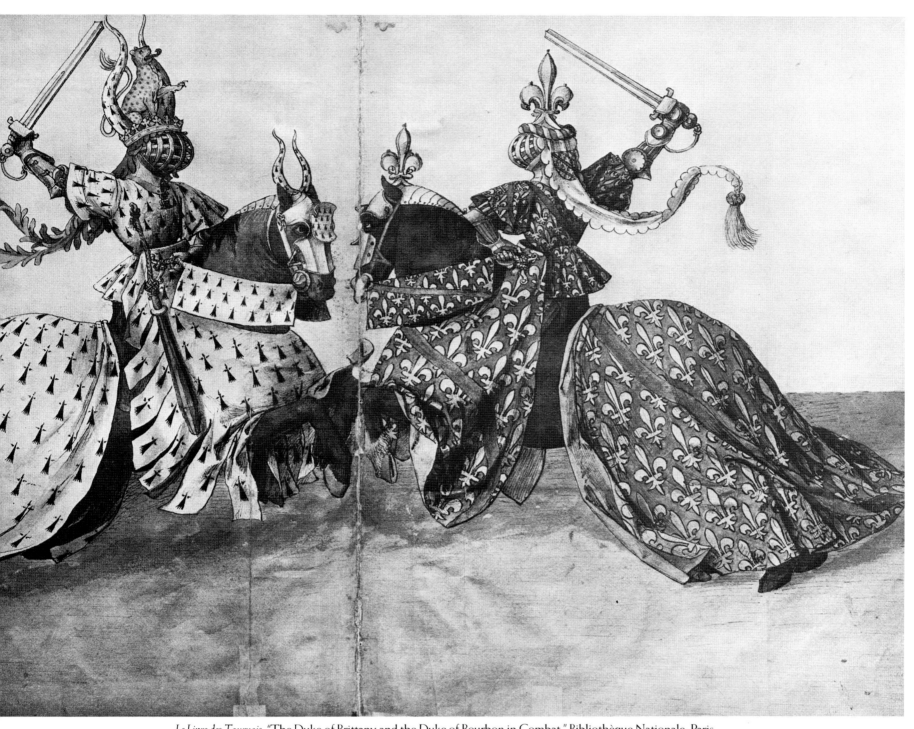

Le Livre des Tournois. "The Duke of Brittany and the Duke of Bourbon in Combat." Bibliothèque Nationale, Paris

VERVE
Numbers 17/18 Summer 1947

Couleur de Bonnard

The long-standing friendship between Tériade and Bonnard grew even stronger during the war. Bonnard and his wife, who was gravely ill, were at Le Cannet, on the Côte d'Azur, cut off from the outside world; Tériade lavished thoughtful gestures on them. From Souillac, the publisher sent food parcels to the artist every week without fail, and each time a deeply appreciative Bonnard thanked him with touching humility. Judging by the (unpublished) correspondence between them, the painter was at a low ebb. He would not see anyone for weeks at a time. The death of his wife, Marthe, and that of Tériade's associate, Angèle Lamotte, brought the two of them even closer together.

Bonnard's *Correspondences*, written and drawn by the artist in violet ink with an old-fashioned pen, was the first volume in *Verve*'s Great Book series. As early as 1939, the year of its publication, Tériade was considering a special issue of *Verve* devoted to Bonnard.

Verve No. 1 had featured a Bonnard interior; *Verve* No. 3 combined reproductions of his work with a Rogi-André photographic essay on the painter. Then, in *Verve* Nos. 5/6, there are Bonnard color lithographs: *Portrait* and *Breakfast* and, in *Verve* No. 8, a two-page spread with Bonnard's dazzling *Sunset Over the Mediterranean*.

Finally, *Couleur de Bonnard* came out, but not—unfortunately—until 1947, when Bonnard had already passed away.

"This issue of *Verve* brings together works that Pierre Bonnard completed these last fifteen years," Tériade writes in his foreword. "The artist did the cover, the frontispiece *(The Sun)*, and all the decorative work during the fall of 1946."

In the eye-catching cover for this slim issue, yellow spots float amid swirls of blue ink, against a mauve background. The title of the magazine is inscribed within a cartouche in the middle of the cover. Compared with this "school notebook" appearance, the frontispiece is majestic: an incandescent sun, rendered in wax crayon, scorches a stretch of multicolored countryside.

Both works are signed originals.

In his substantive introduction, Charles Terrasse writes: "The dazzling sun, the majesty of the sea—these are the themes [Bonnard] develops here. With all-encompassing genius, the painter stresses the breadth and sweep of things. [Also,] a series of drawings in colored pencils, from his sketchbooks, reveals a little-known side of his art. There are nudes, too, and some black-and-white drawings round out the ensemble."

A vignette above this text features a Rogi-André photograph of Bonnard in his studio, working on several paintings at a time, and showing the peculiar habit he had of thumbtacking his canvases right to the wall. One of the very canvases we see in the photograph *(Stormy Skies over Cannes)* reappears in the magazine as a two-page spread. What a pity the painting was subsequently framed! The stretcher confines the pictorial space and puts blinders on our field of vision.

Verve Nos. 17/18 includes two historical curiosities: photos of *Flowering Almond Tree* and *Before Noon* in their next-to-last stage. Terrasse notes the changes that Bonnard later made in the paintings:

"The ground the almond tree stands on is now more balanced in the left section. The foliage in *Before Noon* is highlighted with black."

A Brassaï photograph of Bonnard's garden at Le Cannet serves as a lead-in to a *Notebook* that includes a text and original illustrations by the artist. Was this to have been published in book form, like *Correspondances*? There is no way to know for sure. In his letters to Tériade, Bonnard does mention books from time to time—in particular, illustrated versions of the *Iliad* and the *Odyssey*—but never this notebook.

Terrasse goes on to tell us that the originals of these pastels from Bonnard's own sketchbooks feature variations on the theme of everyday life at Le Cannet: a garden pathway, an interior in the villa, a road leading toward the mountains, an olive grove, landscapes, an open window, bunches of flowers, a passer-by seen from a window, a basket of fruit, a farm scene, the seashore. These crowded Intimist scenes look more like scaled-down paintings than sketches. In some cases, on the opposite page, Tériade juxtaposed a charcoal drawing, often a nude.

Throughout the portfolio there appear terse, *haiku*-like notations that make up a kind of mental self-portrait of the painter.

"See the object just a single time, or a thousand."

"Beware of local color."

"Once in a while, count as in music, one, two, three, etc."

"Importance of an unexpected impression."

"The improbable is quite often truth itself."

"It's all right to mount a hobby horse, as long as you don't think it's Pegasus."

"One day a house painter said to me, 'Sir, there's never any problem with the first coat. Let's see how you handle the second.' "

"A woman's charm can tell an artist a great many things about his art."

"Some of nature's beauty is untranslatable except on a large scale."

"Color is more rationalizing than line. A brush in one hand, a rag in the other."

"Judge the way a milliner judges the hat she is making."

"Shortcomings are sometimes the very thing that gives a painting life."

"Museums are full of uprooted artwork."

"Boucher, Ingres—the first modern craftsmen."

After this "portfolio" comes a second, entitled *Marines* (Seascapes), with drawings and paintings that include pen-and-inks of Chinese fish.

Verve's tribute to Bonnard concludes with two important texts: remarks the artist made to Tériade (Le Cannet, 1942), and above all, "The Bouquet of Roses," Bonnard's words recorded in 1943 by Angèle Lamotte, through which the artist's creative process is revealed.

"On the table there is a bouquet of roses, full and round. Bonnard speaks:

" 'I tried to paint it directly, scrupulously, I was absorbed by the details, I was completely immersed in painting roses. Then I realized that I was floundering, I wasn't getting anywhere. I had lost my original thought and couldn't get it back again; I couldn't find what it was that had captivated me, my starting point. I thought I might regain it, if only I could recapture that initial charm.

" 'I often see interesting things all around me, but for me to want to paint them they've got to have a special allure: beauty, or whatever they mean by beauty. I paint them, trying all the while not to lose control over the initial idea. But I am weak, and if I don't get a grip on myself, a moment later I've lost that first vision and I don't know where I'm headed. Just like what happened with the bouquet of roses.

Pierre Bonnard. Title Page for a Notebook

" 'The physical presence of an object, of a subject, is a very bothersome thing for a painter while he is painting. . . .' "

"Am I to understand that you never work on the subject?"

" 'Yes, I'll work on it. But I leave it, I go away to regain my control, then I come back a while later. I don't let myself get wrapped up in the object itself. I paint alone in my studio; I do everything in my studio. In short, a conflict arises between the original concept—which is the right one, the painter's own—and the inconsistent, fleeting world of the object, of the subject that inspired him in the first place.' "

Bonnard goes on to talk about an artist's struggle with reality, and compares his experiences with those of great painters before him.

Pierre Bonnard. *Landscape*

*I*mportance of an unexpected impression.

The improbable is quite often truth itself.

Pierre Bonnard. *Landscape*

It's all right to mount a hobby horse,

as long as you don't think it's Pegasus.

173

REMARKS BY PIERRE BONNARD
TO TÉRIADE
(Le Cannet, 1942)

A painting is a series of marks that join together to form an object or work over which one's eyes may freely roam. What makes an ancient marble statue beautiful if not the uniqueness of the aggregate finger movements that created it?

The virtuosos realized that their artwork had to be completely readable. However, the way they went about it was sometimes less than forthright. The technique of oil painting allowed them a series of colors that sometimes lack substance. With a single drop of oil, Titian painted an arm from end to end. Cézanne, however, endeavored to give everything he painted a palpable presence. But we must not condemn transparent effects, though excessive use of them should be repudiated. Rembrandt made use of transparent effects, but just look at them!

Not everything you see moves you to transports of delight. Yet painters can capture and put into their pictures pleasing relationships that are quite striking. There's beauty in everything, just waiting to be drawn out.

I approved of collages when they started taking bits and pieces of the outside world and incorporating them into pictures. By their very nature they remind us of the artificiality of painting. Thus, I am especially partial to the elaborate gilded backgrounds, as well as the armorial bearings and heraldic devices, that illuminators and early masters introduced into their paintings.

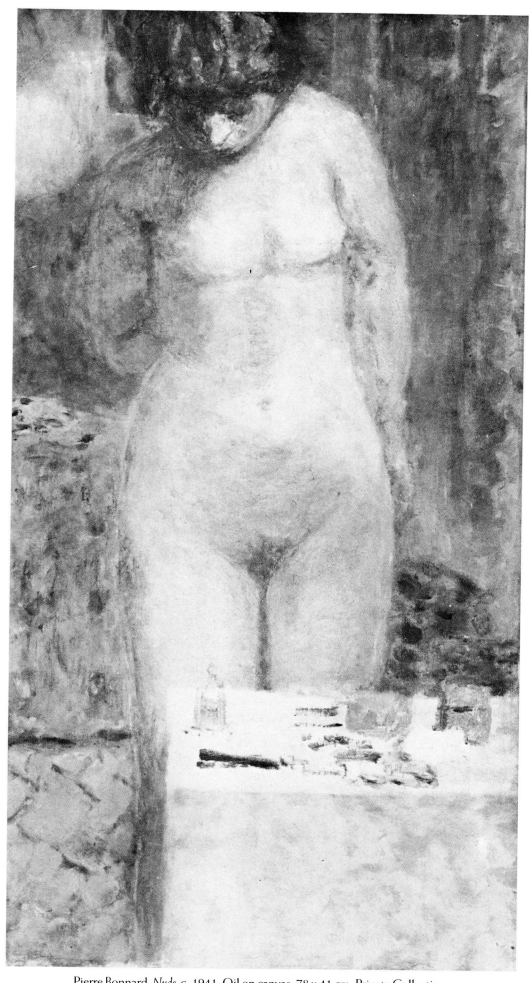

Pierre Bonnard. *Nude.* c. 1941. Oil on canvas, 78 x 41 cm. Private Collection

Pierre Bonnard. *Interior*

Abstraction is his real departure.

Abstract art is a compartment of art.

Pierre Bonnard. *Landscape with a Pink Road*

The tone or the color that one isolates and the same tone or color,

seen in close proximity to others, show how different they are.

OBSERVATIONS BY PIERRE BONNARD TO ANGÈLE LAMOTTE

(1943)

Very few painters have taken on their subjects just as they see them, and those who did so successfully protected themselves in highly personal ways. Cézanne had a definite idea of what he wanted to do and took from nature only what tied in with that idea. Often he would just stay there and bask in the sun without so much as lifting a brush. He would wait for things to fit in with what he had in mind. No painter was more heavily armed against nature, nor purer, not more sincere.

Renoir painted Renoirs, first and foremost. Often his models had dull skin, but he painted it lustrous anyway. He used models for movement, for form; but he did not copy. He never lost sight of what he could do with them. One day when we were walking he said, "Bonnard, you've got to embellish." By embellish he meant what an artist has to put into his picture to begin with.

Claude Monet painted subjects directly, but for no more than ten minutes at a stretch. He did not give things enough time to captivate him. He would resume work when the light matched what he originally had in mind. He could afford to wait, as he worked on several paintings at the same time.

By virtue of their methods and techniques, the Impressionists were better protected against their subjects than the others. Nowhere is this clearer than in Pissarro's work; he arranged things, his painting was more systematic. All Seurat did was tiny studies after nature; everything else was created in the studio.

One can get a sense of the difference between painters who could protect themselves and those who could not by visiting the Prado and comparing the Titians and the Velázquez's. Titian was completely shielded from his subject. All of his pictures bear the stamp of Titian; he had a mental picture of what they would look like and painted them accordingly. In the work of Velázquez, however, there are tremendous qualitative differences between the subjects that fascinated him (such as the portraits of the *infantes*) and his sweeping academic compositions in which all we see is models and things, just as they are, but get no sense of what initially inspired them.

Through captivation or an initial inspiration, a painter achieves universality. It's captivation that tells him which subject to choose and precisely how a picture should be. Take away that captivation or initial concept, and all that's left is a particular subject that overwhelms the painter. From that moment on, he is no longer painting his own picture. For some painters—Titian, for instance—that captivation is so powerful that they never lose it, even if they remain in direct contact with their subject for a very long time. I, however, am very weak. I find it difficult to control myself when my subject is right in front of me.

Pierre Bonnard. *Nude Bending Forward*. Crayon

Pierre Bonnard. *La Cueillette des Fruits*. 1946. Oil on canvas.
Fragment of a mural in six panels. Private Collection

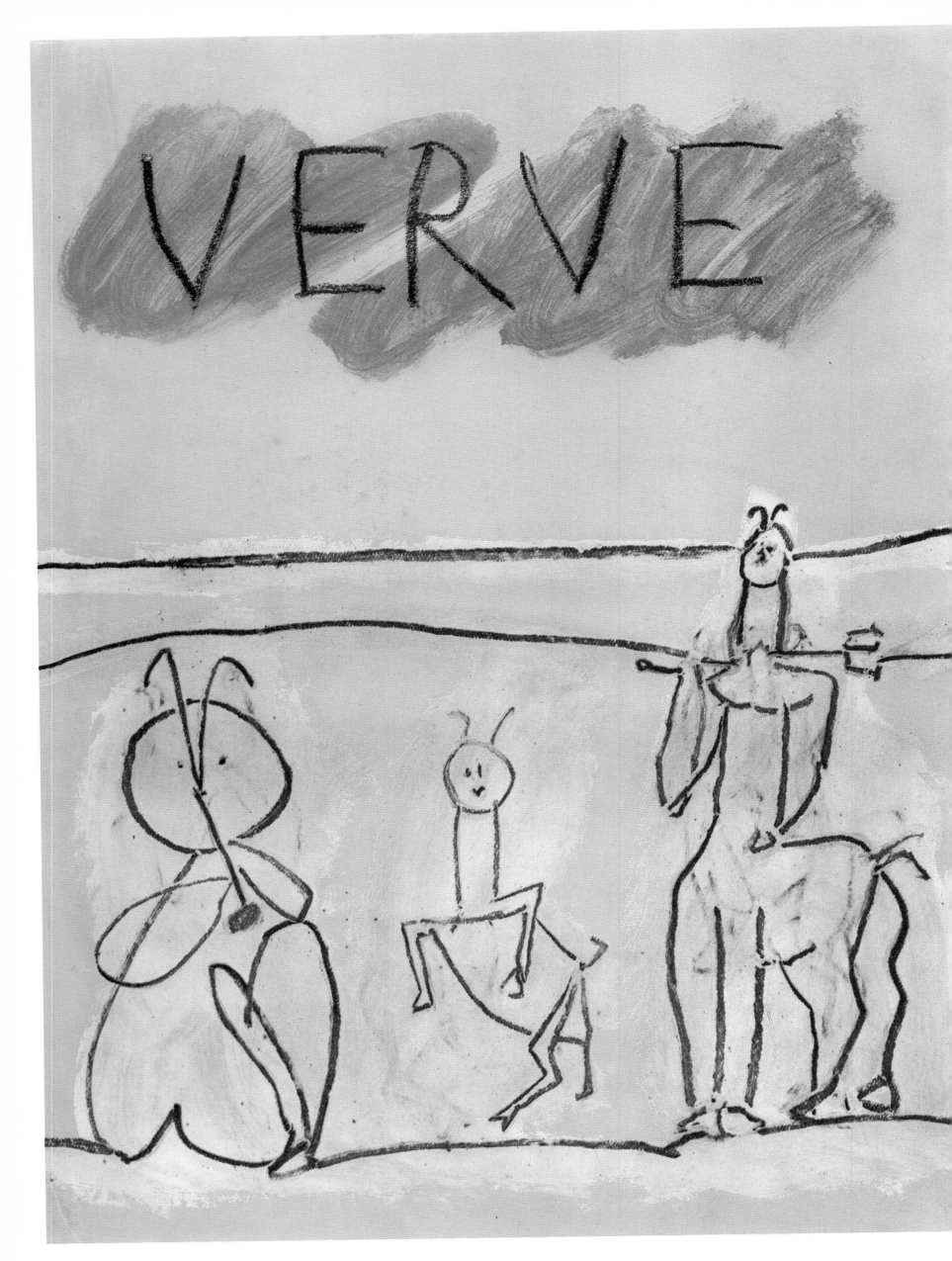

VERVE

Numbers 19/20 April 1948

Couleur de Picasso

The grace and the magic of Picasso. Well-worn clichés, to be sure, and yet they unavoidably spring to mind when we open the pages of this issue of *Verve*, dedicated to Picasso and his work at Antibes under the title "Antipolis 1946" or "*Couleur de Picasso.*"

Beginning with the title page, Picasso invades and fills the space with nervous, inspired strokes of his pencil. They surge up from the depths, assert themselves effortlessly, defy analysis. The title itself— ANTIPOLIS—is drawn with consummate skill. Despite the apparent gestural freedom, a seasoned calligrapher is at work here, expertly positioning the letters: the "I" curled into the "L," as well as the "O" and the "A" that mirror a satyr on the opposite page, playing his panpipes (against a blue background). Drawings and letters share the same line, and the audacity of this title apparently flung down onto the page is actually very well considered.

Picasso was in Antibes, living in a château on the city's ramparts that his friend Dor de la Souchère (curator of the Antibes Museum) had found for him, and he began to fill this sprawling building, then half-empty and in ruins, with Mediterranean art. Antibes, formerly Antipolis, a Greek colony in the fifth century B.C., offered him a land whose dimensions matched his own, a new field to sow and cultivate, promising inexhaustible freedom and inspiration. The sea, the light that passed through the château's narrow windows, the bustling city nearby, even the seaside climate (against which, nonetheless, he had to take precautions, painting on pieces of asbestos concrete)—everything here agreed with him. "Antipolis" also contains a sly reference to Tériade's Greek origins. And wasn't it Picasso who had been commissioned by Tériade to create the first cover for *Minotaure*—a work that would generate many others?

In Antibes, Picasso found the sincerity and sense of exaltation that Jaime Sabartès notes accurately in this issue of *Verve*: "It is impossible to fathom how, without exaltation, a person can win a battle, and, with every reaction and response, Picasso's self-induced battle reached an ever higher pitch—for exaltation is the underlying source of his creative strength.

"One can criticize Picasso, but he himself doesn't criticize. He is content to watch the pageant of Art and Life, as a spectator, registering neither amazement nor surprise. Everything seems natural to him, so he has an abundance of the serenity indispensable to an appreciation, in true perspective, of everything that offers itself to his inquisitive gaze."

Then there is Picasso's humor, the gaiety that invests his figures with that blend of calm irony and beaming jubilation that is the hallmark of great intelligence. Picasso was master of himself, his forms, his inspiration. There was nothing left for him to prove. He drew and painted for the sheer joy of it, the way one breathes or swims or kisses a child. Jaime Sabartès quotes Picasso in his article: "The ideal would be to strike a spark from a block of ice." Contrary to what the man-on-the-street may think, there is nothing provocative in Picasso's work—just "calm assurance" and an uncommon vigor. Within the cavernous château whose spaces he felt compelled to fill, Picasso unleashed not only his own energies but a mythological world as well—a bestiary, one might say. Satyrs and centaurs sported horns and wielded tridents, playing panpipes in the most natural fashion.

Cover by Picasso

Verve Nos. 19/20 reaps an extraordinary harvest without imposing any chronological order—it is arranged solely to please the eye. In his preface, Sabartès mentions telling Picasso about a blonde whom he had found attractive, although he [Sabartès] had thought himself attracted only to brunettes. Picasso shot back: "You've got to take things as they come. What does color or shape matter? . . . Do you think she would be better in any way other than that which caught your eye? Instead of accepting what you see just as it is, letting yourself enjoy, even discover its qualities, you persist in passing judgment based on ingrained responses. And you deprive yourself of the pleasure of contemplating the real world." Although Picasso was discussing a woman, when we consider these words, how can we not think of painting?

Picasso was constantly reacting to his surroundings, even to the castle's whitewashed walls. A smudge or an unevenness was enough to start his creative juices flowing.

And this is also one of the unique qualities of *Verve* Nos. 19/20: a unity of time and place that gives this form of presentation—known in English as a "work-in-progress"—its singular character. The page layout, proceeding through formal oppositions and connections, as well as specific graphic couplings, conceived in conjunction with Picasso, reinforce this impression.

But formal relationships should not cause us to overlook the subject matter—one might even be tempted to say the "motifs," in a musical sense—of these works. Satyrs (some playing panpipes, some not) and centaurs are the basic elements in this "bestiary" created by Picasso in Antibes in 1946, but others come to mind. Equally memorable are: the drawing *La Femme* dated May 1, 1946; the bathers on the La Garoupe beach humorously rendered in trapezoidal forms; the large, recumbent nudes painted on asbestos panels now located in the Musée Picasso in Antibes; and a series of romantic drawings, in which the male figure does not yet exhibit the cruel traits of a graybeard that would characterize him in Picasso's late work. In 1946 Picasso was involved with Françoise Gilot and, despite the bearded-faun mask affected by the male, these drawings are filled with a tenderness, a mood of happiness and serenity, that the man Chagall nicknamed *L'Espagnol* did not always enjoy.

A series of marvelous drawings embodies this bucolic, mythological world in which Picasso immersed himself so happily. A shepherd with a panpipe, a shepherdess, and an animal that looks more like a doe than a sheep: this is sufficient for a universe. Tériade, son of Lesbos, the homeland of Daphnis and Chloe, could not have been anything less than enchanted.

Later in this issue, the "plot thickens" with the arrival of a centaur who also seduces the young woman—in two drawings where the composition of the bodies, both animal and human (a difficult subject), is very harmoniously rendered. The artist's jubilation is so overwhelming that the characters meet as if in a dream: hence the superb facing pages upon which a young female nude in the foreground gazes now at a man, now at another woman stretched out with her on the bed.

And then the goat arrives, the faun's cousin, absorbed in a dream, or by her own internal emptiness—how can we know?—and whose bony form seems to enchant Picasso. We see her again in several drawings or paintings, always a trifle lonely, even if occasionally she does turn an attentive ear to the sounds of the panpipe.

This double issue of *Verve* also contains a prose poem by Picasso (heavily influenced by Surrealist *écriture automatique*), as well as observations made by Picasso to Tériade, some of which had been previously published in *L'Intransigeant* (June 15, 1932). Providing a sort of echo to the foreword by Jaime Sabartès, these remarks include general comments about the paintings and drawings reunited in this issue.

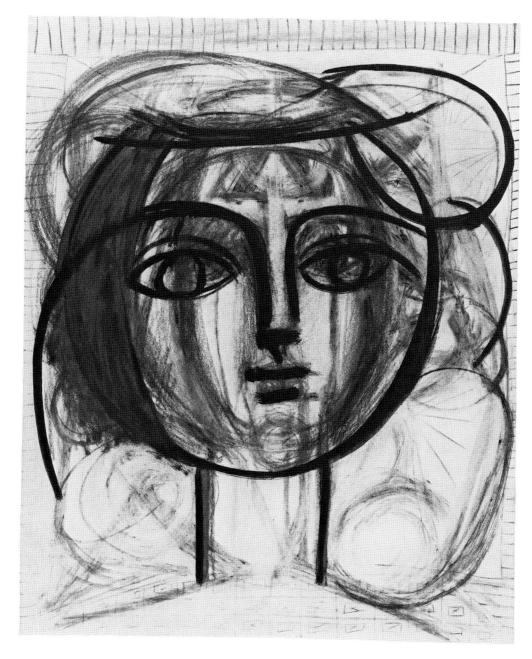

Picasso. *Head*

This text is accompanied and followed by scenes of fighting centaurs (dated summer 1946), and a major series of drawings in which the centaur and his companion welcome the birth of a child. Could this be an allusion to Claude, the son Picasso had with Françoise Gilot? These are idyllic scenes, reminiscent of Adam and Eve in the Garden of Eden. In one, we see the centaur cooking fish on a spit, while his companion blows on the fire and the little centaur clambers onto his father's back. The mood of affection and exuberance reaches a climax at the very end, where we find the centaur, his companion, and their child dancing for joy and frolicking with birds on the beach.

Facing these drawings is an apt remark that Picasso once made to Tériade: "In the final analysis, there is nothing but love. No matter what kind. They should put out painters' eyes—the way they blind goldfinches to make them sing more beautifully."

An assortment of still lifes and a drawing of an owl-like creature bring "Antipolis 1946" to a close.

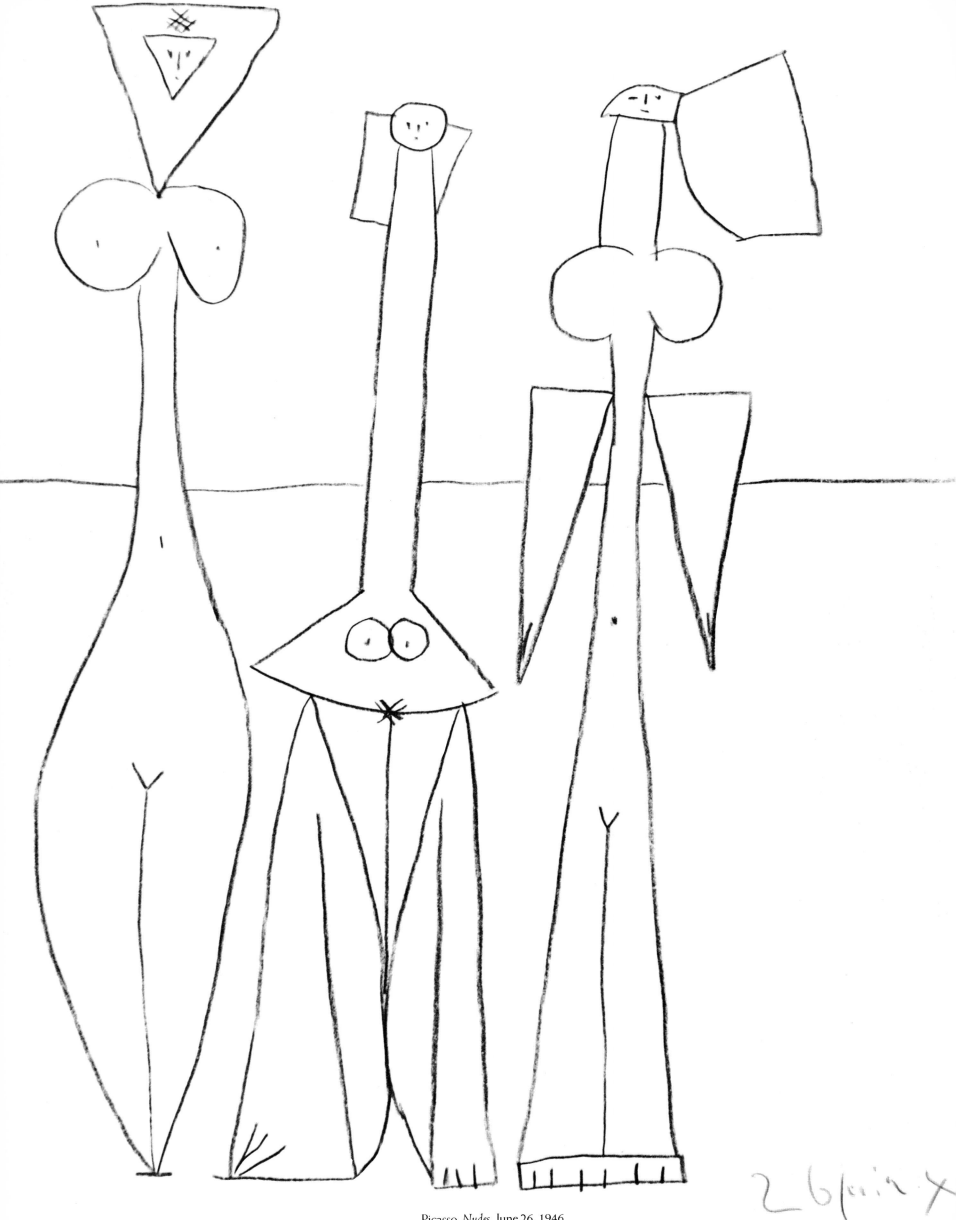

Picasso. *Nudes.* June 26, 1946

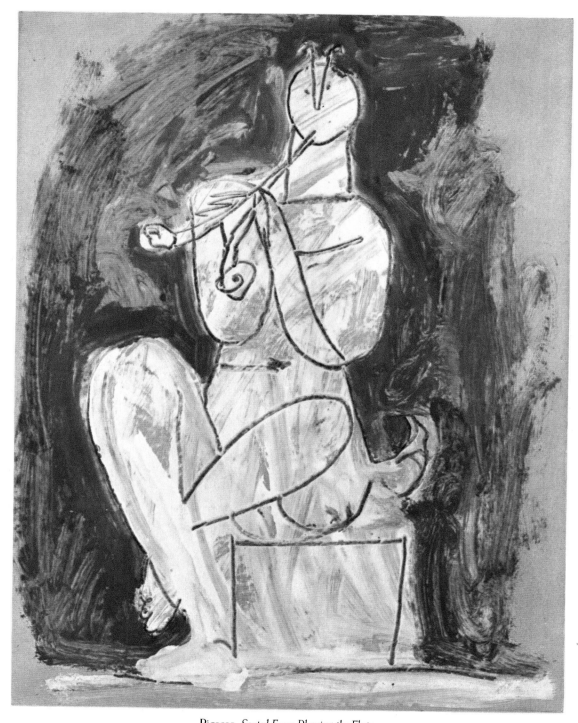

Picasso. *Seated Faun Playing the Flute*

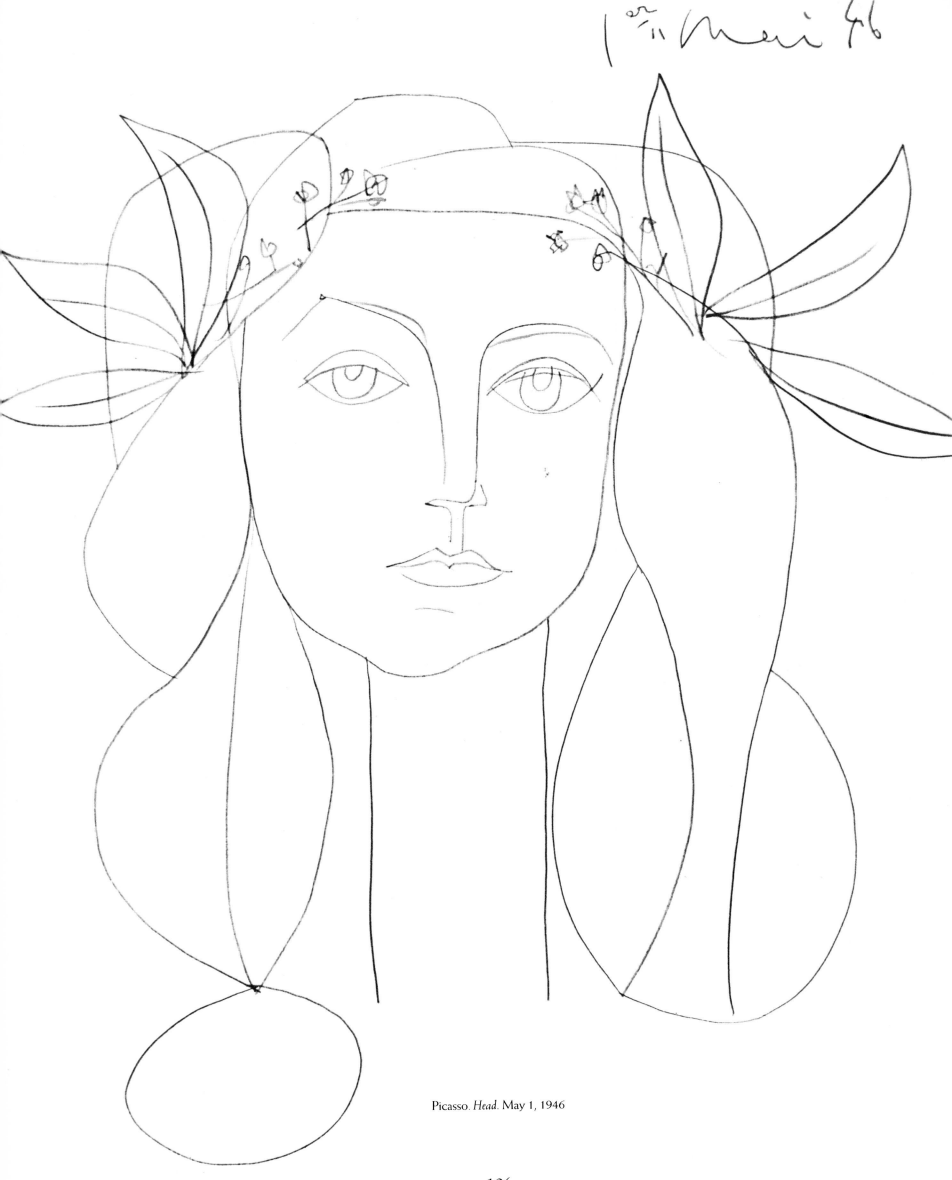

Picasso. *Head.* May 1, 1946

Picasso. Manuscript (*Excerpt*)

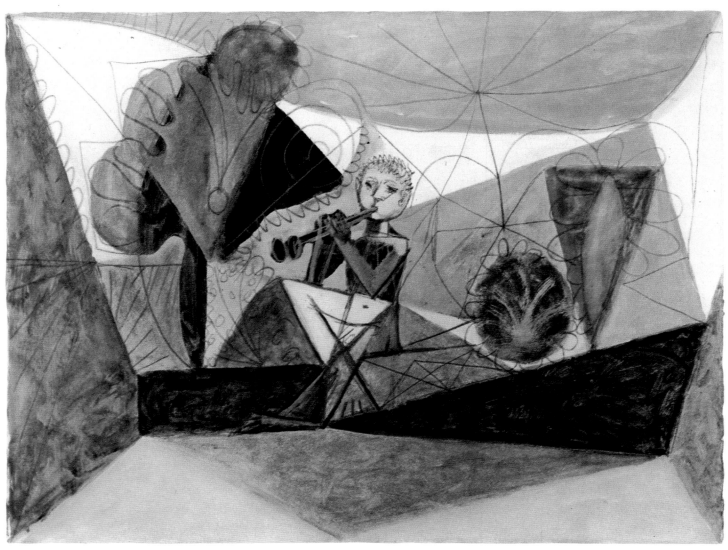

Picasso. *Child Playing the Flute*

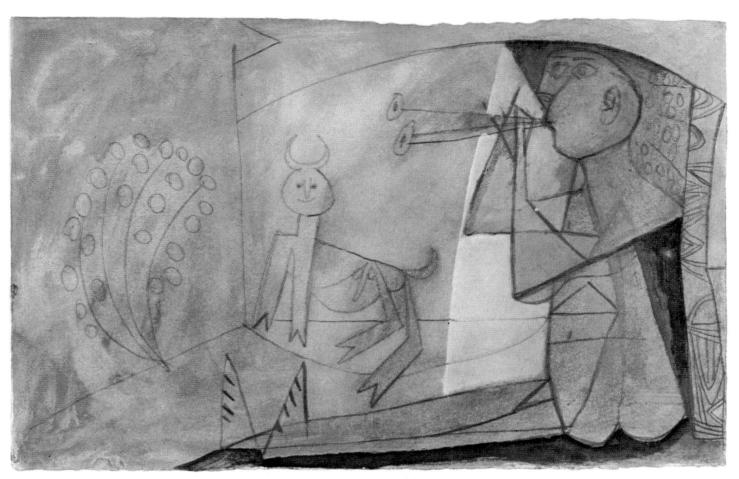

Picasso. *Seated Figure and Centaur*

Pages 190 and 191:
Picasso.
Satyr, Faun, and Centaur with a Trident.
Triptych. 1946.
Oil and charcoal on three panels, 248.5 x 360 cm.
Musée Picasso, Antibes. Photograph by Bérard

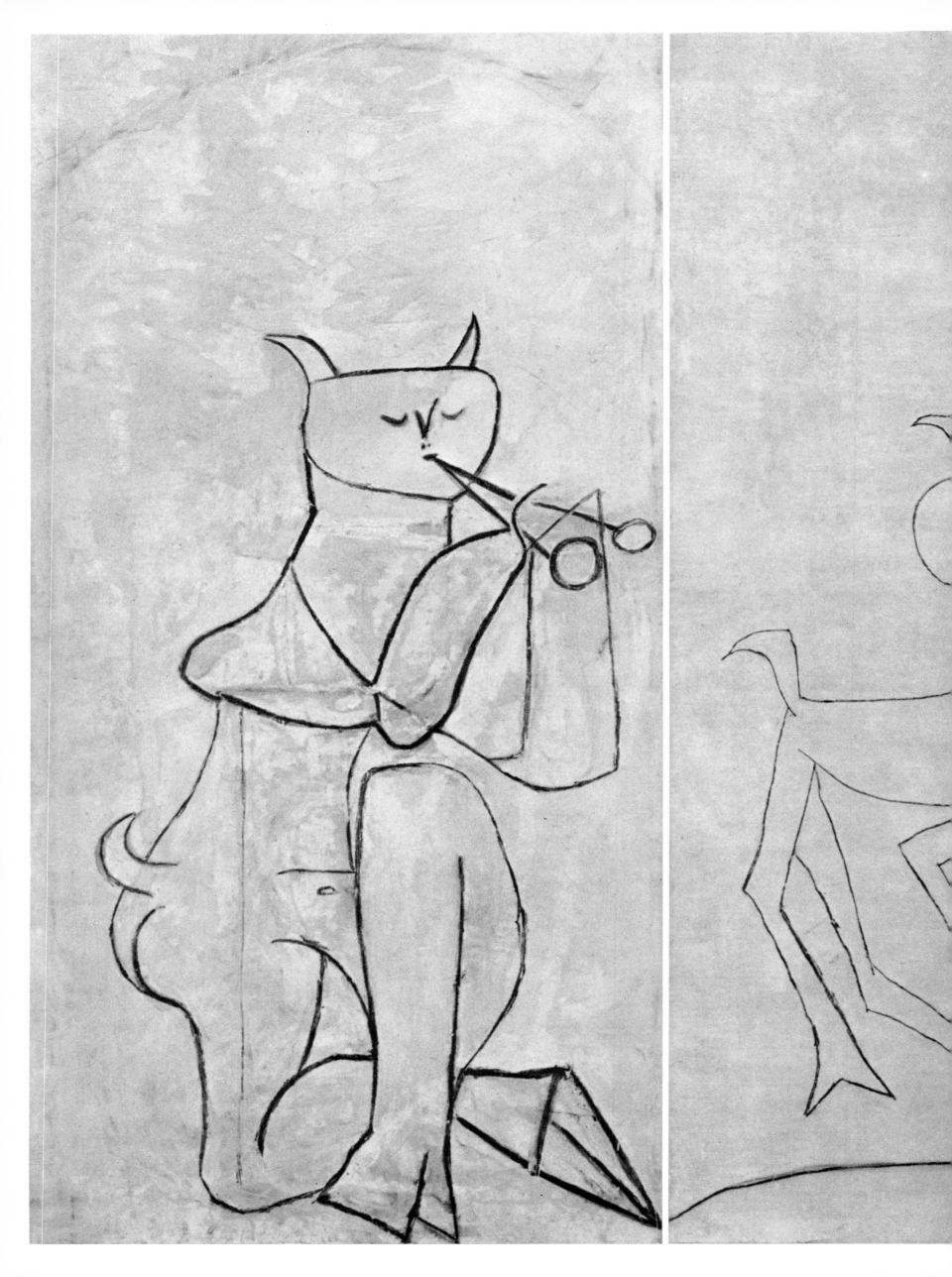

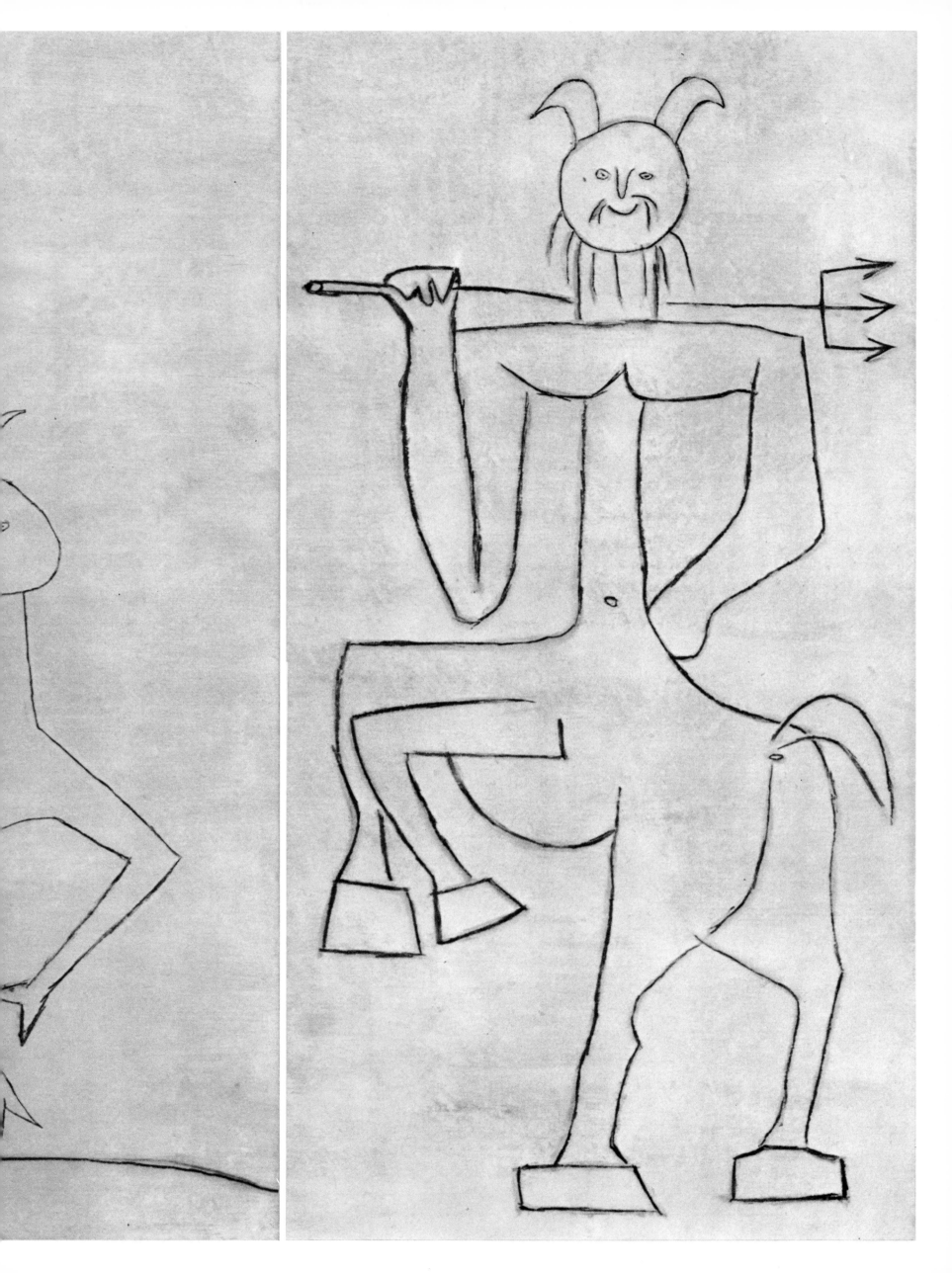

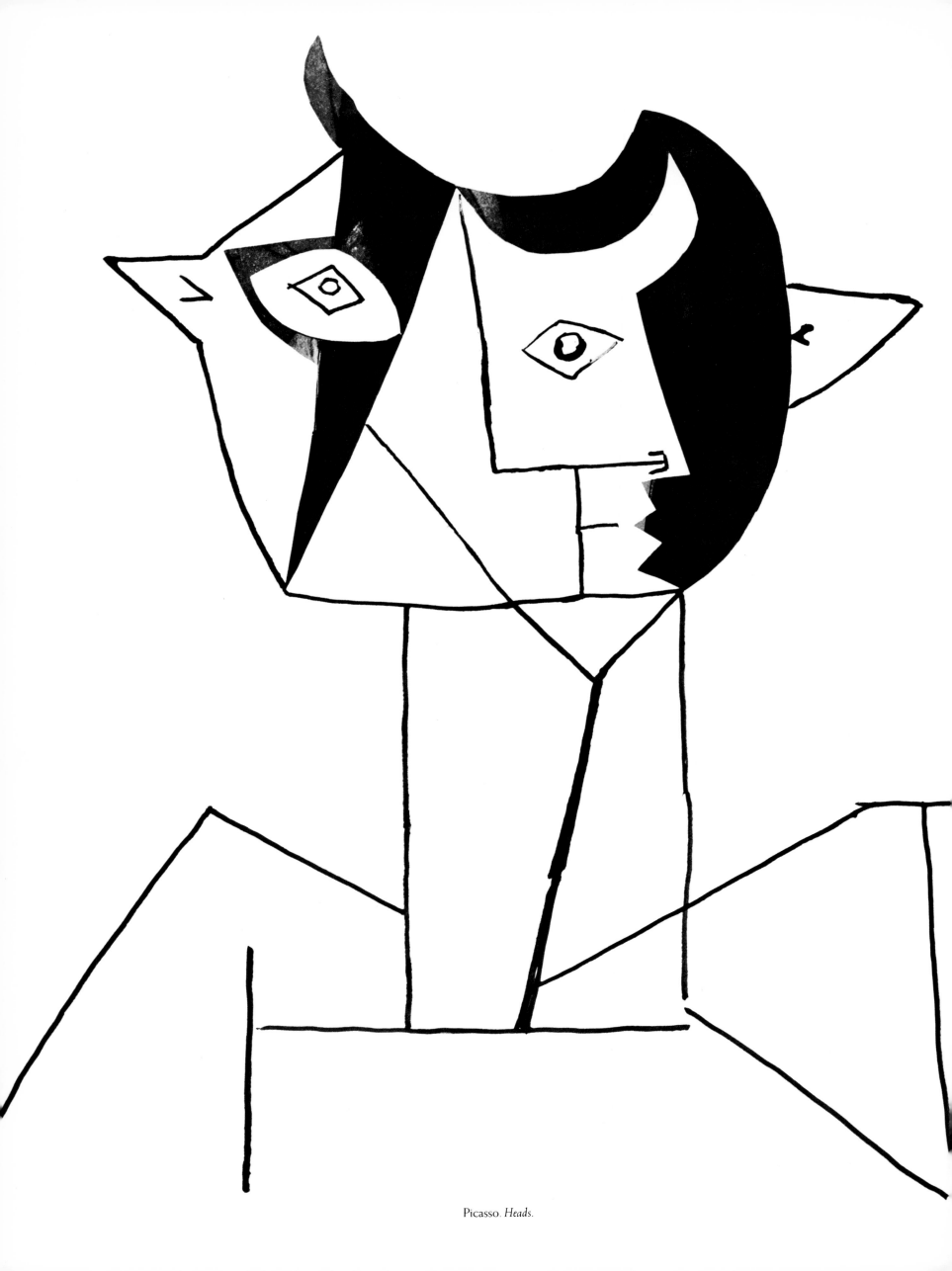

Picasso. *Heads.*

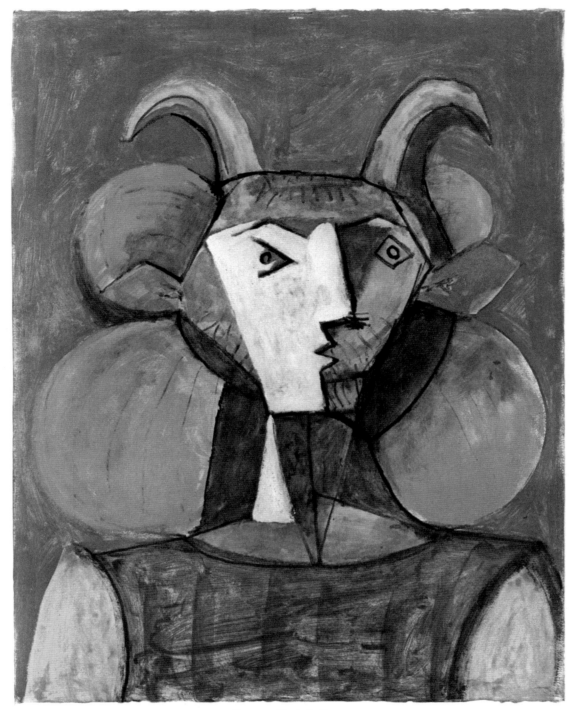

Picasso, *Head of a Faun*

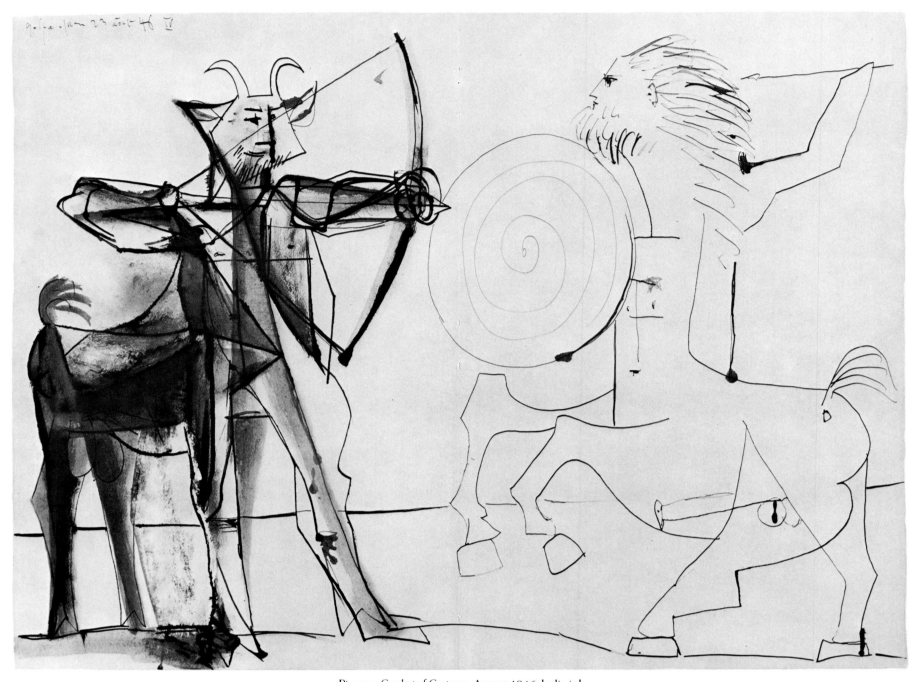

Picasso. *Combat of Centaurs*. August 1946. India ink

OBSERVATIONS BY PICASSO
TO TÉRIADE

(first published in *L'Intransigeant*, June 15, 1932)

How many times, at the very moment when I was about to apply some blue, would I realize that I didn't have any more. So I'd take some red and use that instead of the blue. So much for creative vanity!

When you come right down to it, it's up to you. It's a matter of having a sun with a thousand rays in your belly. The rest is nothing. It's only because of this, for example, that Matisse is Matisse. It's because he carries the sun in his belly. That's why something can be accomplished from time to time.

The work that one does is a way of keeping a journal.

During an exhibition, when a painter sees some of his pictures return from afar, they seem to him like prodigal children, only now dressed in raiments of gold.

Painters beget pictures the way princes beget children—with shepherdesses. It's never the Parthenon or a Louis XV armchair that one paints. Instead it's a shack in the Midi, or a pack of tobacco, or an old chair.

In the final analysis, there is nothing but love. No matter what kind. They should put out painters' eyes—the way they blind goldfinches to make them sing more beautifully.

One of the ugliest things in art is the "I-Beg-to-Remain-Sir-Yours-Very-Truly"—that obedience to public taste that has always spoiled even the best of pictures.

A friend writing a book on my sculpture began it like this: "Picasso told me one day that a straight line is the shortest distance between two points." Needless to say, I was very surprised and asked him, "Are you sure *I* was the one who discovered that?"

If you begin with a portrait and pare more and more in your search for pure form, for clean, basic volume, you'll inevitably end up with an egg [shape]. Likewise, if you start out with an egg [shape] and follow the same path in the opposite direction, you may end up with a portrait. But art, I think, escapes this over-simplified process of going from one extreme to the other. One must learn to stop in time.

Everything of interest in art happens at the very start. Once you're past the beginning, you're already at the end.

I don't work "after" nature, but before nature, and with her.

The other day I stopped in at the retrospective at the Salon. I noticed something. A good painting among bad ones becomes a bad painting. And a bad painting among good ones ends up becoming good.

Someone asked me how I was going to arrange my exhibition. "Badly," I replied. Because an exhibition, like a painting, whether "arranged" well or badly, comes down to the same thing. What counts is logical consistency in one's thinking. And when that consistency is there, then, even as in the most incompatible households, everything turns out all right.

Nothing can be accomplished without solitude. I have created a kind of solitude for myself that no one would suspect. It's very difficult to be alone nowadays because we have watches. Have you ever seen a saint wearing a watch? I've looked high and low and have never found a single one, not even among those who are supposed to be the patron saints of clockmakers.

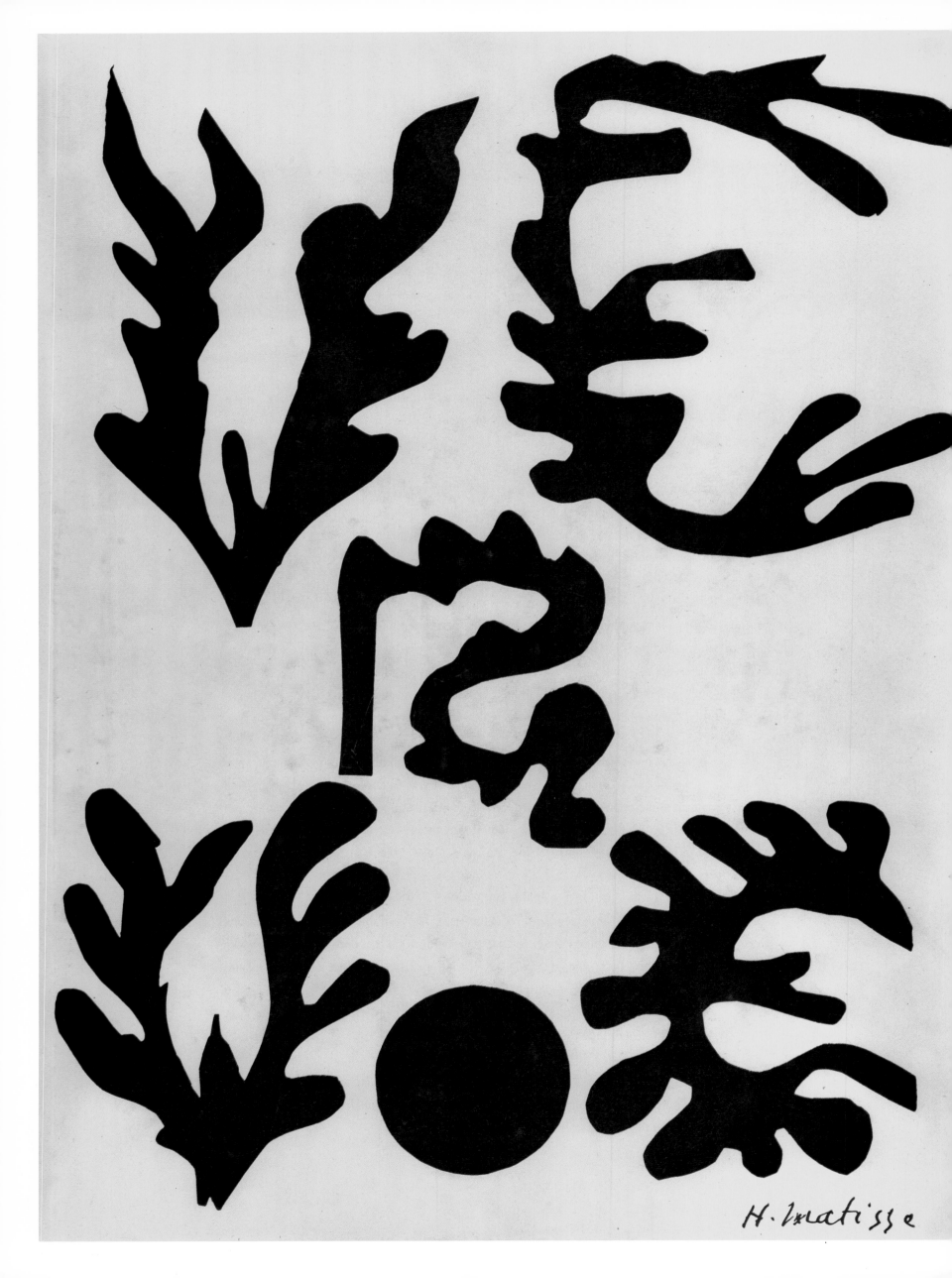

VERVE
Numbers 21/22 Fall 1948

Vence, 1944–1948: Henri Matisse

The success of "*De la Couleur*" (*Verve* No. 13, Summer 1945) and Matisse's steady outpouring of work during the postwar years prompted Tériade to devote another issue of his magazine to this painter's recent work.

Originally, Matisse had fled Cimiez to escape the German bombings. However, after the war, he extended his stay in Vence. There, he had a garden, a house, the proximity of friends, all of which suited him perfectly. As the title of this issue suggests ("Vence, 1944–1948"), this was a special period for him and one which he wished to have remembered.

The project got under way while Tériade was spending Christmas of 1947 at Saint-Jean-Cap-Ferrat. The paintings strewn about Matisse's studio and house were important enough (and there were enough of them) to fill an issue of *Verve*. Apparently, Matisse was quite willing to round out reproductions of this work with line drawings he would do in his garden and in the garden of Tériade's Villa Natacha. Pomegranates, acanthus leaves, oranges and orange-tree leaves, ivy leaves cast on white pages, provide this issue with a rhythmic "breathing" and act as interstitial tissue between the paintings. These line drawings, done quickly without corrections, were repetitions of a single motif. Matisse drew them while sitting in his wheelchair; often the work was physically taxing. Today they strike us as spiritual exercises, an ascesis of the eyes. Even then they were precursors of the designs for the glazed ceramic tiles in the Chapel of the Rosary in Vence and in Tériade's dining room in the Villa Natacha.

As the year drew to a close, Matisse wrote Tériade a letter to tell him how glad he was to be back in Vence after spending some time in Paris. "It's a good thing I returned to Vence. Just this morning I heard on the radio that it's two degrees [C] in Paris. Since I got back two weeks ago, I've enjoyed some heavenly days here. Long live the South of France and [Villa] Natacha!"

Matisse's cover for *Verve* Nos. 21/22, an original lithograph, fairly bursts with this delight in the sun and Mediterranean light. A blinding yellow background sets off some of those half-plant, half-shell cut-outs of which the artist was so fond. (Reminiscences of Tahiti?) This "hymn to the sun" spills over onto the back cover, where its rays overwhelm the entire surface, and is extended to include the frontispiece (a lithograph that features a solar eclipse).

There is no text in this issue, aside from some prefatory lines handwritten by Matisse. ("These paintings were done in Vence between 1944 and 1948. I did the decorative drawings in the garden.") The absence of any literary contribution is striking: this is the only issue of *Verve* that does not include a poem, article, or some other form of original writing. The reason for this omission is an interesting one.

The text originally intended for this "Matisse issue" was to have come from none other than André Breton! That may seem surprising, since Matisse is not usually associated with Surrealism. Was it Tériade's idea? Not very likely, considering his stormy relationship with the Surrealists when he had been in charge of *Minotaure*. During that period, Tériade had consistently sided with Bataille, Michaux, and Reverdy, since—even while acknowledging the contribution the Surrealist legacy had made to literature—he felt that Surrealism had had a detrimental effect on painting. Above all else, he found Breton's hard-line approach difficult to bear.

According to Pierre Schneider, here is how the whole thing started. "Shortly after the end of the Second World War, André Breton paid a visit to Matisse. They discussed the idea of the poet writing a study of the painter."[1] However, "the project fell through, since Matisse refused to be classified as a Surrealist." But there is more to it than that. It seems that Tériade dragged his feet, reluctant to ask Breton for the article that he, Breton, had promised Matisse. Letters from Matisse to Tériade bear this out—for example, this one dated March 10, 1948:

"Breton readily agrees to write an article on me for the next issue of *Verve*, that is, the one due out next autumn. It's understood that he won't be polemical. He'd like to know how long it's supposed to be. I told him that you're the publisher, the decision rests with you, and that you're asking him through me and that you'll write to him about it. That's that!"

On May 9, Matisse wrote Tériade another letter in which he begins by relating the emotions stirred in him by the meridional spring: "The cherries are being harvested now, among the flowers—irises and roses." In a second part of the letter he returns to the matter of Breton.

"Have you seen or written to Breton? I didn't remind you during your last visit. I didn't think it was necessary. It would be well to do it as soon as possible; you told me you would when you where here. There's nothing to be gained by putting it off any longer. Put yourself in his place. His address is 42 Rue Fontaine. Perhaps it's already been taken care of?"

Tériade did not say no to Matisse flat out—that was not his way. Above all, he did not want to jeopardize this issue of *Verve*. He knew that Matisse was keen on having the Breton article, but he may have felt that the "Pope of Surrealism" was interested in Matisse for the wrong reasons—literary, even parapsychological reasons.[2] On a deeper, more personal level, Tériade probably did not wish to have any further dealings with Breton. As far as he was concerned, his association with the Surrealists had come to an end with his resignation from *Minotaure*. There was no reason for him to relive those days. Close friends of his, poets and writers, had felt the sting of Breton's sectarianism, and to solicit material from Breton may have seemed tantamount to a betrayal. Finally, Tériade had an exalted opinion of *Verve* (and rightly so). He had what could almost be called an "ideal" concept of it, in the classical or Greek sense, but in the Hegelian sense, too: *Verve* had a historic mission to fulfill, and, in his view, Breton would have been out of place in its pantheon.

It may be difficult for us to appreciate how strongly he felt about this, but fanaticism breeds fanaticism. However, turning down Breton's text would have put Tériade on a collision course with Matisse. To avoid a direct confrontation, he "neglected" to ask Breton for the article; it was an "oversight." He came up with alternative proposals for text material, but the artist rejected them in midsummer of 1948.

"Don't count on my text for *Verve*," Matisse wrote to Tériade on August 21. "I am quite put out that after all I've done I couldn't come up with a text that meets with your approval. As for putting quotations from famous writers alongside reproductions of my work—they sound like platitudes, even Goethe's. While the texts themselves may not be known word for word, what they have to say is commonplace, and putting them where you suggest would make people with any intelligence ridicule us. You must find yourself in an awkward position, but then again, why have you been so obviously negligent in not asking Breton for the text that you yourself had me solicit on your behalf? Every time I spoke with him about it, Breton insisted that you make your request properly, that is, without any go-between. In light of your failure to do so, and since you used me as a mediator to explain away implausible delays, you've succeeded in turning him against me, thanks to your rudeness. Rest assured, my dear

Monsieur Tériade, that I am most displeased about this matter, responsibility for which lies wholly with you."

Real friendships, however, can be strengthened by clashes and confrontations. After all, the production of *Jazz* had also occasioned its share of sharp exchanges and stinging telegrams. But Matisse was basically sincere and straightforward. In the end, he was able to acknowledge Tériade's success with the "Matisse issue" in a letter dated November 14, 1948.

"Yesterday I received two copies of the *Verve*-Matisse. It's all right! Word has reached me that Bérès displayed it in his window and that it looked very nice. I'm not surprised. Red-white-black—well-proportioned, or well enough.

"I'm sorry that the red in the large interior did not come out better. Surely you know which one I mean, because when you showed it to me you said, 'It'll be better.' Well, it isn't.

"Anyway, let's wish it every success. Everyone did his best. As we all know, reproductions can only be approximations."

Four days later, when the success of *Verve* Nos. 21/22 had become even more apparent, Matisse wrote Tériade a long letter.

"Dear Recluse of Rue Férou,

"Take a look at the November 15 issue of *Combat*.[3] A Mr. Charles Etienne, whom I do not know, talks about our recent *Verve* and hails it as 'an event, for it gives us our first look at the paintings Matisse did in Vence, and in flawless color reproductions.'

"Obviously that's what all of us were hoping for. So let's all be happy and satisfied."

Matisse had shown himself to be a good sport. The rest of the letter deals with *Poèmes de Charles d'Orléans*, a book of lithographs that Tériade would publish sometime later.

For Matisse, this dazzling series of interiors was a form of deliverance. The serious operation he had undergone in Lyons during the winter of 1940–41 had left him feeling as though he had risen from the dead and entered into a "second life." In 1942 he had written to Louis Aragon: "I have at last seriously come to grips with painting."[4]

Six years later he wrote to André Rouveyre: "I'm full of curiosity, as when one visits a new country. For I've never before advanced this far in the expression of colors. Up to now I've been merely tarrying at the temple gates."[5]

1. Pierre Schneider, *Matisse*.

2. "His reaction is understandable. But so too is Breton's attitude. In the strangeness of certain forms that emerged from Matisse's brush, and still more in 'the fury that sent him rushing blindly to the empty canvas, as if he had never painted before' (as Mallarmé had said about Manet), Breton recognized the fierce, cruel, baffling presence of an unknown force. A 'force,' as Matisse was to say in 1952, 'which I see today as something alien to my life as a normal man,' and which possessed him, transforming him into a medium." (Schneider, *op. cit.*, p. 217)

3. *Combat*, a national daily headed by Albert Camus when France was liberated, exerted a strong influence on artists and the intelligentsia.

4. Louis Aragon, *Henri Matisse, roman*, Gallimard, Paris, 1971.

5. Schneider, *op. cit.*

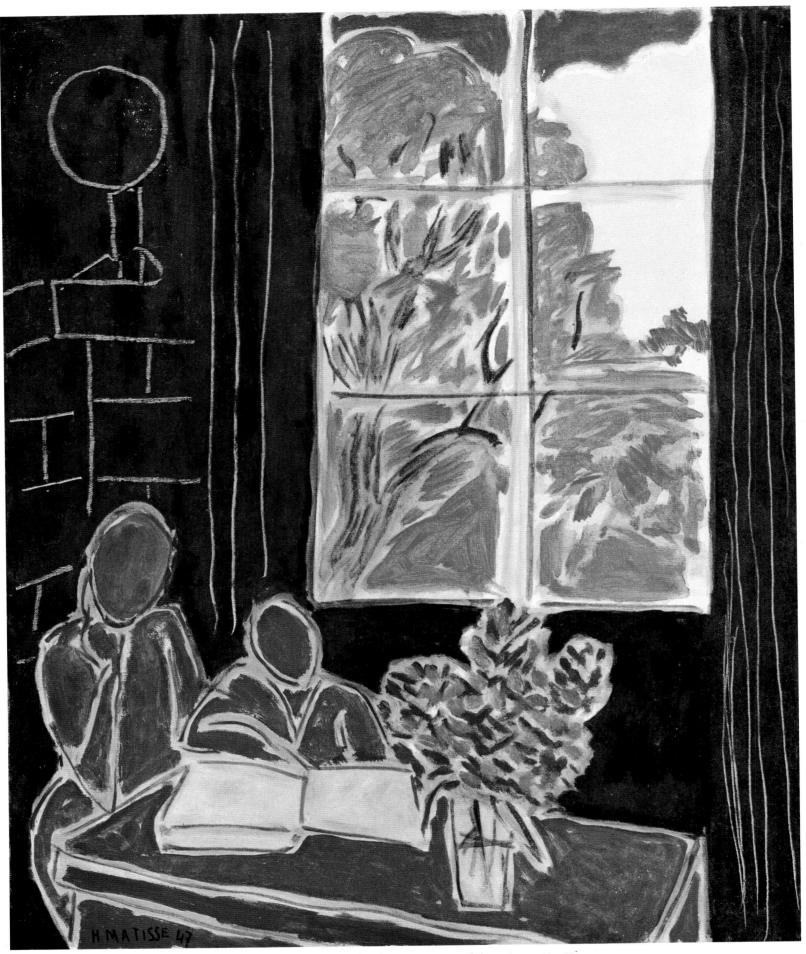

Henri Matisse. *Le Silence Habité des Maisons*. 1947. Oil on canvas, 61 x 50 cm.

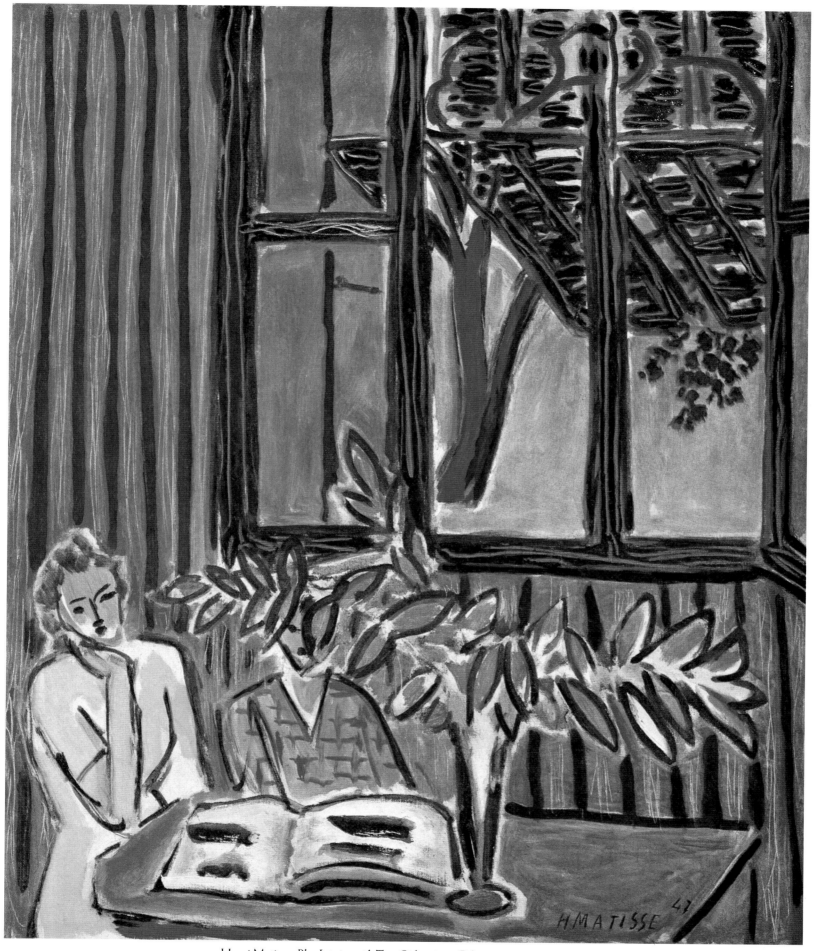

Henri Matisse. *Blue Interior with Two Girls*. 1947. Oil on canvas, 65 x 54 cm.

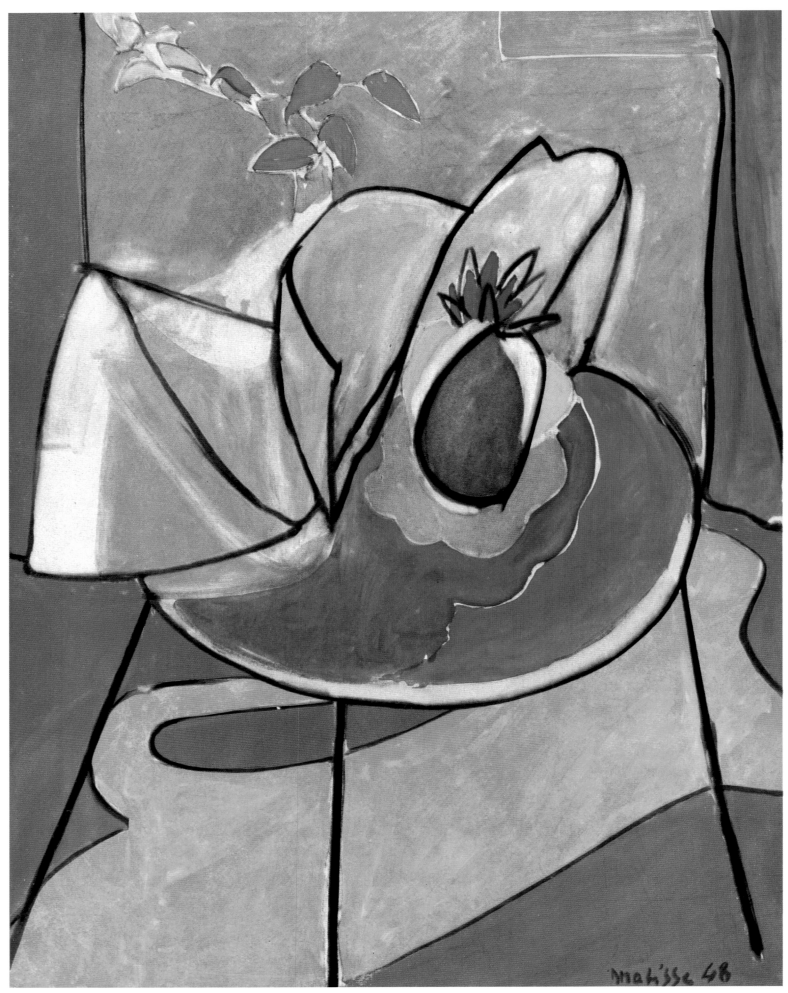

Henri Matisse. *The Pineapple.* 1948. Oil on canvas, 116 x 89 cm.

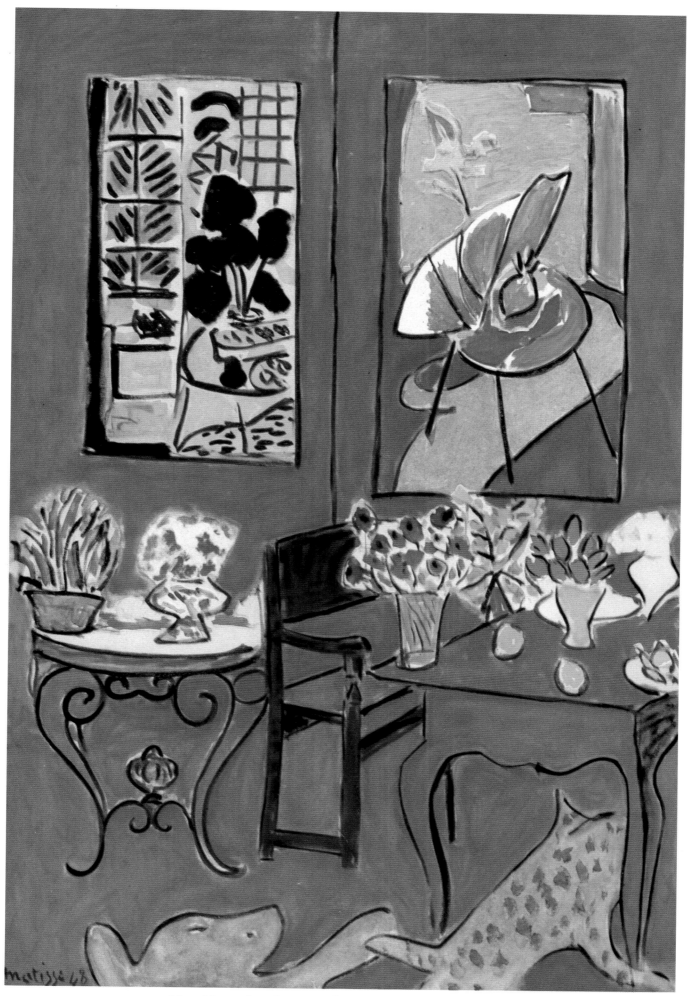

Henri Matisse. *Large Interior in Red.* 1948. Oil on canvas, 146 x 97 cm.
Musée National d'Art Moderne, Centre Georges Pompidou, Paris

Left and above: Henri Matisse. *Ornaments*

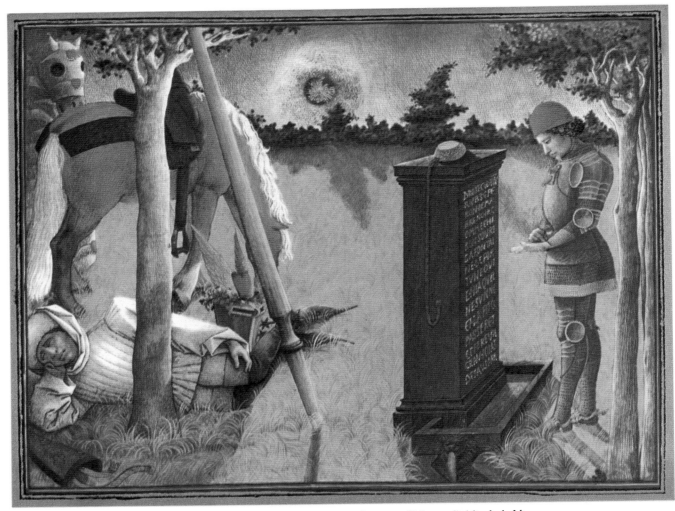

Le Livre du Coeur d'Amour Epris. "The Spring of Fortune." Nationalbibliothek, Vienna

VERVE

Number 23 April 1949

Le Livre du Coeur d'Amour Epris

"One night last month, King René, weary, preoccupied with thoughts of love, retired to his bedchamber. Half-asleep, half-awake, he beheld Amour, God of Love, taking his heart from his breast and giving it to Ardent Desire, a handsome young man garbed in white."

So begins the simplified, modernized version of "The Legend of the Love-Stricken Heart." It was probably written by René d'Anjou, a patron of the arts and distinguished bibliophile who commissioned some of the most exquisite manuscripts of his day.

The pride of Vienna's Nationalbibliothek, this manuscript was exhibited in the Petit Palais in Paris as part of a 1947 show called "Treasures from Viennese Museums." It was there that photographs were taken of paintings from the oldest known copy of the *Livre du Coeur d'Amour Epris*, composed in 1457 by René, Duke of Anjou, Count of Provence, King of Naples, and which he dedicated to his nephew, Jean, Duke of Bourbon. It then belonged to Catherine of Lorraine, Duchess of Bourbon, the sister of Henri IV, then to Eugène, Duke of Savoy, whose books were placed in the Austrian Imperial Library in Vienna in 1738.

"As monumental as frescoes, as autonomous as easel paintings," to quote from André Chamson's preface, these sixteen miniatures are suffused with an uncanny, dreamlike mood considered unprecedented for that period. Resorting to the convention of a dream or figment of the imagination ("half-asleep, half-awake"), the painter bids us enter a world that has shed religious or even moral significance.

These paintings, Chamson tells us, have a mysterious power to fascinate. But what do they actually depict? Nothing more than a bedchamber at night illuminated by lamplight, a meadow at the edge of a forest at daybreak, the chapel of a hermitage down in the woods at high noon, a lone tree beneath a pitch-black sky studded with stars but growing overcast with storm clouds, a secluded hut, streams, knolls, roads winding around hillsides and down to the sea where a ship is setting sail for islands under the starry night sky. Scenes of every kind, depicted at various times of day and night. As Chamson points out, there is something "majestic" about them—the majesty of time and space, of changing light and shifting perspective.

Perhaps what makes these late fifteenth-century miniatures so beautiful and enigmatic is that they contain all the elements that would position Western painting (and French painting in particular) upon its triumphant path from the Renaissance to modern times. But it was to be a gradual process—it would take another century and a half before landscapes would begin to look like something other than stage sets.

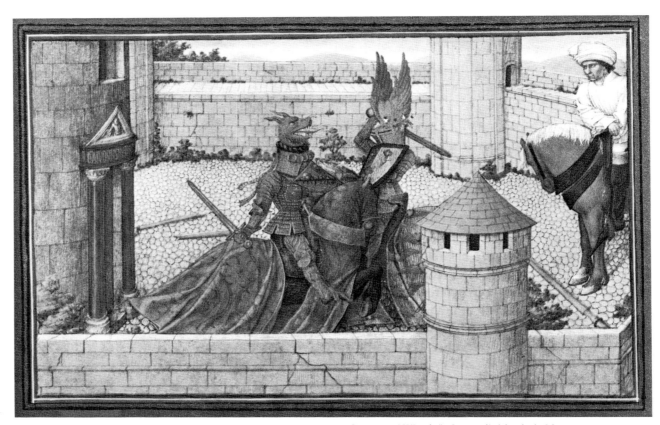

Le Livre du Coeur d'Amour Epris. "The Combat between Coeur and Wrath." Nationalbibliothek, Vienna

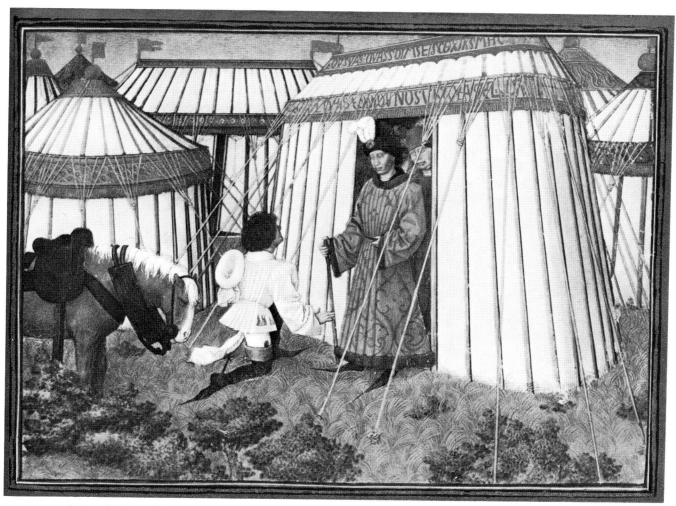

Le Livre du Coeur d'Amour Epris. "Ardent Desire implores Honor to rescue Coeur." Nationalbibliothek, Vienna

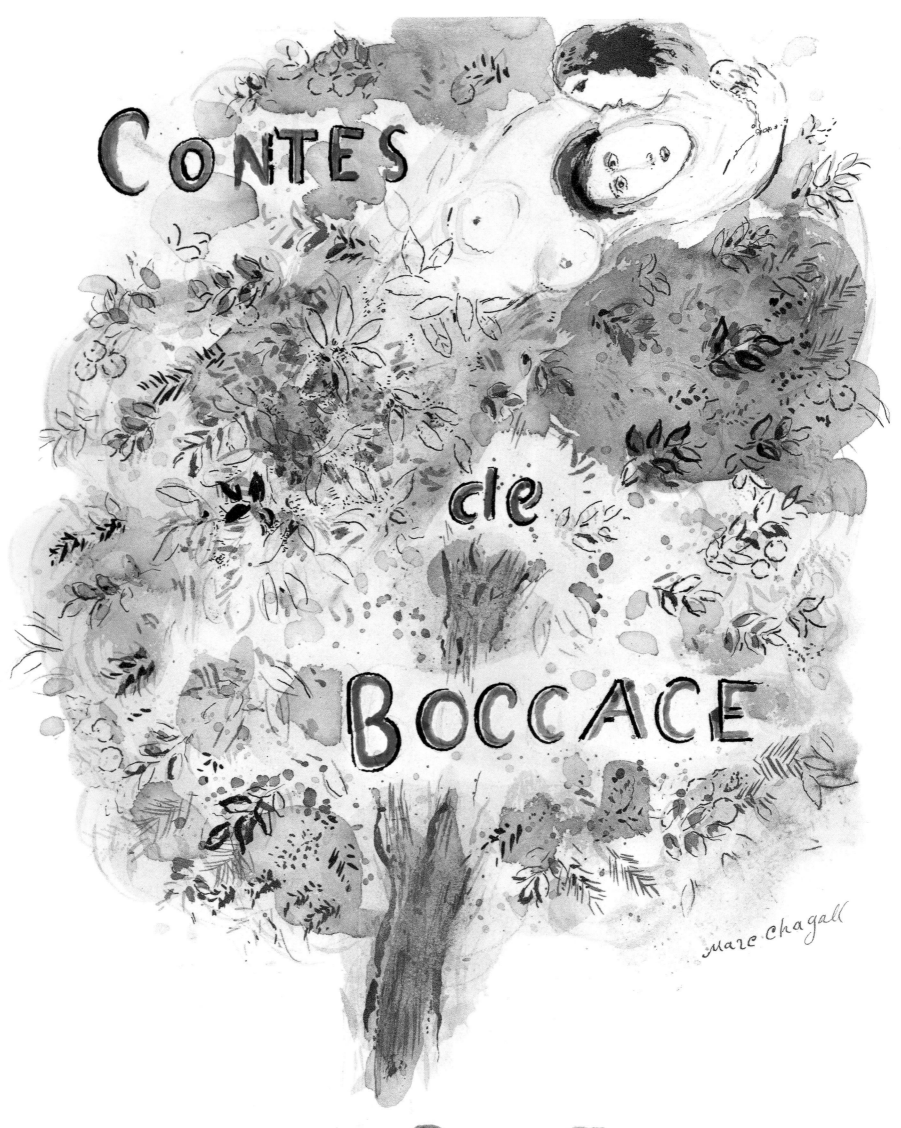

VERVE
Number 24 April 1950

Boccaccio's *Decameron*, illustrated by Marc Chagall

This issue of *Verve*, with illustrations by Marc Chagall, is less well known than the two issues on the *Bible* that were published several years later. However, *Verve* No. 24, created by Tériade in close collaboration with the artist, has a particular quality and richness that commands our attention.

It was nothing new for *Verve* to juxtapose medieval miniatures and artwork by prominent contemporary painters. In this issue, the miniatures were drawn from the so-called Duke of Burgundy version of Boccaccio's *Decameron*. In a preface, Frantz Calot, then curator of the Bibliothèque de l'Arsenal, describes this manuscript: "[It] includes a hundred full-page illuminations, one for each of the hundred tales in Boccaccio's collection. They offer us a quasi-literal, straightforward, faithful interpretation, though at a lower pitch, at a less frenzied pace, in a more restrained, better behaved, almost chaste mood. Yet, they are not untrue to the author's intentions, nor do they conceal anything that might 'appropriately' be depicted in this dumb show of a human comedy in which love figures so prominently and expresses itself so broadly and lustily."

The polychrome paintings from the manuscript are magnificently reproduced using color photogravure. However, despite the extraordinary quality of the illuminated miniatures, it is Chagall's contributions that capture our attention: against these richly-colored little paintings, he juxtaposes black-and-white ink washes.

He illustrates the text without adhering strictly to the interpretations of the medieval illuminator. He turns back to Boccaccio, remaining faithful to the plot and spirit of each tale, while giving all of them a personal interpretation.

According to Franz Meyer,[1] the wash drawings "are quite unrelated to anything he had done before. Using every possible shade of black, from an agate-like sheen to the palest shade of gray, he produced plates that have an extremely colorful intensity. Working chiefly with a brush, but also with a pen, he drew and painted, he let the ink run and evaporate, he scraped, he daubed."

In the fall of 1948, when Tériade first discovered these washes in Chagall's studio (the still lifes with fruit and flowers in particular), he suggested juxtaposing the miniatures from the Boccaccio manuscript with Chagall's startling drawings that suggest colors by means of gradations of light. Two worlds that might have seemed poles apart were united by Tériade's passion for them both.

This issue of *Verve* opens with a lengthy original poem by Jacques Prévert.

1. Franz Meyer, *Marc Chagall*, trans. Robert Allen, Thames and Hudson, London, 1964.

Boccaccio's *Decameron*. "The Scholar's Revenge." Bibliothèque de l'Arsenal, Paris

THE SCHOLAR'S REVENGE

Rinieri, a nobleman just returned from studying in Paris, resolved to do everything he could to win the favors of Elena, a fair Florentine widow who, rather than remarry, had taken a handsome young man as her lover. Elena noticed the scholar's budding passion and led him on. When her lover became jealous, she decided to show him how little Rinieri really meant to her and asked the scholar to meet her in the courtyard of her house on Christmas Eve. Rinieri stood there waiting in the snow until daybreak, numbed to the bone, while Elena whiled away the night with her lover. Soon afterward, however, Elena's lover left her for another woman. It occurred to her that a man like Rinieri should know some magic way to help her regain the love of her paramour. Only too happy to take his revenge, the scholar instructed her to climb naked to the top of a tower on a midsummer's night and recite a magic formula. This she did, but then Rinieri locked her up in the tower and forced her to stay there the next day in the scorching sun and among stinging flies. Elena learned her lesson. She gave no more thought to her lover, never fell in love again, and refrained from playing tricks—especially on scholars.

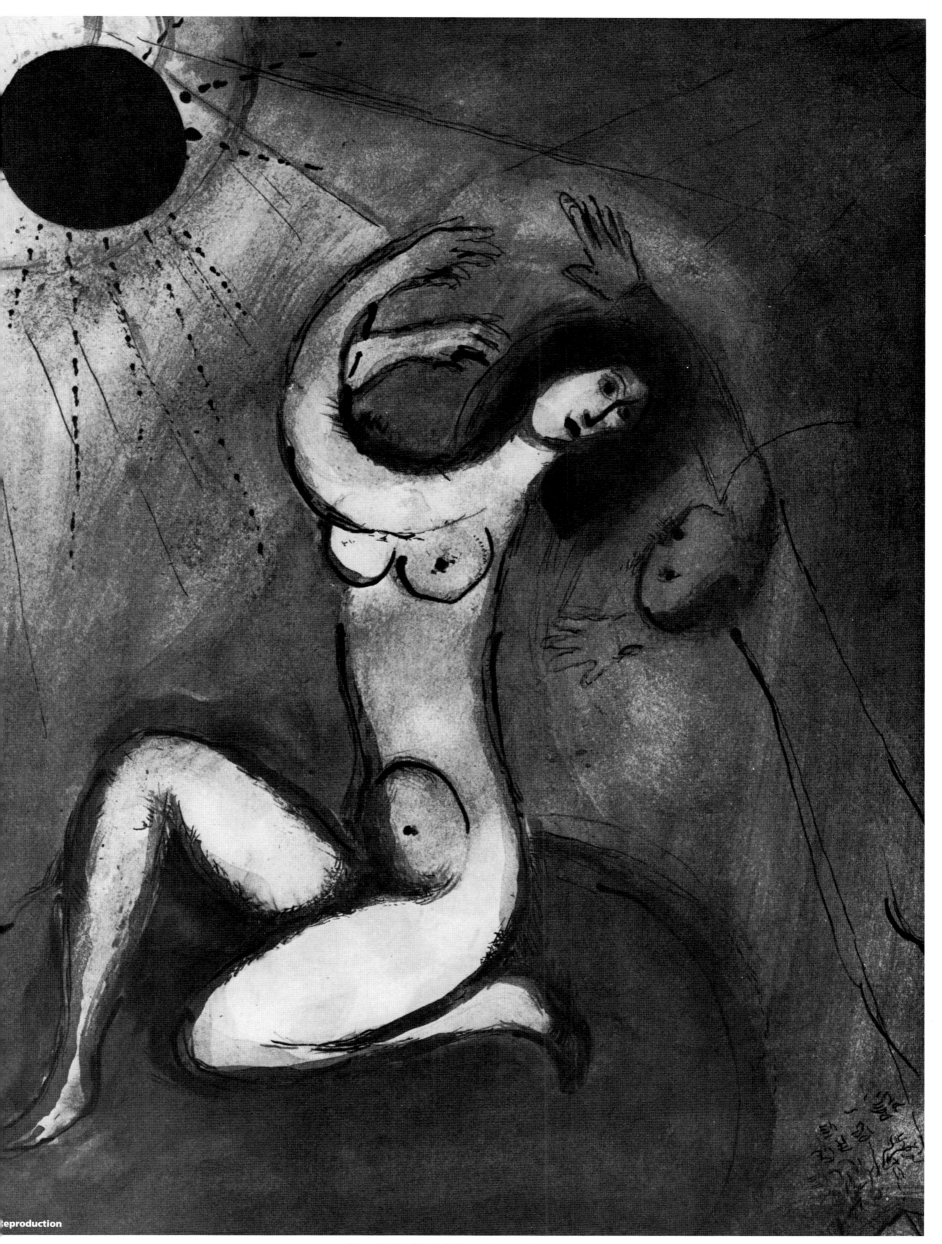

Chagall. *The Scholar's Revenge* (reproduction)

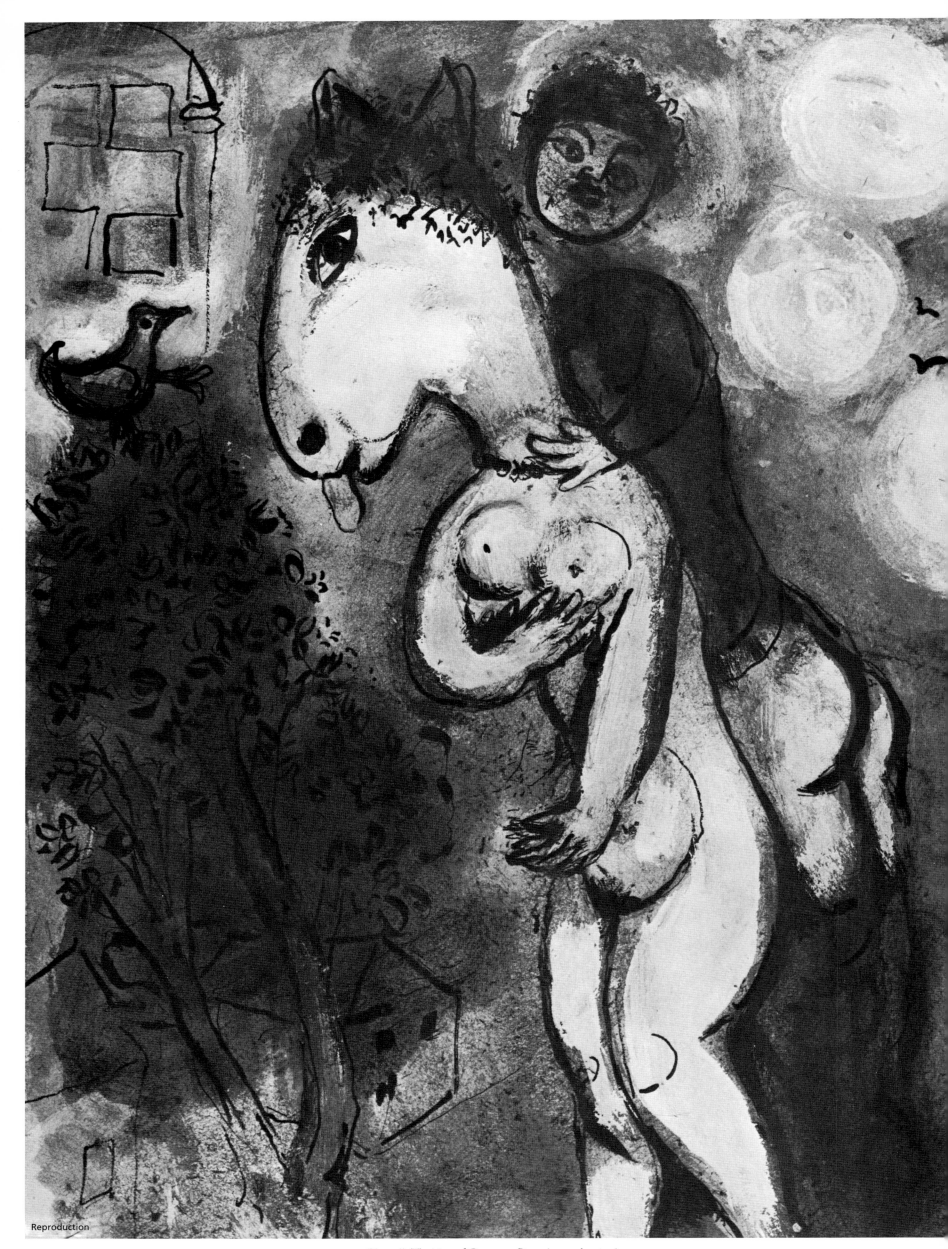

Chagall. *The Mare of Compare Pietro* (reproduction)

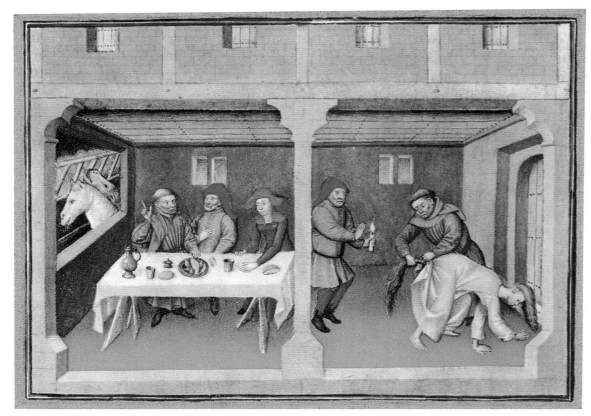

Boccaccio's *Decameron*. "The Mare of *Compare* Pietro." Bibliothèque de l'Arsenal, Paris

THE MARE OF *COMPARE* PIETRO

To supplement his income, a priest carried goods around on his mare, buying and selling at the fairs in Apulia. In the course of his travels, he met up with a certain Pietro who plied the same trade, but using a donkey. From time to time, *Compare* Pietro entertained the priest, who had to bed down on straw in the stable alongside his mare. One day, the priest told Pietro's wife Gemmata that he could transform his mare into a fair young maiden. Gemmata told her husband about this wondrous power, adding that if the priest were willing to transform her, Gemmata, into a mare, they could make twice as much money. The priest agreed to teach Pietro his secret. He gave Pietro a candle to hold and made him promise not to budge or make a sound while the transformation was taking place. But when he tried to place the tail, Pietro did not find this part to his liking and started to shout and tug at the priest's cassock. The priest accused him of ruining the spell. Gemmata, who had begun to enjoy the proceedings, scolded her husband for spoiling things for both of them.

VERVE
Numbers 25/26 Fall 1951

Picasso at Vallauris, 1949–1951

There is something emblematic in Picasso's wonderful title page for this issue of *Verve*. With the unself-consciousness and mastery that are the hallmarks of genius, the artist illuminates the page with brightly colored letters and numbers that seem to flow into one another like the colors of a rainbow. To offset what might otherwise seem like an overly gaudy effect, Picasso brings things down to earth by leaving ink smudges—telltale signs that this is actually the first page of a sketchbook. What we are about to see is not a discrete, self-contained period in an artist's career, but a "moment" in an ongoing oeuvre (although it is true that the two years Picasso spent at Vallauris were extraordinarily productive).

All too often, people associate Picasso's Vallauris period with ceramics. It is true that after Picasso came to work at the Ramiés he produced many important pieces in this medium and inspired other great artists of the day to follow suit. However, that does not mean that he stopped painting, sculpting, or drawing. Indeed, Tériade's objective was to provide a record of Picasso's supremely uninhibited creativity in all its facets. And if there is one thing *Verve* Nos. 25/26 proves, it is that different techniques or mediums could not obscure the artist's underlying consistency. He toyed with them the way a virtuoso tries out new instruments. Everything is grist for the mill of genius, be it a telephone line (as in the first painting appearing in this issue) or the curved clay bricks (*gazelles*) potters use as supports in kilns during firing. It is as if Picasso felt that there was no real dividing line between "fine" and "applied" arts or between "lofty" or "lowly" subjects, and that such divisions deserved to be exposed for the specious categories they really are.

In a long introduction entitled "Le Sujet Chez Picasso," Daniel-Henri Kahnweiler tells of a conversation he once had with the artist. "It was November 9, 1944. He was talking about a series of little landscapes of the Cité he'd painted the year before and which delighted some people who visited him in his studio—the very people who were taken aback by his human figures. 'Of course, they are just like my nudes and still lifes,' he said, 'but when people look at my figures they notice that their noses are crooked; whereas there's nothing shocking about a bridge. But I made the noses crooked on purpose. Make no mistake: I did it so they'd be *forced* to see a nose. Later on, they saw, or would see, that it *wasn't* crooked. The important thing was for them not to go on seeing just *nicely balanced color schemes* or *exquisite colors*.' "

In an insightful account of Picasso's career, Kahnweiler stresses that the artist never went out of his way to be provocative for the sake of provocation: "So-called Cubist painters had to come to grips with two problems at the same time. On the one hand, the problem of composition, that is, of the dichotomy between what the painter experiences and the forms those experiences assume, and on the other, the problem of finding something 'truer' than 'illusionist figuration.' "

Then we come to the famous definition: "It may be said that Cubism's principal concern was to create painting that no longer sought to imitate a *single* aspect of an object, but that instead aims either to convey information about this object from many different viewpoints (Analytical Cubism) or to concentrate everything the artist knows about it into an intellectual totality (Synthetic Cubism). In the

work of Picasso, the least hidebound person on earth, both facets of Cubism appeared in succession, then ended up overlapping."

Kahnweiler was not only Picasso's dealer—and a very important one at that—but also an astute critic of Picasso's work. Here is what he had to say about the paintings from the winter of 1950–51 (reproduced in this issue of *Verve*): "The dreary south of France he saw and loved this past winter at Vallauris was altogether different from the colorful place of the spring and summer months. A series of landscapes bears this out. As he leafed through books, he became enthusiastic about paintings [he saw there]. He 'copied' them. Picasso feels this curious urge to transform things that already exist into something else.... The paintings from 1950–51, more subdued in color [than those from 1949], once again express his affection for human beings, for the outside world. Some say this painter has no feelings; actually, he is soft-hearted." The affection to which Kahnweiler refers comes to the fore in Picasso's portraits of his children: Claude and Paloma, Paloma and Claude, Claude by himself, Paloma by herself, Claude drawing, Françoise Gilot writing while Claude plays with a toy train on the floor and Paloma watches from her highchair, Françoise clasping her children in a maternal embrace, Claude behind the steering wheel of a red car, Françoise wrapped in thought, Claude's ski cap—intimate domestic scenes that Georges Perec has described elsewhere in great detail. A mantle of happiness envelops Picasso's family. The artist looks on, astonished, and this sense of wonder comes through in these paintings. Kahnweiler accurately—and with no intimation of paradox—describes Picasso's attitude as "respect for others."

Another key text in *Verve* Nos. 25/26, "Equivalences Chez Picasso," was written by Odysseus Elytis, probably Tériade's closest and most respected Greek friend (although the publisher despaired of ever being able to translate his poetry). This marks a break in the flow. The first section of the issue consisted of Kahnweiler's article grouped around reproductions of Picasso's paintings, many in color. Suddenly, we switch to monochrome photogravure illustrations of sculpture, pottery, and drawings from the Vallauris period. Elytis describes Picasso's epic struggle with reality: "All of a sudden, Picasso appeared among this crowd of unwilling actors, looking like Alexander the Great except that he held a brush in his right hand instead of a sword. By hacking his way through the real world, he blazes a trail and forges ahead. For he knows that the main thing is to advance. At all costs and by any means, save submission, compromise, or blind obedience.

"Speed is no stumbling block for him. It is a normal state, in which he can freely develop all of his faculties and engage in those famous twists and turns, at the end of which are captured for all time so many undreamt-of aspects of reality.... In this way, Picasso manages to *disconcert*, as it were, the nature of things."

With intriguing photographs of Picasso's studio to back him up, Elytis maintains that the artist's brand of realism is not a "commitment" in the narrow sense of the word. "In spite of what's been said about him time and time again, it may be that Picasso has never been concerned with illustrating the times he lives in.... When one examines his recent sources of inspiration, one is more inclined to feel that Picasso has been trying to counter the vagaries of his contemporaries with something solid, a sort of physical and mental well-being that comes from his passionate quest for truth and which he probably considers the ultimate wisdom acquired during his long career.

"He never looked for Greece; Greece found him.... Standing straight up, his face sunburnt, he presses on, followed by the two archetypes that best represent his message: a pregnant woman and his famous goat."

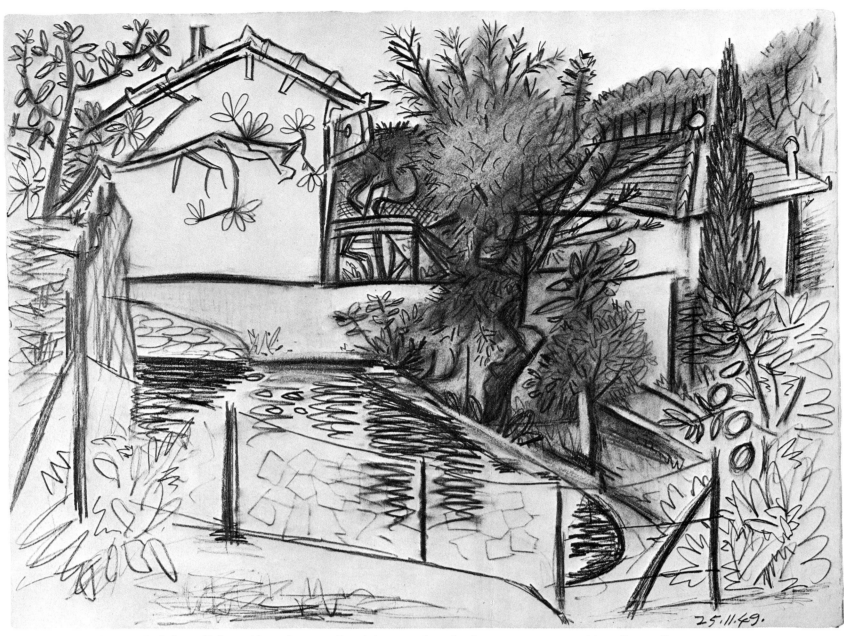

Picasso. *La Galloise à Vallauris.* November 1949. Pencil drawing softened with a stump, 51 x 66 cm. Musée Picasso, Paris

In a lyrical passage, Elytis then describes his visit to Picasso's studio and likens the work he saw there to primitive artifacts from the Aegean islands. "[His is a] poetic instinct, an instinct to build, the kind you see in the humble delight fishermen take in building their boats, or villagers their homes. And that is why the work of this grown-up lad of the masses seems something as *useful* as boats or houses."

The medium Picasso was working with at the time, pottery, is traditionally used for utilitarian objects. That does not mean, however, that he was heading in a purely utilitarian direction. Elytis is talking about utility of a different kind, one that has more to do with the elemental than the serviceable.

It was Georges Ramié and his wife who suggested that Picasso try his hand at pottery, and then put their place in Vallauris at the artist s disposal. In the third and final text of *Verve* Nos. 25/26, Ramié recalls four years of work and almost daily contact with Picasso. There was the time he redid a series of "big vases in pink clay highlighted with white slip and decorated with incised drawings of nude women." Having put them aside for awhile, he then changed his mind and covered the female bodies with clothing. In the interim, however, Tériade had paid Picasso a visit and managed to get hold of two of the vases while they were still *au naturel!*

Picasso. *Portrait of a Woman Leaning on Her Elbow.* August 1950.
Pencil and blue crayon drawing softened with a stump, 66 x 50 cm. Musée Picasso, Paris

Picasso. *Child.* 1951. Oil on canvas, 27 x 22 cm.

CERAMICS

By GEORGES RAMIÉ

*I*t has been four years since Picasso, looking for a few hours' recreation, sat down behind the potter's wheel. A whole world opened up before him, a still unfolding world that intrigues and excites him to this day.

If it were someone else, we could say that this period was dedicated to applying all the knowledge he had accumulated, day by day. But Picasso brings to mind that watchmaker who spent years studying cosmography and chronometry so that he could channel all his knowledge into making a magic watch designed to measure nothing but the movement of his imagination. Once they had recovered from their initial surprise, people soon acknowledged that, when all is said and done, the only true time is that which one organizes oneself, and, since fantasy and reality so often coincide, this unorthodox watch was the only one that could measure time in human terms.

So it is with Picasso. These subtle twists and turns presented under the guise of bold statements, the insistence upon our own constant introspection, the meticulous analysis of a system for no other reason than to take it apart and re-assemble it his own way—that is what the spirit of Picasso is all about.

His recent ceramic works are another manifestation of this spirit. When they were still naked and unadorned, their form or intended use seemed reason enough for them to exist. Since then, they have become supports for so many allusions and so many contrasts that their original design, volume, and meaning have undergone a complete transformation, so as to be reinterpreted in a fresh and exciting way. Something unpredictable has been breathed into them, and now their forms seem to have no other purpose than to make us admire this innovation. Even those who saw them wearing far less cannot imagine a more fitting attire, far removed though it is from the original concept. And those who encounter the works for the first time will not fail to see the thought processes that lead from the unreal to the obvious, and whose boldness captivates us at once and makes them all the more persuasive.

A similar thought process presided over the very material of which they are made. Having familiarized himself with the ceramist's many resources, the vast array of daunting or mysterious techniques, Picasso—like our watchmaker—took advantage of his experience only to put it to a different use. The end result is solely the fruit of his imagination, sustained by the flames of the kiln. Both produce unfathomable reverberations and undreamt-of harmonies; and the flames seem pleased to have been obliged to deal with problems they have never had to face before, and whose solutions entail fresh enigmas. *(Excerpt)*

*T*he story of how [Picasso] designed and made these statuettes is as interesting as the statuettes themselves.

Most of them started out as pieces he had originally thrown as close-necked bottles. As his thumbs pressed against the wet clay, the cylindrical shape of the bottles changed. The air trapped inside gave the clay an added resistance that prevented any buckling and allowed him to return and rework the same detail.

His sole objective had been to evoke a pose, to see how light and shadow affected volume. These pieces were fired in all their original simplicity and so remained.

Quite recently, this state, deemed too rudimentary, was enhanced by painted decoration and several refirings. Pure, spare form joined forces with enchantingly beautiful decoration and brought things to a new and delicate conclusion.

These figurines have a remarkable vitality that makes them without a doubt the most incomparably human, most deeply felt pieces of pottery Picasso has ever made. *(Excerpt)*

GEORGES RAMIÉ

Picasso. *Women.* Paintings on *gazelles*
(curved clay bricks)

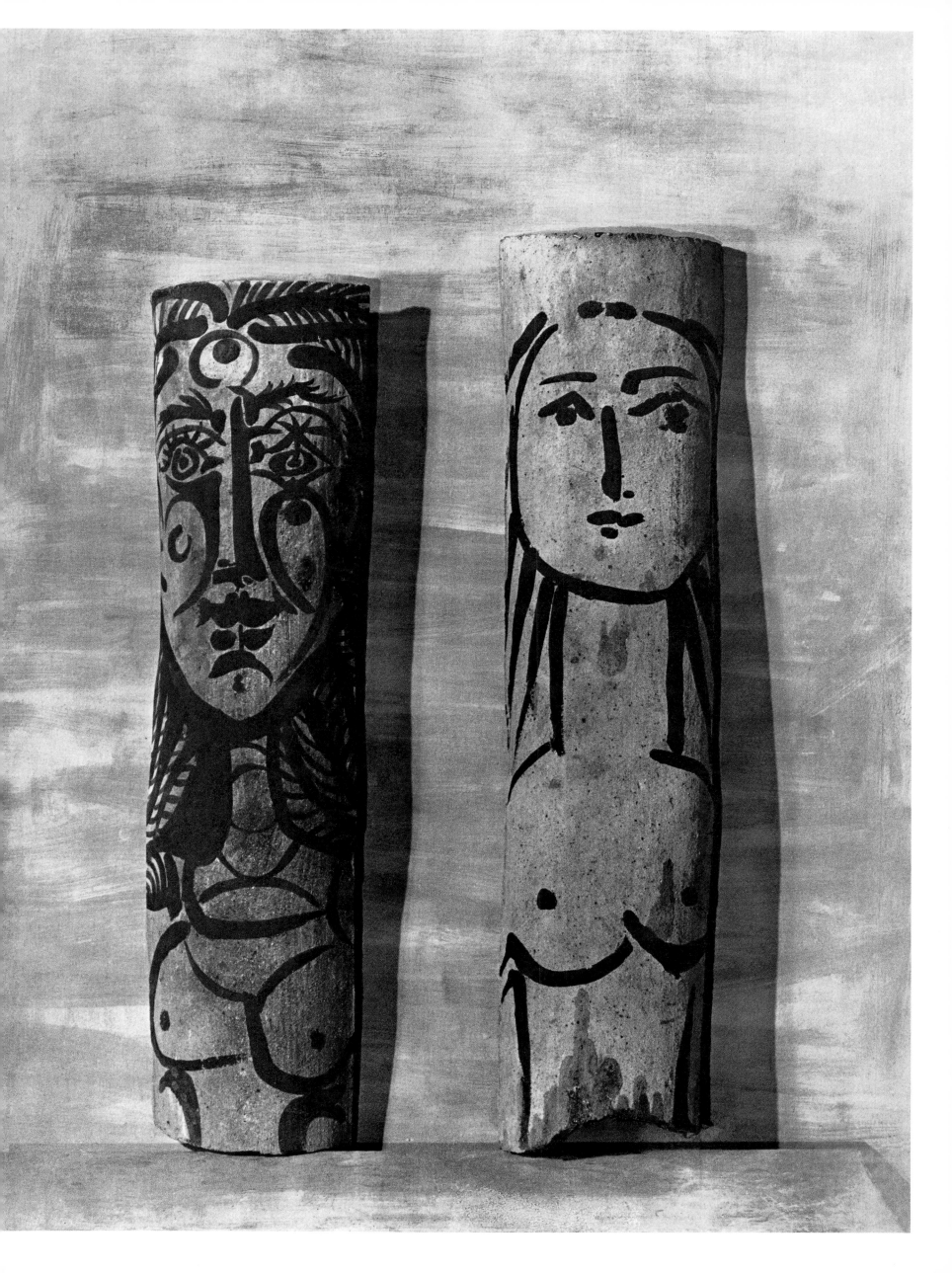

*T*here's nothing more salutary than putting certain things aside and all but forgetting them.... This period of benign neglect both clears and enriches the mind, so that when you return to them they seem fresh and ripened to perfection. It's as though they were born full-grown, like the gods of classical antiquity.

Fully grown! That means you cannot make allowances for them anymore, as you would with children. You must be strict with them, weighing merits and deficiencies alike.

At first, those big pink clay vases, highlighted with white slip, bore only incised drawings of nude women. After drying and firing, they were set aside and forgotten—for good it seemed. What was so ingenious about each piece was not just the way he decorated a vase with a woman's body, but the way he broadened the figure at the bust, narrowed it at the waist, and flared it out at the hips, so that body and vase were indistinguishable.

In a single phase, everything seemed to have been expressed about these subjects, which had a grandeur reminiscent of ancient ware. Once finished, as with so many other pieces, there was nothing more to interest him. Besides—until then—he had held to a hard-and-fast rule that, if for one reason or another a piece no longer seemed right, it was better to think it through again and start a new work rather than return to a previous one. His judiciousness stemmed, not from passive fatalism, but from an awareness that man is an aggregate of successive states. For [Picasso] a miscalculation or accident was an opportunity to be exploited without delay.

However, there came a day when, like the *Tanagras* [figurines], these nude women were deemed worthy of renewed interest. For the first time—and this was most uncharacteristic—he became involved in work that had been presumed finished. He clothed the chaste nudes in flimsy veils, thus superimposing two different modes of expression separated by an interval of several months. He had refined something which, upon reflection, he may have found too precipitate, too extemporaneous, and created a new song from an old refrain.

Was it more than just a variation on a forgotten theme, a transposition of a reconsidered subject, a follow-up on an unduly evanescent concept? Probably, but no one will ever know. *(Excerpts)*

GEORGES RAMIÉ

Picasso. *Large Vase with Clothed Women.* 1950. Earthenware, 65.8 cm. high, 32 cm. wide.

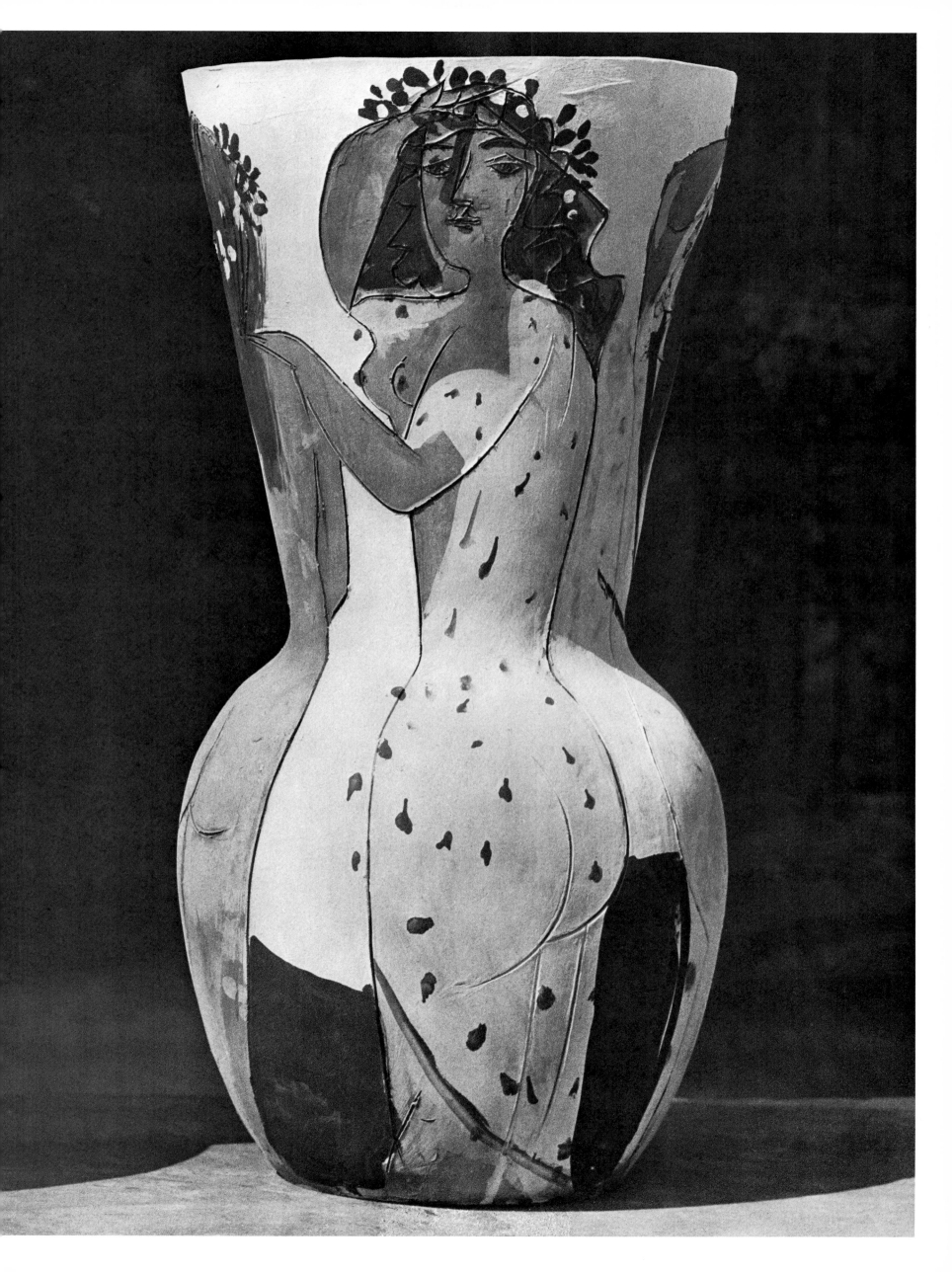

Picasso. *Kid*. Terra-cotta.

Picasso. Mural paintings in the
home of Jean Ramié at Vallauris

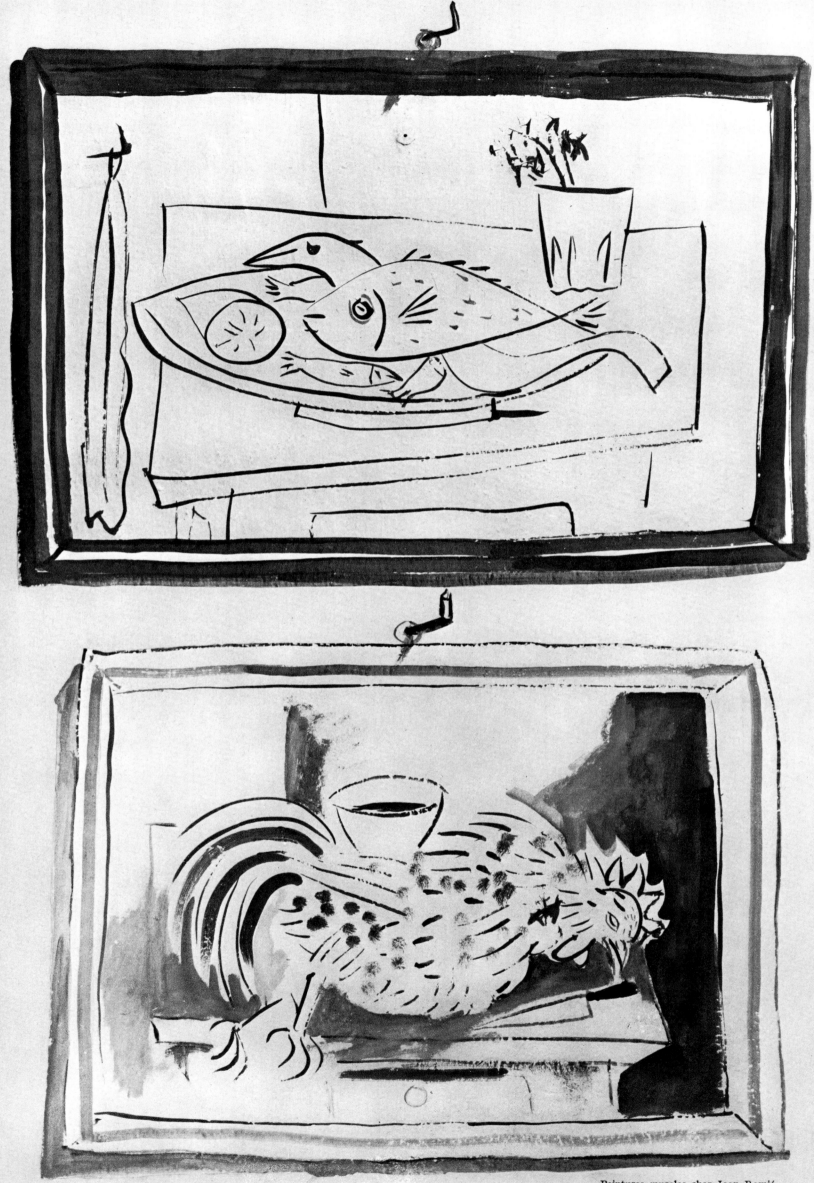

Peintures murales chez Jean Ramié.

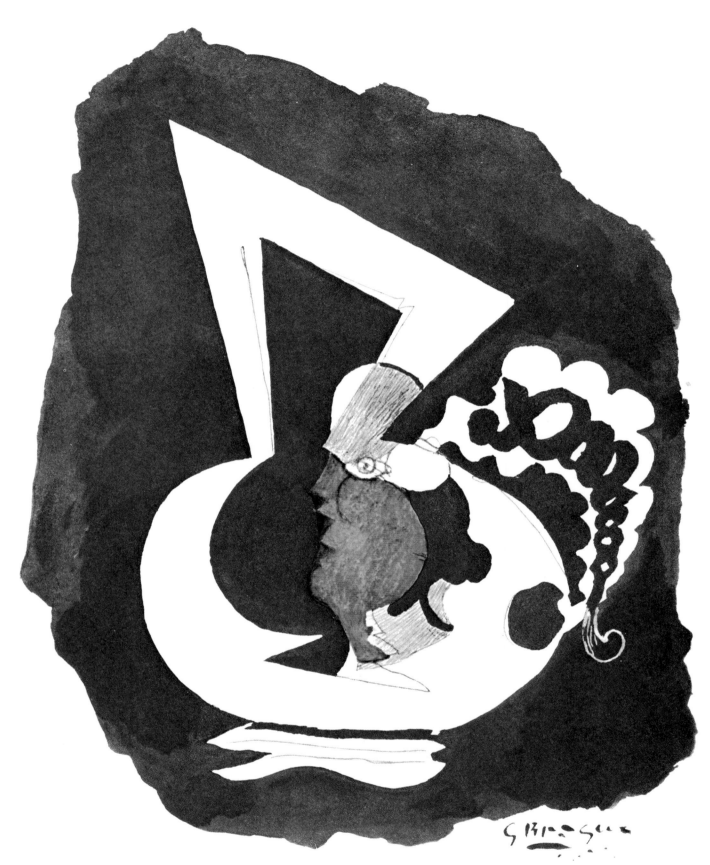

VERVE

Numbers 27/28 December 1952

Ever since *"La Nature de la France"* (*Verve* No. 8), Tériade seemed to have abandoned the "general issue" format that had characterized the first few years of the magazine's run. The war had made it impossible to sustain the earlier pace and variety of subjects. Thus, the *numéros variés* gave way to issues devoted to illuminated manuscripts and individual artists. There was one exception, however: *Verve* Nos. 27/28.

Although this double issue has no title or heading, there can be no mistaking the thematic core of its paintings, miniatures, photographs, and texts: the quest for reality. Here was a subject that literally obsessed Tériade, as it does every artist. This issue's theme can be considered in conjunction with those of other "thematic issues" (*Verve* No. 3, *Verve* Nos. 5/6, *Verve* No. 8, and *Verve* No. 13). Taken together, they provide an intellectual portrait accurately reflecting Tériade's outlook.

Georges Braque designed the cover of *Verve* Nos. 27/28, a lithograph printed—as had become the custom—by Fernand Mourlot. Braque also did the "double frontispiece" that opens the issue: on the front, a superb drawing of a vase of flowers; on the back, a pair of wading birds against a blue background. Both are lithographs.

"Take things, see things as they are—as if the whole history of mankind had *not* been not to have taken things as they are." An important text by Pierre Reverdy forms a kind of preface for this volume. Reverdy, Tériade's beloved and admired friend and colleague, gives vent to a series of "sour notes" on the "prescribed" theme. "The reality of unreality. Currency, money, has no meaning except by common consent. It can be worth everything in one place, nothing in another. And its agreed-upon significance is subject to change, as we know all too well at the present time. Money is the medium most responsible for misleading people about reality because of its miraculous power to gratify the desires of those who have it." Don't close your eyes to things that mislead or deceive—that is what poets, and Reverdy in particular, ask of us. Reverdy, who spent nearly his entire life in poverty, acknowledges in one adverb—*merveilleusement*—the miraculous power of the illusory to transform everyday reality.

Instead of discussing "reality" as a philosopher or art critic, Reverdy attempts to clarify its meaning through self-analysis, through his own work as a poet. "The mind becomes freer the greater its capacity to intellectualize the real world, and even unreality; in short, the more adept it is at taking liberties with reality, at freeing itself from the obfuscating hold of reality, from that servitude we can only bluff our way out of. Because once you've come to the end of the road to liberation, you will always find shackles waiting. . . . It's not a matter of leaving the real world for good—that would be tantamount to [entering] the void—but to soar above it and then come back, the way a droplet of water returns to a river after it has burst from the surface and had a chance to flash like a diamond in mid-air." In the final analysis, then, reality is life itself. Hence, happiness?

"No, death is not the cause of man's anxiety. We've been misled as far as that subject is concerned. It is even remarkable how, on countless occasions, it weighs upon us hardly at all; just think of all the times we court danger. No, it is life that makes us uneasy. Religions have been responsible for denying death, for exacerbating our anxieties about it, with their sinister talk about good and evil, or of an eternal

life of hellfire or honey." Here, the agnostic, freethinking side of the poet comes to the fore: "I, for one, *need* to think about death. It is not pleasurable, but when you're losing your foothold, there is no more soothing, more convenient, more reliable counterweight." Reverdy ends his disquisition on artistic creation with an (unintentional?) alexandrine: *"Par moments, j'ai besoin d'une musique d'ombre."*

The magazine resumes its flow with a Matisse "portfolio": two drawings of nudes and, above all, framed between two pomegranates, Matisse's *Sorrow of the King* (gouache on paper cut-out, 1952), now in the Musée National d'Art Moderne, Centre Georges-Pompidou, Paris.

Matisse describes the work in a letter to Father Marie-Alain Couturier (May 8, 1952). "Have you seen in my studio a large gouache panel with these figures: a sad king, a seductive female dancer, and a character playing a sort of guitar from which golden flying saucers fly out, circle around the upper part of the composition, and finish en masse around the woman as she dances?"

Here is what Pierre Schneider has to say about it: "Despite its technique and its formal vocabulary, *Sorrow of the King* comes closer to classical painting than Matisse had ever been before. It depicts an action, touches on psychological themes (he thought it had 'a profoundly pathetic expression'), and represents a subject which combines two of the themes treated by two master oil painters Matisse admired particularly, although for different reasons: Rembrandt (*David and Saul*) and Gustave Moreau (*Hérodiade*). Following their example, Matisse painted his last self-portrait—the portrait of an old man."[1]

Braque, Reverdy, Matisse, Laurens, Giacometti, Chagall—truly a garden of delights for Tériade! There had been others, of course, starting with Bonnard, Beaudin, and Borès. But those six were the artists he never stopped loving and cherishing. They comprised his pantheon, as it were, and, as we turn the opening pages of *Verve* Nos. 27/28, we sense the maturation of an entire generation, a feeling of confidence—one that is heightened when we come to the pages containing a lithograph by Henri Laurens opposite a text by Alberto Giacometti. The sculptor's article[2] exemplifies an approach to art that is diametrically opposed to conventional, "literary" criticism: "Seen from the back, one evening at dusk, Laurens walking down the Rue Saint-Benoît. Green leaves, a sentence uttered as he and Madame Laurens are out for a drive in the country. 'There's our old house.' " Reality. Between life and art? "For me, Laurens's sculpture, more than anyone else's, is a veritable projection of himself into space. . . . The very way he breathes, touches, feels, thinks becomes an object, turns into sculpture. . . . "

Giacometti's tribute continues with two Laurens lithographs, *Daphné* and *Apollo*—both very close in spirit to the three classics Laurens had illustrated for Tériade (the Theocritus *Idylls* and Lucian of Samosata's *Dialogues* and *Lucius, or The Ass*)—followed by photographs of sculpture. Then, two airy Giacometti lithographs (*La Rue* and *L'Arbre*), and one of his seminal texts, "Mai 1920," (illustrated with drawings). The sculptor begins by telling how Tintoretto had dazzled him. "But . . . as I stood before the Giottos, I felt as though the wind had been knocked out of me. I felt disoriented and lost, I immediately experienced tremendous pain and distress. The same thing had happened to Tintoretto. There was no holding out against the power of Giotto; I was overwhelmed by those immutable figures, dense as basalt, their precise, measured movements fraught with meaning and unbounded tenderness, such as the way Mary's hand caresses the cheek of the dead Christ.

"That evening, all of these contradictory sensations turned everything upside down when I caught sight of two or three girls walking in front of me. They seemed huge, all out of proportion; everything about them and about the way they moved seemed filled with frightening violence. I watched them as if in a kind of hallucination. A feeling of terror came over me. It was like a tear in reality. The meaning and

relationships of things had all changed. The Tintorettos and Giottos became tiny, puny, limp, flimsy, like a naive, clumsy, inarticulate stammering."

It was also Giacometti who "inspired" the following pages: an Italian landscape by Balthus (opposite a short text by Albert Camus, entitled "Peut-être"). And, above all, a two-page spread with a black-and-white photograph of *La Chambre*, a Balthus painting that, to our knowledge, had never been reproduced before. (Curiously, neither the catalogue of the Balthus retrospective at the Centre Georges-Pompidou nor the one published by the Metropolitan Museum of Art mentions this. Since the painting is believed to date from 1952–54 and this issue of *Verve* came out in December 1952, it must have been photographed during the fall of 1952 at the latest.)

A portfolio of André Masson lithographs with symbolic overtones (presented in the manner Tériade preferred: black-and-white right-hand page/two-page color spread/black-and-white left-hand page) leads us to a group of illustrations for "Rembrandt, Hokusai and Van Gogh," by the then-director of the Stedelijk Museum, W. Sandberg. His free-verse text is divided into three sections: "On the Function of the Artist," "Artists," and "Drawing."

He writes: "In every line we sense speed, pressure, the way the artist lifts his pen or brings it back down again to make contact with the paper…

"A finished painting is always a thought edited for the consumption of others.

"When an artist draws, he works for no one but himself

"he can give free rein to impulses as they occur

"he has nothing to hide."

The text is punctuated by dramatic juxtapositions—Hokusai/Van Gogh, Rembrandt/Van Gogh—that stress graphic and plastic parallels between artists from different centuries and civilizations.

Then, a change of pace: Gaston Bachelard ushers us into the mysterious world of Monet's *Water Lilies*, flowers that the critic sees as a symbol of Impressionism. "When evening comes—Monet saw it countless times—the young blossom withdraws to spend the night underwater. They say that its stalk retracts, pulling it down into the dark, muddy depths. At daybreak, after a sound midsummer night's sleep, the water lily, that huge, sensitive aquatic plant, is reborn with the first light, morning after morning. It is forever young, the undefiled daughter of the water and the sun.

"Such recaptured youth, such unfailing obedience to the rhythm of day and night, such punctual announcement of dawn—that is why the water lily is Impressionism's own flower. The water lily is an instant in the world. It is a morning of the eyes. It is the amazing flower of a summer's dawn."

Cartier-Bresson's two photographs of the pond at Giverny give us an idea of what Monet saw and felt. (The continuity with the artist here is unsettling. Bachelard's observations about Monet may be said to apply both to the artist and to the photographer: " … an overwhelming love of beauty, the way the man encouraged everything conducive to beauty, the way he had of enhancing the beauty of everything he beheld his whole life long.") This section ends with a lengthy text, "Monet le Fondateur," by André Masson: "The work of Monet—a major turning point in painting. An upheaval. The primacy of light (or, if you prefer, light/color). … Consider *Water Lilies*, his crowning achievement. Though monumental in size, they do not recall in the least large-scale Venetian or Flemish decorations. The mood here strikes me as being that of a great "easel" painter who has decided to provide his vision with a field big enough, commanding enough, to take in the world. (A reflecting pool can hold a Universe.). … May I say in all seriousness that the Orangerie in the Tuileries is the Sistine Chapel of Impressionism. It is a deserted spot in the very heart of Paris, as if to impart to the mighty work

inside—a high point of French genius—a feeling of inaccessibility."

Another high point in French art, Georges Braque, is represented in this issue with several major works that proved to be a prelude to a "Braque issue" that would appear three years later ("*Carnets Intimes de Georges Braque*," *Verve* Nos. 31/32). Wonderful photographs of the shore and cliffs at Varengeville by Mariette Lachaud, as well as some statements Braque made to Tériade in the spring of 1952, introduce this section.

Although Tériade was not the first person to publish interviews with artists, he figured prominently in the amassing of priceless information that reveals, "point blank" (*à bout portant*), the inner workings of a painter's mind. He began to combine art and journalism as early as the 1930s, in *L'Intransigeant* (columns such as "Voyages d'Artistes" [Léger in Berlin] and "Confidences d'Artistes"). To use an expression that would come into vogue some years later, Tériade "gave painters the floor."

It would have been unthinkable to devote an issue of *Verve* to "reality" and not include Fernand Léger, who invites the reader to a *Country Outing* (lithograph).

Venice: archipelago of illusions, of shifting vantage points, a labyrinth where reality is fleeting. This is the starting point for "Venice from My Window," by Jean-Paul Sartre: "Nothing is uncomplicated in Venice. You see, it's not a city; it's an archipelago. As if one could ever forget it. From your little island you gaze longingly at the little island across the way. Out there, there's . . . what? Seclusion, a purity, a silence you'd swear doesn't exist where you are now. The real Venice, wherever you may be, is something you always find somewhere else. At least that's the way it is for me. Usually I am pretty satisfied with what I have. But in Venice I am prey to a kind of jealous rage. If I didn't restrain myself, I'd always be on the bridges or in gondolas, desperately searching for the undiscovered Venice down that *calle* on the opposite side. Needless to say, as soon as I get there, everything fades away. I look back: now it's the other side that seems cloaked in a mysterious calm. I've been resigned to it for a long, long time: Venice is wherever I am not."

Then, another "portfolio" of lithographs: a two-page spread of Joan Miró's *Dog Barking at the Moon* in jarring colors, enclosed between two "frontispieces."

Miró is our introduction to Spain and a section on the Spanish still life. An appreciation by Jean Cassou ties in works by Juan Gris, Picasso, Goya, Cotan, Zurbarán, and Borès: "The Spanish temperament is well suited to the still life, an essentially silent genre, one without any particular eloquence, without any preconceived or obvious composition, one that compares or contrasts everyday things, arranges objects, puts them on display. If it 'refines' them, it does so within the strictly defined bounds of rhetoric, thereby creating maximum effect from nothing but the form of the objects. . . . Thus, we can speak of the metaphysical—in other words, surreal—quality of Spanish still lifes. A black background heightens the wondrous aspect of the objects depicted." This analysis is particularly convincing since it is illustrated by Fray Juan Sanchez Cotan's *Quince, Cabbage, Melon, and Cucumber* (Fine Arts Gallery, San Diego, California). Here, fruit and vegetables "are fantastically arranged in a window frame that looks out to *nada*. . . . Everything is lifelike, but extraordinarily so. Real, brutally real, but contrived, too. They are as much a part of the realm of caprice as of that of nature. . . . These disparate, unfathomable objects leap out at you from a barren backdrop. They have a presence created by the same rule of silence and austerity that governs the strictest convents. Yet, they are ordinary fruit and vegetables. The difference is that they no longer belong to our world; they are part of the cloistered community that eats only when praying, as if eating were a form of prayer."

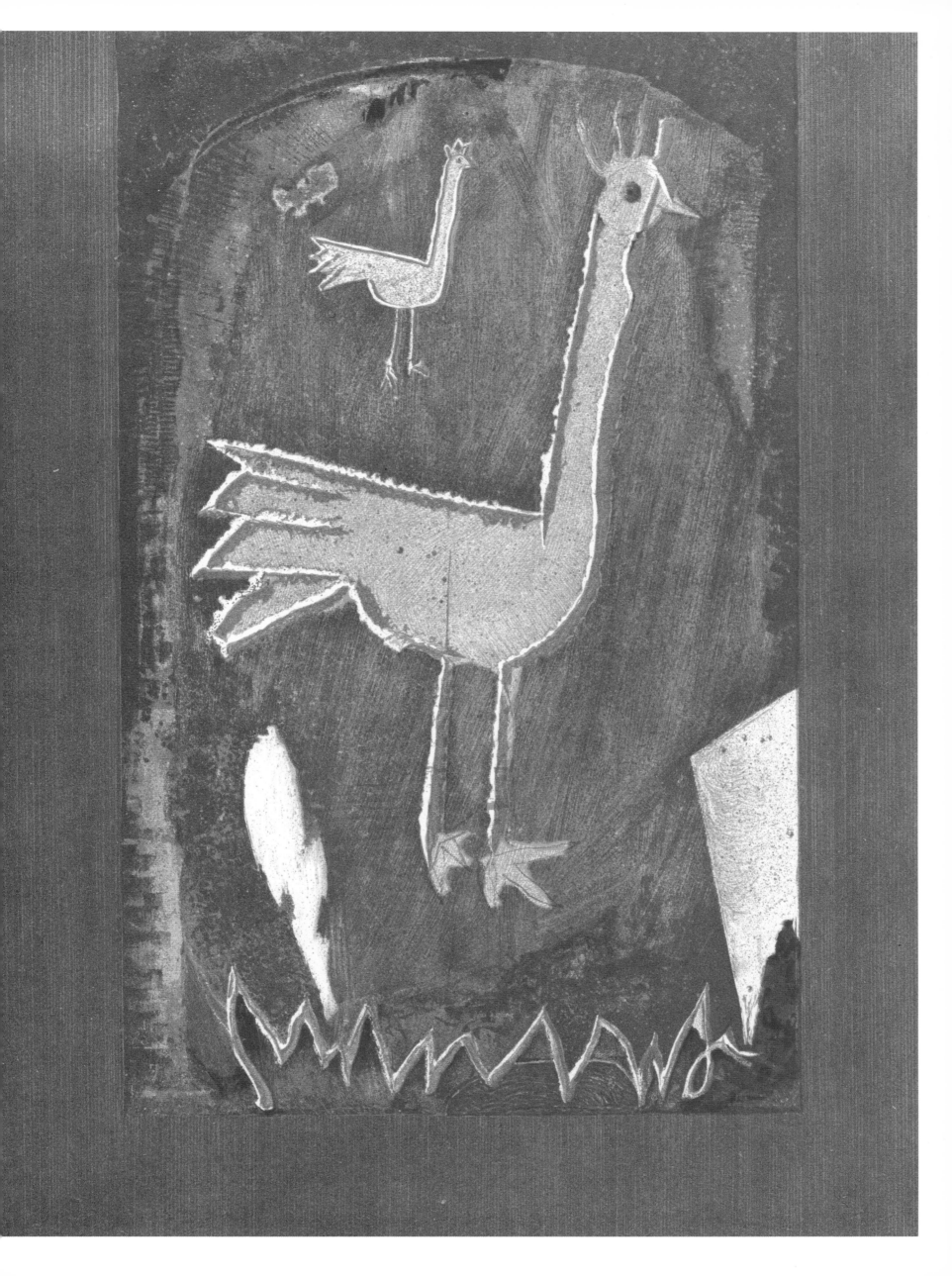

The section following these observations on Spanish still life was inspired by Alberto Giacometti—with whom Tériade had almost a familial relationship. In fact, *Verve* Nos. 27/28 as a whole was an outgrowth of their conversations and shared views. In addition to contributing two texts and two original lithographs, Giacometti suggested featuring a composite of paintings by artists with whom he felt a certain kinship. Nostalgic longing for a lost community? An unconscious desire to replace the Surrealist family with another—to escape his solitude? Whatever the reason, some of his choices are rather puzzling. Indeed, Giacometti himself seems to have had his doubts. "I've been meaning to write to you for a fortnight," we read in a letter to Tériade (one probably followed by long discussions), "but I couldn't put my mind to it. I'm moving in slow motion on every level. Now, what was I about to say? Oh yes, first and foremost: I saw Balthus's painting[3] (I hadn't seen it in that state yet). I completely agree with you. He's made tremendous strides. [It's the] best thing he's ever done, and [there's] another under way—though (?) not better—the one with the street.[4] I'm worried about his appearing in the magazine with Hélion, Gruber, and Roux. He's not going to be happy about it. They'll all be lumped together, and he has nothing in common with the others, especially Gruber. If I were with them I wouldn't care, I mean, everything would be all right and I wouldn't be at all concerned, [as long as] things were separated and there were more pages in between. It would be disagreeable to me if they weren't set somewhat apart, too. Actually, though, I don't deserve any better than they; I'm no better than they. We've got to find some way around this, another solution. I'm truly sorry I didn't see this when you were still here! What do you think? We've got to do something. I am in the Café de Flore, it's 1:30 in the morning, there's not a soul in the place, and they're closing up."

Perhaps it was already too late. Reproductions of work by Jean Hélion, Francis Gruber, and Gaston-Louis Roux did appear as an ensemble, but together with compositions by Derain, Cézanne, and Gromaire. This portfolio is "prefaced" by an article, "Note sur la Réalité," by Jean Wahl: "The more a philosopher ponders reality, the more abstract and all-embracing the word becomes. It is everything. Everything is a part of reality, even dreaming, even appearance. There is nothing outside reality. Fallacies are as much a part of it as truths. . . . But for a philosopher who is pondering the subject of painting, or any other art form, reality is something different. . . . The reality a painter offers us is more than just semblance. It is a transmutation, at times a stylization, a thickening and lightening. It encompasses unrealities. Without trying to, Chagall demonstrates better than anyone else that a painter paints by concentrating symbols, the way a poet does. Appearance becomes reality, the real becomes surreal. It's the same with a Chagall, a Rouault, or a Picasso."

With "The Portraits of Fayoum," we come to yet another aspect of reality (equally linked to Giacometti): the human figure. "They are, " as Jean Grenier rightly observes, "the culmination of the oldest art form on earth, one which, from the very beginning, was the handmaiden of a timeless religious concept: survival, not just of the soul, but of the body. Whence came the practice of embalming. A picture of the deceased appears on both the lid and bottom of the mummy case; at times it is lavishly decorated with purple and gold. The head is a stylized replica of that of the mummy, reduced to its essential features. It is, therefore, a mask. . . . This is no living being the artist has depicted, a creature of movement. The deceased is already frozen in a pose that will be the same forevermore. Yet the pose is not hieratic, either, and that leads us a bit astray. These portraits have a presence akin to that of a living person, but also of someone who is no longer among us." Couldn't the same be said of the sculptures of Alberto Giacometti?

It was 1952: Marc Chagall had returned a few years earlier to France, to Paris, after spending the

wartime years in New York. His first visit to the capital had been a three-month trip in May 1946. "Chagall rediscovered Paris," writes Franz Meyer.[5] "During his first stay it had made a very deep impression on him, and afterward its light, and contact with its people, had constantly helped him to blossom into what he is. As for motifs, except for a few landscapes during the first months, the town had occupied only a marginal place in his pictures. Now, after many years' absence, Chagall experienced the reality of Paris in a totally different fashion. The sky and the trees, the rows of houses with their peculiar beauty, the Seine with its bridges, all responded in his own language. The buoyant, yet substantial coloring of his American pictures had already prepared him for this. The dynamic concentration of form had become far stronger than before. And the new, unusual colors, reseda and mauve, green and violet, on the black background, created a mood of intoxicating heat. Never before had Chagall reacted so spontaneously to an external stimulus. At first, the sketches were not put to use. For a time he put them aside, and it was not until January 1952 that he decided to use them as the starting point for a series of pictures upon which he worked until the spring of 1954, and which are known as the 'Paris series.'"

The extensive series of original lithographs Chagall did for *Verve* Nos. 27/28—*Visions de Paris*—was part of the outpouring of creativity that coincided with the painter's return to France and celebrated his love for its capital. But there was another cause for celebration: in the spring of 1952 Chagall met his future wife, Madame Valentine (Vava) Brodsky. The dark hours of exile and separation were behind him; the time had come to rejoice. Chagall's joy manifests itself in couples locked in embrace, or bouquets of flowers that flirt with the monuments and cityscapes of Paris. Rarely have black and white expressed such intensity; the ink washes that grace this issue of *Verve* seem no less colorful than the colorplates and their acidulated greens, their range of blues, their reds, violets, and yellows. The artist introduces the Seine, Notre-Dame, the Place de la Concorde, the Eiffel Tower, and the Arc de Triomphe into his compositions, the way he did the houses of Vitebsk: the monumental landscape of Paris becomes a constituent element in Chagall's imaginary world. A striking example of this symbiosis is the embracing couple in the black-and-white plate on page 129 in *Verve* Nos. 27/28—they offer the whiteness of their skin to allegorically represent the space of the Place de la Concorde. Chagall expresses the immensity of his physical plenitude through the immensity of this landmark's space. Another striking element in this work is the presence of a huge black solar disk, poised ominously close to the obelisk. It gives the picture a particular tension, and an intensity reminiscent of Van Gogh.

The trying postwar years were a time of fruitful cooperation between Chagall and Tériade, whom the painter himself referred to as his "second Vollard." After Vollard's death, and with the help of Madame Chagall, Tériade published all of the Chagall books that had been left in limbo: the Bible, Gogol's *Dead Souls,* La Fontaine's *Fables.* Later on, he would publish *Daphnis and Chloe* and *Cirque.*

Chagall may have shown Tériade the gouaches and pastels on dark paper that were, in fact, the early sketches for his paintings. In any event, the artist was anxious to produce lithographs—as he subsequently demonstrated to such dazzling effect. As far back as 1948, he had written to Tériade from High Falls, New York, expressing his impatience "to work for him." The theme of Paris lent itself particularly well to this integration of color and black-and-white lithography, and Chagall had tried his hand at the technique when he hand-colored the books Vollard had commissioned him to illustrate.

According to Jacques Lassaigne,[6] Chagall made the following remarks about the *Visions de Paris* cycle: "Paris is a picture already painted. Instead, America still must be painted." And: "The Paris of which I dreamed in America and which I rediscovered, enriched by new life—it's as if I had to be born again, dry my tears, and start crying again. Absence, war, suffering were needed for all that to awaken in

me and become the frame for my thoughts and my life. But that is only possible for one who has kept his roots." The artist also wrote an epigraph of sorts for these eight lithographs: "Visions of Paris, which may be the same, yet are not the same. Paris, mirror of my heart. Would that I could melt away into her, and not be alone with myself."

The rest of *Verve* Nos. 27/28 is a varied ensemble. A text by Louis Guilloux, "Avantage de l'Ignorance," ends as follows: "When there are things to be done, you do them, and doing them becomes an act of self-creation. For that you do not need theories or schools or manifestos or anything at all, least of all commitments. All you need is your own ignorance. With that as your starting point, you've got to innovate against all odds, so that you may rouse dormant truths in others as ignorant as you, so that you may shatter the gloom of night with a sign, a signal...." To illustrate the text, Tériade included color reproductions of Degas's *Femmes au Café* and *Les Figurants,* as well as of Rouault's *Vieux Faubourg* and *Aux Rives du Jourdain.*

This exuberant double issue of *Verve* ends with a series of miniatures from illuminated manuscripts in the Bibliothèque de l'Arsenal in Paris (the *Térence des Ducs,* the *Renaut de Montauban,* and the *Livre d'Heures du Maître aux Fleurs),* and with a commentary by curator Frantz Calot.

1. Pierre Schneider, *op. cit.,* p. 698.
2. From an article in *Labyrinthe,* January 15, 1945.
3. Probably *La Chambre.*
4. In all likelihood, the *Passage du Commerce-Saint-André.*
5. Franz Meyer, *op. cit.*
6. Jacques Lassaigne, *Chagall,* Paris, 1957.

Georges Braque. *Vase and Flowers.*
Crayon and India ink

HENRI LAURENS

By ALBERTO GIACOMETTI

saw, I felt the street, clear at eleven o'clock in the morning. "I'm off to Laurens's place," the yellow trees of the Villa Brune, the railroad embankment. The tall, gray door of the studio. My anxiety as I knock. "What if he's not in?" My disappointment as the silence grows longer. My joy when I hear footsteps approach from within. Laurens's smile, the color, the shape of his head as I catch a quick, but immediately satisfying glimpse of his sculptures. Seen from the back, one evening at dusk, Laurens walking down the Rue Saint-Benoît. Green leaves, a sentence uttered as he and Madame Laurens are out for a drive in the country. "There's our old house." The pleasant feeling created by relations of height and width when I see a Laurens work for the first time. The immediate certainty: "This sculpture is just right, now and always."

Among these mental images, there is one in particular that recurs, and little by little crowds out all the others, the only one that has no direct connection to reality.

I saw myself in an unfamiliar clearing, a vaguely circular space generally the color of autumn leaves, whose rather narrow boundaries faded into a very pleasant atmosphere that was airy and dense at the same time. Around me there appeared odd little hills, unevenly scattered and rising some thirty centimeters above the ground, alternating with indistinct, whitish buildings that looked like little castles seen through a screen of mist. But these hills, these buildings were complex, enveloped in resonances, and I sensed that they were gestures, sounds of voices, movements, markings, sensations that had once existed, but far removed from one another, spanning many years. Now, however, these sensations-become-objects existed simultaneously in the space around me and *filled me with delight*.

At first, I took them for my own memories, but yesterday, in trying to write what I felt about Laurens's sculpture, and what it means to me, I realized to my surprise that I was simply reconstructing those little hills, the visions in the clearing, albeit with different words and through different paths. It was in this roundabout way that his oeuvre had taken shape in my imagination, and that's how it has been from the very first evening I sat down to write this article.

For me, Laurens's sculpture, more than anyone else's, is a veritable projection of himself into space, a bit like a shadow in three dimensions. The very way he breathes, touches, feels, and thinks becomes an object, becomes sculpture. This sculpture is complex; it is as real as a glass (I meant to add "or as a root," but I'm less certain of that, although in some respects it is more like a root than a glass). At the same time, it reminds me of a human figure that has been reinvented; above all, it is a "counterpart" of that which makes Laurens so consistent over time. Yet, each of his sculptures is also the crystallization of a particular moment of that time. (One might think that the same is true of all sculpture, but I think not, at least not in the same way nor to the same extent.)

The artist filters the smallest details of this sculpture through his sensibility, over and over again, until it becomes a part of his sensibility. Laurens only progresses in his work through absolute control, and never tries to proceed any further. The same profound, complex sensibility sets, clarifies, and determines the size, proportion, and dynamics of his sculpture.

As he shapes the clay, Laurens also shapes the empty space around it, space itself becoming a volume. Laurens creates volume from space and volume from clay simultaneously. These volumes alternate, balance one another, and together become sculpture. And that sculpture is a *clear sphere*. (Excerpt)

Henri Laurens. *Daphné*. Lithograph

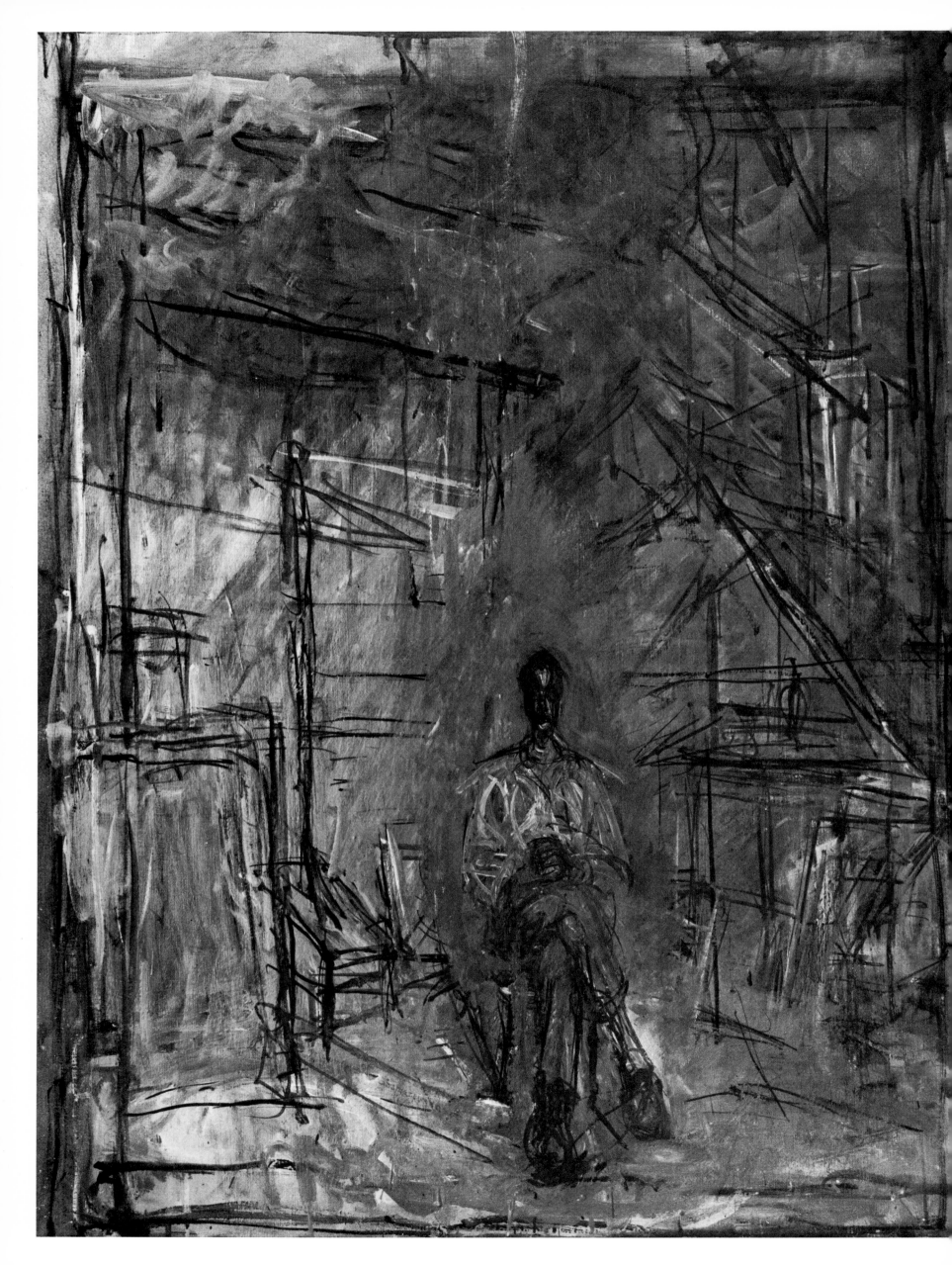

Balthus. *Italian Landscape.* 1951. Oil on canvas, 59 x 87 cm.

PERHAPS

By ALBERT CAMUS

The secret that I am looking for is buried in a valley of olive trees, beneath grass and the violets of March, near an old house that smells of ripened vine shoots. For more than twenty years I searched that valley and others like it, I questioned silent goatherds, I knocked at the doors of uninhabited ruins. At times, when the first star appeared in a sky still blue, beneath a shower of fine light, I thought I knew. I did know, in fact. I still do, perhaps. But no one where I live wants anything to do with this secret, I probably don't either, no doubt, and cannot part with those close to me. I live with my family, which rules over cities prosperous and hideous, cities of stone and fog. Day and night, it speaks in a loud voice, and all bend before it who bend before nothing else: it is ailing and deaf to all secrets. Its strength, which sustains me, annoys me nonetheless, and there are times when I grow weary of its shouting. But its misfortune is mine, we are of the same blood. Ailing, too, arrogant, complicitous and noisy, haven't I also shouted among the stones? I, too, do my best to forget, I walk along streets of iron and fire, I smile bravely at the night, I call out to storms, I shall be faithful. I have forgotten, in truth; busy and deaf, from now on. But perhaps one day, when we are about to die of weariness and ignorance, I shall be able at least to renounce our gaudy tombs in order to stretch out in the valley, beneath the same light, and learn one last time that which I know.

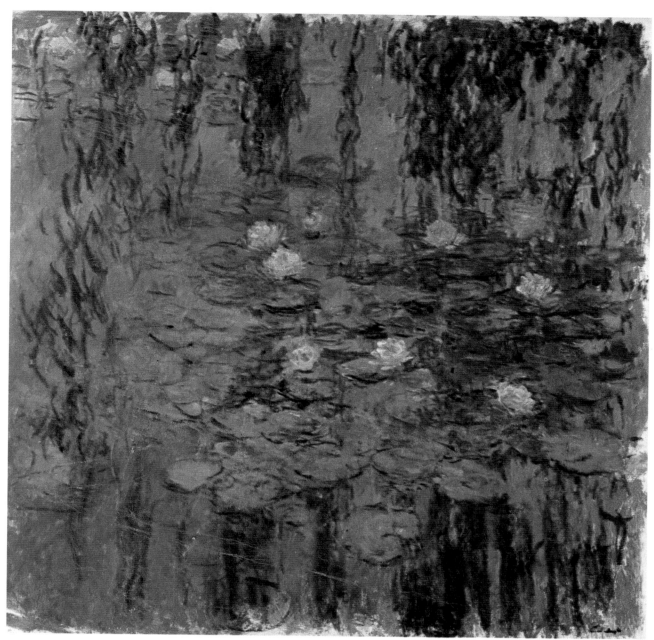

Claude Monet. *Blue Water Lilies*. Oil on canvas

The world longs to be seen: before there were eyes to see with, the eye of the water, the great, large eye of peaceful waters, watched flowers as they blossomed. And it is in that reflection—who would deny it!—that the world first became aware of its own beauty. In the same way, ever since Claude Monet looked at water lilies, the water lilies of the Ile-de-France are more beautiful, larger. They drift along our rivers with more leaves, more peacefully, as well-behaved as images of Lotus-children. I once read—I forget where—that in the gardens of the Orient, in order to make the flowers lovelier, and blossom more quickly, more profusely, with a clear confidence in their beauty, people showed their concern and love by placing two lamps and a mirror in front of a healthy stalk that held the promise of a young bloom. That way, the flower could admire itself even at night. Thus, it had a never-ending enjoyment of its own splendor. *(Excerpt)*

GASTON BACHELARD

The water-lily pond at Giverny.
Photograph by Cartier-Bresson

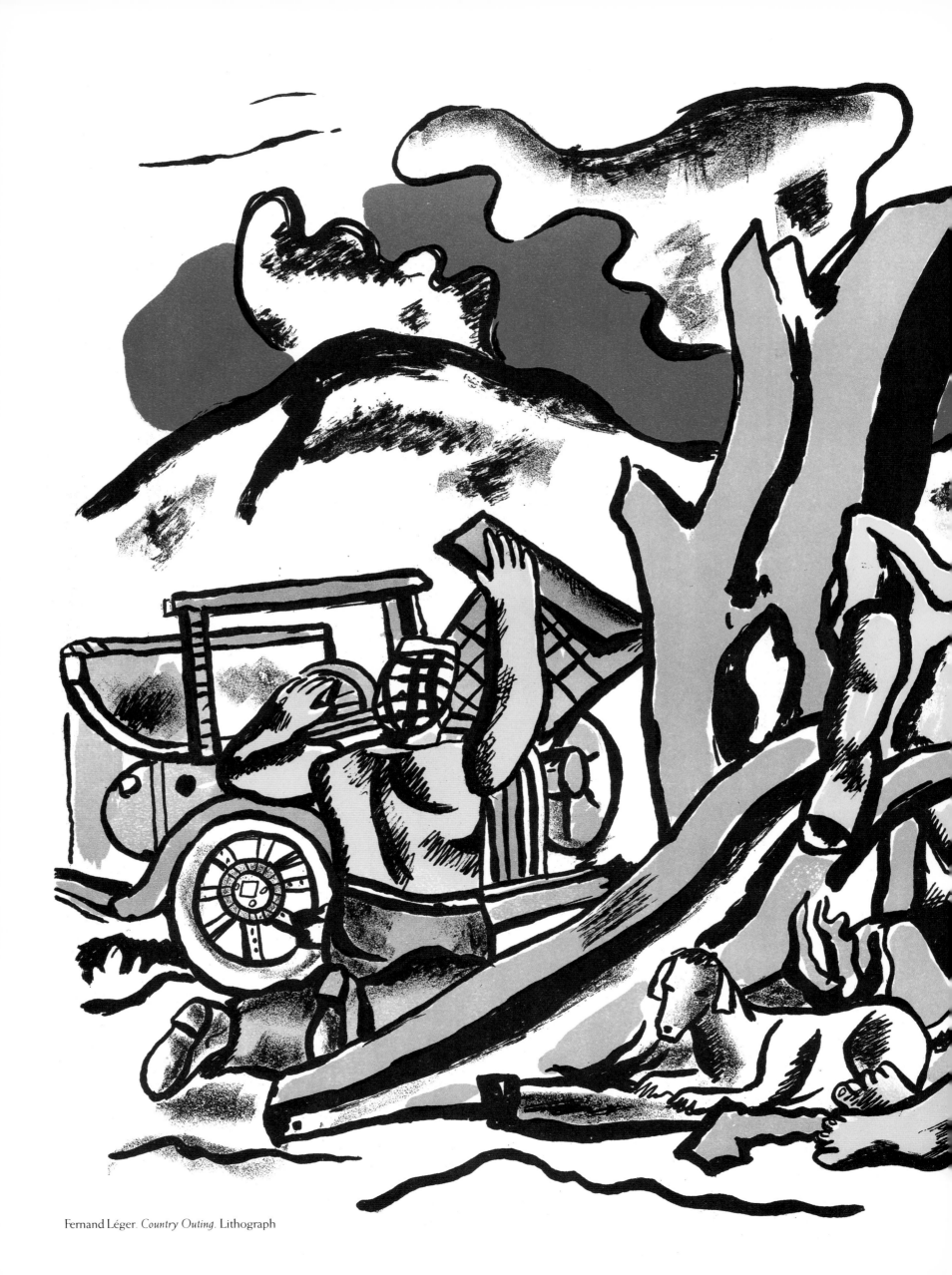

Fernand Léger. *Country Outing*. Lithograph

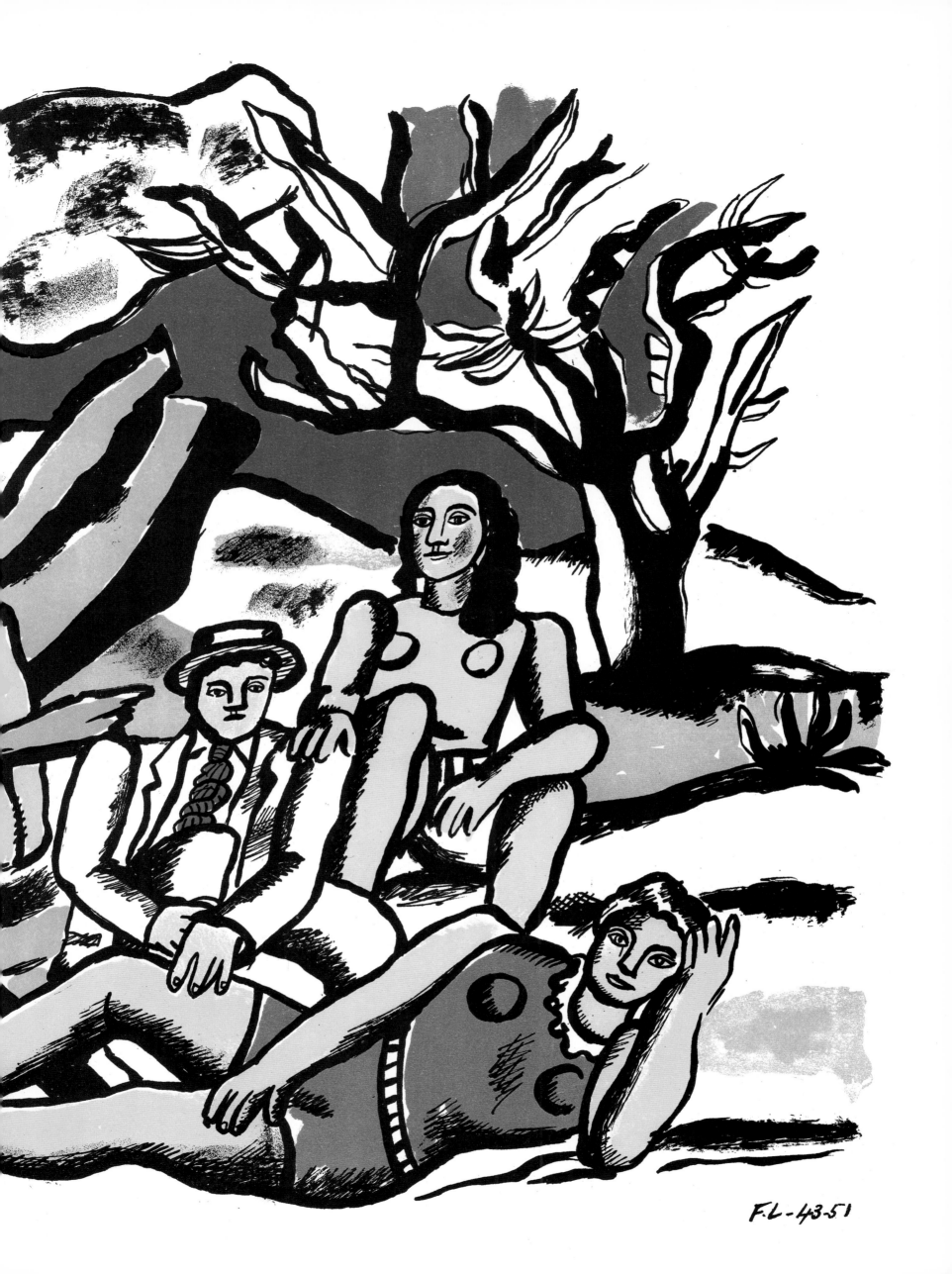

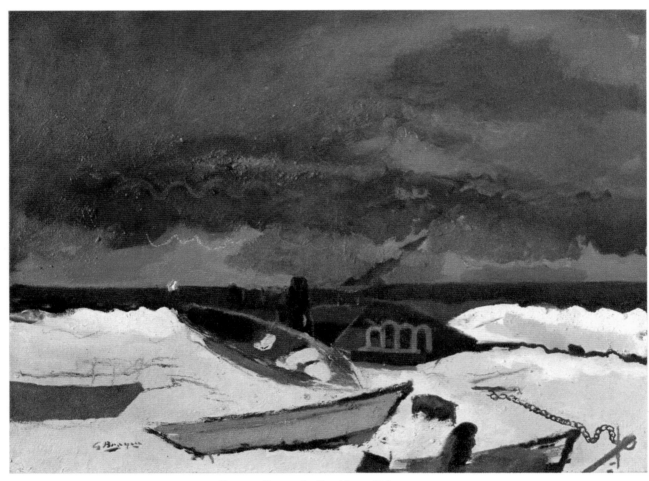

Georges Braque. *Le Gros Nuage.* Oil on canvas.

Georges Braque. *Seascapes*. Oil on canvas

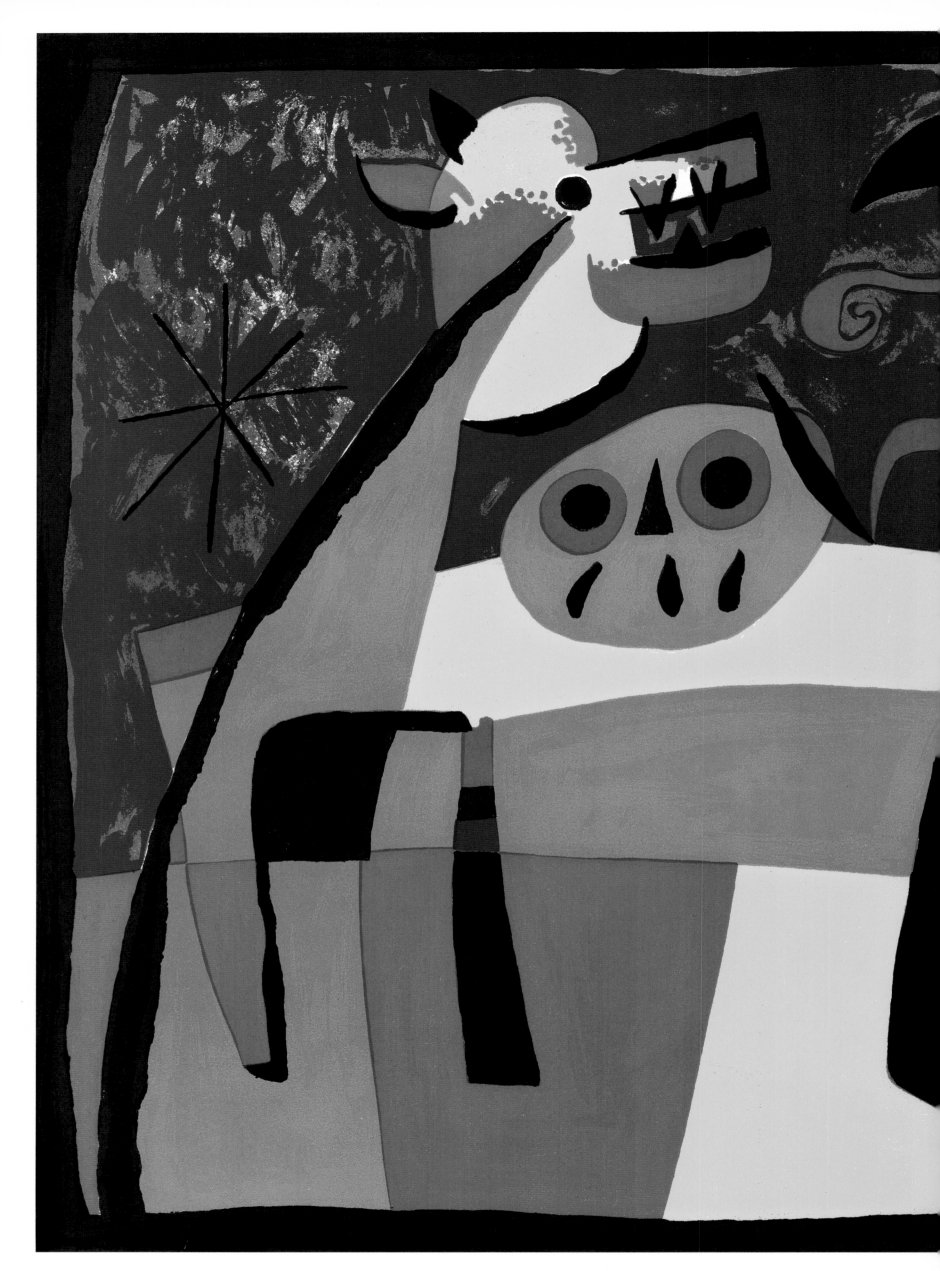

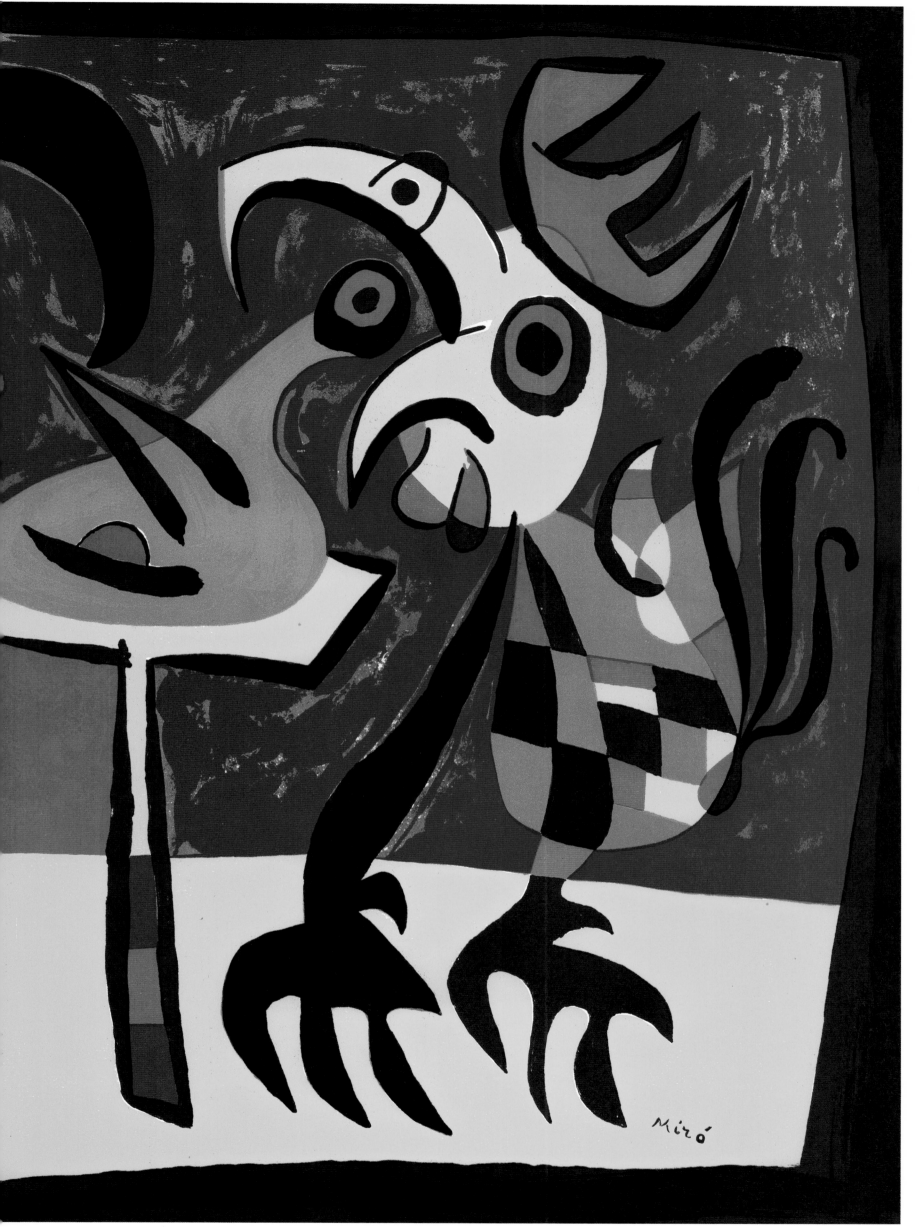

Joan Miró. *The Dog and the Rooster*. Lithograph

VERVE

VERVE
Numbers 29/30 Fall 1954

One Hundred and Eighty Drawings by Picasso
(November 28, 1953—February 3, 1954)

This double issue of *Verve* is introduced by that rarest of phenomena—a preface *signed* by Tériade.

"Last winter, from mid-December to the end of January 1954, Picasso was working indefatigably on this series of drawings, which rank among the finest, boldest, most poignantly human of all he has produced in the course of his long and brilliant career... [drawings] bathed in a light that, too, is real, the very light of day. Almost one could fancy that in his lonely nights at Vallauris these denizens of a world invented by him crowded into the artist's room, sat for him, confessed unblushingly their most shameful secrets. And all alike fell in with their creator's whims, played up to his caprices, pandered to his 'black' humor—in a word, helped Picasso to reveal his inmost self to us.

"Like Baudelaire when he wrote *Mon Coeur Mis à Nu*, a great painter was passing through a lacerating phase of his emotional life. Picasso did not shrink from the ordeal, but met it with the calm assurance of a man who knows himself the master of his fate. The artist who, in utter solitude, thought up these burlesque, sensual scenes, this ironically devastating satire on men's lives (his own included), could vouch for it from personal experience.

"The revolutionary elements in Picasso's art stem, not from the pride of a dessicated intellectualism seeking to conceal the void within, but from a superabundant energy that he has always sought to master and to canalize in ever austerer forms. Many great artists have tended to surrender to the lures of facile charm; Picasso has left these far behind, though he once had to fight them down and even to mask them with a facade of new, spectacular discoveries. He is one of that small company of artists whose lot it is to shape the destinies of painting."

Tériade proceeds with an overview of Picasso's work, in order to better situate these 180 drawings within the context of the artist's career.

"Today, Picasso is making a halt in his long pilgrimage. In the solitude of his Vallauris nights he is taking stock of his life's work, an oeuvre from which he now stands aloof as though it were extraneous to him, but which lives on in the world of men. It forms a fully integrated whole, with its well-marked periods, successive discoveries, each leading to the next... its seeming inconsistencies, its phases of alternate harshness and serenity, moods of violence and tranquil joy.... Is it journey's end? No, that is unthinkable; this journey will end only with the ending of our great artist's life. But now he has had a sudden impulse to cast his eyes back to those early days when, long before he had attained his present mastery of plastic art, he drew everything—the life he saw, painters, women painters, and painters with their women....

"We have published the series of drawings in its entirety. They form an organic whole, born of a surging uprush of the creative spirit, and to have omitted any of its elements would have been a mutilation. Nevertheless, when we isolate any one of these elements and fix our attention on a single page, we find the fragment almost as eye-filling as the ensemble. All the drawings are reproduced in the exact size of the originals and in the chronological order of their making."

Cover by Picasso

In a powerful text entitled "Picasso and the Human Comedy, or The Avatars of Fat-Foot," Michel Leiris uses some thoughts on the theater as a starting point for his comments on this extraordinary series of drawings. "It is on this plane—accessible only to the very greatest artists—that naturalism *à outrance* and flights of purest fancy are integrated into an organic whole, as in this sequence of drawings and lithographs made by Picasso in the winter of 1953–1954. Mostly in black-and-white but some in colored pencil, they served him as a sort of day-to-day journal, graphic not verbal, of an odious 'Season in Hell,' a crisis in his private life that led him toward a new orientation, a stocktaking of life in general. For whenever a man comes up against an emotionally shattering experience, he is bound, if he is in the least degree sensitive, to call everything into question, to review his outlook on the world at large.

"...Thus, in the masked ball to which Picasso invites us here, old themes and personages reappear, ironically treated; all have aged terribly and, despite the masks, we see the stark reality, paltry or pitiable as the case may be. But for Picasso, who is no idealist, there is no question of creating an illusion of eternity on the lines of a Proustian *temps retrouvé*. Far from serving to halt the flux of time and that inescapable decline which is the lot of all flesh, this recapitulation of themes and figures of earlier days has an opposite effect; we are conscious that all alike are swept on ruthlessly by a torrent which there is no resisting, and Picasso seems to make a point of stressing its violence."

Leiris then attempts to explain how Picasso's oeuvre is inextricably bound up in his social and private life. "Almost all the themes used by Picasso in his successive periods have linked up intimately with his personal life: details of personal experience, people for whom he had developed a sensual or sentimental attachment, pathetic or picturesque figures that had caught his youthful eye. Then came big compositions on the epic scale, beginning with *Guernica,* and characters stemming from the myths of classical antiquity or a folklore of his own invention. All these motifs, not only those relating to things actually seen but also those which conjure up some more or less imaginary world, have a precise connection with the artist's physical or emotional condition at the time; in fact Picasso's art is autobiographical through and through."

For Leiris, too, art had to ring true; but Picasso's truth is filtered through a process of metamorphosis represented by the mask. "In the drawings and lithographs in which Picasso seems to play the part of his own historiographer—for they are an expression of his life, and time flows for them as it flows for him—we cannot fail to be struck by the great number of *masked* figures. Here we have that leitmotif of metamorphosis treated in a derisive form.

"...Picasso, one feels, was aware from earliest youth that every myth is fated to become sooner or later an old wives' tale; that almost every ceremony has not a little of the carnival; that genuine magic often goes hand in hand with quackery. Metamorphosis, like magic, may be 'black' or 'white' and both species are illustrated by the circus acrobat who, in his feats of virtuosity and glittering attire, hints at the supernatural, yet is *au fond* a thing of shreds and patches."

A third text, by Rebecca West, immediately precedes the portfolio of drawings. To put her observations into context, we should mention that Françoise Gilot, the woman who had borne Picasso two children (Claude and Paloma) had just left him. "Picasso simply set down on paper the images which passed through his mind during these nine weeks, which were for him a period of acute emotional disturbance.... But there is one idea which runs through the whole collection: the relationship between a painter and his model.... If the painter were not there to paint the model, she would be just a big, strong girl, sitting about. There is, of course, a primary sexual interpretation of her dependence on him. One looks in vain for any sign or indication that a beautiful woman should not be loved."

West's conclusion? "Art is a function as vital as sex."

Picasso. *The Painter and His Model.* 1953

PICASSO
AND THE HUMAN COMEDY
OR THE AVATARS OF FAT-FOOT

By MICHEL LEIRIS

Almost all the themes used by Picasso in his successive periods have linked up intimately with his personal life: details of personal experience, people for whom he had developed a sensual or sentimental attachment, pathetic or picturesque figures that had caught his youthful eye. Then came big compositions on the epic scale, beginning with *Guernica*, and characters stemming from the myths of classical antiquity or a folklore of his own invention. All these motifs, not only those relating to things actually seen but also those which conjure up some more or less imaginary world, have a precise connection with the artist's physical or emotional condition at the time; in fact Picasso's art is autobiographical through and through. Indeed so close is the association between the subjects of his paintings and the man himself that their evolution seems to run parallel with his own. Moreover, far from being milestones, as it were, in his career as an artist, which once attained are left behind for good and all, all these various themes and *trouvailles* are incorporated in his artistic baggage, intermingle and give rise to new creations.

Thus the Pegasus with a winged ballerina on its back which figured on the curtain of the ballet *Parade* developed, years later, into its horrid counterpart, the picador's horse in the last scene of the fourth act of the play *Les Quatre Petites Filles* where we see it with its entrails gushing forth and on its head the owl whose prototype was a tame bird. (This owl has constantly reappeared in Picasso's paintings, sculpture, and, above all, in his ceramics.) The stage direction runs: "Enter a big white winged horse, dragging its guts after it and surrounded by wings, an owl perched on its head. After stopping for a moment in front of the little girl it trots across the stage and vanishes." Later, in *War and Peace*, this same Pegasus (which to start with was a circus horse) is seen yoked to a plough and driven by a child. Flying or sitting, alone or in association with women's faces, the Dove of Peace too had its prototypes. These were the live pigeons Picasso used to keep in his studio in the Rue des Grands-Augustins, Paris; also perhaps, to look still further back, the pigeons which so often figured in the paintings of Ruiz Blasco, Picasso's father. When Picasso was old enough to assist in the work which was the family's means of livelihood, his father left to him the painting of the pigeons' legs. In a recent drawing the dove is perched on the hand of a naked woman who is proffering it to a standing clown holding an olive branch (or foliage of some kind). There is a family likeness between Picasso's minotaurs and his bearded athletes, the mossy growth on whose faces so curiously assimilates them to members of the animal or vegetable kingdom and to such subhuman, or if you will superhuman, creatures as the man-bull, man-horse, or the man-goat. We are shown minotaurs—animalized men or humanized animals—galloping, banqueting, fornicating, and sometimes being done to death in an arena or, stricken with blindness, leaning on sticks, their vacant eyes turned to the stars, with a child Antigone to guide them. In the *Battle of Minotaurs* one is plunging forward, an arm stretched out as if to thrust aside an obstacle or, perhaps, to tear the veil from some ineffable mystery. Others

(continued on page 262)

258

Picasso. *The Monkey and the Apple.* 1954. Watercolor, India ink, gouache, and pastel, 24 x 32 cm.

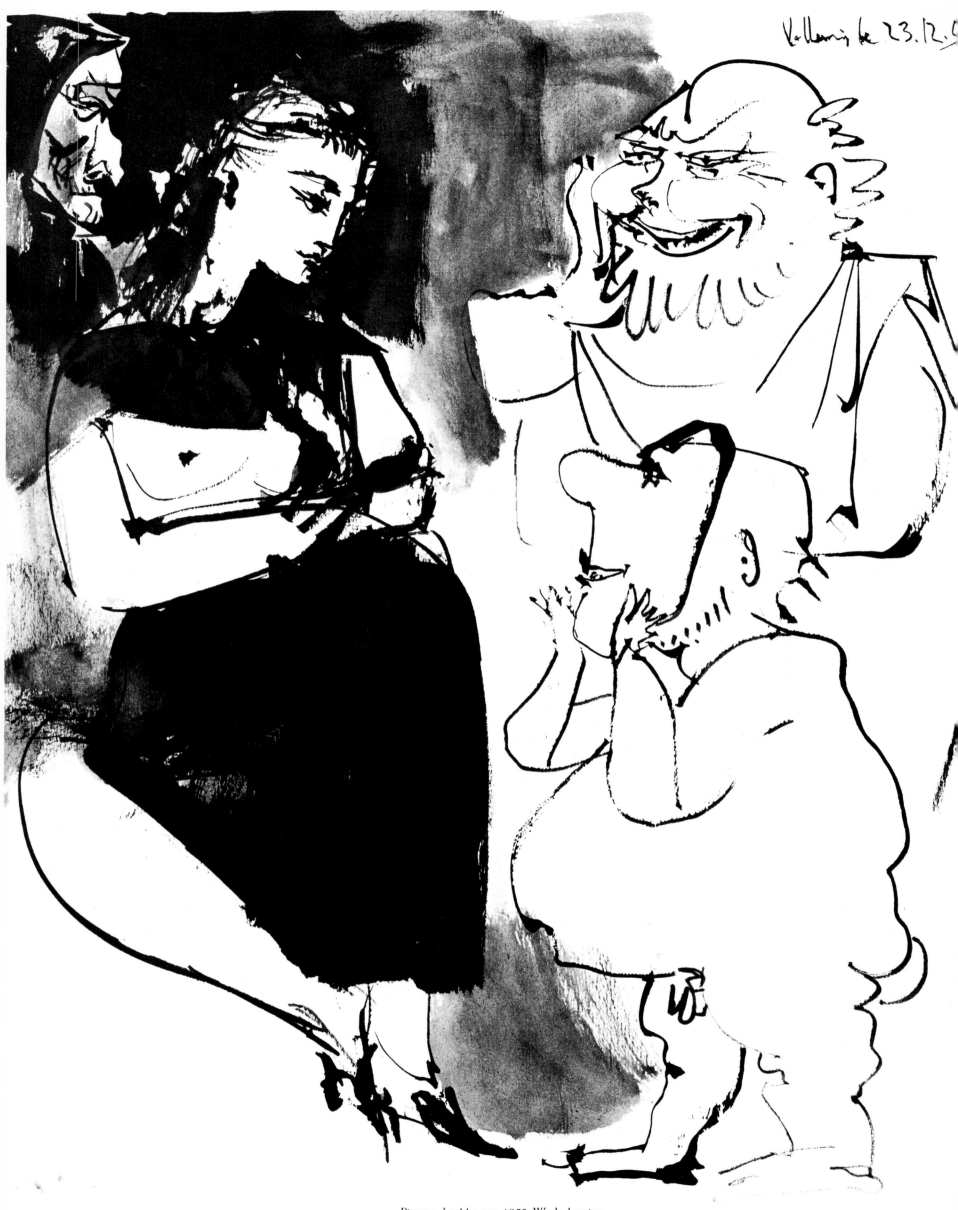

Picasso. *Les Masques*. 1953. Wash drawing

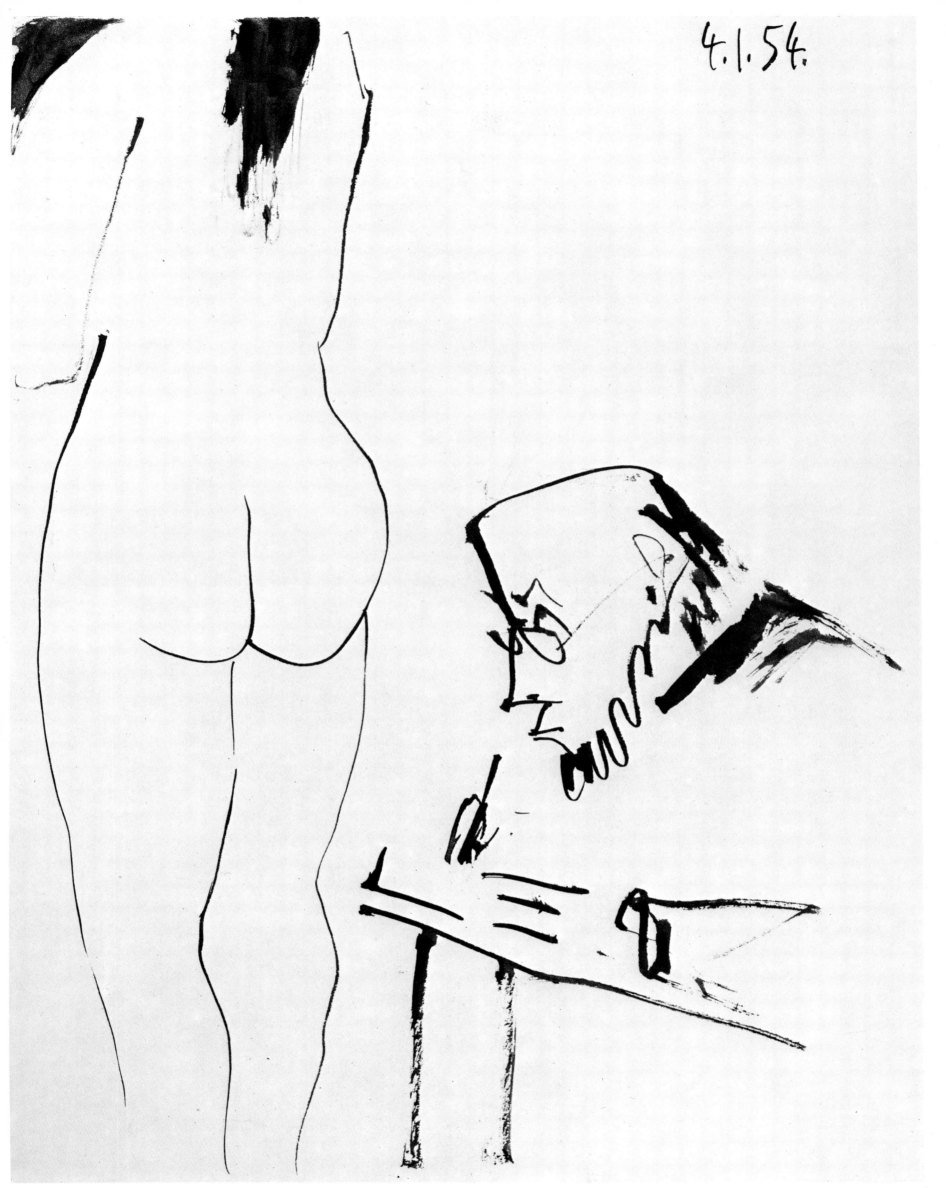

4.1.54.

Picasso. *The Painter and His Model*. 1954. India ink

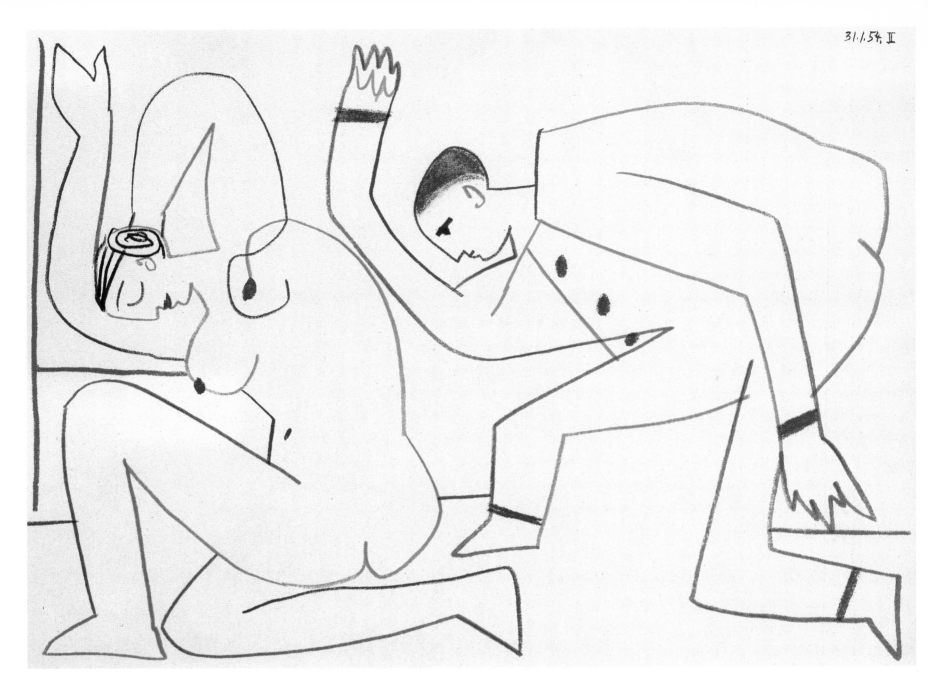

Picasso. *Pierrot and Nude Woman.* 1954

taking part in this strange scene, bathed half in shadow, half in light, are a little girl wearing a short dress and a big beret, who holds a lighted candle and a bunch of flowers; a woman dressed as a torero, her breast bare, and carrying the bull-fighter's short sword; an almost naked man climbing a ladder, and looking round to see what is happening; two women watching from a window on whose sill two pigeons have alighted. In a 1937 picture named *The End of a Monster*, a naked woman armed with a lance is tendering a mirror to a minotaur pierced by an arrow. Finally, in a picture sequence made some months ago, the minotaur has dwindled to a bearded athlete holding to his face or on his chest a bull's head of the kind used by Spanish children in their bullfight games.

It would seem that of all the figures of classical mythology, those embodying a permanent metamorphosis interest Picasso most, for there is no question of his predilection for creatures such as centaurs, fauns, the Minotaur. He, too, seems always in a state of metamorphosis; never has he "settled down" to any fixed style and even when the subject of the picture is not a metamorphosis in the strict sense, he has a way of transforming all that meets his eye. And is there, in fact, any essential difference between an ape whose skull, jaws, and face are built up with two little toy automobiles

placed wheel to wheel and a minotaur, a bull-headed man? When an artist sets out to make "something else" of a picture painted by Manet, El Greco, Cranach, Courbet, or Poussin is he not undertaking something that, in the last analysis, is an attempt to invent new signs for an old *datum*? And when he deals thus with a work by an earlier artist is he not treating it as an object that has been integrated into the real world, something that must not be allowed to fossilize but must be helped, so to speak, to fulfill its natural evolution by being given a new lease on life? Nothing, it would seem, can stay inert once it has come under Picasso's notice or into his hands. Whether he effects an abrupt metamorphosis or serializes, as it were, the vagaries and adventures lived through by his models, we always find the same unwillingness to allow any object, any living being, to be what it is, once and for all, or any field of visual experience to lie fallow.

In the drawings and lithographs in which Picasso seems to play the part of his own historiographer—for they are an expression of his life and time flows for them as it flows for him—we cannot fail to be struck by the great number of *masked* figures. Here we have that leitmotif of metamorphosis treated in a derisive form. For a disguise that necessarily fails to take us in is no more than a travesty of a miracle, a botched attempt at transfor-

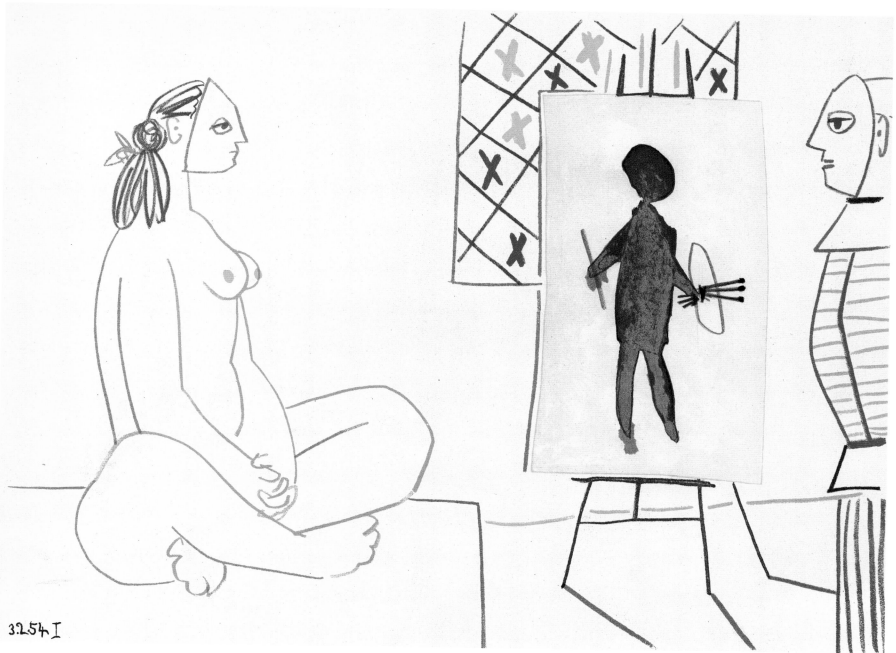

32541

Picasso. *The Painter and a Masked Model.* 1954

mation. Far from cutting a tragic figure, the man detected *flagrante delicto* in imposture can be regarded only as a fraud or a buffoon, that is to say a comic figure. As early as *Parade* Picasso had indulged in effects of this order. After the Pegasus on the curtain we were shown a grotesque horse prancing on the stage, a sort of parody of the celestial steed, its legs being obviously "manned" by members of the ballet company. Similarly in a quite recent series of engravings representing scenes of chivalry, some of the caparisoned "horses" ridden by the knights are pages dressed up for the part.

Picasso, one feels, was aware from earliest youth that every myth is fated to become sooner or later an old wives' tale; that almost every ceremony has not a little of the carnival; that genuine magic often goes hand in hand with quackery. Metamorphosis, like magic, may be "black" or "white" and both species are illustrated by the circus acrobat who, in his feats of virtuosity and glittering attire, hints at the supernatural, yet is *au fond* a thing of shreds and patches.

During the nineteenth century—a period which began, *pace* the strict chronologist, in France, in 1789, and ended with the October Revolution—alongside the myth of the artist as demiurge (a myth built on the ruins of religious faith and dealt a first blow by Rimbaud when, having sensed the vanity of the poet's dream, he withdrew into silence) there flourished the myth of the artist despised and rejected among men. Thus we have Baudelaire's *Le Vieux Saltimbanque,* Nerval's "*illustre Brisacier*" (the actor who is hissed), Mallarmé's sonnet *Le Pitre Châtié* and, later, Raymond Roussel's novel *La Doublure,* written when the artist in a moment of exaltation fancied himself a demiurge. Thus, too, in Chaplin's last film we are shown the "funny man" no longer able to raise a laugh and playing to an empty house. From the romantic viewpoint the creative artist is radically different from the average man and his vocation swings between two extremes. Whether a triumphant or a martyred god, whether an inspired prophet or a madman jeered at by the crowd—"his giant wings hinder him from walking"—he stands alone, and in his lifelong struggle with a hostile world experiences the ups and downs of Balzac's courtesans, their *splendeurs et misères.* In his early days Picasso painted beggars, cripples, prostitutes, and on occasion friends (such as Jaime Sabartès), choosing the moments when they most keenly felt their isolation from the world at large. Common to all was their condition as outcasts, denizens of that fringe of society on which the artist lives, most typical being the strolling players, at once

(*continued on page 266*)

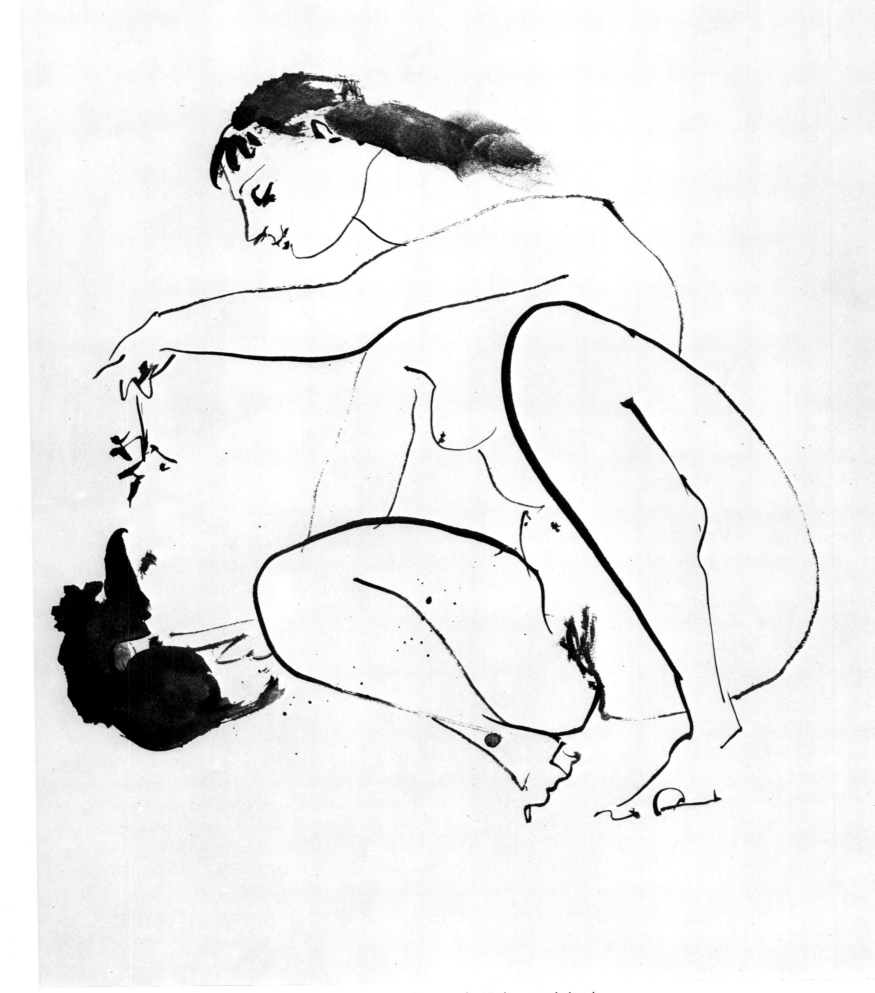

4.1.54.

Picasso. *Woman with a Monkey*. 1954. India ink

264

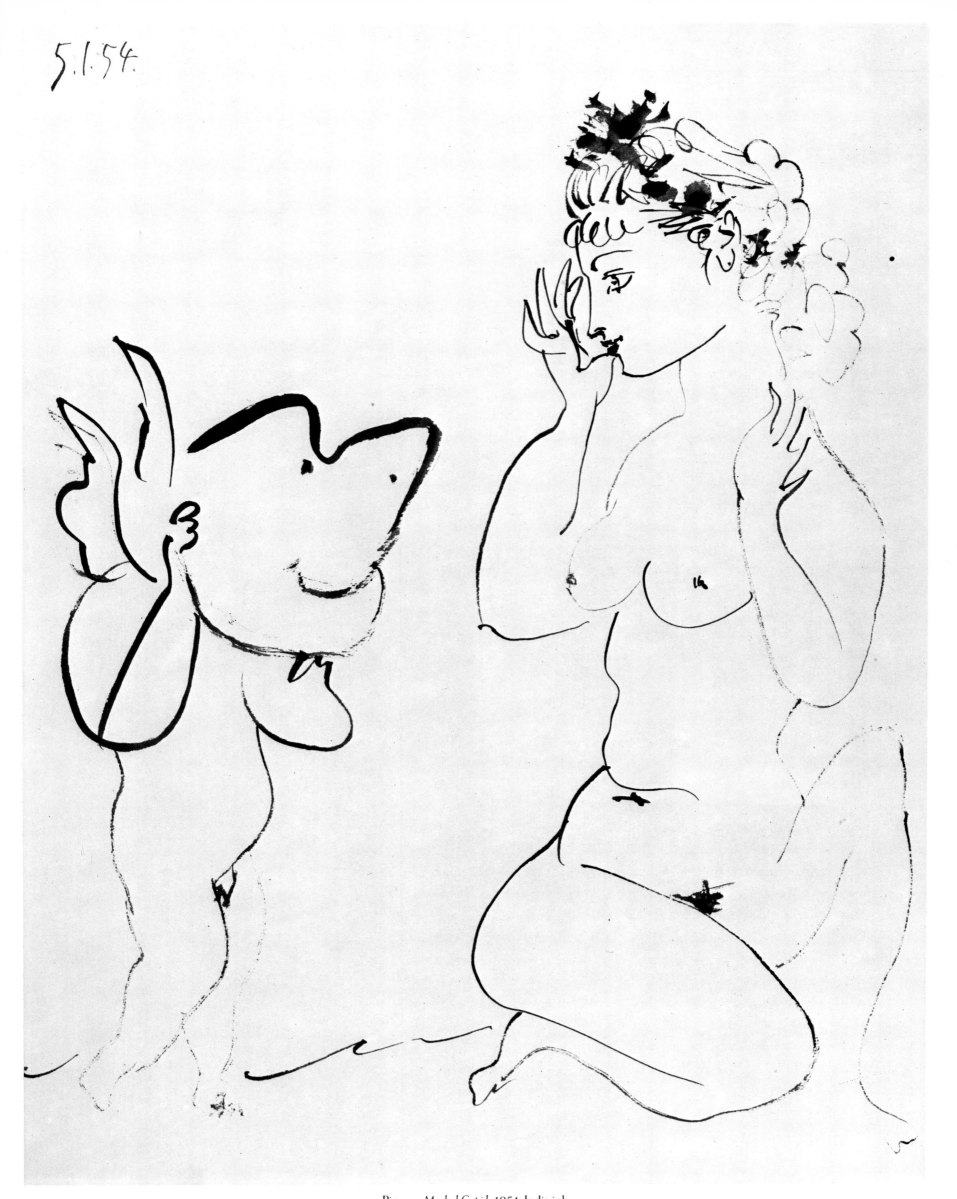

5.1.54.

purveyors of glamour and vagabonds never sure where the next meal is coming from. Talking of Picasso as he was at the beginning of his Blue Period (the hue, notoriously, is that of melancholy), Sarbatès wrote in his *Picasso, Portraits and Reminiscences*: "He regards art as a product of sadness and pain—and on this we agree. He believes that sadness teaches us to meditate; that suffering lies at the root of life."

Disgusted by the conventions of organized society and challenging the whole structure of the world around him, the romantic artist alternates between savage irony and rapturous effusion. When he ceases to idealize, the Romantic takes to "debunking," showing up the flaws of the established order. The man who uses irony whether as a mask or a weapon of offense knows all too well that behind laughter there may be tears; and if the actor's "truth" is often but a stage effect, another, truer truth may underlie the mummery. Hence the progeny of those curiously ambivalent punchinellos who made their appearance as far back as in the work of the younger Tiepolo; *L'homme qui rit* and the tragic clown (e.g., Triboulet whom Shakespeare prefigured with Yorick's skull and of whom Verdi made his *Rigoletto*) combine with the ill-starred *fille de joie*—Fantine and La Dame aux Camélias who in Italy became the "woman gone astray" or *Traviata*—to prove how misleading it may be to trust appearances. And perhaps in *Pagliacci*, where the theme of the man who weeps behind a laughing mask and remains his own sad self under the motley is carried to its logical conclusion, we have the "type genus," as a naturalist would say, of melodrama.

It is often rewarding to look behind the scenes and to observe what is happening in the wings. Beneath the semblance of play is something serious, and behind seriousness something laughable; hence the touch of clowning in the man who stands on his dignity, the sadness of the professional laugh-maker. There is food for entertainment as well as instruction when we take the familiar puppets to pieces. In his latest drawings Picasso shows both sides of the picture: the great artist as a figure of fun and the mountebank as a man of sorrow, and he does this so effectively that we suspect there is an element of each in his own make-up, despite the clear transcendence of his genius. For the romantic-minded artist everything hinges on this give-and-take between appearance and reality; thus many have succumbed to the lure of finding in it a justification for insisting on appearances. Picasso, however, is too clear-sighted in his quest of truth to become a more or less involuntary dupe: Not for him any escape into a dreamworld any more than a rejection of the all-too-human. In his art behind the perpetually challenged, dissected, and transfigured data of appearances always we find a hard core of reality ("There am I, and there I always am," as Rimbaud said).

Picasso has explored the field of art so thoroughly that he well knows its limits. All his life long, from the "infant prodigy" stage and that of the fifteen-year-old who had all the Old Masters' secrets at his fingertips, up to the present day, he has never tired of inventing new procedures—perhaps because for a virtuoso like himself this was the only way of continuing on his path without being bored. The doctrine of "art for art's sake" has no more determined opponent than Picasso; not that he denies art's absolute validity but that he seeks to transcend it. Yet it is equally true to say that no artist has ever dedicated his life to art more passionately than he, for what appeals to him in art—a product of the imagination—is its eminently human quality. His conception of the role to be assigned to art, that of a lifelong mistress to whom the artist gives himself up unreservedly without vainglory or exaggerated ideas about a "vocation," is illustrated, it would seem, by the frequency with which he has employed and still employs the theme of the painter and his model.

In the illustrations of Balzac's *Unknown Masterpiece* this theme—painter and model—is treated from what we might call the professional angle: that tussle between the craftsman and his sitter which is at once the central idea of the story and a résumé of a basic human situation.

(*continued on page 268*)

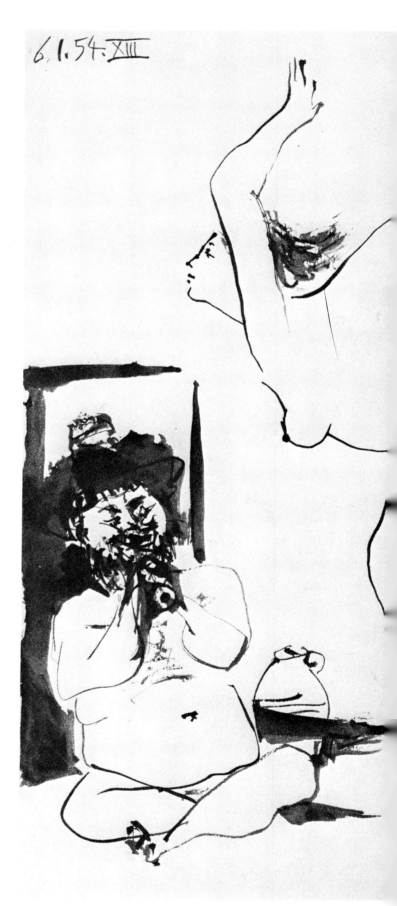

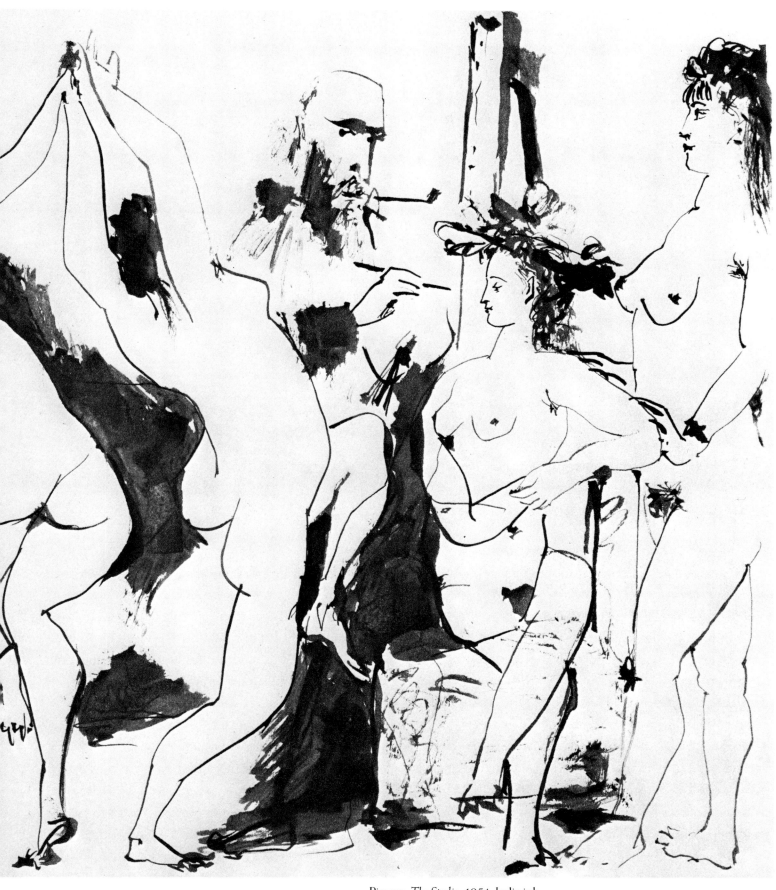

Picasso. *The Studio.* 1954. India ink

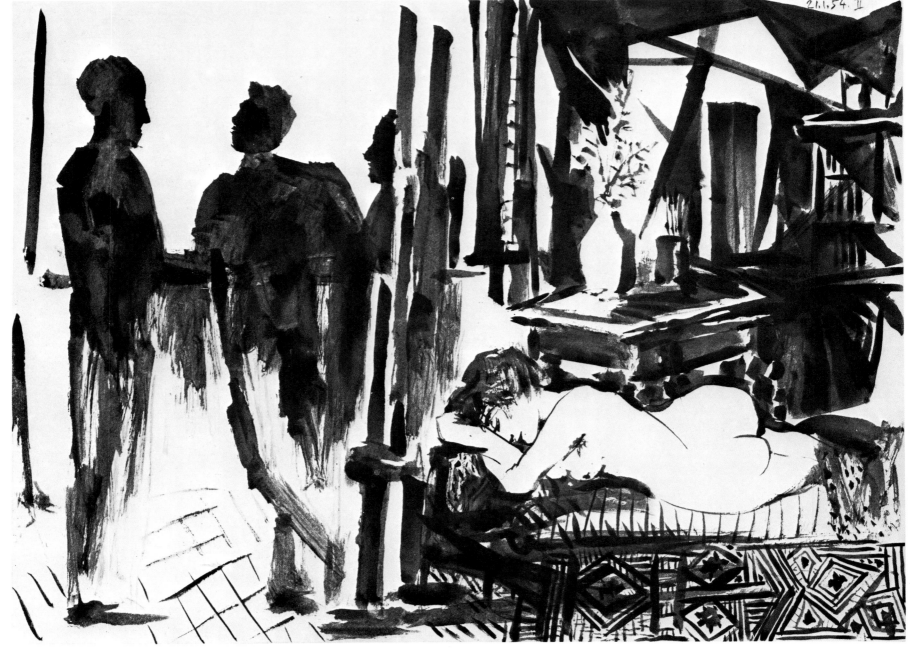

Picasso. *The Visit to the Studio*. 1954. India ink

Painter and model, man and woman—in the field of art as in that of love, there is always a duel going on between the subject and the object, adversaries forever facing each other and separated by a gap that no one, however great his genius, can hope to bridge. As a symbol of the conflict that takes place within a studio, one of the illustrations shows a bull charging a horse, in other words, a fight to the death.

Timeless, almost mythological figures in *The Unknown Masterpiece*, the artist and his model are treated differently in these later drawings. Both are strongly characterized, sometimes to the point of caricature. As a rule the models have little claim to beauty; some indeed are aged harridans and some wear such objects of everyday use as wristwatches, shoes, and socks. The painters, too, are of every conceivable type, young and old, short-sighted or lynx-eyed, desperately in earnest or mere triflers. Often we see an old or ugly man facing a young woman who, like La Tarte in "Gros-Pied's Artistic Studio," may be described as "gloriously beautiful." The painter-and-model situation is but one of the many occasions when man and woman face up to each other; and these, in turn, are included in that wider predicament of the conscious self confronting the not-self, "somebody else." Thus in many drawings the painter is replaced by quite differ-

ent figures, and we are shown a freak wooing a lovely lady, a masked Cupid, a Carnival "King," the melancholy clown (a survivor from Picasso's circus-folk period), a monkey (another reminiscence of his youth), an old man who has something of the buffoon and something of a Chinese wrestler and whose cynical smile tells of long experience of the world. Each leading figure is attended by his or her acolytes—a group of observers facing a group of observed, striking attitudes or parading their venal charms; sometimes, too, by a third party who on close inspection turns out to be the painter himself. It is as though by dint of toying with so many masked figures and performing animals (another species of masquerade) the artist had been caught in his own trap and since his métier was to render others' figures, he too had come to exist only in, so to say, the figurative sense, as a supernumerary, an onlooker, a shadowy presence—a Don Juan punished for his insatiable zest for new adventure by being transformed into a lifeless effigy of the Commander.

On one sheet of this amazing sequence we see a bearded man gazing with gloating satisfaction (like a matador after a successful *estocada*) at a picture he has made of a naked woman in the pose of a fallen Bacchante. We have here a mockery of the artist's "triumph," no less burlesque than

268

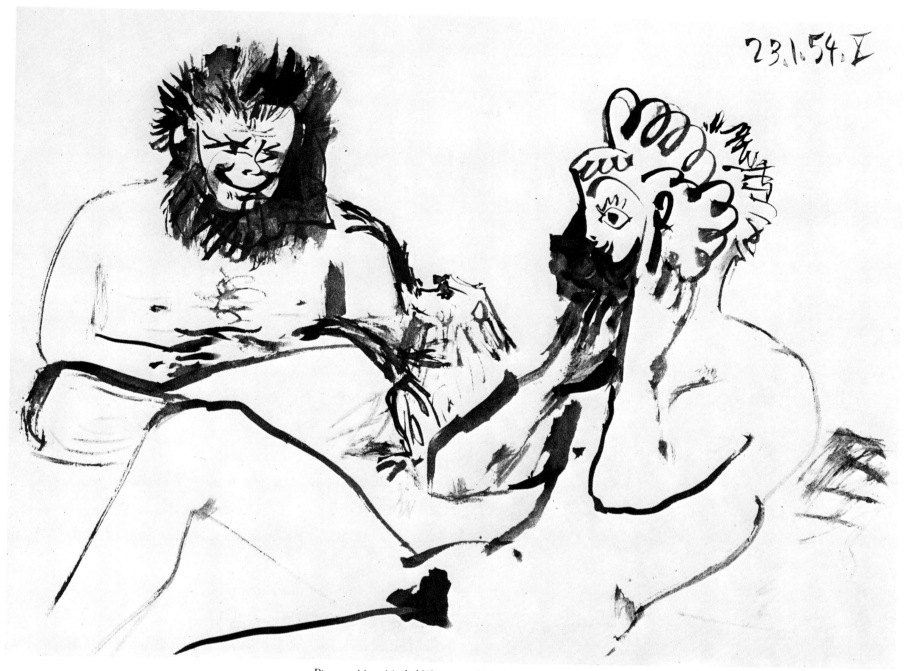

23.1.54.Ⅴ

Picasso. *Man, Masked Woman, and Monkey*. 1954. India ink

the studio scenes with visitors voicing fatuous admiration of a picture that obviously mystifies them. All alike, connoisseurs, critics, and fellow-artists of both sexes gaze at it without paying the least attention to the lush beauty of the sleeping model and equally with only the shadowiest idea of what they are extolling. In fact all concerned are mystified in one way or another; except, perhaps, the sleeping woman.

In this richly diverse masquerade, which combines something of the English Christmas pantomime and something of the Commedia dell' Arte with touches of a *danse macabre*, the very magnificence of the draftsman-ship seems to strike an added note of irony. Never has such stupendous virtuosity been so lightheartedly employed for making fun of art. Never, too, has it been proved so conclusively that the man of genius who can bring off everything he wishes with his brain and his ten fingers comes up like all of us against the basic facts of life—of life which is at best a losing game, ending in the inevitable checkmate. Behind all the scenes, ever more eye-filling, that an artist worthy of the name lavishes like a film-producer on the world, and despite the fame they bring him, he remains as he was in the beginning, as helpless as the common run of mortals: a clown titivating his eyebrows in front of a small mirror in the presence of his wife, who is feeding a baby at the breast, or a pretty young woman pulling on her stockings. However inspired he be, no man can escape from the human situation; neither art nor love can halt the flux of time which, once the gay adventure of youth is over, plunges him into a game of blind man's bluff in which the winners too (the "jackpot-snatchers" as they are called *chez* Gros-Pied) are losers....

For nothing survives except, so long as we remain alive, that human tension shared by all the living and binding us to them. And may it not be that those two terms "nobody" and "all" stand for two complementaries, not opposites, the poles between which has evolved, to the rhythm of a *dramma giocoso* ruling out optimism and despair alike, the amazing art of Pablo Picasso, by common consent the greatest artist of our age? It is perhaps worth noting in conclusion that both he and that great exponent of the comic sense of life, Charlie Chaplin, made their first bow to the public at almost exactly the same time; that both alike came on the stage with a minimum of make-up and by the same token a minimum of defer-ence to the conventions of the day—and that both have lived to witness a social revolution worldwide in scope.

(Excerpts)

269

VERVE
Numbers 31/32 Fall 1955

Carnets Intimes de Georges Braque

Throughout his life, Georges Braque kept a kind of "illustrated diary" that was a repository for sketches and drawings, as well as for thoughts and maxims. Its primary purpose was to capture an idea or impression as it flashed across Braque's mind, and was intended solely for his own use. Consequently, he was not inclined to make his notebooks public. It took the insistence—and friendship—of Jean Paulhan (who published collected excerpts from the *Carnets*) and Tériade, to coax Braque into sharing with the world a series of pages from these notebooks filled with drawings that are often as complex as paintings.

If these works on paper use the techniques of drawing—sketches mostly in charcoal or pen-and-ink—they belong to the world of painting. Braque handled his drawing implement as though it were a brush, as if he were trying to load his lines with ink the way a painter loads his brushstrokes with paint. There were times he did add color, unobtrusively: acidulated yellow contrasting with light brown, verdigris green, and above all, blues, blues, and more blues. The blues of Braque!

On page after page, on loose sheets of paper that Tériade photographed in the artist's Paris studio on the Rue du Douanier (Braque refused to be separated from his precious notebooks), the artist observes objects in space. He made a rapid sketch of his initial vision, sometimes pushing its execution very far; the addition of his signature certified that he considered it a finished work.

From the profusion of notebooks spread open [in the studio], Tériade selected material and decided how all of it might best be arranged in *Verve*.

This double issue opens with a prefatory statement: "This publication contains a group of drawings from the notebooks of Georges Braque. Ever since he was a young man, the artist has made it a daily practice to set down visually his artistic ideas and whatever stimulated him emotionally. These books constitute a veritable diary, similar to a writer's diary, but composed of drawings, gouaches, and watercolors. Until now, Braque has refused to publicly share his notebooks, from which he is rarely separated, and which form the core of his graphic oeuvre. He has just authorized us to reproduce some pages from them and was good enough to help us in the selection process."

Unfortunately, Tériade did not specify the dates, or even the periods, when these drawings were done. According to Will Grohmann, who helped prepare *Verve* Nos. 31/32 for publication: "The chaos that had engulfed the world in those years during and just after the war inspired Braque to paint these pictures with their resonant colors depicting everyday objects—not musical instruments, pipes, or playing cards, but pitchers and washbasins with a cake of soap and a hairbrush, or kitchen tables, or little cylindrical stoves; or still lifes with a loaf of bread, a coffee mill, a piece of gourd or a sickle, occasionally some flowers (and notably, in 1944, one *Salon*). Unable to leave his house on Rue du Douanier, Braque confined himself to his immediate surroundings, to the necessities of daily life, to the mundane objects to which he knew how to give artistic value, as he had done during the Cubist period."

There is nothing even remotely contrived or deliberate about these notebooks. Braque observed. Eyes and hands. Consider the "accuracy" of the dazzling series of female faces at the beginning of *Verve*

Nos. 31/32. They embody the vigor, and frailty, of real young women. The faces are distinctive, sturdy, yet so sensitive. For Braque, Cubism was no longer a methodology; it was simply one of many means at his disposal to interpret what he saw.

Here, Braque is in full possession of his artistic means. "As you get older, art and life become indistinguishable," he wrote. However, as Grohmann points out, because Braque was at the pinnacle of his personal and artistic maturity, he could also say, "Now I am going to begin."

The frontispiece—a splendid original lithograph entitled *Attelage* (1955)—is a mythological subject, a descendant of the oneiric figures that first surfaced in Braque's illustrations for Hesiod's *Theogony.*

The chariot, driven by a goddess and drawn by a team of three horses, seems to bring together a number of themes that will develop more fully as the reader turns the pages of the magazine. In the same way, the large birds that cross the title page will also return later on. There is a musical quality to every issue of *Verve,* and this two-page spread is like the overture to an opera.

Several of the lithographs enlarge upon this theme of the chariot: we see Braque's predilection for teams of horses, the figural combination of space and action, the contrast between hooves and wheels. (And the thought must have crossed Tériade's mind as he leafed through Braque's notebooks: Might not some of these drawings be suitable for a book whose inspiration would be ancient Greece?)

After this introduction, the reader is invited to enter the artist's studio and finds a young woman seated by a cast-iron stove, her hands on the nape of her neck. Not a sound; this is a world apart: the woman offers her body to the gentle glow of the crackling flames.

A magnificent series of young women's faces (all with serious expressions) leads us to a succession of nudes—contrasts of light and shadow, presence and disappearance, remembrance and death.

The principal leitmotifs of the next section involve the bull, the bullfight (four original color lithographs), the horse, the model in the studio, women playing musical instruments, women at a dressing table, profiles, and—of course—birds (lithographs in blue and black).

It is not generally known that Braque did these now-famous lithographs expressly for this issue of *Verve.*

The remainder of the magazine proceeds on two levels: (imaginary?) female figures in the studio, and sketches of flowers and leaves. There are also startling pages filled with hats, bicycles, and crabs.

In conclusion, a magnificent lithograph that shows a large bird spreading its unmodulated wings across two pages brings this issue of *Verve* to a close. Paradoxically, *Verve* Nos. 31/32 turned these personal notebooks into a public monument to Braque's glory!

Georges Braque. Page from a notebook

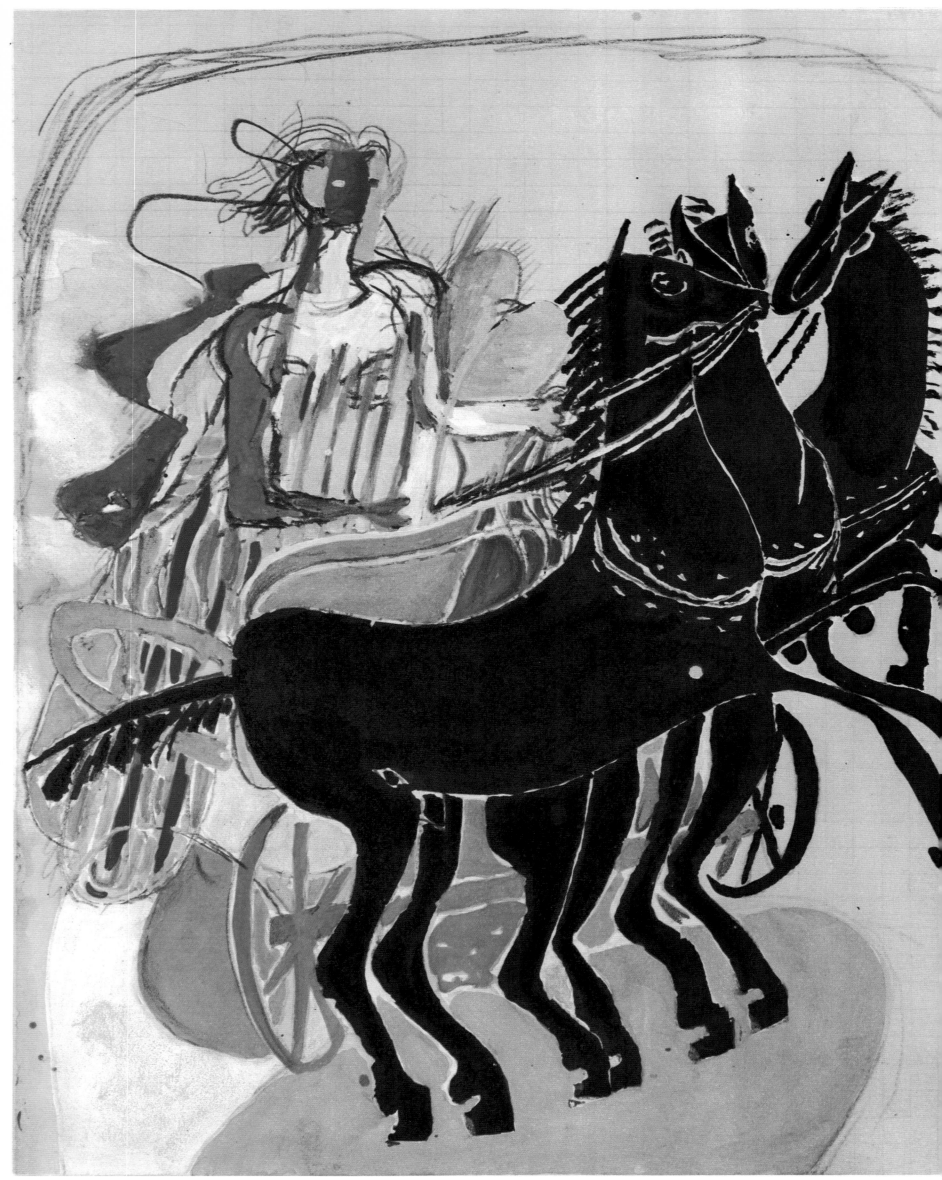

Above: Georges Braque. *Attelage*. Frontispiece. Lithograph Right: Georges Braque. Title page

CARNETS
intimes

DE

G. BRAQUE.

VERVE~

Left and above: Georges Braque. Pages from his notebooks

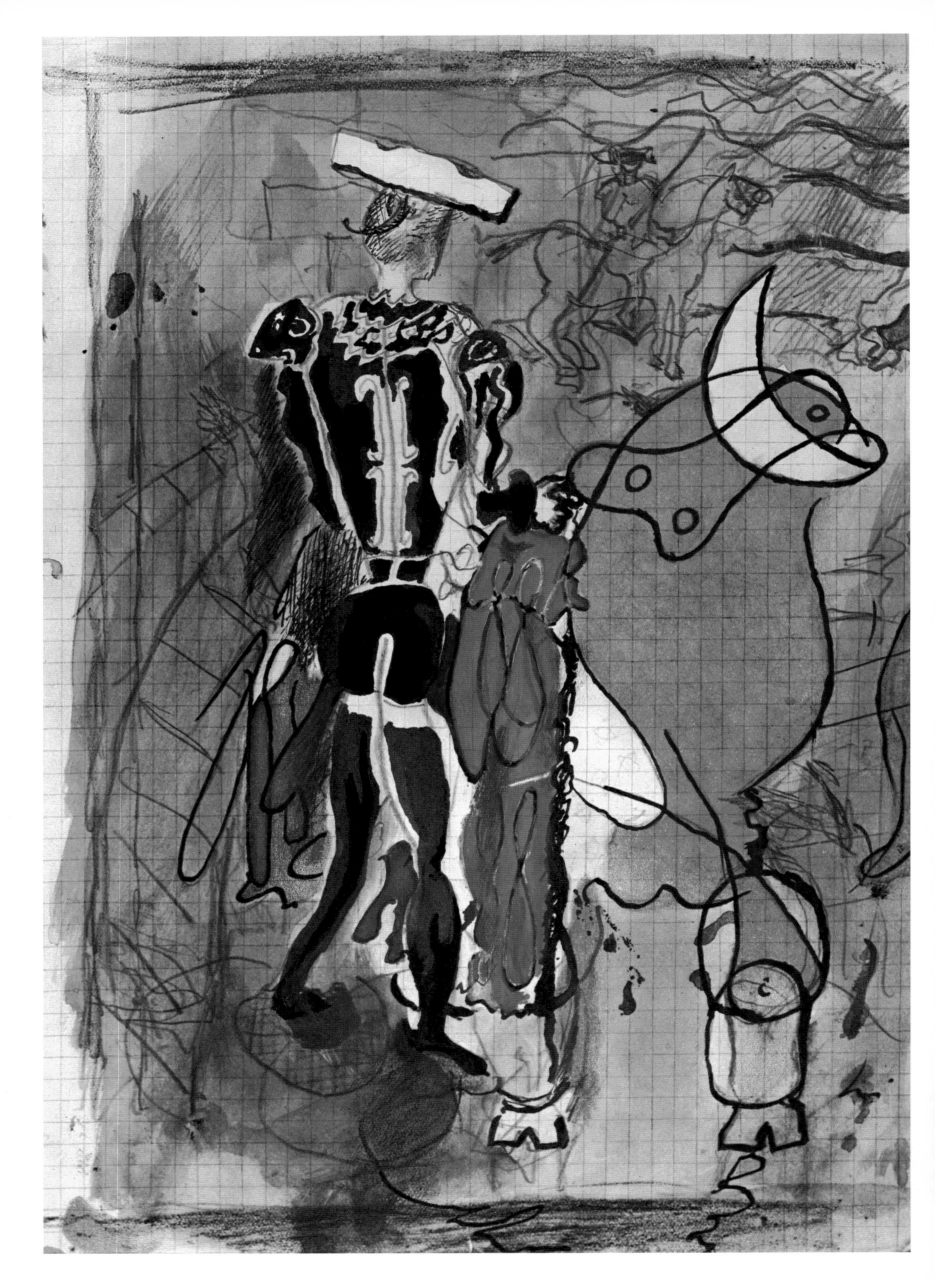

Left and above: Georges Braque. Pages from his notebooks

Above and right: Georges Braque. Pages from his notebooks

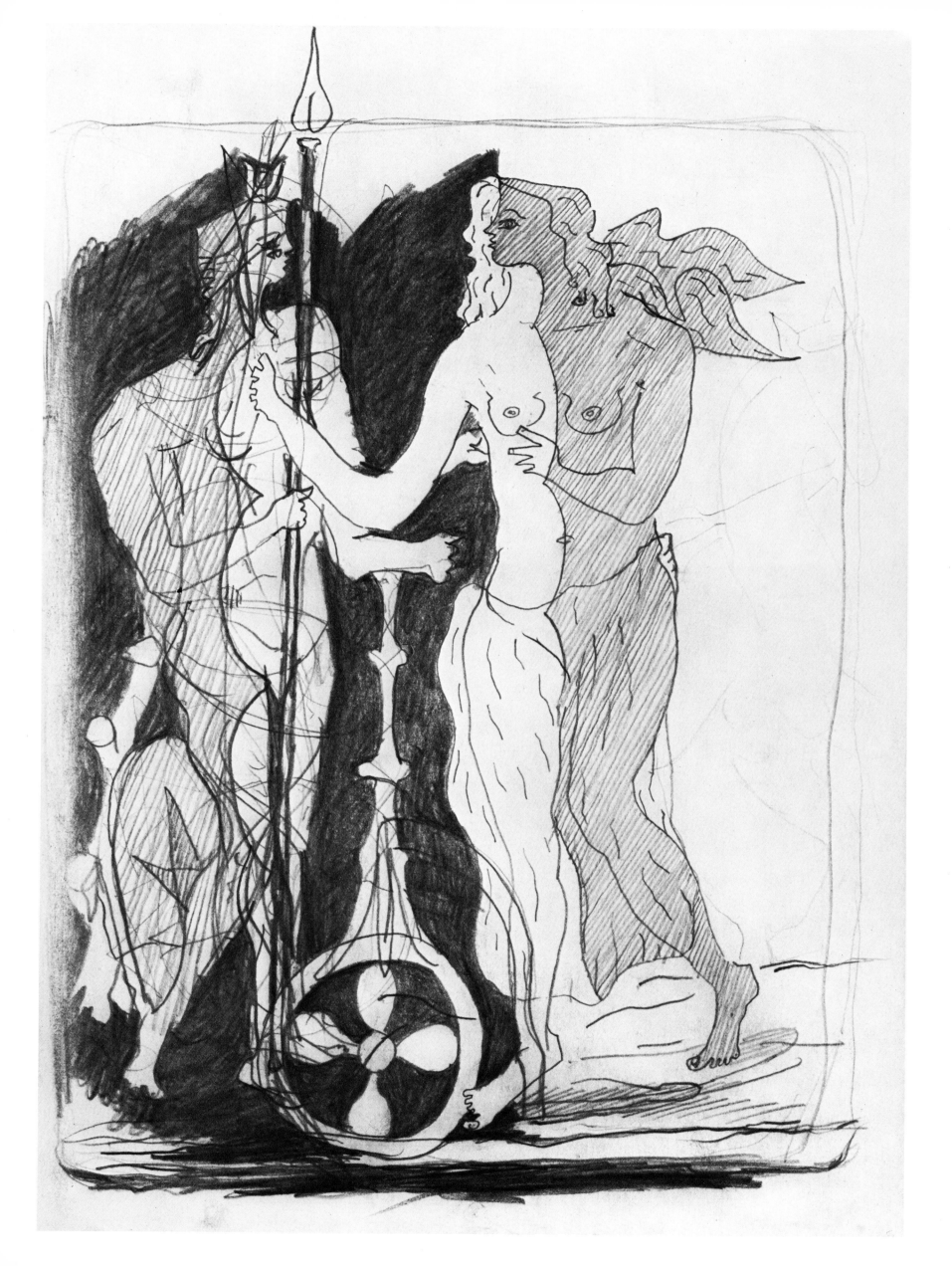

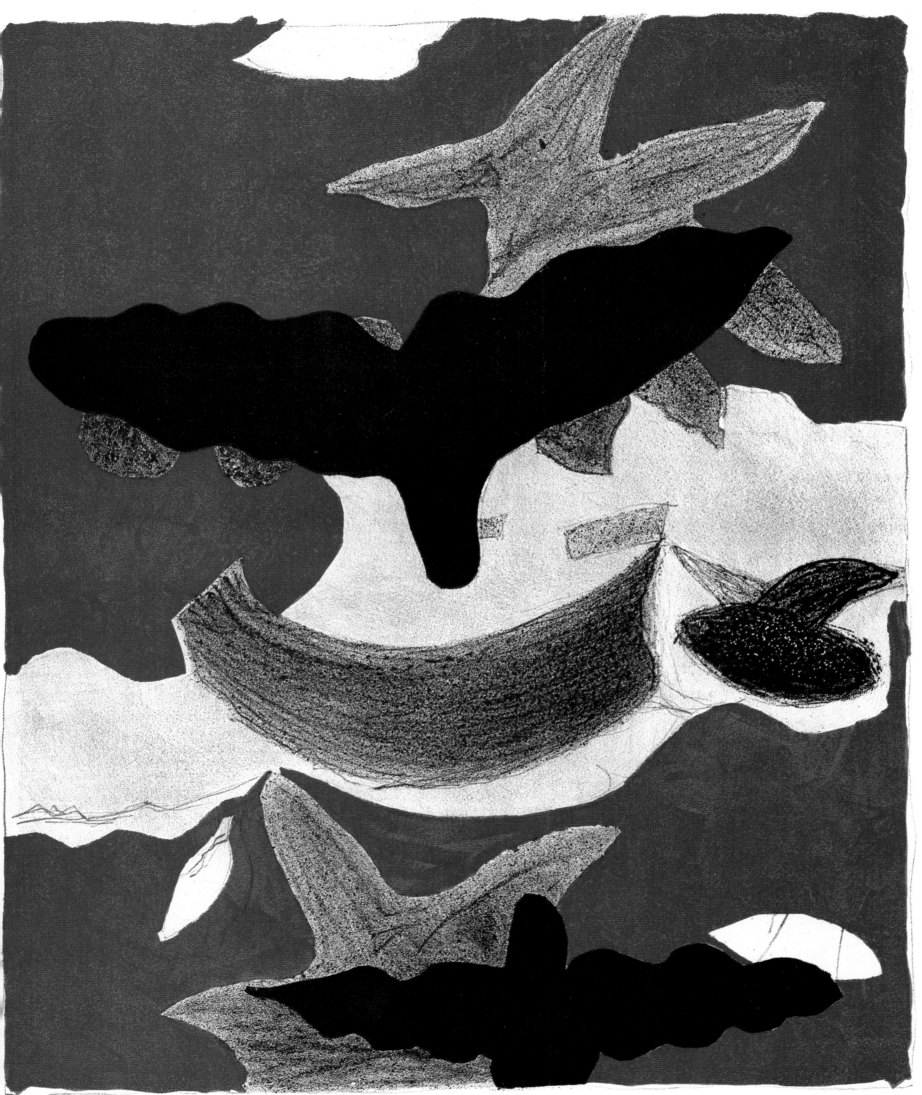

Left and above: Georges Braque. *Birds*. Lithographs

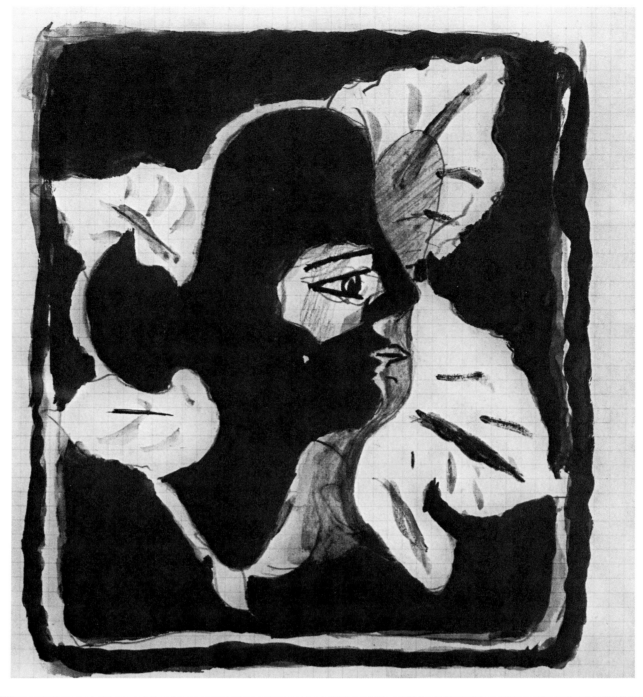

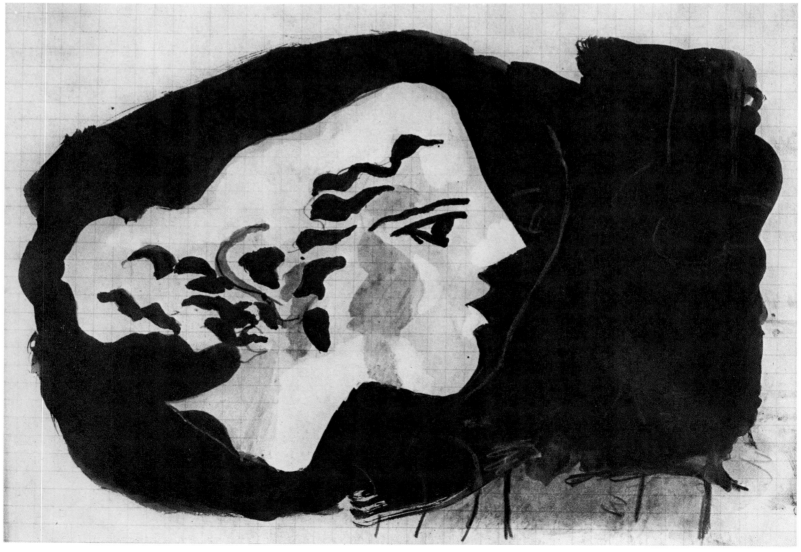

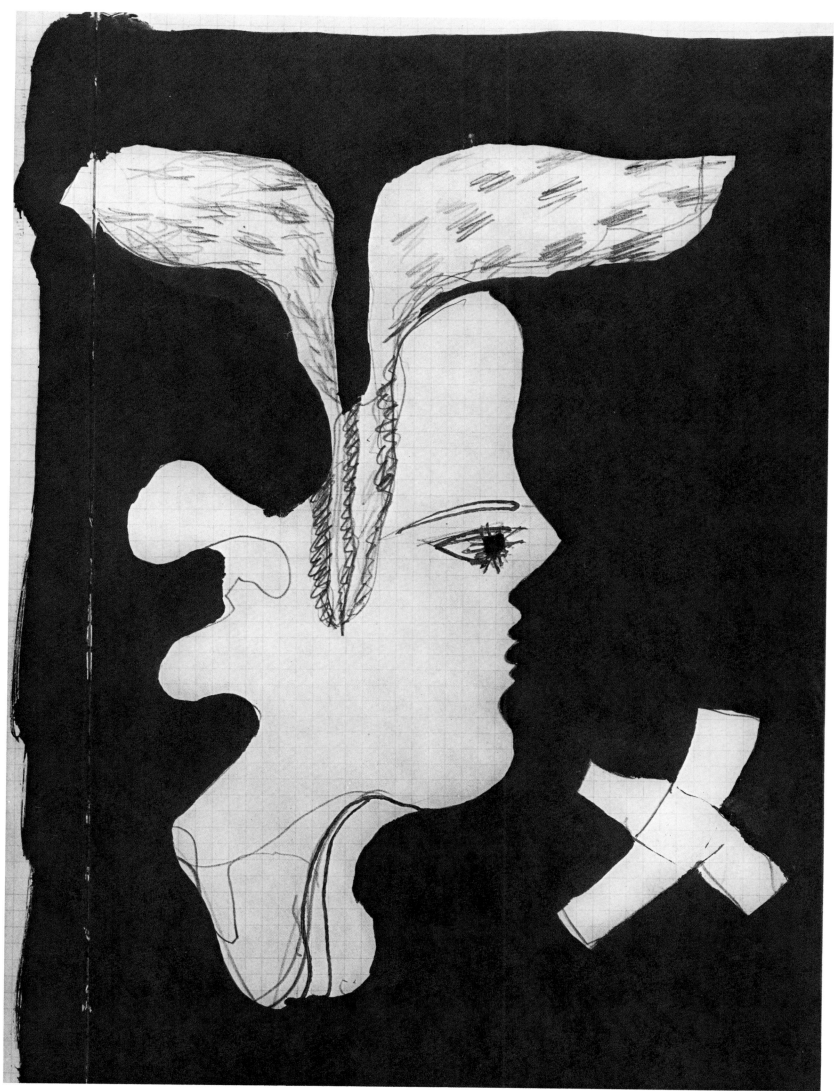

Left and above: Georges Braque. Pages from his notebook.

Pages 286 and 287: Georges Braque. *Bird*

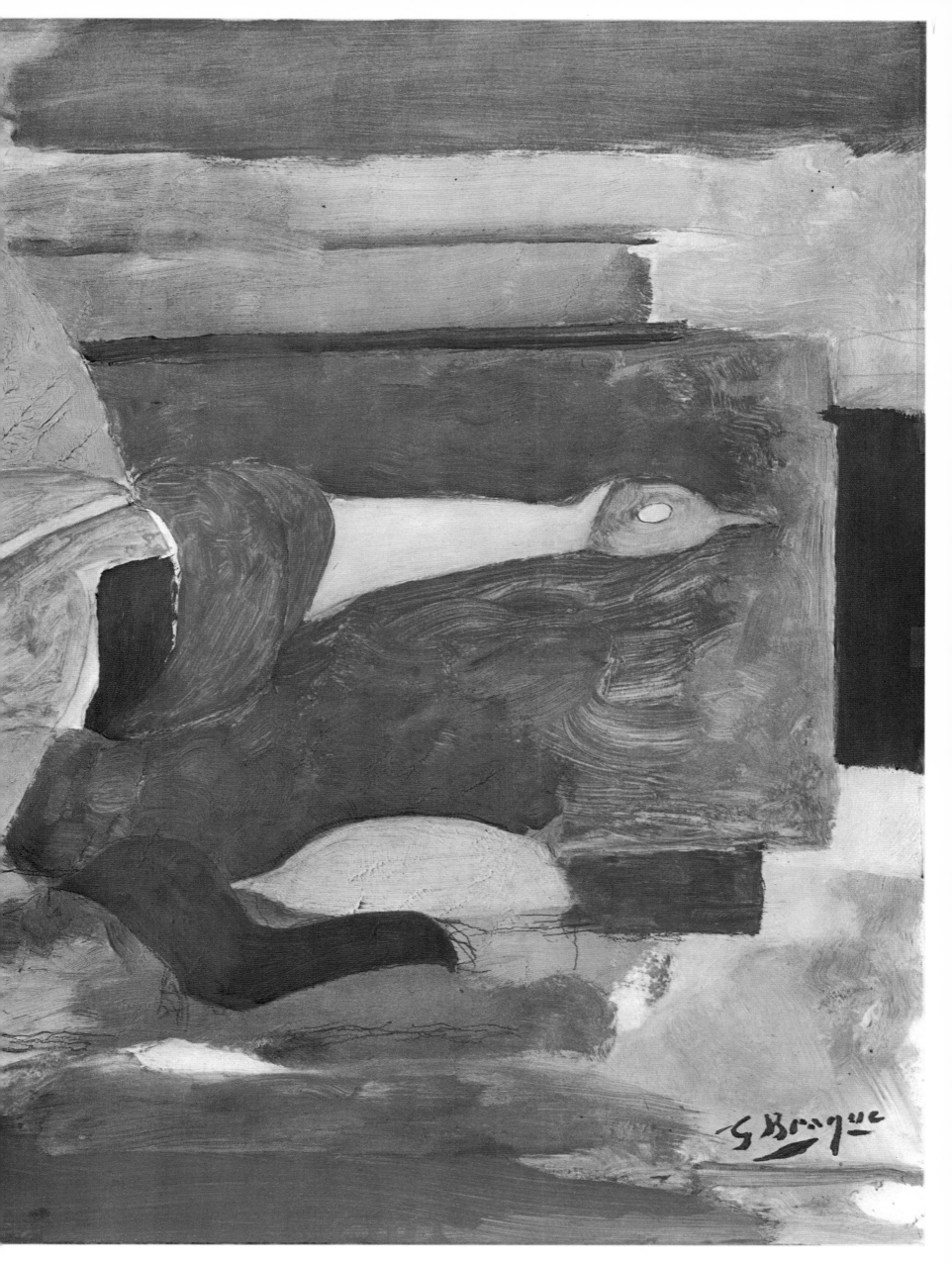

Left and above: Georges Braque. Pages from his notebooks

BIBLE

Marc Chagall

VERVE

VERVE
Numbers 33/34 September 1956

This double issue of *Verve* contains photogravure reproductions of all 105 etchings Marc Chagall did between 1930 and 1955 for his illustrated Bible. (Chagall also created sixteen color and twelve black-and-white lithographs expressly for *Verve* Nos. 33/34, as well as the cover and title page.)

Of all the painters with whom Tériade worked, Chagall is perhaps the most deserving of the title "Master Architect of the Book." Each series of works (to which he would devote many years) is a veritable monument. Unafraid to bare his innermost soul, he interiorized every text he illustrated with love and almost religious humility. His Bible and his "Drawings for the Bible" (*Verve* Nos. 37/38) bear witness to the tremendous amount of labor that went into what Chagall himself later referred to as *Le Message biblique*. Using only the elements furnished by the text, he neither added nor deleted. It was by reliving each event from within that Chagall worked his magic, and the special chemistry that resulted makes each of his books an organic whole.

Tériade published five Chagall books. The first three (Gogol's *Dead Souls*, La Fontaine's *Fables*, and the *Bible*) had originally been commissioned by Ambroise Vollard, who died [in 1939] before they could be published.

Each of these books marks a crucial juncture in the cyclical process of Marc Chagall's work. The etchings for the Bible, for example, were done at the height of Nazism, which accounts for their seeming urgency and need to express a growing anguish.

To follow the *Fables*, Chagall and Vollard had begun discussing a monumental project: the idea of an illustrated Old Testament, from Genesis to the Prophets. Dissatisfied with his initial attempts, Chagall decided that the best source of inspiration for these sacred texts would be the Holy Land itself. He traveled to Syria and Palestine in 1931; the experience made a lasting impression upon him. The paintings that he did on this theme bear the traces of this encounter that would run throughout his work. His linework became more dense; his faces acquired the magical presence of masks.

The Bible project left its mark on every aspect of Chagall's art. When Vollard died, sixty-six engraved copper plates were finished and another thirty-nine roughed out. The work had been done in the studios of Maurice Potin, a painter-engraver, who pulled the sixty-six etchings between 1931 and 1939. The artist reworked and completed the remaining thirty-nine plates with the assistance of Raymond Haasen, who printed them between 1952 and 1956.

The book assumed its definitive form with the help of Ida Chagall, who patiently culled verses from the Holy Scriptures. The passages that appear in Chagall's illustrated Bible are based on Hebrew texts translated by the Clerics and Teachers of Geneva in 1638.

The painter's efforts thus extended over a very long period, to say the least: from 1931 to 1952 for the etchings, and to 1956 for the original lithographs published in this issue of *Verve*. Although these illustrations date from different periods in the artist's career, they all reflect a tremendous unity—that of the tradition and intensity of the Holy Scriptures themselves. Yet, Chagall's *craft* may have had as much to do with this as his source of inspiration. To quote Franz Meyer,[1] his "graphic technique was now one of great purity and simplicity. The texture of lines, now loosely, now compactly woven, gives the etching

its forms, creates light and dark, makes delicate shadowings and the blacks pervaded by light. Through the density and overlapping of lines, through subtlety and fervor, the graphic material suggests the plumage of birds. . . . Chagall often fixes etched parts with varnish; however, such parts are more frequently than before [in the *Fables*] worked over with etching, and the result is a quite unique texture of light and shadow. By using sandpaper or transparent varnish, he obtains an extreme subtlety of tonality, such as sometimes occurs in a particularly luminous sky."

In addition to the original lithograph on the cover of *Verve* Nos. 33/34, the frontispiece, and the title page, Chagall also drew the titles and the editorial credits.

The order of the material in this volume, and especially of the twenty-eight original lithographs Chagall created for *Verve* Nos. 33/34, corresponds to that in his illustrated Bible. There are four main sections: Genesis, Moses, Kings, and Prophets.

Franz Meyer writes of these new lithographs: "They complete and enlarge the earlier sequence, some being based on new themes, others laying a particular stress on some of the old themes and thus shifting their accent. All have the same freedom of technique as the most recent drawings and gouaches. The color is laid on in broad expanses, or surges up with sudden intensity from the background, in contrast to the light nuances of the blacks in the reproduced drawings."[2]

This issue of *Verve* opens with an appreciation of Chagall's vision of the Old Testament, by Meyer Schapiro.

1. Franz Meyer, *Chagall: His Graphic Work*, Harry N. Abrams, New York, 1957.
2. *Ibid.*

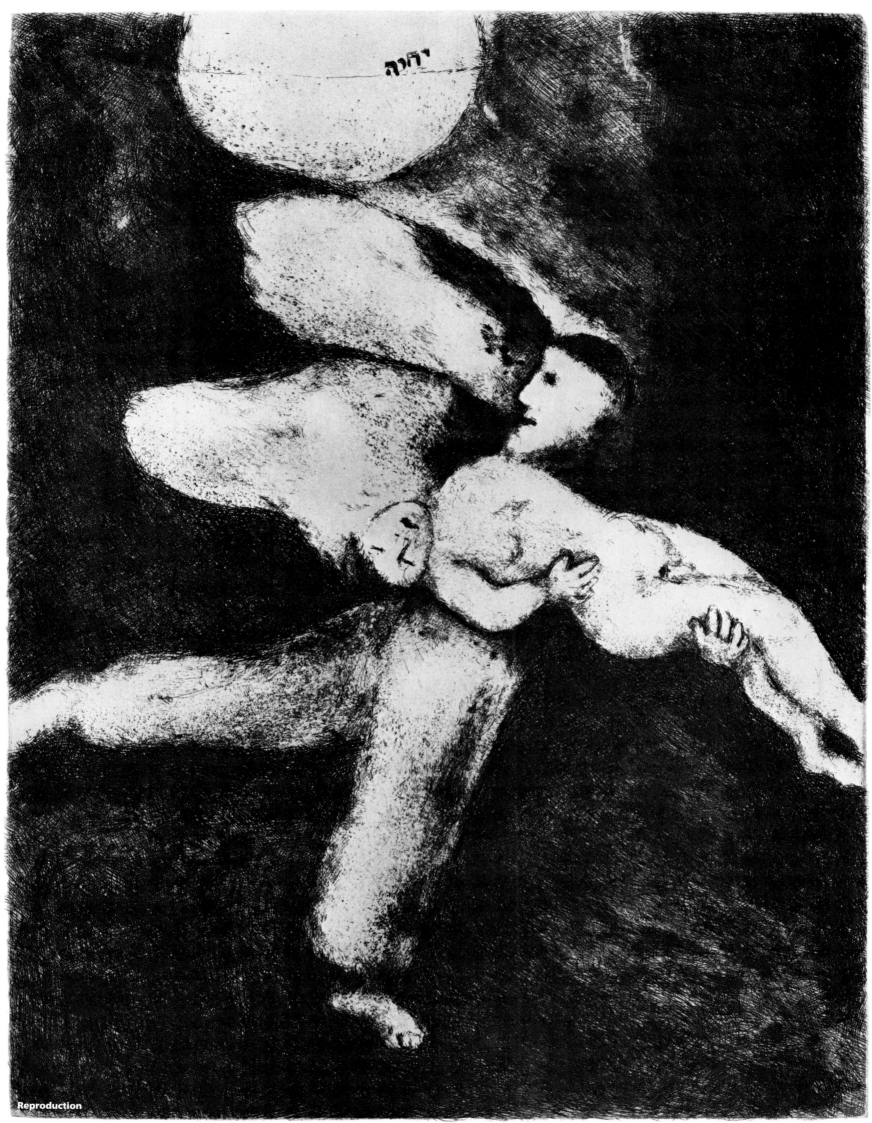

Chagall. *God Creates Man and Gives Him the Breath of Life* (reproduction)

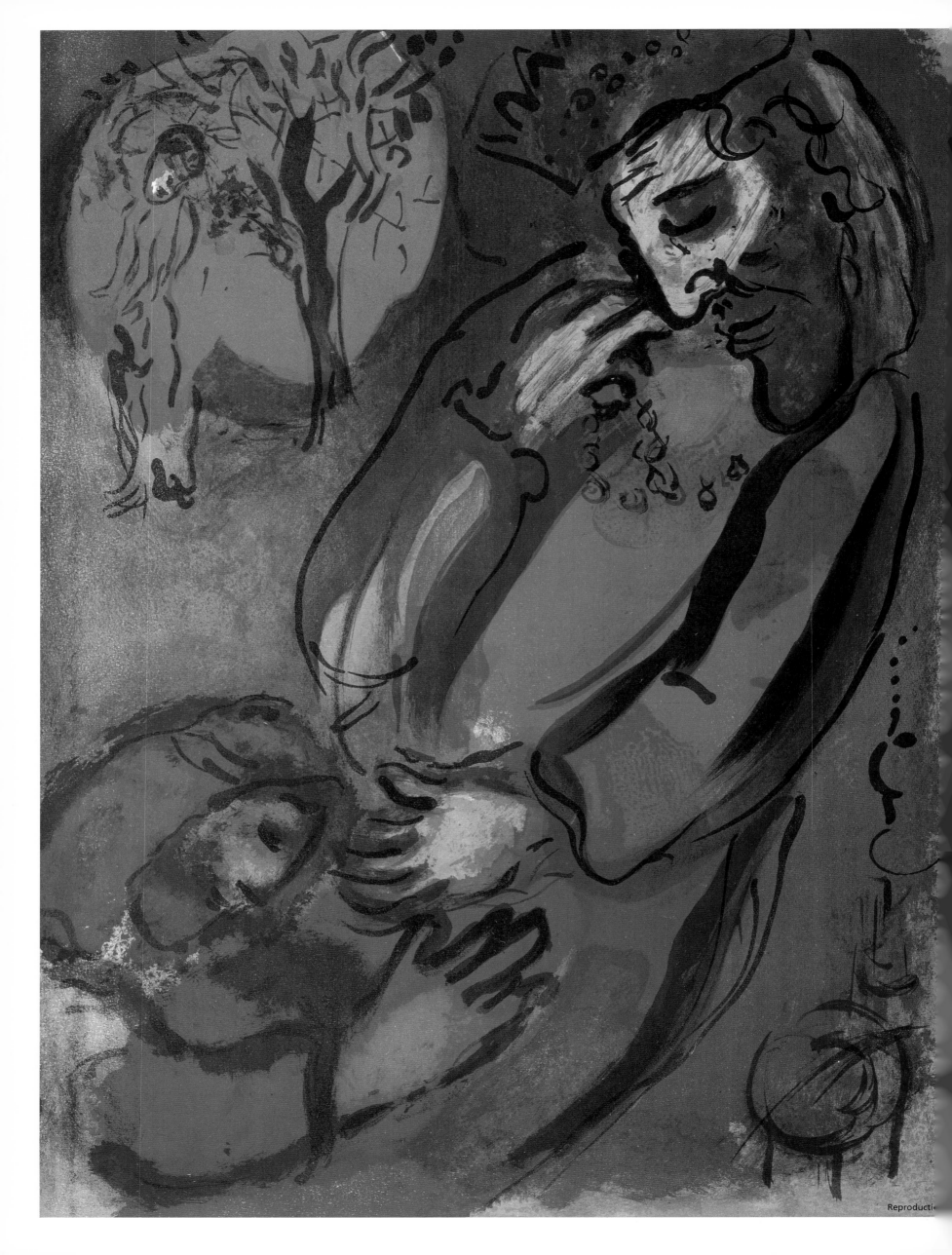

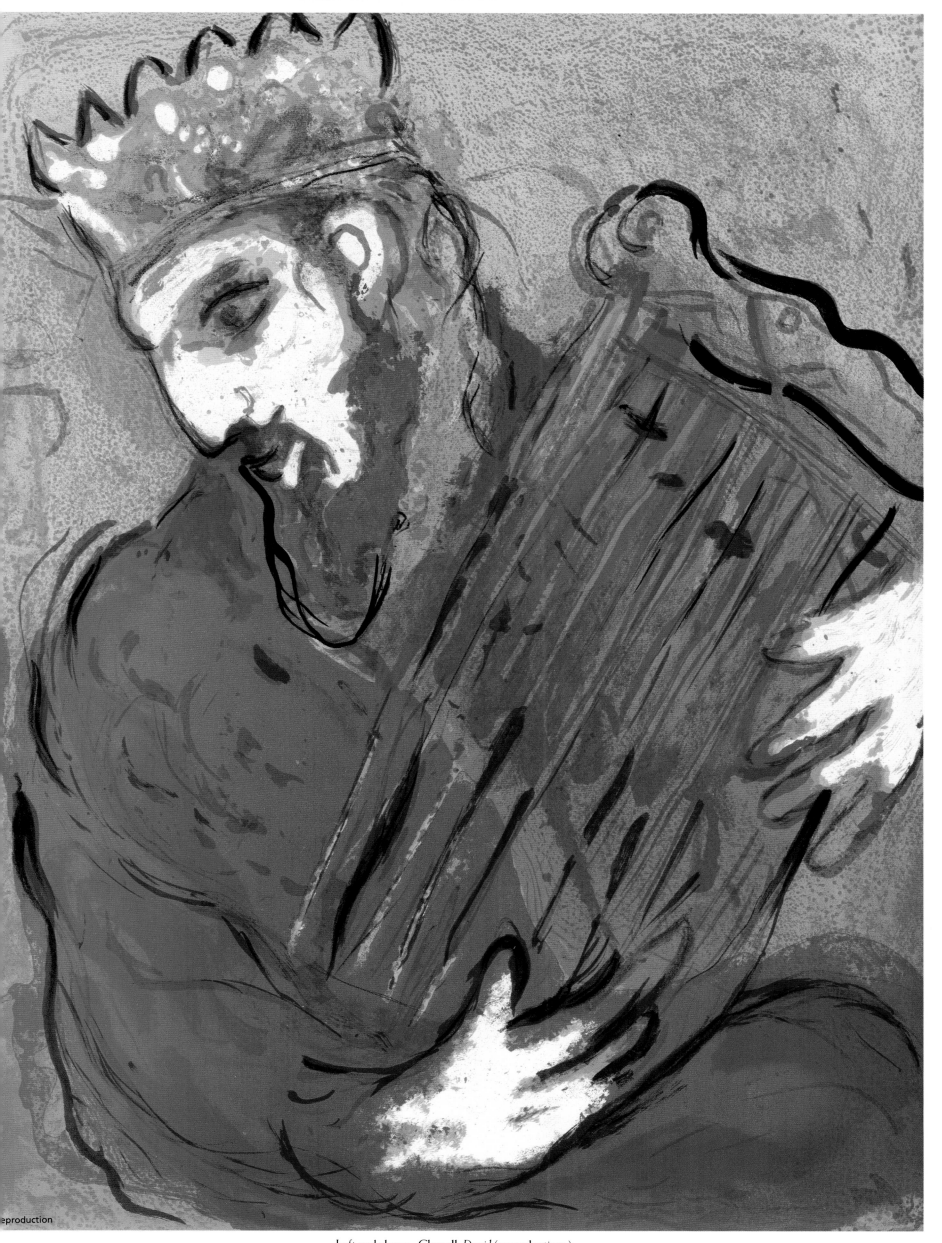

Left and above: Chagall. *David* (reproductions)

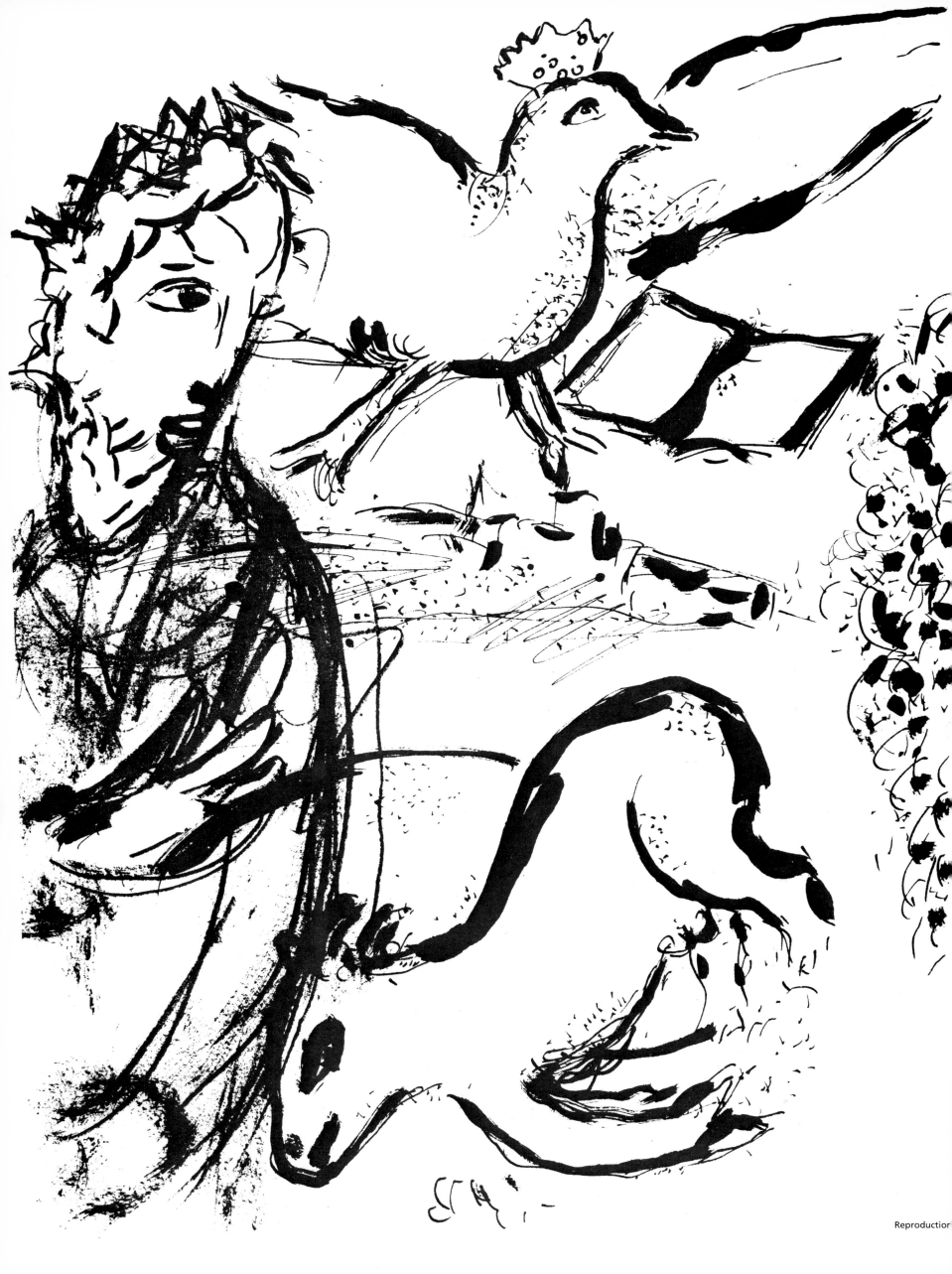

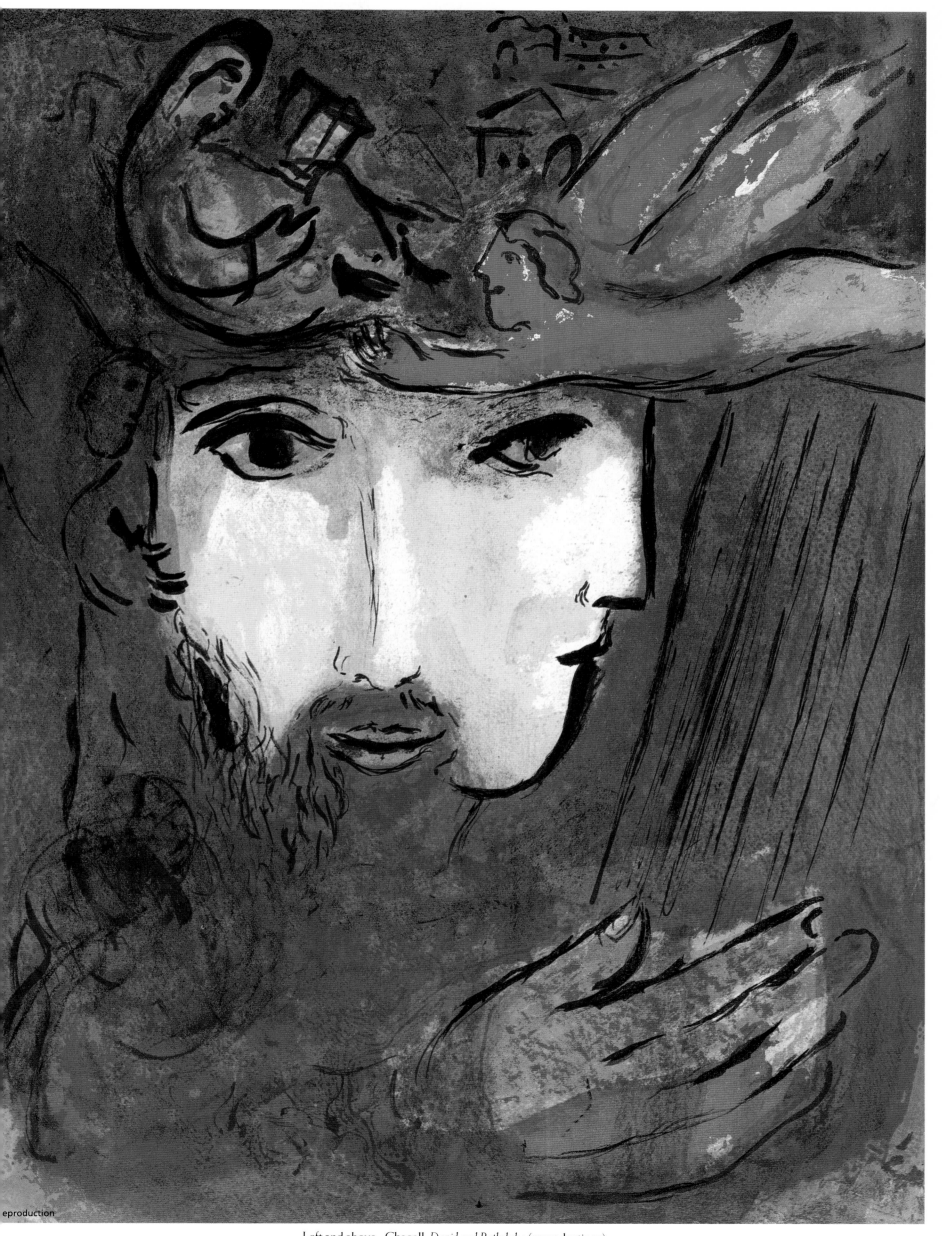

Left and above: Chagall. *David and Bathsheba* (reproductions)

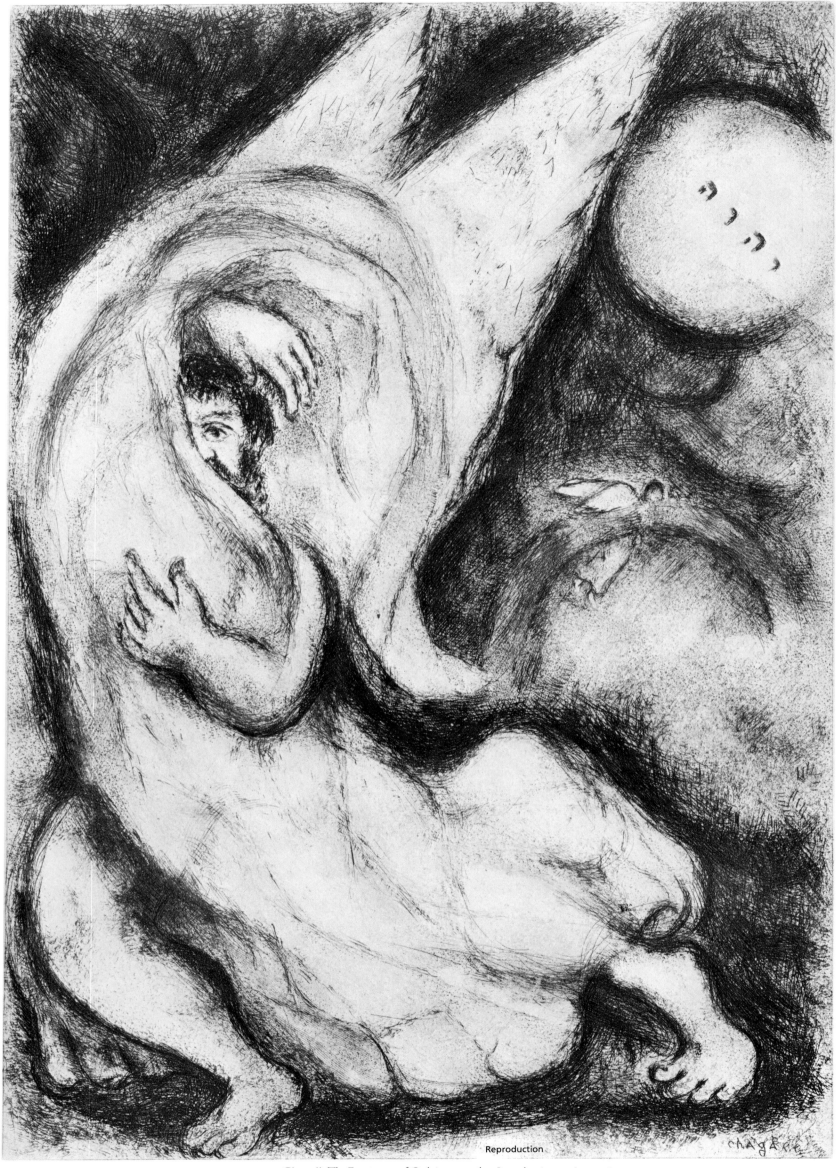

Chagall. *The Forgiveness of God Announced to Jerusalem* (reproduction)

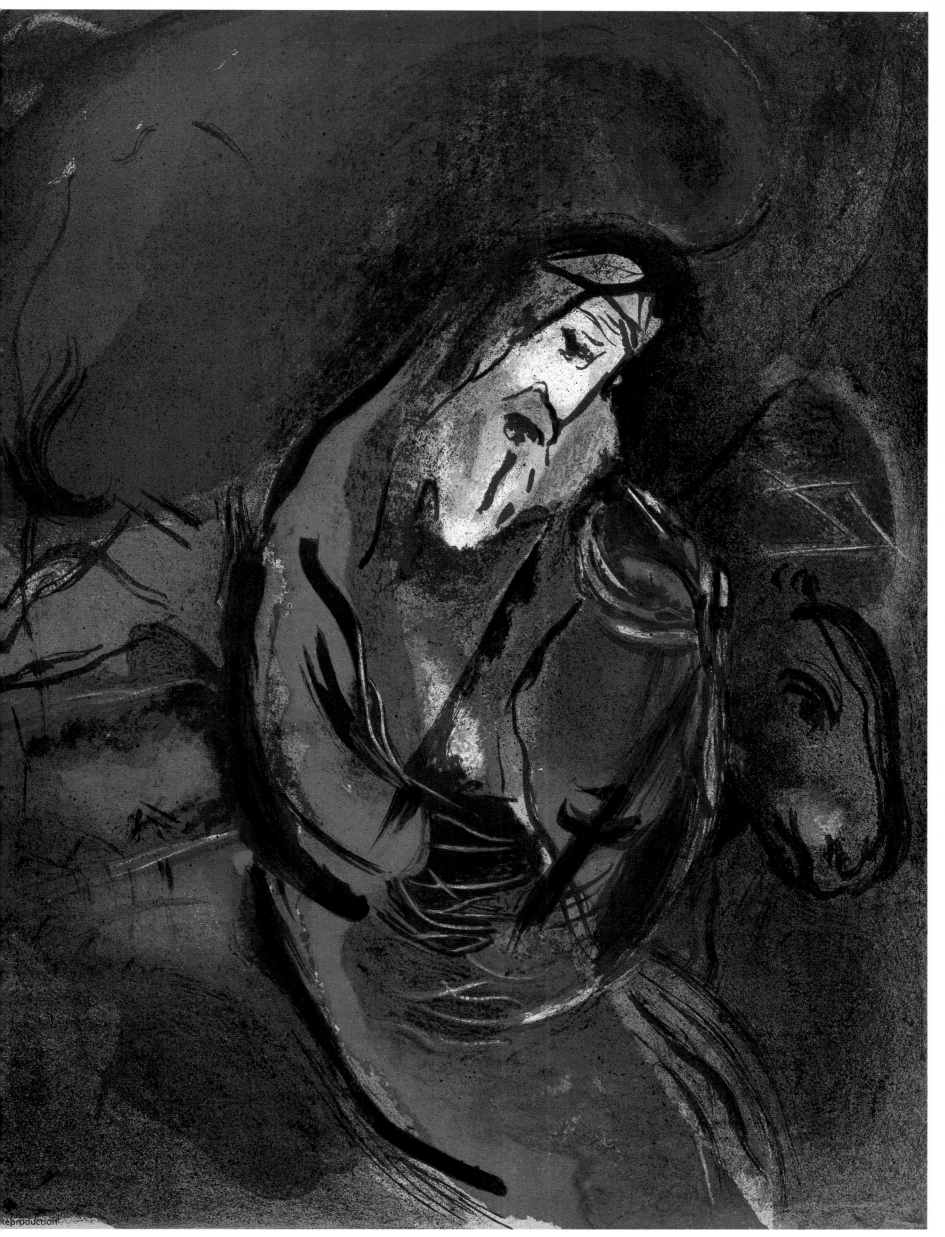

Chagall. *Jeremiah* (reproduction)

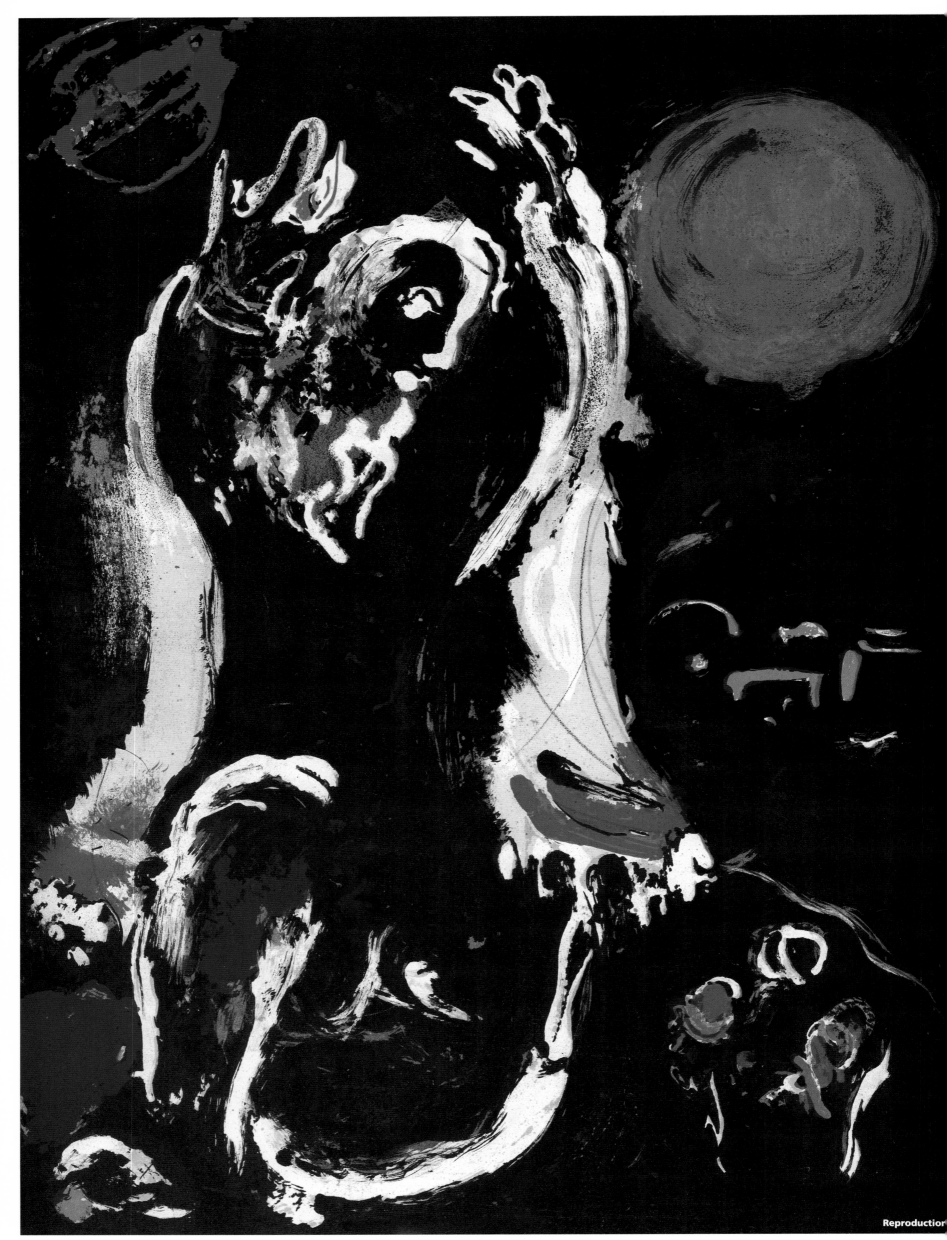

Chagall. *Isaiah* (reproduction)

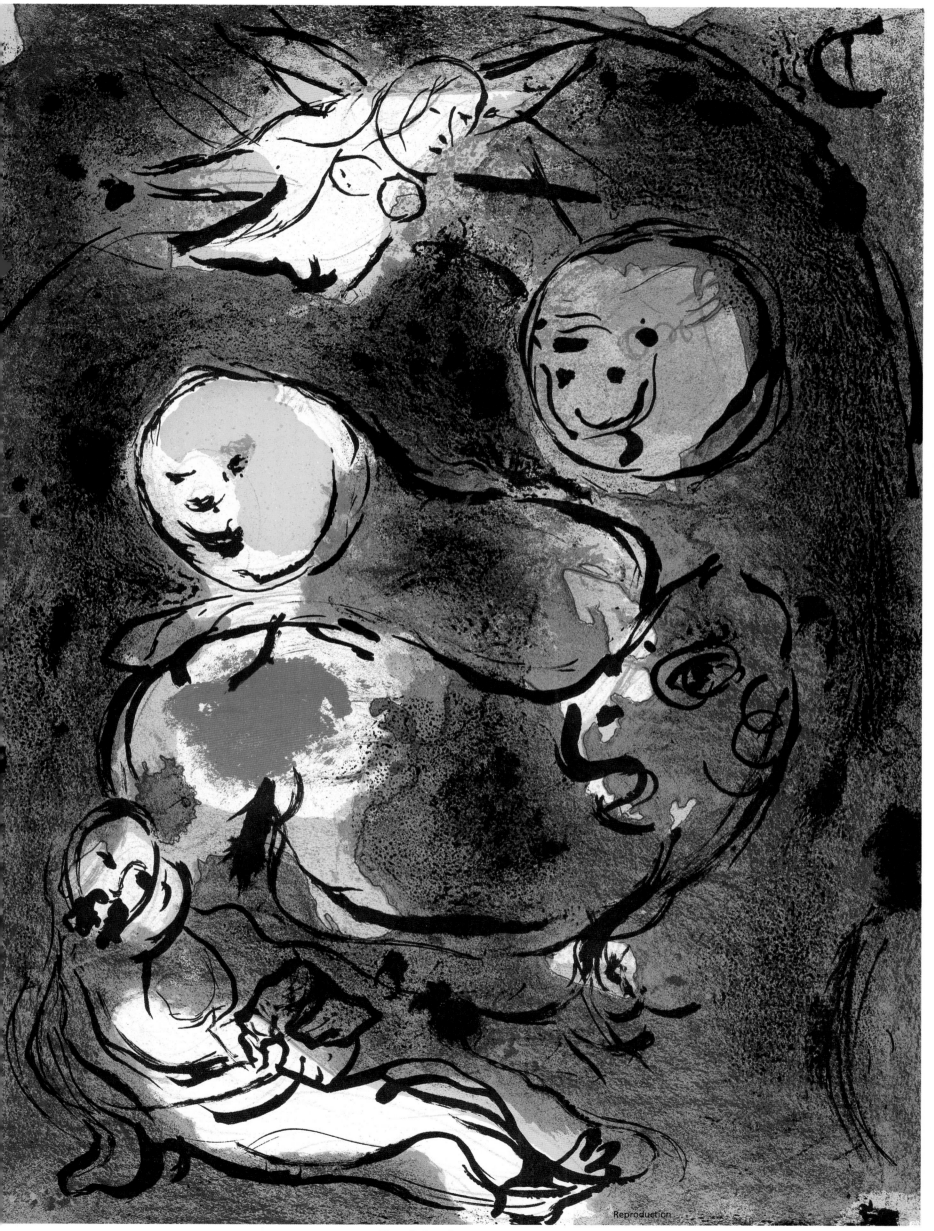

Chagall. *Daniel* (reproduction)

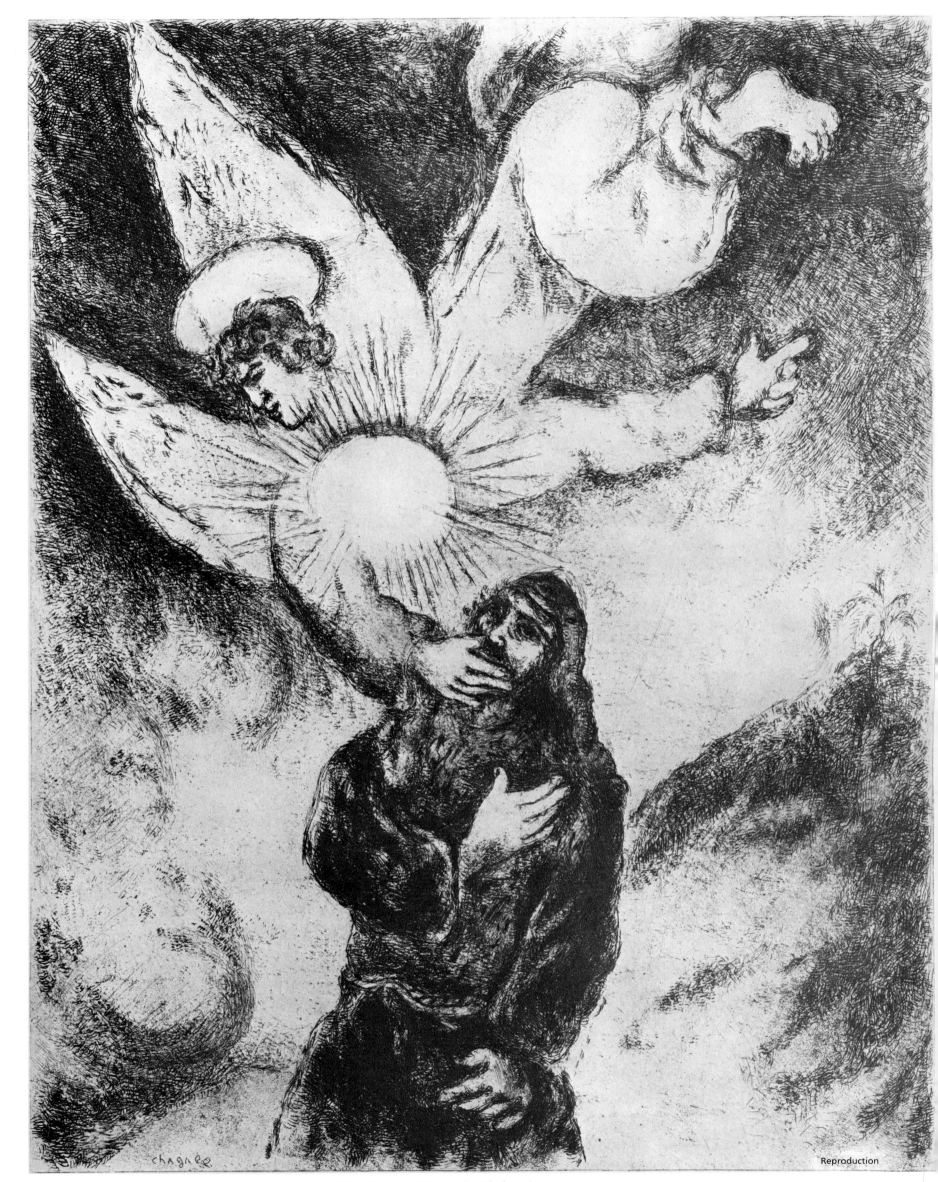

Chagall. *Jeremiah Receives the Gift of Prophecy* (reproduction)

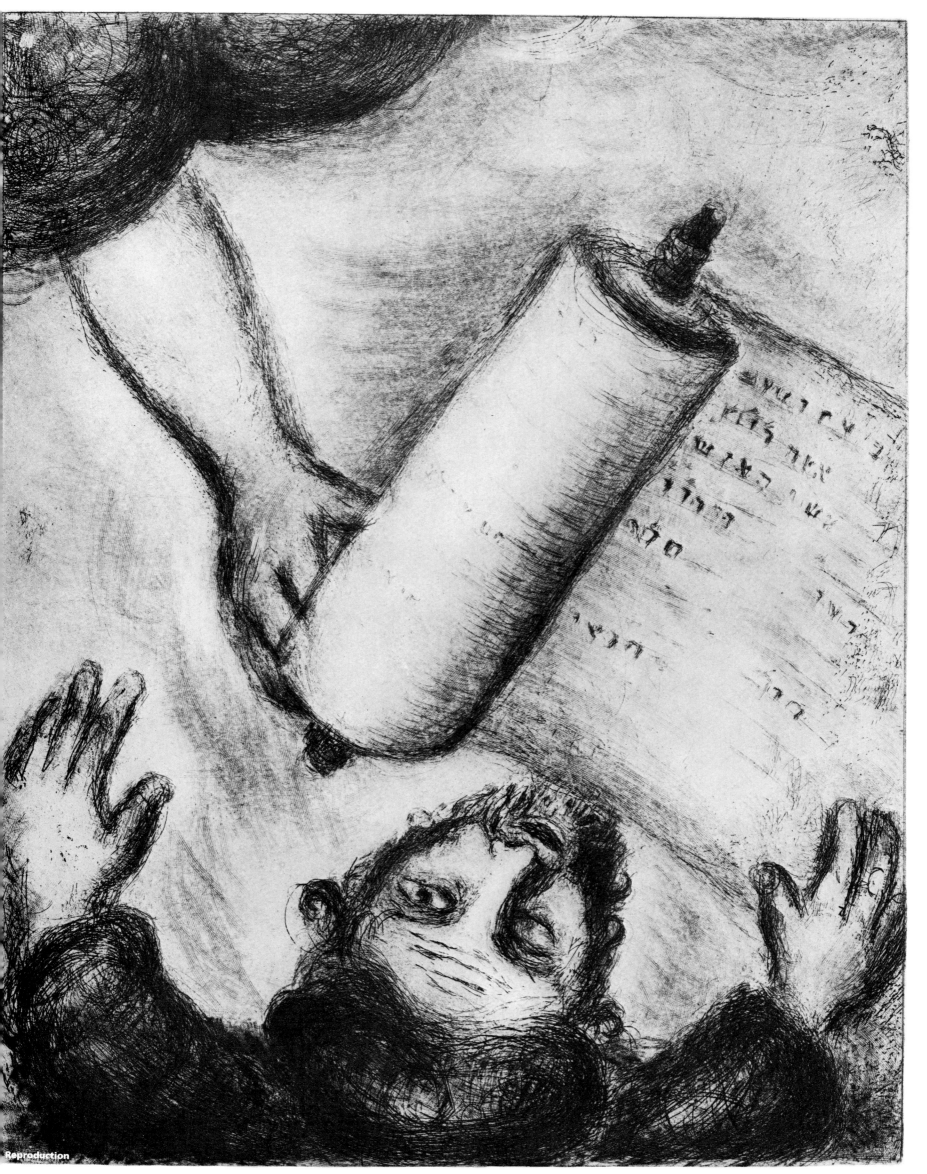

Chagall. *Ezekiel and the Roll of Prophecy* (reproduction)

Last Works of Matisse: *1950–1954*

With this issue, *Verve's* life cycle had almost reached its conclusion. It was late summer, the time of the harvest: beautiful, ripe fruit fell into Tériade's hands in this enchanted orchard! Like the first issue, twenty-one years earlier, the next-to-last features a cover by Henri Matisse. In this posthumous tribute to the artist, this *orange issue* so filled with sunshine, we find a sumptuous echo of the pictorial revolution launched by *Jazz*. "This double issue of *Verve* is devoted entirely to the last works of Henri Matisse, 1950–1954," Tériade writes in his introductory note. "Reproduced by color lithography, they were done in gouache on paper which the artist cut out with a scissors and pasted onto other paper. They are accompanied by drawings from the same period or earlier. Matisse did the cover expressly for this issue. The first lithograph plates were printed under his supervision in 1954. The lithography is by Mourlot Frères, photogravure and typography by the master printers, Draeger Frères. Printed July 28, 1958."

A lengthy text by Pierre Reverdy, "Matisse in Light and Happiness," introduces the volume, using these two words in their strongest sense—light and happiness being the two brilliant stars illuminating the final eight years of Matisse's life. In the final chapter of his monumental book, *Matisse*,[1] Pierre Schneider observes: "What distinguishes these new works is their luminosity—a luminosity that is unprecedented not only in his own work but in all Western art. He himself, incidentally, was aware of this. On August 25, 1953, when a journalist from *Look* magazine asked him what direction he thought modern art was taking, he replied, 'Light.'

"…Light no longer nourished [his] forms and colors, it devoured them." An airplane trip to London in 1937 had made a lasting impression on the artist. "When we have returned to our modest condition of walking," Matisse later wrote, "we will no longer feel the weight of the gray sky weighing upon us because we will remember that beyond this wall of clouds, so easily crossed, there exists the splendor of the sun, the perception of limitless space, in which we felt for a brief moment so free."[2]

This decisive experience, which the artist called a "revelation," inspired a new program: "Find joy in the sky." The Chapel of the Rosary in Vence, *Jazz*, and this issue of *Verve* were manifestations of it. The means of achieving this conquest were drawings done in brush and India ink, as well as the systematic use of colored gouache paper cut-outs. Comparing this light to the kind he had tried to capture in his Fauvist paintings, Matisse said, "At that time, I was ignorant of the light that comes from within, the mental, or if you prefer, moral light. Now, each day is lived in that light."

Matisse first started making paper cut-outs from pages of printer's-ink specimen albums Tériade had given him in the *Verve* office on Rue Férou; these *papiers découpés* were used on the covers of *Verve* before they appeared in *Jazz* or in the work done for the Barnes Foundation (*The Dance*).

As for the second part of Reveredy's title—happiness—Matisse's battle was indeed hard-won. Concerning the illness that confined him to bed, Pierre Schneider notes: "…spasms plagued him, condemning him to insomnia and anxiety, and took away 'a good deal of my tranquility. My work is always paid for by a small depression like the one I've just emerged from.' His strength failed him. 'I've

been working a little, but I tire very quickly.' Yet, the work from this difficult period is totally happy, tranquil, and gives no evidence of fatigue. It is the fruit of the mnemonic function which removes the aging man willy-nilly from his present circumstances. . . .

"There are two striking aspects in the extraordinary production of 1952–53, . . . On the one hand, and no doubt as his point of departure, Matisse turned toward feminine nudes of relatively modest dimensions, and on the other hand toward enormous decorations based on vegetal motifs. These were the two components of the vision of earthly paradise he had sought to portray ever since *La Joie de Vivre*: men and women tasting the delights of a garden."[3]

The same two themes resurface throughout this portfolio of drawings and lithographs. Their point of convergence, as Schneider points out, is a quest for a Golden Age, "happiness perceived in the light of the sacred." This does not exclude, of course, any of the decorative exuberance of Matisse's work.

The artist himself spelled out his objective in remarks related by Reverdy. "What I dream of is an art of balance, of purity and serenity, devoid of troubling or depressing subject matter . . . something like a good armchair." He spoke of his arrival in Nice in 1917: "It was raining, but the next day, when, upon opening my window, it occurred to me that I was going to have that light before my eyes each and every day, I couldn't believe my good fortune."

Reverdy writes: "The prerequisite for happiness—a gift one is born with—is an innate, visceral will to be happy, a steadfastness, a perseverance, something I call an orientation toward happiness . . .

"If I say these things—at the risk of sounding impertinent, I fear—it is not to pry with intolerable indiscretion into a man's personal life when it's his work that interests us. I do so because I, who don't know the first thing about painting, critically speaking, can say nothing about his work unless I say that what impresses one about it, from first glance to last, and in all the glances in between, is the incalculable force of its happiness. . . .

"More than anyone else, he helped rid painting of meaningless prattle. Perhaps that is why, standing before his pictures, we are not inclined to expatiate upon them, no matter how intense their impact. The pleasure and sense of wonder they arouse within us are more conducive to contemplation. . . .

" . . . He ground his pink and blue colors the way others did harsh tones. His pictures fill our eyes with sky the way large seashells fill our ears with the distant sound of murmuring waves. . . .

"Since he was certainly born good, the aging Matisse could not help getting better as he got older, especially having learned, during a long, exemplary life of hard work, how to take serene immobility from the sky and eternal restlessness from the sea."

At the conclusion of Reverdy's superb text is a reproduction of *Chinese Fish*, the stained glass window in the dining room of Tériade's Villa Natacha.

A second section, in black-and-white, opens with the outspread branches of a tree (from 1951). Then, a series of extremely sensuous nudes—*Sirène* (1949); *Woman in a Loose-Fitting Blouse* (1951); a charcoal sketch of parts of a body. Interspersed among these works are large color lithographs done after well-known Matisse paintings (*The Negress*, *Sorrow of the King*, etc.). At times, this riot of color spills over onto three pages (*The Parakeet and the Mermaid*), or even four (*Swimming Pool*). The large nudes in brush and India ink alternate with blue nudes, airy cut-outs from gouached paper. The flat colors of lithography here convey the maximum visual impact.

A text by Georges Duthuit, aptly entitled "The Hewer of Light," probes the significance of those last, magnificent years. Duthuit observes that, "for the first time, the technique of sculpting was applied

to the medium of paint. The artist hews a block, not of sandstone or marble, but of color." This meant a new set of rules: "Matisse found himself in the same situation as that of an organism suddenly called upon to radically change its breathing apparatus, to switch from lungs to gills. His work started to breathe by means of a subtle expansion and contraction arising solely from the way he arranged his forms, since there was nothing more to be done with the unidimensionality of surface and the flatness of color...."

"Decorativeness, yes—but only in this sense: so that the surrounding world, the earth and its forms, the sky and its fires, our setting, might not seem alien to us any more, thanks to the intermediation of his works. They are nature's floodgate, its porch, or a pavilion amid her luxuriance, an extension of her bounteousness that reaches into the very heart of accursed cities. And the message is so vast that it adapts itself to the sparest of languages, almost to silence itself: an art that breathes in unison with the elements, rediscovered and preferred...."

Duthuit concludes this collection devoted to the glory of Mattise with a final homage: "The day of Matisse's funeral, the weather in Nice was dreary and overcast. But just as the procession was regrouping after the service to take him to his final resting place on the Cimiez heights, sunbeams suddenly pierced the canvas of clouds, drenching the sky with exactly that radiance, that luster that he had attempted all his life to capture and reflect. It was hard not to think—without meaning to be sentimental, but only because that's the way it seemed—that the sun, also, was paying a sympathetic tribute to its most faithful of servants, and that in its appearance, it was saying, 'He came as a witness, in order to bear witness to light.' "

1. Pierre Schneider, *op. cit.*
2. *Ibid.*, pp. 659–660
3. *Ibid.*, pp. 698–699

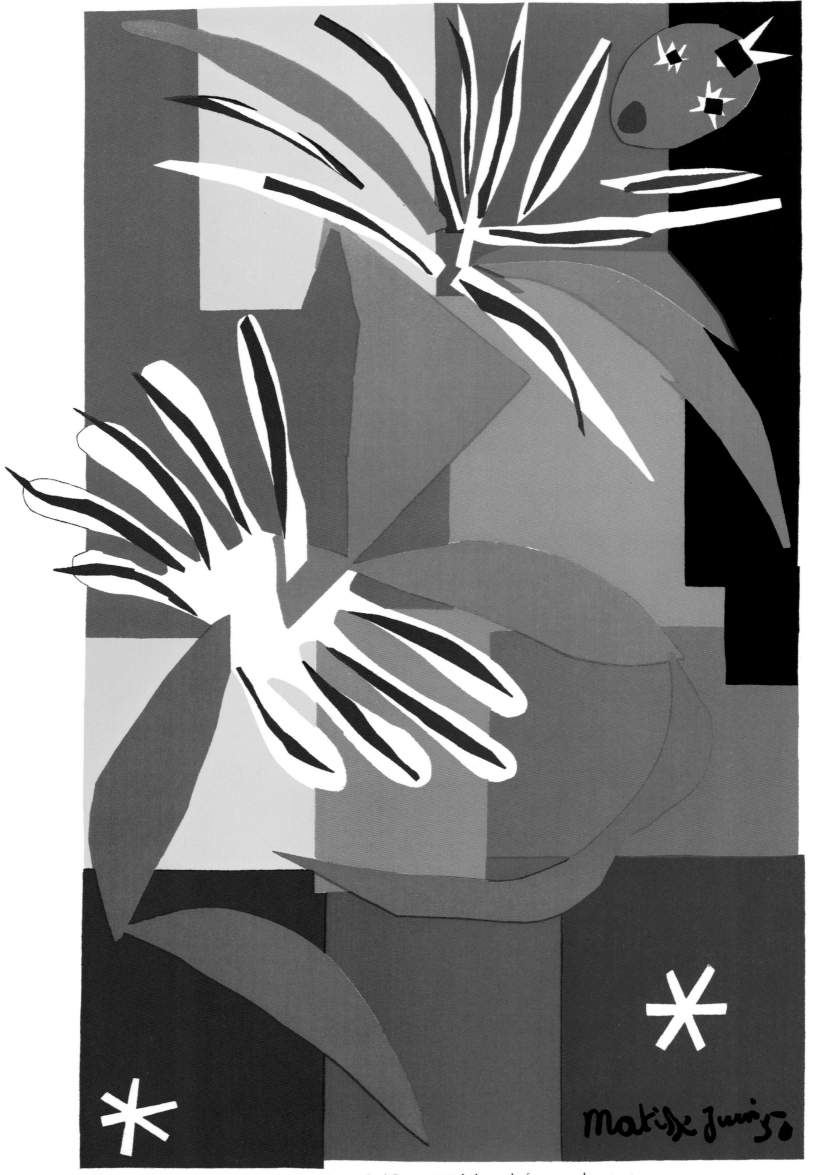

Henri Matisse. *Creole Dancer.* 1950. Lithograph after a gouache cut-out

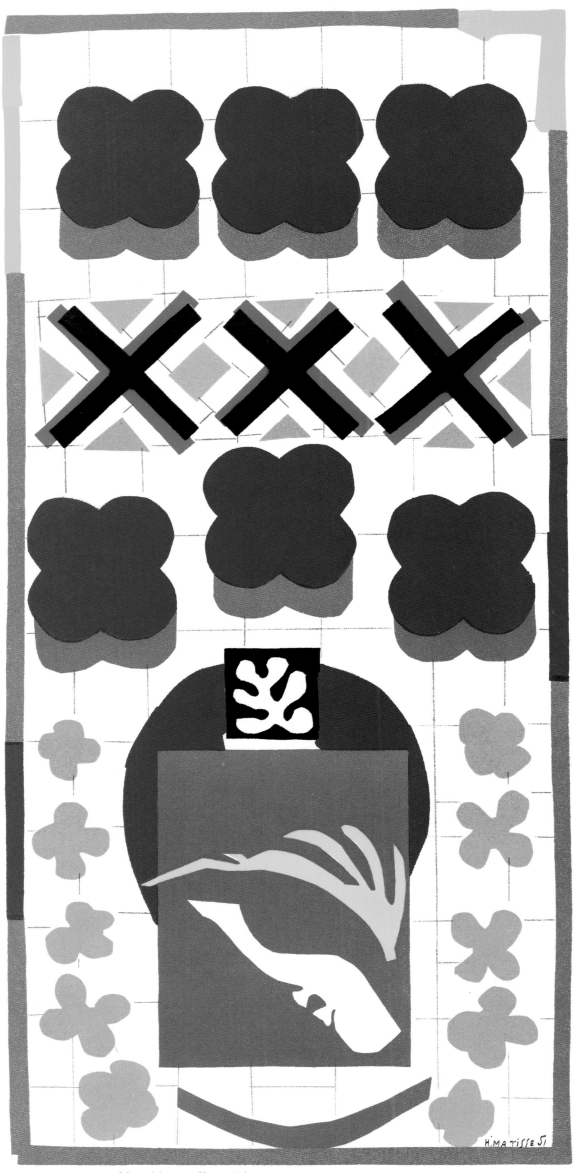

Henri Matisse. *Chinese Fish*. 1951. Lithograph after a gouache cut-out
Stained-glass window in Tériade's Villa Natacha, St. Jean-Cap-Ferrat

Henri Matisse.
Nude. 1949.
Crayon

Henri Matisse.
Sirène. 1949.
Crayon

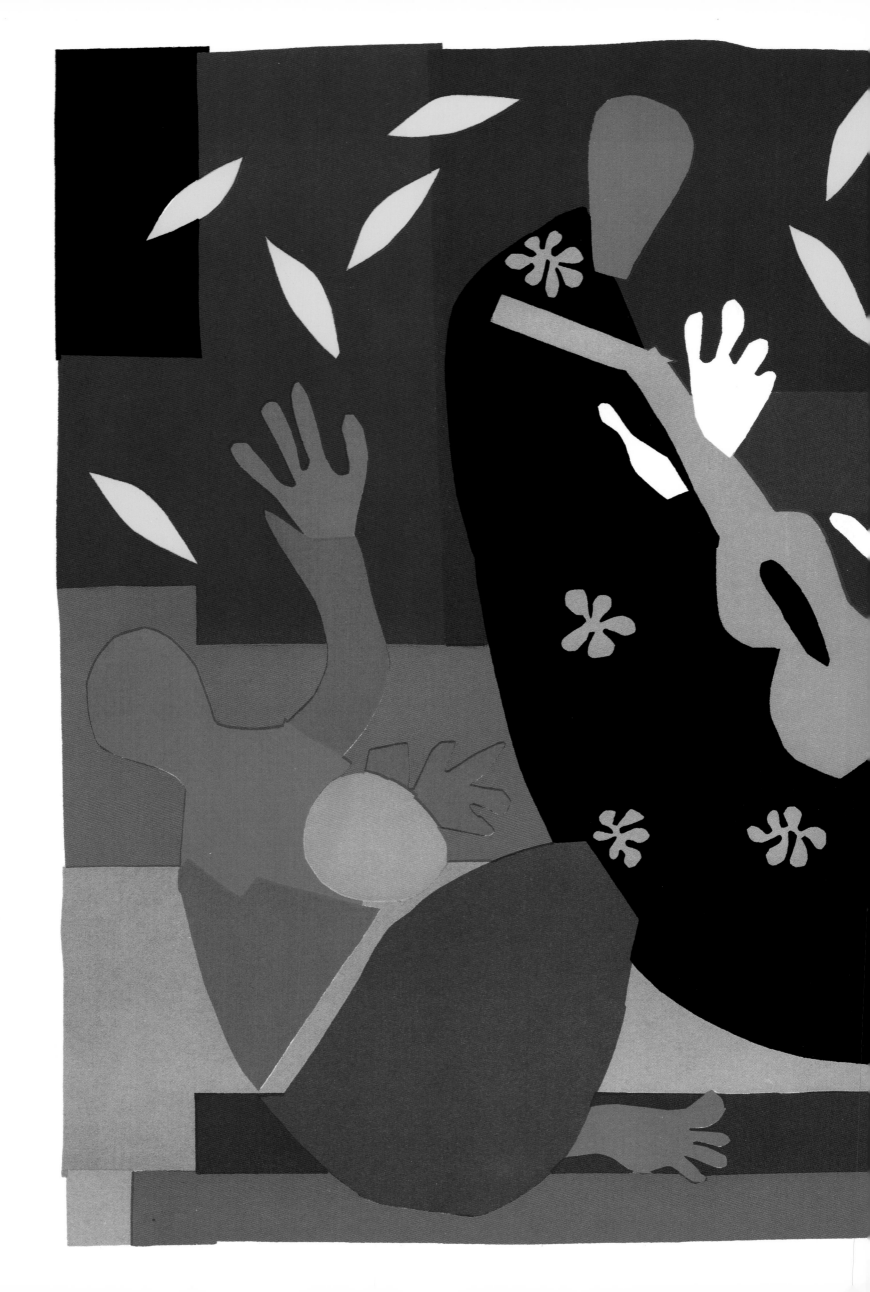

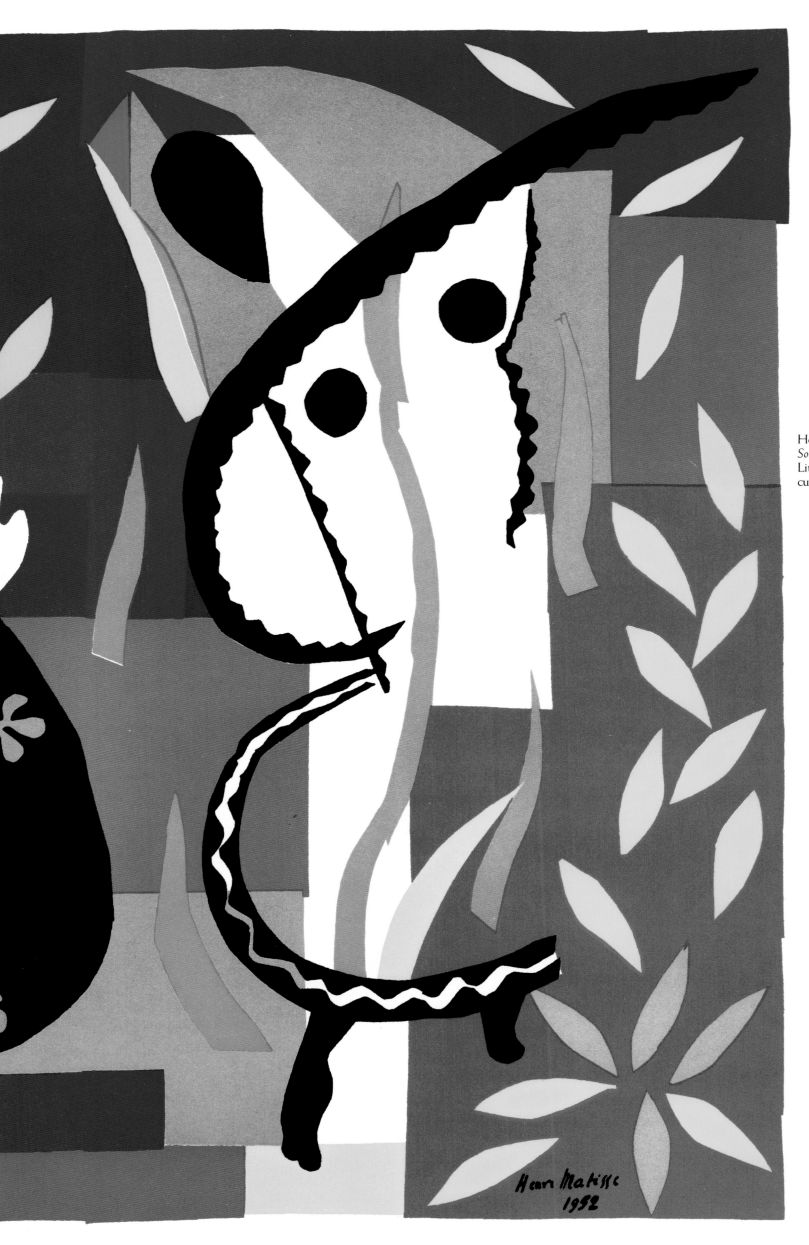

Henri Matisse.
Sorrow of the King. 1952.
Lithograph after a gouache
cut-out

MATISSE
IN LIGHT AND HAPPINESS

By PIERRE REVERDY

could not say in all honesty that I firmly believe in the predestination of names, but I believe in it a little, to the extent that one can believe in anything at all in our blissful, uncertain times. However, Matisse strikes me as being a name with something of real substance to it, one that implies its bearer would rather make his presence felt by deeds of strength, but not of brutality, a strong hand made for clasping and weighing, not for knocking down, for kneading and compressing in order to make whatever he undertakes as compact as possible. But the final syllable hisses slightly, like a soaring rocket, the flash of light above the soil in a dazzling flower bed. And it just so happens that Matisse talked about and painted flowers like no one else—and the subject of flowers and gardens is as good a place to start as any.

As soon as one attempts to define what constitutes happiness on earth, inevitably the obfuscating concept of perfect happiness springs to mind. This comes from the notion of a state of absolute perfection, solely conceivable as a place so elusive, so purely imaginary, that when we refer to it as a Garden or Paradise we have pretty much covered everything we know about it.

But a person cannot stay in his garden forever. That is not the kind of happiness I mean when I say that, thanks to the extraordinary benevolence of the occult forces that may have presided over his birth, Matisse seems to me to be as unmistakably pointed toward happiness as ever the needle of a compass pointed North.

He made the following remark when he was still quite young: "I should like to live like a monk in a cell, provided I have something to paint, free from all trouble and care." If that is so, then he must have felt early on that his greatest happiness could only come from work and that, if he worked hard, he would have a tremendous amount of genius to bring into the world. What followed bears out everything else beyond a shadow of a doubt. Actually, this orientation towards happiness asserted itself in word and deed throughout his life. That goes for his concept of art, too. "The thing I seek above all else is expression," he said back in 1908. "What I dream of is an art of balance, of purity and serenity, devoid of troubling or depressing subject matter . . . something like a good armchair." That was in reference to aesthetics, but in addition he took a sensual delight in nature, eloquently summed up in a remark he made during an interview. The subject was his arrival in Nice in 1917. "It was raining, but the next day, when, upon opening my window, it occurred to me that I was going to have that light before my eyes each and every day, I couldn't believe my good fortune."

The prerequisite for happiness—a gift one is born with—is an innate, visceral will to be happy, a steadfastness, a perseverance, something I call an orientation toward happiness, just as others have been cursed with the opposite inclination and who can or will never know what it is to be happy.

Just wanting to be happy probably does not make it so, but the desire is itself a kind of foundation, a safeguard that, to a certain extent, fosters conditions conducive to happiness. It enables you to be receptive to them when they appear, so that you may profit from their presence, instead of turning your back on them and letting them vanish into thin air.

If I say these things—at the risk of sounding impertinent, I fear—it is not to pry with intolerable indiscretion into a man's personal life when it's his work that interests us. I do so because I, who don't know the first thing about painting, critically speaking, can say nothing about his work unless I say that what impresses one about it, from first glance to last, and in all the glances in between, is the incalculable force of its happiness.

(continued on page 318)

Henri Matisse. *Kneeling Nude.* Charcoal

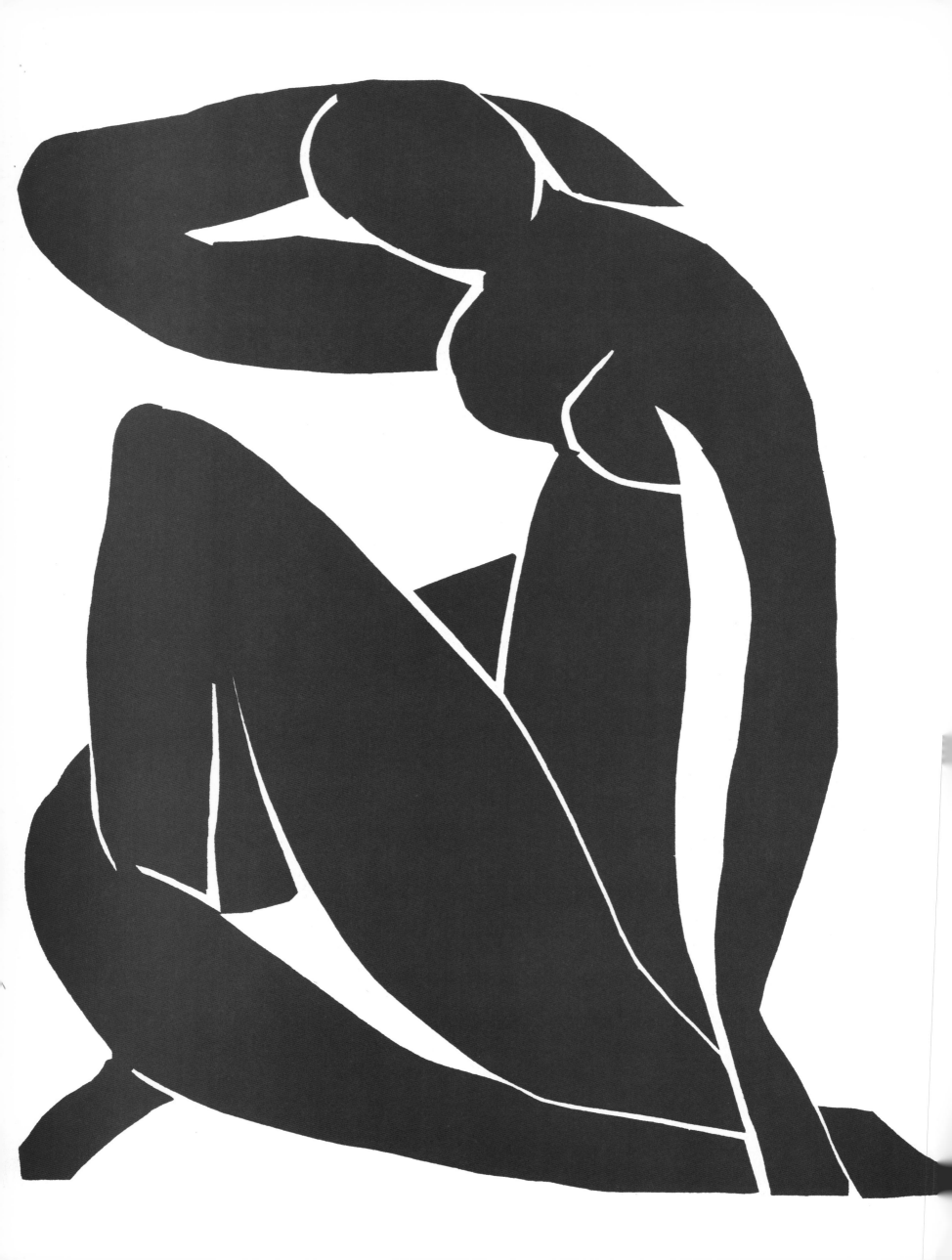

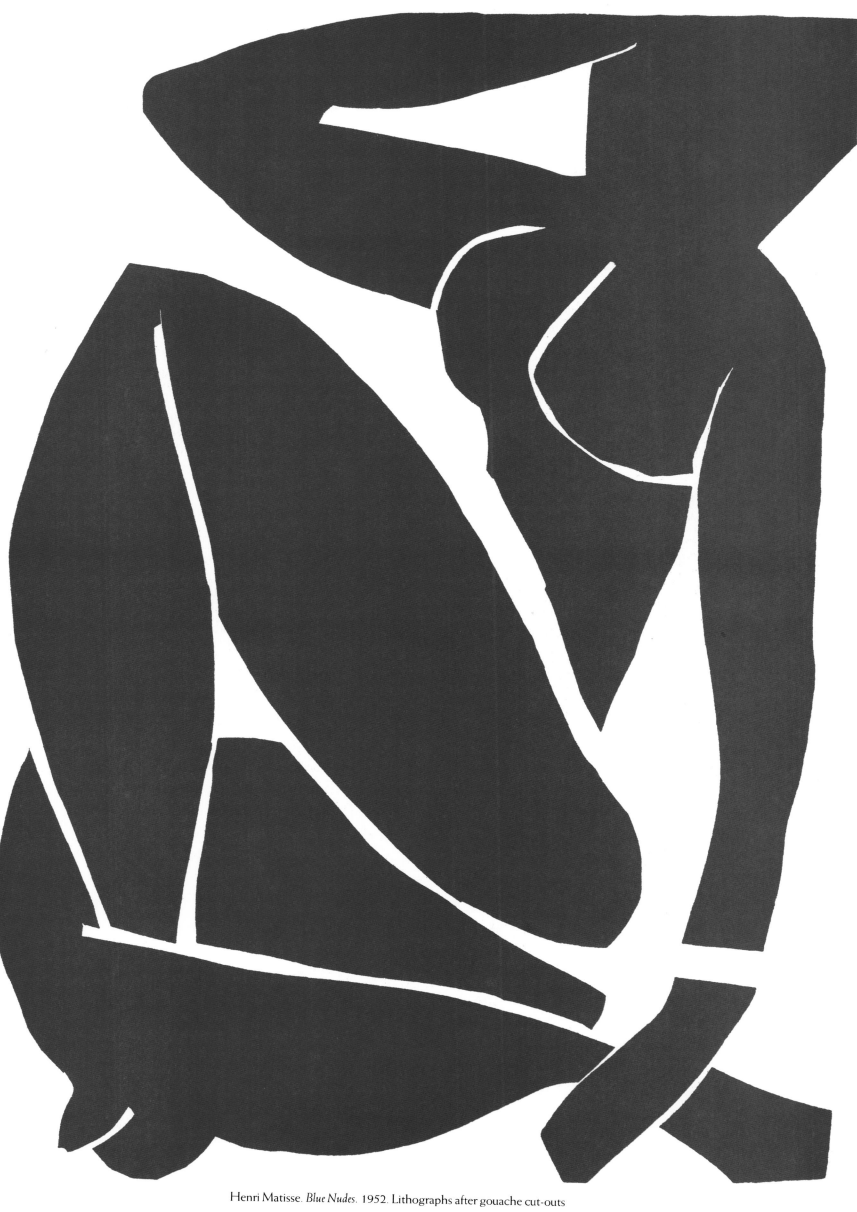

Henri Matisse. *Blue Nudes*. 1952. Lithographs after gouache cut-outs

I think it highly unlikely that Matisse ever wasted much time searching for the absolute. He was far too intelligent and clear-headed for that, but perhaps he found it anyway. He is a painter and, through his work, puts you in front of "Painting." Period.

Later, much later—because for the time being we are, unfortunately, denied the pleasure of looking at very many of his works at one time, scattered as they are among museums, great collections, and dealers—I hope that they may all be brought together in one huge building where everyone will have a chance to take stock of the monumental importance of one of the most wonderful oeuvres of our day.

In the interim, I picture it as a fabulous rainbow spanning the globe, way up high, and which triggers the same joy that used to well up inside me when I was little and saw a real rainbow after a storm, because I'd been told that it brought good luck.

As a matter of fact, although I met Matisse more than forty years ago, I cannot think of him without his image being accompanied in my mind by the notion, more or less diffuse, of happiness. And yet...

Yes, that is what comes to mind, despite the terrible ransom all great lives, and little ones too, must pay at the turnstile on their way into the theater of the world, no matter which side of the stage you're on—actor or onlooker—until they find themselves at the same dark crossroads as they exit.

Every now and then people argue about which plays a bigger part in artistic creation, critical discernment or imagination. Now, you would think the process has to be set in motion by the imagination, suggesting things based on everything it has absorbed from nature, and transforming them according to the abilities of the particular artist. Enter critical discernment, which selects, accepts, or rejects from everything that is thrown at it pell-mell, sorting out whatever is useless from that which meshes with the artist's feelings and which is deemed to be most suitable for their expression. It is, you would think, the supreme arbiter and therefore primarily responsible for the outcome, whatever it may be. But that is debatable. It would be most interesting to know what happens when imagination and critical discernment operate simultaneously. In fact, it would appear that, at least in some cases, the critical sense leads the way, stimulates the imagination, and remains in control during the entire process. There are no retouchings or calm corrections after a period of reflection, mind you; on the very first attempt—it happens fairly often—a work of art can achieve a state requiring very few changes for it to be perfect.

Be that as it may, Matisse's critical discernment was clearly unrivaled. It had to have been to organize the wealth of possibilities his daring, inexhaustible imagination kept offering. But isn't that what genius is: a balance between critical discernment and an overflowing imagination?

Yet what the painter had to say about his drawings is so rigorously exact that, as we read it, we are strongly inclined to think creativity in all great art depends largely on a very incisive, confident critical judgment. "My drawings are the purest expression of my feelings. Simplification of means makes that possible. However, these drawings are more complete than they would appear to those who liken them to sketches of one kind or another. They are generators of light; viewed in subdued daylight or indirect light, they contain not only lines in all their savor and sensitivity, but light and gradations of value that correspond to colors in an unmistakable way. To many, these qualities are just as easy to see in broad daylight."

Needless to say, good painting—and admittedly, sometimes even bad—is done more with the head than with the arms. But when it comes to writing, be it prose or poetry, things are not quite the same. The head depends solely on the head, words being nothing more than shared symbols with limited meaning. Forms and colors, however, are universally understood by all people who can see and are intrinsically more a help than a hindrance. The stuff they are made of is already irrefutably real. If a painter like Matisse is described as classical, it is not merely to shock those who will consider him a firebrand until the day they die—although, in a sense, through their progeny they shall never die—but to suggest that in his work, thought always takes precedence over feelings, that feelings are never expressed directly but exist solely to sustain the thoughts behind them instead of blossoming in one stroke or by trial and error, without any kind of premeditation.

(continued on page 323)

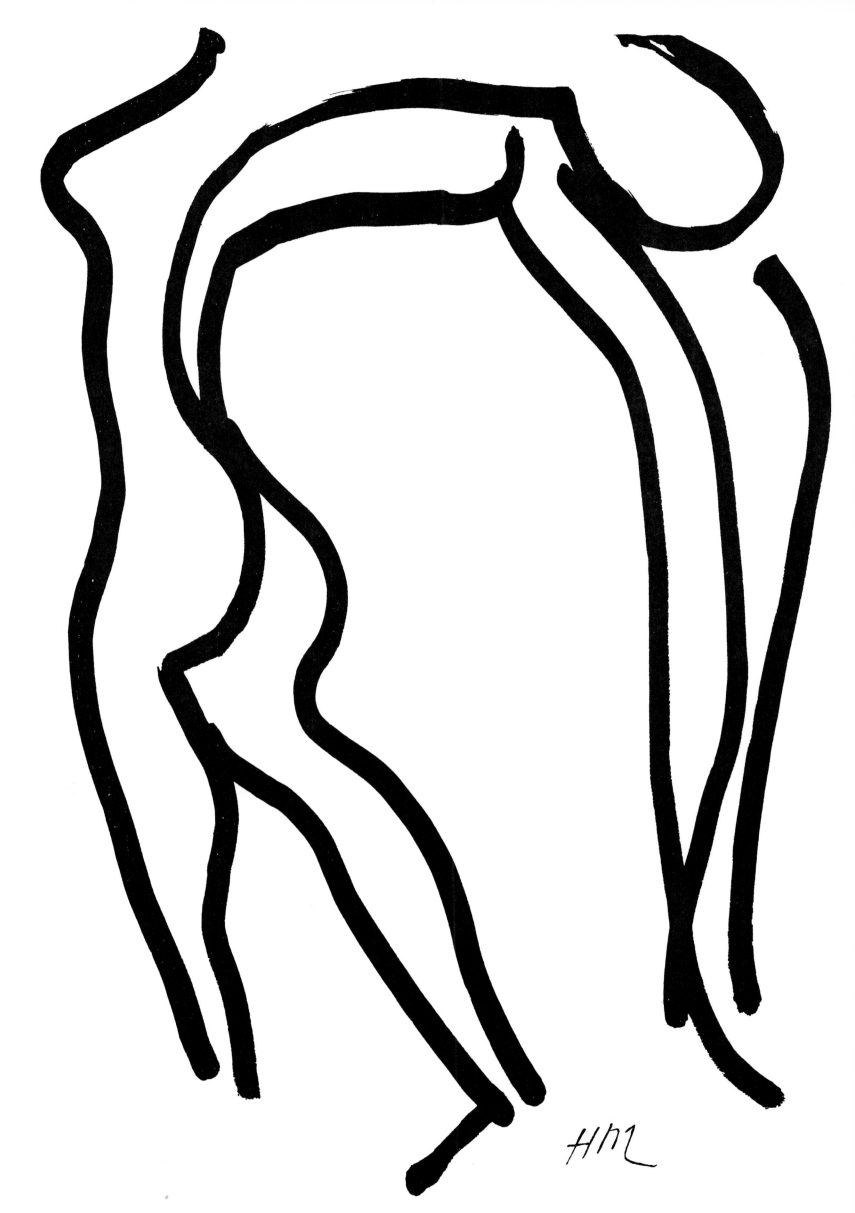

Henri Matisse. *Acrobat.* 1952. India ink

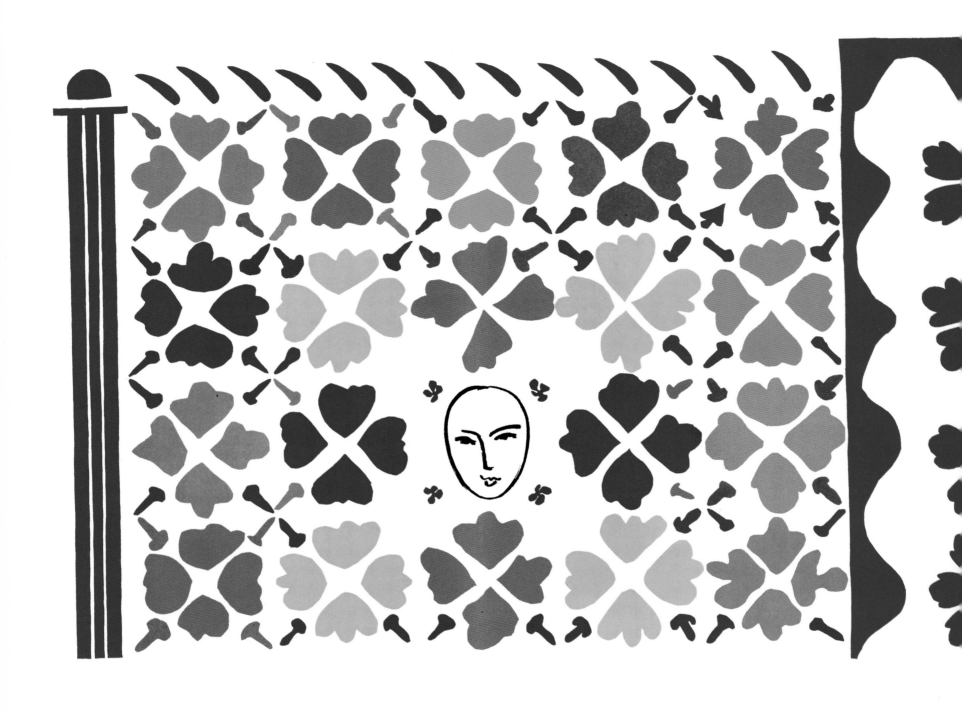

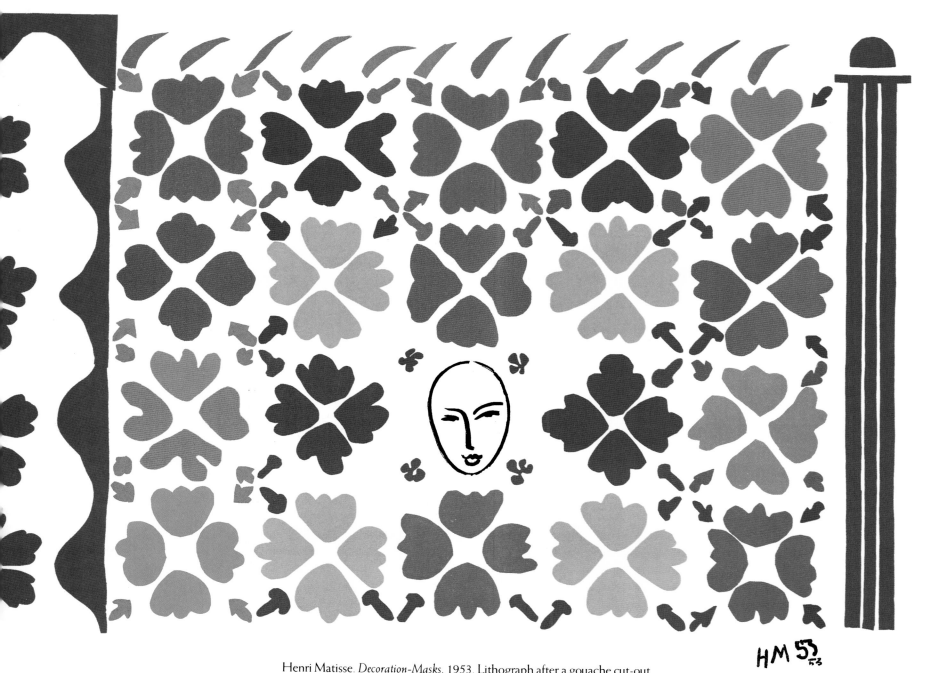

Henri Matisse. *Decoration-Masks.* 1953. Lithograph after a gouache cut-out

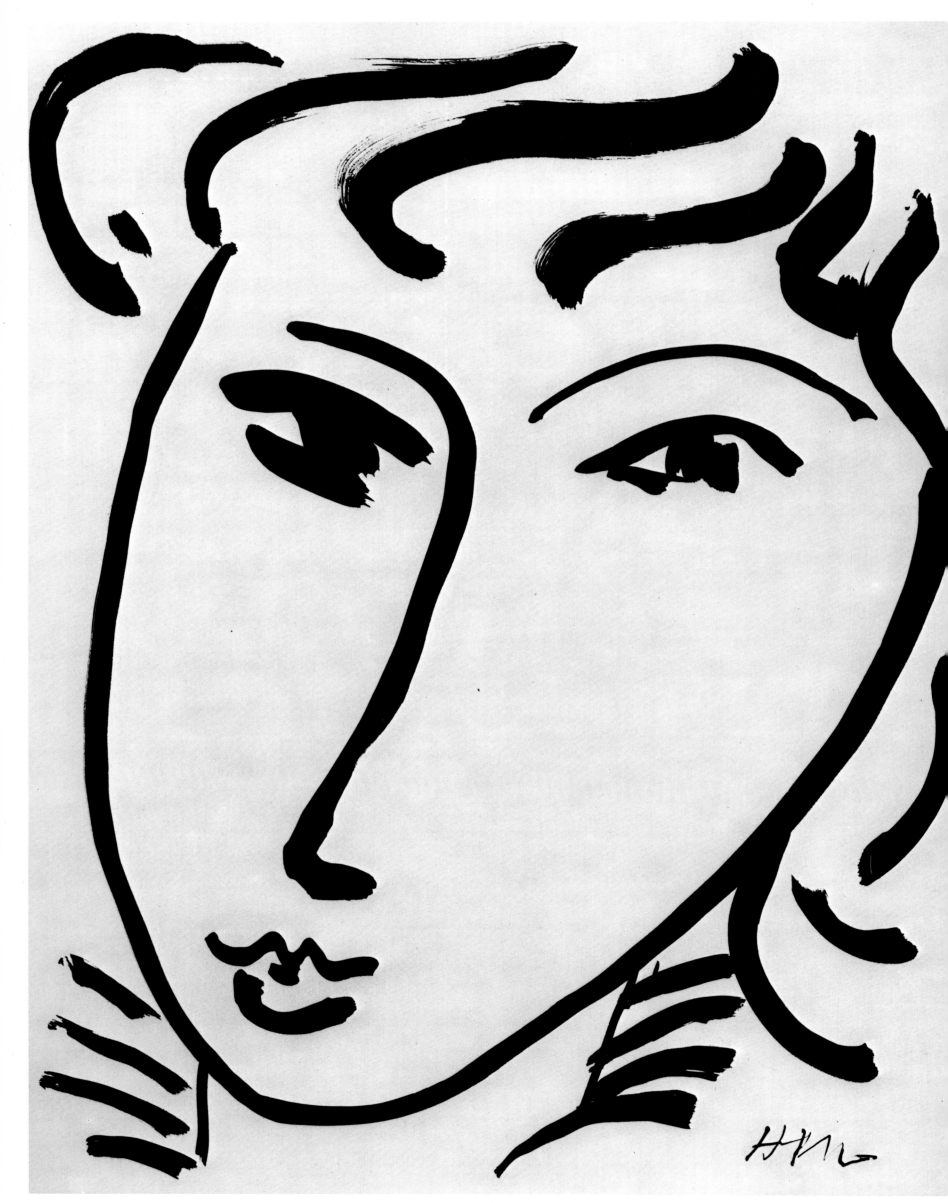

Henri Matisse. *Head*. India ink with brush

More than anyone else, he helped rid painting of meaningless prattle. Perhaps that is why, standing before his pictures, we are not inclined to expatiate upon them, no matter how intense their impact. The pleasure and sense of wonder they arouse within us are more conducive to contemplation. Skill and conscientiousness are the two pillars that sustain his mighty genius and give his entire oeuvre an uplifting solemnity, imposing a rigorous order while—at the same time—retaining the dazzling freshness of improvisation.

Matisse is classical because his pictures are constructed in accordance with the most orthodox rules of composition. As his life drew to a close, he made a point of saying so himself and demonstrated it by publishing together reproductions of sketches and the finished paintings that had evolved from them. They are simple drawings, quickly done but thorough, particularly with respect to his instructions concerning colors. One can see that the colors in the paintings and corresponding sketches match perfectly and in exactly the places indicated. Thus, the paintings were already conceived, worked out, virtually fully formed in his mind before his hand ever lifted a brush.

Consequently, his works are not, and probably never were, derived from Impressionist techniques or means, but from the pure, classical rules he studied, probed, and practiced as he copied paintings in museums.

This does not mean he lacked honesty or forthrightness when he talked about sensation and emotion—elements that give his pictures all their savor and brilliance. But it is to patient, methodical forethought that his paintings owe their compactness, static rigor, and powerful impact.

Some of his paintings are almost inordinately exuberant—at times so full, so adorned with forms and objects, so lavishly colored and filled to overflowing with all manner of decoration (although never at the expense of discipline or good taste), that they are like overly vigorous trees, so thick that you'd almost rather they were pruned back. At first, you have greater difficulty breathing in them, compared to other works that are more restrained and uncongested. Yet, you can suddenly be overwhelmed by something as simple as a line against a colored background or a stroke of color against a blank page, nothing more than that.

Matisse said somewhere that he could not fathom Ingres's remark that "drawing is the probity of art," but that he could readily see why Hokusai was described as "the old man crazy about drawing." Of Matisse it may be said without hesitation that he was not only the greatest colorist of his day, but the greatest optimist in all of French painting. He ground his pink and blue colors the way others did harsh tones. His pictures fill our eyes with sky the way large seashells fill our ears with the distant sound of murmuring waves.

Within the context of his era, he will be seen as representing the forefront of freedom—intense, passionate, yet calm and collected—while at the other extremity emerged a kind of untamed austerity, a tight discipline of heroic proportions.

It's not the violence of the colors a painter uses that makes him a colorist. The brightest, most aggressive colors straight from the tube can remain inert once they've been spread across the canvas. If the fermenting action of the mind is missing, their very excess can make them heavy as lead. The brilliance, intensity, lightness, or density an artist gives all his colors depend upon the way he orchestrates them, the way he causes them to interact and coalesce into a composition. What matters more than anything else is how the mind controlling the composition operates....

However, when one looks at most of his paintings, one is almost always overcome by intense joy, as well as a sense of surprise so pleasant that it verges on enchantment. They display such a rare concentration of talents, handled so boldly, so masterfully, that one is left, as it were, in a state of placid captivation. At the same time, he has amazing powers of transfiguration and exercises them dauntlessly up to the point where transfiguration ends and fantasy begins. It is at that moment that the best emotion wells up inside the onlooker, a sensation that brakes are being slammed on to prevent things from going too far. The result is a heightened reality that detaches itself from the real world to pass into another order, gaining more in aesthetic intensity than it has lost in demonstrable truth.

Invention of forms replaced the traditional imitation of reality. No longer did the imagination simply act upon a subject (actual or literary) that was supposed to be represented; it became a free agent, filling the canvas with forms and colors capable of creating within its bounds a reality of a different order, a reality created by the painter and by him alone.

(continued on page 326)

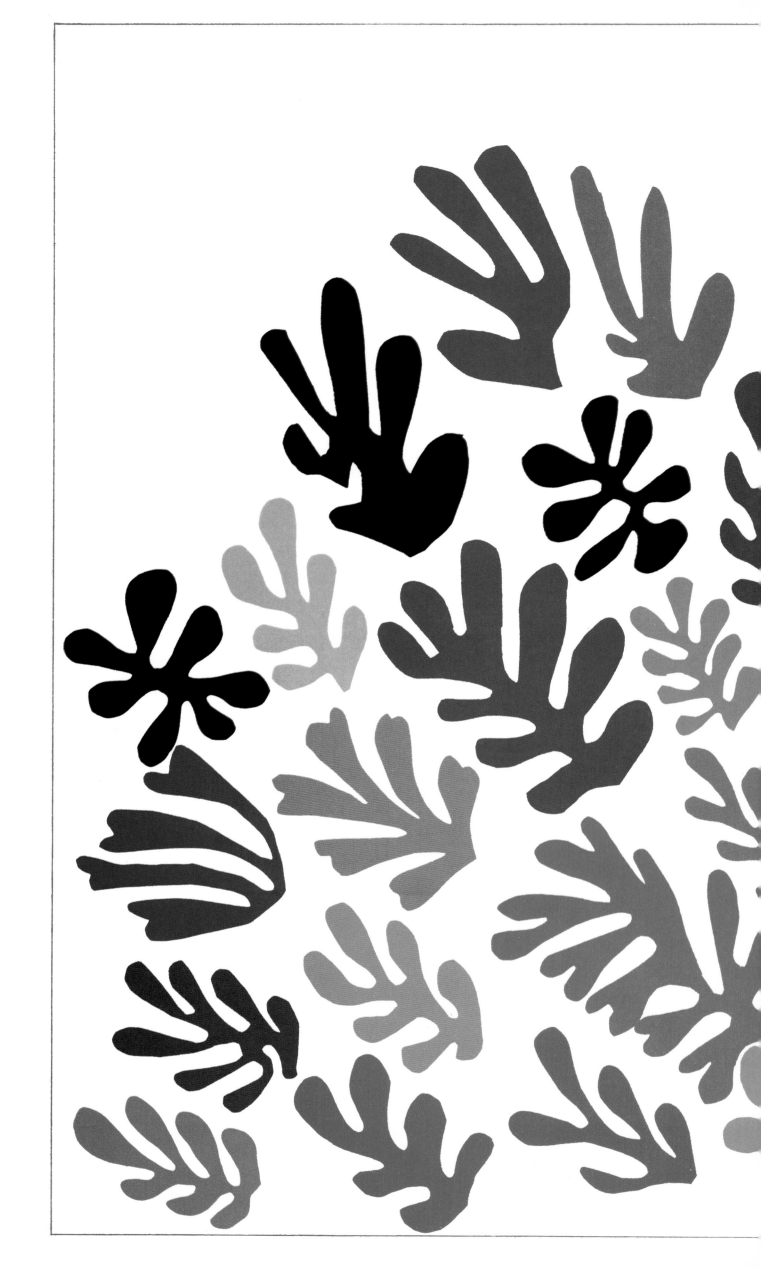

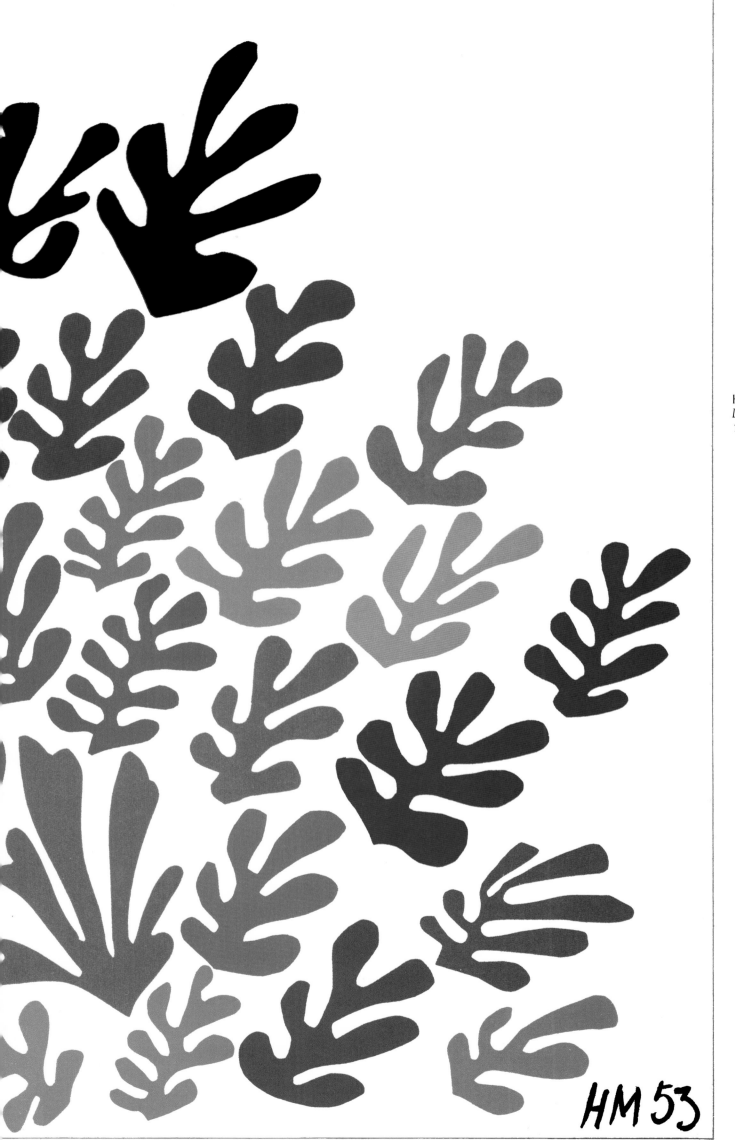

Henri Matisse.
La Gerbe (maquette for ceramic tiles).
1953. Lithograph after a gouache cut-out

HM 53

One of the most astounding and felicitous strokes of genius this great innovator can take credit for is that, without resorting to sleight-of-hand, he allowed subject matter just enough presence to give his pictures the proper impact and human value. He retained all the inherent savor and significance, but not so much as to shift the aesthetic balance from the imaginary to the purely anecdotal.

Another remarkable aspect is the part the figure or human body plays in his paintings. Probably in keeping with a broader liberation, he never gave them greater emphasis than objects. As with the latter, they are form-supports for colors, masses within a composition. He eliminated overly characteristic details that might monopolize one's attention and thus undermine or interfere with the part the colored body *qua* mass is supposed to play within the composition as a whole. What matters is not whether it's a being or an object—"I don't paint a woman," Matisse once said, "I paint above all a picture"—but the value that forms or that colors will have in the painting. The decoration in the Chapel [of the Rosary] in Vence, which he himself considered the culmination of his entire career, attests to this philosophy of neutrality.

The same goes for the heads of his human subjects. Stripped of recognizable facial features, these ovals demonstrate his deft handling of values. He knew when to add and when to take away; he knew what could work to a picture's advantage and what might work to its detriment. The resulting unity and harmony perfectly expresses his need for serenity. Placidity and plasticity: Probably no two words better sum up his kind of genius.

Certainly he is static, but he must have been wild about movement. And since nothing he attempted seems ever to have been left unrealized, every picture took on a lightness and freedom not found even in a real-life dancer holding a position or in a bird on the wing, captured in a snapshot. He himself spelled out quite clearly why there is greater emotional spontaneity in his drawings, why they are the most direct vehicles for his feelings. "It's to bring out grace and naturalness that I study so much before I do a pen-and-ink. I never subject myself to coercion. On the contrary: I am [like] a dancer or acrobat who begins the day with several hours of limbering-up exercises, so that every part of his body will respond during a performance when he wishes to express his feelings through a series of fast or slow dance movements or by an elegant pirouette."

(Parenthetically, some have said that Matisse is a reticent painter; yet it must be pointed out that few painters have been so open about themselves.)

"Now, as for perspective. My finished drawings always create a luminous space and the objects in them are situated at various levels, hence, in perspective—but in *emotional* perspective, in implied perspective. I have always considered drawing, not as a test of skill or dexterity, but as above all a way to express one's moods and innermost feelings—only simplified, so as to give that expression, which must be conveyed unimpeded to the onlooker's mind, greater simplicity and spontaneity."

If there is one thing of which no one can ever accuse him—this painter so unburdened by the weight of things—it is heaviness, and that goes for his paintings and drawings alike. Only, in the latter, reason seems to play a less despotic role, and the speedier execution gives his feelings greater latitude.

That is not to say that he paid no heed to the real world. Just the opposite: he had an unquenchable thirst, a burning curiosity for it. There was nothing he did not long to see and discover. Yet, having seen and discovered everything, he could forget it all once he got down to work; therein lies the chief reason for his staggering success. That is what gives his art, even his most concentrated and meticulously balanced works, their baffling freshness.

Another remarkable thing about Matisse's paintings is how noticeably full and expansive each one of them becomes when reproduced, regardless of its actual size. Even the smallest of them has a sweep to it, because composition, chromatic interaction, felicitous proportion of form, and free arrangement of objects conspire to create space that is always wonderfully suggestive. Big or small, each is as full as an egg; it has everything it needs, never more, never less. For some painters, just the opposite is true: their big paintings always look like mere enlargements.

He is one of those artists whose gifts, virtues, and abilities are so great that it would be impossible to calmly enumerate all the good things about him without doing violence to one's feelings. With him, as with so many others, we are faced with the eternally mysterious problem of individuality, the fact that those whose individuality asserts

(continued on page 330)

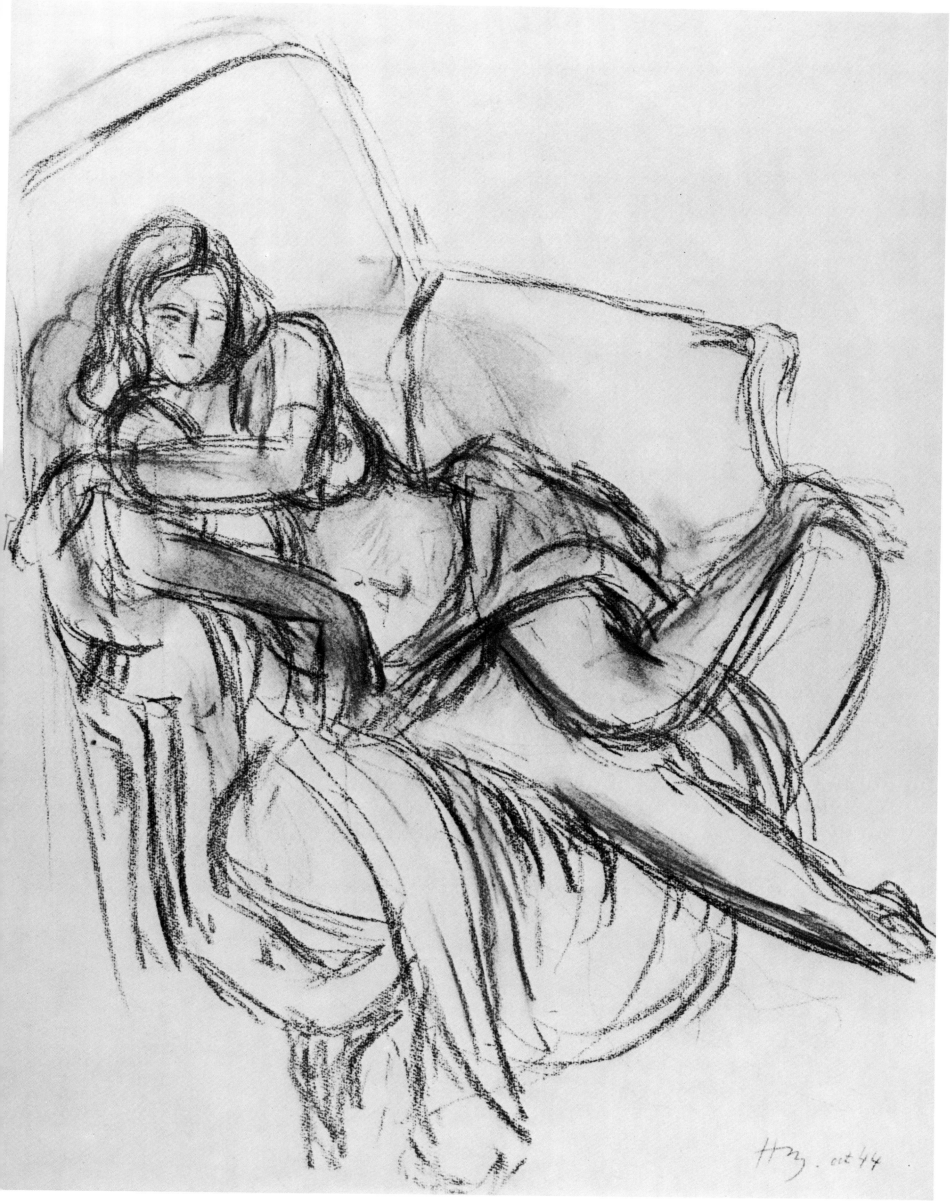

Henri Matisse. *Seated Nude.* 1944. Charcoal

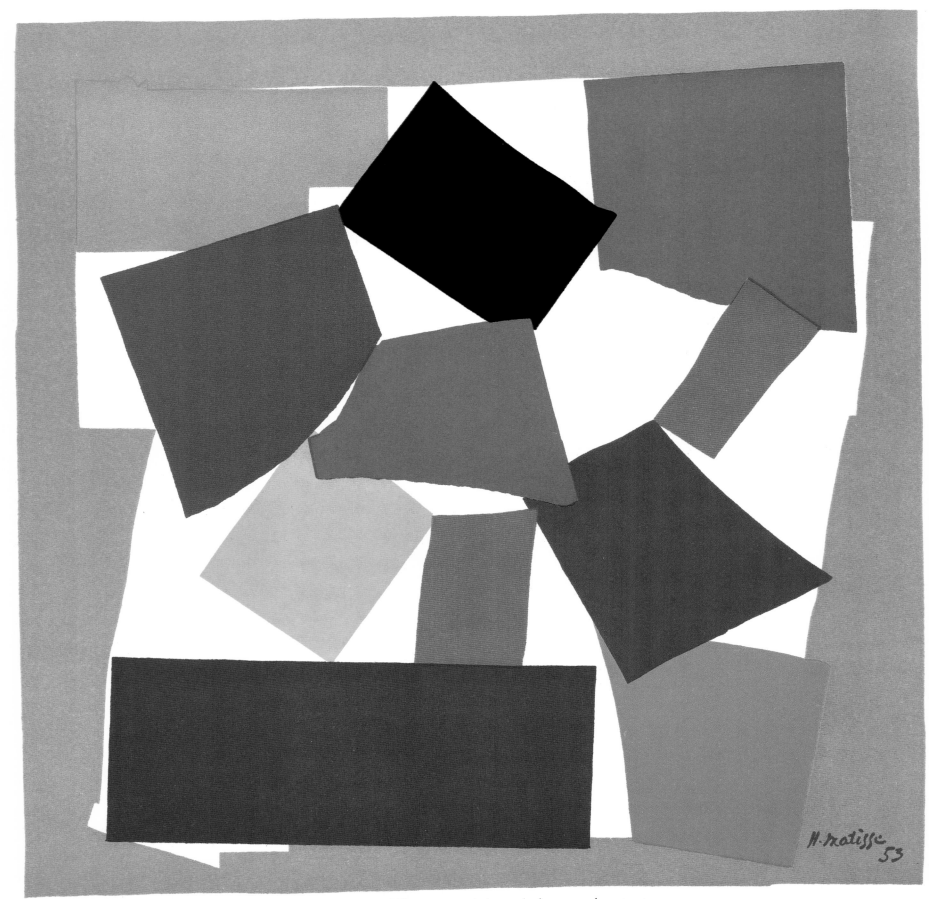

Henri Matisse. *L'Escargot*. 1953. Lithograph after a gouache cut-out

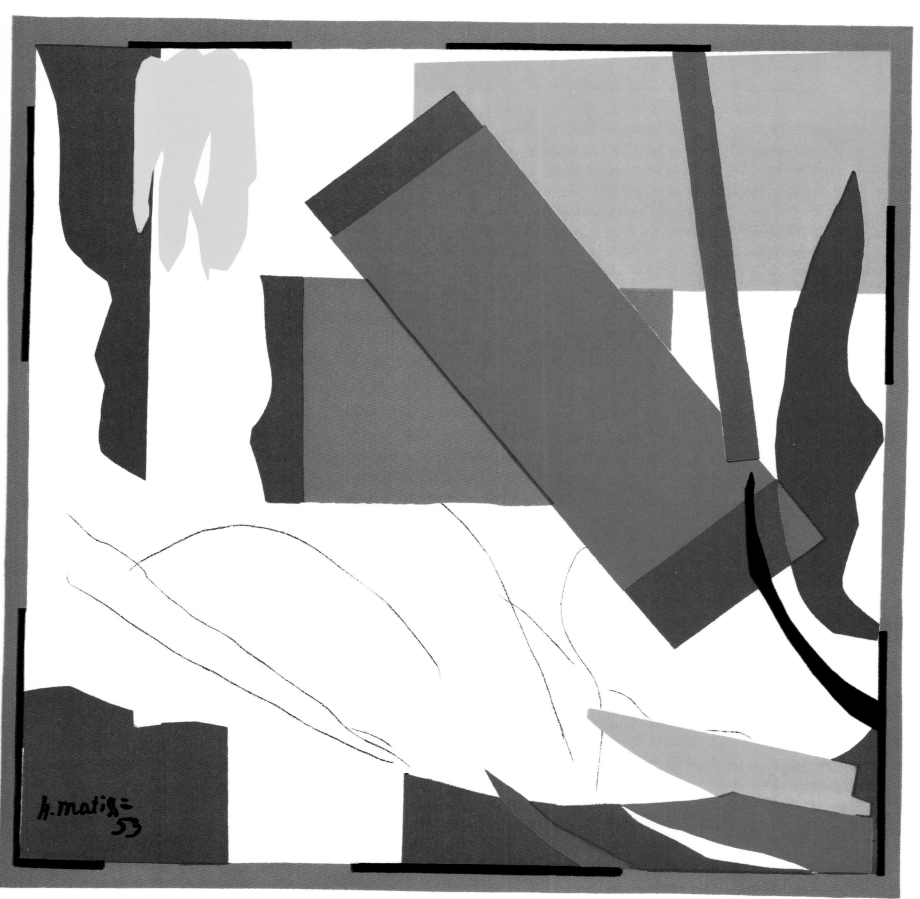

Henri Matisse. *Souvenir d'Océanie.* 1953. Lithograph after a gouache cut-out

itself most forcefully later on are willing to conform to disciplines adhered to by their predecessors, whether it be the ancients or simply their elders. Matisse copied paintings in the Louvre late in his career. His whole life long, he was mindful of what his elders had done; he saw them as an example, as something to learn from. First, curiosity about the work of contemporaries, even when their orientation differed from or conflicted with his own; then, the explosion of an outlook so distinctive, so extraordinary, it seemed to have come from nowhere, or no one in particular.

One of the things that arouses in me the highest regard for Matisse—over and above the fact that I admire his painting—is that at no time has he ever given anyone reason to say that his painting had anything in common with poetry, either in form or content. That is a rather nasty habit people have been indulging in for much too long now. In some cases it may be justifiable, to a certain extent. Applied to Matisse, however, a statement like that would be meaningless.

I can't quite recall anymore which great painter it was who said about another painter probably just as famous: "So-and-So is just an eye, but what an eye!" Of Matisse, because of the way he pushed expression to an extreme (but always toward aesthetic joy), because of the pure plasticity of his work (yet without form or color becoming means of expressing feelings alien to art), it seems to me one could also say that all the faculties of his soul were concentrated in his eye.

Someone once questioned him about his work and those means he used to distract himself when he needed to rest. "And suppose it irritates me to be distracted from my work?" he retorted.

No one can appreciate the full meaning of that remark better than I, knowing as I do that art is itself the greatest distraction on earth, especially for those who don't practice it. Besides, speaking for myself, I have never particularly suffered from a pressing need to use work as a way to take my mind off life.

I believe that a rather skeptical, flippant air that Matisse had—especially when he was young—may have misled people about his true nature (which came to the fore particularly later on). What appeared to be imperturbability was simply a continual repression of feelings that would have seemed excessive had he not been so good at controlling them throughout his life, and had he not had at his command such wonderful means of channeling them almost entirely into his stupendous oeuvre. That is why he was able to write the following late in life: "Do I believe in God? Yes, when I am working. When I am submissive and self-effacing, I feel as though I am being assisted by someone who is causing me to do things that transcend me. Yet, I feel no gratitude towards *Him*, because it's as though I were watching a magician whose tricks I do not understand. I feel I've been cheated out of the experience that should be the reward for my effort. I am a remorseless ingrate."

How could so indomitable an outlook and temperament have failed to culminate in that state, which for so many others is purely mythical, known as happiness? *(Excerpts)*

Henri Matisse. *Woman in an Armchair.* 1944. Charcoal

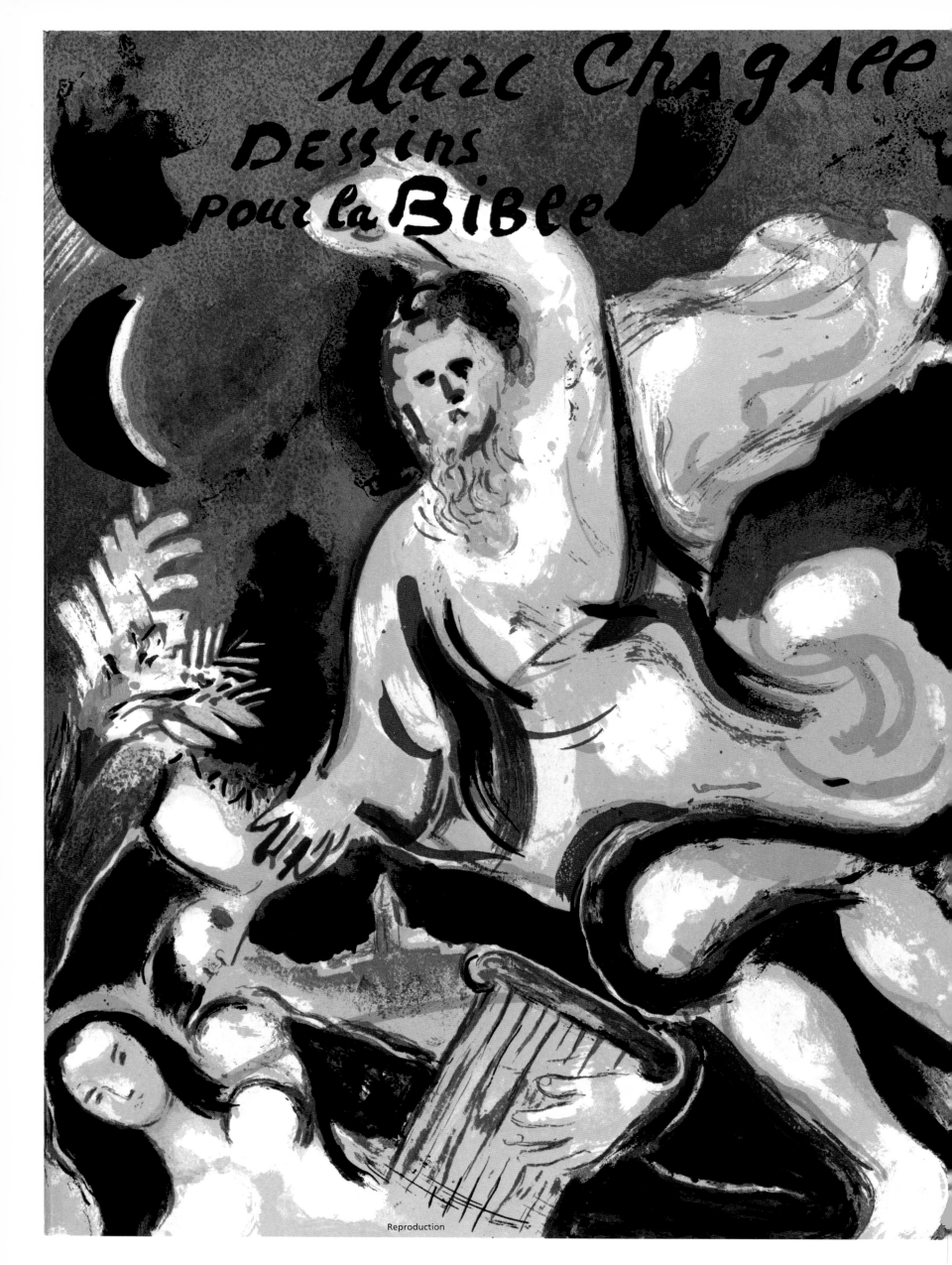

VERVE
Numbers 37/38 Summer 1960

Marc Chagall: Illustrations for the Bible

Four years after the appearance of *Verve* Nos. 33/34, featuring the publication of Marc Chagall's *Bible* etchings and original lithographs, Tériade published another edition (the final issue of *Verve*) that represented the work of the same artist, on the same theme, and of equal importance. As is often the case with Chagall's work, the drawings originally begun as counterpoints to the etchings became part of a major cycle that later culminated in the great paintings of *Le Message biblique*.

In his prefatory statment, Tériade writes: "This double issue of *Verve* includes drawings Marc Chagall did in 1958 and 1959 on biblical themes not dealt with in his etchings illustrating the Bible, reproduced in *Verve* Nos. 33/34."

On the title page we see an angel, a donkey, and a sheaf of wheat. On the frontispiece, against a red-orange background, an angel brandishing a sword seems to be threatening a couple embracing in the foreground. Chagall entitled the work *The Virgin of Israel.*[1]

The beautiful young woman, her bosom exposed, presses against her a wide-eyed young man who seems about her own age. The only clue to the meaning of the scene is in the position of the man's arms: this is probably the Virgin Mary cradling the dead Christ at the foot of the Cross. But in Chagall's vision, grief, while not ignored, is transfigured; the representation of the entwined couple is suffused with a tremendous tenderness. He is already slipping away, but the two are being reunited in their love, and their mystery. Here, Chagall recalls the vision of the early masters.

In the middle ground, the Child Jesus reaches out to his mother. Finally, hovering above, is the angel with the sword, resplendent in all his glory.

If Chagall and Tériade decided to use this scene as a frontispiece, it was not just because of its artistic qualities. It allows us to enter into Chagall's highly personal reading of the Bible, or at least to grasp one of the many dimensions of the holy text.

The artist seems to be taking liberties with scripture; in fact, he is skillfully illustrating the mystery of Mater Dolorosa and the apparent defeat that Christ will turn into his supreme triumph. As is often the case with Chagall, an underlying and profound symbolism links all three elements: Child, Christ, and victorious Archangel are part of a cycle, three moments in one and the same destiny.

This sorrowful vision, however, is less dark than in the etchings done during the Nazi reign. Now the painter studies the Bible from another perspective, calm and mellow, "a 'relationship' already consolidated in grief and joy whose corollary is the sacrifice,"[2] as Franz Meyer says of *Abraham and the Three Angels*.

A single text, by Gaston Bachelard, introduces this voluminous issue. The philosopher of *L'Eau et les Rêves*, the epistemologist of the poetic imagination, plunges into the Chagallian universe with rapture: "Chagall has enlightened my ear," he notes in a terse observation. "Because Chagall's eye gazes upon the greatest of all pasts: he discovers, he sees, he shows the forebears of the human race; he brings to life that time before time when the first human beings were born and grew like inflexible stalks, and all were, from the very beginning, superhuman." Chagall, Bachelard points out, deals with the archaic and

the archetypal, which gives this work a universal quality. Thus, the painter brings the face of the Prophets into view, or rather, according to that beautiful Bachelardian phrase, "the Voice that speaks."

Perhaps even more than the *Bible* in *Verve* Nos. 33/34—devoted primarily to etchings begun in 1930—this issue demonstrated what Chagall was capable of doing with works-on-paper: all of the plates united in *Verve* Nos. 37/38 (gouaches, drawings, and lithographs) show how free his handling had become. As Franz Meyer writes: "It was no longer a matter of completing or extending a pre-existing series. All were done about the same time—in 1958–1959—and show a similar attitude toward the text. Thus, it is not surprising that this publication, in which color and black-and-white, image and typography are so harmoniously united, is one of Chagall's finest 'books.' "[3]

While scenes and other personages in the first "Chagall issue" were drawn from the four Old Testament books, *Verve* Nos. 37/38 covers the Bible more broadly, including a number of little-known stories. First, the Five Books of Moses: Genesis (nos. 1–28), Exodus (29–36), and Numbers (37). Then, the historical books: Joshua (38), Judges (39–41), Ruth (42–44), Samuel and Kings (45–50), Esdras (51), Nehemiah (52), and Esther (53–59). Next, the books of wisdom and poetry: Job (60,61), Psalms (62, 63), Ecclesiastes (64, 65), and The Song of Songs (66–73). Lastly, the Prophets: Daniel (74–76), Joel (77–79), Amos (80–82), Obadiah (83, 84), Jonah (85–90), Micah (91), Habakkuk (92), Zachariah (93–95), and Malachi (96).

Color lithographs are divided fairly evenly among the various books of the Old Testament. And, if we compare each drawing or lithograph with its corresponding passage from the Bible (quoted in full at the end of the magazine), we cannot fail to be struck by the intensity of Chagall's reading. He did not work from memory, nor did he take his cue from abstractions or theories. Instead, he followed the Bible stories quite literally. For Chagall, the Bible had always been an intensely personal thing. He read it from beginning to end as though it were one long uninterrupted tale. He allowed the text to determine which technique he would use or how "finished" a picture would be. Some are quite elaborate; others are kept at the stage of an initial impression. But no matter what the technique or the degree of completion, Chagall always entered into an intimate relation with the holy text. Long acquaintanceship made him feel as much at home with the stories in Numbers as with the visions of the Prophets.

"Chagall had been familiar with the Bible from childhood," writes Franz Meyer.[4] "In those days he saw in the stories of the patriarchs, the kings, and the prophets not merely a chronicle of events which had occurred centuries before, but rather an account of another world that still existed behind the world of daily reality. Abraham and Jacob, Moses and David were almost as real as his grandfather in Lyozno or his innumerable uncles and aunts. Thus, at Passover, the house door was left open for the Prophet Elijah and a place laid for him at the table. Chagall tells how, as a child, he anxiously awaited the prophet's arrival: 'But where is Elijah in his white chariot? Is he still lingering in the courtyard to enter the house in the guise of a sickly old man, a stooped beggar, with a sack on his back and a cane in his hand?'[5] The history of the Jewish people in a historical context that is not their own always remains like that described in the Torah, and kept alive in the Jewish festivals throughout the year. At Passover, Chagall saw in the wine in 'Papa's glass, reflected deep purple, royal, the ghetto marked out for the Jewish people and the burning heat of the Arabian desert, crossed with so much suffering.'[6] As Erich Neumann[7] says, 'For the Jewish people alone these stories are the history of their ancestors and the living reality from which, whether the individual realizes it or not, his own inner history stems.' "

In this new interpretation of the Bible, Franz Meyer notes the *feminine* character: "In the etched Bible the simple thread to which the individual illustrations adhere, is Israel's progress through the ages.

This second series is more complex. The themes treated are almost always different. Basically, they touch on two questions: the role of woman in biblical history, and the confrontation of man with nature. So it is a *feminine* Bible as opposed to the *masculine* Bible of the prewar period.

"Everywhere are relationships with the pictures Chagall had painted in recent years, those linked with the south of France and the Greek cycle. It almost seems that Chagall's art now moves within a biblical space, so that every 'secular' concern has an echo of the sacred. Despite the choice of 'feminine' themes, the biblical influence is as strong as ever, although less linked to the Word and the force of its divinely inspired radiation than to the interior world in which it resounds. . . . Chagall truly *sees* our first parents in the Garden of Eden, Moses and Zipporah, Hagar and Ishmael, he sees the prophets, all present in every fiber and yet centuries old, timeless and irradiated by the proximity of the divine."[8]

1. Isaiah VII, 13–14: "And he said, 'Hear ye now, O house of David! Is it too little for you to weary men, that you must weary my God as well? Therefore the Lord himself will give you a sign. Behold, a young woman shall conceive and bear a son, and shall call his name Immanuel.' "
2. Franz Meyer, *op. cit.*
3. *Ibid.*
4. *Ibid.*
5. Marc Chagall, *My Life.*
6. *Ibid.*
7. Erich Neumann, "Chagall und die Bibel," *Merkur* XII, no. 130 (Stuttgart, 1958), p. 1154f.
8. Franz Meyer, *op. cit.*

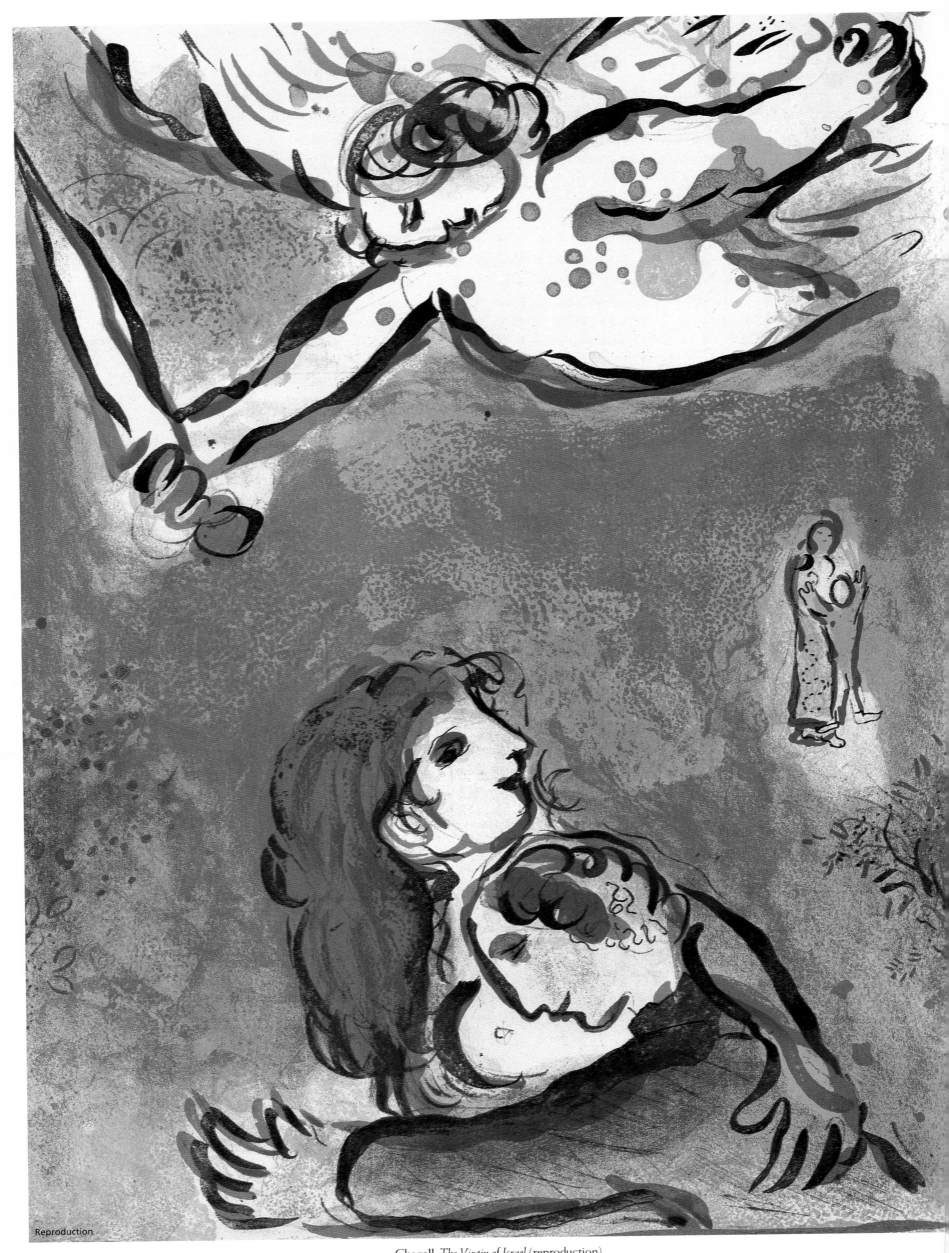

Chagall. *The Virgin of Israel* (reproduction)

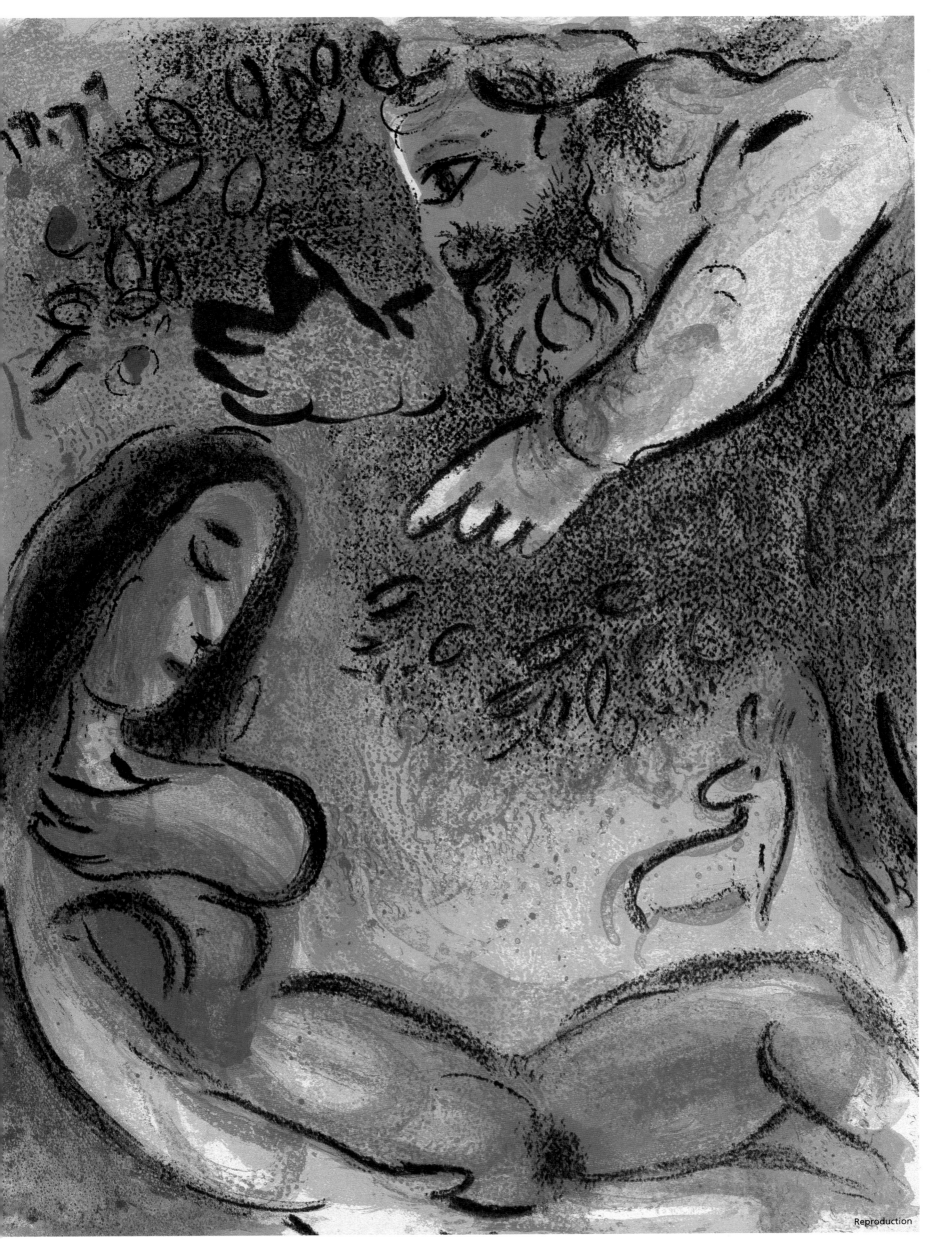

Chagall. *Eve Cursed by God* (reproduction)

But Woman picked the apple. With that single gesture, Paradise was devastated. God the Creator is now God the Judge. In his paintings, Chagall depicts this revolution of both God and men. God, in heaven, appears as an avenging finger. Adam and Eve take flight before the pointing index finger of this Wrathful God.

But—Chagallian benevolence—in one colorplate where Eve is cursed by God for her transgression, in the foreground Chagall has drawn a startled lamb in front of her. A lamb? Or perhaps that Chagallian creature is more a cross between a donkey and a goat—an androgynous animal that Chagall slips into many of his paintings. Does not this allusion to the tranquil innocence of animals underscore man's dramatic responsibility with regard to the joys of living?

In any case, Paradise is henceforth off limits. The rest of the Bible, through the prophets, goes on to tell of the destiny of man. . . . (*Excerpt*)

GASTON BACHELARD

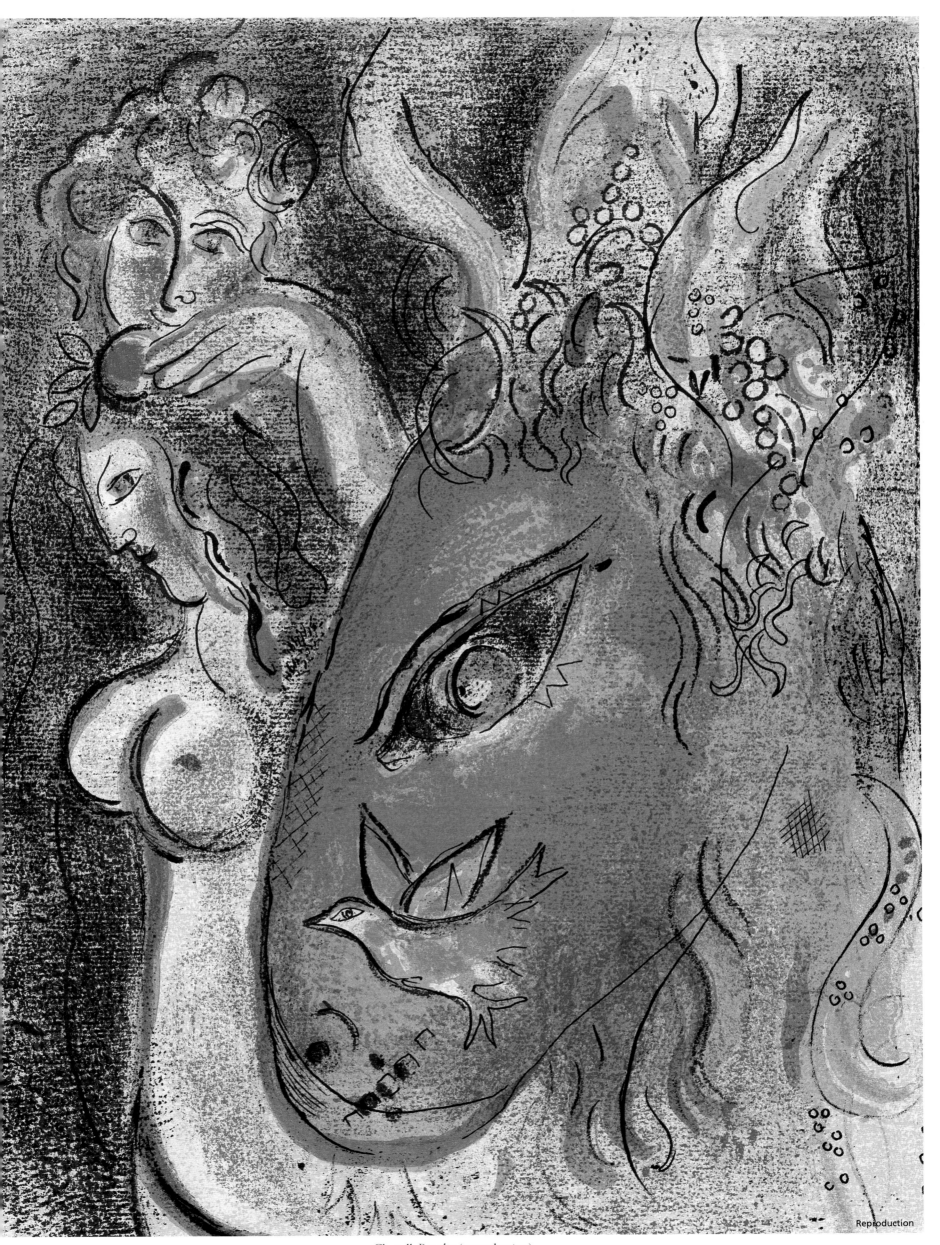

Chagall. *Paradise* (reproduction)

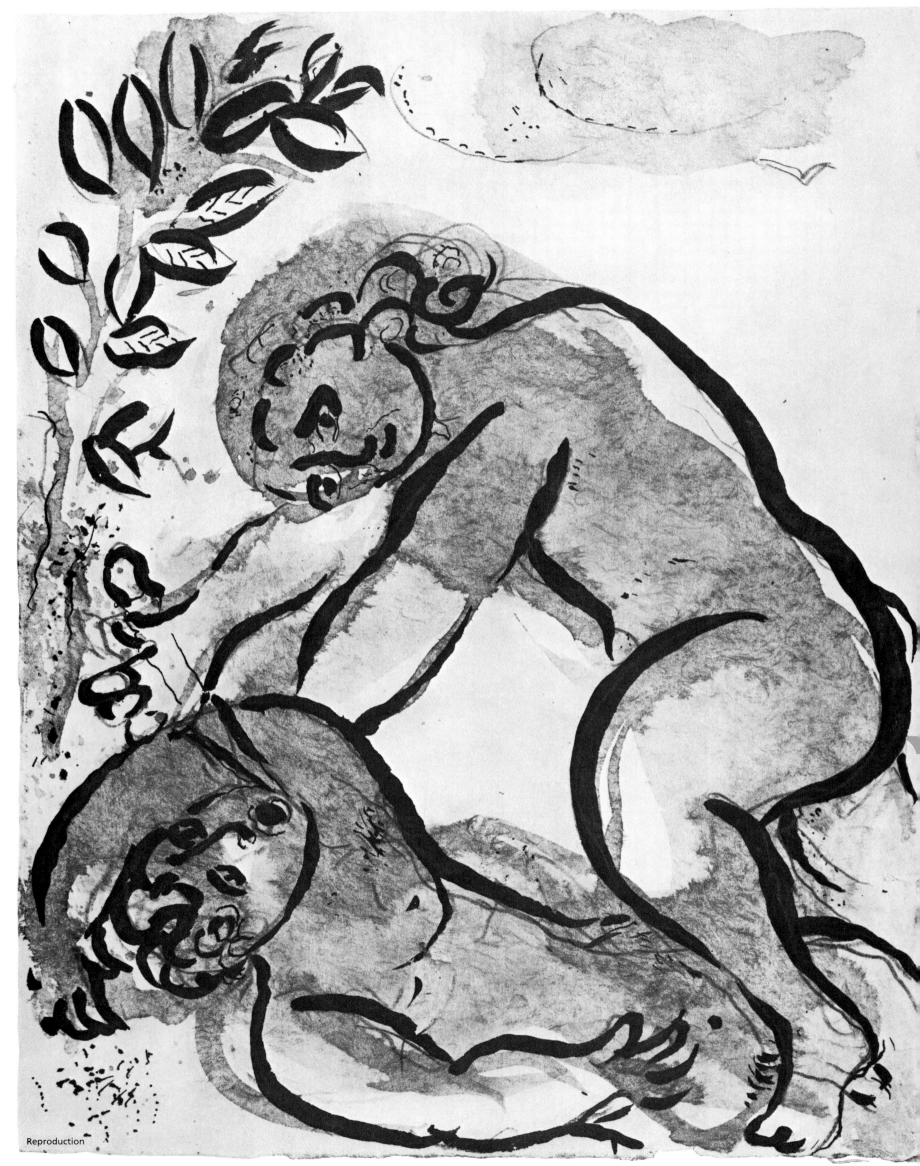

Chagall. *Cain the Murderer* (reproduction)

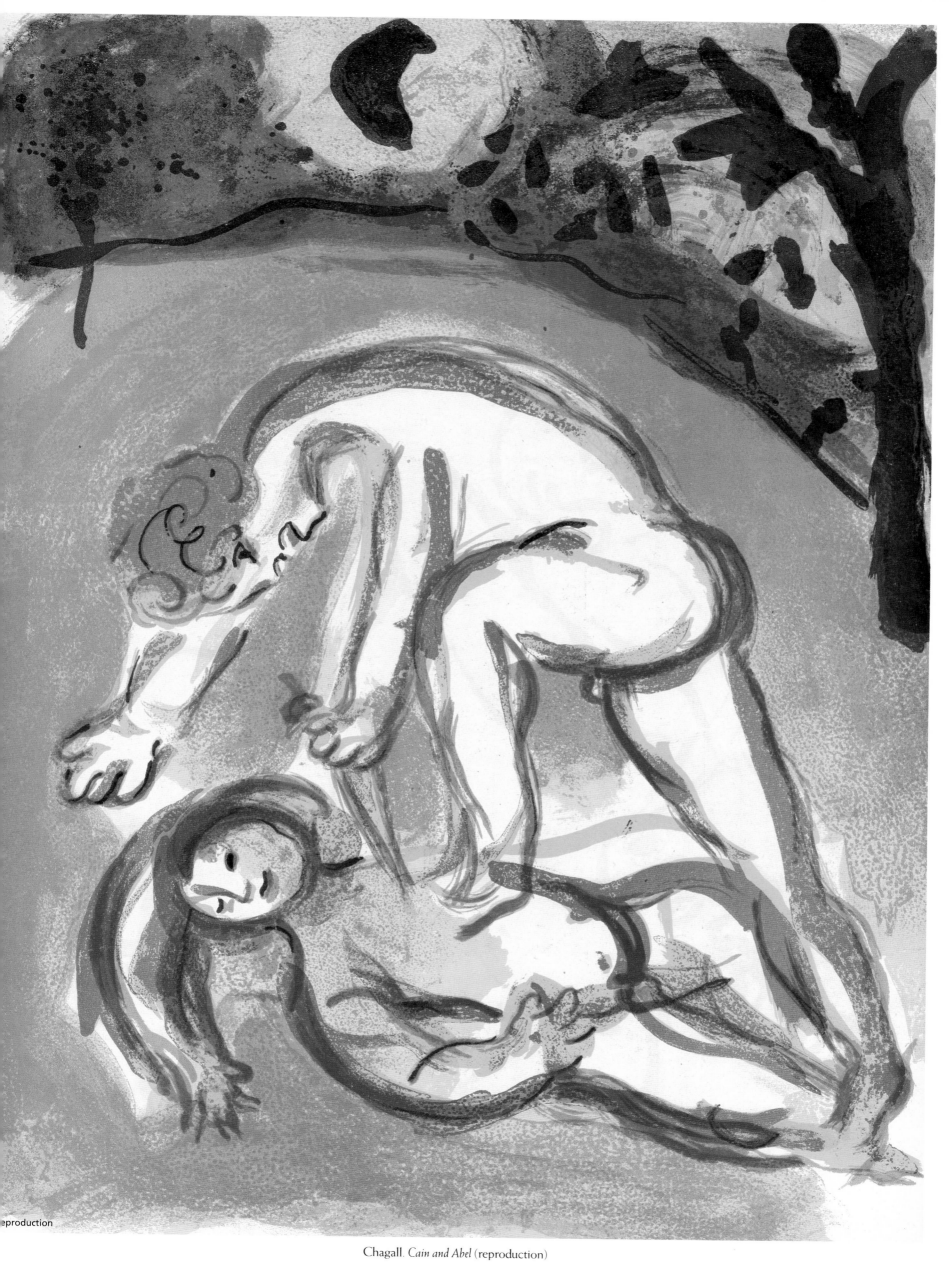

Chagall. *Cain and Abel* (reproduction)

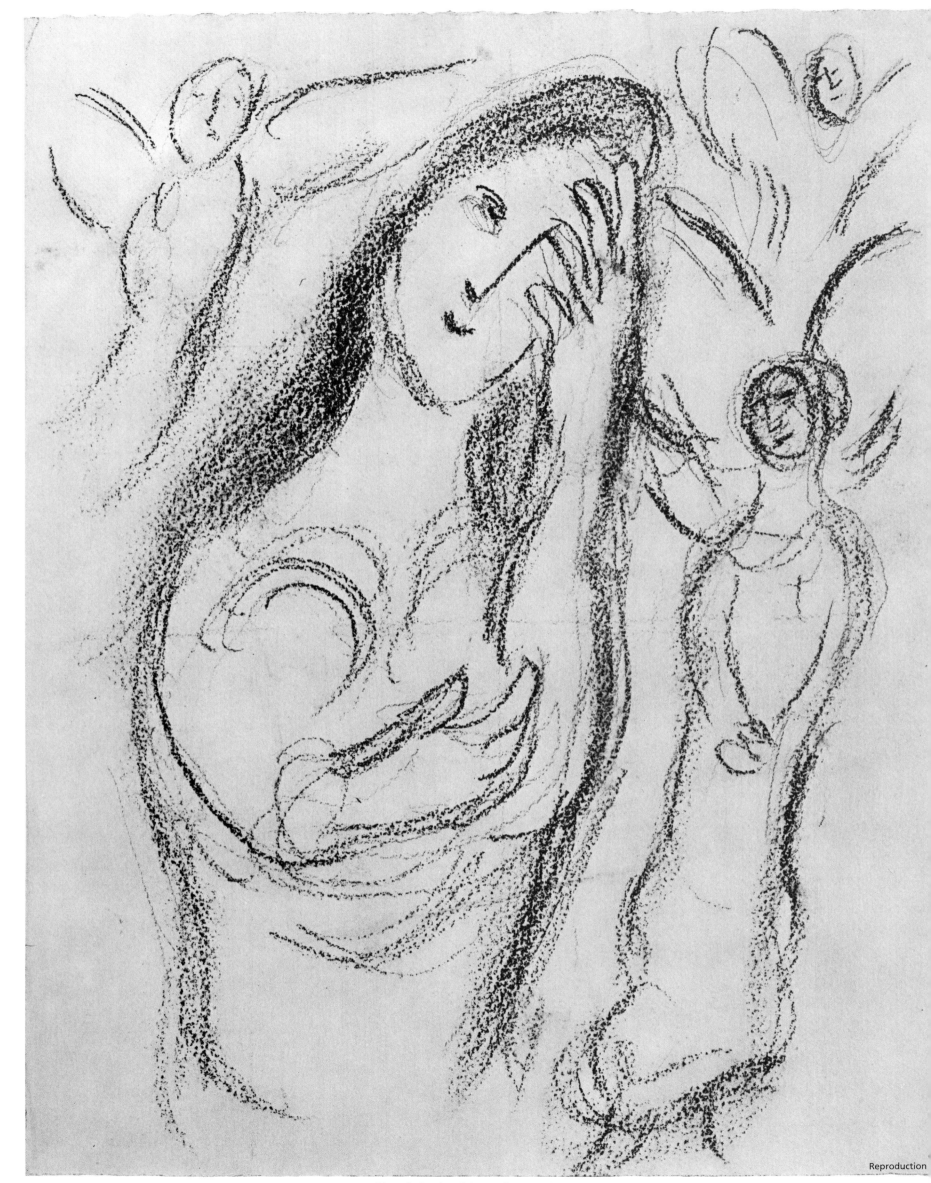

Chagall. *Sarah and the Angels* (reproduction)

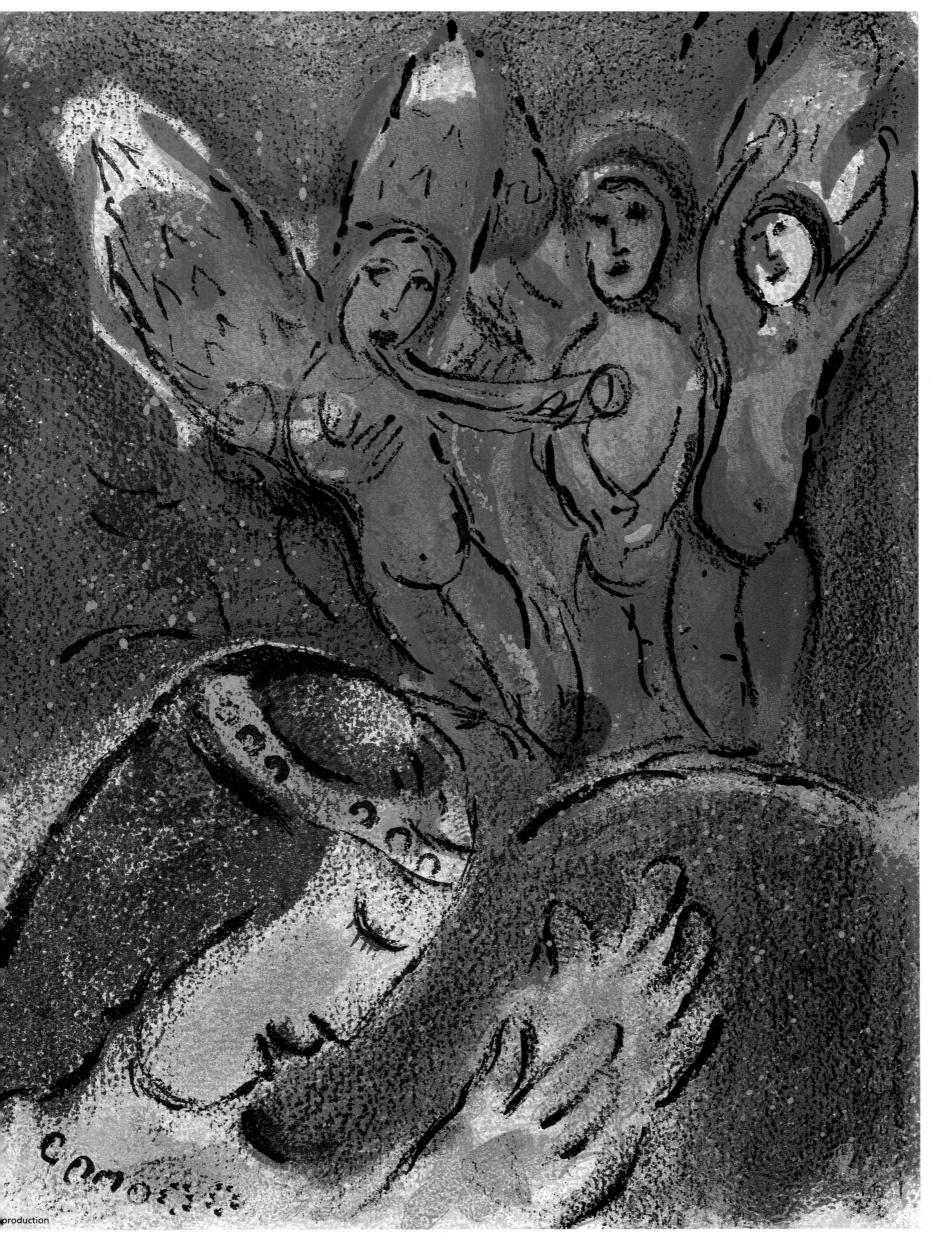

Chagall. *Sarah and the Angels* (reproduction)

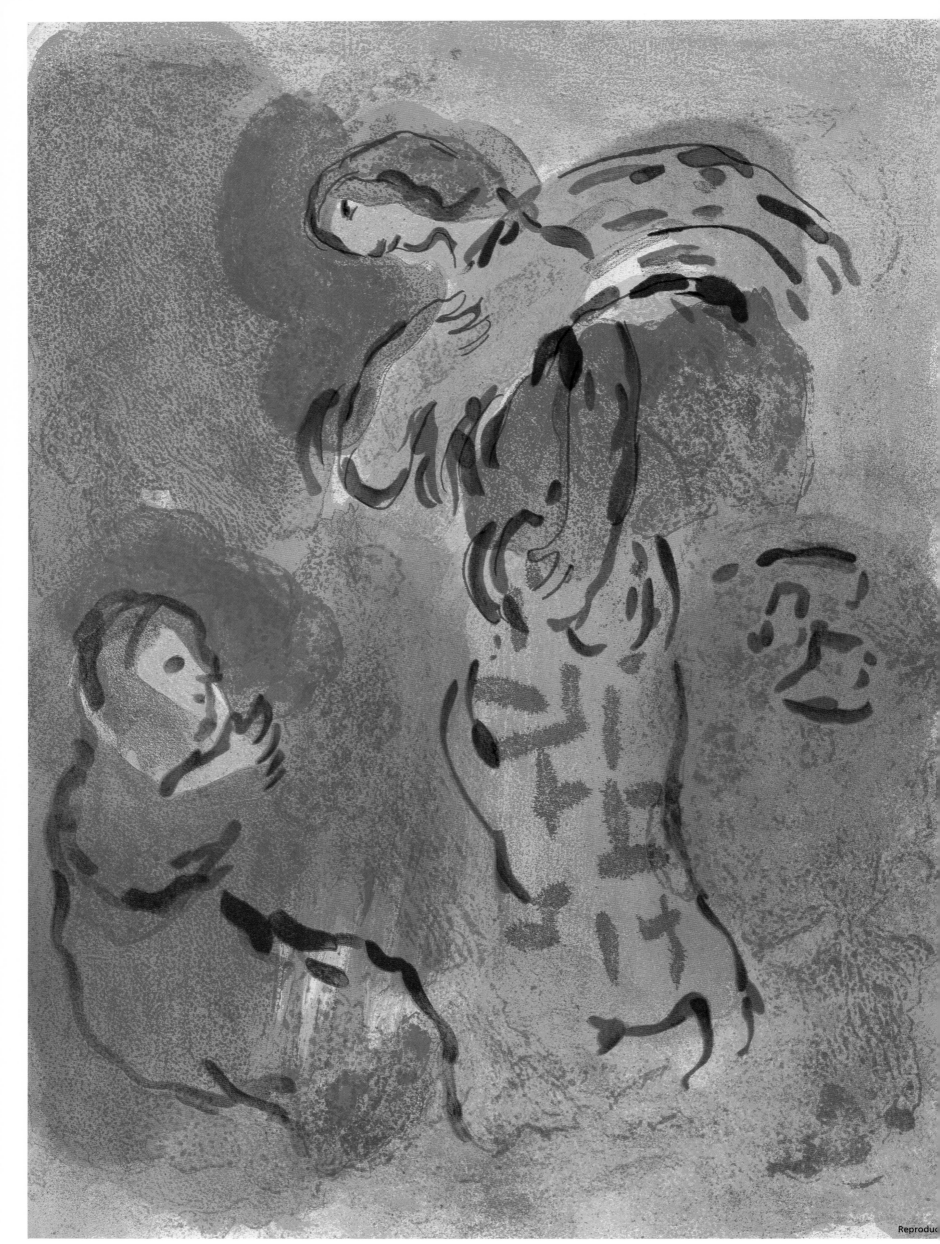

Chagall. *Ruth Gleaning* (reproduction)

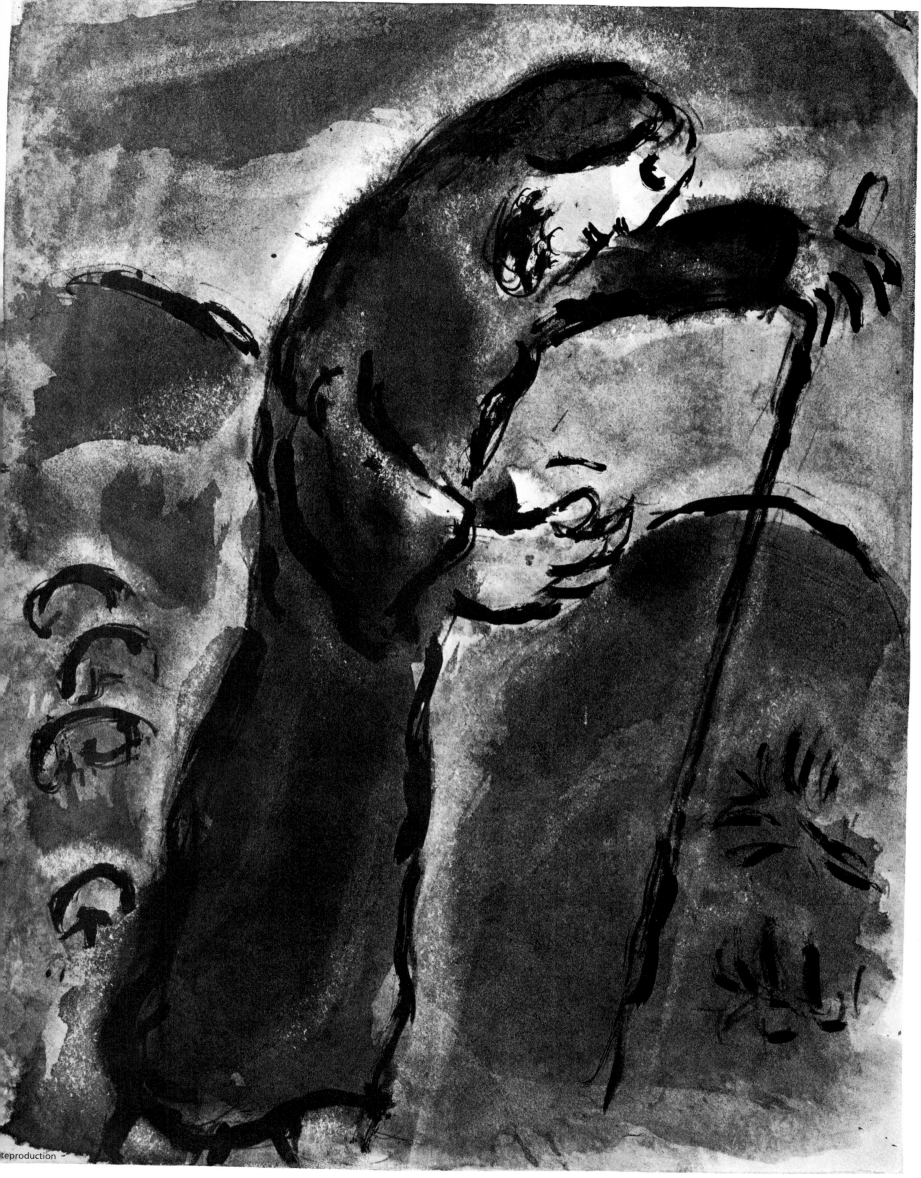

Chagall. *The Prophecy of Amos* (reproduction)

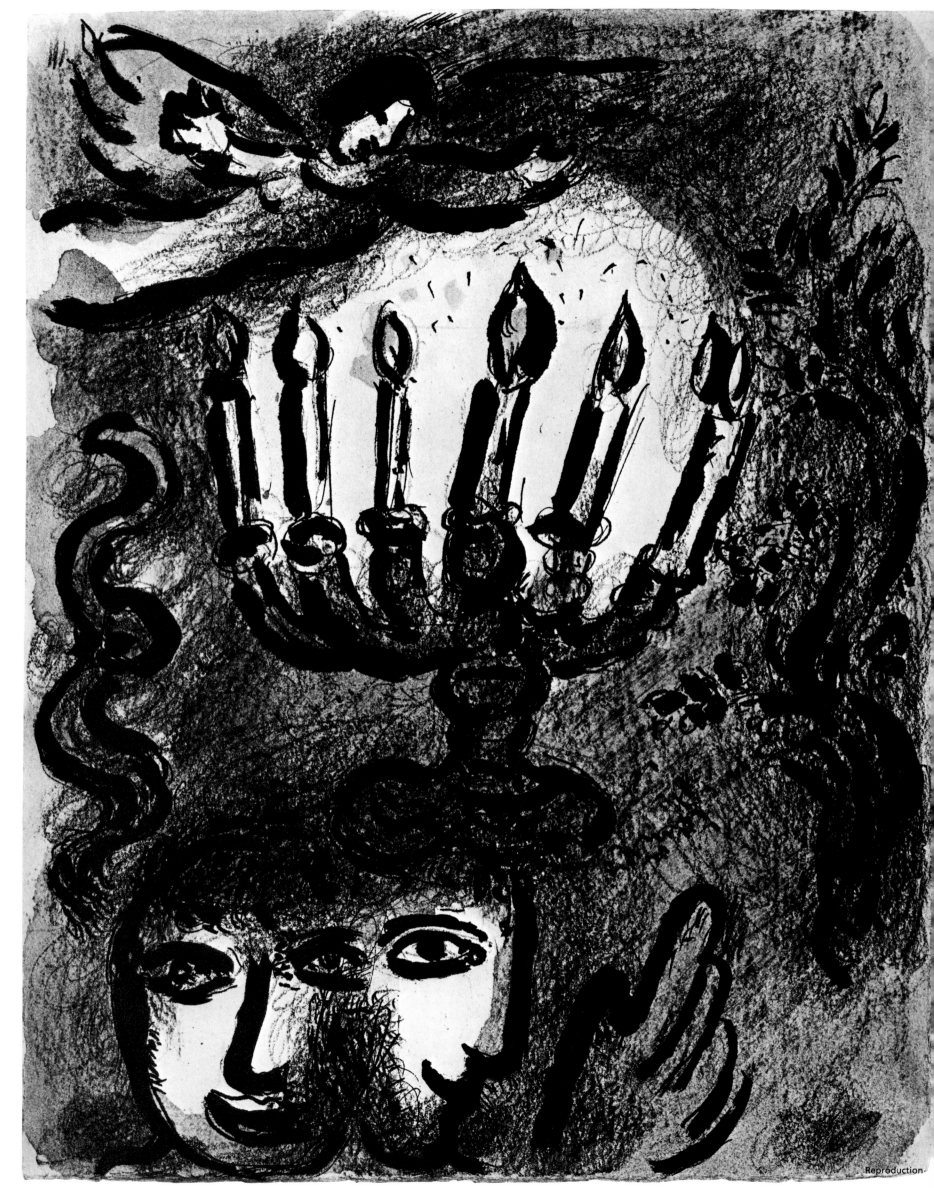

Chagall. *The Candelabra of Zachariah* (reproduction)

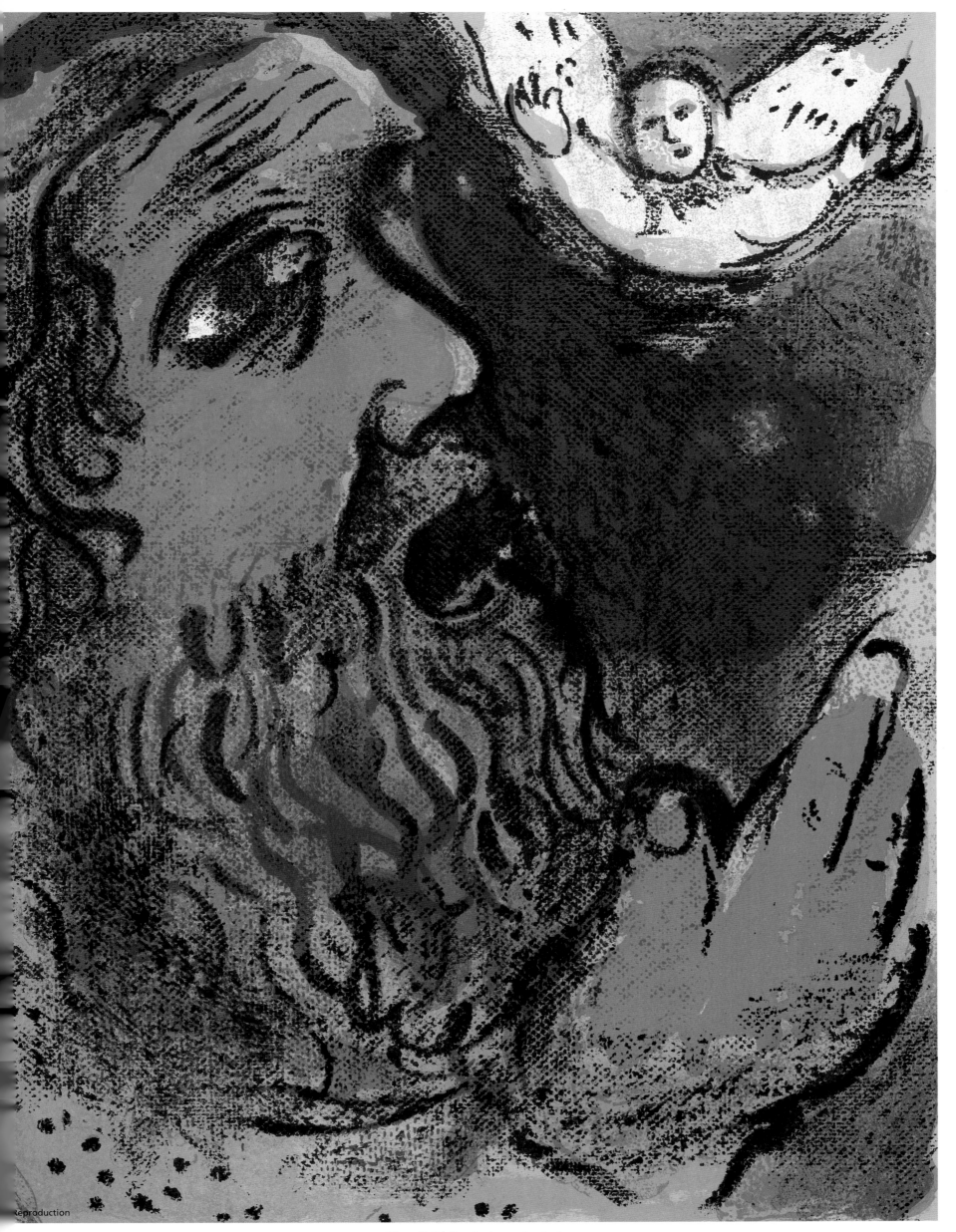

Chagall. *Job Praying* (reproduction)

VERVE DOCUMENTATION

VERVE's Covers and Selected Spreads

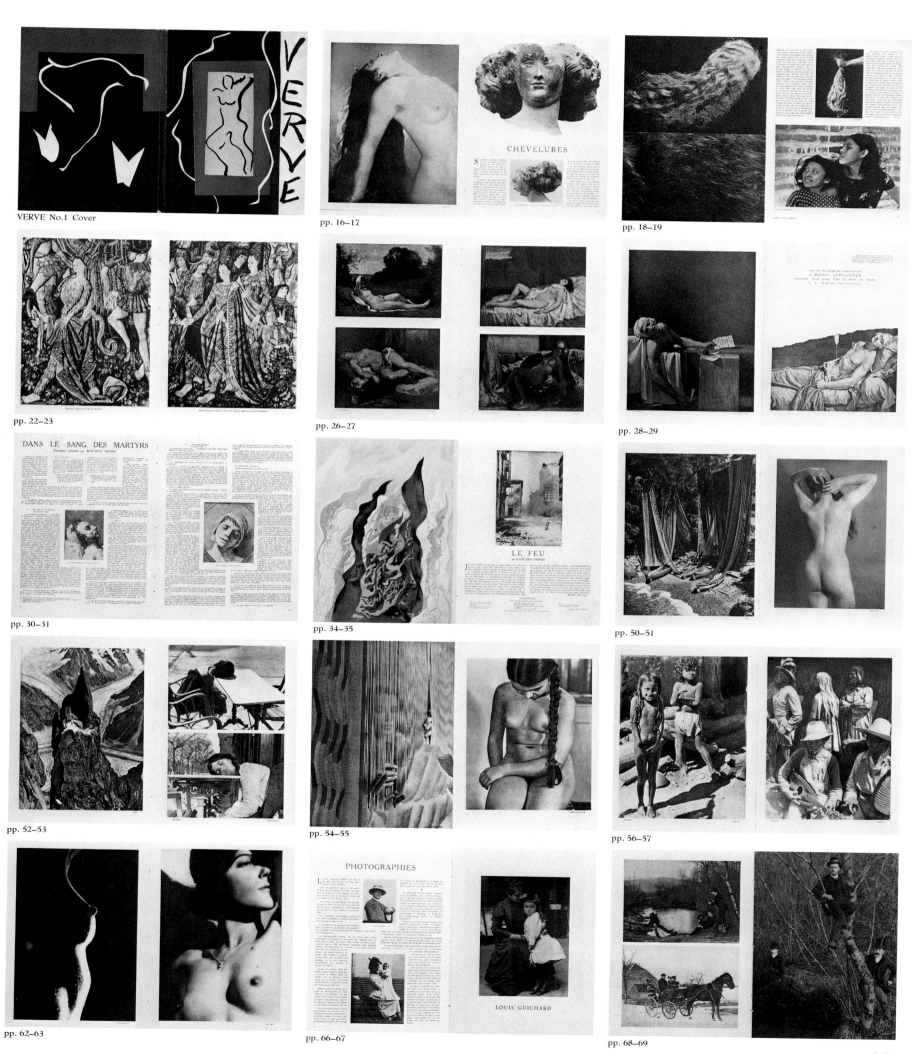

VERVE No.1 Cover

pp. 16–17

pp. 18–19

pp. 22–23

pp. 26–27

pp. 28–29

pp. 30–31

pp. 34–35

pp. 50–51

pp. 52–53

pp. 54–55

pp. 56–57

pp. 62–63

pp. 66–67

pp. 68–69

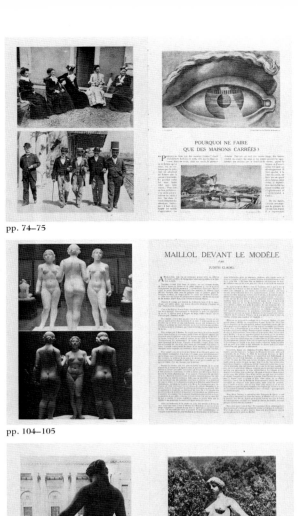

pp. 74–75

pp. 82–83

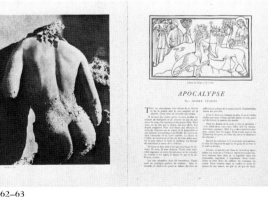

pp. 88–89

pp. 104–105

VERVE No.2 Cover

pp. 28–29

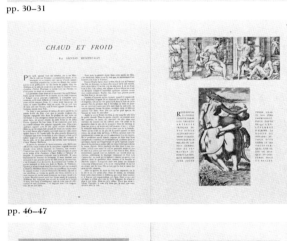

pp. 30–31

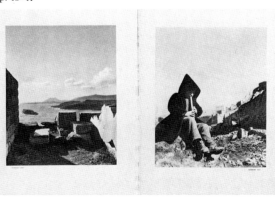

pp. 34–35

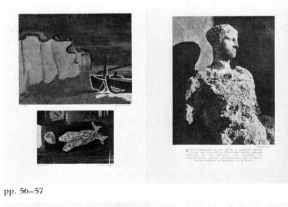

pp. 40–41

pp. 46–47

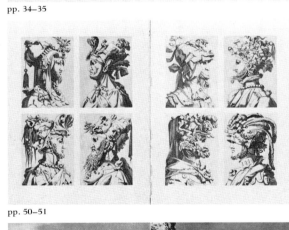

pp. 50–51

pp. 56–57

pp. 58–59

pp. 60–61

pp. 62–63

pp. 64–65

pp. 66–67

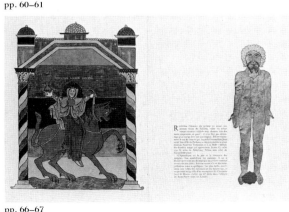

pp. 70–71

pp. 72–73

pp. 74–75

pp. 86–87

pp. 88–89

pp. 90–91

pp. 96–97

pp. 98–99

pp. 100–101

pp. 106–107

pp. 108–109

pp. 116–117

pp. 118–119

VERVE No.3 Cover

pp. 8–9

pp. 14–15

pp. 22–23

pp. 28–29

pp. 30–31

pp. 32–33

pp. 36–37

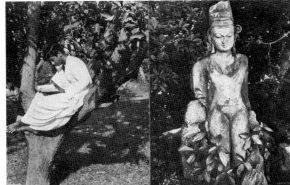

pp. 38–39

pp. 40–41

pp. 42–43

pp. 48–49

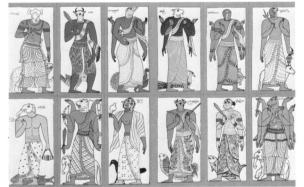

pp. 54–55

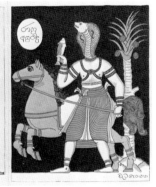

pp. 56–57

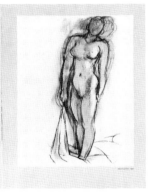

pp. 58–59

pp. 72–73

pp. 74–75

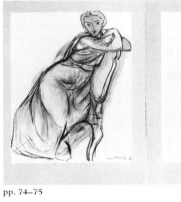

pp. 78–79

pp. 90–91

pp. 94–95

pp. 112–113

pp. 118–119

pp. 120–121

pp. 124–125

VERVE No.4 Cover

pp. 6–7

pp. 8–9

pp. 10–11

pp. 12–13

pp. 16–17

pp. 24–25

pp. 32–33

pp. 38–39

pp. 42–43

pp. 48–49

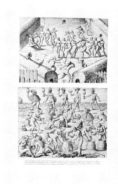

pp. 60–61

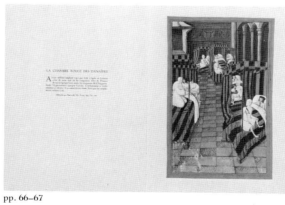

pp. 64–65

pp. 66–67

pp. 72–73

pp. 76–77

pp. 82–83

pp. 88–89

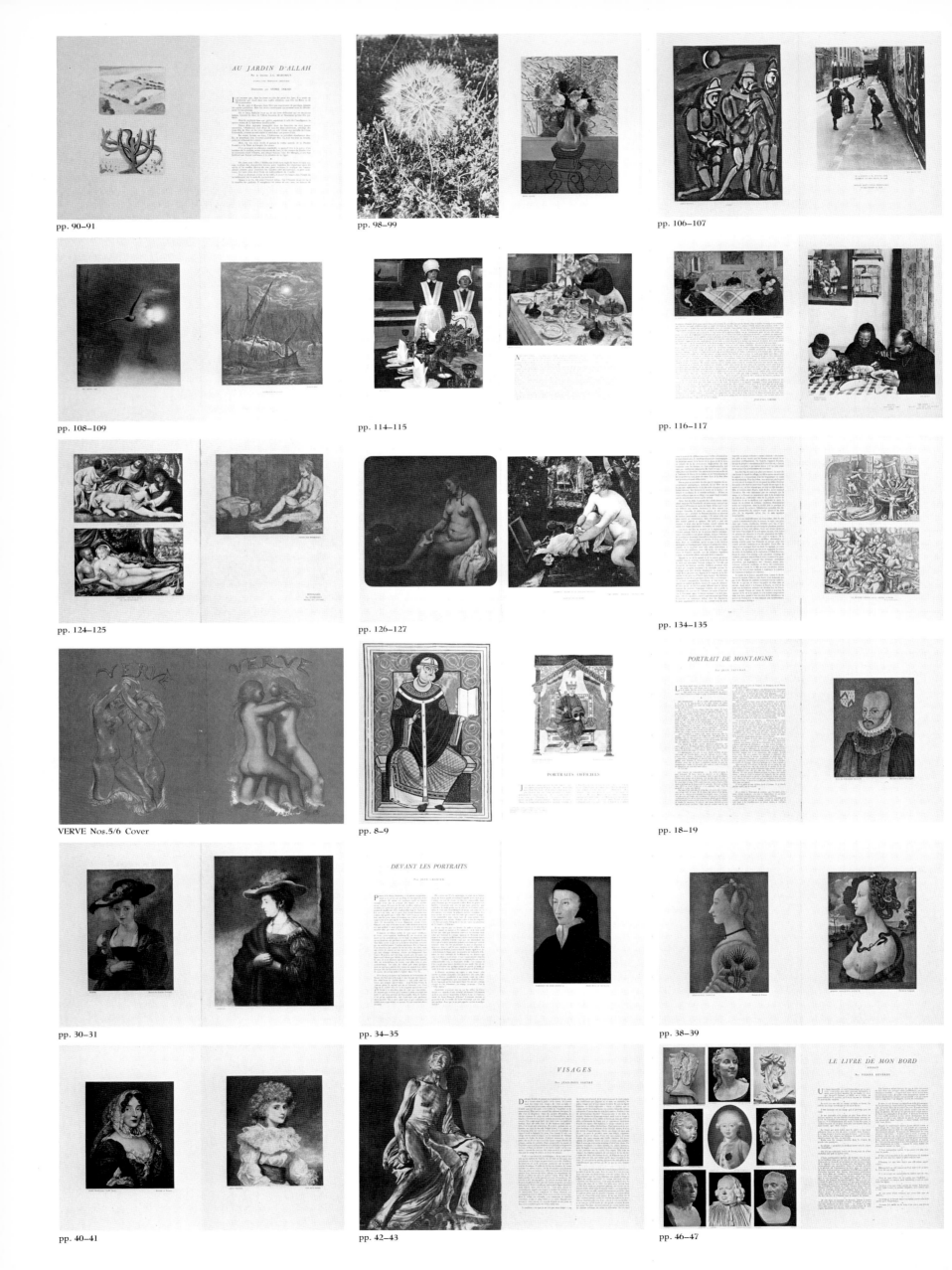

pp. 90–91

pp. 98–99

pp. 106–107

pp. 108–109

pp. 114–115

pp. 116–117

pp. 124–125

pp. 126–127

pp. 134–135

VERVE Nos. 5/6 Cover

pp. 8–9

pp. 18–19

pp. 30–31

pp. 34–35

pp. 38–39

pp. 40–41

pp. 42–43

pp. 46–47

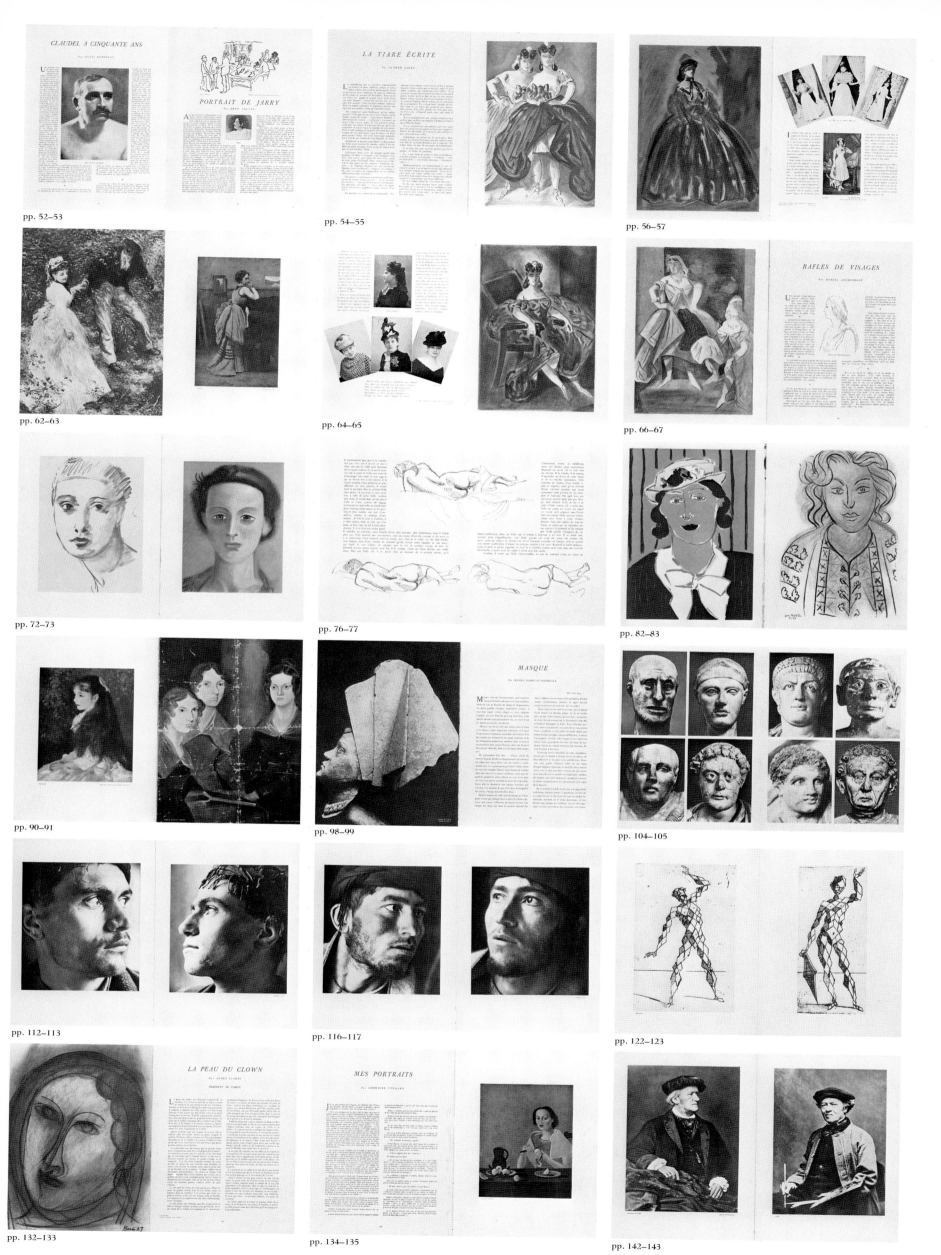

pp. 52–53

pp. 54–55

pp. 56–57

pp. 62–63

pp. 64–65

pp. 66–67

pp. 72–73

pp. 76–77

pp. 82–83

pp. 90–91

pp. 98–99

pp. 104–105

pp. 112–113

pp. 116–117

pp. 122–123

pp. 132–133

pp. 134–135

pp. 142–143

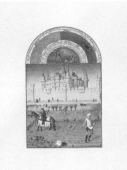

LES
TRÈS RICHES HEURES
DU
DUC DE BERRY

VERVE
7

VERVE No.7 Cover and p.25

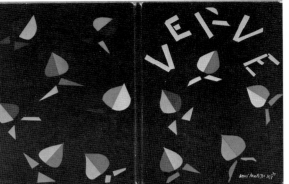

VERVE No.8 Cover

pp. 6–7

UN COIN DE FRANCE

pp. 8–9

Visage de la France

pp. 12–13

L'OASIS

pp. 20–21

CALENDRIER
DE CHARLES
D'ANGOULÊME
&
CALENDRIER
COMPOSÉ PAR
ANDRÉ DERAIN

pp. 28–29

pp. 32–33

pp. 40–41

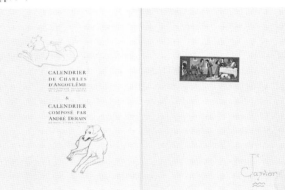

pp. 46–47

pp. 52–53

LA NATURE AUX ABOIS

pp. 54–55

pp. 58–59

pp. 62–63

pp. 74–75

LES
FOVQVET
DE LA
BIBLIOTHÈQUE
NATIONALE

VERVE

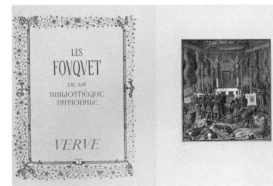

VERVE No.9 Cover and p.33

LES
TRÈS RICHES HEVRES
DV
DVC DE BERRY
IMAGES
DE LA
VIE DE JÉSUS

VERVE

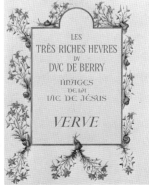

VERVE No.10 Cover and p.13

LES
FOVQVET
DE
CHANTILLY
VIE DE JÉSVS

VERVE

VERVE No.11 Cover and p.15

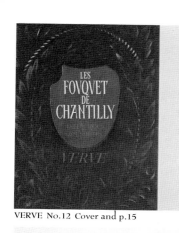

VERVE No.12 Cover and p.15

VERVE No.13 Cover

pp. 4–5

pp. 18–19

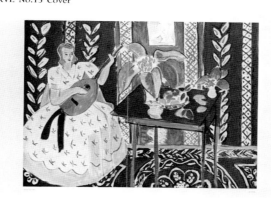

pp. 22–23

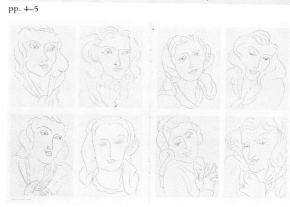

pp. 24–25

pp. 28–29

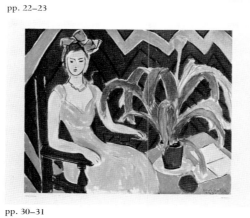

pp. 30–31

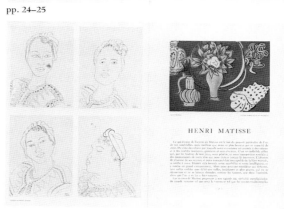

pp. 34–35

pp. 36–37

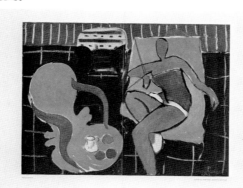

pp. 42–43

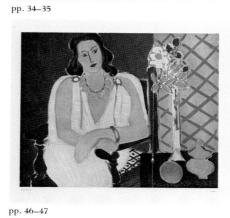

pp. 46–47

pp. 56–57

VERVE Nos.14/15 Cover and p.91

pp. 10–11

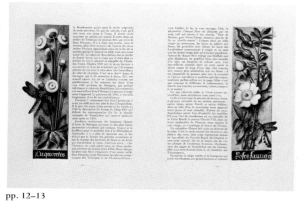

pp. 12–13

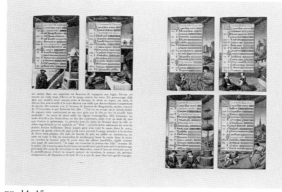

pp. 14–15

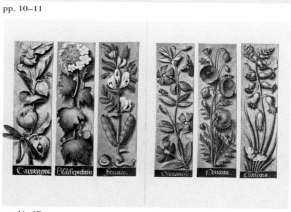

pp. 16–17

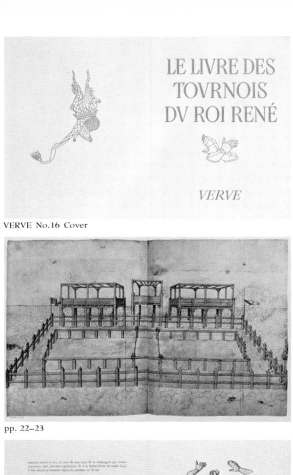

VERVE No.16 Cover

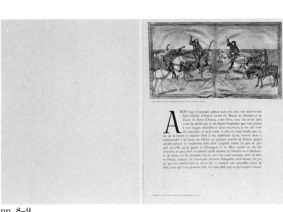

pp. 8–9

pp. 10–11

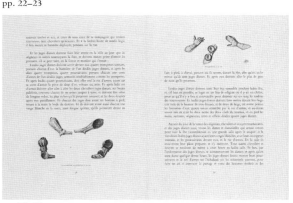

pp. 22–23

pp. 26–27

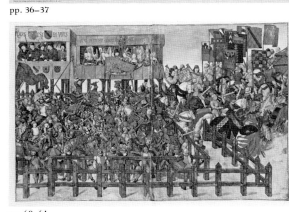

pp. 36–37

pp. 38–39

pp. 46–47

pp. 60–61

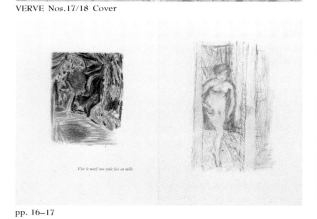

VERVE Nos.17/18 Cover

pp. 4–5

pp. 8–9

pp. 16–17

pp. 20–21

pp. 22–23

pp. 24–25

pp. 28–29

pp. 30–31

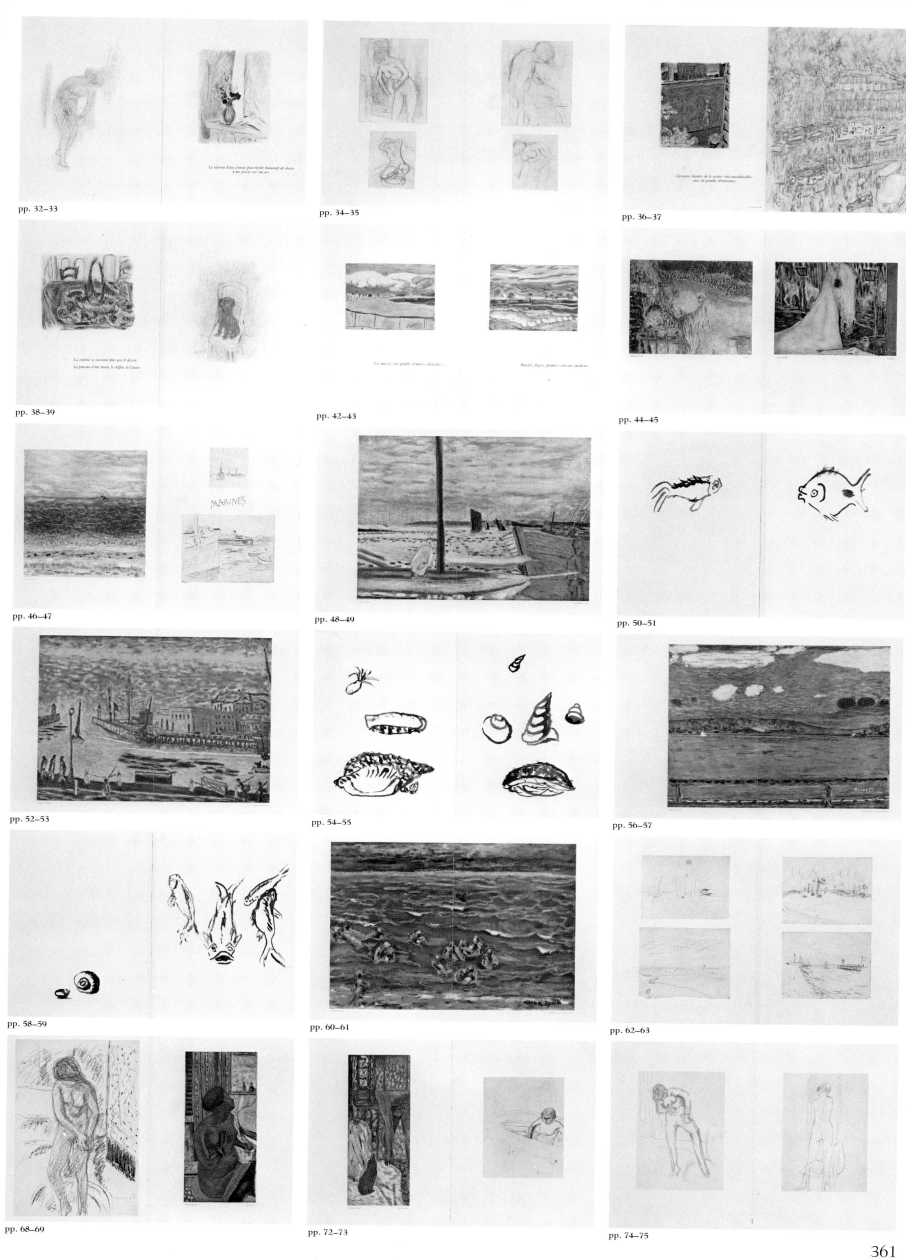

pp. 32–33

pp. 34–35

pp. 36–37

pp. 38–39

pp. 42–43

pp. 44–45

pp. 46–47

pp. 48–49

pp. 50–51

pp. 52–53

pp. 54–55

pp. 56–57

pp. 58–59

pp. 60–61

pp. 62–63

pp. 68–69

pp. 72–73

pp. 74–75

pp. 76–77

pp. 84–85

VERVE Nos.19/20 Cover

pp. 4–5

pp. 8–9

pp. 14–15

pp. 16–17

pp. 20–21

pp. 24–25

pp. 26–27

pp. 28–29

pp. 30–31

pp. 32–33

pp. 34–35

pp. 36–37

pp. 38–39

pp. 40–41

pp. 42–43

pp. 44–45

pp. 46–47

pp. 48–49

pp. 54–55

pp. 56–57

pp. 58–59

pp. 60–61

pp. 66–67

pp. 70–71

pp. 76–77

pp. 78–79

pp. 80–81

VERVE Nos.21/22 Cover

pp. 4–5

pp. 6–7

pp. 8–9

pp. 10–11

pp. 16–17

pp. 24–25

pp. 26–27

pp. 28–29

pp. 30–31

pp. 36–37

pp. 38–39

pp. 40–41

pp. 44–45

pp. 48–49

pp. 52–53

pp. 54–55

pp. 56–57

pp. 60–61

VERVE No.23 Cover and p.11

VERVE No.24 Cover

pp. 14–15

pp. 18–19

pp. 20–21

pp. 24–25

pp. 26–27

pp. 28–29

pp. 30–31

pp. 32–33

pp. 34–35

pp. 36–37

pp. 38–39

pp. 40–41

pp. 44–45

pp. 46–47

pp. 48–49

pp. 50–51

pp. 54–55

pp. 56–57

pp. 58–59

pp. 60–61

pp. 62–63

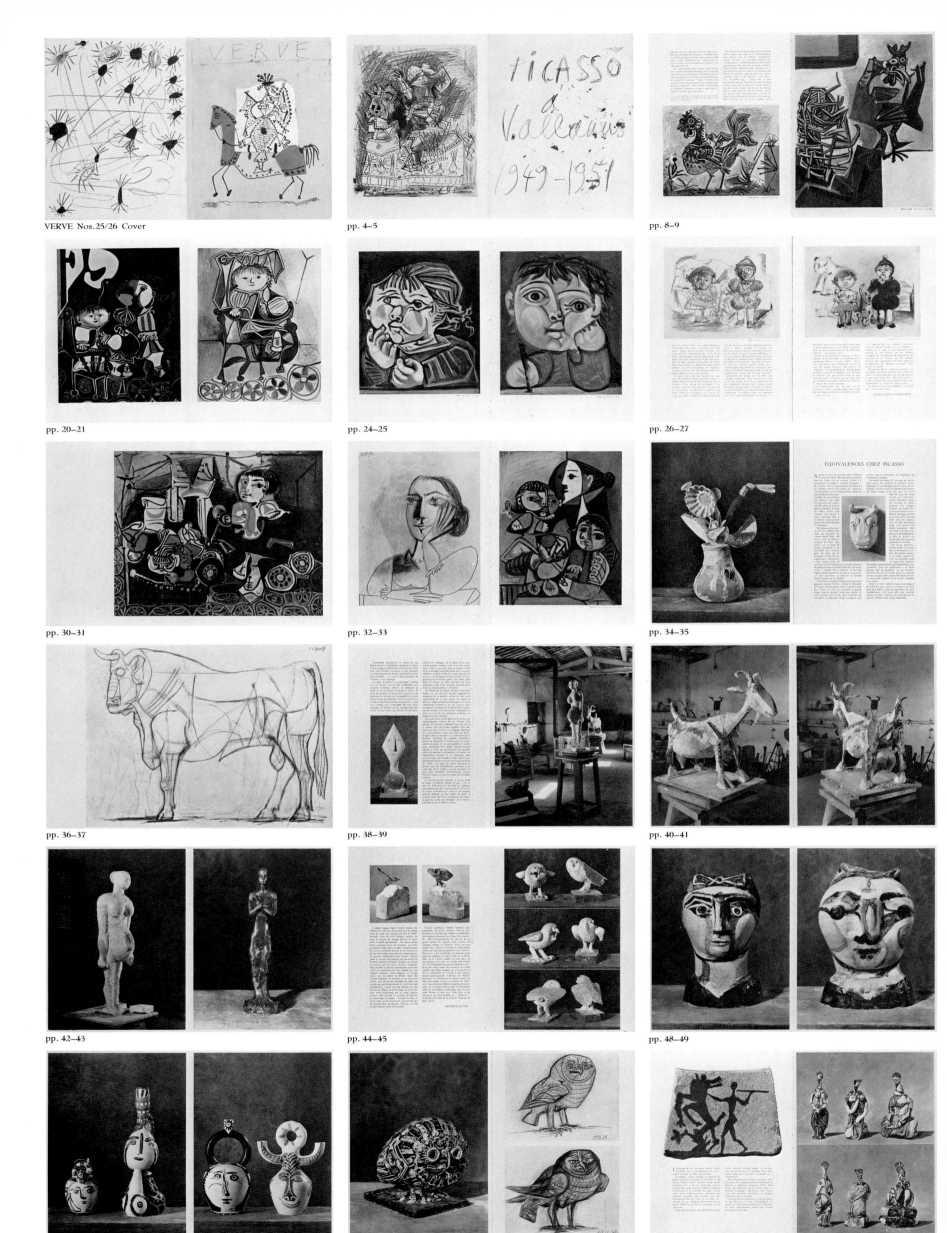

VERVE Nos.25/26 Cover

pp. 4–5

pp. 8–9

pp. 20–21

pp. 24–25

pp. 26–27

pp. 30–31

pp. 32–33

pp. 34–35

pp. 36–37

pp. 38–39

pp. 40–41

pp. 42–43

pp. 44–45

pp. 48–49

pp. 50–51

pp. 54–55

pp. 58–59

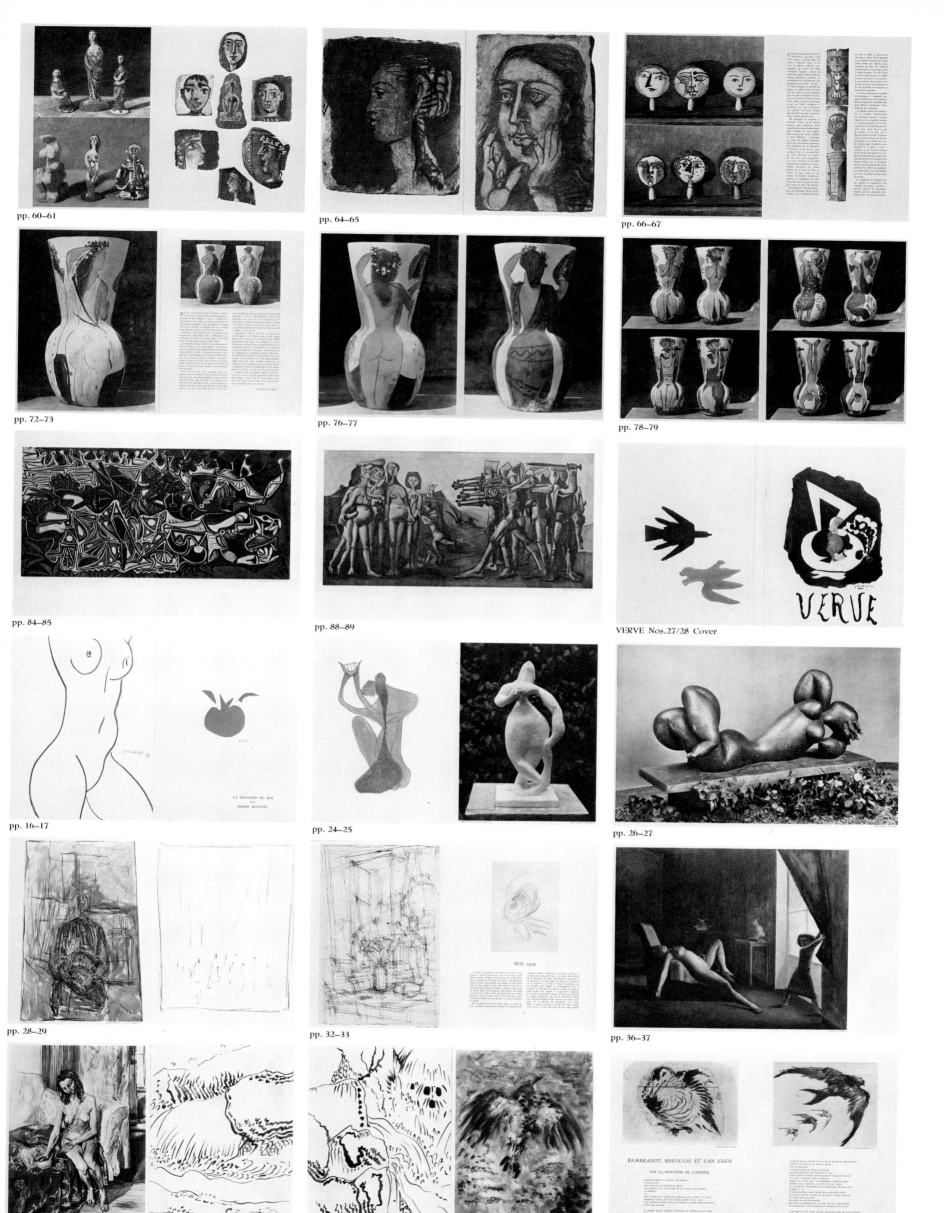

pp. 60–61

pp. 64–65

pp. 66–67

pp. 72–73

pp. 76–77

pp. 78–79

pp. 84–85

pp. 88–89

VERVE Nos.27/28 Cover

pp. 16–17

pp. 24–25

pp. 26–27

pp. 28–29

pp. 32–33

pp. 36–37

pp. 38–39

pp. 42–43

pp. 44–45

pp. 46–47

pp. 50–51

pp. 52–53

pp. 54–55

pp. 56–57

pp. 64–65

pp. 66–67

pp. 68–69

pp. 70–71

pp. 74–75

pp. 76–77

pp. 90–91

pp. 94–95

pp. 96–97

pp. 100–101

pp. 102–103

pp. 110–111

pp. 112–113

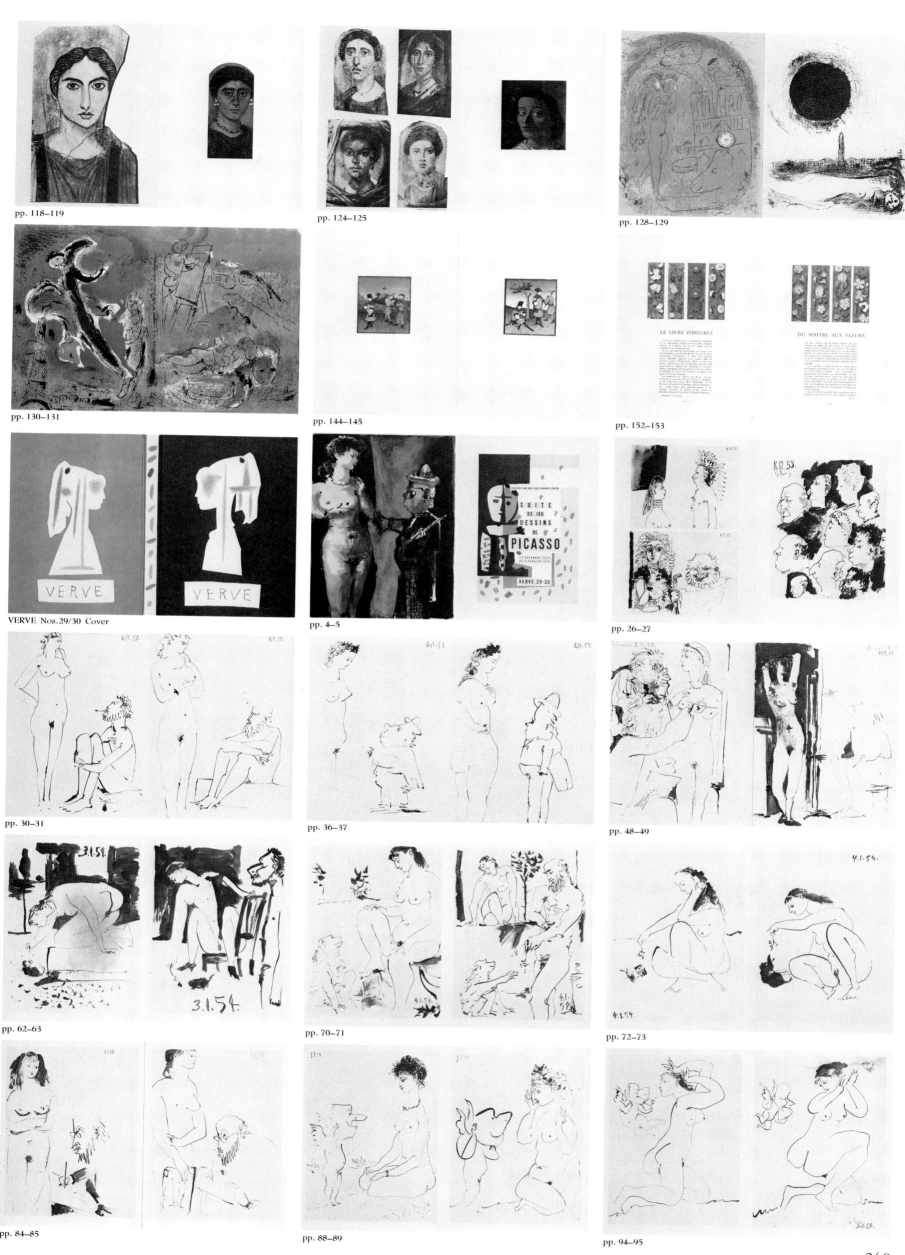

pp. 118–119

pp. 124–125

pp. 128–129

pp. 130–131

pp. 144–145

pp. 152–153

VERVE Nos.29/30 Cover

pp. 4–5

pp. 26–27

pp. 30–31

pp. 36–37

pp. 48–49

pp. 62–63

pp. 70–71

pp. 72–73

pp. 84–85

pp. 88–89

pp. 94–95

pp. 98–99

pp. 102–103

pp. 106–107

pp. 112–113

pp. 140–141

pp. 148–149

pp. 152–153

pp. 154–155

pp. 164–165

pp. 176–177

pp. 180–181

pp. 190–191

pp. 202–203

pp. 206–207

pp. 208–209

VERVE Nos. 31/32 Cover

pp. 8–9

pp. 22–23

pp. 34–35

pp. 40–41

pp. 42–43

pp. 44–45

pp. 52–53

pp. 58–59

pp. 64–65

pp. 66–67

pp. 74–75

pp. 110–111

pp. 118–119

pp. 140–141

pp. 144–145

pp. 148–149

pp. 158–159

pp. 160–161

VERVE Nos. 33/34 Cover

pp. 6–7

pp. 20–21

pp. 34–35

pp. 38–39

pp. 42–43

pp. 44–45

pp. 48–49

pp. 54–55

pp. 56–57

pp. 58–59

pp. 64–65

pp. 72–73

pp. 78–79

pp. 88–89

pp. 90–91

pp. 92–93

pp. 98–99

pp. 106–107

pp. 110–111

pp. 120–121

pp. 128–129

pp. 130–131

pp. 132–133

pp. 138–139

pp. 142–143

pp. 150–151

pp. 152–153

pp. 154–155

VERVE Nos.35/36 Cover

pp. 4–5

pp. 14–15

pp. 20–21

pp. 26–27

pp. 34–35

pp. 38–39

pp. 42–43

pp. 54–55

pp. 56–57

pp. 58–59

pp. 62–63

pp. 64–65

pp. 66–67

pp. 70–71

pp. 72–73

pp. 86–87

pp. 110–111

pp. 128–129

pp. 136–137

pp. 150–151

pp. 156–157

pp. 164–165

pp. 172–173

pp. 176–177

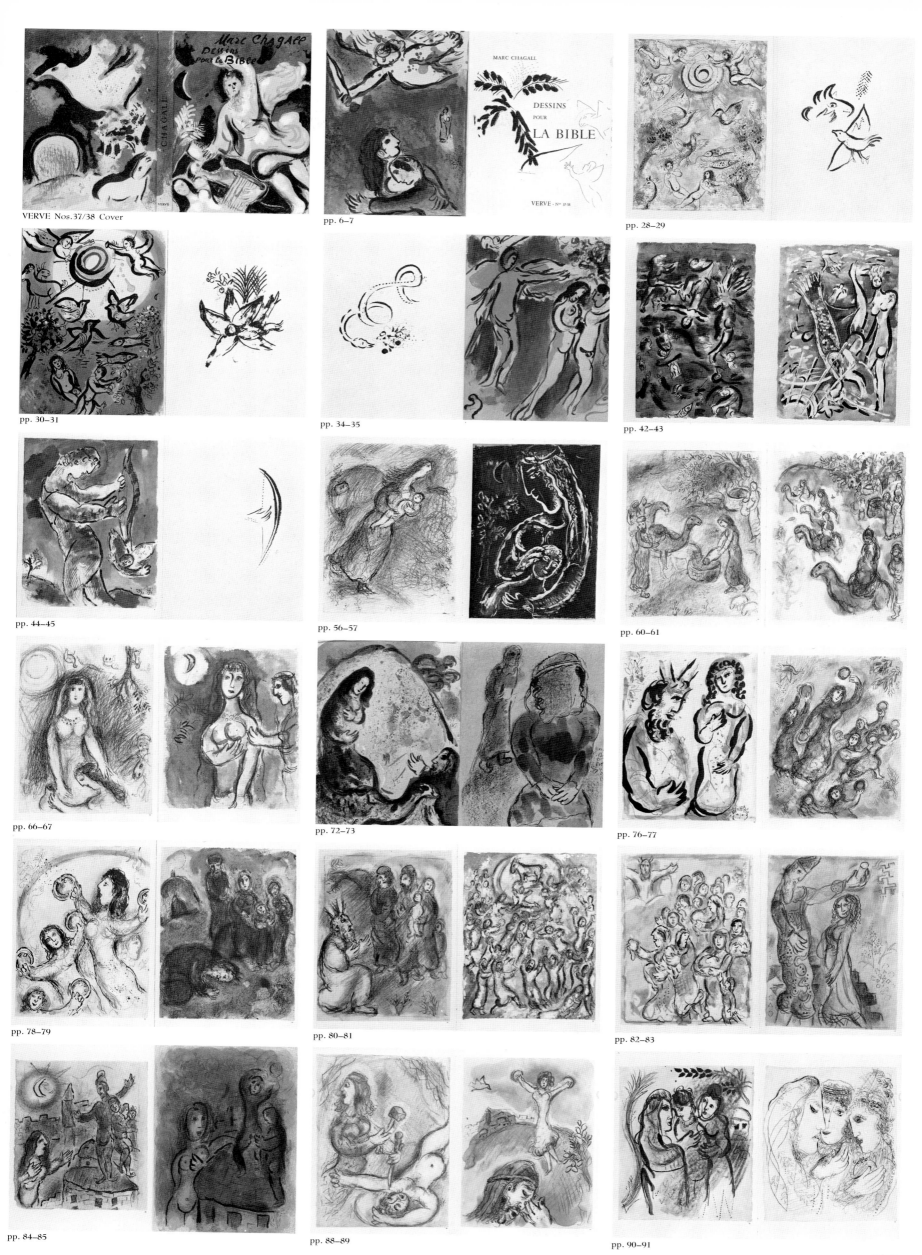

VERVE Nos. 37/38 Cover

pp. 6–7

pp. 28–29

pp. 30–31

pp. 34–35

pp. 42–43

pp. 44–45

pp. 56–57

pp. 60–61

pp. 66–67

pp. 72–73

pp. 76–77

pp. 78–79

pp. 80–81

pp. 82–83

pp. 84–85

pp. 88–89

pp. 90–91

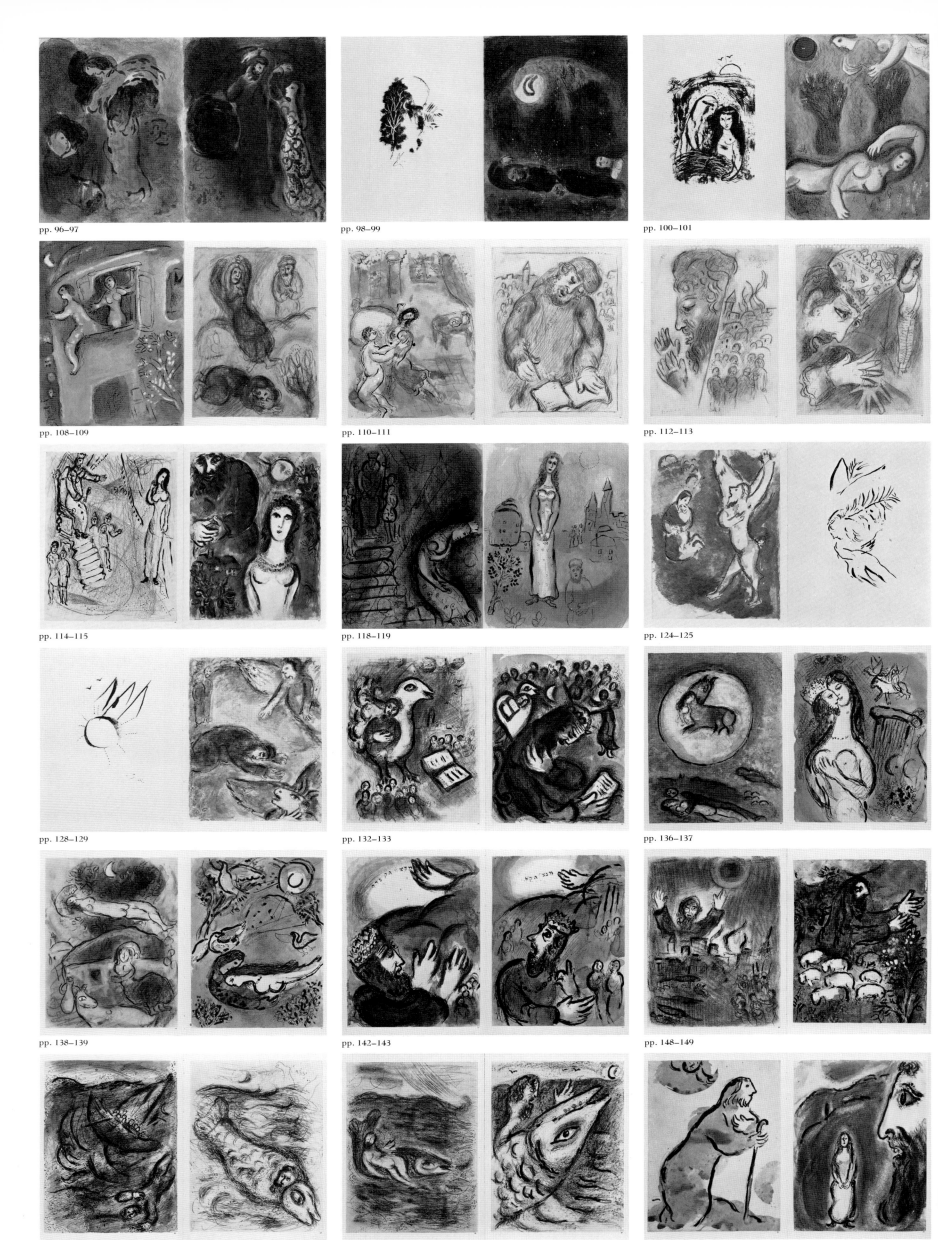

pp. 96–97

pp. 98–99

pp. 100–101

pp. 108–109

pp. 110–111

pp. 112–113

pp. 114–115

pp. 118–119

pp. 124–125

pp. 128–129

pp. 132–133

pp. 136–137

pp. 138–139

pp. 142–143

pp. 148–149

pp. 154–155

pp. 156–157

pp. 158–159

Index

The index lists, by name of artist or author, all artwork and articles published in VERVE.
Page numbers in **boldface** indicate where reproductions or excerpts
may be found in this book; all others refer to issues of VERVE.
(The following issues of VERVE appeared in both French- and English-language editions:
Nos. 1–4, 5/6, 7, 8, and 29/30. Page numbers on which articles or artwork
appear may vary slightly between the two editions.)

63; XVIII *The Crucifixion*, p. 65; XIX *The Pietà*, p. 67; Lives of the Saints, color illuminations: XX *St. Cosmas and St. Damian*, p. 73; XXI *St. Peter of Verona*, p. 75; XXII *St. Nicholas*, p. 77, **p. 162**; XXIII *St. Martin*, p. 79; XXIV *St. Hubert*, p. 81; XXV *St. Ursula and Companions*, p. 83; XXVI *St. Mary Magdalene*, p. 85; XXVII *St. Margaret*, p. 87, **p. 163**; XXVIII *St. Sebastian*, p. 89; XXIX *St. Maurice and the Martyrs of Agaunum*, p. 91; XXX *The Virgins*, p. 93.

BOVIS, Marcel, b. 1904. Photographer.
VERVE No. 1: *Snowy Landscape*, photograph. Photogravure, p. 49.

BOYVIN, René, c. 1525–c. 1580 or 1598. Engraver.
VERVE No. 2: *Roman Charity*, engraving, 1542, p. 47; *The Rape of Europa*, engraving, p. 47; *Series of Masks for a Ballet*, engravings, pp. 48, 50, 51; *Nymphs Dancing a Roundelay*, engraving, p. 49; *The Three Fates*, engraving, p. 49.

BOZE, Joseph, 1744–1826. Portrait painter.
VERVE Nos. 5/6: *The Duke of Angoulême*, pastel. Colorplate, p. 46.

BRACELLI, Giovanni Battista, 1584–1609. Painter, engraver.
VERVE Nos. 5/6: Drawings, 16th century, pp. 122, 123, 125.

BRADY, Mathew B., 1843–1896. Photographer.
VERVE Nos. 5/6: *Edward VII, Prince of Wales, in New York, 1860*, photograph. Photogravure, p. 137; *General Ricketts and His Wife*, photograph. Photogravure, p. 138; *Edgar Allan Poe*, daguerreotype, p. 146, **p. 118**; *Walt Whitman*, photograph. Photogravure, p. 148.

BRANDT, Bill, 1904–1983. Photographer.
VERVE No. 2: Photograph of Georges Braque, p. 52, **p. 64**; Photograph of Braque's reading stand, taken in Braque's studio, p. 55, **p. 65**. Photogravure, p.118; *London, Children*, photograph. Photogravure, p. 119; *London, Children*, photograph.
VERVE No. 4: "Gustave Doré's London Rediscovered by Bill Brandt in 1938": 5 photographs, pp. 107, 108, 110, 112, 114; *Spanish Dinner*, photograph, p. 117.

BRAQUE, Georges, 1882–1963. Painter.
VERVE No. 2: Cover designed expressly for this issue by Braque, **p. 54**; drawing, p. 4; *Io*, bas-relief, p. 7, **p. 57**; "Réflexions" [*Reflections*], text, excerpts from Braque's notebooks, p. 7, **p. 57**; photograph of Braque by Bill Brandt, p. 52, **p. 64**; *Woman with a Mandolin*, painting. Colorplate, p. 53; photograph of Braque by Elliott, p. 54; photograph of Braque's reading stand, by Bill Brandt, p. 55, **p. 65**; *The Beach*, painting. Colorplate, p. 56; *Still Life*, painting. Colorplate, p. 56.
VERVE Nos. 5/6: *Figure* (detail), color lithograph, p. 69, **p. 113**.
VERVE No. 8: "Réflexions" [*Reflections*], text by Georges Braque, pp. 56–57, **pp. 134–135**; *Still Life*, painting. Color reproduction, p. 56, black-

and-white, **p. 134**; *Still Life*, painting, 1939. Color reproduction, p. 57, black-and-white, **p. 135**.
VERVE Nos. 27/28: Cover designed expressly for this issue by Braque, **p. 232**; frontispiece, color lithograph, p. 8, **p. 237**; *Oysters*, painting. Black-and-white reproduction, p. 71; remarks by Georges Braque, spring 1952, pp. 71, 80; *Le Gros Nuage*, painting. Color reproduction, p. 72, **p. 250**; 3 *Seascapes*, paintings. Black-and-white reproduction, p. 73, **p. 251**; *Sunflowers*, painting. Color reproduction, p. 74; engraved plaster slab, p. 75; *The Bench*, painting. Color reproduction, p. 76; drawing, p. 77; *Heavy Shower*, painting. Color reproduction, p. 78; *Wheat Field*, painting. Color reproduction, p. 79; drawing, p. 80; *The Bicycle*. Color reproduction, p. 81; *Bouquet of Yellow Flowers*, painting. Color reproduction, p. 82; *Vase and Flowers*, drawing, **p. 240**.
VERVE Nos. 31/32: Cover designed expressly for this issue by Braque, **p. 270**; *Attelage*, color lithograph, p. 2, **p. 274**; "Carnets Intimes de Georges Braque," title page. Color reproduction, p. 3, **p. 275**; *Attelage*, color lithograph, p. 9; *Attelage*, color lithograph, p. 16; *Seated Woman*, color lithograph, p. 25, **p. 279**; *Head of a Woman*, drawing, p. 27; *Head of a Woman*, drawing, p. 28; *Head of a Woman*, drawing, p. 29; *Head of a Woman*, drawing, p. 30; *Head of a Woman*, drawing, p. 31; *Head of a Woman*, drawing, p. 32; *Head of a Woman*, drawing, p. 33, **p. 273**; *Nude*, drawing, p. 34; *Nude*, drawing, p. 35; *Nude*, drawing, p. 35; *Figures*, drawing, p. 36; *Nude*, drawing, p. 37; *Figure*, drawing, p. 38; *Figure*, drawing, p. 39; *Nude and Animal*, drawing, p. 40; *Figure and Animal*, drawing, p. 41; *Bull*, drawing, p. 42; *Bull*, drawing, p. 43; *Bullfight*, color lithograph, p. 44; *Bullfight*, color lithograph, p. 46; *Bullfight*, color lithograph, p. 47, **p. 278**; *Bullfight*, color lithograph, p. 49; *Bull*, drawing, p. 51; *Horse*, drawing, p. 51; sketch of a horse's head, p. 52; sketch of a horse, p. 53; *Chariot and Horses*, drawing, p. 54; *Landscape*, drawing, p. 55; *Animals*, drawing, p. 56; *Animals*, drawing, p. 57; *Animals*, drawing, p. 58; *Animals*, drawing, p. 59; *Head*, drawing, p. 60; *Head*, drawing, p. 60; *Chariot and Horses*, drawing, p. 60; notebook page, **p. 280**; *Figures*, drawing, p. 61, **p. 281**; *Figures*, drawing, pp. 62–63; *Nude*, drawing, p. 64, **p. 276**; *Figure Playing Music*, drawing, p. 64, **p. 276**; *Figure Playing Music*, p. 65, p. 277; *Painter in the Studio*, drawing, p. 66; *Figure and Interior*, drawing, p. 67; *Figure Playing Music*, drawing, p. 68; *Figure Playing Music*, drawing, p. 69; *Figure and Interior*, drawing, p. 70; *Figure and Interior*, drawing, p. 71; *Head with Hat*, drawing, p. 72; *Head with Hat*, drawing, p. 73; *Head of a Woman*, drawing, p. 73; *Head*, black-and-white reproduction, p. 74, **p. 284**; *Head*, black-and-white reproduction, p. 75, **p. 285**; *Head*, drawing, p. 76; *Head and Still Life*, drawing with colors noted, p. 77; drawing, p. 78; drawing, p. 79; *Bird*, drawing with colors noted, p. 80; *Bird*, drawing, p. 80; *Stork*, drawing, p. 81; *Sky*, drawing, p. 82; *Bird*, drawing, p. 83; *Birds*, color lithograph, p. 84; *Birds*, color lithograph, p. 86, **p. 282**; *Birds*, color lithograph, p. 87, **p. 283**; *Birds*, color lithograph, p. 89 (the last four works are

sketches for the ceiling decoration of the Etruscan Room in the Louvre); *Insect*, black-and-white reproduction, p. 90; design for a stained-glass window depicting St. Dominic for the church at Varengeville, drawing with colors noted, p. 91; drawing, p. 92; *Still Life*, drawing, p. 93; *Figures*, drawing, p. 94; *Head*, drawing, p. 94; *Figure*, drawing, p. 95; *Head*, drawing, p. 95; *Woman*, drawing, p. 96; *Woman*, drawing, p. 97; *Figure Playing Music*, drawing, p. 98; *Woman with an Umbrella*, drawing, p. 99; *Woman, Flower, and Easel*, drawing, p. 100; *Woman, Balcony*, p. 101; *Interiors*, drawing, p. 102; *Interiors*, drawing, p. 102; *Interiors*, drawing, p. 103; study of 4 chairs, p. 104; *Seated Figure*, drawing, p. 105; *Seated Woman and Still Life*, p. 106; *Seated Woman*, drawing, p. 107; *Interiors*, drawing, p. 108; *Interiors*, drawing, p. 109; *Figure*, drawing with colors noted, p. 110; *Figures in a Cafe*, p. 111; *Interiors*, drawing, p. 111; *Seated Woman*, drawing, p. 112; *Seated Woman*, drawing, p. 113; *Seated Figures*, drawing, pp. 114–115; *Head*, black-and-white reproduction, p. 116; *Vase of Flowers*, black-and-white reproduction, p. 117; *Woman*, drawing, p. 118; *Vase of Flowers*, drawing, p. 119; *Seated Woman*, drawing with colors noted, p. 120; *Head of a Woman*, drawing with colors noted, p. 120; *Woman*, drawing, p. 121; *Head*, drawing, p. 121; *Seated Woman*, drawing, p. 121; *Orange Lily, White Lily*, drawing, p. 122; *Landscape*, black-and-white reproduction, p. 123; *Leaves*, color reproduction, p. 124; *Head*, drawing, p. 125; *Vase of Flowers*, color reproduction, p. 126; *Vase of Flowers*, color reproduction, p. 127; *Flower*, black-and-white reproduction, p. 128; *Flowers*, color reproduction, p. 129; *Flowers*, black-and-white reproduction, p. 130; *Flowers*, drawing, p. 131; *Vase of Flowers*, drawing, p. 132; *Vase of Flowers*, drawing, p. 133; *Vase of Foliage*, drawing, p. 134; *Vase of Foliage*, drawing, p. 135; *Woman*, drawing, p. 136, **p. 288**; *Woman with Hats*, drawing, p. 137, **p. 289**; *Seated Woman*, drawing, p. 138; *Woman with Hat*, drawing, p. 139; study of hats, p. 140; *Head of a Woman*, drawing, p. 141; study of bicycles, p. 142; *Figure and Bicycle*, drawing, p. 143; *Animals, Crabs, Crayfish*, drawings, p. 144; *Bird*, color reproduction, pp. 146–147, **pp. 286–287**; *Animals, Fish*, p. 149; *Landscape*, drawing, p. 149; *Head*, drawing, p. 149; *Heads*, drawing, p. 150; *Vase of Foliage*, color reproduction, p. 152; *Study of an Iris*, drawing with colors noted, p. 153; *Iris*, drawing, p. 154; *Iris*, drawing, p. 155; *Iris*, drawing, p. 156; *Vase of Flowers*, color reproduction, p. 157.

BRASSAÏ (Gyula Halasz), 1899–1984. Photographer.
VERVE No. 1: *Henri Matisse's Aviary in His Paris Studio*, photographs, pp. 13–15; *Fireworks*, photograph. Photogravure, p. 59; *Tree*, photograph, p. 60; 12 photographs in *Aristide Maillol, Marly-le-Roi, 1937*, pp. 90–100, **p. 50**.
VERVE No. 2: *A Street at Night*, photograph. Photogravure, p. 105; *Horses*, photograph, p. 106.
VERVE No. 4: *The Hunt: Dogs*, photograph, p. 45;

CRÉPET, Jacques.
VERVE Nos. 5/6: "La Mendiante Rousse" [*The Red-Haired Beggar Girl*], text, p. 51.

D

DAUMAL, René, 1908–1944. Writer.
VERVE No. 3: Introduction to illustrations from *Chevalier Gentil's Souvenirs of India*, text, pp. 41–44.
VERVE Nos. 5/6: "L'Envers de la Tête" [*The Head Inside Out*], text, pp. 109–110.

DAVID, Jacques-Louis, 1748–1825. Painter.
VERVE No. 1: *Marat Assassiné*, painting. Color reproduction, p. 28; *Assassinat de Le Peletier*, reproduction of the only surviving copy of the engraving after David's painting, p. 29; *Assassinat de Le Peletier*, drawing, p. 30; *Marat Assassiné*, drawing, p. 31.
VERVE Nos. 5/6: *The Tennis Court Oath* (detail), painting. Black-and-white reproduction, p. 124.

DEGAS, Hilaire Germain Edgar, 1834–1917. Painter.
VERVE No. 4: *La Maison Tellier*, painting. Black-and-white reproduction, p. 130.
VERVE Nos. 27/28: *Femmes au Café*, painting. Color reproduction, p. 135; *Les Figurants*, painting. Color reproduction, p. 138.

DELACROIX, Eugène, 1798–1863. Painter.
VERVE No. 1: *L'Odalisque*, painting. Color reproduction, p. 26; *Woman with a Parrot*, painting. Color reproduction, p. 27.
VERVE No. 3: Study for *Women of Algiers*, p. 125; *Women of Algiers*, painting, 1834. Colorplate, pp. 126–127.

DENKSTEIN, Jenö.
VERVE No. 2: *Budapest*, photograph, p. 120, **p. 68**.

DERAIN, André, 1880–1954. Painter.
VERVE No. 4: *In the Garden of Allah*, 4 color lithographs illustrating a text by J.-C. Mardrus, pp. 89, 90, 95, 96.
VERVE Nos. 5/6: *Portrait of a Young Woman*, color lithograph, p. 72, **p. 115**; *Portrait of a Young Woman*, color lithograph, p. 73, black-and-white reproduction, **p. 115**; drawings illustrating a text by Jean Giraudoux, pp. 76–77; *Portrait*, painting. Colorplate, p. 135.
VERVE No. 8: *Calendar* by Derain (drawings, titles, signs of the zodiac) accompanying the *Calendar of Charles d'Angoulême*. *January*, title, color, p. 29; *February*, drawing, color, p. 30; *February*, title, color, p. 31; *March*, drawing, color, p. 32; *March*, title, drawing, p. 33; *April*, drawing, color, p. 34; *April*, title, color, p. 35; *May*, drawing, color, p. 36; *May*, title, color, p. 37; *June*, drawing, color, p. 38, black-and-white, **p. 130**; *June*, title, color, p. 39, black-and-white, **p. 131**; drawing, color, pp. 40–41; *July*, drawing, color, p. 42; *July*, title, color, p. 43; *August*, drawing, color, p. 44; *August*, title, color, p. 45; *September*, drawing, color, p. 46; *September*, title, color, p. 47; *October*, drawing, color, p. 48; *October*, title,

color, p. 49; *November*, drawing, color, p. 50; *November*, title, color, p. 51; *December*, drawing, color, p. 52; *Landscape, Ault*, painting. Colorplate, p. 60; *Ault*, painting. Black-and-white reproduction, p. 65.
VERVE Nos. 27/28: *Painting*, p. 125.

DEROY, Emile, 1825–1848. Painter, lithographer.
VERVE Nos. 5/6: *The Red-Haired Beggar Girl*, painting. Colorplate, with poems by Charles Baudelaire and Théodore de Banville, p. 51.

DEVAUX-BREITENBACH. Photographer.
VERVE No. 4: *The Scent Given Off by a Rose Petal*, photograph. Photogravure, p. 88.

DISDERI, André Adolphe Eugène, 1813–1889. Photographer.
VERVE Nos. 5/6: *The Parc de Neuilly, c. 1800*, photograph. Photogravure, pp. 60–61.

DORÉ, Gustave, 1833–1883. Illustrator, painter.
VERVE No. 4: *Hay-Boats on the Thames*, engraving, p. 109; *A Chiswick Fête*, engraving, p. 111; *Coffee Stall. Early Morning*, engraving. Black-and-white reproduction, p. 113.

DOS PASSOS, John Roderigo, 1896–1970. Writer.
VERVE No. 1: "Le Feu" [*Fire*], April 1937, text, p. 35.

DUMAS, Nora. Photographer.
VERVE No. 1: *Nudes*, photograph, p. 58.

DÜRER, Albrecht, 1471–1528. Painter, engraver.
VERVE Nos. 5/6: *Portrait of a Young Woman*, painting. Colorplate, p. 89.

DUTHUIT, Georges. Writer.
VERVE Nos. 37/38: "Le Tailleur de Lumière" [*The Hewer of Light*], text, pp. 75–78, 113–114, 139–140, 145–146.

E

EGER-TERMET.
VERVE Nos. 5/6: *In the Storerooms of the Louvre*, photograph. Photogravure, pp. 114–115.

ELLIOTT.
VERVE No. 2: *Georges Braque*, photograph, p. 54.

ELYTIS, Odysseus, b. 1911. Poet.
VERVE Nos. 25/26: "Equivalences Chez Picasso" [*Equivalences in Picasso's Work*], text, pp. 35, 38, 44.

ERWÉ.
VERVE No. 4: *The Sun*, photograph, p. 97.

EYCK, Jan van, c. 1370–1441. Painter.
VERVE Nos. 5/6: *The Virgin of Autun*, painting. Colorplate, p. 154.

F

FAURE, Elie, 1873–1937. Essayist, art historian.
VERVE No. 1: "Equivalences," the last text Faure wrote before he died, pp. 111–112.

FAYOUM (Egypt), portraits from
VERVE Nos. 27/28: Paintings on wooden panels (1st–4th century) by Greek artists, discovered by Champollion in Egyptian tombs. 13 photographs of portraits from Al-Fayoum, submitted by Jean Grenier, pp. 117–118, 123–124.

FERNEIX de, 18th century. Sculptor.
VERVE Nos. 5/6: Portrait busts of *Madame Favart* and *Madame de Fourville*, p. 46.

FOUQUET, Gaetan. Photographer.
VERVE No. 3: "Hindu Portfolio": 8 photographs. Photogravure. *Snake Charmer*, p. 37; *A Pupil from the University of Rabindranath Tagore*, p. 38; *Landscape*, p. 33; *Actors from a Theater in Malabar*, p. 45; *Fakir*, p. 46; *Shepherd*, p. 47; *Bathing in the Ganges*, p. 48.

FOUQUET, Jean, c. 1420–c. 1478. Painter, illuminator.
VERVE Nos. 5/6: "The Fouquets of the Condé Museum at Chantilly": *The Book of Hours of Etienne Chevalier*, 15th century. All illuminations listed below are reproduced in color-and-gold photogravure: *Etienne Chevalier Before the Virgin*, p. 157; *The Marriage of the Virgin*, p. 159; *The Birth of St. John the Baptist* (Luke 1), p. 161; *Adoration of the Magi*, p. 163; *Jesus Before Pilate*, p. 165; *Job on His Dungheap* (Job 2), p. 167; *Martyrdom of St. Apollonia*, p. 169; *Burial of Etienne Chevalier*, p. 171; *Annunciation of the Death of the Virgin*, p. 173; *Coronation of the Virgin*, p. 175; *The Trinity in Its Glory*, p. 177.
VERVE No. 9: is devoted to "The Fouquets in the Bibliothèque Nationale, Paris," preface by Paul Valéry, texts by Emile A. Van Moé. *The Establishment of the Order of St. Michael*, color illumination, p. 5; *The Antiquitates of Flavius Josephus*, captions, pp. 10–11; I *Punition de Nathan. Armed Men Doing Battle* (Antiquitates IV), p. 13; II *Prise de Jericho. Touraine Landscape* (Antiquitates V), p. 15; III *Perte de L'Arche. An Old Town* (Antiquitates VI), p. 17; IV *Désespoir du David. A Winding Valley* (Antiquitates VII), p. 19; V *La Construction du Temple. The Cathedral* (Antiquitates VIII), p. 21, **p. 136**; VI *Triomphe de Josephat. Landscape* (Antiquitates IX), p. 23, **p. 139**; VII *L'Incendie du Temple. Fighting Before a Town* (Antiquitates X), p. 25; VIII *Clémence de Cyrus. Castle* (Antiquitates XI), p. 27; IX *Entrée de Ptolemy. French Town* (Antiquitates XII), p. 29; X *Le Combat contre Bacchides. French Castle* (Antiquitates XIII), p. 31; XI *Pompeé au Temple. Memory of Rome* (Antiquitates XIV), p. 33; XII *Hérode au Temple. Another Memory of Rome* (Antiquitates XV), p. 35.
VERVE No. 11: is devoted to "The Life of Jesus" from *The Book of Hours of Etienne Chevalier*, 15th century (Musée Condé, Chantilly). Introduction by Henri Malo, pp. 4–5; captions, pp. 6–7; the illuminations are reproduced in color. I *Annunciation to the Virgin*, p. 9; II *Visitation*, p. 11; III *Nativity*, p. 13; IV *St. John at the Last Supper*, p. 15; V *The Magdalene Wiping Christ's Feet*, p. 17; VI *Arrest of Jesus*, p. 19, **p. 144**; VII *Bearing of the Cross*, p. 21; VIII

HOPPENOT, Henri.
VERVE Nos. 5/6: "Claudel à Cinquante Ans" [Claudel at Fifty], text, with a photograph of Claudel taken in Brazil, p. 52.

HOUDON, Jean-Antoine, 1741–1828. Sculptor.
VERVE Nos. 5/6: Busts of Marie Antoinette, Louise Brongniart, Sabine Houdon, Louis XIV, Diderot, p. 46.

HOYNINGEN-HUENE, George, 1900–1968. Photographer.
VERVE No. 3: (Chinese Portfolio) Statue, photograph, p. 107.

HURAULT, Charles.
VERVE No. 3: Nude, photograph, p. 122.

HUYGHE, René, b. 1906. Historian.
VERVE No. 1: "La Peinture de la Realité au XVIIIᵉ Siècle" [Reality in Eighteenth-Century Painting], text, p. 24.

I

INGRES, Jean Auguste Dominique, 1780–1867. Painter.
VERVE No. 2: The Turkish Bath, painting. Photogravure, p. 11, **p. 59**.
VERVE No. 3: Odalisque with a Slave, painting. Black-and-white reproduction, p. 128.
VERVE Nos. 5/6: Bonaparte as First Consul, painting. Black-and-white reproduction, p. 12.

J

JARRY, Alfred, 1873–1907. Writer.
VERVE Nos. 5/6: Photograph of Jarry, p. 53; "Portrait de Jarry" [Portrait of Jarry], text by Jean Saltas, p. 53; Jarry in Fencing Attire in Bonnard's Studio, drawing by Bonnard, p. 53; "La Tiare Ecrite" [Tiara of Words], text, p. 54, **p. 114**.

JOUHANDEAU, Marcel, 1888–1979. Writer.
VERVE Nos. 5/6: "Rafles de Visages" [Making Raids on Faces], text, with a drawing by Marie Laurencin, pp. 67–68, **p. 112**.

JOYCE, James, 1882–1941. Poet, novelist.
VERVE No. 2: "A Phoenix Park Nocturne," text, p. 26, **p. 60**.

K

KAHNWEILER, Daniel-Henri, 1884–1979. Art dealer, critic.
VERVE Nos. 25/26: "Le Sujet Chez Picasso" [The Subject in Picasso's Work], text, pp. 7, 8, 13, 15, 26, 27.

KANDINSKY, Wassily, 1866–1944. Painter.
VERVE No. 2: Stars, lithographs, 1938. Black-and-white color reproductions, pp. 93, 94, **pp. 62, 63**; Comets, lithograph. Color reproduction, p. 96.

KLEE, Paul, 1879–1940. Painter.
VERVE No. 3: Winter, color lithograph, p. 115, **p. 87**; Winter, lithograph. Black-and-white reproduction, p. 116, **p. 86**.

VERVE Nos. 5/6: Child's Head, color lithograph, p. 84, **p. 116**.

L

LACHAUD, Mariette.
VERVE Nos. 27/28: Varengeville, photographs, p. 70.

LANCRET, Nicolas, 1690–1743. Painter, illustrator, engraver.
VERVE No. 1: La Puce (detail), painting. Black-and-white reproduction, p. 24.

LANIEPCE.
VERVE No. 4: Photograph of Magnasco's Bohemians At Table, pp. 118–119.

LAURENCIN, Marie, 1885–1956. Painter.
VERVE Nos. 5/6: Young Woman, drawing, p. 67, **p. 112**.

LAURENS, Henri, 1885–1954. Sculptor, painter, engraver, illustrator.
VERVE No. 4: Amphion or the Musician, sculpture, p. 87, **p. 99**.
VERVE Nos. 27/28: "Henri Laurens," text by Alberto Giacometti, p. 22, **p. 242**; Daphné, color lithograph, p. 23, **p. 243**; Apollo, color lithograph, p. 24; La Bacchante, sculpture, p. 25; Reclining Nude, sculpture, pp. 26–27.

LEDOUX, Claude Nicolas, 1736–1806. Architect, illustrator.
VERVE No. 1: "Pourquoi Ne Faire Que des Maisons Carrées?" [Why Build Only Square Houses?], text and material on C. N. Ledoux, signed M. R., pp. 75–76; The Théâtre de Besançon at a Glance, p. 75; Design for a Bridge, p. 75; Cemetery, Elevation, p. 76; Design for a Cemetery, p. 76; Cemetery, Section, p. 76; Design for an Agricultural Storehouse, p. 76.

LÉGER, Fernand, 1881–1955. Painter.
VERVE No. 1: Water, color lithograph, 1937, p. 6, **p. 39**; Exposition 1037, text and drawings by Léger, p. 106, **p. 53**.
VERVE Nos. 5/6: Head and Leaf, color lithograph, 1930, p. 74.
VERVE Nos. 27/28: Country Outing, lithograph. Black-and-white reproduction, p. 83; Country Outing, color lithograph, pp. 84–85, **pp. 248–249**; Country Outing, lithograph. Black-and-white reproduction, p. 86.

LEIRIS, Michel, b. 1901. Writer.
VERVE Nos. 29/30: "Picasso et la Comedie Humaine ou les Avatars de Gros-Pied" [Picasso and the Human Comedy, or The Avatars of Fat-Foot], text, pp. 11–18, **pp. 258–269**.

LE PRAT, Thérèse, 1895–1966. Photographer.
VERVE No. 3: (Chinese Portfolio), Chinese Boy with Tulip, photograph, p. 103, **p. 85**; Chinese Countryside, photograph, p. 104, **p. 84**; The Great Wall of China, photograph, p. 104, **p. 84**; Fish, photograph, p. 119.

LÉRY, Jean de, c. 1534–c. 1613.
VERVE No. 4: Women Preparing Drinks for the Warriors, engraving. Black-and-white reproduction, p. 60.

LI CHANG-YIN, late T'ang Dynasty. Poet.
VERVE No. 3: Chinese poems: "Solitude," pp. 112–113; untitled, p. 113; "Le Luth Peint" [The Painted Lute], p. 113.

LIU YI-KING. Poet.
VERVE No. 3: "Extravaganzas," tales from the She-Shuo-Sin-Yu, by Liu (420–427, Six Dynasties period), pp. 112–113.

LIMBOURG BROTHERS (Pol, Herman, and Jean), 14th century–c. 1416. Illuminators.
VERVE No. 7: is devoted to the Calendar miniatures from Les Très Riches Heures du Duc de Berry, illustrated by the Limbourg Brothers and Jean Colombe. Introduction by Henri Malo, pp. 10–11. January. The Duke of Berry at a Banquet, p. 13; February. Village in the Snow, p. 15; March. The Château at Lusignan, p. 17; April. The Château at Dourdan, p. 19; May. The Town of Riom, p. 21; June. The Palace and Sainte-Chapelle, p. 23; July. The Château at Poitiers, p. 25, **p. 120**; August. The Château d'Étampes, p. 27; September. The Château at Saumur, p. 29; October. The Louvre, p. 31; November. Gathering Acorns, p. 33; December. The Château at Vincennes, p. 35, **p. 123**; captions, pp. 37–39.
VERVE No. 10: is devoted to Images de la Vie de Jésus from Les Très Riches Heures du Duc de Berry, illustrated by the Limbourg Brothers and Jean Colombe. Introduction by Henri Malo, pp. 4–6; captions, p. 7; Fall of Man, p. 9; Fall of the Rebel Angels, p. 11; Purgatory, p. 13; Hell, p. 15, **p. 140**; captions, pp. 18–19; Scenes from the Life of Christ, pp. 18–19; Nativity, p. 21; Annunciation to the Shepherds, p. 23; The Meeting of the Magi, p. 25, **p. 143**; Adoration of the Magi, p. 27; Purification of the Virgin, p. 29; Raising of Lazarus, p. 31; Feeding of the Five Thousand, p. 33; The Agony in the Garden, p. 35; Christ Leaving the Praetorium, p. 37; Descent from the Cross, p. 39; Entombment, p. 41; decorative illustration for the Mass for the Fourth Sunday in Lent, cover.

LIST, Herbert, 1903–1975. Photographer.
VERVE No. 2: Phantoms of Greece, photographs. Photogravure. Salvaged statues lost at sea in the 4th century, p. 57, 62; Cape Sounion, p. 58; Pastoral Scene, Acrocorinthus, p. 59; Mythological Mirages on Mt. Lycabettus, pp. 60–61; Mykonos, Child, photograph. Photogravure, p. 115.
VERVE Nos. 5/6: Cretan Shepherds, 1939, 6 photographs, pp. 111–113, 116–118.

LOTAR, Eli, 1905–1969. Photographer.
VERVE No. 1: Madrid, photograph, p. 53.

LUCAS VAN LEYDEN, 1489 or 1494–1533. Painter.
VERVE No. 4: (attrib.) Lot's Daughters, painting. Colorplate, p. 122.

M

MAAR, Dora. Photographer.
VERVE No. 1: Photograph of Picasso's *Guernica*, taken in his studio, pp. 36–37, **pp. 40–41.**

MACHATSCHEK, K.
VERVE No. 2: *Snow-Covered Tree*, photograph, p. 108; *Man Walking in the Snow*, photograph, p. 109.

MAGNASCO, Alessandro, 1667–1749. Painter.
VERVE No. 4: *Bohemians At Table*, painting. Photograph by Laniepce, pp. 118–119; *Monks At Table*, painting. Black-and-white reproduction, p. 120.

MAILLOL, Aristide, 1861–1944. Sculptor.
VERVE No. 1: Four studies. Color reproduction, p. 88; *Aristide Maillol, Marly-le-Roi, 1937*: 12 photographs by Brassaï **(p. 50)**, 7 by Blumenfeld **(pp. 51–52)**, pp. 89–104; "Maillol Devant le Modèle" [*Maillol and His Model*], text by Judith Cladel, p. 105.
VERVE Nos. 5/6: Cover designed expressly for this issue by Maillol, **p. 104;** woodcuts by Maillol illustrating excerpts from Virgil's *Georgics: Fig Tree. Figs*, p. 14; photograph of Maillol's studio by Brassaï, p. 121.

MAÎTRE DU ROI RENÉ
Cf. René d'Anjou.
VERVE No. 16: is devoted to *Le Traité de la Forme et Devis d'un Tournoi*, text by René d'Anjou. The illuminations are attributed, albeit not with certainty, to the Master of René d'Anjou. *The King of Arms Holding Four Banners*. Illumination, color, p. 7; *Two Heralds and Two Poursuivants-at-Arms Announcing the Tourney*. Black-and-white reproduction, p. 9; *The Duke of Brittany Hands Over His Sword to the King of Arms*. Black-and-white reproduction, p. 10; *The Duke of Brittany and the Duke of Bourbon in Combat*. Black-and-white reproduction, pp. 12–13, **pp. 166–167;** *The King of Arms Presents the Coats-of-Arms of Eight Lords to the Duke of Bourbon*. Black-and-white reproduction, p. 14; *The King of Arms Approaches the Four Judges*. Black-and-white reproduction, p. 15; *The King of Arms Announces the Tourney*, p. 16; *Confrontation of the Seigneur of La Gruthuyse and the Seigneur of Ghistelle*. Color and gold reproduction, pp. 18–19; *The Lists*. Black-and-white reproduction, pp. 22–23; *The Retinue of the Duke of Brittany Entering the Town*. Black-and-white reproduction, pp. 24–25; *The Contestants' Lodgings Bedecked in Coats-of-Arms, Pennants, and Banners*. Black-and-white reproduction, pp. 26–27; *Entry of the Four Judges*. Color and gold reproduction, pp. 30–31; *The Heaume* [heavy helmet]. Black-and-white reproduction, p. 33; *The Cuirass*. Black-and-white reproduction, p. 35; *The Procession Bearing the Heaumes Entering the Tourney Enclosure*. Black-and-white reproduction, pp. 36–37; *The Vambraces. The Braces*. Black-and-white reproduction, p. 38; *The Gauntlets*. Black-and-white reproduction, p. 39; *Blunted Sword and Mace*. Black-and-white reproduction, p. 40; *Inspection of the Heaumes*. Color and gold reproduction, pp. 42–43;

Inspection of the Heaumes (detail). Black-and-white reproduction, p. 45; *Padded Horse-Armor (front)*. Black-and-white reproduction, p. 46; *Padded Horse-Armor (back)*. Black-and-white reproduction, p. 47; *The Contestants Take Their Oath*. Black-and-white reproduction, pp. 48–49; *Padded Horse-Armor (pouch)*. Black-and-white reproduction, p. 50; *Padded Horse-Armor (emblazoned cover)*. Black-and-white reproduction, p. 51; *Entry of the Combatants into the Lists*. Color and gold reproduction, pp. 54–55. *The Mêlée*. Color and gold reproduction, pp. 60–61; *The Presentation of the Prize*. Black-and-white reproduction, p. 63; *The Presentation of the Prize*. Color and gold reproduction, p. 65, **p. 164.**
VERVE No. 23: is devoted to *Le Livre du Coeur d'Amour Epris* (1457), text by René d'Anjou. Set of 16 illuminations, color and gold, pp. 9–10; I *Love Gives the King's Heart to Ardent Desire*, p. 11; II *Dame Hope*, p. 13; III *The Meeting with Jealousy*, p. 15; IV *Coeur and Ardent Desire Asleep*, p. 17; V *The Spring of Fortune*, p. 19, **p. 208;** VI *Visit with Dame Melancholy*, p. 21; VII *The Knight Soulcy*, p. 23; VIII *Coeur Rescued by Dame Hope*, p. 25; IX *The Fortress of Sadness and Wrath*, p. 27; X *The Combat Between Coeur and Wrath*, p. 29, **p. 210;** XI *Ardent Desire Encounters Modest Plea*, p. 31; XII *Ardent Desire Begs Honor to Rescue Coeur*, p. 33, **p. 211;** XIII *Generosity, Coeur, and Ardent Desire*, p. 35; XIV *The Hermitage in the Forest*, p. 37; XV *The Ladies Confidante and Accord in the Boat*, p. 33; XVI *Sociability and Friendship*, p. 41.

MAKOWSKA.
VERVE No. 1: *Gobelins Tapestry-Making*, photograph. Photogravure, p. 54.

MÂLE, Emile, 1862–1954. Art historian.
VERVE No. 8: Introduction to *The Book of Hours of Anne of Brittany*, pp. 9–14, 19–24.

MALO, Henri. Curator, Musée Condé, Chantilly.
VERVE Nos. 5/6: "The Fouquets of the Condé Museum at Chantilly," text, pp. 155–156.
VERVE No. 7: "Les Très Riches Heures du Duc de Berry," text, pp. 10–11.
VERVE No. 10: "Scenes from the Life of Christ As Depicted in *Les Très Riches Heures du Duc de Berry*," text, pp. 4–6.
VERVE No. 11: "The Fouquets of Chantilly: Life of Christ," text, pp. 4–5.
VERVE No. 12: "The Fouquets of Chantilly: The Virgin and Saints," pp. 4–5.

MALRAUX, André, 1901–1976. Writer.
VERVE No. 1: "Psychologie de l'Art" [*The Psychology of Art*], text, pp. 41–48, **p. 42.**
VERVE No. 2: "Psychologie des Renaissances" [*Renaissance Psychology*], text, with reproductions of Italian paintings. 1. The Fundamental Problems of the Trecento. Excerpt from *The Psychology of Art* (book in preparation at the time), pp. 21–25.
VERVE No. 3: "De la Representation en Occident et en Extrême-Orient" [*Portrayal in the West and Far East*], text, pp. 69–72.

VERVE No. 8: "Esquisse d'une Psychologie du Cinema" [*Outlines of a Psychology of the Cinema*], text, pp. 69–73.

MANTEGNA, Andrea, c. 1430–1506. Painter, illuminator, sculptor, architect, engraver.
VERVE No. 4: *Bacchus*, engraving, pp. 128–129, **pp. 102–103.**

MARDRUS, Joseph-Charles, 1868–1949.
VERVE No. 3: "Balkis de Saba" [*Balkis of Sheba*], text, pp. 95–99.
VERVE No. 4: "Au Jardin d'Allah" [*In the Garden of Allah*], text based on an Eastern folktale, with illustrations by A. Derain, pp. 91–94.

MARIE.
VERVE No. 2: *Nude*, photograph by Marie and Borel. Photogravure, p. 92.

MARINUS. 16th century. Painter.
VERVE Nos. 5/6: *Two Bankers or Usurers*, painting. Colorplate, p. 29.

MASSIGNON, Louis, 1883–1962. Orientalist.
VERVE No. 3: "Remarque sur l'Art Musulman" [*Remarks on Moslem Art*], text, p. 16.

MASSON, André, 1896–1987. Painter.
VERVE No. 2: 2 drawings, 1938, illustrating a text by G. Bataille, pp. 97, 98–99; *Sun*, color lithograph, p. 101; *Moon*, color lithograph, p. 103, **p. 67.**
VERVE No. 4: *Summer Diversions*, painting with commentary by Masson. Colorplate, p. 81.
VERVE Nos. 27/28: Lithograph. Black-and-white reproduction, p. 39; *Mountain Stream*, color lithograph, pp. 40–41; lithograph. Black-and-white reproduction, p. 42; *Bird Over the Valley*, painting. Black-and-white reproduction, p. 43; "Monet le Fondateur" [*Monet the Founder*], text, p. 68.

MATISSE, Henri, 1869–1954. Painter.
VERVE No. 1: Cover, **p. 34;** *Henri Matisse's Aviary in His Paris Studio*, photographs by Brassaï, pp. 13–15; "Divagations," text, pp. 81, 84, **p. 45;** *Woman's Face*, drawing, p. 80, **p. 44;** *Woman Leaning on Her Elbow*, 1935, p. 81, **p. 45;** drawings on the subject of daydreaming, 1937, pp. 82, 83, 84; *Nude*, color reproduction, p. 85.
VERVE No. 3: *Seated Woman*, drawing, 1938, p. 74; *Nude*, drawing, 1938, p. 75; *Figure*, drawing, Nice, 1938, p. 76; *Composition*, painting, 1938. Colorplate, p. 77; *Odalisque with Magnolia*, painting. Colorplate, pp. 78–79; *Portrait*, painting. Colorplate, p. 80.
VERVE No. 4: 3 drawings to accompany the Calendar from *Les Heures de Rohan: Remember*, p. 9; *Flowers*, pp. 12–13; *Fruit*, p. 16; *Skater* (I), linocut, p. 51, **p. 95;** *La Danse*, color lithograph. Copy of *La Danse* (Moscow) painted expressly for *Verve*, pp. 52–53, **pp. 96–97;** *Skater* (II), linocut, p. 54, **p. 95;** *Flowers*, painting. Colorplate, p. 99; *La Desserte*, painting, 1897. Colorplate, p. 115.
VERVE Nos. 5/6: *Femme au Chapeau*, color lithograph, 1935, p. 82; *Head*, lithograph, July 1938. Black-and-white reproduction, p. 83.
VERVE No. 8: Cover designed expressly for this is-

sue, **p. 124**; *Representation of France*, painting, 1939. Colorplate, p. 6; *Head of a Woman*, drawing, December 1939, p. 7, **p. 127**.

VERVE No. 13: Cover designed expressly for this issue, Summer 1943, **p. 148**; *De la Couleur*, title page, Summer 1943, p. 5; *The Fall of Icarus*, color frontispiece, June 1943, p. 7, **p. 151**; introductory text by Matisse, August 30, 1945, pp. 9–10; *Young Woman by a Window*, drawing with colors noted, p. 11; *Young Woman by a Window, White Dress and Black Belt*, painting, September 1942. Color reproduction, p. 12; "Matisse: Conversation with Tériade" (from *Minotaure*, 1936), p. 13, **p. 158**; *The Purple Dress*, drawing with handwritten notations about colors, p. 14; *The Purple Dress*, painting, September 1942. Color reproduction, p. 15; *Young Woman in a Pink Dress*, drawing with handwritten notations about colors, p. 16; *Young Woman in a Pink Dress, Open Window and Closed Shutters*, painting, September 1942. Color reproduction, p. 17, **p. 153**; *The Black Door*, drawing with colors noted, p. 18; *The Black Door*, painting, September 1942. Color reproduction, p. 19; conversation with Tériade (*Minotaure*, 1934), p. 20; *The Lute*, drawing with colors noted, p. 21; *The Lute*, painting, February 1943. Color reproduction, pp. 23–23; *Women's Heads*, 8 drawings, pp. 24–25; *Tabac Royal*, painting, March 1943. Color reproduction, pp. 26–27, **pp. 154–155**; *Tabac Royal*, drawing with colors noted, p. 28; *Michaella*, drawing with colors noted, p. 29; *Michaella*, painting, January 1943. Color reproduction, pp. 30–31; *The Yellow Dress and the Scottish Dress*, drawing with colors noted, p. 32; *The Yellow Dress and the Scottish Dress*, painting. Color reproduction, p. 33; *Woman's Head*, 4 drawings, Haiti, March 1943, p. 34; *Red Still Life with Magnolia*, painting, December 1941. Color reproduction, p. 35; *Red Still Life with Magnolia*, drawing with colors noted, p. 36; *Still Life with Christmas Roses and Saxifrages*, drawing with colors noted, p. 37; *Still Life with Christmas Roses and Saxifrages*, painting, January 1944. Color reproduction, p. 38; *Dancer at Rest*, drawing with colors noted, p. 39, **p. 157**; *Dancer at Rest, Pink and Blue Tiles*, p. 40, **p. 156**; *Dancer, Black Background*, drawing with colors noted, p. 41; *Dancer, Black Background, The Rococo Armchair*, painting, September 1942. Color reproduction, pp. 42–43; 8 self-portraits, drawings, July 1944, pp. 44–45, **p. 159**; *The Idol*, painting, December 1942. Color reproduction, pp. 46–47; *The Idol*, drawing with colors noted, p. 48; *Lemons and Saxifrages*, drawing with colors noted, p. 49; *Lemons and Saxifrages*, painting, 1943. Color reproduction, p. 50; *Lemons on a Pink Fleur-de-Lys Background*, painting, March 1943. Color reproduction, p. 51; *Lemons on a Pink Fleur-de-Lys Background*, drawing with colors noted, p. 54; *Peaches*, painting, July 1940. Color reproduction, p. 55; *Peaches*, drawing with colors noted, p. 56; *Flowers*, p. 57.

VERVE Nos. 21/22: Cover, **p. 197**; *Ornament*, p. 28; *Young Englishwoman*, painting, 1947. Color reproduction, p. 29; *Ornament*, p. 30; *Two Girls, Bouquet of Peonies Against a Black Background*, painting, 1947. Color reproduction, p. 31; *Orna-*

ment, p. 32; *Two Girls in a Blue Interior, Black Tree*, painting, 1947. Color reproduction, p. 33; *Ornaments*, pp. 34–35; *Two Girls, Yellow and Red Background*, painting. Color reproduction, p. 36; *Ornament*, p. 37; *Two Girls, Red and Green Background*, painting, 1947. Color reproduction, p. 38; *Ornament*, p. 39; *Two Girls, Gray Background, Blue Window*, painting, 1947. Color reproduction, p. 40; *Ornament*, p. 41; *Le Silence Habité des Maisons*, painting, 1947. Color reproduction, p. 42, **p. 200**; *Blue Interior with Two Girls*, painting, 1947. Color reproduction, p. 43, **p. 201**; *Ornament*, p. 44; *Two Girls, Coral Background, Blue Garden*, painting, 1947. Color reproduction, p. 45; *Ornaments*, pp. 46–47; *Standing Nude*, painting, 1947. Color reproduction, p. 48; *Ornament*, p. 49; *Red Interior, Still Life on a Blue Table*, painting, 1947. Color reproduction, p. 50. *Still Life with Pomegranates, Black Background*, painting, 1947. Color reproduction, p. 51; *Ornament*, p. 52; *Interior with Egyptian Curtain*, painting, 1948. Color reproduction, p. 53; *Ornaments*, pp. 54–55; *Plum Blossoms, Green Background*, painting, 1948. Color reproduction, p. 56; *Ornaments*, pp. 57–60; *Interior with Black Fern*, painting, Vence, 1948. Color reproduction, p. 61; *Ornaments*, pp. 62–63; *The Pineapple*, painting, 1948. Color reproduction, p. 64, **p. 204**; *Ornaments*, pp. 65–68; *Large Interior in Red*, painting, 1948. Color reproduction, p. 69, **p. 205**; *Ornaments*, p. 70.

VERVE No. 23: Cover designed expressly for this issue, *"Le Livre du Coeur d'Amour Epris."*

VERVE Nos. 27/28: *Nude*, drawing, 1948, p. 16; *Nude*, drawing, 1948, p. 21; *Sorrow of the King*, color lithograph, 1952, p. 17; *Sorrow of the King*, color lithograph, p. 18–19; *Sorrow of the King*, color lithograph, p. 20.

VERVE Nos. 35/36: is devoted to Matisse's last works, 1950–1954. Reproduced as color lithographs, they were originally paper cut-outs which the artist painted with gouache and pasted onto paper. Also included are drawings dating from the same period or earlier. Cover designed expressly for *Verve*, **p. 304**; *Nude with Oranges*, color lithograph, p. 4; *Nude*, drawing, p. 5; *Creole Dancer*, June 1950, color lithograph, p. 10, **p. 308**; *Zulma*, 1950, color lithograph, p. 16; *Vegetables*, 1952, color lithograph, p. 20; *Snow Flowers*, 1951, color lithograph, p. 21; *Christmas Eve*, maquette for a stained-glass window, color lithograph, p. 26; *Chinese Fish*, maquette for a stained-glass window, 1951, color lithograph, p. 31, **p. 309**; *Tree*, drawing, December 1951, p. 33; *Woman*, drawing, 1951, p. 34; *Woman*, drawing, January 1951, p. 35; *Nude*, drawing, October 1949, p. 36, **p. 310**; *Sirène*, drawing, 1949, p. 37, **p. 311**; *Woman*, drawing, January 1951, p. 38; *Woman*, drawing, January 1951, p. 39; *Woman*, drawing, January 1951, p. 40; *The Negress*, 1952, color lithograph, pp. 42–43; *Nude*, drawing, 1942, p. 45; *Nude*, drawing, 1936, p. 46; *Kneeling Nude*, drawing, p. 47, **p. 315**; *Nude*, drawing, January 1942, p. 48; *Sorrow of the King*, 1952, color lithograph, pp. 50–51, **pp. 312–313**; *Nude*, drawing, 1936, p. 53; *Nude*, drawing, April 1947, p. 54; *Nude*, drawing, December 1941, p. 55; *Tree*, drawing, December 1951, p. 56; *The Parakeet*

and the Mermaid, 1952, color lithograph (foldout plate), pp. 58–60; *Nude*, drawing, p. 63; *Blue Nude*, 1952, color lithographs, pp. 64, 66–67, 69, 72, 74, 79, 81; *Nude*, drawings, pp. 70–71; *Acrobat*, drawing, p. 82, **p. 319**; *The Swimming Pool*, maquette for a piece of pottery, 1952: Panel A, color foldout, pp. 85–88; Panel B, color foldout, pp. 97–100; *Women and Monkeys*, 1952, color lithograph, pp. 92–93; *Nude*, drawing, p. 103; *Blue Nudes*, 1952, color lithographs, pp. 104, 106, **p. 316**; p. 107, **p. 317**; p. 109; *Nude*, drawing, p. 109; *Acrobats*, 1952, color lithograph, p. 112; *Tree*, drawing, 1952, p. 115; *Tree*, drawing, 1952, pp. 116–117; *Tree*, drawing, December 1951, p. 118; *Decoration-Masks*, maquette for a ceramic, 1953, color foldout, pp. 123–126, **pp. 320–321**; *Head*, drawing, pp. 129–131, **p. 322**; *Decoration. Fruit*, maquette for a ceramic, 1953 (unfinished), color foldout, pp. 134–136, **pp. 324–325**; *Apollo*, maquette for a ceramic, 1953, color lithograph, pp. 142–143; *La Gerbe*, maquette for a ceramic, 1953, color lithograph, pp. 148–149, **pp. 324–325**; *Ivy*, 1953, color lithograph, p. 152; *L'Escargot*, color composition, 1953, color lithograph, p. 154, **p. 328**; *Souvenir d'Oceanie*, 1953, color lithograph, p. 155, **p. 329**; *Ivy in Flower*, maquette for a stained-glass window, 1953, color lithograph, p. 157; *Seated Nude*, drawing, October 1944, p. 159, **p. 327**; *Nude*, drawing, p. 160; *Acanthus*, maquette for a piece of pottery, 1953, color lithograph, pp. 162–163; *Woman in an Armchair*, drawing, September 1944, p. 165, **p. 331**; *Nude*, drawing, September 1944, p. 166; *Boat*, 1952, color lithograph, p. 168; *Bather in the Reeds*, 1952, color lithograph, pp. 170–171; *Vine*, maquette for a stained-glass window, 1953, color lithograph, p. 173; *Carmen*, drawing, October 1950, p. 175; *Nude*, drawing, 1951, p. 176; *Poppies*, maquette for a stained-glass window, 1953, color lithograph, pp. 178–179; *Claude*, drawing, October 1950, p. 181; *Nude*, drawing, May 1943, p. 183; *Rose Window*, maquette for a stained-glass window, Protestant chapel, 1954, p. 183.

MAYWALD, Wilhelm, 1907–1985. Photographer.
VERVE No. 2: *Bust of a Child by Renoir*, photograph. Photogravure, p. 29; *Venus by Renoir*, photograph. Photogravure, p. 31; *Pathway on Renoir's Estate, Cagnes*, photograph. Photogravure, p. 32; *Renoir's Studio*, photograph. Photogravure, p. 33; *Cafe in the Hotel Where Van Gogh Stayed, Auvers-sur-Oise*, photograph. Photogravure, p. 34; *The Room in which Van Gogh Died, Auvers-sur-Oise*, photograph. Photogravure, p. 35.
VERVE No. 4: 3 photographs of women posing, p. 73; *La Grande Jatte*, 1938, 2 photographs, pp. 74–75; *Painter and Model*, photograph, pp. 76–77; *Lily Pond*, photograph, p. 78; *Lily Pond*, photograph, p. 79.

MICHAUX, Henri, 1899–1985. Poet.
VERVE No. 1: "Portrait du Chinois" [*Chinese Portrait*], text, p. 65.
VERVE No. 2: "Enfants" [*Children*], text, p. 114.
VERVE No. 3: "Idoles" [*Idolatry*], text, pp. 49–50, **p. 74**.

paintings in the home of Jean Ramié at Vallauris. Black-and-white reproduction, p. 12, **p. 231**; *Landscape*, oil on panel, January 23, 1950. Black-and-white reproduction, p. 13; *Landscape*, oil on canvas, February 15, 1951. Color reproduction, p. 14; *Landscape*, oil on canvas, February 16, 1951. Color reproduction, p. 14; *Landscape*, oil on canvas, February 2, 1951. Black-and-white reproduction, p. 15; *Landscape*, oil on panel, December 22, 1950. Color reproduction, pp. 16–17; *Child*, oil on panel, January 9, 1951. Black-and-white reproduction, p. 18; *Woman and Child*, oil on panel, April 23, 1950. Black-and-white reproduction, p. 19; *Children*, oil on panel, January 20, 1950. Color reproduction, p. 20; *Child*, oil on panel, January 26, 1950. Black-and-white reproduction, p. 21; *Child*, oil on canvas, January 8, 1951. Color reproduction, p. 22; *Child*, oil on canvas, January 7, 1951. Color reproduction, p. 23, **p. 223**; *Child*, oil on canvas, January 11, 1951. Black-and-white reproduction, p. 24; *Child*, oil on canvas, January 11, 1951. Color reproduction, p. 25; *Children*, oil on panel, March 18, 1951. Black-and-white reproduction, p. 26; *Children*, oil on panel, March 18, 1951. Black-and-white reproduction, p. 27; *Woman*, oil on panel, March 13, 1951. Color reproduction, p. 28; *Woman*, September 2, 1950. Black-and-white reproduction, p. 29; *Children*, oil on panel, December 25, 1950. Color reproduction, pp. 30–31; *Portrait of a Woman Leaning on Her Elbow*, August 31, 1950. Black-and-white reproduction, p. 32, **p. 222**; *Woman and Children*, oil on panel, January 25, 1951. Color reproduction, p. 33; *Vase of Flowers*, pottery, p. 34; *Animal Head*, p. 35; "Equivalences Chez Picasso" [*Equivalences in Picasso's Work*], text by Odysseus Elytis, pp. 35–38, 44; *Bull*, June 30, 1949. Black-and-white reproduction, pp. 36–37; *Vase*, pottery, p. 38; *Goat and Pregnant Woman*, pottery, p. 39; *Goat*, sculpture, p. 40; *Kid*, sculpture, p. 41; *Pregnant Woman*, sculpture, p. 42; *Woman*, sculpture, p. 44; *Bird*, sculpture, p. 44; *Birds*, sculpture, 3 photographs taken from different angles, p. 45; *Head*, ceramic. Black-and-white reproduction, p. 46; *Head*, ceramic. Black-and-white reproduction, p. 47; "Céramiques" [*Ceramics*], text by Georges Ramié, pp. 47, 58, 67, 73, **pp. 225, 226, 228**; *Head*, ceramic. Black-and-white reproduction, p. 48; *Head*, ceramic. Black-and-white reproduction, p. 49, **p. 224**; *Vases*, ceramic. Black-and-white reproduction, p. 50; *Vases*, ceramic. Black-and-white reproduction, p. 51; *Vases*, ceramic. 2 black-and-white reproductions, p. 52; *Vases*, ceramic. 2 black-and-white reproductions, p. 53; *Owl*, ceramic. Black-and-white reproduction, p. 54; *Owl*, drawing, December 27, 1949, p. 55; *Owl*, drawing, December 25, 1949, p. 55; *Statuettes*, ceramic. Black-and-white reproduction, p. 56; *Statuettes*, ceramic. Color reproduction, p. 57; drawing on stone, p. 58; *Statuettes*, ceramic, front view, p. 59; *Statuettes*, ceramic, back view, p. 59; *Statuettes*, ceramic. 2 black-and-white reproductions, p. 60; *Heads* from drawings on ceramic. Black-and-white reproduction, p. 61; *Medallions*. Photograph of 6 carved medallions, p. 62; *Head*, pottery, p. 63; *Head*,

medallion, p. 63; *Kid*, terra-cotta, p. 63, **p. 230**; *Head of a Woman*, drawing on stone, p. 64; *Head of a Woman*, drawing on stone, p. 65; *Heads*, paintings on *gazelles* (curved clay bricks). Black-and-white reproduction, p. 66; *Child*, painting on a *gazelle*. Black-and-white reproduction, p. 67; *Man*, painting on a *gazelle*. Black-and-white reproduction, p. 67; *Women*, paintings on *gazelles*. Black-and-white reproduction, p. 68, **p. 227**; *Man and Woman*, 2 paintings on *gazelles*. Black-and-white reproduction, p. 69; *Nudes*, painting on a *gazelle*. Black-and-white reproduction, p. 70; *Women*, painting on a *gazelle*. Black-and-white reproduction, p. 71; *Draped Nude*, drawing on a vase. Black-and-white reproduction, p. 72; *Draped Nude*, drawing on 2 vases. Black-and-white reproduction, p. 73; *Large Vase with Clothed Women*, 1950. Black-and-white reproduction, p. 74, **p. 229**; *Draped Nude*, drawing on a vase. Black-and-white reproduction, p. 75; *Draped Nude*, drawing on a vase. Black-and-white reproduction, p. 76; *Draped Nude*, drawing on a vase. Black-and-white reproduction, p. 77; *Nudes*, drawings on 2 vases. Black-and-white reproduction, p. 78; *Draped Nudes*, drawings on 2 vases. Black-and-white reproduction, p. 78; *Draped Nudes*, drawings on 2 vases. Black-and-white reproduction, p. 79; *Nudes*, drawings on 2 vases. Black-and-white reproduction, p. 79; *Dolls*, black-and-white reproduction of 7 dolls, p. 80; *Dolls*, black-and-white reproduction of 3 painted dolls' heads, p. 80; *Rider in Armor*, January 25, 1951. Black-and-white reproduction, p. 81; *Painter*, oil, February 22, 1950. Color reproduction, p. 82; *Rider in Armor*, January 24, 1951, II. Black-and-white reproduction, p. 83; *Couple*, oil on panel, February 8, 1950. Color reproduction, pp. 84–85; *Rider in Armor*, January 23, 1951, II. Black-and-white reproduction, p. 86; *Rider in Armor*, January 21, 1951, VIII. Black-and-white reproduction, p. 87; *War*, oil on panel, 1951. Color reproduction, pp. 88–89; *Rider in Armor*, January 23, 1951, I. Black-and-white reproduction, p. 90; *Still Life with Skull*, painting. Black-and-white reproduction, p. 96; "La Nature Morte Espagnole" [*The Spanish Still Life*], text by Jean Cassou, pp. 95, 100. VERVE Nos. 29/30: One hundred eighty drawings by Picasso. Cover designed expressly for this issue, **p. 254**; frontispiece, color reproduction, p. 4; color drawing, 1954, p. 5; introduction by Tériade, pp. 7–8; *The Painter and His Model*, Vallauris, December 14, 1953 and November 27, 1953. Color reproduction, p. 10, black-and-white, **p. 257**; "Picasso et la Comédie Humaine ou les Avatars de Gros-Pied" [*Picasso and the Human Comedy, or The Avatars of Fat-Foot*], text by Michel Leiris, pp. 11–18, **pp. 258–269**; *The Monkey and the Apple*, January 26, 1954. Color reproduction, p. 19, **pp. 258–259**; text by Rebecca West, pp. 21–24; *The Painter and His Model*, drawing, p. 25; *Couple*, drawing, December 16, 1953, p. 26; *Heads*, drawing, Vallauris, December 16, 1953, p. 27; *Couple*, drawing, December 16, 1953, p. 28; *Couple*, drawing, December 16, 1953, p. 29; *Couple*, drawing, December 18, 1953, p. 30; *Couple*, drawing, December 18, 1953, p. 31; *Couple*,

drawing, December 18, 1953, p. 32; *Couple*, drawing, December 18, 1953, p. 33; *Two Men*, drawing, December 18, 1953, p. 34; *Couple*, drawing, December 18, 1953, p. 35; *The Painter and His Model*, drawing, December 18, 1953, p. 36; *The Painter and His Model*, drawing, December 18, 1953, p. 37; *The Painter and His Model*, drawing, Vallauris, December 23, 1953, p. 38; *Les Masques*, drawing, Vallauris, December 23, 1953, p. 39, **p. 260**; *The Painter and His Model*, drawing, Vallauris, December 24, 1953, p. 40; *idem*, p. 41; *idem*, p. 42; *idem*, p. 43; *idem*, p. 44; *idem*, p. 45; *idem*, p. 46; *idem*, p. 47; *idem*, p. 48; *idem*, p. 49; *idem*, p. 50; *idem*, p. 51; *idem*, p. 52; *idem*, p. 53; *idem*, p. 54; *The Painter and His Model*, drawing, Vallauris, December 26, 1953, p. 55; *Writers*, drawing, Vallauris, December 26, 1953, p. 56; *idem*, p. 57; *idem*, p. 58; *idem*, p. 59; *idem*, p. 60; *Model Playing with a Cat*, drawing, January 3, 1954, p. 61; *idem*, p. 62; *idem*, p. 63; *idem*, p. 64; *Pierrot and Nude Woman*, drawing, January 31, 1954. Color reproduction, p. 66, **p. 262**; *Model Playing with an Animal*, drawing, January 31, 1954, p. 69; *idem*, p. 70; *Painters and Models*, drawing, January 3, 1954, p. 71; *Model Playing with a Monkey*, drawing, January 4, 1954, p. 72; *Model and Nude Playing with a Monkey*, drawing, January 4, 1954, p. 73; *Woman with a Monkey*, drawing, January 4, 1954, p. 74; *idem*, p. 75, **p. 264**; *idem*, p. 76; *Figure and Nude Woman*, color drawing, January 27, 1954, p. 79; *Model Playing with a Monkey*, drawing, January 4, 1954, p. 81; *idem*, p. 82; *idem*, p. 83; *The Painter and His Model*, drawing, January 4, 1954, p. 84; *idem*, p. 85; *idem*, p. 86; *idem*, p. 87; *idem*, p. 88; *idem*, p. 89; *idem*, p. 90; *idem*, p. 91, **p. 261**; *Masked Cupid*, drawing, January 5, 1954, p. 92, **p. 265**; *idem*, p. 93; *idem*, p. 94; *idem*, p. 95; *idem*, p. 96; *idem*, p. 97; *idem*, p. 98; *idem*, p. 99; *idem*, p. 100; *idem*, p. 101; *Model and Little Old Man*, drawing, January 5, 1954, p. 102; *Masked Cupid*, drawing, January 5, 1954, p. 103; *idem*, p. 104; *idem*, p. 105; *idem*, p. 106; *idem*, p. 107; *idem*, p. 108; *idem*, p. 109; *Circus Rider on His Horse*, drawing, January 6, 1954, p. 110; *idem*, p. 111; *idem*, p. 112; *Circus Rider and Tamer*, color drawing, January 30, 1954, II, p. 114; *Tightrope Walkers*, drawing, January 6, IV, p. 117; *Clown and Nude*, drawing, January 6, 1954, V, p. 118; *idem*, p. 119; *idem*, VII, p. 120; *idem*, VIII, p. 121; *idem*, IX, p. 122; *idem*, X, p. 123; *idem*, XI, p. 124; *Model and Masked Dwarf*, color drawing, January 29, 1954, II, p. 125; *Circus People*, drawing, January 6, 1954, XII, p. 127; *The Painter and His Model*, drawing, January 6, 1954, XIV, p. 128; *idem*, XIII (*The Studio*), p. 129, **pp. 266–267**; *The Painter and His Model*, drawing, January 7, 1954, I, p. 130; *Circus People*, drawing, January 7, 1954, II, p. 131; *Nudes*, drawing, January 7, 1954, III, p. 132; *idem*, IV, p. 133; *Satyr and Nude*, drawing, January 7, 1954, V, p. 134; *idem*, VI, p. 135; *Nudes*, drawing, January 10, 1954, I, p. 136; *Circus Rider and Circus People*, color drawing, January 31, 1954, VII, p. 138; *Circus Figures and Animals*, drawing, January 10, 1954, II, p. 141; *Animal Tamers*, drawing, January 10, 1954, III, p. 142; *Circus Acrobats*, drawing, January 10, 1954, IV, p. 143; *The*

Selected Bibliography

BOOKS PUBLISHED BY TÉRIADE

Livres de Peintres

André Beaudin
Sylvie, by Gérard de Nerval
Thirty-four original color lithographs printed by Mourlot Frères. Typesetting and printing: Imprimerie Nationale. January 1960. Format: 25 x 33 cm.

Pierre Bonnard
Correspondances
Text entirely handwritten in pen by the artist. Includes (fictitious) "Lettres de Jeunesse" [*Letters from My Youth*] with twenty-eight pencil and pen-and-ink illustrations drawn expressly for this book. August 1944. Format: 22 x 31 cm.

Marc Chagall
Les Ames Mortes by Nikolai Gogol
Ambroise Vollard asked Marc Chagall to illustrate this edition of Gogol's *Dead Souls* (French trans. Henri Mongault) in 1923. The artist engraved the copperplates in 1927, and Louis Fort printed the 118 etchings that year under Vollard's supervision. The original run appears in a version of the book prepared at the time. Assisted by Ida Chagall, Tériade resumed work on the book in 1947. Typesetting and printing: Imprimerie Nationale. March 1948. Format: 28 x 38 cm., two volumes.

Fables de La Fontaine
Ambroise Vollard asked Marc Chagall to illustrate this edition of La Fontaine's *Fables* in 1927. Maurice Potin printed the original etchings under Vollard's supervision, and they appeared in a version of the book prepared at the time. Work on the project resumed in 1950. In 1952, the artist engraved original etchings for the covers of both volumes, and they were printed by Raymond Haasen. Typesetting and printing: Imprimerie Nationale. March 1952. Format: 30 x 39 cm., two volumes.

Bible
In 1930, Ambroise Vollard asked Marc Chagall to illustrate this edition of the *Bible*, ultimately published by Tériade. Chagall spent from 1931 to 1939 engraving 105 copperplates; during that period he worked with painter-engraver Maurice

Potin to print sixty-six of these etchings. Chagall reworked and completed the remaining thirty-nine with the help of Raymond Haasen, who printed them between 1952 and 1956. Typesetting and printing: Imprimerie Nationale. December 1956. Format: 33 x 44 cm., two volumes.

Daphnis et Chloé
The forty-two original color lithographs Marc Chagall did for this edition of Longus's pastoral romance (trans. Amyot, revised and completed by Paul-Louis Courier) were printed by Mourlot Frères. Typesetting and printing: Imprimerie Nationale. March 1961. Format: 32 x 42 cm., two volumes.

Cirque
Original text by Marc Chagall. The thirty-eight original color illustrations Chagall did for this book were lithographed by Mourlot Frères. Typesetting and printing: Imprimerie Nationale. March 1967. Format: 32 x 42 cm.

Alberto Giacometti
Paris Sans Fin
Text by Alberto Giacometti written expressly for this book. One hundred fifty original lithographs printed by Mourlot Frères. Typesetting and printing: Imprimerie Nationale. March 1969. Format: 32 x 42.5 cm.

Juan Gris
Au Soleil du Plafond by Pierre Reverdy
This illustrated collection of twenty poems was published in 1955, but Reverdy and Gris came up with the idea for the book thirty years earlier. There are only eleven lithographs: Gris died in 1927, leaving half of his work on the project unfinished. A preliminary version was completed in 1926 or 1927. Printed on February 4, 1955 on the hand presses of Mourlot Frères. Format: 32 x 42 cm.

Marcel Gromaire
Macbeth by William Shakespeare
Gromaire's twenty-two original etchings for this edition of *Macbeth* (trans. François-Victor Hugo) were printed by Raymond Haasen. Typesetting and printing: Imprimerie Nationale. September 1958. Format: 28 x 38 cm.

Gaspard de la Nuit by Aloysius Bertrand
Ten stories from *Gaspard de la Nuit*, with ten origi-

nal etchings Gromaire engraved in 1930; printed in 1962 by Raymond Haasen. Typesetting and printing: Imprimerie Nationale. September 1962. Format: 33 x 25 cm.

Henri Laurens
Les Idylls by Theocritus
Woodcuts by Théo Schmied after thirty-eight illustrations by Henri Laurens. Embossed cover by Laurens. Printed on the hand presses of Théo Schmied, G. Rougeaux, and R. Dré. January 1945. Format: 25 x 33 cm.

Loukios ou l'Ane [Lucius, or The Ass] by Lucian of Samostata
Fifty-eight original woodcuts by Henri Laurens. Typesetting and printing (of text and illustrations) by Pierre Boucher. December 1946. Format: 21 x 29.5 cm.

Dialogues by Lucian of Samostata
Henri Laurens's thirty-four original color woodcuts for this edition of Lucian's *Dialogues* (trans. Emile Chambry) were printed on the hand presses of Théo Schmied. May 1951. Format: 29.5 x 39 cm.

Le Corbusier
Poème de l'Angle Droit
Written and designed entirely by Le Corbusier, with twenty-one color and seventy black-and-white lithographs printed by Mourlot Frères. September 1955. Format: 32 x 42 cm.

Fernand Léger
Cirque
Both handwritten text and illustrations were produced through original lithographs (thirty-five color and thirty black-and-white) by Fernand Léger. Printing: Mourlot Frères. October 1950. Format: 32 x 42 cm.

La Ville
Léger worked on this book (which was to have been similar to *Cirque*) the last three years of his life. Thirty prints completed at the time of his death were reproduced as a set of original color lithographs by Mourlot Frères. 1958. Format: 60 x 65 cm.

Henri Matisse
Lettres de la Religieuse Portugaise [Letters of a Portuguese Nun] by Mariana Alcoforado
Sixty-eight original lithographs by Matisse, who also

396

designed the maquette, cover, inset plates, initial letters, and ornaments. Lithograph printing: Mourlot Frères. Typesetting: Joude et Allard. 1946. Format: 22 x 26.5 cm.

Jazz
Handwritten text by Henri Matisse. Twenty stencil colorplates (including fifteen two-page spreads) after collages and paper cut-outs by Matisse. The printer, Edmond Vairel, used the same Linel gouaches as the artist. Cover and handwritten pages engraved and printed by Draeger Frères. An album comprising plates only was also produced. September 1947. Format: 32 x 42 cm.

Poèmes de Charles d'Orléans
Handwritten book entirely designed by Henri Matisse. One hundred lithographs printed by Mourlot Frères. 1950. Format: 26.5 x 41 cm.

Une Fête en Cimmière by Georges Duthuit
Thirty-one original lithographs (including one on the cover) by Henri Matisse (1949), printed on the hand presses of Mourlot Frères. Text typeset and printed by the Imprimerie Nationale. 1949. Format: 13.5 x 29.5 cm.

Joan Miró
Ubu Roi by Alfred Jarry
Thirteen original lithographs by Joan Miró, printed by Mourlot Frères. Typesetting and printing: Imprimerie Nationale. April 1966. Format: 32 x 42 cm.

Ubu aux Baléares
Designed by Joan Miró. Handwritten preface, twenty-three original color lithographs, and title page all by the artist. November 1971. Format: 50.6 x 66 cm.

Pablo Picasso
Le Chant des Morts by Pierre Reverdy
Handwritten poems by Pierre Reverdy. One hundred twenty-four original lithographs by Picasso, printed by Mourlot Frères. Texts printed by Draeger Frères. 1948. Format: 32 x 42 cm.

Georges Rouault
Divertissement
Handwritten book painted in its entirety by Georges Rouault, with fifteen color prints done expressly for this book. Engraving and printing: Draeger Frères. February 1943. Format: 32 x 42 cm.

Jacques Villon
Les Travaux et les Jours [Works and Days] by Hesiod
Nineteen original color etchings by Jacques Villon, printed by Crommelynck and Georges Leblanc. Typesetting and printing: Imprimerie Nationale. July 1962. Format: 28 x 38 cm.

Albums and Monographs

No survey of Tériade's publishing career would be complete without mentioning four books that appeared between 1953 and 1961, which were of great importance to him: two albums of photographs by Henri Cartier-Bresson, and monographs on Beaudin and Borès.

Photography Albums

Images à la Sauvette
Marguerite Lang came up with the title for *Images à la Sauvette* [Pictures on the Sly], which was published in 1953. Original cover by Henri Matisse. Text, and 126 photographs taken throughout the world, by Cartier-Bresson.

Les Européens
Les Européens was published in 1955. Original cover by Joan Miró. One hundred fourteen photographs by Cartier-Bresson taken in Europe (Germany, England, Austria, Spain, France, Greece, Ireland, Italy, Switzerland, and the Soviet Union) between 1950 and 1955. Text and captions by Cartier-Bresson. "In the old days they used to illustrate world geography with pictures of great monuments or ethnic 'types.' Today, photography provides a human element that both supplements and discomfits that viewpoint."

Monographs

André Beaudin
This book, published during the summer of 1961, covers the artist's work from 1921 to 1961. Text by Georges Limbour.

Francisco Borès
Appearing at the same time as the *Beaudin* monograph, this book is similar in size and style. It was no coincidence: both artists suffered the same historical fate, caught between Cubism, whose legacy they had absorbed, and Surrealism, to which they refused to commit themselves (Borès less so than Beaudin). They stood apart, in proud isolation, as they do to this day. Tériade had wanted to do a major book with Borès; despite a number of plans, the project never came to fruition. Jean Grenier wrote a text on Borès's oeuvre (1925–1960) at Tériade's request.

Musée des Grandes Architectures Series

Four books on French architectural achievements, were a joint publishing venture of Tériade and Draeger:

Versailles (text by Michel Mauricheau-Beaupré)
Fontainebleau (text by Charles Terrasse)
Les Châteaux de la Loire (text by Charles Terrasse)
Chartres (text by Louis Grodecki)

PRINCIPAL PUBLICATIONS ABOUT TÉRIADE

Hommage à Tériade. Text by Michel Anthonioz, preface by Jean Leymarie, envoi by Bernard Anthonioz. Centre National d'Art Contemporain, Paris, 1973.

"Hommage à Tériade." Text by François Chapon (nine pages). *Bulletin du Bibliophile*, 1973–II, Paris.

Hommage à Tériade. Text by Michel Anthonioz, preface by W. T. Monnington. Royal Academy of Arts, London, 1975.

Ommagio a Teriade. Text by Michel Anthonioz, preface by Giovanni Spadolini. Alberto Marotta, Naples, 1976.

De Bonnard à Miró—Homenaje a Teriade. Text by Michel Anthonioz. Ministerio de Educación y Ciencia, Madrid, 1977.

Hommage à Tériade. Text by Michel Anthonioz, prefaces by Jean-Pierre Brunet, Christoph B. Rüger, Bernd Schürmann, Bernard Anthonioz, and Jean Leymarie. Rheinland Verlag GmbH, Cologne, 1978.

Tériade Éditeur—Revue Verve: Livres Illustrés du XXe Siècle. Catalogue of June 8, 1978 auction sale at Kornfeld's in Berne, Switzerland. Kornfeld und Klipstein, Berne, 1978.

De Bonnard à Miró—Homenagen a Teriade. Text by Michel Anthonioz. Editados pela Fundasão Calouste Gulbenkian, Lisbon.

Μια Ακομη προεθορα Του. Text by Yannis Tsaroukis. Ζυτοε Magazine, Athens, 1979.

Bonnardtól Miroig—Hommage à Tériade. Text by Michel Anthonioz, prefaces by Jacques Lecompt, Bernard Anthonioz. Budapest, 1981.

Καθαλογος Μονγειον—Βιβλιοτηκης—Στρατη Ελενθερκαδη (Tériade). Text by Michel Anthonioz, preface by Manalis Kalyenis. 1985.

Le Peintre et le Livre by François Chapon. Flammarion, Paris, 1987.